Handbook

Pricing & Ethical Guidelines

9th

e d i t i o n

EDITORIAL

Director & project coordinator,
Paul Basista, CAE

Project manager
Simms Taback

Editor
Rachel Burd

Research & editorial production
Yvonne Perano

Counsel
Charles T. McGrath, Esq.

GRAPHIC ARTISTS GUILD

Executive Director
Paul Basista, CAE

National President
Polly Law

DESIGN AND PRODUCTION

Art direction
Simms Taback

Cover art
John Craig

Interior design & prepress
Marilyn Rose Design

Cover printing
Phoenix Color Corp.

Film for book interior
Typeline

Interior printing & binding
Maple Vail Book Manufacturing Group
Vail-Ballou Press

Publisher
Graphic Artists Guild, Inc.

Distributors to the trade
North Light Books
A Division of F&W Publications, Inc.
1507 Dana Avenue
Cincinnati, OH 45207
1.800.289.0963

Direct-mail distribution
Graphic Artists Guild
90 John Street, Suite 403
New York, NY 10038
Voicemail: 1.800.878.2753
http://www.gag.org

Contents

.

Foreword

When I took my first stab at entering this profession I was 15 years old and still in high school. Eagerly, I dropped off my portfolio of cartoons and drawings with a very famous magazine art director. I didn't realize until I returned to fetch it the next day that "drop off" was actually synonymous with "drop dead." There was no indication that he had looked at it. I didn't even receive a preprinted rejection note for my trouble. The experience was so humiliating that it took another year before I gathered my courage to make another foray into the unknown.

I still had no idea what to expect. All I knew then was that I wanted to be a commercial artist. So what I lacked in knowledge I made up for in chutzpah.

Nevertheless, I would have welcomed a guide. If not a warm-blooded mentor, then some kind of road map to steer me through the maze of art directors, art buyers, studio managers, and other such powerful folk who guarded the gates like bouncers at a hip nightspot. Even as I became more experienced, there were always new situations, new practices and traditions, to learn by trial and error in order to succeed. Instead, I felt like a pinball bounced around from one office to the next, until finally, luckily, and gratefully I hit my own jackpot—a small newspaper, where I got my first break.

Back in the late 1960s there was no Graphic Artists Guild, and the exclusive professional clubs and organizations wouldn't accept a novice or even a midlevel practitioner in their ranks. There were no guides or docents to walk one through or explain the ins and outs of the field. Sure, it was comparatively smaller then, but that didn't mean it was any easier. In fact, it was harder; the community was very tight-knit.

Enter the Graphic Artists Guild, and thank heavens for the *Pricing & Ethical Guidelines*. It is a needed and welcome tool. While talent is still the requisite, knowledge levels the playing field. This volume may not prevent all the problems young and old practitioners may encounter, but it is insurance against many of them.

<div align="right">

Steve Heller
The New York Times

</div>

To the
113 Detroit artists
who founded the
Graphic Artists Guild
1967-1997

President's
Prologue

Many pundits and futurists have labeled the current era the Age of Information. In reality, we in the graphics community have always lived in the age of information. Our function is the presentation and distribution of information. Some of us commission it, some of us create it, some of us prepare, and some of us distribute. Together we provide the world with the ideas and images that persuade, entertain, teach, and decorate, but, most of all, we inform. The only factor that sets the late twentieth century apart is the technology we employ. Whether the work is done by block print or the latest HTML Website graphic, it is still information.

In order to promote the fairest and most ethical dealings between creators and the rest of this community, and therefore increase the flow of information, the Graphic Artists Guild produces the book you now hold in your hands. The *Graphic Artists Guild Handbook: Pricing & Ethical Guidelines* is the embodiment of the

Guild's mission to its members and other stakeholders. We endeavor to survey and distill the experience of thousands of graphic artists and then present it in a form that is as clear, concise, and readable as possible. In the best of all possible worlds, this book would not be necessary. But we do not live in such a utopia. This *Handbook*, then, is the antidote to the various ills of our industry from lowballing on prices to infringement in the form of "comping." Our industry, which should be the most keenly aware of the deleterious effects of these and other practices like them, continues to be undermined. In the race to the bottom, we all end up in the sludge.

So, read and use the *Handbook*, remember the Golden Rule, or at least keep in mind a message I once got from an almond cookie: "Good things are not cheap, cheap things are not good."

Insolitores res contiguerunt

Polly Law
National President

Acknowledgments

oducing the *Handbook: Pricing & Ethical Guidelines* is a massive undertaking requiring the coordination and input of dozens of volunteers, experts, and staff. Every one of them shares the commitment that this new edition contain the most current information. The individuals and organizations listed here, contributing time and expertise to this project, are the reasons for its continued success. Without their participation, this monumental project would not have occurred. The last three editions, each with three printings, all reached or exceeded 50,000 sold-out copies. We expect this ninth edition to do even better.

Special thanks are due to Simms Taback, who has art directed and supervised the production of every edition of the *Handbook* since the first edition in 1973. With his extraordinary guidance, his brainchild has matured from a 20-page booklet to a major resource for buyers and sellers in the visual communications industries. Special thanks are also due to Rachel Burd, editor; Marilyn Rose, graphic designer; Yvonne Perano, researcher; and Rivka Oldak, statistician.

Paul Basista, CAE
Executive Director
Project Coordinator

Daniel Abraham
Kathie Abrams
Mike Adams
Ray Alma
Tammy Aramian
Ilene Avery
Carol Bancroft
Shawn Banner
Judith Barker
Tom Batiuk
Bruce Beattie
Bruce Blank
Mary Bono
Elizabeth Bourne
Theresa Bower
Larry Brady
Steven Brodner
Lou Brooks
Steven Brower
Terrence Brown
Kathy Brown-Wing
Diana Bryan
Ernest Burden
Julia Hierl Burmesch
Terrence Carroll, Esq.
Fred Carlson
CHID
Anne Cicale
Tad Crawford, Esq.
Margaret Cusack
Kathy Davis
Paul Davis
Robert Dunleavey
John Ennis
Ross Evertson
Teresa Fasolino
Joe Feigenbaum
Charles Field
Joanne Fink
Jamie Fogle
Cameron Foote
Eric N. Fowler
Mort Gerberg
Karen Lynn Gilman
Dale Gladstone
Roz Goldfarb
Melanie Hope Greenberg
Ric Gref
Sam Gross
Larry Hama
Neil O. Hardy
Lesley Ellen Harris, Esq.
Art Heisner

Steven Heller
Arnold Hendrick
Mark Hess
DK Holland
Diana G. Ison
Larry Jacobs
Iskra Johnson
William Just
Steffie Kaplan
Harriet Kasak
Matthew Kelly
Mona Kiely
Lara Kisielewska
Josh Klein
Jerry Klein
Tom Klem
Terry Knight
Ruth Kolbert
Debra Kovacs
Ken Krug
Wendy Lambert
Polly M. Law
Nancy Lawrence, Esq.
Amy Kilgallen Lee
Jared Lee
Mike Lee
H. B. Lewis
Ellie Lipetz
Richard Lipton
Lorraine Louie
Jeff Massie
Doug May
Michael Mazzeo
Wilson McLean
William T. McGrath, Esq.
Jim McMullan
Wendell Minor
Robert Mollenhauer,
 CPA PC
Jacqui Morgan
Vicki Morgan
Kristen Mosbaek
Barbara Nessim
Rivka Oldak
Regina Ortenzi
Michael Partington
Daniel Pelavin
Maria Pallante, Esq.
Marybeth Peters, Esq.
Nannette Petruzzelli, Esq.
Bob Pinaha
Michael Pinto
Katherine Radcliffe

Lorna Reeves
Duncan Reid, Esq.
John Reiner
Ellen Rixford
Willie Rosas
Peter Ross
Sharon Rothman
Susan Rudich
Reynold Ruffins
Jeff Seaver
Liane Sebastian
Gregg Seelhoff
Fran Seigel
Glen Serbin
Paul Shaw
Elwood Smith
Laura Smith
Martha Spelman
Lee Stewart
Stephanie Stouffer
David Tabor
Barbara Torode
Ezra Tucker
Peggy Veltri
Greg Victoroff, Esq.
Sam Viviano
Rosemary Volpe
Carol Wahler
James Waldron
Bill Westwood
Bridey Whelan
Roger Whitehouse
David Wilcox
Charles Woods
John Workman
Jennie Yip
Mark Yurkiw
Paul O. Zelinsky
Kathy Ziegler

American Institute of
Graphic Arts

American Society of
Architectural
Perspectivists

Association of Medical
Illustrators

Broadcast Design
Association

Canadian Association of
Photographers and
Illustrators in
Communications

Children's Book
Illustrators' Group

Creative Access

Fashion Roundtable

Joint Ethics Committee

Letter Arts Review

Motion Picture Screen
Cartoonists, Local 839,
IATSE

National Cartoonists
Society

Serbin Communications

Society of Broadcast
Designers

Society of Children's
Book Writers and
Illustrators

Society of Environmental
Graphic Design

Society of Graphic
Designers of Canada

Society of Illustrators

Type Directors Club

U.S. Copyright Office

Introduction

For almost 25 years, the *Graphic Artists Guild Handbook: Pricing & Ethical Guidelines* has provided both graphic artists and their clients with compilations of current pricing methods, ranges, and professional business practices applied throughout the visual communications industry. The growing complexity of uses, fee arrangements, advancing technologies, and business and financial considerations makes information of this type essential for all participants in the field.

We work very hard to improve each edition, with impressive results. The extraordinarily successful eighth edition, reprinted three times, has nearly 52,000 copies in circulation. We believe this new ninth edition of the *Handbook* is even better.

Legal Rights and Issues is updated with new legislative initiatives, recent court decisions, and current trade practices that affect the sale of artwork and design. The nature of the global market prompted an examination of international issues, and this chapter compares and contrasts Canadian and U.S. copyright laws. The revised Professional Issues chapter discusses tax issues (including the problematic area of sales tax), employment issues, cancellation and rejection provisions, speculation, and contests and competitions.

The dramatic impact computers have had on the industry is discussed in the chapter on New Technology Issues. Most important, this edition reflects current pricing information for illustration and design for audiovisual works, multimedia, CD-ROMs, and the World Wide Web.

Introduction

.

For almost 25 years, the *Graphic Artists Guild Handbook: Pricing & Ethical Guidelines* has provided both graphic artists and their clients with compilations of current pricing methods, ranges, and professional business practices applied throughout the visual communications industry. The growing complexity of uses, fee arrangements, advancing technologies, and business and financial considerations makes information of <u>this type essential</u> for all participants in the field.

We work very hard to improve each edition, with impressive results. The extraordinarily successful eighth edition, reprinted three times, has nearly 52,000 copies in circulation. We believe this new ninth edition of the *Handbook* is even better.

Legal Rights and Issues is updated with new legislative initiatives, recent court decisions, and current trade practices that affect the sale of artwork and design. The nature of the global market prompted an examination of international issues, and this chapter compares and contrasts Canadian and U.S. copyright laws. The revised Professional Issues chapter discusses tax issues (including the problematic area of sales tax), employment issues, cancellation and rejection provisions, speculation, and contests and competitions.

The dramatic impact computers have had on the industry is discussed in the chapter on New Technology Issues. Most important, this edition reflects current pricing information for illustration and design for audiovisual works, multimedia, CD-ROMs, and the World Wide Web.

Daniel Abraham
Kathie Abrams
Mike Adams
Ray Alma
Tammy Aramian
Ilene Avery
Carol Bancroft
Shawn Banner
Judith Barker
Tom Batiuk
Bruce Beattie
Bruce Blank
Mary Bono
Elizabeth Bourne
Theresa Bower
Larry Brady
Steven Brodner
Lou Brooks
Steven Brower
Terrence Brown
Kathy Brown-Wing
Diana Bryan
Ernest Burden
Julia Hierl Burmesch
Terrence Carroll, Esq.
Fred Carlson
CHID
Anne Cicale
Tad Crawford, Esq.
Margaret Cusack
Kathy Davis
Paul Davis
Robert Dunleavey
John Ennis
Ross Evertson
Teresa Fasolino
Joe Feigenbaum
Charles Field
Joanne Fink
Jamie Fogle
Cameron Foote
Eric N. Fowler
Mort Gerberg
Karen Lynn Gilman
Dale Gladstone
Roz Goldfarb
Melanie Hope Greenberg
Ric Gref
Sam Gross
Larry Hama
Neil O. Hardy
Lesley Ellen Harris, Esq.
Art Heisner

Steven Heller
Arnold Hendrick
Mark Hess
DK Holland
Diana G. Ison
Larry Jacobs
Iskra Johnson
William Just
Steffie Kaplan
Harriet Kasak
Matthew Kelly
Mona Kiely
Lara Kisielewska
Josh Klein
Jerry Klein
Tom Klem
Terry Knight
Ruth Kolbert
Debra Kovacs
Ken Krug
Wendy Lambert
Polly M. Law
Nancy Lawrence, Esq.
Amy Kilgallen Lee
Jared Lee
Mike Lee
H. B. Lewis
Ellie Lipetz
Richard Lipton
Lorraine Louie
Jeff Massie
Doug May
Michael Mazzeo
Wilson McLean
William T. McGrath, Esq.
Jim McMullan
Wendell Minor
Robert Mollenhauer,
 CPA PC
Jacqui Morgan
Vicki Morgan
Kristen Mosbaek
Barbara Nessim
Rivka Oldak
Regina Ortenzi
Michael Partington
Daniel Pelavin
Maria Pallante, Esq.
Marybeth Peters, Esq.
Nannette Petruzzelli, Esq.
Bob Pinaha
Michael Pinto
Katherine Radcliffe

Lorna Reeves
Duncan Reid, Esq.
John Reiner
Ellen Rixford
Willie Rosas
Peter Ross
Sharon Rothman
Susan Rudich
Reynold Ruffins
Jeff Seaver
Liane Sebastian
Gregg Seelhoff
Fran Seigel
Glen Serbin
Paul Shaw
Elwood Smith
Laura Smith
Martha Spelman
Lee Stewart
Stephanie Stouffer
David Tabor
Barbara Torode
Ezra Tucker
Peggy Veltri
Greg Victoroff, Esq.
Sam Viviano
Rosemary Volpe
Carol Wahler
James Waldron
Bill Westwood
Bridey Whelan
Roger Whitehouse
David Wilcox
Charles Woods
John Workman
Jennie Yip
Mark Yurkiw
Paul O. Zelinsky
Kathy Ziegler

American Institute of
Graphic Arts

American Society of
Architectural
Perspectivists

Association of Medical
Illustrators

Broadcast Design
Association

Canadian Association of
Photographers and
Illustrators in
Communications

Children's Book
Illustrators' Group

Creative Access

Fashion Roundtable

Joint Ethics Committee

Letter Arts Review

Motion Picture Screen
Cartoonists, Local 839,
IATSE

National Cartoonists
Society

Serbin Communications

Society of Broadcast
Designers

Society of Children's
Book Writers and
Illustrators

Society of Environmental
Graphic Design

Society of Graphic
Designers of Canada

Society of Illustrators

Type Directors Club

U.S. Copyright Office

President's
Prologue

Many pundits and futurists have labeled the current era the Age of Information. In reality, we in the graphics community have always lived in the age of information. Our function is the presentation and distribution of information. Some of us commission it, some of us create it, some of us prepare, and some of us distribute. Together we provide the world with the ideas and images that persuade, entertain, teach, and decorate, but, most of all, we inform. The only factor that sets the late twentieth century apart is the technology we employ. Whether the work is done by block print or the latest HTML Website graphic, it is still information.

In order to promote the fairest and most ethical dealings between creators and the rest of this community, and therefore increase the flow of information, the Graphic Artists Guild produces the book you now hold in your hands. The *Graphic Artists Guild Handbook: Pricing & Ethical Guidelines* is the embodiment of the Guild's mission to its members and other stakeholders. We endeavor to survey and distill the experience of thousands of graphic artists and then present it in a form that is as clear, concise, and readable as possible. In the best of all possible worlds, this book would not be necessary. But we do not live in such a utopia. This *Handbook*, then, is the antidote to the various ills of our industry from lowballing on prices to infringement in the form of "comping." Our industry, which should be the most keenly aware of the deleterious effects of these and other practices like them, continues to be undermined. In the race to the bottom, we all end up in the sludge.

So, read and use the *Handbook*, remember the Golden Rule, or at least keep in mind a message I once got from an almond cookie: "Good things are not cheap, cheap things are not good."

Insolitores res contiguerunt

Polly Law
National President

Acknowledgments
• • • • • • • • • • • • • • •

oducing the *Handbook: Pricing & Ethical Guidelines* is a massive undertaking requiring the coordination and input of dozens of volunteers, experts, and staff. Every one of them shares the commitment that this new edition contain the most current information. The individuals and organizations listed here, contributing time and expertise to this project, are the reasons for its continued success. Without their participation, this monumental project would not have occurred. The last three editions, each with three printings, all reached or exceeded 50,000 sold-out copies. We expect this ninth edition to do even better.

Special thanks are due to Simms Taback, who has art directed and supervised the production of every edition of the *Handbook* since the first edition in 1973. With his extraordinary guidance, his brainchild has matured from a 20-page booklet to a major resource for buyers and sellers in the visual communications industries. Special thanks are also due to Rachel Burd, editor; Marilyn Rose, graphic designer; Yvonne Perano, researcher; and Rivka Oldak, statistician.

<div align="right">

Paul Basista, CAE
Executive Director
Project Coordinator

</div>

Pricing and Marketing Artwork is designed to help sellers and buyers understand how business is transacted, and it includes tips on negotiating the best deals. The sections on the $102 billion licensing and merchandising market was updated and expanded, as were other areas concerning secondary markets for reuse, which are increasingly important to artists.

The Prices and Trade Customs chapters for each discipline reflect the results of latest surveys. More than 24,000 surveys were sent to illustrators and designers in the United States and Canada. The responses were compiled, tabulated, and analyzed. Ranges, when they appear, reflect the most statistically frequent number of responses. This implies, of course, that there are individuals who do much better than the indicated ranges, as well as others who do not do as well as even the lowest indicated response.

Our Standard Contracts were revised and expanded, and provide the most complete set of forms ever assembled for all work specialties in the industry. Artists and designers are encouraged to adapt these model agreements to their personal circumstances.

The mission of the Graphic Artists Guild is to promote and protect the economic inter-

ests of its members. It is committed to improving conditions for all creators of graphic art and raising standards for the entire industry. We strongly believe this effort helps realize that purpose. Nevertheless, each artist should independently decide how to price his or her work. The purpose of the *Graphic Artists Guild Handbook: Pricing & Ethical Guidelines* is to inform each artist fully so that he or she may independently decide how to price his or her work.

We have no doubts that the result of our efforts, now in your hands, will be more valuable to you than its predecessors. No other trade reference in the lightning-paced communications industry has so much useful information in one place (no wonder it's often called the "bible" of the industry).

The *Graphic Artists Guild Handbook: Pricing & Ethical Guidelines* is not a product but a process. As the visual communications industry changes and grows, so will this book. Be part of the process—forward your comments and suggestions for future editions.

Paul Basista, CAE
Executive Director
Project Coordinator

THE
Professional
RELATIONSHIP

The professional
relationship

• • • • • • • • • • • • • •

G raphic artists often specialize, focusing their talents to serve markets within the communications industry such as magazine or book publishing, or on corporations, manufacturers, retailers, advertising agencies, or broadcasting companies. Clients may be individuals, small companies, or conglomerates. Some clients purchase art on a regular basis and some are first-time, one-time, or infrequent buyers.

How artwork is commissioned

The client

A client may commission artwork from an artist directly or indirectly, through an artist's representative or other agent. The Guild recommends that a written agreement be signed by both parties prior to beginning the work. For more information about contracts, please refer to the Pricing and Marketing Artwork and Standard Contracts

and Business Tools chapters.

Regular buyers usually have staff specifically responsible for purchasing: i.e., art directors or other representatives with expertise in commissioning art assignments. In a large corporation, for example, the art director, art buyer, or stylist probably has some experience in professional practices and pricing. Clients occasionally contract with an art director, design firm, studio, or agency to hire artists for a particular project .

In both cases clients, as the experts in their fields, must communicate their needs and

objectives to the graphic artists in terms of the product and the market. Using their particular style and expertise, artists offer the client solutions to the visual communications problem posed.

The practical basis of a successful partnership between clients and artists is ethical professional practices as well as the ability to describe problems effectively and envision solutions.

During initial meetings, artists and clients discuss the design problem in terms of the client's objectives and possible solutions, fees, usage, and contract terms. These discussions create a relationship that addresses the concerns of both parties.

The art director

In many organizations, art directors manage a number of projects or accounts simultaneously. They are responsible for finding the artists, negotiating the terms of the job, and supervising the assignment to ensure its proper execution within prescribed budgeting and time constraints. Art directors base their choices of talent for a project on their knowledge of the client's concerns and on the diverse styles of the professionals available. An art director may rely on talent sourcebooks, advertising directories, or major trade publications, call in artists to review their portfolios, place ads in the papers, or contact employment services.

When speaking with artists, art directors need to be familiar with the time schedule for the project, the budget, how the artwork will be used, and a variety of other factors. Freelance artists then negotiate appropriate rights, terms, and fees with the art director or client for that specific project. The factors used to determine those terms are described in this book.

Advertising agencies

Artwork for advertising agencies usually is purchased by an art buyer and/or art director who work together to select the freelance artists to be used on a job; the buyer usually is responsible for negotiating purchase of usage rights and other terms. Art buyers often handle the budgets, schedules, traffic, and invoicing on each freelance assignment.

Often an art buyer will oversee the assembling of a selection of freelance artists' portfolios for review by the creative group, who choose artists based on the style of art needed and the portfolio submitted.

At the time of assignment, most agencies provide artists with a purchase order that details the rights purchased, ownership of the art, delivery dates for sketch and finish, prices for the completed assignment, the cancellation fee at sketch and finish stages, and any additional expenses that will be covered, such as delivery charges or shipping. All terms on a purchase order may be negotiated until ones agreeable to both parties are reached.

When both parties have signed the purchase order, it signifies that an understanding (i.e., a contract) between them has been reached. As contractors, artists and designers should take responsibility for sending a contract that sets out the understanding. A Confirmation of Engagement does this nicely; see the Standard Contracts and Business Tools chapter for a sample form. Rights purchased may be in any or all of a number of categories, which should be spelled out in the purchase order. Each artist should decide independently how to price each usage of his or her work. Roughly in order of increasing value, some of these categories are:

♦ *presentation and research*: generally purchased at the lowest rates in the advertising market, since the material will be used only in-house or in front of small groups. Agreements permitting more extensive uses generally will indicate that additional fees will be paid.

♦ *test market:* historically purchased at low rates for use in a limited number of markets. As in presentation and research use, an artist's agreement should cover additional fees if use is expanded.

♦ *display/trade shows/PR usage.*

♦ *electronic rights.*

♦ *point-of-purchase:* includes all point-of-sale materials such as signs, leaflets, shopping cart posters, catalogs, brochures, counter displays, etc.

♦ *outdoor use:* all posters that are not point-of-sale, such as billboards, painted bulletins, 30-sheet posters, transit posters, bus shelters, etc.

♦ *publication:* includes use in newspapers, magazines, Sunday supplements, internal publications, and any material included as part of a publication, such as freestanding inserts or advertorials.

♦ *TV use:* television rights only.

The above categories are examples of purchases of limited rights, which may range from one-time to extensive use. All rights being granted are expressed clearly in the purchase order and normally name a specific market category, medium, time period, and geographic region:

for example, national (region) consumer magazine (medium) advertising (market area) rights for a period of one year (time). Exclusivity within the markets purchased ("noncompetition") usually is guaranteed. Sale of the original artwork is a separate transaction.

Noncompeting rights may be sold elsewhere, unless purchase orders are signed to the contrary. Artists should note that many clients who use their artwork for high-exposure products and services may seek to purchase additional rights. Fees should be adjusted accordingly.

♦ *unlimited rights:* the purchase of all rights connected with the product for all media in all markets for an unlimited time. In this sale, the artist retains the copyright. Rights that do not compete with the purchaser's product may be sold.

♦ *exclusive unlimited rights:* The artist may not sell any use to anyone else. Sale of the original art is a separate transaction. The artist may display the work and retains authorship rights. Under copyright law, the artist may reclaim these rights after 35 years. Long-standing trade custom also provides that artwork may be reproduced by the artist for self-promotion.

♦ *buyout:* This vague term, though widely used, means different things to different people. It is an imprecise term that can lead to misunderstanding—most often to an artist's disadvantage. The Guild recommends that specific usage rights sold and the status of ownership of the original art be explicitly stated in the agreement.

Packagers

Packagers, who work predominantly in book publishing, coordinate all the components of a project and either present the finished concepts to publishers for execution or manufacture the books themselves and deliver bound volumes to the publisher. Just like a publisher, packagers will contract with illustrators, designers, and writers, and any negotiations should be handled just as if the packager is a publisher. Because of the relatively small size and weak financial strength of packagers compared to publishers, the importance of a written agreement cannot be overemphasized.

Representatives

In an ideal world, artists would spend all their time creating their art. They wouldn't have to pound the pavement trying to set up client meets or dropping off (and picking up) portfolios with art directors or advertising their work.

Some artists are better skilled at solving a visual problem than they are at marketing or promoting their own talent. Sometimes they are misunderstood by the "corporate culture," which can confuse appearances with abilities. Less skilled in negotiation techniques, artists may be less than diplomatic when negotiating a deal, losing a potentially good relationship with a client.

For these artists, a professional representing their interests can mean thousands of dollars in additional revenue. With representation, an artist can spend more time producing creative work, rather than on marketing or administration. Professional representatives may be better skilled at negotiations, resulting in better terms and higher fees than an artist could secure for him or herself. Representatives expend time, energy, and resources seeking work for artists, saving artists those costs. They are only compensated when they find work for their clients; it is therefore in their interest to find the best outlets for artists.

But not every situation is ideal. It should be clear that the representative or agent works for the artist, not the other way around. In the best artist-agent relationships, a healthy partnership exists, where artist and agent jointly benefit. If an artist feels that he or she is just another "horse in a stable," or if a representative continually fails to secure work for an artist while insisting on receiving commissions for work secured by the artist, those relationships should be evaluated critically. And some unscrupulous agents will lowball fees to ensure a good personal relationship with a buyer, at the expense of the artist whose interests they're pledged to protect. Obviously, relationships with unscrupulous or unethical representatives should be avoided.

Finding a suitable representative

Representatives who handle a number of artists often concentrate on a particular style or market. For example, some may represent artists with a highly realistic, painterly style, while others may concentrate on humorous work. Some representatives have cultivated strong contacts in advertising, while others have a strong network in the editorial or children's book market. An artist needs to research which representatives would best serve their needs. When an artist thinks his or her career has reached the point where it would benefit from professional representation,

the following should be considered:

♦ *Be objective about your talent and stature.* A reputable agent is interested in representing highly marketable talent, i.e., a successful artist who no longer has time to call new clients cold or follow up with existing clients. Although an entry-level artist could benefit from the services of a representative, it is unlikely that a good agent will be interested in risking time and resources on someone who is untried and unknown.

♦ *Identify and target your market.* An artist needs to find out which representatives would be the best match. At this point, a frank appraisal of one's work is necessary. Someone with a sketchy humorous style would be wasting her time by seeking out agents who represent painterly styles predominantly. Similarly, if one's work is best suited for the editorial or book cover market, pursuing a representative with a strong agency clientele would not be very productive, though reps will, on occasion, seek out artists with strong potential to cross over into other markets.

A good place to research the talent and clients handled by particular representatives is in the major sourcebooks and talent directories (see Sources of Talent section later in this chapter for further information). *American Showcase, The Black Book, The Workbook, The Graphic Artists Guild Directory of Illustration, RSVP,* and others display many pages of advertising that are placed (in whole or in part) by artist's representatives. An interested artist can determine easily with which representatives he or she is most likely to fit. Similarly, representatives looking to cultivate additional talent often use these books to target suitable artists.

Once you've narrowed your list, contact the representatives. If they are interested, and an understanding on terms seems likely, references should be checked.

Remember: No business professional would ever enter into a long-term relationship with another professional without checking with other artists for references. If this holds true before hiring attorneys, accountants, and other contractors, it also holds true for representatives. Among the questions that should be answered are: Was the relationship productive for both parties? Were payments received promptly? How were disputes (if any) resolved? If the relationship was terminated, why? Was the termination amicable? Did the representative pay an equitable share of advertising and promotional expenses? How much work did the representative generate over the year?

Talking to other artists is the best way to find out who's great and who's not even good among the sizable number of representatives working in the industry. Artists should also trust their own first impressions; as the rep impresses the artist, so will he or she impress prospective clients.

Artists' representatives or agents have the authority to act on behalf of the artists they represent. They can obligate the artist legally, but only in matters agreed to in the artist-representative contract.

Artist-representative arrangements are best put in writing. Artists should have a lawyer read any contract and make certain the terms are understood clearly before signing. The Guild's Artist/Agent Agreement and Textile Designer/Agent Agreement can be found in the Standard Contracts and Business Tools section of this book. If a more casual relationship is undertaken, the Guild recommends that both parties sign a memo that spells out the responsibilities of each.

Some topics that should be considered when negotiating an artist-agent agreement are:

♦ *exclusive or nonexclusive:* In one kind of nonexclusive relationship, artists are free to promote their work in all markets, even those handled by the representative. In another nonexclusive arrangement, representatives handle only certain markets, such as advertising or publishing or certain geographic areas, and artists retain the right to promote their work in other areas. When representatives handle all markets that the artist produces for, they will often insist that the artist work through them exclusively. However, it is not uncommon for reps who work exclusively with artists to agree to the artist continuing to work directly with one (or a few) previously established house accounts (for further description, see section following). Countless artist-rep arrangements are possible and negotiable, limited only by the potential for the mutual benefit of both parties.

Exclusivity or nonexclusivity is a crucial issue in any contract, since artists must feel that all of their work will be marketed in the best possible manner. Representatives who ask for exclusive contracts should be especially willing to identify the other artists whom they represent, so that references may be checked. Policies concerning stock and reuse should also be discussed in detail.

- *mounting of portfolio pieces, presentations, laminations, etc.:* The agreement should cover who pays for preparation of portfolio and promotion pieces. It should state for the record that these pieces remain the property of the artist and that they will be returned to the artist upon termination of the relationship.
- *directory advertising, direct mail promotion, shipping of artwork, insurance, etc.:* Many representatives will split these expenses with the artist (often in the same ratio reflected by their commission) or absorb them. The arrangement should be understood clearly by both parties—and put in writing.
- *billing:* Whether it is wiser for agent or artist to handle billing will depend on the circumstances. A reputable party handling billing (whether it's the artist or the representative) will supply copies of all purchase orders and invoices to the other party. If a purchase order does not exist, a copy of the check should be supplied to the other party. One practical benefit of this procedure is that if the person handling the billing dies, goes into bankruptcy, or reorganizes, the other party has proof of what is owed. If the representative is handling billing, the Guild recommends that artists maintain complete records of all paperwork and any decisions made orally should be logged.
- *commissions:* The conventional artist-representative arrangement currently indicates a 20 to 30 percent commission to the representative, with the majority reflecting 25 percent and the higher numbers tending to go for representing artists outside the United States. In textile design, commissions historically have ranged from 25 to 50 percent of the fees paid, excluding expenses. Expenses not billable to the client generally are subtracted from a flat fee before the commission is computed. Expenses billed to the client as line items on an invoice normally are reimbursed to the one who incurred the expense, separate from any commission paid. If the agent is given accounts that artists had prior to retaining a representative (sometimes called house accounts), they usually are serviced by the agent at a lower commission rate for an agreed-upon period of time.
- *finder's fee:* Occasionally, a special opportunity is presented to an artist by an agent or broker even though a formal relationship does not exist between that artist and agent. In those special circumstances, current information indicates it's not unusual for the agent to receive a finder's fee of 10 percent of the negotiated fee or advance. Because no formal relationship exists, this is usually a one-time-only fee, and should further work be assigned by that client, no further commissions would be due. Sometimes an artist will ask a rep to negotiate a difficult deal, on a one-time basis, that the artist has secured, for 10 percent or more.
- *termination:* This is a sensitive area for both agent and artist. Each party should be able to terminate on 30 days' written notice, but an agent may receive commissions after the termination date on work that is generated from an account developed by the agent for an agreed upon period of time, usually for three months after the termination date. If an agent has represented an artist for more than six months, the right to receive commissions after termination often is increased by one month for each additional six months of representation (i.e., after two years of representation, the agent would receive commissions for six months after termination).

The circumstances in each case differ, but artists should rarely agree to give agents commissions on assignments obtained more than six months after the effective date of termination. Of course, if an agent is entitled to receive a commission on an assignment obtained within the agreed time even if it is not started until after the end of the termination period; it is due even if the client's payment arrives after that time. This right should not, however, apply to house accounts.

All termination terms should be agreed upon at the beginning of a relationship. Most agents do not show artists' work during termination periods unless the artist specifically requests it. It is advisable for agents to return artwork to the artist immediately upon termination.

Subcontracting

Art directors, design firms, or other art buyers who assume creative control of a project for a client often subcontract freelance artists for work they cannot create themselves. Payment is due from these contractors in a timely manner no matter when they receive payment from their client.

Brokers

Most brokers do not represent talent exclusively but rely instead on their contacts among clients and their knowledge of various talents to put together a deal. As with studios, some projects can be quite complex. Most of the points raised in the sections on representatives and studios would apply. It cannot be emphasized too strongly that price, relative responsibilities, and working conditions should be established before accepting the assignment. In the absence of a formalized artist-agent agreement, artists should establish a price that they consider adequate for the work, leaving the broker free to negotiate above that price and keep the difference as a commission.

Employment agencies

Employment agencies in various cities around the country refer artists to clients for a fee. They operate in the same way that most employment agencies do but specialize in the visual communications markets. Often these agencies are listed in trade magazines and the telephone book. Some Graphic Artist Guild Chapters also collect information on available positions. Others offer a number of different forms of referral services.

Recruitment and search agencies (most often referred to as headhunters) are a unique talent resource for a firm in need of specialized employees. They also represent an employment resource for the person seeking a position that might not be readily available through other channels. These agencies are an advanced variation of an employment agency. While employment agencies place individuals in jobs and receive payment from the person placed, recruitment firms are hired and paid by clients who are in need of filling specific positions. These agencies receive the job description from the client and their task is to find the proper person. Client relationships are confidential and the job descriptions need not be made public. They are, nonetheless, subject to equal opportunity employment laws.

Recruiters often place ads in local newspapers to advertise positions. Because the recruiting agency's fees are paid by the client seeking an artist and not by the artist who is placed in the position, the term "fee paid" included in the advertisement indicates that the job candidate has no financial obligation to the agency.

Sources of talent

There are several resources available to clients and artists to find and/or promote talent. Among the most widely known and used are the advertising directories. These directories generally showcase a specific type of work, such as illustration or graphic design. Artists purchase space in a directory that displays representative work chosen by the artist and gives a contact address for either the artist or the artist's representative. Others are compilations of juried shows. Directories also serve the industry as references for the types and styles of work being done in the field.

Among the best-known directories nationally for illustration are: *American Showcase, The Black Book, The Graphic Artists Guild Directory of Illustration, New York Gold, Chicago Talent, The Workbook,* and *RSVP.* Directories of juried shows include: *The Society of Illustrators Annual, American Illustration,* and *Art Directors Annual.* For design: *AIGA Annual, The Black Book, The Workbook,* and *Art Directors Annual.* There are many publications from juried shows in areas of special interest such as dimensional illustration, humorous illustration, and international design and illustration. Directories can be requested from their publishers or found at most art supply stores.

Ethical standards

The Graphic Artists Guild, established by artists, is mandated by its constitution to monitor, support, and foster ethical standards in all dealings between graphic artists and art buyers. This is accomplished through Guild programs for members, through cooperation with related organizations, and through legislative activity on local, state, and federal levels. As part of this responsibility, the Guild has Professional Practices and Grievance committees that work with members in addressing issues of professional relations that help members to resolve disputes with clients over violations of agreements and commonly accepted trade standards. As with all other Guild programs, these committees draw from members' experiences in the field, track industry standards, and publicize any changes in the field that affect contracts and trade practices.

The Joint Ethics Committee Code of Fair Practice

In 1945 a group of artists and art directors in New York City, concerned with growing abuses and misunderstandings—as well as with an increasing disregard—of uniform standards of conduct, met to consider possibilities for improvement. They realized that any efforts must have the most widespread backing and, further, that it must be a continuing, not a temporary, activity. On their recommendation, three leading New York art organizations together established and financed a committee known as the Joint Ethics Committee, which wrote and published a Code of Fair Practice for the graphic communication industry in 1948. In 1989 the committee revised the code.

Formulated in 1948, the Code was conceived to promote equity for those engaged in creating, selling, buying, and using graphic arts. The Code has been used successfully since its formulation by thousands of industry professionals to establish equitable relationships in the practices of selling and buying art.

The word "artist" should be understood to include creative people in the field of visual communications such as illustration, graphic design, photography, film, and television. This code provides the graphic communications industry with an accepted standard of ethics and professional conduct. It presents guidelines for the voluntary conduct of persons in the industry which may be modified by written agreement between the parties. Each artist individually should decide whether to enter art contests or design competitions, provide free services, work on speculation, or work on a contingent basis. Each artist should decide independently how to price his or her work.

Article 1. Negotiations between an artist or the artist's representative and a client should be conducted only through an authorized buyer.

Article 2. Orders or agreements between an artist or artist's representative and buyer should be in writing and shall include the specific rights which are being transferred, the specific fee arrangement agreed to by the parties, delivery date, and a summarized description of the work.

Article 3. All changes or additions not due to the fault of the artist or artist's representative should be billed to the buyer as an additional and separate charge.

Article 4. There should be no charges to the buyer for revisions or retakes made necessary by errors on the part of the artist or the artist's representative.

Article 5. If work commissioned by a buyer is postponed or cancelled, a "kill-fee" should be negotiated based on time allotted, effort expended and expenses incurred.

Article 6. Completed work shall be paid for in full and the artwork shall be returned promptly to the artist.

Article 7. Alterations shall not be made without consulting the artist. Where alterations or retakes are necessary, the artist shall be given the opportunity of making such changes.

Article 8. The artist shall notify the buyer of any anticipated delay in delivery. Should the artist fail to keep the contract through unreasonable delay or nonconformance with agreed specifications, it will be considered a breach of contract by the artist.

Article 9. *

Article 10. There shall be no undisclosed rebates, discounts, gifts, or bonuses requested by or given to buyers by the artist or representative.

Article 11. Artwork and copyright ownership are vested in the hands of the artist.

Article 12. Original artwork remains the property of the artist unless it is specifically purchased. It is distinct from the purchase of any reproduction rights.† All transactions shall be in writing.

Article 13. In case of copyright transfers, only specified rights are transferred. All unspecified rights remain vested with the artist. All transactions shall be in writing.

Article 14. Commissioned artwork is not to be considered as "work for hire."

Article 15. When the price of work is based on limited use and later such work is used more extensively, the artist shall receive additional payment.

Article 16. If exploratory work, comprehensives, or preliminary photographs from an assignment are subsequently used for reproduction, the artist's prior permission shall be secured and the artist shall receive fair additional payment.

Article 17. If exploratory work, comprehensives, or photographs are bought from an artist with the intention or possibility that another artist will be assigned to do the finished work, this shall be in writing at the time of placing the order.

Article 18. If no transfer of copyright ownership has been executed, the publisher of any reproduction of artwork shall publish the artist's copyright notice if the artist so

requests at the time of agreement.[†]

Article 19. The right to remove the artist's name on published artwork is subject to agreement between artist and buyer.

Article 20. There shall be no plagiarism of any artwork.

Article 21. If an artist is specifically requested to produce any artwork during unreasonable working hours, fair additional remuneration shall be paid.

Article 22. All artwork or photography submitted as samples to a buyer should bear the name of the artist or artists responsible for the work. An artist shall not claim authorship of another's work.

Article 23. All companies and their employees who receive artist portfolios, samples, etc. shall be responsible for the return of the portfolio to the artist in the same condition as received.

Article 24. An artist entering into an agreement with a representative, studio, or production company for an exclusive representation shall not accept an order from nor permit work to be shown by any other representative or studio. Any agreement which is not intended to be exclusive should set forth the exact restrictions agreed upon between the parties.

Article 25. No representative should continue to show an artist's samples after the termination of an association.

Article 26. After termination of an association between artist and representative, the representative should be entitled to a commission for a period of six months on accounts which the representative has secured, unless otherwise specified by contract.

Article 27. Examples of an artist's work furnished to a representative or submitted to a prospective buyer shall remain the property of the artist, should not be duplicated without the artist's consent and shall be returned promptly to the artist in good condition.

Article 28.[*]

Article 29. Interpretation of the Code for the purposes of mediation and arbitration shall be in the hands of the Joint Ethics Committee and is subject to changes and additions at the discretion of the parent organizations through their appointed representatives on the Committee. Submitting to mediation and arbitration under the auspices of the Joint Ethics Committee is voluntary and requires the consent of all parties to the dispute.

Article 30. Work on speculation: contests
The artist should be alert to potential exploitation by prospective clients who ask the artist to submit work without any assurance of payment, either as "work on speculation" or in the form of a "contest" under improper circumstances.
Specifically:

(i) The artist should be alert to parties who solicit work on speculation or who sponsor contests but have no intention of actually paying for any artist's services, and instead intend to sample work submitted by various artists at no cost for the purpose of misappropriating them for their own use or for the purpose of using them as a basis of comparison against work being performed by another artists.

(ii) The artist should be alert to parties who engage in false advertising, especially in connection with contests. Artists may be encouraged to create and submit work on the expectation that a winner will be chosen and awarded a prize, when in fact there may be no winner and no prize.

(iii) The artist should be alert to parties who solicit work on speculation or sponsor contests and do not return the artist's work, or who require the artist to pay in order to have the work returned, without disclosing this in advance.

(iv) The artist should be alert to violations of the federal copyright laws. If an artist is asked to create and submit work, and that work is stolen or copied without permission and with no compensation to the artist, this can amount to copyright infringement.

(v) The artist may be able to protect against abuses of this kind by entering into an agreement with the other party prior to or at the time of submitting any work explicitly addressing these issues. The terms are up to the artist and the other party, of course. Each artist should decide individually whether to enter contests or design competitions, provide free services, work on speculation, or work on a contingent basis. These practices are not at variance with the Code, but the artist is entitled to determine in advance whether full disclosure is being made as to the purpose for which the competition is being held, the likelihood of being selected, the prospects for remuneration, the use to which the works will be put, the persons to whom the

works will be shown, arrangements for return of the work, the ownership of all copyrights, and other material features of the solicitation. Moreover, each artist should independently decide how to price his or her work.

* Articles 9 and 28 have been deleted from this publication and are replaced by Article 30.

† Artwork ownership, copyright ownership, and ownership and rights transferred after January 1, 1978, are to be in compliance with the Federal Copyright Revision Act of 1976.

Copyright 1995 by The Joint Ethics Committee, Post Office Box Number 179, Grand Central Station, New York, NY 10017.

The Graphic Artists Guild Professional Practices Committee

The Professional Practices Committee seeks to improve professional relations between artists and buyers by fostering an ongoing dialogue with all involved parties. Misunderstandings and disputes in graphic communications industries, much as in any others, are inevitable due to the nature of interactions between people. However, the Guild believes that a sizable degree of contention results from lack of awareness, or disregard, of common standards of professional practices.

It is the Guild's position that such problems can be reduced and that mutually beneficial and productive business practices can be advanced through discussion and negotiation. Both formal and informal communication between the Guild and major buyers has existed since the Guild's inception. The Guild has acknowledged the legitimate concerns of both sides of professional issues. Through the activities of these committees, the Guild seeks to contribute to a broader and fuller understanding and commitment to professional standards of practice. The committee is equipped to assist local members in resolving violations of agreements and commonly accepted trade standards.

Most Guild chapters have a Professional Practices Committee to assist local members in resolving violations of agreements and commonly accepted trade standards. These committees assist Guild members in resolving disputes and preventing the occurrence of grievances in general through the use of accepted business and legal procedures. Depending on the unique factors of each case, the committee's assistance generally involves: guiding the member's personal efforts to resolve the grievance through direct negotiation between the parties; direct intervention with the buyer on the member's behalf; and mediating, if requested by both parties, to achieve a private settlement.

If further action becomes necessary, other relevant alternatives are proposed by the committee. These may include: arbitration; small claims court; collection methods; lawyer referral; or litigation. (Please see Part IV: Collecting in the Pricing and Marketing Artwork chapter for further information on these alternatives.)

Professional Practices Committee assistance is open only to members of the Graphic Artists Guild, and those wishing assistance should contact their Guild Chapter. Members wishing to report unprofessional practices also should forward them directly to the Professional Practices Committee at their local Chapter.

Guild Professional Practices Committees encourage artists and art buyers of all disciplines to report unprofessional practices. When such reports are not forwarded, vital information is unavailable and an opportunity to change unethical practices may be lost.

Graphic Artists Be Aware column

The Guild periodically publishes a "Graphic Artists Be Aware" column to inform its membership of and to acknowledge advancements made in artist-buyer practices. The column, which appears in national and local Guild newsletters, cites individual buyers and companies that have established improved terms for art commissions as a matter of policy. Such advances may have resulted through negotiations with the Guild, from communication with the Professional Practices Committee or have been determined independently. The Guild welcomes notification of such new practices. Please contact the National Guild Office.

Similarly, buyers reported for flagrant, repeated, or unresolved unprofessional practices are selected for citation in the "Graphic Artists Be Aware" column of the Guild's chapter and national newsletters. By citing these companies and individuals, the Guild forewarns the community of graphic artists of unethical or unfair practices. At the same time, the Guild puts such practitioners on notice that they can no longer exploit artists with impunity.

Media articles

The committee focuses attention on professional practices by initiating research into specific issues and producing articles for industry and Guild publications. The selection of topics results both from monitoring industry practices and from correspondence received by the Committee.

Legal
Rights and Issues

Legal
rights &
issues
• • • • • • • • • • • •

In the development of the U.S. Constitution, our nation's founders recognized the need to stimulate the spread of learning and the dissemination of ideas by creating protection for creators of intellectual property. Article I, Section 8, empowers Congress to "promote the progress of science and useful arts by securing for limited times to authors and inventors the exclusive right to their respective writings and discoveries."

This established the foundation for our copyright laws, which acknowledge artwork as intellectual property that is traded in the marketplace as a valuable economic resource.

In today's visual world, the works created by graphic artists are among the most powerful vehicles for communicating ideas in our society. A successful illustration can singlehandedly sell a product. A successful logo can singlehandedly evoke a company's goodwill in the public mind. A successful poster can move an entire population to action.

Like other creative professionals (actors, musicians, dancers, writers, photographers), graphic artists occupy a special place in our society and economy. Their unique vision, skill, and style enable them to attract clients, sell their work, and earn their livelihood. Like other professionals, graphic artists provide their highly skilled services and creative input within a framework of professional standards and ethics. But the work of graphic artists is vulnerable and requires the maximum protection of our laws, not only to prevent unauthorized exploitation, but also to ensure that artists can continue to work without economic or competitive disadvantages.

The Graphic Artists Guild's constitution and membership mandate it to "promote and maintain high professional standards of ethics and practice, and to secure the conformance of all buyers, users, sellers, and employers to established standards." Further, the Guild seeks to "establish, implement, and enforce laws and policies … designed to accomplish these ends." The organization's legislative agenda, therefore, is based on the needs and desires expressed by its members and its constitutionally mandated goals.

One of the primary goals of the Graphic Artists Guild is to help buyers recognize the value of graphic art to their businesses and the importance of fair and ethical relationships with graphic artists. The Guild upholds the standard of a value-for-value exchange, recognizing that both client and artist contribute to a successful working relationship.

The Guild monitors and influences public policy developments, including legislative initiatives at the local, state, and federal levels, and regulatory actions by a range of agencies. Some initiatives include: local proposals concerning sales and use taxes; state laws to encourage fair practices and protect artists' authorship rights; federal legislation closing the work-for-hire loophole of the U.S. Copyright Act, strengthening protections against infringement, creating tax equity for artists; developing a national standard for artists' authorship rights (known as "moral rights"); and extending the copyright term to conform to the European standard of life plus 70 years. The Guild has drafted model legislation and lobbied locally and nationally on these issues. Early successes in California, Oregon, New York, and Massachusetts created a wave of interest in artists' rights legislation. With Guild involvement, Georgia passed legislation that strengthens artists' protections against copyright infringement.

The Guild spearheaded the "Ask First" initiative, organizing a coalition of creators and publishers organizations to advance a copyright awareness campaign designed to educate users of images about appropriate and ethical practices. The Guild also reached out to gallery artists in the fine arts communities by cofounding Artists For Tax Equity (AFTE), a coalition representing nearly 1 million creators that successfully lobbied Congress for exemption from an onerous tax provision. In addition, Guild testimony before both House and Senate subcommittees helped advance copyright protections.

Copyright

Freelance artists' livelihoods depend on their ability to claim authorship for the pieces they produce. They build their reputations—and therefore their ability to attract clients and build a career—on the basis of past performance. Indeed, artists' careers succeed or fail by their skill and style in communicating the ideas and messages society needs to disseminate. Artists' rights to control the usage of their original creative art is defined primarily by copyright law, which also provides the basis for pricing and fair trade practices.

Copyright law flows from the U.S. Constitution, Article 1, Section 8, and was created by Congress to extend to artists and other creators limited monopolies that provided economic rewards and protections to artists and other authors. This encourages the dissemination of ideas, thereby serving the public interest. Current copyright law (the Copyright Act of 1976) became effective January 1, 1978.

A bundle of rights

An artist's copyright is actually a bundle of individual rights. Each specific use can be transferred separately. These broadly include the rights to copy a work (commonly known as the "right of reproduction"), display a work, distribute a work, perform a work, or create a derivative work from an existing work. Fees are determined primarily by the value agreed upon for the specific rights licensed. Any rights not transferred explicitly remain the property of the creator.

The ability to sell limited usage, or limited rights, to a work of art for a fee is an issue of basic fairness. The true value of a work, however, is difficult to determine (particularly before the work has been executed), considering that the potential economic life of the work is the length of time granted by copyright law, currently the author's life plus 50 years. Therefore, negotiations over the price of a commissioned work normally are based on the initial rights the client wishes to purchase.

Transferring rights

An agreement to transfer any (except nonexclusive) rights must be in writing and signed by the artist or the artist's agent. Those rights not specifically transferred in writing are retained by the artist. Nonexclusive rights, which can be transferred to more than one client at a time, may be transferred verbally.

For contributions to collective works such

as magazines, anthologies, encyclopedias, etc., where there is no signed agreement, the law presumes the transfer of only nonexclusive rights for use in that particular collective work. All other rights remain vested with the artist.

Exclusive or all-rights transfers must be in writing to be valid. Copyright is separate from the physical art, and is sold separately. State laws in New York and California require the transfer of the original, physical art to be in writing, due to successful lobbying by artists who were losing their art to clients that insisted transactions transferring only reproduction rights also included the sale of the original.

Termination of rights transfers

Transfers of copyright may be terminated by the artist during a five-year period beginning 35 years after execution of the transfer. This "right of reversion" feature of the 1978 copyright law is particularly important when transfers or licenses are for exceptionally long periods of time and where artists who have since become successful wish to regain rights in their early work.

The formalities of termination are detailed. Artists or their heirs whose grants of rights are approaching 35 years should contact the Copyright Office for forms and procedures. See the Resources and References chapter for Copyright Office address. The exact form of notice is specified by, and must be filed with, the Copyright Office. Artists will lose their opportunity to reclaim rights to their creations, unless the grants otherwise terminate, if they fail to comply with the proper procedures.

The right of termination does not apply to work for hire or transfers made by a will.

Copyright notice

Although current copyright law automatically protects original artwork from the moment of its creation even without inscribing a copyright notice, failing to place one on artwork may make it vulnerable to so-called innocent infringers, who may claim they did not know the work was protected. Since the requirement to inscribe a copyright notice or a work ended in 1988, users should safely assume a work is protected by copyright even if no notice is affixed. It is best if the artist's copyright notice accompanies a public display, distribution, or publication of any art. The elements that make up a copyright notice are Copyright, Copr., or ©; the artist's name, an abbreviation of the name, or an alternate designation by which the artist is known; and the year of publication; for

example, © Jane Artist 1991. The form and placement of the notice should be understood by artist and client and reflected in a written agreement. When use of the art has been granted to a client temporarily, the notice preferably should be in the artist's name, but may be in the client's for the duration of the usage.

The copyright notice can be placed on the back of an artwork or, when it is published, adjacent to the artwork. Other reasonable placements of the copyright notice for published works are specified by the regulations of the Copyright Office. Pieces in an artist's portfolio should have copyright notices on them, including published pieces when the artist has retained the copyright. It is best for artists to have their copyright notice appear with the contribution when it is published; this helps avoid certain risks of infringement.

Registering copyright

Current copyright law automatically "protects" original artwork from the moment it is created, even without a copyright notice. Protection means that an artist retains the right to assert a claim for copyright infringement even if he or she has not registered the work in question. This is an improvement over previous law, when copyrights were lost permanently if work was published without registration or with incorrect notice. But the bulk of the benefits the copyright law offers to artists are still available through formally registering the art with the Copyright Office.

Registration establishes a public record of the artist's claim to the artwork, and is a necessary prerequisite to asserting a copyright claim in court. Once in court, the information in the registration is prima facie evidence, which means the other party has the burden to *disprove* it. Registration within three months of publication and/or before infringement enables the artist to sue for attorneys' fees and for statutory damages. The possibility of recovering attorneys' fees is useful when trying to hire a lawyer.

Statutory damages require a brief explanation. A court considers the issue of damages only after infringement has been proved. If the plaintiff has not done a timely registration, his or her recovery is limited to the amount of actual damage that has been proven. But if the plaintiff has done a timely registration, he or she can recover statutory damages, which are set by the law (statute) and imposed by the court. Unlike actual damages, they do not need

to be proven. They are imposed because of the infringement independent of any actual damage suffered, and can run much higher than actual damages. Efforts are underway to make attorneys' fees and statutory damages available without registration.

Many myths surround copyright registration, one of the most persistent being that mailing copies to oneself is an effective substitute. Self-mailed copies are not prima facie evidence and will not allow recovery of statutory damages or attorneys' fees—and the artist will still have to register in order to go to court. The only shortcut to the protection registration offers is group registration of unpublished works or work published in periodicals (see section following).

The registration procedure is relatively easy. Form VA is used by graphic artists to register pictorial, graphic, or sculptural artwork and should be accompanied by one copy of the work if unpublished or two copies of the work if published (e.g., tearsheets) along with a $20 fee. Original art should not be sent to the Copyright Office in order to register a work. While the copyrightable content of an artwork must be shown, this can be done with transparencies or photocopies. The Copyright Office has specific circulars, numbers 40, 40a, 41, and 44, that will be especially helpful. The Guild's Website (http://www.gag.org) has a direct link to the Copyright Office's homepage, from which forms and circulars may be downloaded.

Completed forms and enclosures are mailed to: Register of Copyrights, Copyright Office, Library of Congress, Washington, D.C. 20559. Include your ZIP code in your return address and a daytime telephone number where you can be reached. At press time, the Copyright Office is experimenting with procedures to facilitate online registration. The accompanying example of a completed VA form is for a published illustration appearing in a book.

At times other registration forms may be needed by graphic artists. If audiovisual work is created, including motion pictures, then Form PA is the appropriate registration form. When an artist creates both art and text in a work, and the text predominates, Form TX should be used to register the work and the description should indicate "text with accompanying art." Generally, Form TX is used for registration of computer software, including any graphics which are part of screen displays generated by that software. Form VA may also be used for graphics, even those originally created with the use of a computer, including multimedia. All forms come with line-by-line instructions if these instructions are requested specifically from the Copyright Office. All artworks can be registered, whether they are published or not.

Group registration

Unpublished artworks may be grouped under a single title and registered together for a single $20 fee. For example, five numbered drawings could be collected in a binder and registered as "Drawings By Artist, Series 1." Or, a videotape containing up to 2,400 images can be submitted (as long as each image has been taped for at least three seconds) and registered as "Drawings By Artist, Series 1, 1997." Only one $20 fee would then be required and the art would not have to be registered again when published. Inexpensive group registration is also available for published artwork that appeared in periodicals within a one-year period and that included the individual artist's copyright notice. In this latter instance, Form GR/CP must be completed in addition to the other appropriate forms.

In submitting copies of the artwork along with the registration form(s), original art should not be submitted. The artist may submit tearsheets, photocopies, or transparencies, but the Copyright Office prefers the best edition of published work. Whatever type of copies are submitted, they should show all copyrightable contents of the artwork.

The Copyright Office receives more than 600,000 registrations annually, so you will not receive an acknowledgment or receipt of the submission of your application. Receipt of a certificate of registration should be expected between 16 and 24 weeks of submission, or you may receive a letter or telephone call from a Copyright Office staff member if further information is needed. If the application cannot be accepted, you will receive a letter explaining why it has been rejected. If you want to know when the Copyright Office receives your material, send it by registered or certified mail and request a return receipt from the post office. You should allow at least three weeks for the return of your receipt.

A copyright registration is effective on the date that all the required elements (application, fee, and deposit) in acceptable form are received in the Copyright Office, regardless of the length of time it takes the Copyright Office to process the application and mail the certificate of registration. You do not have to receive

your certificate before you publish or produce your work, nor do you need permission from the Copyright Office to place a notice of copyright on your material.

Automatic copyright renewal

The Copyright Act of 1909 required that copyrights expiring after the initial 28-year term had to be renewed by completing a specific renewal form in order to extend protections for another 28 years. Because of this onerous provision, many valuable works, such as the famous Frank Capra movie *It's a Wonderful Life*, fell into the public domain, to the detriment of their creators (or the creators' heirs). In 1992, the Automatic Renewal Act was passed, and it was specifically designed to protect the "widows and orphans" of authors who did not, or could not, register the copyright's renewal. The law provides that copyrights secured prior to 1978 live out their 28-year first term and, if renewed, for an additional 47-year second term. (Works created after 1978 are automatically protected for the lifetime of the author plus 50 years, with no renewal available thereafter.) The 1992 Automatic Renewal Act automatically renews copyrights initially secured from 1964 through

FORM VA
For a Work of the Visual Arts
UNITED STATES COPYRIGHT OFFICE

REGISTRATION NUMBER

VA VAU

EFFECTIVE DATE OF REGISTRATION

Month Day Year

DO NOT WRITE ABOVE THIS LINE. IF YOU NEED MORE SPACE, USE A SEPARATE CONTINUATION SHEET.

1
TITLE OF THIS WORK ▼ NATURE OF THIS WORK ▼ See instructions

GRAPE EXPECTATIONS ACRYLIC ON BOARD

PREVIOUS OR ALTERNATIVE TITLES ▼

PUBLICATION AS A CONTRIBUTION If this work was published as a contribution to a periodical, serial, or collection, give information about the collective work in which the contribution appeared. Title of Collective Work ▼

FAMILY CIRCLE

If published in a periodical or serial give: Volume ▼ 12 Number ▼ 4 Issue Date ▼ APRIL 1997 On Pages ▼ 16

2 a
NAME OF AUTHOR ▼ DATES OF BIRTH AND DEATH
Year Born ▼ Year Died ▼

Was this contribution to the work a "work made for hire"? AUTHOR'S NATIONALITY OR DOMICILE Name of Country WAS THIS AUTHOR'S CONTRIBUTION TO THE WORK
☐ Yes OR { Citizen of ▶ USA Anonymous? ☐ Yes ☑ No If the answer to either of these questions is "Yes," see detailed instructions.
☐ No Domiciled in ▶ Pseudonymous? ☐ Yes ☑ No

NOTE
Under the law, the "author" of a "work made for hire" is generally the employer, not the employee (see instructions). For any part of this work that was "made for hire" check "Yes" in the space provided, give the employer (or other person for whom the work was prepared) as "Author" of that part, and leave the space for dates of birth and death blank.

NATURE OF AUTHORSHIP Check appropriate box(es). See instructions
☐ 3-Dimensional sculpture ☐ Map ☐ Technical drawing
☑ 2-Dimensional artwork ☐ Photograph ☐ Text
☐ Reproduction of work of art ☐ Jewelry design ☐ Architectural work
☐ Design on sheetlike material

b
NAME OF AUTHOR ▼ DATES OF BIRTH AND DEATH
Year Born ▼ Year Died ▼

Was this contribution to the work a "work made for hire"? AUTHOR'S NATIONALITY OR DOMICILE Name of Country WAS THIS AUTHOR'S CONTRIBUTION TO THE WORK
☐ Yes OR { Citizen of ▶ Anonymous? ☐ Yes ☐ No If the answer to either of these questions is "Yes," see detailed instructions.
☐ No Domiciled in ▶ Pseudonymous? ☐ Yes ☐ No

NATURE OF AUTHORSHIP Check appropriate box(es). See instructions
☐ 3-Dimensional sculpture ☐ Map ☐ Technical drawing
☐ 2-Dimensional artwork ☐ Photograph ☐ Text
☐ Reproduction of work of art ☐ Jewelry design ☐ Architectural work
☐ Design on sheetlike material

3 a
YEAR IN WHICH CREATION OF THIS WORK WAS COMPLETED This information must be given in all cases. 1997 ◀Year **b** DATE AND NATION OF FIRST PUBLICATION OF THIS PARTICULAR WORK Complete this information ONLY if this work has been published. Month ▶ APRIL Day ▶ 1 Year ▶ 1997 USA ◀ Nation

4
See instructions before completing this space.

COPYRIGHT CLAIMANT(S) Name and address must be given even if the claimant is the same as the author given in space 2. ▼
CARRIE HAMILTON
101 SHELDON ST
BOSTON, MA 02129

APPLICATION RECEIVED
ONE DEPOSIT RECEIVED
TWO DEPOSITS RECEIVED
FUNDS RECEIVED
DO NOT WRITE HERE OFFICE USE ONLY

TRANSFER If the claimant(s) named here in space 4 is (are) different from the author(s) named in space 2, give a brief statement of how the claimant(s) obtained ownership of the copyright. ▼

MORE ON BACK ▶ • Complete all applicable spaces (numbers 5-9) on the reverse side of this page. DO NOT WRITE HERE
• See detailed instructions. • Sign the form at line 8. Page 1 of ____ pages

1977. This 47-year renewal term begins automatically when the 28-year first term expires—without a renewal application. There are, however, benefits to voluntarily submitting an application for renewal registration in the twenty-eighth year. These include:

♦ If the copyright owner registers and then dies before the year ends, the renewal term will belong to his/her estate. Otherwise, it will belong to the person(s) who, on the last day of the twenty-eighth year, is/are statutorily entitled to the renewal term in the event of the author's death. These are, first, the surviving spouse and children; if none

survive, the author's executor; if no will was executed, his or her next of kin.

♦ The certificate of registration constitutes prima facie evidence of the validity of the copyright renewal and the facts stated in it. This is a major advantage if the copyright is infringed during the renewal term. Registration creates a useful record for future transactions.

♦ In some circumstances, the registration prevents use in the renewal term of films and other derivative works based on the author's work. For example: Where the author licensed the derivative right for both

EXAMINED BY _____

CHECKED BY _____

FORM VA

☐ CORRESPONDENCE
Yes

FOR COPYRIGHT OFFICE USE ONLY

DO NOT WRITE ABOVE THIS LINE. IF YOU NEED MORE SPACE, USE A SEPARATE CONTINUATION SHEET.

PREVIOUS REGISTRATION Has registration for this work, or for an earlier version of this work, already been made in the Copyright Office?
☐ Yes ☑No If your answer is "Yes," why is another registration being sought? (Check appropriate box) ▼
a. ☐ This is the first published edition of a work previously registered in unpublished form.
b. ☐ This is the first application submitted by this author as copyright claimant.
c. ☐ This is a changed version of the work, as shown by space 6 on this application.
If your answer is "Yes," give: **Previous Registration Number** ▼ **Year of Registration** ▼

5

DERIVATIVE WORK OR COMPILATION Complete both space 6a and 6b for a derivative work; complete only 6b for a compilation.
a. **Preexisting Material** Identify any preexisting work or works that this work is based on or incorporates. ▼

b. **Material Added to This Work** Give a brief, general statement of the material that has been added to this work and in which copyright is claimed. ▼

6

See instructions before completing this space.

DEPOSIT ACCOUNT If the registration fee is to be charged to a Deposit Account established in the Copyright Office, give name and number of Account.
Name ▼ **Account Number** ▼

7

CORRESPONDENCE Give name and address to which correspondence about this application should be sent. Name/Address/Apt/City/State/ZIP ▼
CARRIE HAMILTON
101 SHELDON ST
BOSTON, MA 02129

Area Code and Telephone Number ▶ (617) 555-8693

Be sure to give your daytime phone number

8

CERTIFICATION* I, the undersigned, hereby certify that I am the
check only one ▼
☑ author
☐ other copyright claimant
☐ owner of exclusive right(s)
☐ authorized agent of _____
Name of author or other copyright claimant, or owner of exclusive right(s) ▲

of the work identified in this application and that the statements made by me in this application are correct to the best of my knowledge.

Typed or printed name and date ▼ If this application gives a date of publication in space 3, do not sign and submit it before that date.
CARRIE HAMILTON Date▶ 3/24/97

☞ **Handwritten signature (X)** ▼
Carrie Hamilton

9

Mail certificate to:

Certificate will be mailed in window envelope

Name ▼
CARRIE HAMILTON
Number/Street/Apt ▼
101 SHELDON ST.
City/State/ZIP ▼
BOSTON, MA 02129

YOU MUST:
• Complete all necessary spaces
• Sign your application in space 8
SEND ALL 3 ELEMENTS IN THE SAME PACKAGE:
1. Application form
2. Nonrefundable $20 filing fee in check or money order payable to *Register of Copyrights*
3. Deposit material
MAIL TO:
Register of Copyrights
Library of Congress
Washington, D.C. 20559-6000

*17 U.S.C. § 506(e): Any person who knowingly makes a false representation of a material fact in the application for copyright registration provided for by section 409, or in any written statement filed in connection with the application, shall be fined not more than $2,500.
March 1995—300,000 ☆U.S. COPYRIGHT OFFICE WWW FORM: 1995

terms, but died before the twenty-eighth year, failure to renew registration in that year permits continued use of the derivative work, though not the making of new versions of it.

A voluntary renewal application also can be filed at any time during the second term to obtain added protection against infringements (because there is a "presumptive evidence" with a registration form), but it does not yield these benefits. The renewal registration fee is $20. A twenty-eighth-year renewal application is advisable for 1965–1977 copyrights in works that may have continuing commercial value. A renewal registration made after the twenty-eighth year may carry evidentiary weight, which is determined by a court within its discretionary powers.

Copyrights initially secured after 1977 have a single term that continues for the author's life and then for 50 years after his or her death without need for renewal. There are efforts underway by creators' groups to increase this latter term to 70 years; see Copyright Extension Section elsewhere in this chapter. As with pre-1977 copyrights, the Act provides for termination of long-term grants of rights.

Fair use

Artists, as copyright owners, have the exclusive right to reproduce or sell their work, prepare derivative works (such as a poster copied from a painting), and perform or display their work. (The owner of a copy of the work may also display it.) Anyone who violates these rights is infringing on the artist's copyright and can be penalized and prevented from continuing the infringement.

There are, however, some limitations on artists' exclusive controls of their work. One such limitation allows for so-called fair use of a copyrighted work, including use for such purposes as news reporting, teaching, scholarship, or research. Copyright law provides for the consent necessary to use works in these ways by others. The law does not define fair use specifically, but courts will resolve the question of whether a particular use was fair by examining: the purpose and character of the use; the nature of the copyrighted work; the amount and substantiality of the portion used in relation to the copyrighted work as a whole; and the effect of the use on the potential market for, or value of, the copyrighted work. For example, a magazine may use an artist's illustration to accompany or illustrate an article about the artist's life. Fair use also permits

artists to display a work executed for a client in their portfolio.

Risks of invasion and infringement

All illustration or design has the potential for invasion of privacy or copyright infringement problems. For example, the advertising or trade use of a living person's name or likeness without permission is an invasion of privacy, and claims may be in the hundreds of thousands of dollars for an infringement. "Advertising or trade" means virtually all uses outside of the factual editorial content of magazines, newspapers, books, television programs, etc.; it includes print and TV ads, company brochures, packaging, and other commercial uses. Public and private figures are protected equally.

The test of "likeness" is whether an ordinary person would recognize the complainant as the person in the illustration. It needn't be a perfect likeness. The best protection in these cases is a signed release from the person whose likeness is used (i.e., a model release), and any contract should provide for this if a problem is likely to arise.

If an artist copies another work (i.e., a photograph) in making an illustration, the photographer or copyright holder might sue for copyright infringement. The test of an infringement is whether an ordinary person would say that one work is copied from the other; the copying need not be exact.

Given the substantial amount of photography used in reference files for illustration, as well as the frequent incorporation of photographs into designs, everyone, particularly freelance artists, should exercise extreme caution in this area. Of course, common themes and images (such as squares or triangles) are in the public domain and may be used freely. Infringement requires copying substantial portions of a work, so a mere similarity in style or concept will not automatically be an infringement.

Because of the privacy and infringement risks, many advertisers and publishers carry special liability insurance to cover these types of claims. That, however, may not provide complete protection, particularly for the freelance artist, who may be sued along with the client. Or clients might insist that artists incorporate images that might infringe on someone's right of privacy or copyright. Artists should incorporate an indemnification clause in their agreements that would hold an artist harmless in this situation. Claims and lawsuits mean

increased insurance premiums or loss of coverage altogether.

Compulsory licensing

Another provision of copyright law, dealing with compulsory licensing, permits a noncommercial, educational broadcasting station to use certain published work without the artist's consent so long as the station pays the government-set royalty rate (some published works, such as dramatic ones, are not covered by this license). If the broadcaster doesn't pay the license fee, or underpays it, the use will be considered an infringement. Other compulsory licenses concern distribution of musical works.

The Copyright Royalty Tribunal Reform Act passed by Congress on December 17, 1993, established copyright arbitration royalty panels (CARPs) that set rates of compensation for the use of musical, graphic, sculptural, and pictorial works by noncommercial educational broadcasting stations. The law also allows interested parties to negotiate voluntary agreements instead of invoking a CARP. Three panelists are chosen from lists of arbitrators provided by arbitration associations. Two of them are appointed by the Librarian of Congress upon the recommendation of the Register of Copyrights, and those two choose the third panelist from the same list.

The panel will convene every five years and will weigh evidence presented by copyright users (i.e., the Public Broadcasting System, National Public Radio, college, and religious stations) and copyright owners (e.g., ASCAP, BMI, SESAC, and organizations representing visual artists) in order to make its decisions.

Programs produced independently for airing on public stations are eligible for compulsory licenses, but the license does not extend to secondary markets (after-broadcast markets) such as merchandising, toys, books, or videocassette sales.

The rates of this schedule are for unlimited broadcast use for three years from the date of the first broadcast use under this schedule. Succeeding broadcast use periods will require the following additional payment: second three-year period, 50 percent; each three years thereafter, 25 percent.

Users are required to make payments to each copyright owner not later than July 31 of the calendar year for uses during the first six months of that calendar year, and not later than January 31 for uses during the last six months of the preceding calendar year.

Users are also required to maintain and

1993–1997 Compulsory Royalty Rates*

FOR USES IN A PBS-DISTRIBUTED PROGRAM†

Featured display of a work (substantially full-screen display for 3 seconds)	$61.00
Background and montage display	$29.75
Program identification or thematic use	$120.25
Display of an art reproduction copyrighted separately from the work of fine art from which the work was reproduced	$39.50

FOR USES IN OTHER THAN PBS-DISTRIBUTED PROGRAMS†

Featured display of a work	$39.50
Background and montage display	$20.25
Program identification or thematic use	$80.75
Display of an art reproduction copyrighted separately from the work of fine art from which the work was reproduced	$20.25

* For the use of published pictorial, graphic, and sculptural works

† The rate for the thematic use of work in an entire series shall be double the single-program theme rate.

furnish, either to copyright owners or to the offices of generally recognized organizations representing the copyright owners of pictorial, graphic, and sculptural works, copies of their standard lists containing the works displayed on their programs. These lists should include: the name of the copyright owner, if known; the specific source from which the work was taken; a description of the work used; the title of the program on which the work was used; and the date of the original broadcast of the program.

If PBS and its stations are not aware of the identity of, or unable to locate, a copyright owner who is entitled to receive a royalty payment, they are required to retain the required fee in a segregated trust account for three years from the date of the required payment. No claim to such royalty fees shall be valid after the expiration of the three-year period.

Copyright extension

As a participating member of the Coalition of Creators and Copyright Owners, the Graphic Artists Guild has been advocating extending the term of United States copyright law from life plus 50 years to life plus 70 years, which

would bring it into harmony with most other Berne Convention signatories. In the view of the approximately 20 organizations comprising the coalition, the following reasons, among others, support extending the term of copyright:

♦ Artists and other authors now live for a longer time, and the term of copyright must be adjusted to reflect this. Further, currently created works now have greater value for longer periods of time.

♦ Term extension would allow the United States to continue to be a leader in international copyright. Intellectual property generally, and copyright in particular, are among the brightest spots in our balance of trade. The copyrighted works the world wants are overwhelmingly works created in the United States.

♦ A longer term of copyright would be good for American business. United States copyright and information-related industries account for more than 5 percent of the gross national product and return a trade surplus of more than $1 billion per year. More than 5.5 million Americans work in our copyright industries, and they account for over 5 percent of our nation's employment.

♦ The European Community (EC) is now moving toward a new, harmonized standard of life plus 70 years for copyright. Germany already has established this basic term, and it is the rule in France for musical works. The United States should extend our term of copyright protection to bring it into line with other countries.

♦ Term extension would discourage retaliatory legislation and trade policies by other countries. The European Community countries plan to protect United States copyrights for the shorter term of "life plus 50" only, while protecting European copyrights for the longer term. This places United States copyright holders at a tremendous disadvantage in the global marketplace.

♦ Worldwide harmonization would facilitate international trade and a greater exchange of copyrighted property between countries.

The bill, which survived the 104th Congress, is expected to be reintroduced early in the 105th. Prospects for the passage of this new legislation are good. For further information concerning its progress, contact the Graphic Artists Guild.

State's immunity from copyright infringement

The U.S. Copyright Act, in establishing sanctions (monetary damages, fines, injunctions) against infringement, intended these sanctions to apply to "anyone who violates any of the exclusive rights of the copyright owner." According to the Copyright Office, "anyone" was meant to include states, state institutions, and state employees. But in 1985, the Supreme Court ruled in a 5 to 4 decision that the Eleventh Amendment to the Constitution, which generally grants states immunity from lawsuits and monetary judgments in federal courts, could not be negated by Congress except by explicit and unequivocal language. Subsequent courts decided that under this test the Copyright Act's language was not specific enough and so opened the door for many state-funded institutions to use copyrighted materials without permission, without paying or giving credit and without fear of reprisal from the copyright owner.

In 1990, Congress corrected this court-induced injustice by passing the Copyright Remedy Clarification Act. Now states and their agents are once again subject to all the penalties and sanctions for copyright infringement. Grassroots lobbying by the Guild and its members helped to obtain this new law's passage.

Further information on copyright

For further information on copyright, artists can send for a free copy of the Copyright Information Kit from the Copyright Office, Information and Publications Section, Library of Congress, Washington, DC 20559, or can call the Public Information Office at 202.707.3000 for recorded information that is available 24 hours a day, 7 days a week. Information specialists are on duty from 8:30 a.m. to 5:00 p.m. (EST) Monday through Friday except holidays. The Forms Hotline at 202.707.9100 is available for requests of application forms for registration or informational circulars. Allow two to three weeks for deliveries. Should a quantity of forms be needed, the Copyright Office will accept photocopied forms if they are clear, legible, and on a good grade of 8½" x 11" white paper, suitable for automatic feeding through a photocopier. The forms should be printed in black ink, head to head (so when the sheet is turned over, the top of page 2 is directly behind the top of page 1). Forms not meeting these requirements will be returned. For more information about copy-

right and related issues, artists may check the Graphic Artists Guild Website at http://www.gag.org, which provides links to the Copyright Office, the Library of Congress, and other key sources; see also the Resources and References chapter of this book.

Work for hire

"Work for hire" is a provision of the U.S. Copyright Act intended as a narrow exception to the general rule that the artist or author who actually creates the work owns the copyright to it. The provision transfers authorship and ownership to the employer or other hiring party who commissions the work, leaving the artist with no rights whatsoever. While such a result may be justifiable in a traditional employment setting, the freelance artist, considered to be an independent contractor for all purposes except copyright, has no access to any employee benefits that may compensate for the loss of that copyright and the future earnings it may represent.

Under the law, a work made for hire can come into existence in two ways: an employee creating a copyrightable work within the scope of employment; or an independent contractor creating a specially ordered or commissioned work in one of several categories, verified by a written contract signed by both parties and expressly stating that it is a work for hire.

An employed artist usually is defined as one who works at the employer's office during regular business hours on a scheduled basis, is directed by the employer, and works with tools supplied by the employer. (An artist in this relationship with an employer is an employee who is entitled to employment benefits and should be having taxes withheld from his or her wages.) Please see *CCNV v. Reid,* below, and the Employment Issues section of the Professional Issues chapter for further details.

Even as an employee, however, an artist may negotiate a separate written contract with the employer, apart from the employment agreement, that transfers copyright ownership to the artist in some or all of the work created in the regular course of employment.

Work created by a freelance artist can be work for hire only if the following two conditions are met: the artist and client sign an agreement stating that the work is a work for hire; and it falls under one of the following nine categories as enumerated in the law:

♦ a contribution to a collective work (such as a magazine, newspaper, encyclopedia, or anthology);
♦ a contribution used as part of a motion picture or other audiovisual work;
♦ a supplementary work, which includes pictorial illustrations, maps, charts, etc., done to supplement a work by another author;
♦ a compilation (new arrangement of preexisting works);
♦ a translation;
♦ an atlas;
♦ a test;
♦ answer material for a test;
♦ an instructional text (defined as a literary, pictorial, or graphic work prepared for publication and with the purpose of use in systematic instructional activities).

These criteria apply only to work done on special order or commission by an independent contractor. If there is no written agreement, or if the agreement does not specifically state that the work is made for hire, or if it is not signed, or if the work does not fall into one of the above categories, then there is no work for hire and the artist automatically retains authorship recognition and copyright ownership.

By signing a work-for-hire contract, a freelance artist becomes an employee only for the purposes of the copyright law, but for no other purpose. In addition to losing authorship status and copyright, the artist receives no salary, unemployment, workers compensation, or disability insurance; nor does he or she receive health insurance, sick pay, vacation, pension, or profit-sharing opportunities that a company may provide to its formal, salaried employees. When a freelance artist signs a work-for-hire contract, the artist has no further relationship to the work, cannot display it, copy it, or use it for other purposes such as displaying the work in the artist's portfolio. The client, now considered the legal author, may change the art and use it again without limitation.

Some unscrupulous clients still attempt to gain windfall benefits from work for hire where there was no signed agreement by claiming that extensive supervision, control, and direction made the artist an employee and, therefore, the work was a work for hire. The Supreme Court resolved the issue in *CCNV v. Reid* (see section later in this chapter), affirming that in virtually all cases, commissioned works executed by independent contractors cannot be work for hire unless the work falls under the nine specified categories listed previously and a written agreement stating the work is to be for hire is signed by both parties.

The Graphic Artists Guild emphatically

opposes the use of work-for-hire contracts. Work for hire is an unfair practice that strips the artist of the moral right of paternity, the right to be recognized as author. It gives art buyers economic benefits and recognition that belong to the creative artist. These contracts devalue the integrity of artists and their work by empowering buyers to alter the work without consulting the artist and by preventing artists from obtaining any payment for the future use of their work.

Work-for-hire abuses

Clients who insist on a work-for-hire arrangement may resort to other means that, while unethical, are not prohibited under current copyright law. Some businesses coerce freelancers by denying the assignment to artists who do not accept work for hire. Some clients attempt to designate a work as for hire after the fact by requiring that the artist endorse a payment check or sign a purchase order on which work-for-hire terms appear (usually in fine print). Unless this confirms a previous oral agreement, artists who encounter this should request a new payment check (see *Playboy Enterprises Inc. v. Dumas* following).

Some work-for-hire contracts understood by the artist to be for a single project may actually have work-for-hire language that covers all future work. Artists first entering the industry are especially vulnerable to these blanket work-for-hire agreements; by the time they have the reputation to resist work for hire, clients already have the artist's agreement on file.

With the growth of new technologies, and the as yet unimagined vistas opening in these media, many clients have begun adding increasingly wide rights-ownership language to contracts. Artists should be alert to any clauses variously buying "all electronic rights" or "all rights in all media now in existence or invented in the future in perpetuity throughout the universe." These overly broad grants for rights effectively give the purchaser indefinite and unspecified use of a creator's work without additional compensation or input into uses. These clauses can be as damaging to artists as traditional work-for-hire arrangements; artists lose valuable sources of income and control over their images and reputations. Historically, artists and other creators have been able to withstand these onslaughts by negotiating strenuously (individually or collectively). For more information on artists' negotiating options see the Pricing and Marketing Artwork and Multimedia Prices and Trade Practices chapters of this book.

CCNV v. Reid

In 1989, the Supreme Court ruled unanimously that the employee clause of the Copyright Act could not be applied to independent contractors. However, if the relationship between the artist and the hiring party was determined to be one of conventional employment based on the application of a rigorous test of 13 factors (based on English common law) then the created work would be considered made for hire.

The landmark case pitted freelance sculptor James Earl Reid against homeless advocate Mitch Snyder and the Community for Creative Non-Violence (CCNV) over a commissioned sculpture created by Reid but conceived and partly directed by Snyder. Even though there was no written contract between the parties, and even though sculpture does not fall into any of the nine categories for specially ordered works, the District Court found Reid to be an employee because he was under Snyder's "supervision and control" and awarded the copyright to CCNV.

The factors the Supreme Court relied upon in deciding James Reid's employment status were: the hiring party's right to control the manner and means by which the product was accomplished; the skill required; the source of the "instrumentalities" and tools; the location of the work; the duration of the relationship between the parties; whether the hiring party had the right to assign additional projects to the hired party; the hired party's discretion over when and how long to work; the method of payment; the hired party's role in hiring and paying assistants; whether the work was part of the regular business of the hiring party; whether the hiring party was in business; the provision of employee benefits; and the tax treatment of the hired party.

The Court made it clear that no one of these factors is determinative, but that all the factors must be examined. In applying them to the Reid case, the Court found Reid clearly to be an independent contractor, not an employee.

The practical consequences of this landmark decision are that some clients have reexamined their policies of insisting on work for hire, determining that it is more desirable and economical to purchase only the specific rights needed. Other clients who insist on work for hire comply strictly with the requirement for written agreements stating expressly that a work will be for hire.

But while the Supreme Court's decision narrowed one loophole, it may have widened others. Under the "joint authorship" provision of the Copyright Act a work may be presumed to be a collaborative effort between the artist and the client, granting each party the right to exploit the work independently of the other without regard to the importance of their respective contributions—if each party's contribution is copyrightable—so long as profits are accounted for and divided equally. In the Reid case, for example, it ultimately was decided that the sculptor retained the right to make two- and three-dimensional copies; CCNV retained the right to make two-dimensional copies such as Christmas cards and posters.

Playboy Enterprises Inc. v. Dumas

The Graphic Artists Guild is categorically opposed to the use of work-for-hire contracts. The practice of back-of-check contract terms, used by some clients to force a work-for-hire arrangement, was limited severely by a 1995 federal court decision in the case of *Playboy Enterprises Inc. v. Dumas*. Let stand by the U.S. Supreme Court, the Second Circuit Court of Appeals unequivocally repudiated declarations of "for hire" agreements produced after the contract was fulfilled. However, they did not, as the Graphic Artists Guild argued in an amicus curiae brief, agree that work-for-hire agreements must be established in writing before work begins.

Playboy Enterprises Inc. v. Dumas resulted from an attempt by the widow of artist Patrick Nagle, Jennifer Dumas, to exploit economically after his death work of her husband's that had been commissioned by *Playboy*. He had endorsed checks with work-for-hire language on the back; therefore, claimed *Playboy*, the company was the legal author of the work.

The Court decided "that the written requirement can be met by a writing executed after the work is created, if the writing confirms a prior agreement, either explicit or implicit, made before the creation of the work." The language of the decision unfortunately opens the door to a flood of court actions if unscrupulous clients claim there was an "implicit" work-for-hire agreement, prior to creation, when in fact none existed.

The Graphic Artists Guild strongly recommends that artists and clients confirm all assignments in writing before work begins, detailing the terms of the agreement and the specific rights licensed. This professional practice will avoid any confusion or misunderstanding—or legal action—concerning the rights sold.

Artists confronted with work-for-hire language on the back of fee checks may consider crossing out the work-for-hire language and writing "deposited without preconditions" to mitigate the attempted rights grab.

Rights of celebrity and privacy

Artists occasionally are asked by clients to reproduce or imitate images of public figures and/or another artist's work. The potential for infringing copyright or an individual's privacy can be serious, and underscores the need for including indemnification clauses protecting artists in all contracts.

A recent case that threatens artists concerns the use of celebrity animals and the images associated with professional sports that include animals. Visual artist Jenness Cortez was sued by the New York Racing Association (NYRA) in July 1995 for her use of the Saratoga racing track, including the use of the word "Saratoga," in her original paintings, etchings, and lithographs. The NYRA claimed the right to a portion of the income derived from the sales of her work. In August 1996 a U.S. District Court dismissed the case, saying Cortez's work was covered by the First Amendment.

Shortly afterward, however, Cortez was sued by the owner and agents of the champion racehorse Cigar for trademark infringement and unauthorized use of the horse's image. This case is pending as *Pricing & Ethical Guidelines* goes to press.

Moral rights

Moral rights derive from the French doctrine of *droit moral*, which recognizes certain inherent personal rights of creators in their works, even after the works have been sold or the copyright transferred. These rights stand above and distinct from copyright.

The doctrine traditionally grants to artists and writers four specific rights:
♦ the right to protect the integrity of their work to prevent any modification, distortion, or mutilation that would be prejudicial to their honor or reputation;
♦ the right of attribution (or paternity) to insist that their authorship be acknowl-

edged properly and to prevent use of their names on works they did not create;

♦ the right of disclosure to decide if, when, and how a work is presented to the public; and

♦ the right of recall to withdraw, destroy, or disavow a work if it is changed or no longer represents their views.

The Berne Convention

Moral rights have long been an integral part of copyright protection laws in most European nations but were largely rejected and ignored in the United States. In 1886, the United States refused to join the Berne Convention, a worldwide multinational treaty for the protection of literary and artistic works that accepted moral rights as a matter of course. Member nations participating in Berne are required to conform their copyright laws to certain minimum standards and to guarantee reciprocity to citizens of any other member.

But after 100 years, economic realities and skyrocketing foreign piracy forced the United States to seek entry into the Berne union. By this time, the 1976 Copyright Act had brought the United States closer to Berne standards; the copyright term was extended from a 28-year term with one renewal to the life of the creator plus 50 years, and copyright notice was eliminated as a requirement for bringing an action for infringement.

Several states had enacted various forms of moral rights statutes, due in great part to Guild involvement. Certain moral rights elements had been protected in state and federal courts, which saw them as questions of unfair competition, privacy, or defamation. The totality of the American legal system, therefore, persuaded Berne administrators that the United States qualified for membership.

In 1988, the United States became the eightieth country to sign the Berne Convention, thereby extending protection to American works in 24 nations with which the United States has no separate copyright agreements. This succeeded as well in stemming the loss of billions of dollars in royalties to copyright owners. Although works are now protected at the moment they are created, it is still advisable to affix a copyright notice (e.g., © Jane Artist, 1994 or Copyright, Jane Artist, 1994), as it bars the defense of innocent infringement in court and (in part) because it affords international copyright protection in those countries that are members of the Universal Copyright Convention (UCC), which still requires a copy-right notice on a work. And, while foreign works are exempt, until copyright law is changed, American works still have to be registered with the U.S. Copyright Office before their creators can sue for infringement, statutory damages, and attorneys fees.

The Visual Artists Rights Act

Most of the cases that brought moral rights problems to the public's attention revolve around mutilation of works of fine art, such as Pablo Picasso's *Trois Femmes*, which had been cut into one-inch squares and sold as original Picassos by two entrepreneurs in 1986; the destruction and removal of an Isamu Noguchi sculpture from a New York office lobby; or the alteration by the Marriott Corporation of a historic William Smith mural in a landmark Maryland building.

A much publicized case in the graphic arts area involved Antonio Vargas's series *The Vargas Girls*, which ran in *Esquire* magazine. After Vargas's contract with *Esquire* expired, the magazine continued to run the series under the name *The Esquire Girls* without giving Vargas credit. Vargas brought *Esquire* to court but lost the case: He had no rights left under the contract, even the rights to his own name.

Moral rights legislation at both the state and federal levels has been proposed and supported vigorously by the Graphic Artists Guild since the late 1970s. Successes in California (1979), New York (1983), Maine and Massachusetts (1985), and other states helped sustain the momentum to advance a federal version.

Members of the Graphic Artists Guild have argued strongly that appearance of their artwork with unauthorized alterations or defacement can damage an otherwise vital career. By presenting testimony about the problems that illustrators and designers face, the Graphic Artists Guild was able to broaden the legislation. The bills the Guild helped to pass recognize artists' ongoing relationships with the work they create.

The Visual Artists Rights Act finally was enacted by Congress in 1990. While it is a positive first step toward comprehensive moral rights legislation, the Act has limited application and, ironically, may invalidate many state statutes that may be far more protective through federal preemption.

The law covers only visual arts and only one-of-a-kind works (defined as paintings, drawings, prints, photographs made for exhibition only, and sculptures, existing in a single copy or in a limited edition of 200 copies or

fewer, signed and numbered consecutively by the artist). Specifically excluded are any kind of commercial or applied art (advertising, promotional, packaging); posters, maps, charts, and technical drawings; motion pictures and other audiovisual works; books, magazines, newspapers, and periodicals; electronically produced work; any work for hire; and any noncopyrightable work.

The moral rights protected are limited to those of attribution and integrity. Any distortion, mutilation, or other modification of a work must be intentional; mere natural deterioration is not actionable unless caused by gross negligence. In addition, the Act places two burdens on the artist: to prove that a threatened act would be "prejudicial to his or her honor or reputation" and, in order to prevent destruction of a work, to prove that it is "of recognized stature." Since no guidelines are provided for either standard, their meaning will have to be determined in the courts on a case-by-case basis.

These rights exist exclusively with the artist during his or her lifetime and may not be transferred. They may be waived, but only by an express written and signed agreement. In the case of a joint work, each contributing artist may claim or waive the rights for all the others. The Act also contains special provisions for removal of works that are parts of buildings (murals, bas reliefs), including a procedure to register such works.

A potential problem of this law is that it invokes the doctrine of federal preemption and can be read to supersede any existing state laws that protect equivalent rights against mutilation and defacement. Among the questions that probably will have to be answered in the courts are whether these statutes, many of which apply to other visual works or extend greater protections, are completely preempted or only partially so, and whether they may be invoked after the death of the artist.

Resale royalties

Another time-honored French doctrine that, like moral rights, transcends rights of copyright and ownership of the original work in most Berne signatory countries, is known as *droit de suite*. It grants to creators a share in the value of their works by guaranteeing a certain percentage of the sale price every time a work is resold.

In the United States such rights, known as resale royalties, exist only in California. A provision for resale royalties had been part of the original version of the Visual Artists Rights Act, but it was later dropped because of strong opposition from art dealers, auction houses, and museums. Under the Act's authority, the Copyright Office conducted a study on the adoption of resale royalty legislation and recommended against it, concluding that potential royalties are too far removed to provide the proper incentives to the artists to create. Incredibly, the study suggested that resale royalties might actually have an adverse economic impact on artists, because a buyer anticipating having to pay a future royalty will lower the amount the purchaser is willing to pay. The Copyright Office did suggest, however, that the issue be reexamined if the European Community decides to harmonize existing *droit de suite* laws to extend the resale royalty to all its member states.

Original art

Well-known illustrators can command high prices for the sale of their original art. In fact, many graphic artists also sell their work through galleries, to collectors, and to corporations. Original art may be exhibited, used as portfolio pieces, given as gifts, or bequeathed as part of an estate.

Concern for protecting ownership of an original work stems not only from artists' interests in obtaining additional income from the sale of the original, but also from their interest in protecting their reputations and careers.

Ownership of the physical art, while separate from ownership of copyright, similarly is vested with the artist from the moment it is created. Selling the artwork does not transfer any rights of copyright, as selling a right of reproduction does not give a client any claim to the physical artwork.

The work may be given to the client temporarily so reproductions can be made, but the client must take reasonable care of it and return it undamaged to the artist. Of course, separate fees can be negotiated for the physical artwork with a client or with any other party who wishes to buy it.

Fair practices

The Fair Practices Act, signed into law in Oregon (1981; Sects. 359.350-359.365, Rev. Stat.), in California (1982; Sect. 988, Civil Code). and in New York (1983; Sects. 1401, 1403, Artists and Cultural Affairs Law and

Artists' Authorship Rights law; Sect. 12.9, Gen. Bus. Law), clarifies who owns the original work of art when reproduction rights are sold. This legislation was drafted by the Guild's attorneys based on concerns raised by Guild members.

The Act provides that an original work of art can become the property of a client only if it is sold in writing. The passage of this Act reinforces one of the premises of the copyright law, which is that works of art have value beyond their reproduction for a specific purpose, and that this value rightly belongs to the artist who creates them. The Fair Practices Act prevents clients from holding on to originals unless they have written sales agreements with the creator. In those states where it applies, this Act solves problems that can arise when clients believe they have obtained ownership of the original art when in fact they have only purchased rights of reproduction, or when they believe they have obtained an original through an ambiguous oral agreement.

In Oregon and California the law also provides that any ambiguity as to the ownership of reproduction rights shall be resolved in favor of the creator/artist. For artists whose livelihoods depend on resale of reproduction rights and on sales of original works, these laws are critical.

Another important piece of legislation that prevents unauthorized reproduction of artwork was enacted by a Georgia statute in 1990. The Protection of Artists Act requires commercial printers to obtain written affidavits from their clients attesting that the artist has authorized the reproduction of the work when the printing of the art (painting, drawing, photograph, or work of graphic art) costs $1,000 or more. Echoing the federal copyright law, the Georgia law separates the ownership of artwork from the right to reproduce it, and puts clients on notice that bills of sale or purchase orders must state explicitly the extent of the rights purchased. Any client or printer who uses or reuses artwork without the written permission of the artist would be subject to misdemeanor penalties. The Atlanta Chapter of the Guild was instrumental in getting the law passed.

Trademarks

A trademark may be a work, symbol, design, or slogan, or a combination of works and designs, that identifies and distinguishes the goods or services of one party from those of another. Trademarks identify the source of the goods or services. Marks that identify the source of ser-

vices rather than goods typically are referred to as service marks (e.g., the Graphic Artists Guild logo, the Guild's service mark, appears in print with an ®). Normally, a trademark for goods appears on the product or its packaging, while a service mark usually is used to identify the owner's services in advertising. The protection given to trademarks and service marks is identical, and the terms are sometimes used interchangeably.

While a copyright protects an artistic or literary work and a patent protects an invention, a trademark protects a name or identity. For example, Adobe ® is the word used as the trademark for certain software products; Mickey Mouse is a trademarked character for Disney; and Amtrak is a service mark for railroad service. Sounds, such as jingles, can also be used as trademarks, as can product shapes or configurations such as McDonald's distinctive golden arches.

Trademark protections can last indefinitely if the mark continues to be used for a source-indicating function. A valid trademark gives the owner the right to prevent others from using a mark that would be confusingly similar to the owner's mark. If anyone else uses the mark for similar goods or services and it is similar in sound, connotation, or appearance, then the first user can prevent the latecomer from using the mark. The test for infringement is whether there would be a likelihood of confusion as to the source of the goods or services.

For maximum trademark protection, a party using a trademark in interstate commerce should register the trademark with the U.S. Patent and Trademark Office (PTO), Washington, DC 20231, for $245. It is recommended that a search be conducted to determine whether a trademark is already in use by another party, since the application fee will not be refunded if the application is rejected. Basic information about trademarks can be obtained by calling the PTO at 703.557.4636.

To date, 78 locations around the country have been designated as Patent and Trademark Depository Libraries. The depository receives a CD-ROM database directly from the PTO from which information can be retrieved free of charge via public access terminals. Library personnel will answer general—but not legal—questions and provide preliminary instruction on how to conduct a search. Current listings of attorneys and agents specializing in patents and trademarks are also available at the depository. For the location nearest you, call 703.308.HELP (703.308.4357).

While not mandatory, federal registration protects the trademark throughout the United States, even in geographical areas in which the trademark is not being used. A federal registration is legal evidence of trademark ownership and the exclusive right to use it in interstate commerce. As in copyright, someone with a federal registration can file infringement suits in federal courts and be eligible for special remedies when infringement is proved, including attorneys fees and damages.

The owner of a federal trademark registration may give notice of registration by using the ® symbol. Trademark owners who do not have a federal registration must use the symbol ™ (for trademarks) and ℠ (for service marks).

International and Canadian copyright

Any discussion on this subject is best begun with the proviso that there is no such thing as international copyright law. In other words, there is no one international copyright law; each country has its own copyright laws. However, artists are protected under each country's laws through the copyright relations their home country shares with the others.

In practical terms, this means that a U.S. artist is protected by copyright in most other countries, though protection may be to a different degree than in the United States. For example, moral rights, discussed elsewhere in this book, are protected differently depending on the country. In some countries, such as France, there is much greater moral rights protection for all creators of copyrighted works than in many others. In other countries, such as Canada, moral rights protection for visual and/or fine artists do not extend as far as they do, for example, in France, but the protection extends to all creators of copyright materials, unlike, for example, in the United States.

Copyright laws around the world protect artists and provide them with negotiating power. All copyright laws are based on these same principles. The copyright laws provide a certain copyright culture within a country and help to set industry standards in contractual relationships. For instance, because of the work-for-hire provision in the U.S. Copyright Act, in certain industries, such as the film industry, writers and other creators assign all their rights. In Canada, where there is no work-for-hire provision per se, screenwriters retain the copyright in their scripts and license the rights to a licensee/producer to make a film out of it.

As the graphic communication industries adapt to the global economy, graphic artists can easily reside in one country while serving clients in another. In the business relationships between artists and buyers, political boundaries are blurring. Canadian artists often serve U.S. clients and vice versa. The following section highlights and contrasts the important features of Canadian copyright law as it applies to the visual communications industries.

Canada/United States rights

♦ *registering copyright*: Copyright is automatic in Canada and always has been. There is a voluntary registration system but, unlike in the United States, no deposit system where artists deposit a copy of their works. Registration of copyright works and licenses relating to works has less stringent provisions than in the United States. Canadians will see much more space in contracts devoted to copyright registration and documentation issues in U.S. registration procedures; these are standard clauses in a U.S. agreement. Further, there are no copyright notice provisions under Canadian copyright law, though generally Canadian creators include a copyright notice as a way to remind the public that copyright does exist in their works.

♦ *duration of copyright*: There is no renewal of copyright in Canada, nor are there any works that fall into the public domain and that may be once again protected by copyright. With only two exceptions, in Canada a literary or artistic work is protected for 50 years after the death of the author. Engravings published at the time of an author's death are subject to the life-plus-50 rule. And photographs made on or after January 1, 1944, are protected for 50 years from the end of the calendar year of the making of the initial negative or other plate from which the photograph was directly or indirectly derived or, if there was no negative or other plate, from the making of the initial photograph. Engravings unpublished at the time of an author's death are protected until publication and for 50 years thereafter. A work that is being exploited in Canada and the United States may be licensed for a part of the duration of copyright or for the full term of it.

◆ *reversionary interest proviso*: In Canada,
where the author of a work is the first
owner of the copyright in it (i.e., it is not a
product of employment, a government
work, or a commissioned engraving, photo-
graph, or portrait), any copyright acquired
by contract becomes void 25 years after the
author's death. This does not mean that the
term of copyright is affected. It means that,
if specific conditions apply, any subsequent
owner of copyright will lose his or her
rights 25 years after the author's death. At
this time, the copyright becomes part of the
author's estate and only the estate has the
right to deal with the copyright. Conditions
affecting this reversion include when the
author disposes of the copyright by will for
the period following the 25-year limit.
Thus, the section may be avoided by
bequeathing copyright for the period
between 25 and 50 years after the author's
death.

It also does not apply where a work
has been assigned as part of a collective
work or a work or part thereof has been
licensed to be published in a collective
work such as an encyclopedia or magazine.

◆ *commissioned works:* Under Canadian law,
there is a special rule that only applies to
commissioned engravings, photographs, or
portraits. For these works, the person
ordering it is "deemed" to be the first
owner of the copyright in it if the following
conditions are met:
□ the person ordering the work has offered
valuable consideration, such as money
or services; and
□ the work was created because of the
order and was not created prior to the
order being made.
This is true provided there is no agreement
between the commissioner and the creator
stating that copyright subsists with the cre-
ator of the work.

This is different than the U.S.
work-for-hire provision, as it is limited to
three very specific types of works, and
when the art purchaser is based in Canada,
it is likely that the contract will be based
on Canadian law.

◆ *employment works:* In Canada, three criteria
must be met in order for works made dur-
ing employment to belong initially to the
employer. These are:
□ the employee must be employed under a
"contract of service";
□ the work must be created in the course

of performing this contract; and
□ there must not be any provision in a
contract that states that the employee
owns the copyright (such a contract need
not be in writing).

One important distinction between the
U.S. work-for-hire and the Canadian
employment works provision is that in
Canada, notwithstanding the fact that the
employee does not own the copyright, the
employee continues to retain the moral
rights. An employee can never license
these moral rights, though he or she can
waive them.

◆ *digital rights:* Under Canadian law,
although an agreement may govern only
one jurisdiction, say North America, cer-
tain rights, such as those for the Internet or
World Wide Web, are not necessarily sub-
ject to geographical division. This means
that by virtue of licensing Internet rights,
artists are granting a worldwide license.

◆ *moral rights:* Under Canadian law, there are
three types of moral rights:
□ the right of paternity;
□ the right of integrity;
□ the right of association, or disclosure.
These rights are discussed at length in the
section of this chapter entitled Moral
Rights and the Berne Convention.

Moral rights in Canada last for 50 years
until the calendar year end from the date of a
creator's death. Upon death, they can be
passed to an artist's heirs; they cannot other-
wise be transferred. However, artists can agree
not to exercise one or more of their moral
rights, and this is something artists working
with a Canadian company should be aware of:
Even when an artist transfers copyright, and
even where the work is owned by an employer,
the artist has moral rights unless they are
waived.

The United States has moral rights protec-
tions for limited works of visual art under the
Visual Artists Rights Act (see previous section of
this chapter). The duration depends on when the
work was created and/or transferred. If the work
was created after June 1, 1991, the rights endure
for the life of the artist(s). If the work was creat-
ed prior to June 1, 1991, and the title has not
been transferred to another party, the rights have
the same term as ordinary section 106 rights, as
determined by sections 302–304. If the author
transferred the work prior to June 1, 1991, he or
she has no moral rights in the work.

◆ *fair use/dealing and exceptions:* Canada
does not have a fair use provision, but has

a similar though much narrower provision, known as the fair dealing provision. It is generally only used for quotes from a book or article, etc., and does not apply beyond that or in cases, for example, of multiple copying (i.e., for classroom use) as in the United States. In addition, Canada has fewer exceptions that allow for free uses of copyright materials. A copyright revision bill is pending in the House of Commons as *Pricing & Ethical Guidelines* goes to press; if passed, there will be many more exceptions, primarily for schools, libraries, archives, and museums. This means that a U.S. artist may find that certain free uses of work in the United States may be uses for which permission will be requested and paid for in Canada. The converse is also true: Canadian artists may find that there may be free uses of their work in the United States for which they would be paid in Canada. Generally, this is not something that can be reversed by contract but is subject to the copyright statutes in the respective countries.

♦ *government works:* In Canada, the government owns the copyright in works produced by its employees, and sometimes independent contractors/consultants, and any use of government works requires permission from the government. Thus, a Canadian artist whose work incorporates some government works will probably have cleared copyright in that work before including it in his or her work. However, a U.S. artist may not have cleared copyright in a U.S. government work incorporated in his work; in this situation, although permission may not be required from the U.S. government for use of the work in the United States,

permission will be required when that same work is used in Canada. Therefore, an American artist in this situation should be careful in making any warranties and representations regarding copyright clearance of works incorporating any government materials.

♦ *governing law:* Parties to an agreement generally are free to choose the state/province whose law will govern the agreement. Parties in transborder working relationships must also choose the governing law and in some cases this will be a point of negotiation, as each party will probably want its own jurisdiction to govern the agreement. It is usually in the artist's best interests to have her own state/province's law govern the contract for ease of access to a lawyer in that jurisdiction as well as for convenience and costs should court action be necessary.

However, more and more agreements are now subject to mediation and binding arbitration in a place halfway between the cities of the contracting parties. This can at least limit costs and travel times. A lawyer should be able to help ensure that the laws of another jurisdiction are compatible with the artist's contractual relationship.

For more information on Canadian copyright, see the Resources and References chapter of this book.

The above information does not constitute legal advice, and proper advice should be sought where necessary.

[Thanks to Lesley Ellen Harris, a copyright and new-media lawyer who consults on United States, Canadian, and international copyright matters, for the information contained in this section. She is the author of *Canadian Copyright Law.*]

PROFESSIONAL
Issues

Professional issues

• • • • • • • • • • • • •

A variety of factors affect the way artists and designers work. Changes in business, tax, copyright, or other laws can dramatically affect a creator's business. So can emerging trends or practices that vary from accepted customs. Following are some of the major factors artists, designers, and their clients should be aware of as visual communications projects are transacted.

Deductibility of artwork

There is a popular misconception that artists donating their art to a charitable organization may deduct the "fair market value" of the work. Current law, in fact, distinguishes between "personal property" and "inventory." While anyone may donate personal goods to any charity and deduct the fair market value, businesses may only deduct the actual cost of producing the item. Artists, therefore, may deduct only the cost of producing the work, i.e., the price of the canvas, paint, and other materials. But if an artist sells an original work, the buyer may donate that piece of personal property and deduct the amount paid for it. As a result, artists have either withheld their valuable originals or sold them to private collectors, thus limiting public access.

Legislation signed into law by President Clinton on August 10, 1993, contains a number of significant provisions affecting taxexempt charitable organizations described in section 501(c)(3) of the Internal Revenue Code. Since January 1, 1994, deductions have not been allowed under section 170 of the Internal Revenue Code for any charitable contribution of $250 or more unless the donor has contemporaneously-written substantiation from the charity. The responsibility for obtaining this substantiation lies with the donor, who must request it from the charity. The charity is not required to record or report this information to the IRS on behalf of donors. Generally, if the value of an item (or group of like items) exceeds $5,000, the donor must obtain a qualified appraisal and submit an appraisal summary with the return claiming the deduction.

Sales tax

States have different policies in regard to sales tax. In those that have one, the rate usually ranges from 3 to 9 percent, and it is levied on the sale or use of physical property within the state. A number of exemptions exist, including special rules for the sale of reproduction rights. The applicable state regulations should be consulted.

Generally, services, including the services of transferring reproduction rights, are not subject to sales tax. Transfers of physical property to a client (i.e., original art, designer's mechanicals) generally are not subject to sales tax if they are part of a project that will be billed to a client later by a design firm or other agent, although a resale certificate may have to be obtained. Sales tax is applicable for end sales or retail costs only, not for intermediate subcontracting. An artist may have to file forms showing that materials were intermediate and thus not taxable.

Variations by state

Many tax laws are unclear in relation to the graphic communications industry, though efforts are underway to clarify them (see section on New York State following). In any case in which artists are doubtful about whether to collect the tax, it is safest to collect and remit it to the state sales tax bureau. If artists should collect the tax but don't, they, as well as their clients, will remain liable. It can, however, be difficult to try to collect the tax from clients on assignments that have been performed in the past if an audit or another review determines that sales tax was owed.

The examples of California, Minnesota, and Massachusetts following illustrate the great variation in states' sales tax regulation.

♦ *California:* Following a random audit in 1993, the Board of Equalization (BOE), one of California's taxing agencies, ruled that children's book and stamp illustrator Heather Preston was required to pay sales taxes on four years' worth of royalties for book and rubber stamp illustrations. But she found peculiar catches: The authors of the books Preston illustrated, who turned in hard-copy manuscripts, owed no sales tax on their royalties. And had she sent the work electronically, rather than in hard copy, she would likely not have owed sales tax. On June 21, 1996, following an unsuccessful appeal to the BOE, Preston filed a lawsuit to recover sales taxes and interest

on the ground that the BOE has improperly attempted to treat the grant of use rights as a transfer of tangible property.

The BOE considers hard-copy artwork "tangible," and therefore taxable, but written work is information, and therefore "intangible," and exempt. This distinction is made in addition to numerous other exemptions lobbied for by powerful California industries such as software manufacturers, film studios, and music companies.

Shortly before Preston filed suit, cartoonist Paul Mavrides won an appeal of his back taxes claim. Mavrides's case, which was supported by the California Newspaper Publishers Association, the American Civil Liberties Union, the Cartoonists Legal Defense Fund, and over 30 other organizations, differed in significant respects from Preston's.

In Mavrides's case, the BOE attempted to collect sales tax from cartoonists for the first time following the 1991 repeal of newspapers' exemption from the sales tax. The ruling in his successful appeal was made narrowly, exempting from the tax artists who also write the accompanying script when their work is published in books, magazines, or newspapers, but not when in greeting cards, posters, displays, etc.

♦ *Minnesota:* A March 1993 Minnesota rule states that the sale of an advertising brochure is no longer considered the sale of "tangible personal property" (a physical product, rather than a service or intellectual property such as reproduction rights); it is now considered part of the sale of a "nontaxable advertising service." Since the agency is selling a nontaxable service, it must pay tax on all the taxable "inputs" (all the components of an advertising product that were provided by outside vendors such as illustration, photography, or copywriting) used to create the brochure—including commissioned artwork. In most cases the inputs can no longer be purchased tax exempt.

♦ *Massachusetts:* The Department of Revenue in Massachusetts recently has been attempting to tax activities that previously had been held tax-exempt service activities: specifically, the creation of preliminary artwork; logos designed for corporate use; services in conjunction with newspapers, magazines, and periodicals; and others. There is a growing movement in Massachusetts to resist these changes. For more information,

please contact the Graphic Artists Guild Boston Chapter at 617.455.0363.

♦ *New York State:* For two years beginning in 1990 a coalition representing the American Institute of Graphic Artists (AIGA), the Graphic Artists Guild, and the Society of Environmental Graphic Designers (SEGD) met with representatives of the New York State Sales Tax Authority to establish guide–lines for how graphic designers and illustrators should charge sales tax for their services.

All three organizations clearly recog-nized the need to address the confusion in the industry on this issue. Many in the industry were being told different things by different people (including accountants and other professionals) and consequently faced substantial sales tax assessments if audit-ed. The New York State Tax Department worked with the Guild, the AIGA, and SEGD to provide clear and understandable rules. The guidelines, as they appear here, have been reviewed and approved by the New York State Tax Department

Guidelines for the Interpretation of Sales Tax Requirements in New York State

The following are some frequently asked questions about sales taxes, and their answers, that will enable graphic artists to understand the guidelines provided by the New York State Department of Taxation and Finance, Sales Tax Instruction & Interpretation Unit.

♦ When are graphic designers and illustrators expected to charge sales tax on their services and when are their sales exempt from tax?

♦ When are graphic designers and illustrators expected to pay sales tax on the materials, equip-ment, and services they buy, and when are those purchases exempt from tax?

SPECIAL RESPONSIBILITIES FOR GRAPHIC DESIGNERS AND ILLUSTRATORS WORKING IN NEW YORK CITY

On certain purchases, only New York City sales tax (currently 4 percent) is payable; New York State sales tax (currently 4.25 percent) is not. These purchases are:

♦ consumable materials used to produce work for sale and which are not to be passed along to the client as part of the final product, including knife blades, masking tape, tracing paper, sketch paper, and markers;

♦ maintenance and repair services for equipment predominantly used to produce work for sale, such as computer, laser printer, or copier repair and maintenance;

♦ freelance services used during the production of work for sale, including those employed to work on presentation materials or mechanicals that are part of a contract on which sales tax will be charged.

From a practical standpoint, it is easy to know whether a freelancer's services are subject to the New York City tax, because the projects on which they are working are specific. With consumable materials and maintenance and repair it is not always as clear, and it may be simpler just to pay the full New York City sales tax rather than guess what project they may be used on.

When any of the above items or services are purchased, the graphic designer or illustrator must still issue a valid resale or exempt use certificate to be exempt from the state sales tax, even though the local city tax is being paid.

The Graphic Artists Guild strongly recommends that graphic artists consult an accountant or tax lawyer to determine tax liabilities under these guidelines. Because of their familiarity with an artist's business, these professionals are suited to answer questions best. An alternative would be to contact the New York State Department of Taxation and Finance, Sales Tax Instruction & Interpretation Unit, Room 104A, Building 9, State Campus, Albany, NY 12227, 800.CALL TAX (800.225.5829).

If any ruling is obtained that is contrary to these guidelines, please notify the Graphic Artists Guild.

Charging sales tax

The basic sales tax law imposes a tax on the sale of tangible personal property. Many local authorities add their own sales tax to the tax imposed by the state. The resulting sales tax must be: charged in addition to the rest of the sale; stated as a separate item on any invoice; paid by the purchaser.

Payment of sales tax by the seller (in this case by the graphic designer or illustrator), or failure to itemize it on an invoice, is prohibited. Mixing taxable with nontaxable items on the same invoice subjects the entire invoice to sales tax.

Exemptions from charging sales tax

The six areas of exemption relevant to graphic designers and illustrators are:

♦ *items for resale:* When tangible personal property passes through intermediate owners, taxes are deferred until it reaches the final purchaser. An example is any item purchased in a store. Sales tax is paid by the end customer at the over-the-counter sale; the retailer doesn't pay tax when purchasing from the wholesaler; the wholesaler doesn't pay it when purchasing from the manufacturer. Consequently, any item purchased for resale may be purchased tax-exempt if the purchaser issues a properly completed resale certificate. The responsibility for collecting the tax then falls on the seller when the item is resold to the final purchaser.

♦ *exempt use:* If the final sale is for an exempt use, for instance, promotional materials delivered to a client in New York but to be distributed out of New York State, the vendor must verify the tax-exempt status by obtaining an exempt use certificate from the purchaser.

♦ *sales to exempt organizations:* Nonprofit and educational institutions, and most federal and New York State governmental agencies, have tax-exempt status. In this instance, the vendor must verify the tax-exempt status by obtaining an exempt organization certificate or government purchase order from the purchaser.

♦ *grants of reproduction rights:* At the end of a creative process, if specified restricted rights only are transferred, but there's no transfer of ownership of tangible personal property (e.g., the original, physical artwork or 50,000 brochures), the transaction is not taxable. Grants of rights are not subject to the sales tax.

♦ *tax-exempt services:* Purchases of certain services that do not result in the transfer of tangible personal property are, by their nature, not taxable. For example, professional fees for consultation services provided by doctors, attorneys, or accountants are not taxable.

♦ *out-of-New York State sales:* The sale of work to out-of-state clients, delivered out-of-state, is not subject to sales tax. There must, however, be evidence of out-of-state delivery.

Responsibility of graphic designers and illustrators for payment and collection of sales tax

Whether a graphic designer's or illustrator's services are taxable depends upon whether there is a final transfer of tangible personal property. If there is, the entire contract is taxable, including all consultations, designs, preparation of artwork, etc. If the graphic designer or illustrator transfers comps, mechanicals, computer data, printed materials, or fabricated materials such as exhibits or signs to the client, the artist's services are considered to be transferable personal property.

The results of a graphic designer's or illustrator's services are not considered transferable personal property if they do not provide printing or fabrication services; if they grant reproduction rights only; and if ownership of all the designs, comps, mechanicals, or computer data remains with the artist and are transferred only temporarily for reproduction; afterward they must be returned, unretouched, unaltered, and undisplayed, to the artist.

Corporate identity and logotype programs are a special case. Conceivably, one could state in a contract that only specific limited reproduction rights are being granted. In practice, however, the prospect of a client not having complete rights to their own logotype or corporate identity system is not credible. Therefore, such a project should be considered a taxable sale.

In most cases, graphic designers and illustrators will discover that some of their projects are taxable and some are not. As described below, it is important that taxable and nontaxable work be arranged under separate contracts.

Graphic designers and illustrators must remember that the onus is always on them to prove that a project is nontaxable. Therefore, agreements, invoices, and mechanicals or

comps should have very clear language stating that ownership remains with the artist; that only rights for reproduction are being granted; and any graphic representations or artwork are being transferred temporarily solely for the purpose of reproduction, after which they are to be returned—unretouched, unaltered, undisplayed—to the graphic designer or illustrator.

If you are required to charge a sales tax, you should consult an experienced accountant to determine your specific responsibilities. You will have to register as a vendor and, as a collector of taxes on the state's behalf, will be issued a resale number enabling you to purchase certain materials, free of tax, for the creation of the products to be resold to your clients.

There are two basic exemption documents used by graphic designers and illustrators when making tax-exempt purchases: the resale certificate and the exempt use certificate. The resale certificate is only for items or services that will become a part of the item being sold; for example, the illustration board used for a mechanical. The exempt use certificate is for items used in the production of the final product but that do not become an actual part of it; for example, knife blades used to trim the illustration board.

Graphic designers and illustrators are required to keep accurate records of all items so purchased and for which project they were used. They are also required to retain the subsequent invoice that indicates sales tax has been charged on that item directly or on the item into which it has been incorporated. It is essential that graphic designers and illustrators keep clear, thorough records of all projects, including all purchases for each project, so that in the event of an audit they can show accurately that they paid sales tax on their purchases.

A graphic designer or illustrator is entitled to purchase services or materials for resale, or for production, without paying tax, even if sale of the final product will be exempt from tax; i.e., to an exempt client or if the final product will be shipped out of New York State.

The resale certificate may not be used if the services do not result in a sale, such as when only unrestricted reproduction rights are granted or if the contract is for consultation alone, with no tangible end result. On such projects, the designer must pay tax on all equipment, supplies, and services used.

Equipment, such as computers and laser printers, that is used predominantly for the production of work for sale (i.e., more than 50 percent of the time) also may be purchased exempt from sales tax by submitting an exempt use certificate to the vendor. Don't forget: This means that if only half the artist's work results in taxable sales, and this equipment is used only half the time on design work, then the equipment is being used only 25 percent of the time to produce work for sale, and therefore it is subject to full tax when purchased.

Graphic designers and illustrators working in New York City must be aware that there are special considerations concerning their purchases, as follows:

If most projects are not taxable, it may be simpler to pay tax on all the equipment, supplies, and services you purchase, just to be on the safe side and to simplify matters in the event of an audit.

Where projects may result in a taxable sale it is permissible to divide the project into two entirely separate contracts, one which is taxable and one which is not. As an example, if a client wishes the designer or illustrator also to provide printing and fabrication services, they may set up one contract for design and production of the artwork and an entirely separate contract for printing and fabrication. The design and production contract must specify the transfer of limited reproduction rights only, and the client must be able to terminate the relationship and go elsewhere for printing or fabrication services. A separate contract, to provide printing services, would be taxable (subject to the other relevant exemptions described above, i.e. exempt purchaser, out-of-state delivery, etc.).

In the case described above it is essential to keep the two contracts entirely separate: separate proposals, separate agreements, and separate invoices. Do not make the mistake of mixing the two. If any part of the contract is taxable, it can be only because there is a taxable sale, and consequently the entire project is taxable. There cannot be one contract where some items are taxable and some are not.

Using freelance suppliers

It is important for freelance graphic designers and illustrators to understand that services they use, such as those of freelance typographers, are taxable. All freelancers must charge sales tax on their services to the graphic designer or illustrator, unless the exemptions outlined above apply.

In certain circumstances, the artist who uses freelance services should, for their own

protection, pay any tax due directly to the state (if, for example, the freelancer is a student and not registered as a vendor, or if the freelance supplier does not bill and collect the tax). A specific fill-in section on the sales tax reporting form, entitled "Purchases Subject to Use Tax," is provided for this purpose.

When the graphic designer's or illustrator's services results in a taxable sale, he or she may issue a resale certificate to their freelancer for their work.

When a freelancer works on a project that does not result in a taxable sale for the artist, i.e., where reproduction rights only are being granted to the client, then the artist must pay full tax on the freelancer's fee.

Again, in the event of an audit, it is essential to keep accurate records. Graphic designers and illustrators should keep carefully receipted invoices from freelancers showing that, where appropriate, sales tax has been charged and paid. If the evidence is not clear-cut, the sales tax authorities will expect the artist to pay the taxes.

New technology

In recent years, computers have become a large part of professional artists' day-to-day lives. Artwork is composed and enhanced on computer, stored and altered, and transmitted by telephone lines to satellites for review and production. Artwork created or produced on computer is used in virtually all markets and fields, and new computer-related markets, such as online services and the World Wide Web, have opened.

Concerned with the effects of new technologies on society and the marketplace, the Graphic Artists Guild provided information to the U.S. government about the impact of the technology and the need to develop public policy. This information was considered by the U.S. Department of Commerce when formulating regulations for the National (Global) Information Infrastructure, sometimes known as the "information superhighway."

Among the concerns expressed were that existing copyright law is inadequate to protect artists' works, which can be stored in electronic "image banks," or on electronic information networks, and manipulated and used without the artist's knowledge or permission. While unauthorized uses and alterations already occur, artists are concerned that with the increasing ease and availability of the new technologies these kinds of abuses will proliferate unless public policy is shaped to prevent them.

Legislation introduced by Senate Judiciary Chairman Orrin Hatch (R-Utah) would strengthen copyrights in the digital age in the following ways:

♦ prohibit breaking any security or encoding devices;

♦ make it a criminal act to change any encoded copyright management information (e.g., name of author, use restrictions);

♦ allow libraries to make additional archival copies;

♦ allow braille versions to be produced if the publisher doesn't do it within a year.

While there is potential for great harm to creators, the new technologies also offer the possibility of great creative advances. That is why the Guild advocates that public policy emphasize research into technologies that will help protect authorship rights. (Please consult the New Technology Issues chapter for a thorough discussion of the impact of this equipment on graphic artists, designers, and their clients.)

Employment issues

Portions of the Employment Issues section were reprinted from *Communication Arts* with permission of Tad Crawford
© Tad Crawford, 1993.

Clients should be aware that the Internal Revenue Service takes a dim view of independent contractor relationships. From the government's perspective, employers use so-called independent contractors to evade employment taxes. If independent contractors are hired, the employer should be sure they can justify this designation in the event of an audit. If the IRS successfully reclassifies the independent contractors, the very existence of a firm can be threatened. (Please consult the Legal Rights and Issues chapter for a complete discussion of work for hire.)

In recent years the Internal Revenue Service has cracked down on advertising agencies, design firms, publishers, and others, by examining whether artists providing graphic design, illustration, or production services are actually independent contractors ("freelancers") or employees. In audit after audit, the IRS has determined that so-called freelancers are in fact employees, based upon an analysis of the actual working relationship between the client and the graphic artist.

Especially vulnerable to IRS scrutiny, and a significant risk to the hiring party, are those artists who work as "full-time freelancers." One West Coast comic book publisher, for example, went out of business following the six-figure penalties imposed by the IRS for misclassifying its employees as independent contractors.

There are advantages and disadvantages to each classification for both the artist and the hiring party. Independent contractors are paid a flat fee, simplifying the employer's bookkeeping, and depending on the freelancer's fee structure, the art buyer may realize significant savings on taxes, insurance, and other fringe benefits. Independents retain some control over their copyrights, time, and business tax deductions for materials, overhead on private work space, etc. But independents always risk loss from partial payments when work is rejected or canceled or when they work on speculation, while employees are guaranteed at least the legal minimum wage.

Social Security tax (FICA)

When classified as an employee, 7.65 percent of a graphic artist's gross income up to $60,600 is paid by the employer; the remaining 7.65 percent of the total Social Security payment is withheld from the artist's paycheck. Independent contractors must pay the full 15.3 percent FICA tax on adjusted gross income.

Benefits and insurance

All employees are entitled to receive unemployment, disability, and workers compensation insurance coverage. Depending upon specific company policy, employers may also be obligated to provide optional fringe benefits such as paid vacations, comprehensive medical and hospitalization insurance, employer-funded pension plans, or profit-sharing to every employee. Independent contractors must purchase their own disability coverage and have no access to unemployment insurance or workers compensation. Furthermore, independent contractors must provide their own vacations, medical coverage, and retirement plans.

Tax deductions

Independent contractors can reduce their taxable income significantly by deducting legitimate business expenses. Employees may also deduct unreimbursed expenses, but only for the amount exceeding 2 percent of their adjusted gross income.

Job security

Employees do not enjoy the freedom of working for whom they want and when they want as a freelancer might, but they do enjoy some security of a regular paycheck. The 1980s and 1990s downsizing trend, however, has given longtime employees a greater sense of insecurity about their employment status than previously. Employees have a legal right to organize for the purposes of collective bargaining, a right denied to most independent contractors. The Graphic Artists Guild currently represents one group of employees in a collective bargaining agreement with their employers, at Thirteen/WNET Educational Broadcast Television in New York City. This contract, a three-and-a-half-year agreement effective January 1, 1995, broadened the definition of graphic artists eligible for union representation and benefits; improved attributions and program credits; guarantees approximately 9 percent salary increases during the contract; and provides medical, holiday, and vacation benefits.

Work for hire

The work-for-hire doctrine allows the employer to be the legal author of a work. Independent contractors are recognized as the author of the work and control the copyright unless they sign a contract that specifically states the work is a "work for hire." All work created by employees, however, unless otherwise negotiated, is done as work for hire, which gives authorship and all attendant rights to the employer. Negotiating those rights back, while possible, is not easy.

Determining employee status

The IRS has issued a 20-factor control test (Revenue Ruling 87-41, 1897-1CB296) to clarify the distinction between employees and independent contractors. The control test is easy to state generally: Is the outside help subject to the control of, or right to control by, the firm?

Unfortunately, however, the guidelines are too general to resolve every situation. Often some factors suggest employee status while others suggest independent contractor status. Key factors looked to by the IRS include:

♦ *instructions:* Is the worker required to obey the firm's instructions about when, where, and how work is to be performed? If the firm has the right to require compliance with such instructions, the worker is likely to be an employee.

♦ *training:* Training a worker suggests that

the worker is an employee. The training may be only having a more experienced employee work with the newcomer, by requiring that he or she attend meetings, by correspondence, or by other methods.

♦ *integration:* If a worker's services are part of a firm's operations, this suggests that the worker is subject to the firm's control. This is especially true if the success or continuation of the firm's business is dependent in a significant way upon their services.

♦ *personal services:* If the firm requires that the services be performed in person, this suggests control over an employee.

♦ *use of assistants:* If the firm hires, directs, and pays for the worker's assistants, this indicates their employee status. On the other hand, if the worker hires, directs, and pays for his or her assistants; supplies materials; and works under a contract providing that they are responsible only to achieve certain results, this would be consistent with independent contractor status.

♦ *ongoing relationship:* If the relationship is ongoing, even if frequent work is done on irregular cycles, the worker is likely to be an employee.

♦ *fixed hours of work:* This would suggest that the worker is an employee controlled by the firm.

♦ *full-time work:* If the worker is with the firm full time, this suggests the firm controls the time of work and restricts the worker from taking other jobs. This would show employee status.

♦ *work location:* If the firm requires that the worker be at the firm's premises, this suggests employment. The fact that the worker performs the services off premises implies being an independent contractor, especially if an employee normally would have to perform similar services at an employer's premises.

♦ *work flow:* If the worker must conform to the routines, schedules, and patterns established by the firm, this is consistent with being an employee.

♦ *reports:* A requirement that reports be submitted, whether oral or written, would suggest employee status.

♦ *manner of payment:* Payment by the hour, week, or month suggests an employee, while payment of an agreed upon lump sum for a job suggests an independent contractor.

♦ *expenses:* Payment of expenses by the firm implies the right to control company expenses and thus suggests employment

status.

♦ *tools and equipment:* If the firm provides tools and equipment, it suggests the worker is an employee.

♦ *investment:* If the worker has a significant investment in his or her own equipment, this implies being an independent contractor.

♦ *profit or loss:* Having a profit or loss (due to overhead, project costs, and investment in equipment) is consistent with being an independent contractor.

♦ *multiple clients:* Working for many clients would suggest independent contractor status, although it may be that the worker is an employee of each of the businesses, especially if there is one service arrangement for all the clients.

♦ *marketing:* If the worker markets his or her services to the public on a regular basis, this indicates independent contractor status.

♦ *right to discharge:* If the firm can discharge the worker at any time, this suggests employment. An independent contractor cannot be dismissed without legal liability unless the contract specifications are not met.

♦ *right to quit:* An employee may quit at any time without liability, but an independent contractor may be liable for failure to perform according to the contractual terms.

A matter of intention

The IRS even may argue that workers with a very peripheral connection to the firm—for example, mechanical artists or illustrators—are employees. The exposure for unintentional misclassification of an employee is serious, but not nearly as serious as the penalties for an intentional misclassification. If the misclassification is unintentional, the employer's liability for income taxes is limited to 1.5 percent of the employee's wages. The employer's liability for FICA taxes that should have been paid by the employee would be limited to 20 percent of that amount. The employer would have no right to recover from the employee any amounts determined to be due to the IRS. Also, the employer would still be liable for its own share of FICA or unemployment taxes. Interest and penalties could be assessed by the IRS, but only on the amount of the employer's liability.

If the misclassification is intentional, on the other hand, the employer can be liable for the full amount of income tax that should have been withheld (with an adjustment if the employee has paid or does pay part of the tax) and for the full amount of both the employer and employee shares for FICA (though some of

it may be offset by employee payments of FICA self-employment taxes). In addition, the employer is liable for interest and penalties that are being computed on far larger amounts than when the misclassification is unintentional.

Precautions and safeguards

After conducting a careful review of how their workers should be classified under the IRS's 20-factor control test, a client or firm may remain uncertain of what is correct. A wise approach is certainly to err on the side of caution and classify workers as employees when in doubt.

If the firm believes a worker to be an independent contractor, the two parties should negotiate a carefully worded contract. It should be legally binding and accurately set forth the parties' agreement. To be most helpful in the event of an IRS challenge, it must be apparent from the contract that the worker is an independent contractor under the 20-factor test. The contract must then be adhered to by the parties. If a firm has such contracts in place already, they should be reviewed with the IRS test in mind—and whether the parties in fact are following the terms of the contract.

To protect themselves from an IRS audit and the potential penalties, many clients are treating every artist as an employee, even those who are clearly independent. In these cases, clients are withholding appropriate taxes from creative fees and are issuing end-of-year W-2 forms rather than Form 1099. To counter the potential loss of copyright (since works created by employees are considered works for hire unless otherwise negotiated), artists should: clearly establish themselves as independent contractors, preserving authorship and copyrights; attempt to recoup the rights to their works from the hiring party through negotiation; or authorize a labor organization such as the Graphic Artists Guild to represent them in order to negotiate equitable fees, benefits, and rights. For more information on the potential benefits of collective bargaining in confronting this threat to artist's property rights, contact the Guild's national office.

Cancellation and rejection fees ("kill fees")

Cancellation provision

According to current and historical data, clients usually pay the artist a cancellation fee if the assignment is canceled for reasons beyond the artist's control.

♦ If cancellation occurred prior to the completion of the concept or sketch phase, current data indicates the average cancellation fee to be approximately 25 percent of the original fee for illustrators and approximately 40 percent for graphic designers.

♦ If cancellation occurred after the completion of preliminary work and prior to the completion of finished art, current data indicates the cancellation fee to be between 30 to 65 percent (with an average of approximately 50 percent) for illustrators and 45 to 100 percent (with an average of nearly 80 percent) for graphic designers.

♦ If cancellation occurs after the completion of finished art, the average cancellation fees currently range between 65 to 100 percent of the original fee, with the median response to the Guild's survey being 100 percent.

♦ Historical data indicate that all necessary and related expenses (such as model fees, materials, or overnight shipping fees) are paid in full.

♦ In the event of cancellation, the client obtains all of the originally agreed-upon rights to the use of the artwork upon payment of the cancellation fee (except in royalty arrangements; see the Pricing & Marketing Artwork chapter for more information). Even though the client chooses not to exercise a particular reproduction right at this time, that right is transferred to the client when the purchase is completed with payment. Depending upon the understanding between the parties, the specified right may revert back to the artist if not exercised within a specific period of time.

♦ If preliminary or incomplete work is canceled and later used as finished art, the client usually is obligated contractually to pay the unpaid balance of the original usage fee.

♦ Artists and clients may agree to submit any dispute regarding cancellation fees to a forum for mediation or binding arbitration.

Rejection provision

According to current and historical data, clients may agree to pay the artist a rejection fee if the preliminary or finished artwork is found not to be reasonably satisfactory and the assignment is terminated.

♦ If rejection occurred prior to the completion of the concept or sketch phase, current data indicates the average rejection fee to be

approximately 21 percent of the original fee.

♦ If rejection occurred after the completion of preliminary work and prior to the completion of finished art, current data indicates the rejection fee to be between 27 to 58 percent (with an average of approximately 42 percent).

♦ If rejection occurred after the completion of finished art, the average rejection fees currently range between 53 to 100 percent of the original fee, with 100 percent the median response to the Guild's surveys.

♦ All necessary and related expenses are customarily paid in full.

♦ In the event of rejection, the client has chosen not to obtain any rights to the use of the artwork. Therefore, many artists refuse to permit rejected work to be used for reproduction by the client without a separate fee.

♦ Artists and clients may agree to submit any dispute regarding rejection fees to a forum for mediation or binding arbitration.

The cancellation and rejection fees described in this book are a product of negotiation between the parties. Whether they are paid, and where on the spectrum a particular cancellation or rejection fee is set, depends upon the specific circumstances of each case and upon the artist's determination to require such fees to be paid in an amount commensurate with the effort invested. For example, if preliminary work is unusually complex or the assignment requires completion on a very short deadline, artists may demand higher cancellation or rejection fees. Another consideration often taken into account in setting cancellation or rejection fees is whether other, rewarding, assignments from other clients may have been declined in order to have completed the canceled assignment in a timely manner.

Historically, cancellation and rejection fees are practices that have been widely accepted by clients and artists alike, even when contracts are verbal (or written but lack a cancellation or rejection provision). For additional information on cancellation and rejection fees, see the Professional Issues chapter.

Speculation

Speculative ventures, whether in the financial markets or in the visual communications industries, are fraught with risk. Individuals who choose this course risk loss of capital and expenses. Artists and designers who accept speculative assignments (whether directly from a client or by entering a contest or competition), risk anticipated fees, expenses, and the potential opportunity to pursue other, rewarding assignments. In some circumstances, all of the risks are placed on the artist, with the client or contest holder assuming none: for example, buyers who decide only upon completion of finished art whether or not to compensate the artist. This situation occurs in agreements where payment is dependent on "buyer's satisfaction" or "on publication."

Nonetheless, many individual artists and designers, acting as entrepreneurs, create their own work and exploit those works in any variety of ways. For example, if an artist's book proposal is accepted by a publisher who agrees to pay an advance against a royalty on sales, the artist and the publisher are sharing the risks on their mutual investment. The compensation to both parties is speculative, in this case meaning both are dependent on the market response to the product.

Each artist should decide individually whether to enter art contests or design competitions, provide free services, work on speculation, or work on a contingent basis. Each artist should decide independently how to price his or her work. The purpose of *The Graphic Artists Guild Handbook: Pricing & Ethical Guidelines* is to inform each artist fully so that he or she may decide independently how to price his or her work and negotiate a fair agreement.

Contests and competitions

In 1980, the Graphic Artists Guild together with Designers Saturday (DS), a furniture manufacturers association, developed a competition to meet two goals: to produce high-quality art for the DS annual show and to provide a competition that was ethical and appropriate for professional artists. At the same time, the Guild was receiving complaints from artists around the country concerning the unethical nature of most contests that they were asked to enter.

The results of the experiment with DS were so successful that the Guild decided to see if other competitions and contests could be structured to accomplish the goals met by the DS model.

In an effort to gain a clearer picture of the competition scene nationwide, the Graphic Artists Guild Foundation, with a supporting grant from the National Endowment for the Arts, conducted a nationwide survey of art and design competition holders, as well as an infor-

mal poll of jurors and competition entrants.

This study resulted in the establishment of a list of guidelines for three types of art competitions: those held by art-related organizations or associations to award excellence in the field; those for which the winning entries are used for commercial purposes; and competitions held by nonprofit organizations where the winning entries are used for nonprofit purposes.

Among the findings of the surveys were that:

By far, the largest and most expensive competitions are those operated by associations ancillary to the advertising industry, such as art directors' clubs and industry trade magazines. The purpose of these competitions is to honor excellence within their own communities. While these competitions do not require that original art be submitted, the sponsoring organizations often charge high entry fees for members and nonmembers alike. These competitions generally attract the highest volume of entrants. Historically, contests or competitions requiring the submission of new, original work have attracted the fewest number of entries from professional artists. Most professional artists reported that they did not want or could not afford to take time from income-producing projects to create original work for a competition on a speculative basis. The most popular type of competition for this group is based on work already produced or published.

In most cases, the process for selecting a jury for competitions appears to be quite good. However, jurors noted that often the criteria or process for judging the work is vague or poorly articulated.

Another abuse listed by professional artists concerning competitions is the requirement for all-rights transfers by all entrants to the competition holder.

In response to the data received from the competition study, the following guidelines were developed:

Competitions by art-related organizations/associations to award excellence

1. The call for entry shall define clearly all rules governing competition entries, specifications for work entered, any and all fees for entry, and any and all rights to be transferred by any entrants to the competition holder.
2. Jurors for the competition shall be listed on the call for entry. No juror or employee of the organization holding the competition

shall be eligible to enter the competition.
3. Criteria for jurying the entries and specifications for the artwork to be submitted in all rounds shall be defined clearly in the call for entry as a guide to both entrants and jurors.
4. Deadlines for notification and process for notification for acceptance or rejection of all entries shall be listed in the call for entry.
5. Any and all uses for any and all entries shall be listed clearly in the call for entries, with terms for any rights to be transferred.
6. For the first round, tearsheets, slides, photographs, or other reproductions of existing work shall be requested in order to judge appropriateness of style, technique, and proficiency of entrants. This round shall result in the choice of finalists. If samples from this round are not to be returned to the entrants, that fact shall be listed clearly in the call for entries.
7. If the competition ends in an exhibition, hanging or exhibition fees paid for by the entrants shall be listed in the call for entries.
8. After the first round, the jury may request original art for review. The competition holder shall insure all works against damage or loss until the work is returned to the artist. All original artwork shall be returned to the artist. Any fees charged to the artists for the return of artwork shall be listed in the call for entry.
9. Artwork shall not be altered in any way without the express permission of the artist.
10. All entries and rights to the artwork remain the property of the artist, unless a separate written transfer and payment for the original has been negotiated.
11. If work exhibited by the competition is for sale, any commission taken by the competition holder shall be listed in the call for entries.

Competitions where the winning entries are used for commercial purposes

1. The call for entry shall define clearly all rules governing competition entries, specifications for work entered, any and all fees for, entry and any and all rights to be transferred by any entrants to the competition holder.
2. Jurors for the competition shall be listed

on the call for entry. No juror or employee of the organization holding the competition shall be eligible to enter the competition.

3. Criteria for jurying the entries and specifications for the artwork to be submitted in all rounds shall be defined clearly in the call for entry as a guide to both entrants and jurors.

4. Deadlines for notification and process for notification for acceptance or rejection of all entries shall be listed in the call for entry.

5. Any and all uses for any and all entries shall be listed clearly in the call for entries, with terms for any rights to be transferred.

6. For the first round, tearsheets, slides, photographs, or other reproductions of existing work shall be requested in order to judge appropriateness of style, technique, and proficiency of entrants. This round shall result in the choice of finalists. If samples from this round are not to be returned to the entrants, that fact shall be listed clearly in the call for entries.

7. The number of finalists chosen after the first round should be small. The finalists shall then be required to submit sketches or comprehensive drawings for final judging.

8. Agreements shall be made with each artist working at the final stage, prior to the beginning of work (Graphic Artists Guild contracts or the equivalent can be used). The agreements shall include the nature of the artwork required, deadlines, credit line and copyright ownership for the artist, and the amount of the award.

9. Any work of finalists not received by the required deadline or not in the form required and agreed upon shall be disqualified. All rights to the artwork that has been disqualified shall remain with the artist.

10. The winners shall produce camera-ready or finished art according to the specifications listed in the call for entry. Artwork submitted shall not be altered in any way without the express permission of the artist.

11. The value of any award to the winners shall be at least commensurate with fair market value of the rights transferred. The first-place winner shall receive an award that is significantly greater than that of other winners.

12. The competition holder shall insure original artwork in their possession against loss or damage until it is returned to the artist.

The above guidelines are simply meant to convey what the elements are of a fair competition. Their principal purpose is to enable competition holders and entrants to make their own independent judgments concerning the way fair competitions should be run and whether and on what terms to participate in them.

Competitions held by nonprofit organizations or where the winning entry is used for nonprofit purposes

1. The call for entry shall define clearly all rules governing competition entries, specifications for work entered, any and all fees for entry, and any and all rights to be transferred by any entrants to the competition holder.

2. Jurors for the competition shall be listed on the call for entry. No juror or employee of the organization holding the competition shall be eligible to enter the competition.

3. Criteria for jurying the entries and specifications for the artwork to be submitted in all rounds shall be defined clearly in the call for entry as a guide to both entrants and jurors.

4. Deadlines for notification and process for notification for acceptance or rejection of all entries shall be listed in the call for entry.

5. Any and all uses for any and all entries shall be listed clearly in the call for entries, with terms for any rights to be transferred.

6. For the first round, tearsheets, slides, photographs, or other reproductions of existing work shall be requested in order to judge appropriateness of style, technique, and proficiency of entrants. This round shall result in the choice of finalists. If samples from this round are not to be returned to the entrants, that fact shall be listed clearly in the call for entries.

7. The number of finalists chosen after the first round should be small. The finalists shall then be required to submit sketches or comprehensive drawings for final judging.

8. Agreements shall be made with each artist working at the final stage, prior to the beginning of work (Graphic Artists Guild contracts or the equivalent can be used). The agreements shall include the

nature of the artwork required, deadlines, credit line and copyright ownership for the artist, and the amount of the award.

9. Any work of finalists not received by the required deadline or not in the form required and agreed upon shall be disqualified. All rights to the artwork that has been disqualified shall remain with the artist.

10. The winners shall produce camera-ready or finished art according to the specifications listed in the call for entry. Artwork submitted shall not be altered in any way without the express permission of the artist.

11. The value of the award should, if possible, be commensurate with the fair market price for the job. For nonprofit competition holders, exceptions may be made depending on the budget and use of the artwork for the competition.

12. The competition holder shall insure original artwork in their possession against loss or damage until it is returned to the artist.

Graphic Artists Guild Foundation Seal of Compliance

As a service to competition holders and entrants, the Graphic Artists Guild Foundation will review calls for entry to ascertain whether they meet the minimum standards listed in the guidelines above. If a competition holder meets these standards, they are eligible to carry the Graphic Artists Guild Foundation's Seal of Compliance for ethical competition calls for entry. A sliding scale fee for reviewing calls for entry is available to accommodate the budgets of both nonprofit and for-profit competitions. For further information, contact the Graphic Artists Guild Foundation, 90 John Street, New York, NY 10038.

new

technology

issues

new
technology
issues

• • • • • • • • • • • • •

the change from traditional to electronic publishing, image-making, and image processing has transformed the technology, the terms, and the jobs familiar to clients and graphic artists since the advent of hot type and offset printing. It is not an overstatement to compare the scope of this change to the introduction of the Gutenberg movable-type printing press.

The jobs and tools of numerous professions, trades, and crafts have changed, affecting graphic design, photography, illustration, surface design, audiovisual, broadcast design, printing, and many other fields—almost every area of the visual communication industry. Some jobs, such as pasteup artist or typesetter, are going the way of wood engravers, but new job skills (e.g., Web designers) are emerging. Will they become well-paid, respected professions or low-paid production assistant niches?

The computer is a creative tool. Like pencils, airbrushes, and other tools of expression, computers do not generate work by themselves. It takes a skilled creative professional trained in the technical requirements of software and hardware to produce high-quality results. Talent, persistence, experience, and technological understanding are all required. And as artists and clients have found, the computer is not necessarily a time-saving tool. The multiple creative choices offered, the ready opportunities for changes during a project, and minor-to-disastrous technical glitches can add hours to an estimated schedule.

The computer brings with it a number of new concerns: the high costs of purchasing, maintaining, and upgrading hardware and software; the time and effort required to learn a particular program and to keep abreast of the latest applications; legal and ethical issues raised by the ease of copying or altering computer-generated or reflective artwork scanned into a computer; and workplace changes involving a revolution in job responsibilities, functions, health concerns, and compensation levels. The impact on global graphic art and communication industries is immeasurable.

In coming years changes will be even greater. The advent and development of multimedia, interactive media, CD-ROMs (read-only-memory compact disks), and the Internet are creating new jobs and markets for many graphic artists. The new opportunities also bring questions of appropriate pay for new job titles and for new or extended uses of copyrighted material.

Respect for the skills of graphic artists who have mastered new technologies is on the upswing, and it is reflected in the compensation levels paid. However, many employers are attempting to cast skilled graphic artists in low-level, templike secretarial roles or, conversely, to redefine their office staff as graphic artists. And some buyers of graphic art services continue to abuse markets in insistent attempts to obtain extended rights or work-for-hire authorship transfers from artists at less than market rates, creating a windfall of media-ready assets for the buyer. Similarly, some are proposing artists put their work on rights-free CD-ROMs, as clip art, that provide some upfront income and create a wider exposure of an artist's work. But there are fears among veteran artists that these efforts also become additional factors in driving creators out of the field as salaries or prices fall, inexpensive art proliferates, and sources of future income are diminished. Stock house sales of specific rights provide some additional income from existing work without loss of rights, and give some measure of protection, though they still generate lower fees. Please see the section on rights-free distribution later in this chapter.

Professional issues for graphic design and illustration

The division of labor, project scheduling, and budgeting are among once familiar areas that are changing for all participants. For example, sophisticated software has brought traditional typesetting and technical printer's crafts (such as color separation) into the designer and illustrator's realm of responsibility. Because the industry has not yet come to a common understanding of the parameters of certain roles, responsibilities must be defined clearly and technical issues must be worked out at the outset of each project.

Steps in a typical new tech graphic design job

The designer, even using conventional media, consults with the client, creates a concept and a layout, and specifies type for the typesetter, who receives and enters the client's copy. He or she researches or assigns photography or illustration; scales and crops the visual images; oversees the creation of color separations by outside vendors; creates or oversees the creation of mechanicals, overlays, and proofs; obtains client approvals; and buys and oversees paper stock, printing, die cuts, cutting, binding, and shipping.

These steps still exist in the creation of an electronically produced design job, but the ways in which they are achieved have changed. Now the designer "typesets" the client's copy, preferably having received it on a disk in a digital format that can be imported into a page layout program. The designer still maintains creative control and chooses the type styles but now must own both the chosen fonts and the software to customize them.

Photographs and illustrations are scanned in in low resolution for scaling, cropping, and positioning in the electronic page layout. Or illustrations and charts may be created in drawing programs, stored in any of a number of file formats, and imported into the layout.

Photographs or illustrations scanned in in a high-resolution form may be retouched electronically, but any alterations or manipulation should be done by the original artist or with permission and then substituted for the low-resolution, for-position-only placeholders.

Electronic color separation may be handled through the designer's software and can be outsourced to an imaging center (also known as a service bureau) or to the printer. Electronic color as it appears today on the computer monitor must be registered to match appropriate color swatches to ensure that the desired result is achieved. Responsibility for color separation and its attendant skill of trapping (an advanced, technical registration skill previously handled by a combination of the artist's hand skills and the printer's darkroom techniques) are among the more difficult areas of client-artist-vendor communication for graphic designers and illustrators.

Preparing all this electronic information for accurate translation to the imagesetter is called electronic production or preparation for prepress. It is sometimes shortened to "prepress." Strictly speaking, however, prepress is the actual production of the output materials on machines, steps that formerly were performed by trade or craft union members. The skills of creating a graphic solution to a client's problem, overseeing production, managing

traffic flow, and scheduling client approval at appropriate stages—all crucial to the production of the final piece as envisioned by the client and designer—remain. But the knowledge and skills required to bring about that process via the computer successfully are relatively new and, at the moment, rapidly expanding.

Designers, imaging centers, and printers now have overlapping, and varying, in-house capabilities. Designers must now be familiar with the new abilities and quality levels of their suppliers: Which imaging center scans the best high-resolution image? Should the designer find an alternate vendor to handle color separations and provide film? What kind of proofs should the client see, and at what stages?

Areas of possible misunderstanding between designers and clients

A common area of confusion that has arisen is when both designers and clients have in-house electronic capabilities. The client can save time and money by providing text copy and data for graphics in digital format to the designer. However, the expanded ability to access work in progress can tempt a client to micromanage, try too many alternatives, or make unnecessary changes. It is more efficient for all if the client reserves comments until the designer presents his or her results at appropriate stages of the project.

Clients occasionally assume that electronically produced comps are finished art or that such work can be revised in a jiffy without cost. They may not understand that even apparently simple changes in the size of a logo, for example, require fine-tuning if quality is to be retained. Designers must continually educate clients about software and hardware limitations and explain clearly the parameters of work included in each job estimate.

There is also a tendency for a client to seek disk or electronic file ownership or to acquire a template of a design as an afterthought to an otherwise specific job assignment. However, ownership of the digital file should be negotiated separately, or in advance of receiving a quote for the complete job, because it is in essence a sale of extended rights to a design, which is priced differently than a limited or one-time use. Similarly, creating a template for ongoing use by a client traditionally constituted a separate job for a designer, and should be handled separately when performed electronically as well.

Before the computer era, when designers delivered pasted-up mechanical boards, clients and designers understood that the boards would be returned to, and retained by, the designer. Now that designers have invested thousands in hardware, software, and peripherals, some clients routinely expect the digital equivalent of the mechanical board (the diskettes or digital files) to be turned over to them without cost.

There is no reason to change the historical practice that separates the sale of usage rights from the sale of the original work. The digital files surely are available if a client desires them, but usually after an appropriate fee is negotiated with the designer.

Designers and clients are responsible for fully discussing the intended uses before beginning a job so that an appropriate estimate can be presented that reflects all rights being bought and any physical property—disks, films, etc.— being transferred. Care must be taken to specify the limits of the rights being transferred for fonts, commissioned art, style sheets, and other copyrighted data that may be included on a disk that a client wishes to purchase.

Electronic typesetting presents additional challenges for designers. Type previously was ordered from an outside supplier and billed to the client. Computer-equipped designers now purchase their own fonts and do all typesetting, letterspacing, customizing, and kerning in-house. The client usually is billed at an hourly rate for this work, and this service could be itemized separately on the estimate. To accommodate this process, clients now supply copy digitally in a compatible software format; if not, they usually are billed for the cost of conversion. The job estimate can specify which approach will be used.

Electronic production, or prepress, is a large area of possible confusion. The technical aspects of rendering a completed design camera-ready or press-ready have largely shifted from production artists and machine operators. Most steps can now be performed in any of three places: on the designer's computer, at the imaging center, or at the printer, depending on quality or time requirements, the client's budget, and individual suppliers' capabilities. The party that provides electronic production usually bears responsibility for its satisfactory completion.

The relatively new job title of page composer is sometimes given to the person who carries the design from concept to electronic-file form, a separate designation which may

help designers distinguish these new skills positions from those needing design skills and from the traditional production artist. In addition, an artist who specializes in prepress may be termed a prepress specialist.

Page composition and its final stages of readying electronic files for prepress—making sure all the information is prepared properly, formatted, trapped, etc., for a successful move to the next stage—is an area in which many designers, by necessity, are seeking training and information. Page composition may not be fully separable from other elements of electronic design, since the more skills a designer has in software and hardware use, the more design choices are available. However, designers and clients are seeking to establish common understandings about the production stages of electronic design to better agree on job responsibilities, quality control, and price breakdowns. Please see the Production Artist section of the graphic design chapter for additional views on this area of work.

Designers also share many concerns with illustrators working with computers; please refer to the illustration paragraphs following.

The skills groups approach

Dividing the tasks to be performed into "skills clusters," "groups," or "teams" can clarify and streamline an electronic design project. The groups may not correspond to the employees of the client company, design studio, vendor, or printer, and in fact may overlap among them, but are defined by the jobs that need to be accomplished no matter where they are carried out. *Electronic Design and Publishing: Business Practices*, 2nd edition, by Liane Sebastian (Allworth Press) is an excellent resource to help understand the skills groups approach.

As in the examples below, a project can be divided among the client, design studio, and vendors in a number of different ways; the requirements of each job determine which steps are assigned to which providers.

The client group may handle any of the following: original project proposal, budget, deadline, and expected benefit; decision making and approval of all stages; concept; copy and data; liaison for responsibilities handled by other groups.

The creative group, whether in- or out-of-house, may be responsible for: overall project management, including creative and production aspects and scheduling; creative direction; quality of design and production; research; design concept and execution; copywriting;

editing; proofreading; illustration; photography; page composition; preparation of final elements for prepress; ensuring appropriate approval stages; liaison for responsibilities handled by other groups.

The print group may handle: research and buying of reproduction services; imaging center services; production coordination; prepress services; printing services; liaison for responsibilities handled by other groups.

Steps in creating an electronic illustration

Artistic approaches to electronic illustration are as varied as in traditional media. Methods of conceptualizing and researching an illustration remain the same, though increased computer access to one's own previously created art, stock photography, copyright-free art, or other reference material might mean that some research is done on-screen or online.

Many illustrators first rough out their drawings on paper; a sketch is scanned into the computer and imported into the software program, where it serves as a rough template for the finished illustration. Some illustrators draw and revise their illustration directly on the computer. Others take a collagelike approach, scanning into the computer their own photographs, drawings, or other reference material that will become elements of the finished piece. Care must be taken that such material is in the public domain or that permission is obtained from the copyright owner(s). (Please see Legal and Ethical Issues section for more information.)

Drawing, typography, and color are all as flexible as the software program allows. Sketches are transmitted by modem or are output for client approval on-screen or in hard copy. Once complete, the illustration exists as an electronic file. To whatever degree is necessary, the illustrator must now prepare the work for the client's designated output.

If it is to go directly to print or color separations from a digital state, the artist may deliver the illustration electronically via modem or portable storage medium like a diskette. Since electronic illustration can require huge amounts of storage, larger storage media may be required, such as a removable cartridge that may be delivered to the client by messenger or standard delivery services. To protect their copyright and work inventory, artists should keep a backup copy of the finished art at least until the illustration is returned safely.

If the client requests a transparency or other nondigital form of the art, the output cost is billed to the client. If the artist pays for it, ownership of this tangible copy remains with the artist. If film output is requested, the client is billed for the film, while not obtaining reproduction rights other than those agreed upon. The art director may order color proofs before printing for the artist or designer to make any final adjustments. California artists should note that the form of delivery has an impact on whether or not they will owe sales tax, which is also known as a "use" tax; see the section on sales tax in the Professional Issues chapter.

Color separations can be created readily from full-color electronic art using several software programs. Unlike mechanical overlays, however, preparation of electronic color separations requires trapping, a highly technical registration skill that is not yet an automatic feature of current illustration programs.

If the illustrators are requested to deliver film output of trapped color separations, they become responsible for the quality of the film, the accuracy of the trapping, and to some extent the appearance of the final printed art, concerns traditionally outside most illustrators' area of expertise. Many illustrators do not provide trapping services, citing it as more properly the printer's concern. If it is provided, it is a billable expense (see also section following).

Areas of possible misunderstanding between illustrators and clients

♦ *sketches:* Clients may assume that the sketch they are viewing, especially when seen on-screen, is complete or close to completion, when in fact much more work would be required to render that drawing, even if approved, ready for delivery. At the sketch stage, clients also may assume mistakenly that multiple concepts, color treatments, or sketches for an assortment of proposed page layouts are easy, quick, and cost-free. Better communication between a client and an illustrator about artistic and software requirements and about what that illustrator usually supplies would help avoid potential conflict.

According to industry sources, the number or scope of sketches that the illustrator will present before an additional fee is negotiated generally is discussed and included in the letter of agreement between artist and client. In current trade practice, a change in the shape of an illustration,

unless occurring quite early in the sketch stage, is considered a revision and usually is billed.

♦ *trapping:* Illustrators may be asked to produce color-separated illustrations that are compatible with a variety of page-composition programs and printing specifications. The addition of these specialized technical skills raises questions about training, billing, and responsibility for the final printed appearance of the art.

It is not unusual for illustrators in traditional media to create preseparated art, particularly those who work in cut-shape techniques or in fields where full-color printing is not used. In traditional media, pricing for preseparated art has historically ranged between that for black-and-white art and that for full color. Since the potential for creating electronic color separations and trapping exists in some illustration programs, it is likely most computer illustrators will master them to enhance their artistic options and marketability.

However, an illustrator who undertakes to provide separations, rather than delivering an electronic file or a transparency, becomes responsible for a highly technical service. Trapping, a printer's technique that helps avoid misregistration by creating overlapping areas of adjacent colors, was handled previously as a darkroom procedure. While color separation can be produced in some illustration software programs simply by choosing it from the menu, trapping requires dismantling an illustration and assigning the appropriate colors and traps to the individual components. Determining the correct trap width varies for each job according to printing conditions, paper stock, and so on, and choosing the colors to trap over or under one another is a demanding skill.

Trapping is a function of production, not illustration. Illustrators who assume this responsibility also assume liability for corrections and costs if something goes wrong in the printing. Clients and illustrators should be aware that even if the illustrator or the designer handles trapping, the printer must be available to provide the exact technical information necessary to determine trap widths; the printer also may prefer its own trapping system and usually has superior trapping technology and expertise.

Trapping is a technical production

expense that is, according to industry sources, separated from the creative fee-for-rights, and regardless of who provides this service, a client's project budget should allow for it. Clients may not understand its intricacies or may think the computer "just takes care of it." Future software programs may do so, but the technology is not yet available.

♦ *file maintenance:* Another area of confusion concerns maintenance of electronic files. In current practice, clients are responsible for maintaining an illustration in good condition after its delivery to ensure successful printing and safe return. Electronic files require special care in this regard, as many storage media are vulnerable to loss or damage.

A client holding a backup for electronic art for use in the near future should—with the artist's permission—make any necessary additional backups. This does not grant any additional rights of reproduction. Clients with a delay in printing or who have purchased long-term rights to a work should make transparencies or any necessary archival backups. Illustrators are responsible for having their own backup copies for their own work inventory and copyright protection.

Output methods

The ways images are taken out of the computer are called "outputs." Work produced digitally can be output in a large number of ways, from low- to very high resolution print or photographic methods.

Resolution, when referring to printed results made from data on an electronic file, means the number of dots per inch (dpi) used to render the electronic information onto the paper. The more dots per inch, the higher the quality of the printed image.

Resolution in printing runs along a continuum of quality, from the 72 dots per inch of a coarse dot-matrix printer through the 3,600 dpi of high-resolution imagesetters. Higher-resolution output methods are sometimes called imagesetting; in general they provide resolution at or above 900 dots per inch.

♦ *b&w paper and film output; color-separation plates:* There are a variety of machines available to output computer files onto resin-coated paper (RC paper) or positive or negative film. Resin-coated paper is of perfect reproduction quality, analogous to

photostats or repro copy used in mechanicals. Linotronic Imagesetters™ and Agfa™ Selectset are two prominent brands of imagesetters.

While sometimes produced in-house, imagesetting usually is provided by imaging centers, service bureaus, or output bureaus. Most output vendors have preprinted guidelines to assist the designer or page composer in preparing a disk that is fully compatible with the intended output method and equipment. Advance communication between designer and imaging center is essential for a successful result.

♦ *digital color output:* There are many different brands of color printers, ranging in capability from low to high resolution. Graphic artists must become familiar with them and find the right one to fit the desired result.

Thermal wax (thermal transfer), ink jet, four-color process laser copier, and dye sublimation are four common printer types, and each maker and model also varies in capability. Some popular midrange brands are the Canon Color Laser Copier™ and Xerox 5775™ Digital Color Copier. Iris™, 3M Rainbow™, and Kodak Proofing System™ are examples of high-end color printers.

Raster image processors, or RIPs, are hardware devices, or software, that interpret digital information sent to the printer or imagesetter.

♦ *digital proofs:* Digital high-end proofs for checking color can be made from electronic files. Digital Matchprint™ and Approval™ are two common types.

Although the quality available from digital color printers is improving continually, many graphic artists continue to rely on traditional match prints and bluelines for final client approval before printing.

♦ *photographic output:* Photographic transparencies can be output from files via a number of software programs. New cameras can now record images digitally so they can be imported into imaging software.

Transparencies can be made in various sizes and resolutions from electronic files by an output device called a film recorder. CD-ROMs are also used to store photographic output (photo CDs), especially by multimedia designers.

♦ *direct digital output:* Computer-generated art may go directly to production without ever seeing the light of day on a piece of

reflective copy. No information is lost when moving from electronic file to electronic file, so this procedure is faithful to the original screen image. Resolution depends on the file's specifications.

Many presentations are made directly from the disk, either on a computer monitor or projected as a slide, overhead, or video. In-house or external communications may take place directly by modem or electronic mail (email) directly between computers, or artwork may be stored on a CD-ROM.

More commissioned design and illustration may eventually be electronic in its final form. The explosive growth of the Internet's World Wide Web, and the greater acceptance of CD-ROMs, interactive televisions, and computers to study, read books, magazines, and newspapers, play games, browse through visual files, respond to ads, access entertainment, and so on point to new opportunities.

Pricing considerations for graphic design and illustration

Artists surveyed consider the computer, as the medium by which the artist creates the final art, as a major factor in the general structure of pricing. The rights of reproduction being purchased, the scale and scope of the project, the intended use and market, and the other usual factors in the industry are also still considered of primary importance when structuring the initial creative fee for computer-generated art.

However, computer use has compressed job skills in many fields, making it a challenge to define and break down the billable services involved in a project. Artists also frequently incorporate in their estimates new overhead costs, such as invested capital, training, and necessary downtime when troubleshooting problems that are inherent in using hardware and software.

Artists and clients have found that pricing computer-generated art requires good artist-client communication, production management skills, and a careful periodic review of costs and time use. Specific factors to be considered include:

♦ *overhead:* New assessments of studio overhead may be needed to cover purchases of hardware and software and to plan for future maintenance, upgrades, and business growth. Formal training costs must be included as overhead along with a budget for continuing professional education.

Graphic artists working on desktop computers often initially invest $10,000 or more in hardware and software to meet their clients' needs effectively. This does not include training time, upgrade requirements, and lost time due to hardware and software problems.

♦ *time:* A job done on a computer may be more efficient or may take longer than art produced with traditional media. Having all the data on a project in the computer can save time in moving from comps to finishes, in making alterations, or in creating multiple applications from one overall concept. For illustrators and designers who create their own libraries of images and layouts, time can be saved when the right opportunity arises to use stored information. However, many software programs simply take a long time, hardware has speed limits, and essential approval time must be scheduled.

♦ *creative fee/production costs breakdown:* Most graphic artists using computers reported in a recent survey that they structure their pricing by separating the creative fee from expenses. Like any business, the artist simply bills for each service provided and adds customary markups when appropriate. This accurately reflects the traditional split between creative and technical aspects of a job.

An electronic publishing project can appear more difficult to separate into its new, less familiar, components. In the conventional process, typesetting, picture research, stats, mechanicals, and color separations are subcontracted and the costs billed, or their stages are defined easily, with both client and artist expecting familiar price ranges for each category of production.

In electronic publishing typesetting, scanning, image manipulation, page composition, prepress, and color separation preparation seem to blend into the continuum of producing a job in-house. The artist may feel that there is no clear point at which creation is complete and production begins. Scaling, moving, kerning—it can seem that refining continues throughout the electronic production process.

Once identified, the time, overhead, or skill required for a stage of production may not correspond to the figures both artists and clients were accustomed to in price breakdowns for traditional media. Artists have found that billing accurately, by either an hourly rate or by fee for services, may prove that some

stages cost more than in traditional methods, while other production stages may become simpler, faster, and less expensive.

Artists report that attempting to squeeze electronic production into conventional pricing structures is causing headaches throughout the design and illustration fields. New price breakdown categories such as scanning, image manipulation, page composition, creation of color separations, and trapping more accurately reflect services performed and the new creative and production methods.

In the long run, introducing the necessary new steps in production as a clear part of the billing process will improve artist-client understanding and help minimize arguments over revisions or errors.

Postproduction costs for imaging center output (such as video, transparencies/slides, film), use of removable media, delivery services, rental of peripheral equipment, purchase of specific software to meet a job requirement, etc., are typical expenses that are accounted for and billed separately to the client. Other expenses to be reimbursed typically include subcontractors' fees, supplies, travel, long-distance phone calls, overnight couriers, and messenger services. Markup for these typically range from 15 to 20 percent.

Expenses should be approved by the client in the original estimate and should be billed no higher than 10 percent over without client approval (unless job specifications change, which should be confirmed in writing). Also, consultations (client meetings) often are billed separately. (Please refer to the Standard Contracts and Business Tools chapter for more information.)

Revisions are probably the single largest factor affecting the final charge. Ongoing communication should keep the client informed about revisions that must be billed. This can sometimes mean several adjustments to the original cost estimate. Taking care of this while the job is underway avoids unpleasant discoveries when the client receives a final bill and it allows the client to limit or stop revising before budget allocations or deadlines have run out.

Electronic design is especially vulnerable to revision costs due to a perception that changes are easy to make and a poor understanding of when, how often, and in what form clients should approve work in progress. As deadlines approach, approval time can get compressed or skipped—a shortsighted tactic that can result in high correction or alteration costs.

Increased client awareness and clear communication about when revisions by the client (author's alterations) become chargeable is necessary. The client should see and approve the job at each appropriate stage to ensure satisfaction and protect all parties.

Another area susceptible to revision charges is in prepress, where a page composition or imaging center error or software bugs can cause problems as a job goes to output or to press. Careful communication with the imaging center about specifications required to make the artist's electronic files compatible and usable by imagesetters and printers is necessary. The creation of color separations is a particularly fine skill in prepress. When it comes to the printed color, what you see on the monitor is almost never what you get. Using an appropriate swatchbook is imperative.

When things go wrong

Some general guidelines to improve prepress preparation of electronic files are available from the Scitex Graphic Arts Users Association (see the Resources and References chapter). However, following the computer-ready electronic files (CREF) guidelines is not enough in and of itself to ensure that a particular job will be compatible with a desired end result. No guidelines can be fully comprehensive for this continually maturing industry and do not reflect the requirements of all imaging centers. Nor are they a legal defense for absolving an artist of financial responsibility if electronic files do not image correctly.

Artists should obtain specific guidelines from the intended imaging center in advance of each project, in writing if possible, as determining who is to blame and must absorb the cost of corrections when things go wrong can be difficult. Each job is different. Preparation of electronic files for prepress and a careful schedule of proofing should be arranged among client, designer, imaging center, and printer for each project.

If the artist has prepared electronic files for prepress correctly, according to the imaging center's guidelines, the artist is not likely to be financially responsible for imaging errors. On many occasions problems may be difficult to trace. Problems in fonts, software, or hardware owned by the imaging center, and certain industrywide problems, may not be the fault of any party; many are considered part of the imaging center's overhead.

Just as in traditional work, errors resulting

from poor communication, misunderstanding, or faulty equipment are corrected by the party responsible. For this reason, all instructions should be written and confirmed and proofing schedules adhered to.

Legal and ethical issues

State of current legal practice

The laws of copyright apply to electronically created art in exactly the same manner as to any other work of visual art or audiovisual work. The copyright protection occurs at the time the artwork is created and is vested in the creator except in the case of a traditional, salaried employee, where copyright is held by the employer unless otherwise negotiated. Certain nonexclusive rights may be transferred verbally, but transfer of exclusive rights or of the copyright itself must be done in writing. It is also possible to copyright computer source code as text, protecting the work as it is expressed in fundamental computer language.

Although outside imaging centers that produce typeset output are legally responsible for any violation of the font manufacturer's copyright, it is wise for the graphic artist to make sure that the vendor has purchased any requisite fonts. (Please refer to the Lettering and Type Design section in the Graphic Design Prices and Trade Customs chapter for information on the ATypI Font Publishers antipiracy initiative.)

Electronic artwork is affected mainly, though not solely, by the following copyright ownership provisions: control of the rights of reproduction, the creation of derivative works, performance, distribution, and display of the work.

The easiest way to avoid copyright infringement is to make sure that permission has been obtained in advance, in writing, for any intended use of copyrighted art, such as making a composite, as well as traditional usages.

For more information on copyright basics, please refer to the Legal Rights and Issues chapter.

Rights of reproduction

Reproduction rights give the copyright owner the exclusive right to reproduce or make copies of the image. Grants of reproduction rights may be limited in the number of copies, length of time, geographic area, exclusivity, market, edition, etc., as agreed upon by the rights purchaser and the copyright owner.

Retrieving a copy of art in digital form on a screen is probably exempt from infringement under a copyright exception for loading programs. However, scanning a work into a computer, for example, does constitute making a reproduction; court cases have held that substantive editing of movies for television constitutes infringement.

Derivative works

A derivative work is one that is based on one or more preexisting works. It may be termed a modification, adaptation, translation, etc., and applies to a work that, according to copyright law, is "recast, transformed or adapted." Most substantial alterations, including editorial revisions, of an image probably constitute creation of a derivative work. A derivative work created with the permission of the original copyright holder is itself copyrightable. Created without permission, it probably constitutes infringement.

The creator of the derivative work has rights to contributions that may be considered original and copyrightable from their additional creative input, but obtains no rights to the underlying work (whether it was copyrighted or copyright-free). The degree of originality is weighed by courts in deciding whether a derivative work is itself copyrightable.

Combining images on computer sometimes is termed in the industry "making a composite." In most cases this constitutes the creation of a derivative work of each of the contributing images. A derivative work in which both the original and the second artist have equal, tangible creative input can be a joint work, with copyright held by both parties, if such agreement is made at the time of the work's creation (see Joint Works section).

The dividing line between an unauthorized derivative work that infringes on another copyright owner's rights and a new original work that may make reference to an existing image is still blurred. An exact case of this type has not yet come before the courts. But other cases have established several important criteria to help determine whether a work is derivative:

♦ *substance (importance of the borrowed content's quality):* How much of the meaningful content of a work has been reproduced? This may be a very small portion of a work in terms of size but be the crucial nugget that delivers the main idea of a piece. Another measure of substantial content is whether the element taken is unique, rec-

ognizable, or identifiable.

♦ *extent of work copied (in sheer volume):* How much, literally, of a work has been reproduced? While the specific quantity of permissible copying can only be determined in court, that's a situation to be avoided.

♦ *access:* Did the second artist have access to the original work? If so, a court or jury may infer that a work was copied intentionally.

Most copyright infringement cases depend on a "person-in-the-street" test: if the lay observer, seeing the original art and the altered or copied work side by side, would say that copying took place, an infringement exists. Juries are required to search for similarities, not differences, in arriving at a decision.

A touched-up photograph, for example, where the final image is not substantially different from the original, would probably not be considered a derivative work. Courts have found such changes to be primarily mechanical and thus not original. But as digital imaging skills become more acknowledged, their use may come to be seen by courts as artistic, rather than mechanical, and of substantial contributing originality.

A preexisting work of art used as a base from which a substantially different final work is developed likely will not be held to be a derivative work. This makes it all the more compelling for artists to specify their grants of rights with regard to image manipulation up front, in writing.

Distribution rights

The right to control distribution of a work remains the copyright holder's until it is deemed to have been sold. Once sold, that particular item may be resold, passed on, rented, and so on, though it still may not be copied or used for derivative works.

While pending legislation will clearly define electronic transmission as a copyright, it is assumed that electronic distribution is considered the same as distributing a print version of a work. Purchase of electronic rights is negotiable separately. Technology can now imbed copyright management information electronically, identifying rights holders, permitted uses, exclusions, appropriate fees for a particular use, etc., to any type of work, whether it is text, image, or computer source code. Electronic delivery systems will permit potential users to choose a work, indicate intended uses, and pay appropriate usage fees with the click of a mouse.

Rights-free distribution

Some new technology entrepreneurs are compiling an artist's entire inventory, rights-free, on CD-ROM disks. They offer artists royalties on sales of the physical CD-ROM but not on additional uses of the works published; the rights usually are sold outright. The purchaser has access to hundreds of images he or she may use in any way, including altering and manipulating, combining, or otherwise changing the original, or placement on products, in ads, or as characters in feature films. The artist usually is not paid for the additional uses.

Many artists are concerned about the impact this development will have on their industry. While there is the potential for artists to generate significant upfront money, flooding the market with low-cost images could lower the value of images overall. Clients, they believe, will be reluctant to commission original works when low-cost images are readily available. This is particularly worrisome when the art director or designer can take copyright-free work and manipulate or combine them to create even more new artwork.

Others, however, believe that such practices broaden the recognition of an artist's work, and that clients will still be interested in new and original material. It also, say proponents, makes available otherwise costly work to clients who ordinarily could not afford first-time-rights fees.

Both proponents and opponents of these practices agree that such availability is likely to reduce the amount of newly commissioned art, and may reduce some fees. An alternative scenario is, as noted in the previous section, a mechanism for monitoring rights purchases in manners similar to those in the music and theater industries.

Performance rights

Performance rights may need to be licensed explicitly in work for certain media, such as broadcasting a video or producing a slide show. A court held in one case that a video game was "performed" (played) without authorization by the end user in a public arcade, despite the seemingly obvious intent that a license for video-game use would entail use of the video game.

Joint works

If two or more artists create a work with the intention that their contributions be merged into inseparable or interdependent parts of a unitary whole, according to copyright law the

result is a joint work. Joint authorship must be intended at the time the work is created and implies co-creation of the piece from conception to fulfillment. Modification by a second artist of a piece by a first artist does not constitute joint authorship but is a derivative work (see Derivative Works section).

Joint authors hold copyright as "tenants in common"; either creator can license any rights to the work, providing that the proceeds are shared equally.

Protecting copyright

Protection of creative work under copyright law is still enforced most efficiently by the contracts under which work is commissioned or licensed. Contracts should be clear about rights granted, usage, and amount of time the license is granted. Grants of rights licensing the use of work for any use should specify what is granted and how it will be used, and should reserve all other rights to the artist or copyright holder.

The importance of spelling out the usage rights the client is purchasing in the artist's estimate and in the letter of confirmation cannot be overemphasized. Most legal problems between artist and client arise because the original terms and any later changes were not expressed clearly in writing. The invoice should not be the first time a client sees or hears of copyright. Clients equally must be careful to assess their usage needs in relation to their budget at the start of a project, as historically most artists adjust their fees according to the rights purchased.

In specifying rights of reproduction for digital art, artists will wish to specify the number of copies permitted, the form in which they will be made, the degree of resolution, limitations on scaling up or down, etc. Just as in traditional licensing agreements, quality control is a legitimate negotiating point that affects the artist's reputation and income.

As in traditional rights contracts, other specified limitations usually include: the number of appearances or length of time the rights are being licensed for; the market; the media; the geographic area; and the degree of exclusivity. Recent surveys show that payment may be by flat fee or royalty either on a straight percentage basis or escalating on a sliding scale. Royalties may differ for uses of the same piece in different markets.

Assigning the entire copyright, all rights, or granting complete reproduction and derivative-work rights entitles the receiving party to manipulate the art at will. Many artists prefer to control their work tightly and restrict image manipulations subject to their approval. Some are interested in granting broad rights licenses. Each artist determines what constitutes appropriate compensation for the scope of the licensing rights granted.

Written agreements should be used in granting the right to create a derivative work from an existing image. By granting a general right to prepare a derivative work, an artist permits the client to do anything to the artwork to create something new. Therefore, specifying the resulting intended image may be a better protection of one's rights. As with the license of any copyrighted image, intended markets, rights of reproduction, etc., granted to any derivative work should be specified.

As multimedia markets proliferate, publishers have new types of projects in which to use art. Many of these will be derivative works—compilations joining text, image, and sound, for example. An appropriate license should be agreed on that briefly describes the product and specifies that the client is licensing the right to use the art in the product described. A storyboard, outline, or comp can be attached to help explain the project.

Contracts should specify whether alteration or modification will take place, whether derivative works will be created, or (if the art does not yet exist) whether the creators will collaborate equally to create a new, original joint work with a shared copyright. Advance discussion of these issues can help avoid awkward and unpleasant situations.

A contract may specifically prohibit manipulation. One such limiting phrase is, "This work may not be digitally manipulated, altered, or scanned without specific written permission from the artist." Or, "This license does not give (Buyer) the right to produce any derivative works and (Buyer) agrees not to manipulate the image except as we have agreed in writing, even if such manipulation would not constitute a derivative work."

Without a contractual restriction, the art could be altered to the point where it no longer resembles the original piece enough to be judged a derivative work and thus would not constitute an infringement. Including a limiting phrase gives the artist the ability to prevent unauthorized manipulation on either a copyright infringement or breach of contract.

While typefaces are not copyrightable, the software that produces them is. Owning such software usually implies a license for personal

use; it cannot be lent or copied. (Please refer to the Lettering and Type Design section in the Graphic Design Prices and Trade Customs chapter for information on the ATypI Font Publishers' Antipiracy Initiative.)

While contracts are the clearest overall legal copyright protection, a preemptive line of defense can be taken electronically. Some artwork intended for presentation but not for reproduction can be provided in a low-resolution form that is unsuitable for further use.

Technological approaches are being developed continually to ensure protection and monitor appearances or alterations of a work. Encryption, or programming an invisible, protective code into the body of a piece, may be useful, though determined hackers can break most codes that come out. Still, for everyday commercial use, this may be one solution. Experts have also discussed such methods as including a self-destructing key on an electronic image so that after a certain number of uses it can no longer be accessed.

Digital pictures also can be labeled visibly, so that notice of ownership and the terms of any license always accompany the image. Other types of "watermarking" can be as simple as a copyright notice © imbedded in an image that will be visible if reproduced.

As always, having a paper trail and good records can help prove an infringement. Keep copies of all written agreements and records of telephone conversations in which changes were discussed. Saving copies of work in stages can help prove that an infringement of one's work has been made. Saving reference images with a record of their sources and rights agreements can protect against infringement claims by others.

As in traditional media, every artist-client relationship is based on mutual trust. Be aware that in electronic media, unauthorized uses may be particularly difficult to monitor.

The information superhighway

There are numerous electronic bulletin boards and online service providers, among other resources, that act like TV, cable, or telephone networks, but except for some restrictions on the transmission of adult-oriented material, there is as yet no federal or state regulation of these various electronic "highways." Discussion of intellectual property law with regard to the National Information Infra–structure (information superhighway) is brisk, but at the moment consists of more questions than answers. What goes online and how it is used mixes the copyright, commercial, and

contractual interests of a large variety of interested parties. Online vendors, for example, may be interested mainly in getting a lot of information into the network to attract customers and may have little motivation to monitor what happens to it after the customer pays for access. The publisher or original creator, though, wants to maintain control.

Creators and publishers, however, may be at odds sometimes. A number of freelance writers, members of and supported by the National Writers Union, brought a lawsuit in late 1993 against one database operator and five large media companies, alleging infringement of their copyrights through unauthorized reproduction of their articles on electronic databases and CD-ROMs. The defendants are the New York Times Company; Newsday, a subsidiary of Times-Mirror; Time Inc. Magazine Company, a subsidiary of Time Warner; Mead Data Central Corp., the owners of Nexis, a subsidiary of MeadData; the Atlantic Magazine Company; and University Microfilms International, a division of Bell & Howell. At the time of preparation of this 1997 edition of *PEG*s, this case has not yet been resolved.

Freelance graphic artists have been asked to sign broad contracts agreeing that their work may appear on unlimited electronic media or in future technologies—even some that are as yet unnamed—as a condition of licensing a supposedly one-time right and for no additional payment. Others have received checks in payment for work performed under usual one-time rights contracts that attempt to grant the client additional undiscussed and unremunerated rights by way of new terms stamped on the back of the check. Please see the section discussing *Playboy Enterprises Inc. v. Dumas* in the Legal Rights and Issues chapter for further information.

Strengthening copyright protections

Congress has yet to enact legislation specifically addressing the question of protecting copyrighted material from unauthorized electronic distribution. The current Copyright Act, however, grants broad protection to copyright owners and the rights and remedies provided for in that law can be used to prevent and obtain compensation for unauthorized electronic distribution of copyrighted works.

The American Society of Media Photographers (ASMP) has established a copyright licensing subsidiary, the Media Photographers Copyright Agency (MP©A), that seeks to license photography for electronic media while

serving as a watchdog to protect the copyright of its member photographers. Some observers foresee the establishment of more copyright licensing and monitoring organizations similar to MP©A or to the industry-wide ASCAP and BMI, which oversee use of songs and music and distribute compulsory licensing fees to their member artists.

Stock agencies can take a role in preventing and monitoring unauthorized uses of art owned by artists by using contracts stating that the image may not be manipulated without the artist's permission and that the artist will be given first opportunity to make any desired changes. Providing printed samples to the artist helps monitor the image's appearance. Agencies can protect their own and their artists' interests by conducting random checks of the media to spot unauthorized uses. Please check the Stock Houses section of the Reuse and Other Markets chapter for further information.

Ethical practices

Copyrighted software requires the same respect as any other copyrighted images—permission for use, under federal copyright law. No one, for example, should make unauthorized or pirated copies of application software. Model releases should be obtained from any recognizable people. The eternal urge of editors and other buyers of rights to an image is to crop it or otherwise manipulate it. The ease and affordability of digital retouching offers an opportunity for an art director to retouch an image if the artist is unavailable to do so. A good relationship with an editor or art director can lead to the artist being involved throughout the editorial process so that the best aesthetic results can be obtained.

Artists who know how to make changes on the computer and are willing to do so in appropriate situations will have more control over the final art. Techniques that change the art, such as reverse cropping (adding color or background to an image to expand it, for example, to add room for type) should be discussed between editor and artist.

Changes needed on a job in progress usually are discussed with the artist and the artist given first opportunity to make them or to approve changes that the art director or client would like to make. No image manipulation should take place without the artist's knowledge and permission, and any changes should be made on a duplicate copy of the art. Such permission should be required by contract.

There is a traditional exception for low-resolution images provided by sources such as stock houses. Many of these are intended for use in presentations with the expectation that rights to the image will be purchased if the concept is approved. In 1996 the Graphic Artists Guild spearheaded a campaign in response to an increase in the use of sample or portfolio images in presentations without the artist's permission. Please see the Legal Rights and Issues chapter for more information on the "Ask First" campaign.

Health issues

A number of serious injuries have been reported by individuals who work on computers for extended periods of time, such as creators who spend hour after hour at the computer, especially when deadlines loom. Injuries can occur to an artist's vision, back, arms, wrists, and hands. Headaches and chronic fatigue are also reported. Repetitive motion disorders, an umbrella term describing a large number of repetitive strain injuries that include carpal tunnel syndrome, are not specific to computer users but frequently are suffered by them. Consulting a physician specializing in occupational health is a good way to obtain a proper diagnosis and correct treatment.

Research on the risk of miscarriages from low-level electromagnetic radiation has been inconclusive. Many offices act to reduce workers' risk by placing workstations so that no person is sitting facing the back of a computer, where nonionizing radiation is emitted.

There are a number of preventive measures that can reduce the risk of injury. The setup of a workstation, including table height, the posture of a chair, and the placement of keyboard, copy stand, and monitor are important. Overhead lighting should be indirect and glare reduced. Monitors should be adjusted to low brightness and contrast and turned up only to check colors. Employers are responsible for creating a safe work environment, while independent creators should make a safe setup a priority to avoid future disability.

Correct posture and taking frequent breaks from the computer are chief among the measures to take to reduce stress, back, arm, wrist, and eye strain. A break of 15 minutes for each two hours is recommended by the Communications Workers of America (CWA); hourly breaks are ideal. During a break the artist should allow the eyes to focus farther away than the screen distance, such as out a window, and should practice hand stretches.

The ergonomic qualities of some hardware and furniture need improving. One stylus widely used in broadcast design, for example, is too thin for some hands to hold comfortably. Wrapping it with masking tape or a foam sleeve has been found helpful in avoiding carpal tunnel syndrome. Similarly, a foot pedal was suggested to a manufacturer by one health expert to minimize the carpal tunnel syndrome arising from the hundreds of sideways "sweeps" made daily by broadcast designers in calling up a menu with a hand tool.

Organizations that provide publications and information on computer health issues include:

♦ Arts, Craft and Theater Safety
 181 Thompson Street #23
 New York, NY 10012-2586
 212.777.0062
 Publishes newsletter and books dealing with artists' health hazards and safe working conditions.

♦ Communication Workers of America (CWA)
 District 1
 Health and Safety Program
 80 Pine Street, 37th floor
 New York, NY 10005
 212.344.2515
 Publishes "VDT Work Station Checklist" and related data sheets with complete information on safe workstation setup.

♦ New York Committee for Occupational Safety and Health (NYCOSH)
 275 Seventh Avenue, 8th floor
 New York, NY 10001
 212.627.3900
 NYCOSH is one of 26 COSH coalitions around the country that provide information on VDT safety and other health topics.
 Email: 71112.1020@compuserve.com

♦ Occupational Safety and Health Administration
 U.S. Department of Labor
 200 Constitution Ave NW
 Washington, DC 20210
 202.219.8151
 The Larger View: Graphic arts industry, the computer and the global picture.

♦ Service Employees International Union (SEIU)
 1313 L Street NW
 Washington, DC 20005
 Publishes pamphlets on health.

The labor situation

With the industry in flux and the economy far from booming, companies that are hiring artists are taking full advantage of the changes. Though many companies attempted to exploit the illusory ease of lower-cost computer graphics when the technology first sprang into affordability, many have begun to realize the high level of expertise such techniques require.

Job titles and responsibilities are not well defined. Managers do not know how to specify appropriately whether they need a designer, page composer, prepress specialist, or image manipulator. Usually, a company takes the cheapest way out, whether through lack of understanding or through the hopes of getting something for less, and tries to hire one person to perform all of those job functions—often at the salary level of a pasteup artist. One employment classified in the *New York Times* advertised for a "Receptionist/Graphic Designer," perhaps a prima facie case for the need for certification in the industry.

Classified advertisements describing jobs as "entry level" frequently continue, "requires knowledge of Quark, Photoshop & Illustrator" and offer, even in high-expense New York City, a starting salary in the twenties, a very low and inadequate salary for such expertise for coverage of schooling, ongoing training, and living expenses.

Employer education is needed, along with encouragement to create a hierarchy more fitting to the skills required. In this area graphic artists seeking employment are at some disadvantage compared to those presenting themselves as outside consultants, because the latter are expected to define their roles and rates for the client, whereas employees traditionally have been hired to fill a preestablished position.

Temporary employment agencies

Temporary agencies, while providing work to many artists, are nevertheless currently an obstacle to better understanding computer artists' skills. These agencies advertise that they can supply artists with mastery of a wide array of software applications and familiarity with many hardware systems, but pay the artists only $15 to $18 per hour, the same as secretarial rates (while charging the client two to three times as much). Since these agencies developed from secretarial/word-processing

markets, the graphic artists they employ are tested on typing, spelling, and related skills, but technical mastery of software, much less design skills, may not be reflected accurately in the labor pool agencies offer.

It can be a grab bag for the employer seeking to get an artist suited to the project at hand. Nonetheless, many skilled graphic artists are temporary workers. These artists are often required to sign blanket contracts that ask them to release more rights of privacy, personal financial information, etc., than is relevant to the scope of their job. Some of these contracts would be considered extreme even by regular employees, who generally enjoy better compensation and benefits. This practice may have become common because companies are accustomed to requesting extremely protective contracts from many of their software developers, systems analysts, and other major computer consultants, who will have access to extremely important corporate information and financial data. This rarely applies to a temporary graphic artist, and the same contracts should not be used.

Organizing the employees of temporary agencies into unions under appropriate labor laws could help standardize working conditions by establishing which skills pertain to certain job titles, reducing confusion, and raising the quality of work for both companies and artists.

Employment issues

As much as new technologies have facilitated artists' work, they also have added new workplace dilemmas and stresses. Closely following salary in importance are issues of workplace stress, including hours of work, unrealistic deadlines, and continual changes in a project at hand. One person is likely to be handling a job that in traditional methods of publishing would have been divided among a number of artists and suppliers, but this job compression may not be evident to the employer. (Please refer also to Professional Issues for Graphic Design and Illustration section in this chapter.) Compounding this problem is the mistaken impression that computers take no time; the failure to build proofing and correction time into a production schedule; and the increase of businesspeople without production experience working as creative managers.

An in-house "DTP (desktop publishing) person" may be subject to too many demands from too many departments. "Just do one little thing" can add up to overwork and distraction from priority projects with attendant arguments over who has first call on the artist. Better and appropriate management often is needed, including keeping a close eye on what genuinely needs to be produced, fair scheduling, and realistic deadlines.

A 14-hour workday is common among graphic artists working on computer, leading to high levels of burnout and injury. One graphic artist was hospitalized for stress after working 41 hours over three days. Too often companies, misunderstanding the technical expertise required for computer-generated art, believe that such craftspeople are replaced easily. When faced with expensive errors and poor quality, however, many have begun to address these job openings with greater care.

The never-ending learning curve required of graphic artists working with computers is another stress. Once out of school, access to new programs and machinery is obtainable only in expensive training programs or, occasionally, at work (although in the latter case, the worker usually is required to know the new technology before being hired, creating a Catch-22 situation that can be almost insurmountable).

Organized labor in the United States would like to see U.S. industry follow the Western European countries that are emphasizing the high wages and high skills that make them competitive in the new technologies era. This view stresses building a workforce with unique high-level, well-paid skills rather than lowering the U.S. worker's standard of living to that of the cheap labor in Third World nations.

Signs of renewed respect for crafts are developing and perhaps more understanding that the quality of a job is often dependent, not on the equipment being used, but on the expertise of the craftsperson operating it. The best work is done by the best craftsperson, even though similar equipment is available elsewhere.

There are also some signs of new hiring or new job opportunities. Over the last decade the number of companies and corporations installing computer graphics equipment was astounding, while the attendant layoffs—including of whole departments—was massive as well. The new openings may indicate a realization among managers that skilled workers are needed to achieve the desired results with all the technology. Although corporations don't yet universally understand the valuable skills that graphic artists bring to a job, results are understood better by corporate managers, and skilled graphic artists eventually will be recognized with better pay.

Communication companies of the future

A new form of communications company may be arising: alliances of artists contributing varied creative, technological, and technical skills that provide clients with the widest possible range of services at the best possible price. A group of specialists may even form a company for the purposes of bidding on one project, disband when it is completed, and form a new "skills cluster" for the next project. Or a professional group may be assembled by the client to fulfill a project.

Whether called strategic alliances, teams, skills clusters, joint ventures, or the "virtual corporation," such groupings can include designers, animation, broadcast and multimedia specialists, page composers, prepress, and print specialists, and so on.

Strategic alliances may be cost-efficient and quality-oriented. Ideally, they can attract work closely tailored to each artist's skills and preferences, and that allows for maximum creativity, work-style flexibility, and job variety. On the downside, alliances may mean less regular employment and more reliance on per-project work, and may put pressure on artists to hop from alliance to alliance.

As touched on earlier in this chapter, new jobs are coming into existence, including the prepress specialist, digital design consultant, image-processing specialist, and imagesetting consultants. Graphic artists and production personnel in general may act in a larger consulting role. Some parts of the industry may begin to incorporate graphic skills into earlier editorial stages as the creative process becomes more multimedia and team-oriented and as creation and production continue to merge. It is a large and exciting endeavor to promote and educate clients about new skills that can help smooth the transition into the electronic age.

There may be continued expansion of freelance jobs as well as more hiring to enable companies to maximize their use of expensive equipment purchased under the misperception that a computer can create by itself. As the workforce in the electronic age changes, the nature of organizations that represent it will have to adapt to protect workers' jobs, salaries, and health.

The challenges to these organizations are several. New, largely unorganized groups of workers are coming into existence who urgently need their hours, wages, and working conditions represented. Through collective bargaining and legislative advocacy, unions stay on top of these concerns to improve the economic and social conditions of professional graphic artists.

New technology, particularly computers that can be and are operated by creative personnel rather than by technicians, challenges traditional unions to identify work disciplines that are not limited by control over machinery. From the graphic artist's point of view, old divisions between crafts and art may be an obstacle to getting the best results.

The growth of an at-home workforce, however, is a special organizing challenge. Home workers (such as piece workers in the garment and knitting trades) historically have been exploited, with protection hard to establish and monitor. But the home office may be an inevitable side effect of technology in fields ranging from graphic art to political think tanks; new and existing organizations will have to address the needs of these workers. And with technology changing so swiftly, unions must confront these changes in future collective bargaining agreements.

Computer-generated art already has spawned many new trade associations to help educate both artists and clients. Some of these are listed in the Resources and References chapter later in this book.

PRICING
& Marketing
ARTWORK

Pricing
& marketing
artwork

• • • • • • • • • • • • • •

A s creators, graphic artists have the right to share in the economic benefits generated by their creative product, and to seek out and generate additional opportunities. As business-people, securing these economic interests and rights is their responsibility. To be successful, graphic artists must develop the business skills necessary to market and maintain their work and careers.

Artists must be able to pinpoint and evaluate the critical terms of a job offer. Understanding contract terms, copyright basics, and usual business practices is crucial, and negotiating skillfully within these parameters can make the difference for an artist to reach his or her business and personal goals. (Please see the Legal Rights and Issues chapter for background on current copyright law.) This chapter of *The Graphic Artists Guild Handbook: Pricing & Ethical Guidelines* discusses the fundamental business management issues common to all professionals in the graphic arts, from preparing for the negotiation, to the negotiation process itself, to keeping track of payment schedules, to collection options when the deadlines aren't met.

Part I: Preparation

Graphic art is commissioned in highly competitive and specialized markets. Prices are negotiated between the buyer and the seller, and each artist individually decides how to price his or her work. These prices usually depend upon many factors, including: the use that the buyer intends to make of the art; the size and stature of the client; the graphic artist's reputation; the urgency of the deadline; the complexity of the art; and the client's budget. Both historical and current practices reveal the factors that are often considered in pricing decisions, and these vary from discipline to discipline; therefore, the information in this chapter should be supplemented by reading the appropriate sections for each discipline.

How to set prices or rates

Price determined by use

In order to encourage the free flow of ideas to the public, copyright law vests with the creator of every artistic or literary work a bundle of rights that can be divided and sold in any number of ways (see the Legal Rights and Issues chapter for more detailed descriptions of these rights). Therefore, the price of graphic art historically has been determined primarily by the extent and value of its use. Graphic artists, like photographers, writers, and other creators, customarily sell only specific rights to the use of their creative work. The intended use, or "usage," is indicated by specifying which rights of reproduction are being granted.

Some inexperienced art buyers assume that they are buying a product for a flat fee, with the right to reuse or manipulate the art however they wish. But such purchases historically have been more like licensing agreements in that only the exclusive or nonexclusive right to use the art in a specific media (e.g., billboard, magazine cover), for a limited time period, over a specific geographic area, is sold, or "granted."

The basic standard of sale for a commissioned work of art is "first reproduction rights" or "one-time reproduction rights." While there has been a push by major clients to obtain an overly broad grant of rights, current data indicate that reuse, more extensive use, use in additional markets, foreign use, etc., receive additional compensations. Artists should consider the full potential value of the artwork when estimating the value of "exclusive," "unlimited," or "all-rights" agreements. Sale of the original, physical art (including digital media) is, under copyright law, not included in the sale of reproduction rights and is normally a separate transaction.

In some cases (e.g., corporate logos, advertising, product identity), the buyer may prefer to acquire most or all rights for extended periods of time. Recent surveys report that buyers and sellers both consider additional fees for such extensive grants of rights to be usual and customary. In other cases the buyer has no need for extensive rights. One of the main responsibilities of parties negotiating transfers of rights is to identify the buyer's needs and negotiate the transfer of appropriate rights.

One risk for artists to consider is that selling extensive or all rights at prices usually paid for limited rights provides the buyer with an unpaid inventory of stock art, depriving the artist (and other artists) of income from additional uses and future assignments. Clients may want to consider that paying higher prices for more rights than will be used is expensive and unnecessary. Additionally, purchasing more rights than are needed deprives the public of access to the work, since in most cases only those specific rights are ever exercised. If buyers are asking for an "all-rights" or "work-for-hire" agreement to protect themselves from competitive or embarrassing uses of the work, a limited-rights contract containing exclusivity provisions can be drafted easily that prohibits such use by the artist.

Grants of all rights should specify the category and medium of intended use and the title of the publication or product. Grants of rights may also specify edition, number of appearances, and geographic or time limitations where appropriate. For example: national (region) general-interest consumer magazine (medium) advertising (market category) rights for a period of one year (time). A common formula for editorial assignments is one-time North American magazine (or newspaper) rights.

International uses

Determining the value of work to be used outside the United States follows the same general guidelines as with other uses. In addition to the length of time, how and where material will be used is key. Selling rights to a French-language European edition of a consumer magazine would include distribution in France, Belgium, and Switzerland. A country's economic condition also plays a role. A license for distribution in Japan might be considered more valuable than one for China because a higher percentage of the population would be reached.

Royalties

Historically, artists and clients have found that a good way to compensate an artist's contribution of value to a project is through a royalty arrangement; this has become the accepted method of payment in book publishing and in the licensing industry. A royalty is the percentage of the list price (retail) or wholesale price of the product that is paid to the artist, based on the product's sales. Royalty arrangements also include a nonrefundable advance payment to the artist in anticipation of the royalties, before the product is sold. Royalties are not appropriate in cases where the use of the art

Examples of markets and media

Examples of market categories and some of the media for which they buy art are included in the following chart. Within each category there may be more media than space allows to be listed here.

Advertising

Animation
Client Presentation
 (preproduction, comps)
Collateral and direct mail
 (brochures, direct mailers, flyers,
 handouts, catalogs)
Display and exhibit
Magazines/magazine
 supplements
Newspaper/newspaper
 supplement/advertorials
Online (World Wide Web sites;
 electronic publications/
 periodicals)
Outdoor (billboards, bus and car cards,
 station posters)
Packaging (products, CDs, cassettes,
 videos, food, software)
Point of sale (counter cards, shelf
 signs, posters)
Poster (film, theater, concert, event)
Presentation
Television/cable TV
Other

Book

Anthology
CD-ROM/Online
Educational text
Mass market
Trade
Electronic
Other
 (Also specify hardcover or softcover
 edition, cover, jacket or interior, etc.)

Editorial

Educational
Audiovisual/filmstrip
Encyclopedia
Magazine
Newspaper
Online/database
Television/cable TV
Other

Institutional

Annual report
Audiovisual/filmstrip/video
Brochure
Corporate/employee
publication
Presentation
Other

Manufacturing

Apparel
Domestics
Electronics
Food & beverage
Footware
Home furnishing
Jewelry
Novelty and retail goods
 (paper products, greeting cards, mugs,
 posters for sale, calendars, giftware,
 other)
Toys and games

Promotion

Booklet
Brochure
Calendar
Card
Direct mail
Poster
Press kit
Sales literature
Other

does not involve any direct sales or where a direct sale is difficult to monitor (see also Part V, Reuse and Other Markets, later in this chapter).

Reuse

In most cases, illustration is commissioned for specific use, with any rights not transferred to the client reserved by the artist and remaining available for sale. When the terms of the specified grant of rights are completed (or not exercised within a specified period of time), those rights also return to the artist and may be sold again. Subsequent uses of commissioned art, some of which are called "reuse," "licensing," and "merchandising," have grown dramatically in recent years, creating new sources of income

for many artists. While some artists have expressed concern over a possible consequent drop in new commissions, a significant number of artists have used these new markets to enhance their income potential. Part V of this chapter, Reuse and Other Markets, describes these opportunities.

Per diem rates

Sometimes artists are hired on a per diem or day-rate basis. Surveys of artists and clients have found this to be a perfectly acceptable work arrangement and method of compensation provided that it accurately reflects the work required and is agreed to by both artist and buyer beforehand.

Artists and buyers have found it useful and effective to establish a basic day rate for their work. This, together with an estimate of the number of days needed to complete the work, art direction, consultation, travel, etc., gives both parties a starting point from which to obtain a rough total estimate. A word of caution: Some jobs look deceptively simple, and even the most experienced artists and clients sometimes encounter greater expenditures of time than anticipated. When negotiating, both parties often address questions concerning delivery time, degree of finish, complexity, expenses, and general responsibilities in determining the estimate, and it is established that an estimate is just that and is not assumed to be precise.

Guild members have found that one method of estimating an appropriate per diem rate is to first total all direct and indirect business costs. Add a reasonable salary. Divide this total by 230 business days annually (52 weeks less six weeks' vacation, holiday, and sick time). Add to this figure a reasonable profit margin, which historically has ranged from 10 to 15 percent.

Per Diem Rate Formula

••

Rent, utilities, insurance, employees' salaries and benefits, advertising and promotions, outside professional services, equipment, transportation, office and art supplies, business taxes and entertainment and others):

$ _____

Add a reasonable salary: + _____

Total: $ _____

Divide by 230 working
 business days
 annually: $ _____

Add a reasonable
 profit margin*: + _____

PER DIEM RATE: $ _____

* Artists historically have assumed a
 profit margin of 10–15%.

Hourly rate formula

Whether pricing on a fee-for-use basis or by the hour, graphic artists must know what it costs to conduct business in order to know whether the fee received for a particular project will mean profit, breaking even, or loss. Calculating the individual cost per hour of doing business will assist artists in gauging their financial progress.

Guild members and other industry professionals surveyed describe one simple way of establishing an hourly rate: first, total all direct and indirect business expenses for the year, such as rent, utilities, insurance, employees' salaries and benefits, advertising and promotion, outside professional services, equipment, transportation, office and art supplies, business taxes, and entertainment. Using the figures in Schedule C of IRS Form 1040 makes this task easier. Include a reasonable salary that reflects current market conditions (see the Salaries and Trade Customs chapter). Divide the total by 1,610, which is the number of hours worked in an average year (52 weeks less six weeks' vacation, holiday, and sick time). Add to this figure a reasonable profit margin, which historically has ranged from 10 to 15 percent. The resulting figure is an hourly rate based on a 35-hour week that can be expected to cover all costs of doing business, including the artist's own salary. However, most artists, especially those who are self-employed, indicate that they also divide the annual overhead figure by a much smaller number of working hours to allow for time spent on nonbillable work such as writing proposals, billing, and self-promotion. A figure from 20 to 45 percent less, or roughly 900 to 1,300 hours, has been found to be more practical and accurate. A profit margin may still be added.

The resulting figure is an hourly rate based on a 35-hour week that can be expected to cover all costs of doing business, including the artist's own salary. However, most artists, especially those who are self-employed, indicate that they also divide the annual overhead figure by a much smaller number of working hours to allow for time spent on nonbillable work such as writing proposals, billing, and self-promotion. A figure from 20 to 45 percent less, or roughly 900 to 1,300 hours, has been found to be more practical and accurate. A profit margin may still be added.

When a project is being considered, it is important to estimate accurately the required hours of work. This estimate, multiplied by the hourly rate, demonstrates, say many artists,

whether the client's fee for the project will at least cover costs. If it will not, the artists have found it important to consider negotiating with the client for more money, proposing a solution to the project that will take less time, or searching with the client for another mutually agreeable alternative.

Many large jobs, such as corporate design projects, require that the hours involved be used as a gauge to see if the project is on budget.

Recent surveys indicate that design firms usually have at least two or more hourly rates: one for principals and one for employees. The difference is caused by the salary level. For example, in the graphic design field, the hourly rate for a principal has been found to be, on average, $125, and for studio staff, $50 to $100.

Page-rate pricing

Some illustrators and designers working in the advertising and editorial print media markets check advertising page-rates as another factor in gauging fees. Advertising page-rates vary according to the type and circulation of a

magazine and therefore provide a standard for measuring the extent of usage. These rates, therefore, provide a good barometer of a magazine's resources. For example, *Better Homes and Gardens* (ranked 6 on the Folio 500 list of magazines) had a circulation of 7.6 million copies in 1995 and received $138,000 for each of the 1,856 pages of advertising sold. Obviously, *Better Homes and Gardens* delivers a potential market to the advertisers that makes this cost worthwhile. *Business Week* (ranked 11), with a 1995 circulation base of 877,000, received $59,800 for each of its 3,816 pages of black-and-white advertising. A page in *Popular Mechanics* (ranked 64), with a circulation of 1.59 million copies, costs $50,875. A page in the regional consumer magazine *New York* (ranked 58), with a circulation of 426,000, costs $22,370. A page in specialty consumer magazine *Working Woman* (ranked 158), with a circulation of 764,000, costs $32,000.

Magazine advertising page rates and circulation information can be found in trade journals such as the September issue of *Folio, Advertising Age, Adweek,* and in the publications put out by Standard Rate & Data, *Business Publications* and *Consumer Magazines,* which are available in most business libraries.

Other pricing factors

♦ *inflation:* During periods of inflation, the change in the government's Consumer Price Index (CPI), which measures cost of living fluctuations, is another factor to be considered by an individual artist or designer when calculating an appropriate fee. In 1993, for example, the CPI was 144.5, reflecting a 3 percent increase over the year before. As the costs of printing, paper, distribution, advertising page and TV rates, and other elements of the communications industry rise as time passes, so may prices paid for commissioned art. They generally are reviewed yearly, and any increases in the inflation rate are, say industry professionals, taken into consideration.

♦ *size of print order or ad:* The reproduced size of the ad and the quantity (number) of the print order should be reflected accordingly as a factor in pricing.

♦ *consultation:* If a job requires extensive consultation, recent surveys indicate that artists frequently estimate the number of hours or days required, multiply them by

their individual rate, and add a consultation fee to the basic project fee. It is not uncommon, especially for a brief consultation to solve a particular problem, for the consultation fee to be substantially higher than a normal hourly rate. The nature of the project, proposed usage, unusual time demands, and travel requirements have been considered as factors in estimating a consultation fee.

♦ *large projects:* In some markets, current data show, large orders may carry lower per-unit prices than single or smaller orders. In such cases, lower prices may be in keeping with standard business practices.

Billable expenses for graphic designers

Graphic designers traditionally bill their clients for all the expenses of executing an assignment, though textile designers and illustrators often absorb expenses such as art supplies because those amounts tend to be modest. Necessary additional costs of producing a job, such as model fees, prop rental, research time, typography, photostats, production, shipping, and travel expenses, are routinely billed to the client separately.

These expenses, even as estimates, are generally agreed upon and set down in the original written agreement. Often a maximum amount is indicated beyond which artists may not incur costs without additional authorization by the client.

When artists are required to advance sums on behalf of the client, surveys show that it is customary to charge a markup as a percentage of the expense to cover overhead and provide adequate cash flow. Dimensional illustration, for example, often requires substantial outlays for rental or purchase of materials and photography to achieve desired results. Current data indicate that markups are in the range of 15 to 25 percent, with 16.85 percent being the current average.

Billable expenses for computer-assisted graphics and illustration

Artists who own computer equipment consider their capital investment in their fees, surveys show, and it is important for those artists who rent equipment or use out-of-house service bureaus to maintain strict records of expenses in order to bill the client. Billable expenses usually include rental fees, transportation to and from the equipment, and any costs

incurred in recording work on hard copy, film, or videotape. Fees paid for technical assistants, research and reference costs, and expenses for preparing raw art (photos, stats, line art, etc.) for digitizing camera input usually are billed also.

Other expenses, such as equipment or technology purchases to meet specific demands of the job (e.g., buying a new font or telecommunications program), usually are negotiated.

Artists also usually follow the above basic markup considerations in equipment rental, particularly when time is spent negotiating for rental time or purchasing supplies and services.

Recent data collected show that the going billable rate for video animation systems average $400 to $600 per hour and $500 to $800 for special effects. Rental fees for hardware are about 10 percent of the purchase price; for software, for approximately 20 percent. Any artist working in this area should consider the newness of this technology and the speed with which the technology changes in regularly reviewing expenses and charges.

Freelancer as employee

Both artists and clients should be aware that certain working relationships may be considered traditional employment regardless of a "freelance" title. So-called full-time freelance positions, relationships which are steady and ongoing or relationships which extend over a series of projects, may actually be considered employment under tax or labor law. In these cases, the artist may be entitled to basic employment benefits, including unemployment, workers compensation, and disability insurance. Other benefits such as medical coverage, vacation, pension, and profit sharing may be due. Clients who do not withhold payroll taxes in these cases may be at risk with federal and state agencies and may face penalties equivalent to the taxes that should have been withheld. Please see the Professional Issues chapter for further information.

Other contractual considerations

Cancellation fees ("kill fees")

According to current and historical data, clients usually pay the artist a cancellation fee if the assignment is canceled for reasons beyond the artist's control. The amount of the

fee has in the past ranged from 30 to 100 percent, depending upon the degree of the work's completion. A more detailed discussion on kill fees can be found in the Professional Issues chapter.

While the client may demand all of the originally agreed-upon rights to the use of the artwork upon payment of the cancellation fee, under a royalty arrangement, all rights to the artwork, as well as possession of the original art, generally revert to the artist upon cancellation.

Many artists calculate a project's advance and any anticipated royalties to determine an appropriate kill fee. For example, suppose an illustrator completes the work necessary for a 32-page children's picture book for which the artist was to receive a $5,000 advance against a 5 percent royalty, and the job is killed. If the initial print run was to be 10,000 copies, with each book listing at $12.95, then the anticipated royalty may have been $6,475 (10,000 x $12.95 x 5%). After offsetting the $5,000 advance, the anticipated royalty may have been $1,475.

As when flat-fee projects are canceled, historical data indicate that all necessary and related expenses (such as model fees, materials, or overnight shipping fees) are paid in full.

Cancellation terms should be stipulated in writing in contracts and on confirmation forms and purchase orders. Otherwise, artists report, these fees have been negotiated at the time cancellation occurs, which has made it more difficult to protect the investment of their time and resources. These artists have found that contract language that makes payment of fees contingent upon the buyer's receipt of the artwork, not upon publication, anticipates the possibility of a cancellation after acceptance—and has helped insure timely payment.

Rejection fees

According to current and historical data, clients may agree to pay the artist a rejection fee if the preliminary or finished artwork is found not to be reasonably satisfactory and the assignment is terminated. The amount of the fee varies widely, historically from 20 to 100 percent, depending upon the degree of the work's completion. A more detailed discussion on rejection fees can be found in the Professional Issues chapter.

In the event of rejection, the client has chosen not to obtain any rights to the use of the artwork. Therefore, many artists refuse to permit rejected work to be used for reproduction by the client without a separate fee.

Credit lines

Illustrators usually incorporate their signatures on their artwork, and those typically are reproduced as part of the piece. For important pieces, especially when a letter of agreement is needed to spell out the terms of usage and payment, artists may make credit line requirements part of the deal.

For some this may mean a printed credit line with copyright notice, for others merely the reproduction of the signature in the artwork. In some cases, as is traditional with magazines, both credits may be agreed upon.

A copyright notice can be made part of the credit line simply by adding © before the artist's name and the year date of publication after the name (©Jane Artist 1994). Such a copyright notice benefits the artist without harming the client.

Recent surveys show that some magazine photographers require by contract that their fees be doubled if an adjacent credit line is omitted. Given the modest rates for editorial work, the value of the credit line is, surveys show, as important as the fee. This activity does not constitute a trade practice, but it is becoming more common and is being adopted by some designers and illustrators as well.

Samples of work

It is a courtesy for clients to provide artists with examples of the finished piece as it was reproduced.

This piece, often called a tear sheet, can be used in an artist's portfolio and provides a view of the project in its completed form. Regardless of who owns a copyright in the artwork, artists' use of their own original art in a portfolio is permissible as fair use (one that is not competitive with those the copyright owner might make), except in cases of work for hire, when the client's permission needs to be obtained.

Liability for portfolios and original art

If an artist's portfolio is lost by an art buyer, the law of "bailments" (the holding of another's property) makes the buyer liable for the reasonable value of that portfolio if the loss arose from the buyer's carelessness. If the portfolio contained original art such as drawings, paintings, or original transparencies, the amount in question could be quite substantial. The same potential liability exists with respect to commissioned artwork a client has agreed to return to the artist. A model "Holding Form" for use

by textile designers appears in the Standard Contracts and Business Tools chapter of this book and can be modified for use by other disciplines.

The value or appraisal of originals, transparencies, and other lost items can be verified by obtaining simple written assessments by a number of the artist's other clients, art directors, or vendors and presenting those figures to the party who lost the work or to a court. An independent appraisal by a professional appraiser is also credible. The full value of the work, however, may be nearly impossible to calculate, since no one can be certain what work will be worth over the life of the copyright, currently the artist's lifetime plus 50 years (see Copyright Extension section of Legal Rights and Issues chapter). One factor that can affect a work's value is whether it is generic or specific. Generic works (e.g., an illustration of a bald eagle soaring in flight) may have more potential for economic exploitation than specific works (e.g., an illustration of a specific brand of laundry detergent). Artists who encounter this problem may need to demonstrate that their works have generated additional income through transfers of rights.

There are a number of ways to minimize the risks of losing original work. First, artists should avoid, whenever possible, letting original art out of their possession. Instead of submitting portfolios or finished work, transparencies, color copies, or digital representations of a file should be sufficient. Another is with "valuable paper" insurance that protects against the loss or damage of valuable artwork in the artist's studio, in transit, or while in the client's possession. That, however, is not sufficient, since as with any insurance, deductibles must be met and continued claims will lead to either prohibitive premiums or a complete loss of coverage.

Buyers need effective systems for tracking and storing all original art in their offices. They should ensure that the receipt of every portfolio is recorded and a notation is made of its destination within the organization. If possible, buyers should avoid keeping portfolios overnight and on weekends. All original art should be logged out when it goes to any supplier, such as color separators or printers, and logged in when it returns. Finally, suppliers should understand that they may be held liable for any losses they cause as a result of damage to or disappearance of any original art.

Since absolute guarantees of protection in the handling of original art is impossible, buyers should minimize legal risks through the purchase of suitable insurance and, more important, the installation of proper record-keeping procedures.

Part II: Negotiation

Negotiation is an art by which each party seeks to accommodate both its own needs and those of the other party. Whenever possible, an atmosphere of mutual trust and collaboration should be established. From that point, both sides can create an agreement that will satisfy their respective needs. In negotiations, a "winner-take-all" attitude can do more harm than good, undermining the professional and honorable reputation necessary for long-standing relationships and, thereby, repeat business.

This cooperation is attained not merely by the exchange of concessions but through the attitudes and professional manner of the persons negotiating. Since the terms of a final agreement may not be those stated initially by either party, the participants must use their creative energies to develop solutions that meet the needs of all concerned.

During years of handling grievances between artists and clients, the Guild found that a common source of complaints was a failure by both sides to communicate effectively prior to the commencement of work. Artists and their clients must know their own needs, articulate them, and take the other party's needs into account. Even if only one of the negotiators makes a conscientious effort to understand the other's point of view as well as her own, chances of a misunderstanding and/or conflict are greatly reduced.

Both artist and art buyer must have goals by which to judge a negotiation. A buyer, for example, must stay within the established budget and still obtain satisfactory art. An artist, like any business person, must earn enough to cover overhead and make a reasonable profit. The more information each party has about the other, the more effective the negotiation. Artists who know the budget for a given job and can weigh the many pricing factors will have a good sense of current market forces—and this is precisely why these *Pricing & Ethical Guidelines* have been developed. Similarly, buyers who use the *Guidelines* to keep abreast of current standards and contract terms will be better equipped to establish more accurate budgets and to determine what rights to buy. If either artist or buyer finds that the

other party will not permit them to achieve their essential goals, then the negotiation will break down and the parties will seek to fulfill their needs elsewhere. In all negotiations, the Guild encourages artists and buyers to adhere to the standards of the Joint Ethics Committee's Code of Fair Practice (see the Professional Relationship chapter).

Many artists are reluctant to ask questions or raise objections to a client's demands for fear of appearing to be difficult to work with. Guild members frequently report, however, that as long as the discussion is carried out in an appropriately professional manner, clients appreciate artists who can articulate their needs, since it prevents future misunderstandings. It is important for artists to remember that art buyers are not "the enemy."

Attitude

Relaxation is very important in negotiation. By preparing properly and making the situation as comfortable as possible, it is possible to relax. Focus on breathing and concentrate on relaxing muscles in the head, neck, and shoulders; this can be surprisingly useful in a stressful situation. At the moment the deal at hand may seem like a "make it or break it" proposition, but that is usually not the case. In fact, most careers in the graphic arts are built upon hundreds of projects, not one. It is important to create a mental distance from the anxiety that can come into play in a negotiation. Being objective also can help one respond with agility so that the opportunity to get the right job at the right price won't slip away.

When faced with a negotiation, both sides begin by implying or stating a set of demands based on their needs. These demands should not be confused with underlying needs. It is these needs that a skilled negotiator attempts to discern.

When the problem stated is, "My company is looking for a first-class brochure that we can produce for under $10,000," there may be several underlying needs that are not being articulated directly. The art buyer may actually be indicating, "I want top-quality work at an economical price; can you accommodate me and make me look good, or do I have to worry about explaining a project from hell to my boss." Knowledgeable and skillful questioning will not only determine what kind of brochure is required to meet the client's needs effectively, but whether some other solution can better solve the client's problem within the estab-lished parameters. In responding to the client, a skilled negotiator communicates a number of messages, i.e., "I understand your needs and I am the best choice to solve your problems"; "I'm experienced and I know what I'm doing"; and "I'm going to make you look good." It is important to convey positive expectations about the job. Instead of "What is the deadline?" use a phrase such as, "When would you want me to deliver the art?" From the outset, contact with a client can show a personal interest and attach-ment to the project that is contagious.

The answer to a stated problem will not always be obvious. It is critical to be able to relax and perceive the other person's position. By understanding this there can be a positive response to the underlying meaning of what is being said, and the negotiation can proceed with harmony.

Know when to quit. Getting greedy when things start to go well or pushing too far can lead the other party to abandon the whole deal out of spite. Generosity may pay off in future negotiations.

Preparation and research

Adequate preparation is a key ingredient to successful negotiation. Artists should attempt to know everything possible about a client prior to a meeting. Business libraries contain valuable information about the marketplace; directories for corporations and advertising agencies, such as the Standard Rate & Data series, show amounts of billing, circulation, officers, media bought, etc.

In addition, publication directories list magazines with their circulations, advertising rates, names of staff, etc. A business librarian can help locate the appropriate publications.

Subscriptions to all appropriate major trade magazines should be maintained.

Magazine stands, mass transit posters, bill-boards, retail stores, supermarkets, and book-stores all contain valuable information about clients that artists may use with a new client. Active membership in the Graphic Artists Guild helps to give artists the extra "edge" they need in a job situation.

Agendas and contracts

When beginning a negotiation, it is important to ask the right questions and formulate an agenda for meetings or phone calls that outlines the topics to be covered. Additionally, artists should establish a "position paper" that will help answer the most important questions of all:

"What value (monetary or otherwise), will I derive from this job?" and "What will I do instead if I turn it down or am not right for it?"

Whether a project is interesting purely for the money, because it is a valuable showcase, or because it will help establish a working relationship with a new client, an agenda will affect what the artist will agree to in negotiations.

Before starting work, agreements should be put in writing. This protects the client as well as the artist by confirming terms before a misunderstanding can arise or memory fades. The document can be as simple or as complicated as the situation requires, from an informal letter of agreement to a complicated contract requiring the signatures of all parties. Formulating such letters and contracts or analyzing contracts offered by clients requires a thorough working knowledge of copyright and business law and its common terms. By carefully reviewing the model contracts and supplementary sections of this book, as well as the Legal Rights and Issues chapter for copyright information and other publications (see Resources and References chapter), artists will be able to rephrase contractual terms in ways that clients can better understand, with the knowledge that agreement springs from understanding.

The majority of art directors and creative services personnel who commission art have little or no expertise in copyright and contracts. Like artists, most of them would prefer spending their available time in creative pursuit, rather than administering legal details. They are too busy juggling a number of important, creative projects in unusually hectic, high-pressure surroundings, so having a clear understanding of how to suggest contract amendments and put them into writing can help avoid problems.

Keep thorough, written records of the negotiation, including the initial checklist containing a job description, due dates, fees, and expenses; notes on the person representing the client; records of follow-up meetings and phone calls; hours on the job; layouts; memos; sketches; contracts; invoices; and business letters. This will form a "job packet" that is a paper trail in the event that a disagreement or misunderstanding gets in the way of completing a project and payment.

When clients use work-for-hire clauses in contracts or demand all rights to artwork, every effort should be made to determine the client's real needs. Often such terms were put in a contract by a lawyer trying to anticipate every possible contingency. But such terms usually are excessive and, if priced accordingly, make work too expensive to afford.

Power

Negotiation itself cannot turn every situation into a good contract. There are some relationships where the balance of power is so out of alignment that one party must either yield to unfavorable conditions or give up the opportunity. However, it is possible to maximize assets and protect yourself from an agreement that may be detrimental.

Remember that not every negotiation is destined to end in a deal. Two parties can "agree to disagree" amicably and part ways hoping for another try at a later date. It is this ability to regard a negotiation with level-headed objectivity, keeping it in perspective, that provides a skilled negotiator with the attitude necessary to obtain the most favorable agreement.

Both parties should bear in mind what their course of action will be if the negotiation ends without agreement. "What other jobs do I have?" "What else will I do with my professional time if I don't take this assignment?" are questions that artists should ask themselves, just as the client is asking, "What else can I do, or who else can I hire, to make this project work?" These questions provide both parties with a realistic assessment of how much leverage they actually have in a negotiation. Power can be regarded as the ability to say no; assessing alternatives, therefore, clarifies a position.

Often parties will establish an arbitrary limit from which they will not bend, such as "I won't pay more than $25,000," or "I won't accept less than $3,000." Since the figures or conditions are often selected randomly in the first place it is important to be able to ignore such a limit if necessary. An absolute can become a focal point that inhibits the imagination necessary to establish terms that meet both parties' needs.

When entering into negotiations, it is important to decide what to do if negotiations break off. It's much easier to say no when there is a favorable alternative to pursue. As the saying goes, a bank will lend you money if you can prove you don't need it. In the same way, it's much easier to get a job if you already have one. If an artist is not busy with other jobs, the best alternative is to create a mental priority list of important and valuable projects

to pursue. This helps alleviate the often ill-founded notion that the deal must be made at any cost.

The meeting

As much as possible, create an environment for the meeting that allows as comfortable a situation as possible. If negotiating "on your own turf" is impossible, bring your own turf with you. Clothing should always be professional and neat, but make sure it is also comfortable. Any presentation or portfolio should show the very best work. An unusual, thoughtful, and creative presentation that is well designed goes a long way in establishing the expertise of an artist—and making a sale.

Negotiations should be avoided if the artist lacks sleep, is overtired, taking medication, under the influence of alcohol, or has eaten a heavy meal recently. Very expensive errors can occur when artists are not as sharp as they should be. If the situation is uncomfortable or potentially disruptive, arrange to conduct the negotiation another time. There is a right and a wrong time for negotiation. Recognize an opportunity and make use of it, but recognize also when it is an inopportune time and wait for another day.

The golden rules during a meeting are: Stop, look, and listen.

♦ *Stop:* Quiet down, breathe, and relax. Refrain from lots of small talk unless what's being said has a purpose for the business at hand. A well-placed word here and there does more to establish credibility; giving information not asked for can inadvertently give clues about the artist's situation and weaknesses. Conducting presentations also can distract clients from reviewing the work carefully .

♦ *Look:* A great deal can be learned by close attention to physical clues and the behavior of others. Office environments (wallpaper, furniture, desktops, artwork, and photographs) can give clues about the client's personality. Notice if a seat is offered, if the client consults a watch constantly or is not focused on the discussion. Understanding behavioral clues and "body language" can be a substantial negotiation advantage.

♦ *Listen:* People appreciate someone who is alert and attentive and indicates that he or she understands what is being said. It is important to indicate that understanding even if the listener doesn't agree with the point made. Listen actively, with nods of agreement, encouraging the other parties to express themselves. It is very useful to repeat what was heard, such as, "Let me see if I understand correctly: You're saying that ..." This indicates a good listener who is eager to understand. Listening effectively helps to determine and address the other party's needs and expectations.

Tactics

Tactics are used throughout every negotiation, whether intentional or not. But by separating emotional responses from calm, detached observations of an opposing party's tactics, the effectiveness of the tactic can be defused. It is important not to take things personally during any phase of negotiation. Performance and ability to maneuver are seriously hampered when egos take charge. Consider a few examples:

♦ *Limited authority.* A person claims not to have final say on the terms of a deal. This enables one negotiator to make rigid demands, leaving the other to offer concessions in order to make some headway. One possible solution is to treat the project under discussion as a joint venture, recruiting the other person as your newfound "partner." By emphasizing terms that create a partnership, and sharing a stake in decisions, that person is encouraged to go to bat with the higher-ups to defend the artist's needs and goals.

♦ *Phony legitimacy.* It is stated that a contract is a "standard contract" and cannot be changed. Contracts are working documents that serve to protect two or more parties in an agreement. Don't agree to sign standardized contracts if they don't protect you. Don't be reluctant to strike out unfavorable sections or terms. If necessary, the defense "my attorney has instructed me not to sign contracts with these conditions" may be used to suggest alterations (see the Standard Contracts and Business Tools chapter).

♦ *Emotions.* Anger, threats, derisive laughter, tears, or insults may be convincing and may, in fact, be genuine, but should be regarded as tactical maneuvers. Listen carefully to the point of the message and separate it from the style of delivery. Never escalate an emotional situation. Any attempt to "roll up your sleeves and jump in" is very risky.

Telephone skills

Telephones seem to be very easy for some people to work with and much harder for others. Like personal contact, negotiating by phone has its strengths and weaknesses. Phone calls have distinct advantages over in-person meetings. They provide ample opportunity to refer to written materials for reference and support. Often, when calling from the office or home, being surrounded by one's own environment can bolster confidence.

Telephone skills are very important to a good negotiator; some individuals go so far as to write "scripts" for particularly difficult situations, where performing under pressure can cause confusion. A simple negotiation agenda or checklist can be used to outline all the points that need to be covered. This prevents the problem of forgetting important details and helps keep the conversation centered on the important matters at hand. Taking notes during phone conversations is recommended highly. Artists simultaneously must understand the aesthetic requirements of a project, agree on the business arrangements, and establish rapport with the individual on the phone. These are complicated details and should be written down. Such notes can also be valuable references should a misunderstanding occur during the project.

Negotiating by phone has disadvantages as well. It is easier to refuse someone over the phone. If a difficult demand has to be made, it might be preferable to arrange a meeting. It is also difficult to judge reactions to what is being said when it is impossible to see the other person's face. A person's attention to what is being said may not be focused, and this can make it more difficult to establish the rapport and partnership that is so important to any successful negotiation.

If a discussion becomes difficult, put the caller on hold or get off the telephone and call back when it is more advantageous. This allows time to consult research materials or make phone calls for more information, to cool off if emotions are in play or just gives additional time to make a difficult decision.

Money

Money should be the last item in a discussion, for several reasons. It is the area where the majority of disagreements occur, and it is important in the earliest stages of a negotiation to focus on areas in which it is easiest to reach an accord. In this way the partnership stressed earlier is given time to bloom.

Also, money should only be a reflection of all the factors that lead up to it. The job description, usage and reproduction rights, deadline, expenses, difficulty of execution, etc., all tell how much value a particular job holds for the client. So negotiating about money before reaching agreement on these other items is premature and can be a costly error.

When discussing money, it is advisable whenever possible to outline expectations, then try to get the other party to make the first offer. The old game of "I say 10, you say 6, I say 9, you say 7, we agree on 8" is still played out but is not always necessary. Depending on how it is stated, though, a first offer is rarely a final offer and should almost always be tested. Once again, one must weigh the risk of losing a possible working relationship by refusing to budge past a certain price. It always depends on the situation.

Don't feel obligated to respond right away if someone starts out a negotiation with "I only have $500, but I think you'd be great for the job." One can acknowledge the figure and still bring it up later when there is a foundation of a working relationship on which to base requests for more money.

Often, artists are asked to bid on jobs. It is important to clarify the nature of the bid. Is the client looking for a sealed bid that will be used to compete against other artists? Is this bid an attempt to help structure a budget? Is it only a ballpark estimate? Do they wish to negotiate directly? Since a sealed bid encourages negotiation against yourself, it should be clarified whether the bid is final and binding. It is unfair to ask an artist to develop a competitive sealed bid and then seek further concessions in later negotiations. In a ballpark estimate, the client often will hear only the low figure, so use care to offer a set of figures that brackets the price in the middle. When asked in person for a bid, artists should not hesitate to withdraw and say, "I'll call you later today with a quote." This gives artists time to consider their agenda and their needs. It is not only practical, it's actually good business to ask for a higher price or more favorable contract terms than what one would expect. Like it or not, people in business often like to feel that they've gotten a compromise, and in that sense it is an obligation to manufacture a few concessions without harming one's own interests.

Part III: Keeping Track

Business forms

It is in the interest of both artists and art buyers to put any agreement authorizing the use of an artist's work into writing. These agreements should be specific in naming the rights that are being transferred and in describing the disposition of the original art, cancellation fees if any, and other terms. Written agreements also should reflect the concerns of both the artist and art buyer in a way that will address any issues raised in negotiations specifically. While it is possible to enforce an oral agreement, it is strongly recommended that artist and client confirm any agreement in writing. This is the best protection against faulty memories and future conflicts. A written agreement also can be a valuable tool in helping both parties clarify their needs. Getting it in writing is also evidence that both parties are professionals who treat the investment of their resources with care. Agreements can be realized in many forms, including purchase orders, letters of agreement, memos, invoices, and so on (see Standard Contracts and Business Tools chapter). A written understanding may be sent by mail, messenger, or facsimile.

Terms

Contracts and purchase orders must contain provisions covering at least the following points:
- the names of the artist and client, including the name of the client's authorized art buyer (the commissioning party);
- a complete description of the assignment;
- the fee arrangements, traditionally including the fees for usage, consultations, alterations, travel time, cancellation fees, and reimbursement for billable expenses;
- payment terms, including a schedule for advances, monthly service charges for late payment, expense estimates and/or maximums, and royalty percentages and terms, where applicable;
- specifications regarding when and how the original will be returned;
- any agreement regarding copyright notice requirements and placement of the credit line;
- the assignment of rights described in spe-

cific terms, normally naming a specific market category, medium, time period, and geographic region (see Legal Issues and Rights chapter);
- assignment of responsibility for obtaining releases for the use of people's names and/or images for advertising or trade purposes.

For further information on contracts, please refer to the Standard Contracts and Business Tools and Resources and References chapters of this book and to the index for related topics.

Getting paid on time and in full is the just entitlement of any businessperson, including artists. Proper planning and preparation, in writing, can do much toward ensuring this expectation is met. These preparations may, at times, require extra effort from the artist, but they will certainly pay off in the long run. At the start of each job, artists should have a complete understanding of the negotiated terms and obtain a final agreement in writing to help insure timely and proper payment of fees.

To encourage timely payment, artists historically have included additional terms providing penalties as allowed by law for accounts that are past due and retaining rights until full payment is received (see the section on Extension of Payment Time, following). Since job changes often alter the original terms, it is particularly important to confirm in writing any additional fees due to the artist as a result of such changes.

The Guild's model business forms incorporate a number of these measures and can aid readers in securing their agreement and rights (see Standard Contracts and Business Tools chapter).

To facilitate accurate billing, artists should maintain proper records through job files, job ledgers, or a similar system. Tracking invoices provides the means to remind buyers of outstanding obligations and to take the follow-up steps necessary to obtain payment.

When a buyer refuses to pay, written agreements and invoices can protect the artist's rights, either through negotiation, collection services, arbitration, or a lawsuit.

Keeping records

All artists should have a recordkeeping system to facilitate billing, bill tracking, and fee collection and to document tax deductions.
- *job file:* One common method of recordkeeping is the use of a folder or envelope

labeled for each assignment. All information and documents pertaining to the job, such as agreements, messenger, and expense receipts, letters, phone memos, invoices, and so on, are put into this job file as they are received. The file then provides a single and complete record of all decisions and documents.

Identifying information usually is placed on the folder cover. This may include the job number, the title of the project, the buyer's name, and the delivery date. If the job is complex, the job file should be subdivided into sections to permit easy access to information. All sketches and drawings should be retained as well, at least until payment is received.

♦ *job ledger:* A job ledger contains standard columns for information such as the job description (job number, client, description of artwork, delivery date), rights granted (usage rights granted, status of original artwork), fees and expenses (fee or advance, reimbursable expenses, sales tax, etc.), and billing information (invoice date, invoice amount, payment due date, amount received, date received, late penalties, balance due, artwork returned date). With a job ledger, an artist can at a glance determine the status of each aspect of a job. The ledger's format can vary from a form specifically created by the artist to a printed journal readily available in stationery stores.

Billing procedure

Most art assignments, whether written or verbal, are contractual arrangements. Essentially, the buyer promises to make a specific payment in return for the artist's grant of usage rights. Invoices serve as formal communications to the buyer of payments that have or will become due.

The manner and time of payment normally are established in the written agreement. If the parties have not specified a payment due date, the generally accepted practice is payment within 30 days of delivery of the art.

An invoice should be presented whenever a payment becomes due. In many instances, invoices accompany delivery of the finished art. When a partial payment is due or costs are to be billed during the job, the invoice or statement should be delivered accordingly. If cancellation or rejection occurs, the buyer should be billed immediately, according to the agreement, or if such a provision is absent, according to the standards discussed in the Profes-

sional Issues chapter.

Verbal requests for payment are not substitutes for invoices but are additional means to use in the collection process. In many businesses an invoice is mandatory for the buyer or others to authorize and issue a check. A copy of the invoice should also be sent to the accounting department, if the business is large enough to have one, to facilitate prompt processing.

The wording of invoices should be accurate and complete to avoid payment delays. The artist's Social Security number or federal identification number should be included. Billing may be expedited by including the instructions "Make check payable to Jan Artist or J. Artist Associates," whichever is applicable.

Sales and use taxes

States have varied policies regarding sales and use taxes. In states that have one, the rate usually ranges from 3 to 9 percent, and it is levied on the sale or use of physical property within the state. A number of exemptions exist, including special rules for the sale of reproduction rights. The applicable state regulations should be consulted.

Generally, services, including the service of transferring reproduction rights, are not subject to a sales tax. Transferrals of physical property to a client (i.e., original art, designer's mechanicals) shouldn't be taxed if they are part of a project that will be billed to a client later by a design firm or other agent, although a resale certificate may have to be obtained. Generally, sales tax is applicable for end sales or retail costs only, not for intermediate subcontracting. An artist may have to file forms showing that materials were intermediate and thus not taxable.

Many tax laws are unclear in relation to the graphic communications industry. In any case in which artists are unsure whether to collect the tax, it is safest to collect and remit it to the state sales tax bureau. If artists should collect the tax but don't, they, as well as their clients, remain liable for it. But, it can be difficult to try to collect the tax from clients on assignments that have been performed in the past. Please see the Professional Issues chapter for detailed information on sales taxes.

Checks with conditions

Some clients still attempt to add terms to the contract after the work is done by listing con-

ditions claiming that endorsement of the check transfers all reproduction rights and/or ownership of the original art to the payer. A recent U.S. Supreme Court decision (*Playboy Enterprises, Inc. v. Dumas*, 1995) let stand a lower court decision giving creators mixed rights when faced with additional contract term after the work is completed (see the chapter on Professional Issues for more detailed information). It has always been the Guild's opinion that endorsement of such a check would not constitute a legal contract, especially if it conflicted with a previous contract. When confronted with checks with conditions, an artist has at least three options to consider:

First, simply return the check and request that a new check be issued without conditions. If the conditions on the check violate a prior contract, a refusal to issue a check without conditions will be a breach of contract.

Second, if an artist has signed a contract or sent an invoice that restricts the client's rights of use, and if the artwork has been used already, the artist should strike out the conditions on the check and deposit it. In this case the artist probably should not sign the back of the check, but instead should use a bank endorsement stamp, which eliminates the need for a signature.

If the artwork has not been used, the artist should notify the client in writing that he or she is striking out the conditions on the check. If the client does not respond within two weeks, the check can be deposited safely.

Finally, if the artist has neither signed a contract with the client nor sent an invoice restricting use, the check should be returned in order to protect all rights. Along with the check the artist should include an appropriate invoice restricting usage. Of course, the best procedure is to specify in writing which rights will be transferred before beginning the assignment.

Tracking debts

Once the invoice has been given to the buyer, the artist should monitor the outstanding debt until it is paid. A tracking system should be set up that ties into the artist's recordkeeping. One simple method is to label a folder "accounts receivable." Copies of all invoices forwarded to buyers in order of payment due date, the artist's job number, or the billing date should be kept in this folder.

To track fees, these invoices should be reviewed periodically. When payment is

received, the invoice is moved to the individual job file.

Artists using a job ledger can determine at a glance which payments remain outstanding by referring to the "payment due date" column. When payment is received, the date is entered under "payment received date."

Continual tracking of payments also keeps information on cash flow current and allows for timely follow-up steps to collect past-due fees or other outstanding obligations.

Part IV: Collecting

Having completed and delivered artwork that meets the buyer's specifications, it's natural to expect that payment will be made as agreed. Graphic artists who are not paid in a reasonable time will need to undertake additional efforts to collect outstanding fees if they are to avoid absorbing losses of income and time. Artists can often inoculate themselves from payment problems by taking precautions beforehand, particularly outlining payment and related terms clearly in a written and signed agreement as described previously. A model collections ledger is included in the Standard Contracts and Business Tools chapter.

Whether or not these preparatory steps have been taken, however, artists who do not receive timely payment will want to implement appropriate and efficient collection strategies. Invoices tend to get more difficult to collect as they get older, so prompt action is important. Artists and buyers can lose or misplace important documents or forget details, or new events may complicate matters. At the end of the Artists' Options section is a model guide to steps artists can take themselves to collect outstanding fees. It does not, however, represent legal advice; any actions with legal ramifications should not be undertaken without consulting qualified attorneys.

The first step in a collection strategy is prevention. When dealing with a new client, check credit references, the Better Business Bureau, and credit-reporting agencies such as Dun & Bradstreet to verify worthiness. Direct communication between artist and buyer to determine why payment has not been made is the next logical step if a problem arises. Subsequent steps depend on the nature of the problem and the buyer's response.

In some cases the client may dispute

whether monies are owed, or how much. In most cases artists will be confronting a client's cash-flow problems. A direct discussion may clarify the problem and lead to a solution. If discussion is not sufficient to resolve a misunderstanding or dispute, artists and buyers can take advantage of the support services of a local Guild Grievance Committee (for members only), mediation, or arbitration.

If the artist encounters an unreasonable or evasive buyer, however, more forceful measures may be required, such as engaging a collection agency, suing in small claims court, or hiring a lawyer.

Causes of nonpayment

Artists usually learn why the payment has not been made from the first contacts with the buyer. Following is a look at some of the more common causes and available strategies for responding. These basic negotiation concepts can be applied to other nonpayment situations as well.

◆ *bankruptcy:* If a client files for bankruptcy, there may be little an artist can do, except to be added to the list of unsecured creditors. If the client is forced to liquidate assets to pay the creditors, a percentage of the fee may ultimately be paid to the artist.

Another problem in a bankruptcy may be getting artwork returned, especially if the trustee or court assumes that the artwork in the client's possession is an asset. An artist must claim that the original artwork belongs to the artist and cannot therefore be considered an asset of the bankrupt party. While New York State has passed legislation that protects the work of gallery artists if a gallery files for bankruptcy, those protections are not extended to graphic artists unless their work is similarly on exhibit.

◆ *buyer's error:* Once the artwork is delivered, it's on to the next project for the buyer, who may forget to process the check. One purpose of an invoice is to serve as a physical reminder; the buyer should not be expected to send the check automatically, nor are verbal requests for payment sufficient.

If the cause of nonpayment is oversight, a new due date should be established and the buyer requested to follow up personally. The artist should send a letter confirming when payment will be made.

◆ *artist's error:* Perhaps an invoice was not provided, was sent to the attention of the

wrong person, was incomplete or illegible, or did not document reimbursable expenses. The artist must correct the error in order to expedite the payment process.

◆ *disputes and misunderstandings:* Some disputes are caused by unintentional actions or lack of knowledge of professional standards and practices. For example, buyers may have made an incorrect assumption or may not have been aware of appropriate professional conduct in a particular situation.

If the reason for the payment failure or rights violation is contrary to the agreement or to professional standards, inform the buyer of the correct position. When contacting the buyer, refer to the written (or verbal) agreement. Well-negotiated agreements usually foresee areas of possible dispute and specify either the obligations of the buyer or the rights of the artist. If necessary, alert the buyer to provisions in the agreement providing alternatives or penalties. These provisions can provide additional negotiating leverage.

Direct the buyer's attention to appropriate professional standards as outlined in the industry's Code of Fair Practice (see the Professional Relationship chapter) and the Guild's *Pricing & Ethical Guidelines.*

Ask the buyer to comply with the artist's request or to respond to the issue if further discussion appears appropriate.

Artists' options

Direct negotiation

Unless complex legal matters or large amounts of money are at issue, direct negotiation is usually the most appropriate approach. A phone call or a personal visit may be most effective in resolving a payment problem. Alternately, the artist might send a brief, businesslike letter with a copy of the original invoice attached and marked "Second Notice." Remind the buyer of the overdue payment and request that he handle it immediately. At this stage the artist usually can presume that human error or "red tape" was involved and that the call or letter will clear things up. These reminders often prove sufficient and forestall the need for stronger measures that risk alienating anyone—at least until it becomes clear that the nonpayment is deliberate.

It is in the artist's best interest to act professionally at all times in dealing with the buyer or anyone else who may be contacted. Artists should be objective and realistic while

conducting collection efforts.

When payment problems occur or are anticipated, all correspondence (letters and invoices) should be sent by certified mail, return receipt requested. Artists should keep copies of correspondence and memos of discussions between the parties. Establishing a "paper trail" of the proper documentation may prove to be crucial at a later stage.

Extension of payment time

Buyers may claim to be experiencing a cash-flow problem; that is, they may claim to not have sufficient funds on hand to pay. It is difficult to verify whether this is legitimate or an evasive maneuver.

Nor is it unusual for the buyer to blame the late payment on the company's computer. Long intervals between programmed payments, however, are unreasonable. Exceptions to automatic payments can be, and are, made all the time. In this case, insist that a handwritten check be authorized within a specified number of days.

If the cause of the delay appears legitimate and future payment clearly will be made, the artist may wish to accommodate the buyer and grant a reasonable extension. The new payment deadline, however, should be confirmed in writing.

Granting extensions should be viewed as a professional courtesy on the part of the artist, not the buyer's right. Some artists may demand a service fee as compensation for the delay in payment, often a percentage of the outstanding balance. Artists who employ this practice will notify their clients of the policy in writing before any work is accepted. This practice should be used particularly when longer extensions are granted.

Demand letter

After direct negotiation has been attempted, a buyer may still refuse to make payment. The buyer may not respond to the artist's letters and calls, give unreasonable explanations, not address the issue at hand, or not make payment as promised according to the newly negotiated terms.

Faced with this situation, and as a last effort before turning to stronger alternatives, the artist should send a demand letter. This can be done either directly, through the Graphic Artists Guild's Grievance Committee (see section following), or through a lawyer. The basis of the artist's claim should be restated briefly, with a demand for immediate payment of any outstanding balance.

The demand letter also should apprise the client that legal action will be taken unless payment is received. In view of the artist's determination to pursue his or her legal rights, the buyer should reconsider.

SAMPLE DEMAND LETTER

Dear Mr. Client:

Your account is now [X months] overdue. Unless your check or money order in the amount of $[amount] is received by [usually three days] from receipt of this letter, I will be forced to pursue other methods of collection.

You can still preserve your credit rating by calling me today to discuss payment of this invoice.

If I do not hear from you within [three days], I will be forced to turn your account over to a collection agency [or attorney or the Graphic Artists Guild Professional Practices Committee].*

Very truly yours,

Joe Talent

President, Ads & Such

enc: copy of Invoice marked "Final Notice"
 return envelope for payment

* The Guild's Professional Practices Committee (PPC) handles disputes for members only. Guild members should call their local Chapter or the national office for information.

Step-by-step collection strategy

Caution and restraint should be exercised in all communications with clients so that there is no question of harassment, which is a violation of the federal Fair Debt Collection Practices Law.

1. At the completion of the project, the artist should send an invoice to the client clearly stating the amount owed by the agreed-upon due date. If appropriate, the artist can include a notation that a late payment penalty fee will be applied to all overdue balances. (Many businesses assess a late fee of 1.5 to 2 percent of outstanding balances due.)

2. If the client does not make timely payment, the artist should send a follow-up invoice. A handwritten or stamped message to the effect of, "Have you forgotten to send your payment?" or "Payment overdue—Please remit promptly" may help speed payment. If appropriate, the artist should include any applicable late payment penalty fee incurred to date as part of the balance due on the follow-up invoice. To help expedite payment, the artist may include a self-addressed stamped envelope or their express mail account number for the client to use in mailing back their payment.

3. If the client does not make payment within 10 days of the follow-up invoice, the artist should call the client to remind them that payment is due.

SAMPLE PHONE SCRIPT:

"Hello, Mr. Client. This is Joe Talent, at Ads & Such, and I'm calling to remind you that payment for the [name of project] that was delivered to you on [date] is now over [x] days past due. When can I expect to have payment in my hands?"

At this point the client will probably give the artist a reason for the delay, which should be listened to patiently. Hopefully it was simply an oversight and the client will agree to send payment immediately.

4. If payment is not received within 10 days of the phone call, the artist should send a "Second Notice" that payment is overdue and expected within 10 days of this notice. The Second Notice allows for possible human error or "red tape" that may have caused the delay and presents the client with another copy of the overdue invoice and a self-addressed envelope to simplify and speed payment.

SAMPLE "SECOND NOTICE" LETTER:

Dear Mr. Client:
Ten days ago I spoke with you about the outstanding balance of $[amount] owed for the [project] Ads & Such delivered to you on [month]. You agreed to make payment within 30 days of acceptance, and now, [X days] later, you have still not settled your account.

This may be merely an oversight or your payment has crossed this letter in the mail. If there are other reasons payment has not arrived that I should be aware of, I hope you will call me immediately.

Please do not jeopardize your credit record by failing to respond to this request. If payment has been sent already, accept my thanks. If not, please send a check or money order for $[amount] in the enclosed return envelope no later than [date—usually 10 days from receipt of the letter].

Sincerely yours,
Joe Talent
President, Ads & Such

enc: copy of original invoice (marked "Second Notice")
return envelope for payment

continued on next page

5. If the client does not make payment within 10 days of the Second Notice, the artist can either send them a telegram or a "Final Notice" letter. It should say that if payment is not made within 3 days, the debt will be turned over to either a collection agency, the Graphic Artists Guild's Professional Practices Committee, or an attorney; see sections following for more information on these options.

SAMPLE TELEGRAM:

To: Mr. Client
From: Joe Talent, President, Ads & Such
You have repeatedly promised to make payment on your outstanding balance of $[amount] yet your check or money order has not arrived. If it is not already in the mail, I urge you to send it today.

SAMPLE "FINAL NOTICE" LETTER:

Dear Mr. Client:
You have repeatedly promised to make payment on your outstanding balance of $[amount] yet your check or money order has not arrived. If it is not already in the mail, I urge you to send it today.

Sincerely yours,
Joe Talent
President, Ads & Such

6. Up to this point, a number of reasonable efforts have been made and sufficient time has elapsed to allow the buyer to respond or pay the debt. The artist has also established a "paper trail" of proper documentation verifying the continued indebtedness and the artist's attempts to collect. If the buyer still fails to respond or pay, or acts evasively, the artist may reasonably assume that the buyer is avoiding payment intentionally. The artist must now select the next course of action from among the alternatives discussed in the following sections.

The Graphic Artists Guild Grievance Committee

The Graphic Artists Guild Grievance Committee provides guidance and assistance to members in good standing in resolving differences with their clients. Guild members in need of this service should contact their local Chapter or the National Office. If a grievance cannot be resolved at the Chapter level, it may be referred to the national Grievance Committee for further action.

The following information is required when submitting a grievance (a standardized grievance form is available upon request):

♦ *contact information:* the member's personal and business names, addresses, and phone and fax numbers;
♦ *client information:* the name of the client, the name and title of the art buyer, and the relevant addresses and phone and fax numbers;
♦ *the exact job description;*
♦ *statement of grievance:* the nature of the

grievance, including a chronological narration of facts and the respective positions of the parties;
♦ *resolution attempts:* the names of other agencies and persons (e.g., collection agencies or lawyers) contacted regarding the grievance and the result of such contacts;
♦ *copies, not originals, of relevant documents substantiating the grievance:* agreement forms or purchase orders, invoices, correspondence, receipts, and so on;
♦ *desired remedy:* a statement of what the member would consider an appropriate solution for the grievance.

Members may not claim the support of the Grievance Committee until the Committee has reviewed the case and has notified the member that the case has been accepted. The Grievance Committee may choose not to take a case if the member has begun formal litigation.

The Committee reviews grievances at its earliest opportunity. If it is determined that the

grievance is justified, the Committee contacts the member. A plan of action is recommended and appropriate support provided, ranging from direct communication with the client to testimony in court supporting the member in any follow-up litigation. It is crucial that the member participate fully and keep the Committee advised of subsequent developments.

The Grievance Committee will not offer assistance in a dispute involving questionable professional conduct on a member's part, such as misrepresentation of talent, plagiarism, or any violation of the Joint Ethics Committee's Code of Fair Practice (see Professional Relationship chapter).

Mediation and arbitration

Mediation and arbitration are long-established processes for settling disputes privately and expeditiously. They use the services of an impartial outsider to bring about a resolution. A mediator, acting as an umpire, does everything possible to bring the parties to agreement but cannot impose a decision upon them. If the parties cannot reach an agreement, they must proceed either to arbitration or to court to resolve the dispute. In arbitration, the arbitrator acts as a judge, reviewing the evidence presented by both sides and then making a legally binding decision.

Submitting to mediation or arbitration is voluntary. An arbitration provision in an artist's contract establishes the buyer's consent once the contract is signed. Should a party to the dispute not appear for arbitration, a binding decision may be reached in that party's absence.

Mediation and arbitration are speedier and far less expensive than suing in court. Their conciliatory and private atmosphere may be more conducive to parties who have had or who would like a long business relationship. These services also may be relevant if the artist's monetary claim exceeds the limit of small claims court. Arbitrators' fees, which are usually split between the parties, are relatively moderate and normally consist of a flat fee plus expenses. Either party may choose to use an attorney in arbitration proceedings, but it's not required. Such costs are borne by that party.

The American Arbitration Association is available in 24 cities around the country and its services may be requested in other localities. Arbitration and mediation may also be sponsored by some of the volunteer arts-lawyer groups, including Volunteer Lawyers for the Arts in New York City and California Lawyers for the Arts in San Francisco (see list with

addresses under Consulting or Hiring a Lawyer later in this chapter).

Collection services

If voluntary dispute resolution such as mediation or arbitration cannot be obtained, commercial collection agencies are available to seek payment on the artist's behalf before the last resort of a court judgment is sought. Their efforts involve escalated demands on the buyer through letters, phone calls, or visits or by using a lawyer.

Collection agency fees, in addition to their routine expenses, generally range from 10 to 50 percent of the monies actually recovered, often depending on the amount of money involved and how much time has lapsed since the work was invoiced (older invoices are more difficult to collect). If the agency engages a lawyer, an additional fee usually is required.

A signed agreement between the artist and the agency should be reviewed carefully for actions the agency will take and what it will charge. Particular care should be taken in dealing with a commercial agency that may use practices that could be deemed unprofessional, since they may reflect unfavorably on the artist. Members of the Graphic Artists Guild may elect to take advantage of a Guild-sponsored collection service for a one-time flat fee, regardless of the age of the invoice.

Small claims court

When all else fails, the legal system may still offer a way to remedy a problem. Small claims courts give a grievant access to the legal system while avoiding the usual encumbrances, costs, and length of a formal court proceeding. The small claims procedure is streamlined, speedy, and available for a nominal fee.

Artists can handle their own cases here with a little preparation. Information can be obtained from flyers prepared by the court, "how-to" publications, and, perhaps best, from local rules books. The court clerk or, in some localities, a legal advisor is often available to help with preparation. The small claims procedure forms are also known as "trespass and assumpsit" claims forms.

Artists may bring claims seeking a monetary judgment to small claims court. Such claims may include nonpayment for completed or canceled artwork as well as nonpayment for purchase of the original art, unauthorized reuses, or unreturned or damaged art.

Each state's small claims court has a dollar limit for what it considers a small claim.

Amounts in excess of the limit would require litigation in civil court. Considering the higher costs of pursuing a claim through civil court, it may be more economical overall to reduce the claim to an amount that qualifies as a "small claim," especially if the amount in dispute is only slightly higher than the court's limit. However, this claim must be made with the understanding that the balance above the court's limit is forfeited permanently. It may be possible to split up a larger amount of owed monies into several smaller claims to be sued for individually; for example, if a client owes a large sum made up of payments due from several assignments.

Many small claims court cases are heard by arbitrators rather than judges. This does not prejudice one's case and can even expedite a decision.

Collecting after a judgment

Should a buyer fail to pay after the court has rendered its decision or affirmed an arbitration award, the law authorizes a number of collection remedies. The artist gains the right, within limitations, to place a lien on the buyer's funds and assets. Available funds, such as bank accounts or a portion of an individual's salary, may be seized by a sheriff or marshal and turned over to the artist. Similarly, the proceeds of property or a car sold at a public auction may be used to settle the debt.

Consulting or hiring a lawyer

The services of a lawyer can assist in a number of ways and at different stages in a collection strategy. A lawyer may provide sufficient information to enable continuation of personal collection efforts. Whether a problem relates to rights or to payment due, an initial consultation, whether in person or by phone, could confirm what the relevant law is and whether the artist's position is supportable under the law. The lawyer may be able to advise about available resources, chances for successful resolution, and other legal matters to consider.

For simple payment-due problems a general practitioner or collection lawyer can be engaged whose efforts would be similar to that of a collection agency. The psychological effect of receiving a lawyer's letter or call often produces quick resolutions or conclusions to disputes.

If the dispute involves the artist's legal rights in and economic control over the artwork, a lawyer specializing in art matters should be selected. It is important that the lawyer be familiar with applicable copyright laws and trade practices, as well as the business aspects of the artist's profession. In addition, an attorney's expertise in a specific area should be verified through direct questioning and checking references; e.g., don't use an attorney who has no trial or litigation experience to advance your lawsuit, no matter how great he or she may be at negotiating contracts.

When a dispute must be cleared up before payment can be made, engaging a lawyer to negotiate with the buyer might be helpful. The lawyer may be able to take a more forceful role on the artist's behalf and may bring about a fairer and quicker settlement. A lawyer's presence and negotiation skills may also result in avoiding a lawsuit. When the problem is resolved, and if it proves advisable, a lawyer can provide a written agreement to bring complex issues to a final and binding close.

The Guild offers its members access to a Legal Referral Service. Members who need a lawyer's services should contact their local Chapters for the names of attorneys with expertise in a particular area. Attorneys participating in the Legal Referral Service often will offer reduced rates to Guild members, although any fees and expenses are negotiated directly between the member and the attorney and are the sole responsibility of the member. Contact the Guild's National Office for more information.

Lawyer's fees and structures vary. Some charge a flat fee, some a percentage of the monies recovered. Initial one-time consultation fees are often lower. Artists should discuss fees with the attorney before requesting and/or accepting their advice or assistance. Artists with limited incomes may be able to take advantage of volunteer arts-lawyer groups for collection and other legal needs. Most Volunteer Lawyers for the Arts organizations place limitations on income for eligibility for assistance. Please check with the appropriate office.

Some of these groups around the country are:

CALIFORNIA

California Lawyers for the Arts
(Los Angeles area)
1549 11th Street, Ste. 200
Santa Monica, CA 90401
310.395.8893

California Lawyers for the Arts
(San Francisco area)
Fort Mason Center
Building C, Room 255
San Francisco, CA 94123
415.775.7200

California Lawyers for the Arts
247 4th Street, Ste. 110
Oakland, CA 94607
510.444.6351

San Diego Lawyers for the Arts
1205 Prospect Street, Ste. 400
La Jolla, CA 92037
619.454.9696

COLORADO

Colorado Lawyers for the Arts
200 Grant Street, Ste. 303E
Denver, CO 80203
303.722.7994

CONNECTICUT

Connecticut Volunteer Lawyers for the Arts
Connecticut Commission on the Arts
227 Lawrence Street
Hartford, CT 06106
203.566.4770

DISTRICT OF COLUMBIA

District of Columbia Lawyers Committee for
the Arts
918 Sixteenth Street, N.W., Ste. 400
Washington, DC 20006
202.429.0229

Washington Area Lawyers for the Arts
1325 G Street, N.W., Lower Level
Washington, DC 20005
202.383.2826

FLORIDA

Volunteer Lawyers for the Arts/Broward
ArtServe, Inc.
5900 North Andrews Avenue, Ste. 907
Fort Lauderdale, FL 33309

Business Volunteers for the Arts
Museum Tower
150 West Flagler Street, Ste. 2500
Miami, FL 33130
305.789.3590

GEORGIA

Georgia Volunteer Lawyers for the Arts
141 Pryor Street #2030
Atlanta, GA 30303
404.525.6046

ILLINOIS

Lawyers for the Creative Arts
213 West Institute Place, Ste. 411
Chicago, IL 60610
312.944.ARTS (2787)

KANSAS

Kansas Register of Lawyers for the Arts
c/o Susan J. Whitfield-Lundgren
202 South Second Street
P.O. Box 48
Lindsborg, KS 67456
316.686.1133
913.227.3575

KENTUCKY

Fund for the Arts
623 West Main Street
Louisville, KY 40202
502.582.0100

Lexington Arts & Cultural Council
ArtsPlace
161 North Mill Street
Lexington, KY 40507
606.255.2951

LOUISIANA

Louisiana Volunteer Lawyers for the Arts
c/o Arts Council of New Orleans
821 Gravier Street, Ste. 600
New Orleans, LA 70112
504.523.1465

MAINE

Maine Volunteer Lawyers for the Arts
Maine Arts Commission
55 Capitol Street
State House Station 25
Augusta, ME 04333
207.289.2724

MARYLAND

Maryland Lawyers for the Arts
218 West Saratoga Street
Baltimore, MD 21201
410.752.1633

MASSACHUSETTS

Volunteer Lawyers for the Arts of
Massachusetts
P.O. Box 8784
Boston, MA 02114
617.523.1764

The Arts Extension Service
Division of Continuing Education
University of Massachusetts
Amherst, MA 01003
413.545.2360

Resources and Counseling for the Arts
429 Landmark Center
75 West 5th Street
St. Paul, MN 55102
612.292.3206

St. Louis Volunteer Lawyers and
 Accountants for the Arts
3540 Washington, 2nd Floor
St. Louis, MO 63103
314.652.2410

Kansas City Attorneys for the Arts
Gage & Tucker (Rosalee M. McNamara)
2345 Grand Avenue
Kansas City, MO 64141
816.474.6460

Montana Volunteer Lawyers for the Arts
c/o Joan Jonkel, Esq.
P.O. Box 8687
Missoula, MT 59807
406.721.1835

Volunteer Lawyers for the Arts Program
Albany/Schenectady League of Arts
19 Clinton Avenue
Albany, NY 12207-2221
518.449.5380

Arts Council in Buffalo and Erie County
700 Main Street
Buffalo, NY 14202
716.856.7520

Huntington Arts Council, Inc.
213 Main Street
Huntington, NY 11743
516.271.8423

Volunteer Lawyers for the Arts
1 East 53rd Street, 6th Floor
New York, NY 10022
212.319.ARTS (2787)

North Carolina Volunteer Lawyers for the Arts
P.O. Box 831
Raleigh, NC 27601
919.755.2100

Volunteer Lawyers and
 Accountants for the Arts
c/o Cleveland Bar Association
113 St. Clair Avenue
Cleveland, OH 44114-1253
216.696.3525

Toledo Volunteer Lawyers for the Arts
608 Madison Avenue, Ste. 1523
Toledo, OH 43604
419.255.3344

Oklahoma Accountants and
 Lawyers for the Arts
3000 Pershing Boulevard
Oklahoma City, OK 73107
405.948.6400

Northwest Lawyers and Artists
330 Pacific Building
520 Yamhill
Portland, OR 97204
503.224.1901
503.224.5430

Philadelphia Volunteer Lawyers for the Arts
251 South 18th Street
Philadelphia, PA 19103
215.545.3385

Voluntarios par las Arts
Condumo El Monte
Norte Apt. 518A
Hato Rey, Puerto Rico 00919
809.758.3986

Ocean State Lawyers for the Arts
P.O. Box 19
Saunderstown, RI 02874
401.789.5686

South Carolina Lawyers for the Arts
P.O. Box 8672
Greenville, SC 29604
803.232.3874

South Dakota Arts Council
108 West 11th Street
Sioux Falls, SD 57102-0788
605.339.6646

Tennessee Arts Commission
320 Sixth Avenue N.
Nashville, TN 37219
615.741.1701

Austin Lawyers and Accountants for the Arts
P.O Box 2577
Austin, TX 78768
512.338.4458
FAX.346.1161

Texas Accountants and Lawyers for the Arts
(TALA)
2917 Swiss Avenue
Dallas, TX 75204
214.821.1818
FAX.821.9103

TALA - El Paso
Business Committee for the Arts/
 Chamber of Commerce
#10 Civic Center Plaza
El Paso, TX 79901
915.534.0500

TALA - Houston
1540 Sul Ross
Houston, TX 77006
713.526.4876
FAX.526.1299

TALA - San Antonio
City of San Antonio
Arts & Cultural Affairs Department
P.O. Box 839966
San Antonio, TX 78283-3966
210.222.2787

Utah Lawyers for the Arts
50 South Main Street, Ste. 1600
Salt Lake City, UT 84144
801.482.5373

Suing in civil court

Suing in civil court or federal district court is not normally necessary to resolve a payment or other dispute. Court only should be considered as a last resort when all other options for resolving the problem have been exhausted. If you bring out the big guns of a lawsuit at the beginning of a dispute, you can't fall back to a less drastic position, but if you've pursued every other alternative without any progress, the only remaining choice is all-out war, with an attorney's help.

Monetary claims in excess of the small claims court limit must be brought to civil court. Violation of copyright laws can only be resolved in federal court. Current law requires that a work's copyright be registered with the U.S. Copyright Office before a federal case for copyright infringement can be initiated. Other nonmonetary issues, such as suing for the return of original artwork or other contractual breaches, must also be taken to formal civil court.

The artist does not necessarily have to hire a lawyer in order to sue. The law allows a person to appear as his or her own lawyer; in disputes where the issue is clear, artists usually will not be prejudiced by representing themselves. In disputes that do not involve large sums of money, a lawyer may be hired just to advise the artist on how to prepare the case, rather than for formal representation, keeping legal costs down.

Of course, when a great deal of money or complex legal issues are involved, it is prudent to hire a lawyer. In that case, the fee structure and expenses should be discussed with the lawyer at the outset. Generally, an attorney will either bill their time by the hour or work for a contingency fee. Attorneys who will accept a contingency (generally one third of an award or judgment, plus expenses) feel confident that the case has a good chance of winning and are willing to risk their time to pursue it. If an attorney will accept a case only by billing time, it may be a signal for you to reevaluate your chances of winning the case or how much you can realistically expect to recover.

Part V: Reuse and Other Markets

Maximizing the income potential of artwork enables artists to sustain and improve their business as well as provide buyers with new options for resolving their art needs. While reuse—the sale of additional rights to existing artwork—has long been standard practice, artists should be aware that this market has boomed in recent years, while licensing and merchandising markets for new artwork also have grown. The following section details reuse opportunities and traditional practices and describes several licensing and merchandising possibilities. The Graphic Artists Guild invites readers to submit information on new and unusual opportunities for consideration in future editions of the *Guidelines*.

Reuse

Reuse is an opportunity available to all illustrators and an important area of income for many. In it the artist, authorized agent, or copyright holder sells the right to reproduce artwork originally commissioned for one specified use for a new or additional use. By trade custom, the term "stock art" in general illustration markets means copyrighted artwork for which the user negotiates a "pay-per-use" license, or use fee. Stock art technically includes typographic alphabets, usually prepared in digital form and licensed to buyers by type houses, and typographic dingbats, usually sold as clip art.

The selling of reuse rights represents a logical step in recognizing the extended value of artwork through its copyright. Over the lifetime of the artist plus 50 years, control of a work's copyright and uses can generate a lot more income for an illustrator than the original rights grant.

One source recently showed that advertising and corporate sales of mostly photo stock account for 65 percent of the total of the use of stock art. Textbook, trade, and education publishing account for 15 percent, with magazines and newspapers taking another 15 percent. The growing market for reuse, however, fuels debate about whether stock illustration sales reduce new commissions or harm artists by overexposing or undercontrolling the appearances of an illustration. Commissioned illustration and stock sales may be complementary rather than competing markets, at least in part.

This debate is heightened as well by improvements and growth in technology. The means of cataloging and presenting stock art have improved dramatically, thanks to extraordinary advances in computers, CD-ROMs, and the Internet. Computer technology has made more compact storage possible, as well as: reduced risk; quicker searches, retrievals, and presentations; and accelerated transmission/delivery and digital delivery to plate-making or multimedia end products.

Reuse is also called "second rights" (although it actually may be the third, fourth, or fifteenth time the rights have been sold). In publishing, they are called "subsidiary rights" and are grants of additional usage connected with the project it originally was commissioned for, usually a book; i.e., a chapter may be sold to a magazine in anticipation of publication. In merchandising, where existing art may sell for many different uses to many different clients, grants of usage rights are called "licensing."

A reuse may be sought by the original client to expand the original project or for a new campaign. Or a prospective buyer may desire to use art seen in a directory, stock catalog (an inventory of existing images available for use), or other promotional materials (see section following for full discussion of stock agencies). Some buyers may even have planned a proposed project around a particular image; however, if the desired image is not available, the buyer must be flexible enough to redesign the project using one that is, or commission original work to meet the project's needs.

Sometimes artists themselves envision and market a reuse; for example, an artist may suggest using an existing image for a greeting card or calendar or an editorial insert.

The aesthetic is different when using existing artwork rather than commissioned illustration; the art buyer knows exactly what he or she is getting. The client's risk of being unpleasantly surprised is eliminated. On the other hand, an element of creativity is eliminated also—the tradition and excitement of a creative collaboration between art director and illustrator and the thrill of receiving a superlative new illustration.

The economic climate and the growth in uses of illustration are creating new niches for existing artwork. It is up to the artist to seek them out to better fulfill the artwork's potential value. Artists interested in reselling rights make individual marketing decisions about the best avenues for their inventory of images. Some images might be best marketed personal-

ly, some by a stock agency, and others through a representative.

Who should handle reuse sales?

Stock agencies, representatives, and artists each occasionally have claimed that they know the market best and can negotiate the most appropriate reuse fees.

Artists selling reuse: Many artists handle reuse sales personally. This affords them the opportunity to determine firsthand the client's needs and to custom-tailor the agreement, fee, and quality of the artwork's reproduction. The artist will know the terms of each sale and can arrange to receive tear sheets to monitor the work's appearance.

Some artists feel they are best qualified to negotiate reuse fees because of their knowledge of their work relative to the field, their reputation, or their comfort with negotiating. Artists know their own body of work and may come up with more options or an image better suited to the client's needs while establishing a relationship that might result in future assignments.

Artists who maintain careful records may be able to sell reuse rights to images that can't go through a stock agency, which often requires images with completely or widely available rights. When a potential client contacts an artist with a possible commission but an insufficient budget, the artist can suggest reuse of an existing image that conveys a similar message. If necessary, artists may negotiate back desired reuse rights from a client.

To sell reuse rights personally artists must: maintain accurate records; make duplicate transparencies; handle contracts, invoices, and shipping; monitor sales to prevent conflicts and unauthorized use; and do all the other usual overhead of the illustration business. Some illustrators find it useful to organize a card file corresponding to their slides or transparencies, noting on the card the original and second usages and any limitations on reuse so that they can respond quickly to requests.

To maximize stock illustration sales, some artists feature their available images in targeted promotions. These include: creating their own catalogs of existing work displayed digitally or in print in nonreproducible blue or another format that protects against unauthorized use; and collaborating on a joint promotion of available works.

On the one hand, artists managing their own images for reuse have most of the usual work connected with an illustration assignment without the excitement of creating a new image to solve a client's problem. On the other hand, a little paperwork can produce welcome additional income from an inventory of existing images.

Representatives selling reuse: Artists' representatives may sell reuse rights on behalf of artists as part of their normal artist-agent agreement. Representatives typically handle these rights on the same basis as newly commissioned work; recent survey data indicate that the artist usually receives 75 percent of the fee and the representative the remaining 25 percent. In other usual terms of such agreements, artists share promotion costs with the representative in the same proportion, paying 75 percent of advertising pages, mailing lists, and other agreed-on costs. Artists usually retain the right to refuse a sale, and usually receive tear sheets of the final printed piece.

Though this type of contract historically has been standard for commissioned artwork, representatives may seek to handle reuse differently from commissioned art. For example, while the usual artist-agent split of 75-25 percent is a clear advantage to the artist over the 50-50 percent split of usual stock agency agreements, representatives may seek to change the percentage split to match those common in stock agreements when they modify their businesses to more closely resemble stock agency marketing. Artists are free, however, to negotiate more favorable terms. Other relevant contract terms are discussed later in this section.

Many representatives prefer to handle reuse sales of images originally commissioned through their efforts or appearing on promotion materials carrying their name rather than have the artist or a third party such as a stock house manage them. Having negotiated one-time or limited rights in the initial agreement, they often feel they deserve the opportunity to market the rights that were reserved to the artist through their efforts. Artist-agent contracts should specify whether the representative will handle such sales and, if so, whether that is an exclusive arrangement. Artists and representatives whose relationship predates the rise of the reuse market can attach a letter of agreement to their contract detailing these new arrangements.

Artists' representatives, who have long-standing relationships with their artists and handled the initial agreement with the client, are well positioned to market reuses that both protect the artist's reputation and avoid stepping on the original client's toes. Representatives offer the ability to negotiate reuse fees,

custom-tailor reuse agreements to the clients' needs, and monitor compliance with purchase agreements.

Some representatives are beginning to handle reuses of images that did not originate with them. Among the marketing techniques employed by some representatives are: establishing a special stock division on terms similar to those at stock agencies; developing special promotions of images judged particularly marketable.

It may take a different kind of marketing to achieve successful, sustained reuse sales; clients are not necessarily the same as for commissioned work. Artists' representatives will make individual business decisions about whether it is in their interest and ability to pursue stock illustration sales.

A number of representatives are now planning or implementing more aggressive marketing and distribution of images for stock sales. The degree to which they so change their businesses or diverge from the business of soliciting commissioned work may influence future directions of artist-agent agreements governing reuse sales, commissions, and other terms.

Stock houses: In the stock illustration market, agencies, or stock houses, may acquire the rights to sell reuses of work by a number of artists. Stock illustration was pioneered by agencies that were already established as sources for stock photography; in recent years several illustration-only agencies have been founded. New international agencies have been started to handle stock art; an estimate of the worldwide stock art market, predominately for photography, is $200 million per year. Stock illustration sales may, as has happened with stock photography, reduce demand for originally commissioned work.

The images are marketed to prospective buyers through catalogs, directories, direct mail, CD-ROMs, the Internet and World Wide Web, and other promotions. The artist grants the agency the right, usually exclusive (although in some cases this is negotiable), to resell selected images from the artist's existing work to specified markets for a certain length of time (usually up to five years, or for the shelf life of the promotional vehicle in which the work appears) for a fee set by the agency. Artists can number and describe which images are being submitted under a contract in an attached letter.

A rollover contract is not uncommon, in which the artists must notify the agency within 30 days of the five years' completion to end the agreement. If such notification is not received, the contract is renewed for another five years automatically. Stock agencies interviewed stated that, in actual cases, they would not hold artists to this stringent requirement; nonetheless, rollover contracts put the burden on the artist and make renegotiation more difficult. Computer tracking should allow agencies to notify artists of an upcoming contract termination.

Some artists initially list a small selection of images with an agency and, if sales are encouraging, add images. It should be made clear in writing whether the older contract governs the new pieces (for example, in an addendum to the contract listing those pieces) or whether they will be covered by a new agreement.

The stock agency and the illustrator usually split the proceeds of whatever rights the agency sells. Interviews with major illustration stock houses indicate that the usual agency/artist splits are 50 percent each for sales inside the United States and 40-30-30 for foreign sales, with 40 percent withheld by the foreign agency.

In most contracts the artist bears the full cost of providing reproduction-quality transparencies (usually 4" x 5") of the selected images, a share of the cost of the agency's initial catalog featuring the images, and half the cost of scans and/or slide duplication and any agreed-on additional promotions featuring the artist's images. Most stock agency contracts reviewed do not specify or limit the amount of advance promotional costs or limit the number of duplicate slides that may be required. Many photographers have found that the cost of these unchecked expenses can reduce significantly the value of a stock arrangement. The artist's share of costs often is deducted from future earnings, usually with a limit of 25 percent of earnings deductible each payment period. The agency bears more of the up-front financial risk as part of its overhead.

Stock agencies usually quote reuse prices by referring to in-house charts that rely upon such factors as market, reproduction size, print run, and quantity as benchmarks, but they are still negotiable. A large sale of many images may result in a low price per image, with the profit to the agency derived from search fees charged to the client for each hour the agency's staff searches their libraries.

Artists may find the fees for use negotiated by stock agencies are significantly lower than they would negotiate for themselves. Artists

should review as agencies inform artists of sales periodically, usually quarterly or monthly, by sending out a check with a memo announcing the sale and the client's name, and sometimes the media (or medium) in which it appeared, but not the terms of the reuse. Many artists feel this information is important in order to calculate accurately the income generated from each reuse. Although some agencies request tear sheets, they do not guarantee samples to artists.

Artists under contract to a stock agency do not have the right to refuse a sale, except by indicating in the contract any off-limit markets such as pornography or cigarette advertising. Some agencies, however, occasionally contact artists at their discretion to discuss a proposed sale.

Some stock agencies grant clients the right to alter, tint, crop, or otherwise manipulate images; others do not. This information is contained in the agency's delivery memo, which states standard terms on which the client is buying the rights, but usually is not addressed in the artist-agency contract. Very few agencies discuss intended alterations with the artist or arrange to have the client contact the artist to discuss changes.

When a client commissions new work from an artist through a stock agency, and if the agency acts as agent and negotiates the fee with the client, the agency usually takes a 25 to 30 percent commission. However, when new work is commissioned through a stock agency from an illustrator who has a representative, the agency allows the representative to negotiate the price, taking a smaller, usually 10 percent, finder's fee, or has the buyer contact the representative directly.

Some unrepresented illustrators do not wish to have the stock agency represent them for commissioned work. Illustrators have negotiated artist-agency contracts in which the artist handles the fee and contract negotiations directly with the client and pays the agency a 10 percent finder's fee for attracting new work rather than a full rep's commission. Some agencies do not request a finder's fee for commission referrals.

Occasional errors or abuses have occurred in agencies' reporting of fees received. These would be minimized if artists received a copy of the agency-client delivery memo or invoice with regularly reported sales and income, allowing them to verify prices and terms of sales. Assuring that artists see the terms of sale and a sample of the published result also would aid monitoring of the client's compliance with the delivery memo. Similar agreements where parties share risk often include the right to an audit of the agency's books by a certified public accountant.

There are a number of questions that artists may consider asking when discussing a relationship with a stock house. Among these are: What markets are the house strongest in? What portion of their sales are below (name minimum fee level)? How many artists are they working with? What are the names of artists they represent who would be willing to provide references?

Among the arguments made in favor of marketing illustrations through a stock agency are: artists can maximize the potential for income from a lifetime of work, even leaving such revenues to their heirs; some agencies have established themselves for their abilities to get their images before buyers; agencies offer the chance of generating high-volume reuse sales for little additional work; stock agency sales may help introduce an artist's work to new clients or new markets; artists have more time to create while the agency does the selling; artist can pick the images to be licensed to an agency while retaining others to market personally; the burden of keeping up with new technology and markets is left to the agency. In short, the stock agency offers the possibility of additional sales for less work.

Among the arguments against selling reuses through stock agencies are that the artist: does not determine or negotiate the fee for a sale; pays a higher commission of 50 percent or more of each sale; yields control over the integrity of the art or where it appears. In addition, many stock houses now are large corporations that are often impersonal and seek control and rights to art that may not be in the artist's best interest; the increased use of stock may negatively affect the market for originally commissioned works.

While stock illustration evolved from stock photography, the significant differences in how artwork and photography are created affect each genre's opportunities in the stock market. Photographers create many images in the course of doing business; illustrators create fewer images over their lifetime. This corresponds to fewer potentially income-producing copyrights. But the increase in stock illustration agencies argues that the market exists. If demand grows the market hopefully will provide illustrators with more, and more lucrative, sources of income.

For clients, stock agencies present a range of advantages and disadvantages. They provide complete, available images that can be delivered immediately with assured results; the art director saves time negotiating directly with the agency, rather than with the client, the designer, and the artist; high-resolution digital files are economically separated for print; digital catalogs put a large number of images on the art director's computer without the liability for loss of original artwork; stock may serve as an introduction to an artist's work that leads to additional stock sales or commissioned assignments.

On the other hand, clients miss the chance to discover the artist's skills as a problem-solver and creative collaborator; searching through large numbers of files is time-consuming, and the cost of the designer's time plus the use fee may exceed the price of custom art; scans vary in quality, so there may be static or blur.

Clip art

Grants of reuse rights or stock illustration is not the same as "clip art." Clip art is an image that, once acquired, generally implies a grant of license for any use, depending on the terms of the license agreement accompanying the artwork. It can be artwork that is in the public domain or camera- or computer-ready art to which all rights have been sold by the artist with the understanding that such art will be used as often as desired, altered, cropped, retouched, and so on. Clip art is available to the public in books and on CD-ROM. Some distributors of clip art pay the artist creating a collection of images a royalty on sales, as well as give name credit.

Clip art may compete with commissioned art and with sources of stock illustration. As digital imaging capability grows more sophisticated, designers can create new artwork solely by combining and altering clip art pictures, although it may not be cost-effective to do so when one weighs the designer's investment of time and effort against the cost of outside | commissioned illustration. On the other hand, the low cost and accessibility of clip art has created new users, such as small corporate departments or individual business people who might otherwise not use any graphic elements and may later be inclined to commission new work.

Rights-free art on CD-ROMs

The new technologies are bringing many new opportunities for graphic artists; one controversial new idea is the compilation of an artist's entire inventory, rights-free, on CD-ROM disks; that is, an electronic form of clip art. The proposals usually offer artists royalties on sales of the original disks but not on additional uses; the rights usually are sold outright. The purchasers then get to use the work in any way they choose, including manipulating, combining, or otherwise changing the original, or placement on products, in ads, or as characters in feature films. The artist usually is not paid for the additional uses.

The proposal presents the opportunity to sell a large number of images at one time for an up-front fee, and to receive payments on sales of the CDs, if not for the reuse. Some illustrators and others, however, fear that the release of many rights-free images at low fees will flood the market with low-priced images, discouraging art buyers from purchasing original work at more desirable rates. Please turn to the New Technology Issues chapter for a more detailed discussion of this practice.

Rights-free art on CD also creates new options for graphic designers, who find new opportunities in the availability of many rights-free illustrations on disk and new technological means of manipulating them. However, they do lose the experience of working with a knowledgeable and creative illustrator to generate new and exciting artwork custom-made for their specific needs.

Well-known illustrator Seymour Chwast released a complete inventory of his work, restricting some areas of high-revenue use. At press time, he reported that the release of his CD-ROM package a year prior had not limited the amount of new work he had been offered. Each disk carries a label telling the user that rights to corporate or brand identities, logos, trademarks, or symbols, or on merchandise to be sold, such as greeting cards or clothing, must be negotiated separately. He had not, however, established a system to seek out or monitor illegal uses.

The Graphic Artists Guild and other unions and trade organizations concerned with artists' reprographic rights are exploring means by which such uses can be monitored and assessed.

On-line development

Reuse and sales of illustration on the Internet and World Wide Web are, at the time of this writing, still developing, though given the speed with which the technology has grown over the last few years, that may change again soon. One company, for example, Picture

Network International (PNI), now offers 450,000 watermarked images: 350,000 from several dozen photo houses, and 12,000 clip art images, plus illustrations and fonts. It uses technology that enables the buyer to find an image by describing it in plain language, rather than guessing at key words. The service is free until an image is chosen.

Please turn to the Multimedia Prices and Trade Practices chapter for further information.

Trade practices and contracts

The artist or agent must be clear about which reproduction rights were transferred to a previous buyer and which are retained by the artist. It is of course illegal to sell a usage that breaches an existing contract on exclusivity of market, time frame, geographic region, etc. It is also customary that an artist or agent will not sell a use that competes with another use of the artwork, though definitions of competing use can be hard to pin down. In general, a reuse should not be in the same market and time frame, or for a competing client or product.

Reuse agreements and contracts covering stock illustration sales through artists' representatives or agencies should be discussed carefully and understood fully by both parties. Artists considering prewritten contracts should remember that many points are negotiable, and they may wish to consult a lawyer and other artists before signing a contract. Graphic Artists Guild members have artist-to-artist hotlines and legal referral networks available that provide these services; see the Graphic Artists Guild chapter for further information.

Artists considering signing on with a stock illustration agency or representative might want to request a copy of the agency's standard delivery memo or invoice, which states the standard terms on which a client buys the rights. Information such as whether tear sheets will be provided or alteration permitted currently are found in this agency-client agreement rather than in the artist-agent contract.

Paperwork relating to an image should be reviewed carefully if there is any doubt as to rights previously sold. Contracts for reuse rights, whether drawn up by artists, their representatives, or stock agencies, should state clearly what usage is being granted and the intended market, the size of the reproduction, the print run, the length of the agreement, and so on. Other negotiating points might include reasonable payment schedules, alteration policies, access to accounting records, receipt of copies of delivery memos, and tear sheets.

Please see the Standard Contracts and Business Tools chapter for more information on artist-agent agreements.

Unauthorized reuse

Unauthorized reuse is the reproduction of an image without the artist's or copyright holder's permission. It constitutes a copyright infringement, and the infringer may be liable for attorney's fees and statutory damages if pursued in court. The same may be true of unauthorized alteration of an artist's image. (Please see the Legal Rights and Issues and New Technology Issues chapters for more information.)

An art user who wishes to "pick up" an image from an already published source should contact the artist to arrange for permission and payment of the appropriate usage fee. Failure to reach the artist may not be a sufficient excuse for unauthorized use of an image; legal due diligence (an earnest, concerted effort to obtain the necessary information) must be demonstrated.

Stories of artists' portfolio work being used for client presentation without permission have been growing for several years. New technologies have made it easier for the ignorant and the unscrupulous to produce "ripamatics" and include them in presentations—and artists are rarely if ever consulted, much less compensated.

In 1995, one photographer's representative received a five-figure settlement from a major advertising agency when the artist's portfolio was returned with the transparencies torn from the expensive matting. The agency had had the images duplicated even though the rep had denied it permission to do so. The issue surfaced again in *Direct* magazine, which reported that an artist was suing after an agency allegedly had an illustration re-created by another illustrator with only slight changes for a large direct mail campaign for a major client—and no payment to the original artist. The case revived debate among artists' groups, agents, reps, and directory publishers about how to stem this abuse.

In addition to the obvious issues of infringement, illegal comping directly affects the work of preproduction artists whose livelihoods depend upon assignments to create comps, storyboards, and animatics. As the practice of illegal comping grows, these artists are finding it harder to secure work. The Graphic Artists Guild has brought together more than a dozen professional organizations in an education campaign to inform the industry about the harmful aspects of these prac-

tices. For more information on the "Ask First" campaign, please turn to the Graphic Artists Guild chapter.

Some artists distributing their work via digital catalogs are using electronic watermarks to protect their copyrights. Watermarking clearly indicates ownership for protected art, as opposed to the rights-free clip art and is available as software.

An artist or authorized representative or stock agent who notices an unauthorized reuse usually will contact the infringer and request an appropriate additional fee. Other remedies include legal action, which can include receiving damages and court fees from the user.

Artists and buyers both should be careful to specify in writing rights bought or sold, including whether the client has permission to scan or alter the art electronically. While vigilance and follow-through are important, a well-written agreement is currently the best overall protection for all parties' rights.

Factors to consider in pricing reuse

Reuse pricing is every bit as complex as pricing for original commissioned art. No usual percentage of an original commissioned fee that is common to all markets has been found, according to current surveys. Some markets, such as greeting cards, corporate advertising, and textbooks, have been found to pay 50 to 100 percent of an original commissioned rate for reuse. Others, such as editorial, usually pay a percentage of the usual commissioned rate. And though resale rights usually are sold at less than the rate of commissioned work, in most cases artists can expect to receive from 20 to 75 percent of the fee that they would have charged if the work were commissioned for that use originally, with the vast majority receiving between 45 and 55 percent. Size of reuse image, often smaller than the original art, may also be a factor in pricing.

Licensing and merchandising

The licensing industry, which has grown from $15 billion in North American retail sales in 1980 to $69.93 billion in 1995, presents tremendous opportunities for graphic artists from all disciplines to generate revenue in new markets. Considering that the average royalty for all categories is about 7 percent, licensors (those granting the rights to use a work in a specific way, for a specific time, over a specific area) may real-

ize at least $4.9 billion in royalties.

Sales of licensed merchandise in 1996 is forecasted to increase from 5 to 6 percent over 1995, compared to a 2 to 3 percent rise over the previous year. Corporate trademark and brand-name licensing saw the greatest increase in 1995, with 8 percent over the previous year, perhaps due in part to the Olympics. Although entertainment/character licensing remained the leader in percentage of retail sales, driven by characters such as Power Rangers™, Dilbert™, Hercules™, and the movies *Jumanji* and *Toy Story*, it was down 6 percent from 1994.

Product categories and property types

Whether one works as an illustrator, graphic designer, cartoonist, surface designer, or marbler, there are many possible types of products graphic artists may use to exploit a particular work, including: accessories, apparel (T-shirts, team jackets, or any apparel items containing a designer label), domestics (e.g., shower curtains or bed linens), gifts/novelties (e.g., mugs, pennants, or lunch boxes), publishing (e.g., calendars or postcards), stationery/paper products (e.g., greeting cards or giftwrap), toys/games, video games/software, food/beverage (e.g., boxed candy or beverage bottles), and health/beauty (e.g., exercise equipment or designer fragrances).

Artists who create a specific work or design may also target a particular property type to exploit, including: art (e.g., posters, figurines, commemorative plates, and other limited-edition collectibles), entertainment/character, fashion (e.g., infant wear or handbags), and toys/games.

The accompanying charts, reprinted with the permission of *The Licensing Letter* (© 1996 EPM Communications, Inc.), quantify the growth of the licensing industry over the last two years. Understanding where specific areas of growth may be occurring can help artists chart a targeted marketing course.

Character licensing

Artists who have developed a character suitable for licensing may choose to exploit it into a vast number of items—each one representing a separate license. Character licensing, which accounted for $16 billion in sales in 1995, must meet special requirements before any products can be brought to market.

Before they can become viable as a merchandising vehicle, characters must have a well-developed identity and personality, which

1995 Shares Of All Licensed Product
Retail Sales, U.S. & Canada

By Property Type (Dollar Figures in Billions)

	1995 RETAIL SALES	1994 RETAIL SALES	PERCENTAGE CHANGE '94-'95	% ALL SALES (F95)
Art	$5.08	$4.88	4	7
Celebrities/estates	2.54	2.65	-4	4
Entertainment/characters	16.19	17.22	-6	23
Fashion	12.16	12.04	1	17
Music/video/video games	1.08	1.05	3	2
Nonprofit	0.69	0.68	2	1
Publishing	1.59	1.56	2	2
Sports	13.39	13.80	-3	19
Trademark/brand names	14.20	13.15	8	20
Toys/games	2.78	2.73	2	4
Other	0.22	0.26	0	0
Total	69.93	70.01	-0.1	

By Product Category

	1995 RETAIL SALES	1994 RETAIL SALES	PERCENTAGE CHANGE '94-'95	% ALL SALES (F95)
Accessories	$6.55	$6.82	-4	9
Apparel	11.03	11.37	-3	16
Domestics	4.63	4.45	4	7
Electronics	1.18	1.11	6	2
Food/beverages	5.78	5.45	6	8
Footware	2.15	2.11	2	3
Furniture/home furnishings	0.83	0.78	6	1
Gifts/novelties	6.74	6.54	3	10
Health/beauty aids	4.12	3.92	5	6
Housewares	2.40	2.33	3	3
Infant products	2.38	2.33	2	3
Music/video	1.30	1.24	5	2
Publishing	4.35	4.53	-4	6
Sporting goods	2.46	2.39	3	4
Stationery	3.36	3.26	3	5
Toys/games	7.46	7.77	-4	11
Video games/software	3.13	3.23	-3	4
Other	0.10	0.39	-74	0
Total	69.93	70.01	-0.1	

Note: Figures may not add up exactly due to rounding.

involves creating an entire physical and social environment. This information usually is presented in a manuscript that is used by potential licensees to evaluate the potential success of a project. It is accompanied, of course, by a number of sketches of the character.

Once a publisher or licensee has indicated an interest, a "style and size guide" needs to be prepared to ensure that the visual integrity is maintained in both two and three dimensions; this involves depicting the character from every possible pose, posture, and angle. It is not unusual to contract with a specialist in this area.

Collectibles

Nearly every form of graphic design and illustration can be transformed into a "collectible," theme objects that buyers develop a special fondness for and seek out for purchase. Popular subjects include Americana, folk, animals, flowers, sporting scenes, nostalgia, and children. Artists have developed production techniques that allow them to reproduce a panorama of artistic styles, media, and subjects for these markets. Licensing agreements normally are negotiated for an entire line, collection, or group of products for a particular market.

This industry is significant and offers many licensing opportunities for the creative consultant (an artist who advises but does not contribute artwork to a project), artist, or designer. Fees and royalty rates vary depending upon the company and the marketing of the products—typically artists negotiate an advance against royalties.

Products popularly sought by collectors include dolls, plates, mini collections, steins, ornaments, pewter figurines, crystal, porcelain figurines, bronze sculpture, cold-cast resin products, music boxes, snow globes, wildlife sculpture, commemorative medallions, and functional decor.

Collectibles are sold either through retail outlets or direct mail. Many manufacturers and retailers have developed specialized markets for avid collectors; collectors clubs are popular and are established either by companies or collectors. Large companies such as Enesco, Disney, Lladro, and Hummel offer their products through retail outlets and also produce "membership only" limited editions.

In the 1970s and 1980s, direct marketing changed the direction of the collectible industry. Now a "house list" is compiled of buyers with an interest in specific themes, and once a series is started and the "first issue" is a success, buyers are solicited with brochures and advertisements in selected magazines. A collectible series is then developed, and each subsequent "issue" is offered to the house list. It can be a limited-edition series or open-ended and may develop into 30 to 40 issues. Predetermined mini collections are sold as well, composed of several items on a theme. Collectors often pay in monthly installments and keep payments low.

Determining markets

The industry depends on the expertise of a market team to determine public interest in a given item or subject. Current popular items include angels, teddy bears, Native Americana, nostalgia, lighthouses, cottages, folk art, children, wildlife, and Christmas-specific items such as Santas, ornaments, and Nativities. Licensed collectibles related to a movie or personality are perennial bestsellers, as are images of birds, cats, bears, flowers, and well-known products such as Coca-Cola® and Star Trek®. The coming millennium is projected to be a popular subject.

Production

Once a concept is finalized, an art director will hire an artist who demonstrates a particular style or ability to portray the character or feeling of the projected piece. Work is often obtained by word of mouth between artists who already specialize in product and collectible design. Companies are, however, looking for fresh ideas in already successful product categories and current trends that have detail, style, emotional appeal, humor, and character.

Understanding the product form is essential in this field, as the limitations of the product medium, materials, and final manufacturing costs directly affect design. The artist's resourcefulness in combining any limitations with creative design is often the key to a successfully marketed collectible; e.g., to design porcelain figurines considering the porcelain's brittle nature and undercuts, which may cause problems with making the mold, must be considered. These factors, as well as the fact that they often require multiple firings, make porcelains more expensive, while cold-cast resin products are less costly.

Payment

Historically, artists and clients have found that a good way to determine a fair price in relation

to use is through a royalty arrangement, which in this market has been a percentage of total sales paid to the designer based on the wholesale price of a product. In practice, virtually all royalties historically have ranged between 2 and 10 percent of the wholesale price and currently hover around 5 percent, with some as low as a fraction of a percent on high-volume items. Royalty arrangements also have included a nonrefundable advance reflecting a guarantee of coverage for expenses, and often to be equal to the cost of the artwork if it were sold outright. Creative fees are dependent largely on the size of company; the complexity of the design; the number of images; the audience, etc.

Exclusivity and competition clauses

Some collectibles contracts have included exclusivity clauses, which grant the company exclusive use of the artist's name and image to promote the artist and their product series. Artists should be advised that this form of contract carries risk: such a clause could prohibit the artist from working with any other direct-marketing companies in any capacity as a designer or consultant. This arrangement may raise questions about the artist's employment status; i.e., the designer may be considered a regular, if temporary, employee and may be entitled to other employee benefits. (Please see the Employment Issues section of the Professional Issues chapter.)

Some contracts contain a clause whereby the artist agrees not to permit any accepted design, or designs which are comparable in look or feel to the accepted design, to be used in connection with giftware products, whether competitive with the products or not, during the term of the agreement and for a period of one year thereafter. This can be an overbroad request for grant of rights and a successful negotiation will determine whether it is genuinely needed by the client; if so, the artist should determine appropriate compensation for this sale. Please see Part II, Negotiation, for further information.

Getting into the field

Artists interested in this field should study the types of work already commissioned by major manufacturers such as The Bradford Exchange, The Danbury Mint, The Franklin Mint, The Hamilton Collection, Lenox Collections, Enesco, Reco International, and Anheiser-Busch. Portfolios, photographs, or examples of work should be directed to the Concept or Product Development group. In-house work is a good way to get experience in the field and to become familiar with the specialized requirements for sculpting projects. However, in-house pay is often less than what a freelance sculptor receives.

Freelancing

Freelance work is available at all these companies and generally is paid on a flat fee. Most companies attempt to impose work-for-hire contracts and retain the rights to all sketches and artwork for their concept development. The Graphic Artists Guild is unalterably opposed to work-for-hire contracts; see the Legal Rights and Issues chapter for further information.

Representatives

Collectibles designers frequently use representatives or agents; a complete discussion of author-representative relationships is in the Professional Relationship chapter.

Industry information

A directory of major collectible manufacturers and artists working for them can be found in the Collectibles Market Guide & Price Index published by the Collectors' Information Bureau. The index includes over 45,000 of the most widely traded limited editions in today's collectibles market.

Trade practices

Historically, the following trade practices for collectibles design have been followed by the industry.

1. The intended use of commissioned or licensed work is generally stated clearly in a contract, purchase order, or letter of agreement stating the price and terms of sale. Uses, and terms for uses other than those initially specified, should be negotiated in advance when possible; see the section on reuse earlier in this chapter.

2. Fees should reflect such important factors as deadlines, job complexity, reputation and experience of a particular designer, research, technique or unique quality of expression, and extraordinary or extensive use of the finished art.

3. According to current and historical data, clients usually pay the artist a cancellation fee if the assignment is canceled for reasons beyond the artist's control. According to current data, the amount of

the fee varies considerably, ranging from 30 to 100 percent, depending upon the degree of the work's completion. A more detailed discussion on kill fees can be found in the Professional Issues chapter.

While the client usually obtains all of the originally agreed-upon rights to the use of the artwork upon payment of the cancellation fee, under a royalty arrangement, all rights to the artwork, as well as possession of the original art, generally revert to the artist upon cancellation.

If a job based on "documentary" work or other original art belonging to a client is canceled, payment of a time and/or labor charge has been a widely accepted industry custom.

4. Historically, artists have received additional payment when the client requests artwork changes that were not part of the original agreement.

5. Current data indicate that fees for rush work may increase the original fee by a median of 50 percent. As with all fees, the parties to the transactions must agree upon what they regard as a fair rush fee based upon their independent judgment and the specific circumstances of their arrangement, and the fee should be stated in the contract.

6. Expenses such as travel costs, consultation time, shipping and mailing charges, and other out-of-pocket expenses, should be billed to the client separately. Estimated expenses should be included in the original agreement or billed separately as they occur.

7. The terms of payment should be negotiated prior to the sale and these terms should be stated on the invoice.

8. Current practice indicates that the company normally will place copyright and/or trademark registration notices as stated in the artist's contract on all licensed products and promotional materials. The company may, at the artist's request and expense, register a copyright and trademark and/or service mark in the name of the artist. This protects the artist's licensing rights but does not give the artist any right, title, or interest in or to the product.

9. Original artwork is rarely returned to artists in this field. Should the artist wish to retain ownership of original artwork, this must negotiated and specifically stated in the contract.

10. Initial development costs pertaining to the design and production of the prototype usually are borne by the artist. The licensee bears all other costs of developing, marketing, and selling the products.

11. The company normally submits to the artist, without charge, one sample of each product for the artist's approval prior to manufacture. Some contracts provide that products are assumed approved unless the artist notifies the company in writing within 10 days of the receipt of the sample.

12. The company normally provides two production samples free of charge no later than 30 days from the first day the item is offered for sale at retail. No approval is requested or required for these production samples.

13. It may take up to 14 months for a piece to go from final approved stage to the stores. Contracts often address this time lag and warrant that the company will, during the time of the license, manufacture, sell, distribute, and promote the products. However, if the licensed product is not offered in the store within 24 months from receipt of the artwork, the client may agree to release the unused property back to the artist. If the product is not promoted, is dropped, or is overstocked, the artist may be asked to agree to release it for sale at a discount. Although royalties per sale paid to the artist would drop significantly, the artist will still receive the agreed-upon percentage for all sales.

14. Statements showing the gross and net sale price of each licensed product normally are provided no later than 30 days after the end of each fiscal quarter. Sales normally are based on units sold and shipped at the wholesale price less any trade discounts, credits, returns, and bad debt.

15. The company normally requires artists to warranty that all designs are their own and not done in collaboration with anyone else and not infringing upon any existing copyright, trademark, patent rights, or any similar rights of any third party.

16. If a contract is terminated after production, the company normally retains the right to sell any remaining inventory, but royalties are still applied to all sales and distributed to the artist.

17. Contracts often state specific delivery dates of preliminary and finished designs. Artists may be required to deliver preliminary designs two to four weeks before the

final design is due. After the finished designs are delivered, the artist should be notified promptly by the company whether or not the artwork has been accepted or rejected.

18. Often collectibles gain value from the name recognition of the artist who designed the product. Companies may contract to use the artist's name, photograph, likeness, signature, and/or biographical information in connection with the marketing and sale of the product(s). If such a request is made, the artist should stipulate that permission will be granted only with approval, per product, by the artist.

19. The company is liable for any loss or damage to the designs while they are in the company's possession or in transit between the artist and the company.

The price ranges following do not constitute specific prices for particular jobs. The buyer and seller are free to negotiate, with each artist independently deciding how to price his or her work and taking into account all the factors involved. Please refer to related material in other sections of this book.

Limited-edition prints

Lithography and serigraphy have made the collection of limited-edition prints, numbered and signed by the artist, within the reach of the average collector when original artwork may have sold for thousands of dollars.

Art for limited-edition prints may be created by artists independently or under contract with a gallery or publisher. Recent survey data show that payment is made on a commission or royalty basis, and an advance usually is included. Both the advance and the ultimate payment to the artist will vary depending on the size of the print run, the number of colors printed, and the selling price, among other factors. A typical arrangement of a limited-edition of prints is for an advance against 50 to 67 percent of gross sales revenues (i.e., the gallery's commission is 33 to 50 percent). If the publisher or gallery is responsible for all production costs (platemaking, etching, proofing, paper, ink, etc.) and advertising and promotion, artists traditionally receives less.

A typical edition ranges from 100 to 250 prints. Each print usually is numbered and signed by the artist. The agreement historically has guaranteed the artist a certain number of artist's proofs to use in any way he or she wishes. Artists should be aware that limited editions that number 200 or less are granted the special moral rights protections of the Visual Artists Rights Act; please see the Legal Rights and Issues chapter for more information.

Marketing can make or break a limited-edition venture. Market research should be done prior to entering into a binding agreement, making significant outlays of money, or investing time in creating the art. The market for limited-edition prints is regulated by law in a number of states, including New York, California, and Illinois. Extensive disclosures or disclaimers may have to accompany limited-edition prints sold in these states.

Trade practices for artists creating limited-edition prints follow the same protocols as those of greeting card, novelty, and retail goods illustration.

Licensees and agents

Artists who desire to merchandise their works may grant a license (permission) to an entity (the licensee), which then assumes the risks of manufacture, distribution, and sales. Artists may assume those considerable risks themselves, to increase the profit margin, but they generally do better by sticking to their artwork and leaving the manufacturing and distribution of finished products to professionals in those fields.

Another option for artists is to secure a licensing agent, someone who is well connected to the network of potential licensees and negotiates contract terms. Licensing agents often specialize in specific product categories or property types, so it makes sense for artists to contact only those with the same specialty. Current data indicates that licensing agents are paid commissions of 25 to 50 percent of royalties and sometimes require a monthly retainer until a licensee is secured. For more information about working with agents and representatives, see the Representatives section in the Professional Relationship chapter.

Whether dealing with potential licensees or with a licensing agent, artists should be careful to protect their ideas by copyrighting their work and by using a nondisclosure agreement, which can protect ideas that are not yet fixed in a tangible, copyrightable form. A model nondisclosure agreement can be found in the Standard Contracts and Business Tools chapter.

Three good sources for licensors, licensees, and licensing agents are the North American Licensing Industry Buyers Guide, The Licensing Letter, and the International

Licensing Industry Merchandiser's Association (LIMA). See the Resources and References chapter for contact information.

Terms of licensing agreements

An artist or other owner of a work, as licensor, grants permission to another party, the licensee, to use the art for a limited, specific purpose, for a limited, specific time, for a specific geographic area, in return for a fee or royalty. At the expiration of the license, those rights revert back to the licensor.

The image to be licensed should be described in detail. The intended uses, including the product categories or property types to be developed, should be expressed clearly in writing, as should whether the grant is exclusive or not. An exclusive grant will prevent the legal exploitation of the image by anyone other than the licensee for the duration of the license. A nonexclusive license will allow the licensor to permit others to exploit the work in multiple or overlapping markets. Or, the license might only prevent the licensor from granting additional licenses that compete in the same market or category. For example, a licensee might insist on exclusivity in home furnishings but allow other licenses to be granted in apparel. All agreements should state clearly that all rights not specifically transferred remain the property of the licensor.

The duration of a license should be spelled out clearly. Many licenses are for relatively short, fixed terms with renewal clauses tied to successful performance. This type of agreement is fair to both parties, since it provides for continued license of the art only when the artist is assured of obtaining payment and the client is satisfied with the product.

The agreement should detail the conditions under which the contract could be terminated, e.g., bankruptcy, breach of contract, insufficient sales, etc. Requirements regarding sales, production, or scheduling that provide for the best commercial exploitation of the design should be specified. If these requirements are not met, this is usually grounds to terminate the license. If a license is terminated, the artist or owner is free to license the work to others for the same or similar uses.

Recent industry surveys show that payment under licensing agreements normally is made through royalties, usually a percentage of the retail or wholesale price or a fixed amount per item sold. If the royalty is to be a percentage of the "net," i.e., an amount remaining after expenses, it should be spelled out clearly in the contract how "net" is calculated. Trade custom in the licensing industry usually is to calculate royalties by multiplying the number of sales by the gross list or wholesale price.

The same surveys show that current licensing agreements most frequently include a nonrefundable advance and a nonrefundable guaranteed minimum royalty, regardless of sales. The artist or owner is entitled to periodic accounting statements with details of sales made and royalties due. The artist also should have the right to audit the appropriate books and records to verify the statements and to insure that proper payment is forthcoming.

When a licensor contracts directly with an artist to create artwork for someone else's licensed work, current data indicate that the work generally is done for a flat fee only. For example, if the Disney Corporation contracts with an illustrator to execute artwork of its Mickey Mouse character for a new product, Disney generally pays a flat fee for that artwork and reserves any royalties from sales for itself. On the other hand, if cartoonist Matt Groening develops new artwork for the Simpsons to be applied to a baseball cap, he (as the licensor) would negotiate to receive a favorable royalty on the sale of each item.

To protect their reputations, artists and owners should insist upon proper quality control procedures to prevent inferior goods from being produced and to maximize sales potential. It is up to the artist, in consideration of the client's needs, to set those standards. If the client or manufacturer fails to meet them, the license agreement should permit the licensor to terminate the relationship. The artist also should be sure to reserve the right to approve promotional materials.

Proper copyright notice should accompany the distributed art and, where possible, name credit should be given to the artist. This can be reflected in the licensing agreement.

An excellent book on licensing is *Licensing Art and Design* by Caryn Leland, published by Allworth Press (see Resources and References chapter for ordering information). Model licensing agreements appear in the chapter on Standard Contracts and Business Tools, reprinted from *Licensing Art and Design* by permission of the author.

SALARIES
&
TRADE
CUSTOMS

Salaries
& trade customs

· · · · · · · · · · · · · ·

A salaried graphic artist usually is employed solely by one company. Unless the artist or designer can negotiate a written agreement that states otherwise, all art created on company time is considered work for hire (please see the Legal Rights and Issues chapter for more information on work for hire). Depending upon the responsibilities of the position and the employer, moonlighting for a competitor may be contractually or ethically prohibited;

some employers may require employees to sign noncompete contracts and/or confidentiality forms. Generally, a salaried graphic artist's income is limited to what the artist receives from his or her employer. Freelancing on the side, however, while not encouraged, can be an important source of additional revenue.

Many of the following disciplines overlap in salaried jobs. For instance, an art director may also produce illustrations, designs, or built-up lettering. In fact, few salaried graphic artists specialize so rigidly that they work only in one area; the special requirements of a posi-

tion will dictate the talents sought.

The salary ranges listed here reflect the current market for professional artists holding staff positions. The salaries are based on a traditional 35-hour week with a benefits package that includes vacation pay and holiday and sick pay. For health insurance, employees frequently are required to contribute part of their premiums and use health maintenance organizations (HMOs). Bonuses, stock options, and retirement plans are available, but these benefits usually rely more upon company policy regarding salaried personnel. These jobs are, for the most part, creative positions, not purely

executive or supervisory functions.

Generally, larger companies hire full-time art staff, particularly companies that produce a significant amount of material in-house needing graphic art for advertising, catalogs, corporate graphics, newsletters, or packaging. Freelance talent often is used to supplement an art staff. At times, independent agencies or design firms are put on retainer when there is no art staff or when the company chooses to subcontract a specific project or an area of a large project (e.g., advertising, corporate identity programs, or annual and quarterly reports).

Agencies and corporations downsized their art departments over the last few years, a trend favoring freelance over staff talent. These companies sometimes hire back the same individuals to work as full-time freelancers on the same projects at a lower rate, without any fringe benefits. In cases where the flat fees paid are greater than the salary earned previously, the loss of benefits—and the cost of replacing them—is significant and frequently results in lower total income. This cost-cutting method has serious tax implications for both the employer and the graphic artist. Please refer to the Employment Issues section of the Professional Issues chapter for further information.

Graphic artists in this situation should be aware that the law guarantees time and a half for work in excess of 40 hours per week. If an artist completes 1,000 hours of service, he or she should receive benefits other regular employees enjoy.

Employment conditions

Artists should consider conditions of employment along with salary when applying for a salaried position. Among the conditions generally accepted as standard for full-time workers are:

♦ *policies:* Many employers have written staff policies outlining how a company relates to its employees. New York State companies, for example, are required by law to notify employees "in writing or by publicly posting" policies on sick leave, vacations, personal leave, holidays, and hours. Other items that may be included are: employee grievance procedures, causes for discipline (up to and including discharge), criteria for salary increases and promotions, and maternity/paternity leave. A written staff policy can reveal much about the working environment and a potential employer's attitude toward his or her staff.

♦ *benefits:* All companies are required to offer such basic benefits as a minimum wage, unemployment, workers compensation insurance, and short-term disability insurance. Most companies also offer a benefit package to their employees that may include health, long-term disability, or life or dental insurance plans. Such benefits are at the discretion of the employer and are not currently required by law. Benefits often are related to company size, with smaller companies offering fewer benefits. Larger companies and corporations often offer pension, profit-sharing, and stock option plans or day care facilities or childcare subsidies. An employee may qualify for a company-offered pension depending on the plan specifications and the amount of hours they work. Check with your tax preparer for details.

♦ *job descriptions:* Just as a contract between a client and a freelance artist reflects their understanding of their relationship, a written job description can indicate clearly to artists what is expected of them during their term of employment. The Graphic Artists Guild strongly recommends that all artists taking a salaried position request a written job description, since it will help both employer and employee to avoid expectations and assumptions that are not shared by the other party. It is also useful for the artist to obtain an official "offer letter" on company letterhead, stating the salary, title, start date, and benefits, and signed by the hiring authority. A written job description also is useful in the event a job changes significantly during the term of employment. Such changes may reflect greater responsibilities or functions, justifying a new title or greater compensation. If such changes are made, the job description should be rewritten to reflect those title changes and salary adjustments.

♦ *performance review:* A periodic (semiannual or annual) evaluation of job performance is helpful to both employer and employee. A review allows employees to gauge their performance and raise questions about their job expectations. The review gives the employer the opportunity to discuss job performance and any changes in job descriptions. Formal performance reviews also allow employer and employee to suggest ways to improve the "product" or the role being considered. When handled well, job performance reviews can anticipate

potential problems and help maintain good and productive relationships between employer and employee. Results of the job performance review should be kept on file and employees should be allowed access to their file.

While many of the above conditions of employment are not mandatory, they are designed to help both employer and employee develop and maintain good relations during the term of employment.

Starting salaries

Keep in mind that starting salaries are median salaries in most corporate settings. Each title has a salary range, and new employees are often hired at the low end of the range to provide room for future raises.

Earnings gaps are still a problem: historically, many more women than men have been designers in surface design. While this is well known in the industry, the corollary that men and women are not paid equally for the same job is less well publicized. According to 1990 U.S. Census Bureau statistics, women designers earn only about 59 percent of what men make. Where male designers made on average $597 per week, female designers received only $354; a 1994 study by *Working Woman* magazine had women's salaries increased to 72 cents for every dollar men earn; *HOW* magazine in a survey published in June 1996 listed the average annual salary for a male designer at $53,147 compared to the average annual salary for a female designer of $37,716.

The issue of equal pay for equal work has received a great deal of attention from women's groups and labor organizations. According to the Guild's survey, salaried female artists are currently earning 74 percent of a male artist's average salary. The Graphic Artists Guild believes that equal pay standards should be promoted and supported. Artists with information on problems in this area are encouraged to contact the Guild.

For more detailed descriptions of positions mentioned in the pricing sections of this chapter, please refer to the appropriate freelance sections, which describe the role of each discipline.

Selected job categories

◆ *junior designer:* 1–2 years experience. Good Mac skills: Quark/Illustrator/Basic Photoshop. Support and assist the senior designers as well as have own design pro-

jects. Learning position. Detail oriented; team player; strong typography.
◆ *senior designer:* 5–8 years experience. Strong project management skills. Good computer skills. Quark/Illustrator/Basic Photoshop. Concept development, planning, designing, art direction. Could have some client presentation experience. Ability to supervise print. Work with illustrators and photographers. Team players; detail oriented; self-starting. Supervise junior designers and/or production people.
◆ *creative/design director:* good management and strong leadership skills. Supervisory experience. Responsible for budgets. Governs design direction of firm. Reviews portfolios and hires/fires. Senior designer responsibilities also. Salary range: $75,000–$100,000 (often possible equity share in firm).

Broadcast designers

The work of the broadcast designer, whose role initially developed in the service of the broadcast television networks, is visible in all of the sports, network, news, and music programming available. It includes creating the look for an entire channel or show with opening graphics and "bumpers" (shorter clips of the opening animation ID for a broadcast).

In addition, the development of computer graphics has expanded greatly the design, art direction, and execution of television graphics and animations. This capability now requires broadcast designers to keep up with hardware and software capabilities, enabling them to combine live-action direction with synthetic imagery. In many cases, it places the designer in the place of a producer/director, making him or her responsible for coordinating a crew; coordinating all video and audio production elements; and supervising the project through postproduction.

The demands of the one-eyed television medium that sits in 98 percent of the living rooms in the United States presents unique challenges to broadcast designers. For on-air duties, broadcast designers are required to be illustrators, animators, and type designers. It is necessary for them to be knowledgeable about animation techniques and, on occasion, to prepare and shoot animation on both film and tape. Knowledge of stand photography (i.e., a computerized "table top" unit that permits zooms, pans, and other special effects) and remote still photography (i.e., filming that occurs outside of the plant or studio) is essen-

tial. Broadcast designers devise everything from small-space program-listing ads to full-page newspaper ads for print media, as well as trade publication ads, booklets, brochures, invitations, and similar material.

They also double as corporate designers, coordinating everything from the on-air look to the application of identity logos/marks from stationery, memo pads, and sales promotion materials to new vehicle and, occasionally, helicopter markings.

Scenic design is another area of responsibility. It requires understanding construction techniques, materials and paints, and an awareness of staging, furnishing, lighting, spatial relationships, and camera angles.

Art directors in this field must be skilled managers, proficient in organization, budgeting, purchasing, directing a staff, and working with upper management. Obviously, not all of these skills apply to every individual or situation, and each design staff is built around personal strengths; nevertheless, a broad spectrum of roles for designers does exist.

Job categories

♦ *associate creative director:* handles work assignments, including supervision of designers: able to run creative design department if needed; check portfolios and screen job applicants. Able to cover work of assistant creative director and designer.

♦ *assistant creative director:* assists associate creative director; cover work of designer.

♦ *graphic production assistant:* provides production support to design department.

Surface/textile designers

The following trade practices are particularly relevant to the salaried surface/textile design artist:

♦ *physical working conditions*: Surface/textile designers should survey prospective work spaces and evaluate aspects such as lighting, ventilation, cleanliness, equipment, and supplies, among others.

♦ *freelancing:* Out-of-company freelance work is a common practice in the industry. If the converter (i.e, textile company), manufacturer, or other hiring party requires the surface designer to sign a form stating that he or she will not work for other companies while employed by them (a noncompetition agreement), the surface designer may be considered a regular, if temporary, employee and may be entitled to other employee

benefits. Please see the Employee Issues section of the Professional Issues chapter.

♦ *work practices*: According to the New York State Labor Board (NYSLB) at least one half-hour lunch period in a 9 a.m. to 5 p.m. workday must be provided. Contact the NYSLB for other information on rest periods and working conditions.

It is important for every surface designer to know his or her rights as an employee. Consistently working extra hours without overtime pay, for example, may be illegal.

In mill work, for example, unsafe and abusive working conditions have existed for staff employees for years. Working through weekends, extended travel time, 24-hour shifts (with sleep deprivation), and enduring poor physical conditions at mills are common practices that should be compensated appropriately. However, some advances in these areas are being made with additional compensation, guaranteed days off, overtime pay, and by the hiring of additional personnel to limit shift hours.

To achieve these goals, surface designers should negotiate firmly and/or organize for the purposes of collective bargaining. The Graphic Artists Guild is prepared to assist any and all staff artists to improve their working conditions in this way.

♦ *salary reviews:* Most converters evaluate work quality and salary advancement on an annual basis, and staff artists should be acquainted with the policies of the company to evaluate the feasibility of negotiating merit increases, cost-of-living increases, or other improvements in hours and conditions of work.

♦ *artists on per diem:* Per diem rates usually are lower than prevailing freelance prices and consequently are not beneficial to surface designers. Furthermore, per diem surface designers do not receive fringe benefits such as medical or life insurance or pensions. However, hiring a per diem surface designer for even one day requires the company to pay taxes, social security, and unemployment insurance to the government. Also, according to government regulations, those who work per diem consistently may be eligible for these fringe benefits automatically. The Graphic Artists Guild strongly recommends that surface designers review the ability level required and the work assigned in order to price the work accordingly.

♦ *knockoffs:* A surface/textile designer should not copy or "knock off" a design by

another artist unless that work is in the public domain. It is the special talent of the designer to be able to create a work that is original yet satisfies the fashion dictates of the season or year. No designer should be forced to knock off or copy designs for an employer unless they are willing to indemnify the artist from any actions that may arise as a result of any charges of infringement.

♦ *changing jobs:* Staff surface designers change jobs frequently in order to improve salaries or achieve promotions or better working conditions. The Graphic Artists Guild advises giving present employers a standard two-week notice when leaving a job. Anything less can jeopardize severance or vacation pay due.

Job categories at converters

♦ *stylist:* creative and managerial heads of departments, sometimes referred to as style directors or art buyers.
♦ *assistant stylist:* managerial and creative assistants to stylists; may or may not work at drawing board; may or may not buy art.
♦ *studio head:* directly in charge of nonmanagement studio personnel; answers to stylist; usually works at drawing board.
♦ *designer:* executes original art work.
♦ *colorist:* executes color combinations, usually painted, but sometimes using color chips or tabs (also called "pitching a pattern").
♦ *repeat artist:* executes precise continuous repeat patterns, imitating original artist's "hand."
♦ *mill worker:* is trained to ensure that the printing or engraving is correct, and that the color weights are balanced.

Job categories at studios

♦ *studio director:* creative and managerial head, in some cases the studio owner.
♦ *rep:* sells original artwork or seeks clients who need colorings, repeats, etc. A few also solicit mill work.
♦ *artists:* usually work at the studio; may execute original artwork, colorings, repeats.

Game development/ multimedia

In general, demonstrated skill and knowledge can and frequently are considered a perfectly fine substitute for formal education. Working in testing or development can give designers the experience they need to move up in the industry.

Staff salaries and benefits depend on the size of the employer. This industry has many small partnerships and firms with virtually no benefits except the doubtful privilege of working evenings and weekends on something the artist loves. The industry also has a variety of very large firms with advancement tracks, 401(k)s, good insurance options, vacations, etc., and various stock purchase plans. Significant stock options usually are reserved for founding partners or very key personnel. Employees rarely stay at a company longer than 5 years, and most companies rarely remain under the same management for more than 10 years, making retirement plans similarly unusual.

Staff Salaries

Advertising Agency*	JUNIOR (ENTRY)		INTERMEDIATE (5 YRS)		SENIOR (10+ YRS)	

GENERAL ADVERTISING

Associate creative director	-		-		$100,000 - 150,000+	
Art director (major TV credit)	-		-		200,000+	
Art director/copy writers	$25,000	- 35,000	$45,000	- 60,000	65,000 -	85,00

SALES PROMOTION

Creative directors	-		-		$100,000 - 200,000+	
Associate creative director	-		-		75,000 - 90,000	
Art directors/copy writers	$22,000	- 27,000	$50,000	- 60,000	60,000 - 70,000	

TV PRODUCTION

Line producer	-		$50,000	- 90,000	-	
Production supervisor	-		-		$100,000 - 125,000	

Interactive media

VP/design director	-		-		$120,000 - 185,000	
Design directors (ad agencies)	-		-		90,000 - 150,000	
Design directors (small–midsize firms)	-		-		85,000 - 130,000	
Art directors	-		$50,000	- 65,000	60,000 85,000	
Designers	$30,000	- 40,000	40,000	- 60,000	-	
Web masters	30,000	- 40,000	50,000	- 70,000	-	
Programmers			60,000	- 80,000	-	
Technical directors	-		-		80,000 - 120,000	

PRODUCTION

Advertising/print	$25,000	- 28,000	$40,000	- 50,000	$60,000 - 100,000	
Annual reports	-		-		60,000 - 85,000	
Packaging	-		40,000	- 60,000	75,000 - 100,000	

Identity/branding/environmental/product

Creative director	-		-		$90,000 - 175,000+	
Design director	-		-		75,000+	
Project director	-		-		55,000 - 70,000	
Package design	$28,000	- 32,000	$35,000	- 45,000	-	
Brand & corporate design	28,000	- 32,000	35,000	- 45,000	-	
Identity design	28,000	- 32,000	35,000	- 45,000	-	

PRINT (ANNUAL REPORTS/CORPORATE LITERATURE)

Creative director	-		-		$75,000 - 100,000+	
Design director	-		-		65,000 - 80,000	
Designers	$25,000	- 35,000	$35,000	- 50,000	50,000 - 65,000	

* © 1997 Roz Goldfarb Associates. Excerpted from *Career by Design*, rev. ed., by Roz Goldfarb, Allworth Press.

+ Perks may be included that significantly affect compensation.

Staff Salaries (cont'd)

Editorial Design

	JUNIOR (ENTRY)	INTERMEDIATE (5 YRS)	SENIOR (10+ YRS)
Art director	-	$40,000 - 75,000	$80,000 - 130,000
Associate art director	$35,000 - 40,000	-	-
Assistant art director	30,000 - 35,000	-	-

Corporate Design

VP creative services	-	-	$85,000 - 350,000+
Creative director	-	-	75,000 - 150,000
Design director	-	-	65,000 - 90,000
Design manager	-	$40,000 - 60,000	55,000 - 80,000
Art director	-	-	55,000 - 80,000
Assistant art director/designers	$30,000 - 35,000	35,000 - 50,000	-

Note: Compensation varies by region. In Los Angeles/San Francisco: 10% less; in Midwest, South, Northwest: at least 15% less.

Book Publishing Art Department

Creative director	-	-	$75,000 - 150,000
Art director	-	$35,000 - 45,000	60,000 - 85,000
Designer	$25,000 - 35,000	30,000 - 40,000	-
Production manager	25,000 - 35,000	40,000 - 50,000	

Broadcast Design (includes networks, affiliates, cable and public stations)

VP/creative director	-	-	$100,000 - 200,000
Design director	-	-	55,000 - 110,000
Graphics supervisor/manager	-	-	45,000 - 65,000
Art directors	-	$35,000 - 55,000	40,000 - 65,000
Designers	$26,000 - 48,000	30,000 - 55,000	35,000 - 70,000

Corporate Art Department (includes manufacturing companies)

Vice president	-	-	$150,000+
Creative/design director	-	$50,000 - 85,000	$60,000 - 120,000
Art director	$30,000 - 40,000	35,000 - 65,000	40,000 - 75,000
Graphic designer/coordinator	25,000 - 40,000	35,000 - 55,000	40,000 - 70,000
Audiovisual/multimedia design	-	35,000 - 50,000	40,000 - 60,000
Design manager	-	-	30,000 - 40,000
Illustrator	-	-	30,000 - 50,000

+ Perks may be included that significantly affect compensation.

Staff Salaries (cont'd)

Design Firms and Marketing/Consulting Firms

	JUNIOR (ENTRY)	INTERMEDIATE (5 YRS)	SENIOR (10+ YRS)
President/principal/partner/owner	-	$40,000 - 80,000	$60,000 - 175,000+
Creative director	-	55,000 - 70,000	65,000 - 125,000
Art director	-	40,000 - 50,000	45,000 - 75,000
Graphic designer	24,000 - 40,000	28000 - 45,000	34000 - 70,000

Government Agencies

	JUNIOR (ENTRY)	INTERMEDIATE (5 YRS)	SENIOR (10+ YRS)
Designer/graphic artist	$20,000 - 25,000	$25,000 - 32,000	$30,000 - 46,000
Visual information specialist	-	39000 - 45,000	-
Graphic technician	-	-	37000 - 45,000
Scientific illustrator	-	-	32000 - 42000

Multimedia and Software Companies

	JUNIOR (ENTRY)	INTERMEDIATE (5 YRS)	SENIOR (10+ YRS)
Art director	-	$40,000 - 50,000	$55,000 - 65,000+
Graphic designer	$25,000 - 35,000	35,000 - 45,000	50,000 - 65,000
Concept designer	50,000 - 65,000	-	-
Background artist	-	-	50,000 - 100,000
Illustrator/digital artist	23000 - 35,000	30,000 - 40,000	-

Surface/Textile Design Art Department

	JUNIOR (ENTRY)	INTERMEDIATE (5 YRS)	SENIOR (10+ YRS)
Stylist	-	-	$45,000 - 80,000
Styling manager (liaison)	-	-	45,000 - 65,000
Assistant stylist	-	$35,000 - 50,000	-
Studio manager	-	35,000 - 45,000	-
Repeat artist	$40,000 - 50,000	-	-
Senior designer (with mill work)	-	45,000 - 60,000	-
Junior designer/colorist	23,000 - 30,000	30,000 - 60,000	-
CAD artist	20,000 - 25,000	35,000 - 40,000	50,000 - 60,000

+ Perks may be included that significantly affect compensation.

ILLUSTRATION

prices
and trade
customs

Illustration
prices &
trade customs

• • • • • • • • • • • •

*D*uring the Depression years, illustrators such as Harrison Fisher, Neysa McMein, and Norman Rockwell received $2,500 to $3,000 to provide the cover art for *Cosmopolitan*, *McCall's*, and *The Saturday Evening Post*. For an interior color page, artists were paid about $1,200. For advertising, an automobile manufacturer or a cigarette maker paid up to $5,000 for an illustration.

In 1935, advertisers spent $130 million on magazine advertising and $140 million in newspaper advertising. In 1950, advertisers spent about $450 million on 68,300 pages of magazine advertising. Illustrators were getting about $1,200 for a color editorial page of illustration and $2,000 to $5,000 for advertising.

In 1975, advertising spending had tripled, to about $1.36 billion on 80,000 pages of magazine advertising. Total circulation was up to 249 million, nearly double the 1950 figure. Illustrators were getting about $1,500 for a color editorial page and $3,500 for advertising.

By 1985, magazine advertising revenue totaled $4.92 billion, reflecting 153,000 ad pages. Payment for full-page color editorial illustrations was down to $1,300, and a page of advertising still earned about $5,000.

Today, advertising revenue is probably over $8 billion, covering 168,000 advertising pages. Circulation is over 365 million. Illustrators are still getting between $500 and $2,000 for a color editorial page and between $2,000 and $6,000 for a page of advertising. In 1935, artists could buy a house and land from one advertising assignment. Today, the taxes for that house might be covered.

Outlets and usage have grown, yet reimbursement has not. At the same time that demand for art of all kinds is escalating—as an essential component of sales, persuasion, and education—there is less and less respect for its practitioners. Working conditions are

becoming more onerous, with quicker turn-around times and increasing numbers of inappropriate claims for uncompensated rights.

This historical perspective is not intended to drive contemporary artists to cut their mouse cords in despair, but to encourage illustrators and designers to evaluate the true worth of their work and seek it aggressively. The growth of demand—and of new markets, on the Internet and in multi- and interactive media—suggests that a permanent downward slide is not inevitable. The value of intellectual property has ballooned as the markets have gone global; United States copyright and information-related industries account for more than 5 percent of the gross national product and return a trade surplus of more than $1 billion per year.

More clients will begin to learn that customers will be less convinced by clip art as artists make persistent, concerted efforts to educate them about the true value of what artists do. It behooves—and benefits—clients to see artists as partners in creating their message, and in treating them with the respect and rewards their work deserves.

Overview

Illustrators are graphic artists who create artwork for any of a number of different markets. Most illustrators are freelancers (i.e., independent businesses) who maintain their own studios and work for a variety of clients, as compared to salaried staff artists working for one employer. Some fields in which illustrators usually are hired as staff include animation, comic books, greeting cards, and clip art production houses. While some freelance illustrators have representatives to promote their work to art buyers, many do their own promotion and marketing.

Illustrators use a variety of traditional and new techniques and tools, including pen and ink, airbrush, acrylic and oil painting, watercolor, collage, multidimensional structures, and computers. Most have a signature style, while some are sought for their versatility. Illustrators are responsible for knowing the technical requirements of color separation and printing, including trapping and other production needs introduced with new technologies, that are necessary to maintain the quality of the final printed piece.

Original or specially commissioned illustration is sold primarily on the basis of usage and reproduction rights, but other factors are important (see Pricing and Marketing Artwork chapter). Original artwork, unless sold separately, usually remains the property of the illustrator.

Usage rights generally are sold based on the client's needs. Other uses for a work may be sold to other clients as long as they are non-competitive or do not compromise the commissioning client's market. Clients that manage their businesses well only buy rights particular to the project, as it is uneconomical to pay additionally for rights that are not needed and that will not be used.

Advertising illustration

Illustrators in advertising provide visuals for products or services for specific advertising needs. In this market, the illustrator's first contact is usually an art buyer. This is the contact person who receives and solicits portfolios and often, especially in the larger agencies, remains the primary conduit for the flow of work. For creative guidance, however, illustrators usually work with art directors, account executives, copywriters, and heads of the agency's creative group.

Agencies usually expect illustrators to work in a specific style represented in their portfolios and to follow a sketch supplied by the agency and approved by the client. The terms and fee for the art normally are negotiated with the agency's art director or art buyer by the illustrator or the artist's representative.

Premium prices for illustration are paid in the advertising field, where the highest degree of professionalism and performance is expected from artists working within unusually strict time demands. Changes and last-minute alterations are not uncommon. Many illustrators set fees that include a finite number and type of alterations; e.g., "one reasonable revision." Additional significant changes often involve additional charges. Artists are flexible, however; valued and responsible clients often get greater leeway. Illustrators may need to please several people of varying opinions, since many advertisements are created by committee.

Advertising illustration prices are negotiated strictly on a use basis, with extra pay added for the sale of residual or all rights, complexity of style, or extra-tight deadlines.

Advertisements usually are thought of in terms of multiple appearances. Therefore, a sale of usage rights in advertising may refer to *limited* or *unlimited* use in a *specific area* within a *specified time period*; for example, they may be "limited to one to five insertions in consumer magazines for one year." The media and time period for which advertising rights

are being sold should be made clear and the price agreed upon before the project starts.

Trade practices

The following trade practices have been used historically and, through such traditions, are accepted as standard:

1. The intended use of the art must be stated clearly in a contract, purchase order, or letter of agreement stating the price and terms of sale.
2. Artists normally sell rights to one to five insertions of their artwork within a given medium for one year from date of first use, unless otherwise stated.
3. If artwork is to be used for other than its original purpose, the price usually is negotiated as soon as possible. The secondary use of an illustration may be of greater value than the primary use. Although there is no set formula for reuse fees, current surveys indicate artists add a reuse fee ranging from 50 to 100 percent of the fee that would have been charged had the illustration originally been commissioned for the anticipated usage.
4. Illustrators should negotiate reuse arrangements with the original commissioning party with speed, efficiency, and all due respect to the client's position.
5. Return of original artwork to the artist is automatic unless otherwise negotiated.
6. Historically, artists have charged higher fees for rush work than those listed here, often by an additional 20 to 150 percent.
7. If a job is canceled after the work is begun, through no fault of the artist, historically, a cancellation or kill fee often is charged. Depending upon the stage at which the job is terminated, the fee has covered all work done, including research time, sketches, billable expenses, and compensation for lost opportunities resulting from refusing other offers to make time available for a specific commission. In addition, clients who put commissions "on hold" or withhold approval for commissions for longer than 30 days usually secure the assignment by paying a deposit.
8. Historically, a rejection fee has been agreed upon if the assignment is terminated because the preliminary or finished work is found to be not reasonably satisfactory and steps to correct the problem have been exhausted. The rejection fee for finished work often has been over 50 percent of the full price, depending upon the

ADDITIONAL USAGE FEES FOR

Advertising Illustration

	PERCENTAGE OF ORIGINAL FEE (MEDIANS)
Separate sale of original artwork	75%
Unlimited use within same media for one year	50%
Unlimited use, any print media, no time or geographic limit	100%
Total copyright transfer, not including original art	200%

reason for rejection and the complexity of the job. When the job is rejected at the sketch stage, current surveys indicate a fee of 20 to 50 percent of the original price is customary. This fee may be less for quick, rough sketches and more for highly rendered, time-consuming work.

9. Artists considering working on speculation often assume all risks and should take these into consideration when offered such arrangements; see section on Speculation in the Professional Issues chapter for details.
10. The Graphic Artists Guild is unalterably opposed to the use of work-for-hire contracts, in which authorship and all rights that go with it are transferred to the commissioning party and the independent artist is treated as an employee for copyright purposes only. The independent artist receives no employee benefits and loses the right to claim authorship or profit from future use of the work forever. In the Guild's view, advertising is not eligible to be work for hire, as it does not fall under any of the eligible categories defined in the law. Additional information on work for hire can be found in the Legal Rights and Issues chapter.
11. Customary and usual expenses such as props, costumes, model fees, travel costs, production costs, shipping, picture reference, and consultation time are billed to the client separately. An expense estimate is usually included in the original written

agreement or as an amendment to the agreement.

All prices for illustration in the *Guidelines* are based on a survey of the United States and Canada that was reviewed by a special committee of experienced professionals through the Graphic Artists Guild. These figures, reflecting the responses of established professionals, are meant as a point of reference only and do not necessarily reflect such important factors as deadlines, job complexity, reputation, and experience of a particular illustrator, research, technique, or unique quality of expression and

extraordinary or extensive use of the finished art. Please refer to related material in other sections of this book, especially in the Pricing and Marketing Artwork and Standard Contracts and Business Tools chapters.

The prices shown represent only the specific use for which the illustration is intended and do not necessarily reflect any of the above considerations. The buyer and seller are free to negotiate, with each artist independently deciding how to price his or her artwork and taking into account all the factors involved.

COMPARATIVE FEES FOR

Advertising Illustration

Displays and Exhibits*

ONE SHOW USE	B/W†	COLOR
Poster	$1000 - 2000	$3500 - 7500
Medium	500 - 1500	1500 - 3000
Small	300 - 8000	750 - 2000

ONE YEAR USE		
Poster	$2000 - 3000	$4500 - 9000
Medium	750 - 2000	1000 - 4500
Small	350 - 1000	500 - 3500

* Illustrations displayed in trade shows.

† Current data indicates that an additional 25% is added for each color overlay in addition to black.

Advertorials*

GENERAL INTEREST CONSUMER OR GENERAL BUSINESS MAGAZINES		
Opener†	$2300 - 3700	$2800 - 6000
Spread	1250 - 3000	2000 - 6000
Full page	1000 - 2500	1500 - 4500
Half page	750 - 2000	1000 - 3500
Quarter page	500 - 1500	750 - 2000
Spot	250 - 750	400 - 1500

* Used in special advertising sections added into magazines.

† Based on 1994 data.

SPECIAL-INTEREST CONSUMER OR TRADE, INSTITUTIONAL OR PROFESSIONAL MAGAZINES	B/W	COLOR†
Opener†	$1700 - 2500	$2500 - 4500
Spread	1000 - 3000	1500 - 4000
Full page	750 - 2000	1000 - 3500
Half page	500 - 1500	750 - 2500
Quarter page	250 - 1000	400 - 1500
Spot	175 - 750	250 - 1000

Consumer Magazines*

GENERAL INTEREST (*READER'S DIGEST, PEOPLE WEEKLY*) OR NATIONAL CIRCULATION		
Spread	$2500 - 6000	$3500 - 8000
Full page	1500 - 5000	3000 - 6000
Half page	1000 - 3000	2000 - 4000
Quarter page	750 - 2500	1000 - 3000
Spot	500 - 1000	750 - 2000

SPECIAL INTEREST (*THE NEW YORKER OR THE ATLANTIC MONTHLY*) OR MEDIUM CIRCULATION		
Spread	$1250 - 4000	$2000 - 7000
Full page	1000 - 3500	1500 - 5000
Half page	750 - 3000	1000 - 4000
Quarter page	500 - 1500	500 - 2500
Spot	200 - 900	250 - 1500

Advertising Illustration

Consumer Magazines (cont'd)

SINGLE INTEREST (*SCIENTIFIC AMERICAN, GOLF DIGEST*) OR SMALL CIRCULATION

	B/W†	COLOR
Spread	$1000 - 3000	$1250 - 6000
Full page	700 - 2500	1000 - 4000
Half page	500 - 1500	750 - 3000
Quarter page	200 - 1000	500 - 1800
Spot	100 - 750	250 - 1000

* Illustrations used in advertisements printed in consumer magazines. Original fee covers a limited use of from one to five insertions (within the media specified) for one year from date of first insertion.

Business Magazines*

GENERAL BUSINESS MAGAZINES (*FORTUNE, BUSINESS WEEK, FORBES*) OR LARGE CIRCULATION

Spread	$1500 - 5000	$2000 - 8000
Full page	1000 - 4000	1500 - 6000
Half page	500 - 3000	1000 - 4000
Quarter page	300 - 2000	500 - 3000
Spot	200 - 1200	300 - 2000

TRADE (*CHAIN STORE AGE*), INSTITUTIONAL (*HOSPITALS*), PROFESSIONAL (*ARCHITECTURAL RECORD*) OR SMALL-CIRCULATION MAGAZINES

Spread	$1000 - 4000	$1000 - 5000
Full page	700 - 2500	800 - 3500
Half page	500 - 1800	500 - 2500
Quarter page	250 - 1000	300 - 1500
Spot	175 - 700	250 - 1000

* Illustrations used in advertising in magazines whose readers work in industry or commerce and use business magazines for information about their field or job. Original fee covers a limited use of from one to five insertions (within the media specified) for one year from date of first insertion.

Newspapers*

NATIONAL OR MAJOR METRO AREA NEWSPAPERS OR CIRCULATION OVER 250,000

Spread	$1200 - 5000	$1500 - 6000
Full page	1000 - 4000	1200 - 5000
Half page	750 - 3000	1000 - 4000
Quarter page	500 - 2000	500 - 2500
Spot	250 - 1000	250 - 1200

MIDSIZE METRO AREA NEWSPAPERS OR CIRCULATION FROM 100,000 TO 250,000

	B/W†	COLOR
Spread	$1300	-
4000	$1800	-
5000		
Full page	1000 - 3000	1500 - 4000
Half page	500 - 2000	1000 - 3000
Quarter page	300 - 1500	500 - 2000
Spot	200 - 500	250 - 1000

SMALL METRO AREA NEWSPAPERS OR CIRCULATION UNDER 100,000

Spread	$750 - 2500	$1000 - 3000
Full page	500 - 2000	750 - 2500
Half page	300 - 1500	500 - 2000
Quarter page	200 - 1000	250 - 1500
Spot	100 - 500	125 - 1000

* Illustrations used in advertising in consumer newspapers. Original fee covers a limited use of from one to five insertions (within the media specified) for one year from date of first insertion.

Magazine supplements*

MAGAZINES SUPPLEMENTS MAJOR METRO AREA OR NATIONAL NEWSPAPERS OR CIRCULATION OVER 250,000†

Spread	$1500 - 5000	$2000 - 6000
Full page	1200 - 4000	1500 - 5000
Half page	800 - 3000	1000 - 4000
Quarter page	600 - 2000	750 - 3000
Spot	200 - 1000	500 - 2000

MAGAZINE SUPPLEMENTS - MIDSIZE METRO AREA NEWSPAPERS OR CIRCULATION UNDER 250,000

Spread	$1000 - 4000	$1500 - 5000
Full page	750 - 3000	1000 - 4000
Half page	500 - 2000	750 - 3000
Quarter page	350 - 1000	500 - 2000
Spot	150 - 550	400 - 1000

* Illustrations used in advertising in magazines inserted inside newspapers. Original fee covers a limited use of from one to five insertions (within the media specified) for one year from date of first insertion.

Advertising Illustration

Collateral Illustration*

OVER 100,000

PIECES PRINTED	B/W†	COLOR
Cover	$1000 - 4000	$1500 - 6000
Full page	700 - 3000	1000 - 4000
Half page	500 - 2000	750 - 3000
Quarter page	300 - 1250	500 - 2000
Spot	200 - 750	300 - 1000

10,000 TO 100,000

PIECES PRINTED	B/W	COLOR
Cover	$800 - 3000	$1500 - 4000
Full page	700 - 2000	1000 - 3500
Half page	500 - 1500	750 - 2000
Quarter page	300 - 1000	500 - 1500
Spot	200 - 750	300 - 1000

UNDER 10,000

PIECES PRINTED	B/W	COLOR
Cover	$700 - 2500	$1000 - 4000
Full page	500 - 1800	750 - 2500
Half page	350 - 1200	500 - 2000
Quarter page	250 - 800	350 - 1250
Spot	125 - 500	200 - 750

* Used in brochures, catalogs and direct-response mailers, flyers and handouts.

Point of Sale*

LARGE PRINT RUN: OVER 5,000 PIECES

Poster	$1500 - 5000	$2000 - 6000
Medium	1000 - 3500	1500 - 5000
Small	500 - 2500	1000 - 4500

SMALL PRINT RUN: UNDER 5,000

Poster	$1150 - 4000	$1500 - 4500
Medium	500 - 2000	1000 - 3000
Small	300 - 1000	500 - 2000

* Illustration used on counter cards, shelf signs and posters.

† Current data indicates that an additional 20 to 30% is added for each color overlay in addition to black.

Outdoor Advertising*

BUS, CAR, AND TRANSIT CARS

	B/W†	COLOR
Major campaign		
Large ad	$2000 -10000	$2500 -10000
Medium ad	1500 - 7000	2000 - 7000
Small ad	1000 - 5000	1500 - 5000
Regional campaign		
Large ad	$1500 - 5000	$2000 - 6000
Medium ad	1000 - 4000	1500 - 4500
Small ad	500 - 3000	1000 - 4000
Local campaign		
Large ad	$1000 - 4000	$1500 - 6000
Medium ad	750 - 2000	1000 - 2700
Small ad	500 - 1000	600 - 2000

* Illustrations used on large outdoor and transit displays.

† Current data indicates that an additional 15 to 25% is added for each color overlay in addition to black, and 25% for 3-D or extensions.

STATION/KIOSK POSTER*

Major campaign	$2000 - 3500	$2500 - 5500
Regional campaign	1500 - 3000	2000 - 4000
Local campaign	800 - 2500	1000 - 3500

OUTDOOR BOARDS (BILLBOARDS)*

Number of installations		
Over 40	$2000 - 5000	$4500 -10,000
10–40	1500 - 3000	2000 - 4500
1–10	1000 - 2500	1000 - 4000

* Illustrations used on large outdoor and transit displays.

Advertising Illustration

Motion Picture Posters*

MAJOR PRODUCTION (OVER $5,000,000 BUDGET)	COLOR
Produced poster	$4000 -14000
Finished art, unused	3000 -10000
Comp sketch only	500 - 4000

LIMITED PRODUCTION (UNDER $5,000,000 BUDGET)	COLOR
Produced poster	$2000 -12000
Finished art, unused	2500 - 6000
Comp sketch only	300 - 3500
Day rate	300 - 1000

* Color illustrations used for motion picture advertising, developed in 3 stages: (1) sketch, (2) a highly rendered comp and (3) the finished poster art. Separate fees are usually arranged for each stage of completion.

Theater Posters and Advertisements*

LARGE PRODUCTIONS	1 COLOR	2–3 COLOR	4 COLOR
Complex	$1000 - 3000	$2000 - 6000	$2500 - 10000
Simple	1000 - 2000	1500 - 3500	2000 - 8000
SMALL PRODUCTIONS			
Complex	$1000 - 2000	$1500 - 3500	$2000 - 5000
Simple	750 - 1500	1000 - 2300	1500 - 4500

* Illustration used for theater and event advertising.

Preproduction art (comps, animatics, storyboard illustration, TV and audiovisual illustration)

Artists who specialize in preproduction art service the advertising, television, and motion picture industries and usually are called upon to produce high-caliber professional work within tight deadlines. Although some artists tend to specialize, nearly all are engaged in three areas of preproduction art: comps (formerly called "comprehensives"), storyboards, and animatics.

Comps are visual renderings of proposed advertisements and other printed promotional materials and include headlines, body text, and a "visual," i.e., the rendering of the illustration or photo to be used in the finished piece.

A *storyboard* is a visual presentation of a proposed television commercial or program or feature film, using a limited number of sequential frames. They often are drawn on a telepad, which is a preprinted matrix with frames that are usually 2 ¾" x 3 ¾", although some agencies supply their own telepads in larger formats. In advertising, storyboards generally are used in-house (within an agency) to present the concept of the proposed commercial to the client. An important component of preproduction artwork in advertising is the "key" frame,

a large single frame used in concert with other frames to establish the overall mood or to portray the highlight or key moment of the commercial. It must be given extra attention—and compensation—since it carries most of the narrative burden.

Storyboard renderings for feature films or television are relied upon by producers to envision creative concepts and to evaluate a concept's visual qualities and continuity. Used most often as a reference to an accompanying script, the storyboards and text are filmed as a "photoplay," a critical element in determining a property's value as entertainment and its value as a visual production. Storyboards are the visual blueprint producers rely upon for budgeting and to help avoid cost overruns.

Artist fees for television or feature-film storyboards historically have depended upon the production's budget and its intended distribution. Fees for high-budget productions, which usually require more complex storyboard renderings, generally have been higher than fees for low-budget productions. The break point between low- and high-budget television productions has been $500,000. For feature films, the break point has been $2,000,000.

Storyboards for motion pictures and television features generally are black and white and emphasize camera angles and moves. Because greater numbers of frames generally are produced for feature-length storyboards, the rendering style in demand the most is quick, clean, and realistic. Storyboard artists must work more closely with other members of the creative team than usually occurs in advertising preproduction. It is not unusual for artists to scout locations or to be required to work on location.

An *animatic* is a limited-animation video using camera movements, a select number of drawings, some animation, and a sound track. An animatic usually is produced to test a proposed "spot" or TV commercial. The need for animatics has risen due to the increased desirability of test marketing for advertisers. An animatic must "score" well on audience recall, etc., in order to go into full production. Video storyboards are used more frequently in other markets as well, especially in the motion-picture-for-television market, because of the wider availability of relatively inexpensive video equipment.

Video storyboards use storyboard art only (no moving parts), and movement is achieved with simple camera moves. Often a tighter style than normal is required, which many artists have used to explain fees that are approximately 25 percent higher than regular storyboards.

In pricing animatics, one background illustration and one to one-and-one-half cutout figures comprise one frame. Two figures and their moving parts can constitute one frame when backgrounds are used for several scenes. Preproduction artists generally receive taped copies of their work from production houses so that they can compile a reel of sample commercials for their portfolios.

Fees in this field historically have depended upon job complexity, including factors such as the degree of finish required, the number of subjects in a given frame, the type of background required, and the tightness of the deadline.

Some agencies, production companies, producers, and individuals may request artists sign nondisclosure or noncompete agreements to protect trade secrets and creative properties for specified periods. These conditions may restrict an artist's opportunities for future work and is a factor that should be considered seriously when negotiating fees.

Artists must know ahead of time whether film or videotape will be used, since each has its own special requirements. A good grasp of current TV commercial, film, and music-video styles is crucial to success in this field. Some agencies also will request that artists work in-house, and that should be taken into account when establishing a fee.

Rush work traditionally is billed at an average of 70 percent over the regular fee, but ranges from 50 to 100 percent. Hourly rates, although rarely used, have ranged from $75 to $150 per hour. Flat per-frame rates more accurately reflect all the factors involved in the job, although hourly rates can apply for consultation time if the artist participates in the design of the scene or sequences.

In some cases, a per diem rate of $600 to $650 has been paid, when the artist works on site for extended periods. Be aware that these conditions may open an artist to reclassification as an employee rather than as an independent contractor; not doing so may put the client and the artist at risk, depending on how the client treats the artist. If an artist does not serve any other clients, on-site work may endanger an artist's home office deduction. Please refer to the Employment Issues section found in the Professional Issues chapter.

Trade practices

The following trade practices have been used historically and, through such traditions, are accepted as standard:

1. The intended use of the art must be stated clearly in a contract, purchase order, or letter of agreement stating the price and terms of sale.

2. Artists historically have sold all rights for preproduction work. Since this work is very product-specific (campaigns are often confidential, and the media used, i.e., markers, are "fugitive," or impermanent), frames are almost never reusable. The higher fees available for this work have compensated for the loss of rights, although many art directors will return artwork for an artist's self-promotional use.

3. If artwork is to be used for other than its original purpose, the price usually is negotiated as soon as possible. The secondary use of an illustration may be of greater value than the primary use. Although there is no set formula for reuse fees, current surveys indicate artists add a reuse fee ranging from 20 to 100 percent of the fee that would have been charged had the illustration originally been commissioned for the anticipated usage.

4. Illustrators should negotiate reuse arrangements with the original commissioning party with speed, efficiency, and all due respect to the client's position.

5. Return of original artwork to the artist is not automatic unless otherwise negotiated.

6. Historically, artists have charged higher fees for rush work than those listed here, often by an additional 20 to 150 percent.

7. If a job is canceled after the work is begun, through no fault of the artist, historically, a cancellation or kill fee often is charged. Depending upon the stage at which the job is terminated, the fee has covered all work done, including research time, sketches, billable expenses, and compensation for lost opportunities resulting from refusing other offers to make time available for a specific commission. In addition, clients who put commissions "on hold" or withhold approval for commissions for longer than 30 days usually secure the assignment by paying a deposit.

8. Historically, a rejection fee has been agreed upon if the assignment is terminated because the preliminary or finished work is found to be not reasonably satisfactory and steps to correct the problem have been exhausted. The rejection fee for finished work often has been over 50 percent of the full price, depending upon the reason for rejection and the complexity of the job. When the job is rejected at the sketch stage, current surveys indicate a fee of 20 to 50 percent of the original price is customary. This fee may be less for quick, rough sketches and more for highly rendered, time-consuming work.

9. Artists considering working on speculation often assume all risks and should take these into consideration when offered such arrangements; see section on Speculation in the Professional Issues chapter for details.

10. The Graphic Artists Guild is unalterably opposed to the use of work-for-hire contracts, in which authorship and all rights that go with it are transferred to the commissioning party and the independent artist is treated as an employee for copyright purposes only. The independent artist receives no employee benefits and loses the right to claim authorship or profit from future use of the work forever. Additional information on work for hire can be found in the Legal Rights and Issues chapter.

11. Customary and usual expenses such as props, costumes, model fees, travel costs, production costs, and consultation time are billed to the client separately. An expense estimate should be included in the original written agreement or as an amendment to the agreement.

All prices for illustration in the *Guidelines* are based on a survey of the United States and Canada that was reviewed by a special committee of experienced professionals through the Graphic Artists Guild. These figures, reflecting the responses of established professionals, are meant as a point of reference only and do not necessarily reflect such important factors as deadlines, job complexity, reputation and experience of a particular illustrator, research, technique, or unique quality of expression and extraordinary or extensive use of the finished art. Please refer to related material in other sections of this book, especially in the Pricing and Marketing Artwork and Standard Contracts and Business Tools chapters.

The prices shown represent only the specific use for which the illustration is intended and do not necessarily reflect any of the above considerations. The buyer and seller are free to negotiate, with each artist independently deciding how to price his or her artwork and taking into account all the factors involved.

Preproduction Illustration

Print Preproduction*

COMPS	LINE	TONE†
Major campaign		
Spread	$150 - 600	$300 - 800
Full page	175 - 400	200 - 750
Small campaign		
Spread	$150 - 600	$200 - 800
Full page	100 - 300	125 - 500

* Comprehensive sketches for print advertising.

TV/Film Preproduction

ANIMATICS	PER FRAME*
TV advertising test marketing (30-second ad)	
5 x 7 (8 x 10 bleed)	$250
8 x 10 (11 x 14 bleed)	350
Moving parts	$50 - 200

* Frames consist of background and two figures

Storyboards

TELEVISION ADVERTISING	LINE	TONE†
Miniboards*	$25 - 40	$35 - 55
Telepads*	25 - 45	40 - 75
4 x 5	30 - 75	50 - 100
5 x 7	50 - 100	60 - 250
8 x 10 key frame	100 - 200	150 - 300
9 x 12 key frame	125 - 250	200 - 500

* Miniboards are approximately 1 x 1-½ inches.
 Telepads are 2-¾ x 3-¾ inches.

† Tone may be color or black and white.

Television Programming

MAJOR PRODUCTION (OVER $5,000,000 BUDGET)*	LINE	TONE†
4 x 5	$40 - 70	$50 - 85
5 x 7	50 - 90	75 - 125
Concept/key frame	100 - 120	150 - 300

MINOR PRODUCTION (UNDER $5,000,000 BUDGET)*	LINE	TONE†
4 x 5	$25 - 65	$35 - 80
5 x 7	85	100
Concept/key frame	100	120 - 500

* Per frame.

Film Storyboards*

MAJOR PRODUCTION (OVER $5,000,000 BUDGET)		
2 x 5	$40	$75
4 x 10	150	225
8 x 20	300	400

LIMITED PRODUCTION (UNDER $5,000,000 BUDGET)		
2 x 5	$35	$60
4 x 10	80	110
8 x 20	200	300

* Per frame.

† Tone may be color or black and white.

Corporate and institutional illustration

An illustrator creating corporate or institutional art works with a graphic designer, art director, or in-house personnel such as writers, advertising/marketing managers, or communication service directors to create visuals for annual reports, in-house publications, and other material targeted to internal or specific audiences. The assignment is generally editorial, and the illustrator often is called upon to determine the concept and design of the art. In annual reports particularly, illustrations are "think pieces" that contribute substantially to enhancing the corporation's or institution's public image.

Clients include both Fortune 500 and smaller companies as well as educational institutions, government agencies, and not-for-profit entities, i.e., groups and associations that organize for purposes other than private profit. However, this does not mean not-for-profit organizations operate at a deficit; some, in fact, such as the American Association of Retired Persons (AARP), with over 37 million members, have enormous resources. Other examples of not-for-profits include trade associations and business leagues, hospitals and health-related entities, professional membership societies, unions, philanthropies, museums and other arts organizations, and charitable and educational organizations. Whether a client is for-profit or not-for-profit, pricing in this area will vary according to its size and resources.

Annual reports

An annual report, the yearly fiscal report by a corporation to its stockholders and the financial community, is an important vehicle that the company uses to promote itself. Designers of annual reports often seek thoughtful, provocative illustration that will offset the written and financial material while projecting the company's public image effectively and powerfully.

Fees for illustration historically have been set relative to the size of the corporation and the nature of the annual report and usually have been negotiated on a one-time-use basis only. Artists should be prepared when dealing with large assignments in this area to consider their fee for selling original art, since clients for annual reports frequently make this request.

Corporate calendars

Prices for illustrations for company calendars can vary greatly and usually are dependent upon the size of the company, the complexity of the subject, and the intended use. Calendars designed only for internal use generally will pay less than calendars distributed to consumers as a promotion or by sale.

Trade practices

The following trade practices have been used historically and, through such traditions, are accepted as standard:

1. The intended use of the art must be stated clearly in a contract, purchase order, or letter of agreement stating the price and terms of sale.
2. Artists normally sell only first reproduction rights unless otherwise stated.
3. If artwork is to be used for other than its original purpose, the price usually is negotiated as soon as possible. The secondary use of an illustration may be of greater value than the primary use. Although there is no set formula for reuse fees, current surveys indicate artists add a reuse fee ranging from 50 to 100 percent of the fee that would have been charged had the illustration originally been commissioned for the anticipated usage.
4. Illustrators should negotiate reuse arrangements with the original commissioning party with speed, efficiency, and all due respect to the client's position.
5. Return of original artwork to the artist is automatic unless otherwise negotiated.
6. Historically, artists have charged higher fees for rush work than those listed here, often by an additional 20 to 150 percent.
7. If a job is canceled after the work is begun, through no fault of the artist, historically a cancellation or kill fee is often charged. Depending upon the stage at which the job is terminated, the fee has covered all work done, including research time, sketches, billable expenses, and compensation for lost opportunities resulting from an artist's refusing other offers to make time available for a specific commission. In addition, clients who put commissions "on hold" or withhold approval for commissions for longer than 30 days usually secure the assignment by paying a deposit.
8. Historically, a rejection fee has been agreed upon if the assignment is terminated because the preliminary or finished work is found to be not reasonably satisfactory and steps to correct the problem have been exhausted. The rejection fee for finished work has often been over 50 per-

Corporate and Institutional Illustration

Employee Publications

LARGE CORPORATION OR LARGE PRINT RUN

	B/W*	COLOR
Cover†	$1000 - 3500	$2000 - 5700
Full page	800 - 2800	1000 - 4000
Half page	500 - 2000	700 - 2500
Quarter page	250 - 1250	400 - 1800
Spot	200 - 750	250 - 1000

MEDIUM CORPORATION OR MEDIUM PRINT RUN

	B/W*	COLOR
Cover†	$700 - 2400	$1300 - 3300
Full page	600 - 2000	900 - 2500
Half page	400 - 1800	500 - 2000
Quarter page	200 - 900	300 - 1500
Spot	150 - 600	200 - 1000

SMALL OR NONPROFIT CORPORATION OR SMALL PRINT RUN

	B/W*	COLOR
Cover†	$650 - 2200	$900 - 2400
Full page	500 - 1000	600 - 2000
Half page	250 - 800	300 - 1000
Quarter page	150 - 600	200 - 750
Spot	75 - 500	100 - 500

* Current data indicates that an additional 20–25% is added for each color overlay in addition to black.

† Figures for "covers" reflect 1994 data.

Annual Reports

LARGE CORPORATION OR LARGE DISTRIBUTION

	B/W*	COLOR
Cover†	$1900 - 4600	$2500 - 6750
Full page	1200 - 5000	1500 - 6000
Half page	750 - 2500	1000 - 4000
Quarter page	500 - 2250	750 - 2500
Spot	300 - 1500	500 - 2000

MEDIUM CORPORATION OR MEDIUM DISTRIBUTION

	B/W*	COLOR
Cover†	$1750 - 4100	$1900 - 4900
Full page	750 - 2500	1500 - 4000
Half page	500 - 2000	1000 - 2500
Quarter page	300 - 1750	500 - 2250
Spot	150 - 1000	350 - 2000

SMALL OR NONPROFIT CORPORATION OR LIMITED DISTRIBUTION

	B/W*	COLOR
Cover†	$1100 - 2600	$1550 - 3650
Full page	750 - 3000	1000 - 2500
Half page	500 - 2500	750 - 1100
Quarter page	250 - 1000	400 - 900
Spot	125 - 800	200 - 600

* Current data indicates that an additional 25% is added for each color overlay in addition to black.

† Figures for "covers" reflect 1994 data.

cent of the full price, depending upon the reason for rejection and the complexity of the job. When the job is rejected at the sketch stage, current surveys indicate a fee of 20 to 50 percent of the original price is customary. This fee may be less for quick, rough sketches and more for highly rendered, time-consuming work.

9. Artists considering working on speculation often assume all risks and should take these into consideration when offered such arrangements; see section on Speculation in the Professional Issues chapter for details.

10. The Graphic Artists Guild is unalterably opposed to the use of work-for-hire contracts, in which authorship and all rights that go with it are transferred to the commissioning party and the independent artist is treated as an employee for copyright purposes only. The independent artist receives no employee benefits and loses the right to claim authorship or profit from future use of the work forever. Additional information on work for hire can be found in the chapter on Legal Rights and Issues.

11. Customary and usual expenses such as unusual props, costumes, model fees, travel costs, production costs, and consultation time should be billed to the client separately. An expense estimate should be included in the original written agreement or as an amendment to the agreement.

All prices for illustration in the *Guidelines* are based on a survey of the United States and Canada that was reviewed by a special committee of experienced professionals through the Graphic Artists Guild. These figures, reflecting the responses of established professionals, are meant as a point of reference only and do not necessarily reflect such important factors as deadlines, job complexity, reputation and experience of a particular illustrator, research, technique or unique quality of expression, and extraordinary or extensive use of the finished art. Please refer to related material in other sections of this book, especially in the Pricing and Marketing Artwork and Standard Contracts and Business Tools chapters.

The prices shown represent only the specific use for which the illustration is intended and do not necessarily reflect any of the above considerations. The buyer and seller are free to negotiate, with each artist independently deciding how to price his or her artwork and taking into account all the factors involved.

Book illustration

The publishing business has undergone a tremendous growth and change in the last decade. Most well-known publishing houses have been acquired by multinational conglomerates here and abroad, and many smaller houses have been either eliminated or incorporated as imprints. More recently, an early 1990s boom in sales has leveled off. The inroads made by giant bookstore chains, which often negotiate heavy discounts, and a worldwide jump in paper prices increased the pressure on publishers' bottom lines, though there were indications at press time that paper prices were stabilizing and in some instances publishers were benefitting from discounts.

The use of book packagers has grown in recent years, particularly for pop-up books and various kinds of novelty books, such as book-and-craft-kit combinations. These independent suppliers take over for the publisher some or all of the function of preparing a book. Often they initiate a project, find writers, illustrators, etc., arrange for whatever extra is involved in a novelty book, and strike a deal with a publish-

er, usually supplying a set number of bound books at a set price. Especially when a book idea has been conceived by the packager rather than the publisher, the artist will be asked to sign a contract with the packager rather than the publisher, even before the packager has contracted for the project with a publisher.

Book jacket illustration

Book jacket illustration or design is the second most important ingredient in the promotion and sale of a book, superseded only by the fame and success of the author.

Pricing illustration in the book publishing market is complex, so all the factors involved need serious attention. Romance, science fiction, and other genre paperback covers can command higher fees than hardcover jackets, especially when the projected audience is very large. Artists who design and illustrate jackets may approach their work differently from other graphic artists. (Please refer to the Book jacket design section in the Graphic Design Prices and Trade Customs chapter.)

Historically, illustrators who are selected specially for occasional cover assignments receive higher fees than illustrators who specialize only in book jackets. In addition, artists recognized for their painterly, highly realistic, or dramatic studies have commanded much higher fees than those whose styles are more graphic and design-oriented. Although this practice is prevalent in the entire illustration field, it is particularly evident in publishing.

Some paperback publishers give very specific instructions on assignments, sometimes including the art director's rough notes from a cover conference. If an illustrator is required to read a lengthy manuscript in search of illustrative material and then produce sketches subject to approval by editors, this factor traditionally is taken into account when negotiating the fee.

Other factors that historically have engendered additional fees, and have been negotiated before the assignment is confirmed, include: changes in approach and direction after sketches are completed; requiring new sketches; additional promotional uses that are above and beyond what is the common trade practice (e.g., using the art separately from the cover without the title or author's name); extremely tight color comps done for sales meetings and catalogs. There is a growing after-market for audiocassette covers, and this is a separate right to be negotiated and added to the agreement as an additional use of the

Book Jacket Illustration

HARDCOVER	FRONT COVER	WRAPAROUND
Mass market		
books*	$1500 - 6000	$2000 - 7000
Trade books*		
Major distribution	$1200 - 3000	$2000 - 5000
Minor distribution	1000 - 2500	1500 - 4000

PAPERBACK	FRONT COVER	WRAPAROUND
Mass market		
books*	$1200 - 5000	$2025 - 6000
Trade books*		
Major distribution	1000 - 3000	1500 - 4750
Minor distribution	750 - 2500	1000 - 3000
Young adult books	1000 - 2500	1200 - 3500
Textbooks	750 - 2200	1000 - 3000

* Mass market books appeal to a large audience and are sold in stores other than major retail book stores. Trade books are mostly hardcover and are sold almost exclusively in retail book stores.

artwork. In addition, the growth of CD-ROMs has created a new market for illustration.

Mass market and trade books

Mass market books have large print runs and appeal to a wide audience. They include: blockbuster novels, mysteries, thrillers, gothics, fantasy and science fiction, and historical and modern romance novels. Trade books include poetry, serious fiction, biography, how-to books, and more scholarly works that appeal to a special audience.

Because of their larger print runs and higher gross sales, mass market books historically generate higher fees. When pricing work in these areas, the size of the print run traditionally has been taken into account.

A hardcover assignment might also include paperback rights, for which an additional 50 percent of the original fee customarily is charged. The fee for a book having a considerably larger print run on occasion has amounted to an additional 100 percent of the original fee, and possibly more.

Domestic book club rights usually are included in the original hardcover fee. All other residual rights, especially movie and television rights, are reserved by the artist. Transfer of those and all other rights are negotiated by the artist and the client.

Book interior illustration

Illustrations long have been recognized as an important ingredient in the editorial and marketing value of a book. Book illustrators work with editors, art directors, book designers, or book packagers to create anything from simple instructional line drawings to full-color-spread illustrations for textbooks, young adult books, picture books, and special reprints of classics, among other trade genres.

The text and its related elements (illustration, design, and type) are considered a package. The importance of illustration to a specific book may be significant or limited, depending on needs determined by the publisher.

Outside of children's books, it is exceedingly rare for royalties to be paid for book illustration. If such an opportunity arises, check the Children's Book section below for details on an appropriate contract. Children's picture book and storybook artists usually are paid an advance against royalties. Interior illustrations for all other categories normally are paid for with a one-time flat fee, except that children's novel illustrations increasingly are paid royalties.

Book packagers often offer illustrators either a flat fee or a 10 percent royalty. This royalty is not figured on the book's list price, as with standard publishers' contracts, but on

what the packager will receive from the publisher for the finished books ("base selling price"). Since publishers generally set a book's retail price at four to five times the cost of its production, illustrators should be aware that 10 percent of the base selling price amounts to a 2 to 2.5 percent royalty of the list price.

Publishers generally allot 10 percent (or 5 percent, in the case of mass market material) of list price that the publisher generally allots for author's and illustrator's royalties. When a publisher uses a packager to produce a book, that 10 percent may be absorbed by the publisher, or may be paid to the packager in addition to the base selling price. Sometimes this share is paid to a licensor in exchange for the right to publish a book about a popular property (cartoon characters, etc.) and a packager is hired to create the book. In some cases, particularly where the project originated with the author-artist, all or some of those list-price-royalties may be paid to the artist. It is the publisher's choice to do so; the packager is not likely to promise an artist any of the publisher's royalties.

Thus, the compensation offered to artists for work through packagers is generally at a lower rate than for work that comes directly through publishers. Two factors may mitigate this difference somewhat. Because a packager's contract with a publisher will involve the sale of a predetermined number of books, paid up front, the packager will pay the artist's royalty on the full print run before publication. If a second printing is ordered, royalties on that print run will again be paid in full, rather than if and when the books are sold.

This arrangement brings payment to the artist somewhat sooner than the standard publisher's contract. Rights to reuse the artwork (in other editions or promotions, for example) often are considered when negotiating the advance or the fee.

Other factors affecting advances and fees in this complex area include: the type of book and the importance of the author; the artist's reputation and record of commercial success; the size of the print order; and length of time estimated for the total project.

Historically, illustrators have gotten partial payments for long projects. For example, one third of the total fee customarily is paid upon approval of sketches, one third upon delivery of finished art, and the remainder within 30 days of delivery of finished art. Some artists report payments of 50 percent for sketches and 50 percent for final art.

Children's books

The illustrator's contribution to a children's book can range widely, from a jacket illustration and a few inside drawings for a young adult novel to the entire contents of a wordless picture book. For pricing purposes, the possibilities usually fall into two categories: a flat fee, for books in which the illustrator's contribution is substantially less than the author's; and a royalty contract, in which the contributions of author and illustrator are comparable or in which the illustrator is also the author.

Publishers' flat-fee contracts tend to ask for all possible rights in the art in return for a one-time fee. However, the illustrator often negotiates to retain some of the rights or to provide for additional payment for additional uses, such as the sale of the paperback rights. Retaining rights to the illustrations can be negotiated more easily in cases where the author also has retained rights.

Some children's books meant for an older age level historically have been illustrated for a flat fee, as are most young adult books. A typical flat-fee book includes the execution of a full-color jacket and from 1 to 14 black-and-white interior illustrations of various sizes.

Royalty contracts

An advance against royalties is paid in most children's picture books, storybooks, and mid-level books. If the author and the artist are not the same person, a full royalty of the book's list price is split between the two creators, commonly 50-50 in the case of a picture book. The royalty and amount of the advance are based on the illustrator's reputation, experience, and desirability.

The advance is designed to reflect the anticipated earnings of the book, and will rarely exceed the royalty due on the sales of the book's entire first printing. Frequently, 50 percent of the advance is paid on signing the contract and the remaining 50 percent is paid on delivery of the artwork. Or advances may be paid in thirds on signing, on delivery of rough sketches, and on delivery of the finished art.

An appropriate advance will be earned back within two years after publication. If the advance is earned back after only three months of release, either the advance was too low or the book was an unexpectedly good seller. It is to the illustrator's advantage to obtain as large an advance as possible, since the advance may not be earned back by sales, or it may take considerable time before further royalties actu-

Children's Book Illustration*

PICTURE BOOKS	ADVANCE	ROYALTY†	ROYALTY ESCALATION‡
Illustrations only	$3000 - 12000	3 - 6%	6.25%
Illustrations and text	4000 - 15000	5 - 10%	4.5 - 15%

USE BEYOND ORIGINAL HARDCOVER EDITION	ROYALTY†
Publisher's direct sales	2.5 - 10% of net sales
Remainder sales	2.5 - 10% of net sales
Canadian sales	3 - 10% of net sales
Publisher's own paperback edition	2.5 - 6% of list price

SUBSIDIARY RIGHTS SALES§	
Percentage of receipts	25 - 50%
Foreign publisher, translation, or English-language edition	25 - 80% of net sales
First serial, dramatic TV, motion picture	25 - 85%
Domestic reprint, paperback, book club, digest, anthology or serial , merchandising, audiovisual, sound recording	25 - 65% of net sales

* Based on a 32-page picture book.

† Royalty percentages are based on the list price of the book.

‡ The escalating percentage is the amount to which the royalty increases after a certain number of sales.

§ Low end of these ranges may reflect a split royalty with text author.

ally are paid. If an advance is earned back very quickly, i.e., within the first six-month royalty period, it is a sign that a higher advance might have been appropriate, a point to consider when negotiating future contracts.

It is customary for a nonrefundable advance to be paid against royalties. Artists should scrutinize contracts for provisions that require the advance to be refunded in the event sufficient numbers of books are not sold to earn it back. It is to the illustrator's advantage to secure nonrefundable advances only.

Royalty contracts are complicated and vary from publisher to publisher. "Boilerplate" authors' contracts rarely are written with artists in mind, and they can be difficult to comprehend. The Graphic Artists Guild strongly recommends that an attorney review any unfamiliar contract if it contains terms about which the illustrator is uncertain, especially if it is the artist's first book contract. And even pub-

lishers' "boilerplate" contracts are not carved in stone and can be changed if the changes are agreeable to both parties. Among those sections of a royalty contract that are often negotiated are the lists of the royalty percentages for the publisher's uses of the work ("publisher's direct") and for the sale of subsidiary rights. Please refer to the table in this section for the comparative children's book illustration royalties for uses beyond the original hardcover edition.

These agreements between publisher and illustrator cover considerably more than setting the amount of the advance. The basic provisions of a book royalty contract historically have been:

♦ *grant of rights:* The illustrator grants to the publisher the right to use the art as specified within the contract.

♦ *delivery:* Sets deadlines for finished art and sometimes for rough sketches. This clause

also often has specified what payments are due the artist in the event the project is canceled or rejected (see the Cancellation and Rejection Fees section in the Professional Issues chapter).

♦ *warranty:* A representation that the illustrator has not infringed copyrights or broken any other laws in granting rights to the publisher.

♦ *indemnity:* The illustrator shares the cost of defending any lawsuit brought over the art. An artist who is found to have broken the terms of the warranty bears the entire cost of the lawsuit and any damages that may result. The indemnity provision might present more risk than the illustrator is willing to accept, but without an attorney it is difficult to counter effectively. An illustrator should request to be indemnified by the publisher for any suits arising from a request on the publisher's part, such as making a character look like a famous person.

♦ *copyright:* The publisher agrees to register the copyright in the work in the artist's name.

♦ *agreement to publish:* The book will be published within a specific period of time, usually 18 months from receipt of finished art. If the publisher fails to do so, the rights should revert back to the artist (reversion rights).

♦ *advance and division of royalties:* The main points were discussed above and are reflected in the table following this section. Additional points to consider are:

♦ *paperback advance:* Whether an advance against royalties will be paid for the original publisher's own paperback reprint historically has been negotiated at the time of the original contract. The royalty rate usually has been less than for the hardcover edition.

♦ *escalation:* For trade books, royalties totaling 10 percent (for author and illustrator combined) historically often have escalated to 12.5 percent after sales reach 20,000 copies. Mass market books have had lower royalty rates, which have also escalated.

♦ *deescalation:* Some publisher's contracts historically have provided for royalty rates to decrease dramatically under two conditions: when high discounts are given to distributors or other buyers; or when book sales from a low quantity reprint are slow. Not all publishers include these clauses in their contracts; it is in the artist's interest to strike them, or at least to try to negotiate improvements.

Traditionally, there has been some justification for the illustrator to accept a lower royalty in a book whose sales are increased vastly by a high discount negotiated between the publisher and booksellers, such as bookstore chains. It also has been historical practice for the royalty to decline incrementally once discounts pass 50 percent. It is less favorable for the artist to accept the terms offered by some publishers whereby any discount above, say, 50 percent produces royalties figured not on the book's list price but on the "amount received"—i.e., the wholesale price—which immediately reduces the royalty rate by at least half.

Illustrators also have found it desirable to ensure that this deep discount is given only for "special sales" and is not a part of the publisher's normal trade practice. This latter could mean that publishers are using these discounts to gain sales at the expense of the artist and/or author. Be aware that as giant retail and bookstore chains' domination of the book market has grown, deep discounts have as well. Deep discounts are also customary in sales through book fairs and the publisher's own book club.

By accepting a decrease in royalty for a slow-selling reprint, the illustrator may give the publisher incentive to keep the book in print. But the terms of the decrease should have limitations. For example, the book should have been in print at least two years, be in a reprint edition of 2,500 or fewer copies, and have sales of less than 500 copies in one royalty period. Under these conditions, the royalty might drop to 75 or even 50 percent of the original rate.

A foreign-language edition to be sold domestically also may be published with a lower royalty rate, as it is costlier to produce than a simple reprint and may have limited sales potential. Terms may be set, however, to escalate to a normal royalty rate if sales exceed these low expectations.

♦ *subsidiary sales:* Income derived from the publisher's selling any rights to a third party are divided between publisher and artist and/or author, depending on whether the rights involve art, text, or both. The percentage earned by the illustrator for each type of use is variable and is determined by negotiation. The current matter of electronic rights, either as a subsidiary right or as income derived from the publisher's own electronic products, is much discussed—and little understood by artists.

Book Interior Illustration

ADULT HARDCOVER BOOKS

	B/W*	COLOR
Major publisher or large distribution		
Spread	$1000 - 2000	$1200 - 3200
Full page	500 - 1500	900 - 2500
Half page	250 - 1000	475 - 1800
Quarter page	150 - 700	375 - 1000
Spot†	100 - 450	200 - 750
Small publishers or limited distribution		
Spread	$750 - 1200	$1000 - 3000
Full page	225 - 700	750 - 1500
Half page	150 - 500	400 - 1000
Quarter page	125 - 400	200 - 800
Spot†	100 - 200	150 - 400

YOUNG ADULT BOOKS

	B/W*	COLOR
Major publisher or large distribution		
Spread	$400 - 1500	$800 - 2000
Full page	300 - 750	400 - 1500
Half page	150 - 400	200 - 1000
Quarter page	100 - 375	150 - 500
Spot†	75 - 300	100 - 400
Small publishers or limited distribution		
Spread	$400 - 1000	$500 - 1500
Full page	300 - 500	375 - 1200
Half page	150 - 300	220 - 600
Quarter page	75 - 125	150 - 250
Spot†	50 - 150	100 - 150

COLLEGE TEXTBOOKS

	B/W*	COLOR
Spread	$450 - 1000	$750 - 2000
Full page	400 - 750	500 - 1200
Half page	250 - 500	375 - 1000
Quarter page	150 - 250	200 - 375
Spot†	60 - 150	80 - 200

ELEMENTARY THROUGH HIGH SCHOOL TEXTBOOKS

	B/W*	COLOR
Spread	$400 - 1000	$750 - 1500
Full page	300 - 750	400 - 1000
Half page	200 - 450	300 - 600
Quarter page	100 - 350	100 - 375
Spot†	60 - 150	80 - 200

JUVENILE WORKBOOKS

	B/W*	COLOR
Spread	$300 - 1200	$300 - 1750
Full page	200 - 750	300 - 1000
Half page	150 - 500	200 - 600
Quarter page	100 - 350	125 - 400
Spot†	50 - 250	50 - 300

* Current data indicates that an additional 25% is added for each color overlay in addition to black.

† A spot illustration is one animal, one person, or one inanimate object. Necessary research should be supplied by the publisher or additional compensation may be warranted.

Some publishing contracts leave the category unresolved, stating specifically that terms for electronic rights will be agreed upon mutually when and if the need arises. Please see the New Technology Issues chapter for a more detailed discussion of these concerns.

♦ *author's copies:* Publisher's contracts usually provide 10 free copies of the book to the author, but 20 free copies often are negotiated. Most publishers offer the artist a 40 to 50 percent discount off the list price on purchases of their book. Some publishers will pay royalties on these sales, while others (ungenerously) do not.

♦ *schedule of statements and payments:* This defines when and how accounting will be made. Normally, a royalty period is six months, with the appropriate royalty payment made four months and one day after the period closes. In this section a useful clause found in many contracts allows access by the artist or a designated accountant to examine the publisher's books and records. If, in a given royalty period, errors of 5 percent or more are found in the publisher's favor, the publisher will correct the underpayment and pay the cost of the examination up to the amount of the error.

♦ *pass-through clause:* This takes effect when the illustrator's share of a subsidiary sale exceeds $1,000. The publisher will then send payment within 30 days of receipt rather than holding it for the semiannual royalty reporting date. If the audit costs *more* than the error, artists must pay the difference.

♦ *remaindering:* If the book is to be remaindered, the publisher should notify the illustrator and allow him or her to buy any number of copies at the remaindered price.

♦ *termination of agreement:* This provides that if a work is not or will not be available in any edition in the United States, it is out of print. At that time, the illustrator may request in writing that all rights return to the artist. The publisher usually will have six months to declare an intent to reprint and a reasonable amount of time in which to issue a new edition. Failing this, the agreement terminates and all rights return to the artist.

In some boilerplates, "out-of-print" is defined too narrowly, or the time allowed the publisher can be unreasonably lengthy. Some contracts also grant the illustrator the right to purchase any existing film, plates, die stamps, etc., within 30 days after termination.

♦ *quality control:* Occasionally, a provision is added to contracts that allows the illustrator to consult on the design of the book and to view bluelines, color separations, and proofs while corrections can still be made. However, a good working relationship and an informal agreement with the art director is probably as good a guarantee of this actually occurring.

♦ *revisions without the author's consent:* A clause prohibiting this is good insurance for protecting the integrity of one's work. Another protective measure specifies any fees to be paid in the event of any lost or damaged artwork due to the publisher's negligence.

Many of these contractual points may not add up to much money for any one book, or even a lifetime of books. But illustrators can only manage their careers if they retain control over the work. Therefore, it makes sense to attempt to negotiate the best possible contract, not merely the best possible advance.

Young adult books

Advances or royalties traditionally are not paid in this category; artwork has been done for a straight fee. A typical book includes a full-color wraparound jacket and from 1 to 14 black-and-white interior illustrations of various sizes.

Juvenile workbooks

Most workbooks are assigned through brokers or other publishers agents who historically have established pricing for each book with the publisher. Illustrator fees for these projects may vary considerably; working directly with the publisher is preferable. Brokers and agents specializing in this field represent many illustrators who work in varied styles. Workbooks usually are priced per page, per half page, or per spot. Although fees have been quite low, an entire workbook can add up to a considerable amount of work. Artists who are able to produce this kind of artwork quickly may find this quite lucrative and feel secure that months of work lie ahead. Often, a single book needing a considerable amount of illustration is divided up among several illustrators in order to meet publishing deadlines.

Budgets for workbooks vary considerably depending on the size of the publisher, locality, publication schedules, and experience of the artist.

Trade practices

The following trade practices have been used historically and, through such traditions, are accepted as standard:

1. The intended use of the art must be stated clearly in a contract, purchase order, or letter of agreement stating the price and terms of sale.
2. Artists normally sell only first reproduction rights unless otherwise stated.
3. If artwork is to be used for other than its original purpose, the price usually is negotiated as soon as possible. The secondary use of an illustration may be of greater value than the primary use. While publishers frequently offer work-for-hire contracts in this market, artists may negotiate terms for secondary use. Although there is no set formula for reuse fees, current surveys indicate artists add a reuse fee ranging from 50 to 100 percent of the fee that would have been charged had the illustration originally been commissioned for the anticipated usage.
4. Illustrators should negotiate reuse arrangements with the original commissioning party with speed, efficiency, and all due respect to the client's position.
5. Return of original artwork to the artist is automatic unless otherwise negotiated.
6. Historically, artists have charged higher fees for rush work than those listed here, often by an additional 20 to 100 percent.
7. When satisfactory art has been produced but the publisher, for whatever reason, decides not to use it, the full payment customarily goes to the artist. Rights to the unused work are not transferred to the publisher.

 If a job is canceled after the work is begun, through no fault of the artist, historically, a cancellation or kill fee often is charged. Depending upon the stage at which the job is terminated, the fee has covered all work done, including research time, sketches, billable expenses, and compensation for lost opportunities resulting from an artist's refusing other offers to make time available for a specific commission. In addition, clients who put commissions "on hold" or withhold approval for commissions for longer than 30 days usually secure the assignment by paying a deposit.
8. Historically, a rejection fee has been agreed upon if the assignment is terminated because the preliminary or finished work is found to be not reasonably satisfactory and steps to correct the problem have been exhausted. The rejection fee for finished work often has been over 50 percent of the full price, depending upon the reason for rejection and the complexity of the job. When the job is rejected at the sketch stage, current surveys indicate a fee of 20 to 50 percent of the original price is customary. This fee may be less for quick, rough sketches and more for highly rendered, time-consuming work.
9. Artists considering working on speculation often assume all risks and should take these into consideration when offered such arrangements; see section on Speculation in the Professional Issues chapter for details.
10. The Graphic Artists Guild is unalterably opposed to the use of work-for-hire contracts, in which authorship and all rights that go with it are transferred to the commissioning party and the independent artist is treated as an employee for copyright purposes only. The independent artist receives no employee benefits and loses the right to claim authorship or profit from future use of the work forever. Additional information on work for hire can be found in the chapter on Legal Rights and Issues.
11. Customary and usual expenses such as unusual props, costumes, model fees, travel costs, production costs, and consultation time should be billed to the client separately. An expense estimate should be included in the original written agreement or as an amendment to the agreement.

All prices for illustration in the *Guidelines* are based on a survey of the United States and Canada that was reviewed by a special committee of experienced professionals through the Graphic Artists Guild. These figures, reflecting the responses of established professionals, are meant as a point of reference only and do not necessarily reflect such important factors as deadlines, job complexity, reputation and experience of a particular illustrator, research, technique or unique quality of expression, and extraordinary or extensive use of the finished art. Please refer to related material in other sections of this book, especially in the Pricing and Marketing Artwork and Standard Contracts and Business Tools chapters.

The prices shown represent only the specific use for which the illustration is intended and do not necessarily reflect any of the above

considerations. The buyer and seller are free to negotiate, with each artist independently deciding how to price his or her artwork and taking into account all the factors involved.

Editorial illustration

Editorial illustrators work for art directors and editors of consumer and trade magazines and newspapers to illustrate specific stories, covers, columns, or other editorial material in print or electronic media. Often, the art director, editor, and illustrator discuss the slant and intended literary and graphic impact of a piece before sketches are prepared. If necessary, illustrators might prepare several sketches to explore a range of approaches to the problem. Editorial art usually is commissioned under tight deadlines, especially in news publications and weekly magazines and newspapers.

Trade practices

The following trade practices have been used historically and, through such traditions, are accepted as standard:

1. The intended use of the art must be stated clearly in a contract, purchase order, or letter of agreement stating the price and terms of sale.
2. Artists normally sell only first reproduction rights unless otherwise stated.
3. If artwork is to be used for other than its original purpose, the price usually is negotiated as soon as possible. The secondary use of an illustration may be of greater value than the primary use. Although there is no set formula for reuse fees, current surveys indicate artists add a reuse fee ranging from 50 to 100 percent of the fee that would have been charged had the illustration originally been commissioned for the anticipated usage.
4. Illustrators should negotiate reuse arrangements with the original commissioning party with speed, efficiency, and all due respect to the client's position.
5. Return of original artwork to the artist is automatic unless otherwise negotiated.
6. Historically, artists have charged higher fees for rush work than those listed here, often by an additional 20 to 150 percent.
7. If a job is canceled after the work is begun, through no fault of the artist, historically, a cancellation or kill fee often is charged. Depending upon the stage at which the job is terminated, the fee has covered all work done, including research

time, sketches, billable expenses, and compensation for lost opportunities resulting from an artist's refusing other offers to make time available for a specific commission. In addition, clients who put commissions "on hold" or withhold approval for commissions for longer than 30 days usually secure the assignment by paying a deposit.

8. Historically, clients have paid a rejection fee if the assignment is terminated because the preliminary or finished work is found to be not reasonably satisfactory. The rejection fee for finished work has often been over 50 percent of the full price, depending upon the reason for rejection and the complexity of the job. When the job is rejected at the sketch stage, current surveys indicate a fee of 20 to 50 percent of the original price is customary. This fee may be less for quick, rough sketches and more for highly rendered, time-consuming work.
9. Artists considering working on speculation often assume all risks and should take these into consideration when offered such arrangements; see section on Speculation in the Professional Issues chapter for details.
10. The Graphic Artists Guild is unalterably opposed to the use of work-for-hire contracts, in which authorship and all rights that go with it are transferred to the commissioning party and the independent artist is treated as an employee for copyright purposes only. The independent artist receives no employee benefits and loses the right to claim authorship or profit from future use of the work forever. Additional information on work for hire can be found in the chapter on Legal Rights and Issues.
11. Customary and usual expenses such as unusual props, costumes, model fees, travel costs, production costs, and consultation time should be billed to the client separately. An expense estimate should be included in the original written agreement or as an amendment to the agreement.

All prices for illustration in the *Guidelines* are based on a survey of the United States and Canada that was reviewed by a special committee of experienced professionals through the Graphic Artists Guild. These figures, reflecting the responses of established professionals, are meant as a point of reference only and do not necessarily reflect such important factors as

deadlines, job complexity, reputation and experience of a particular illustrator, research, technique or unique quality of expression, and extraordinary or extensive use of the finished art. Please refer to related material in other sections of this book, especially in the Pricing and Marketing Artwork and Standard Contracts and Business Tools chapters.

The prices shown represent only the specific use for which the illustration is intended and do not necessarily reflect any of the above considerations. The buyer and seller are free to negotiate, with each artist independently deciding how to price his or her artwork and taking into account all the factors involved.

Magazines

Fees for editorial assignments historically have been tied to the magazine's circulation and geographic distribution, which in turn determine its advertising rates and thus its income. Several categories of consumer magazines are presented following. However, magazines don't always fall neatly into one specific category. For example, *Time, Reader's Digest,* and *Family Circle* are high-circulation general interest consumer magazines. *Forbes* is a general business magazine. Distributed nationally, it falls into the regional or medium category because of its comparatively lower circulation of 800,000 copies. It is, however, a highly successful publication that ranked number 17 on the Folio 500, with 1995 revenues of more than $209 million, reflecting 4,542 advertising pages sold at $37,480 per black-and-white page (a 15 percent increase over 1992, when it was ranked number 20). *Popular Mechanics* (ranked number 64 on the Folio: 500, with 1995 revenues of $73.6 million) also is distributed nationally but is considered a single interest magazine. *New York* magazine (ranked number 58 on the Folio: 500) is a special-interest magazine serving a primarily local readership, but because it enjoyed with 1995 revenues of nearly $77.8 million is large enough to place it in the regional or medium category.

For editorial assignments in trade publications, figures on circulation and readership are the most accepted basis for judging the proper categories for publications. Occasionally the type of readership can influence the level of quality of the publication and fees paid for commissioned artwork; i.e., fees may be higher from *The New Yorker* magazine, which historically has had a higher income demographic than similar circulation magazines. Circulation and distribution information is usually available from advertising and subscription departments of magazines.

Spot illustrations are usually one column in width and simple in matter. Although quarter-page illustrations are not spots, some magazines (particularly those with lower budgets) make no distinction between the two. Judging the complexity of the assignment can help determine if a spot rate is appropriate. There has been a tendency in recent years to call any illustration that is less than half a page a spot illustration. This practice fails to describe accurately the commissioned illustration and undermines established trade practices to the detriment of the artist.

Spread illustrations occupy two facing pages in a publication. In the event a spread illustration occupies only one half of each page, one historical basis for fee negotiation has been to add the partial page rates below. However, if only the title or very little text is used on the spread, it could be interpreted as a full-spread illustration. In these cases, discretion should be used.

Newspapers

Some city newspapers, such as the *New York Times* and *Washington Post,* are considered large-circulation, national publications for pricing purposes. They carry national and international news and are distributed both nationally and internationally. Medium-circulation newspapers generally are regional in nature, sell outside the city where they are published, often carry national news and publish four-color supplements and weekend magazines. Local newspapers, naturally, have the lowest circulation. However, even in this category the size of readership varies widely and historically has always been taken into account when determining fees. It is worth noting that this has been one of the lowest-paying fields of illustration and is valued mostly as a trade-off for the excellent exposure that large daily newspapers provide, especially for new and emerging talent.

Magazine Editorial Illustration

Consumer Magazines

GENERAL INTEREST (READER'S DIGEST, PEOPLE WEEKLY) OR LARGE CIRCULATION

	B/W*	COLOR
Cover	-	$2000 - 4000
Spread	-	2500 - 5500
Full page	-	1000 - 3000
Half page	$400 - 2000	600 - 1500
Quarter page	300 - 1000	500 - 1000
Spot	200 - 600	300 - 700

SPECIAL INTEREST (THE NEW YORKER, THE ATLANTIC MONTHLY) OR MEDIUM CIRCULATION

	B/W*	COLOR
Cover	-	$1500 - 4000
Spread	-	1000 - 3000
Full page	-	600 - 2000
Half page	$500 - 1000	400 - 1200
Quarter page	300 - 750	350 - 750
Spot	200 - 500	200 - 600

SINGLE INTEREST (SCIENTIFIC AMERICAN, GOLF DIGEST,) OR SMALL CIRCULATION

	B/W*	COLOR
Cover	-	$1000 - 2500
Spread	-	800 - 2000
Full page	-	500 - 1500
Half page	$200 - 1000	350 - 1000
Quarter page	150 - 600	300 - 750
Spot	100 - 500	150 - 500

* Current data indicates that an additional 25% is added for each color overlay in addition to black.

Business Magazines

GENERAL BUSINESS MAGAZINES (FORTUNE, FORBES, BUSINESS WEEK) OR LARGE CIRCULATION

	B/W*	COLOR
Cover	-	$1000 - 4000
Spread	-	1000 - 4000
Full page	-	850 - 2000
Half page	$600 - 1000	500 - 1200
Quarter page	400 - 750	400 - 1000
Spot	200 - 650	300 - 600

TRADE (CHAIN STORE AGE), INSTITUTIONAL (HOSPITALS), PROFESSIONAL (ARCHITECTURAL RECORD) MAGAZINES OR SMALL CIRCULATION

Cover	-	$750 - 2500
Spread	-	750 - 2500
Full page	$450 - 1500	550 - 1500
Half page	300 - 1000	350 - 1000
Quarter page	150 - 750	250 - 750
Spot	100 - 400	150 - 500

RESEARCH AND ACADEMIC JOURNALS

Cover	$800 - 2000	$800 - 2500
Spread	-	800 - 2000
Full page	400 - 1500	500 - 1500
Half page	300 - 1000	400 - 1000
Quarter page	150 - 750	250 - 800
Spot	100 - 500	200 - 500

Newspaper Editorial Illustration

Newspapers

NATIONAL, LARGE METRO AREA OR LARGE CIRCULATION	B/W	COLOR
Section cover	$600 - 2000	$800 - 3000
Full page	500 - 1500	600 - 2000
Half page	300 - 1000	750 - 1500
Quarter page	200 - 700	550 - 1200
Spot	300 - 600	400 - 900

MIDSIZE AND SMALL METRO AREA OR MEDIUM AND SMALL CIRCULATION	B/W	COLOR
Section cover	$500 - 1500	$750 - 2000
Full page	300 - 1000	500 - 1500
Half page	300 - 750	300 - 1000
Quarter page	125 - 500	300 - 750
Spot	100 - 400	150 - 500

Magazine Supplements for Newspapers

NATIONAL, LARGE METRO AREA OR LARGE CIRCULATION	B/W	COLOR
Section cover	$600 - 3000	$700 - 4000
Spread	500 - 2000	650 - 3000
Full page	500 - 1500	500 - 2000
Half page	400 - 1000	300 - 1500
Quarter page	300 - 850	300 - 1000
Spot	250 - 650	200 - 750

MIDSIZE AND SMALL METRO AREA OR MEDIUM AND SMALL CIRCULATION	B/W	COLOR
Section cover	$500 - 2000	$550 - 2500
Spread	450 - 2000	550 - 2500
Full page	350 - 1500	350 - 2000
Half page	350 - 1000	200 - 1000
Quarter page	300 - 750	200 - 750
Spot	250 - 500	250 - 600

Packaging illustration

The demand for engaging, forceful, and highly creative packaging for recordings has attracted the best of today's talented editorial and advertising illustrators, who in turn have created a new art form. Many record album covers have become collector's items. Several books have been published on record album cover art and an ongoing market has developed for collecting.

With the advent of the smaller format of the CD and cassette during the 1980s, the overall graphic presentation and type design have come to rival cover artwork in importance. The long box gave some large-scale opportunities for artists, but these have been phased out because of concerns about unnecessary waste of materials and space; small boxes allow retailers to display more CDs.

Commissions for recording cover illustration can be lucrative. Based on current data, however, fees vary widely, depending on the recording artist, the particular label and recording company, and the desirability and fame of the illustrator.

With the growth of the number of independent record companies specializing in specific genres, there are many modest-budget, total-package (illustration and design by one supplier) assignments for the diligent creators willing to search for them in many locations around the country. Fees for complex recording packages have gone higher than $10,000. This kind of assignment, however, requires many meetings, sketches, and changes.

Most recording companies produce under several labels, depending on the recording artist and type of music. The minor labels of major recording companies usually are reserved for less commercial records and rereleases of previous recordings. Recent mergers and acquisitions in the recording industry (Sony-Columbia, BMG-RCA, Turner-Time Warner) have all but eliminated any discernible differences in fees based on geographic location, according to current survey data. In all cases, only record company publication

rights are transferred, and the original art is returned to the artist. Sometimes, tie-in poster rights are included.

It is common in the music packaging market for the musicians, their management, or the project's producers to desire to purchase the original art. The artist should be prepared with a dollar amount in case this happens. Possible tie-ins with videotape/disk marketing should also be kept in mind when considering an appropriate fee for the image.

Trade practices

The following trade practices have been used historically and, through such traditions, are accepted as standard:

1. The intended use of the art must be stated clearly in a contract, purchase order, or letter of agreement stating the price and terms of sale.
2. Artists normally sell only first reproduction rights unless otherwise stated.
3. If artwork is to be used for other than its original purpose, the price usually is negotiated as soon as possible. The secondary use of an illustration may be of greater value than the primary use. Although there is no set formula for reuse fees, current surveys indicate artists add a reuse fee ranging from 50 to 100 percent of the fee that would have been charged had the illustration originally been commissioned for the anticipated usage.
4. Illustrators should negotiate reuse arrangements with the original commissioning party with speed, efficiency, and all due respect to the client's position.
5. Return of original artwork to the artist is automatic unless otherwise negotiated.
6. Historically, artists have charged higher fees for rush work than those listed here, often by an additional 20 to 150 percent.
7. If a job is canceled after the work is begun, through no fault of the artist, historically, a cancellation or kill fee often is charged. Depending upon the stage at which the job is terminated, the fee has covered all work done, including research time, sketches, billable expenses, and compensation for lost opportunities resulting from an artist's refusing other offers to make time available for a specific commission. In addition, clients who put commissions "on hold" or withhold approval for commissions for longer than 30 days usually secure the assignment by paying a deposit.

8. Historically, a rejection fee has been agreed upon if the assignment is terminated because the preliminary or finished work is found not to be reasonably satisfactory and steps to correct the problem have been exhausted. The rejection fee for finished work has often been over 50 percent of the full price, depending upon the reason for rejection and the complexity of the job. When the job is rejected at the sketch stage, current surveys indicate a fee of 20 to 50 percent of the original price is customary. This fee may be less for quick, rough sketches and more for highly rendered, time-consuming work.
9. Artists considering working on speculation often assume all risks and should take these into consideration when offered such arrangements; see Speculation section in the Professional Issues chapter for details.
10. The Graphic Artists Guild is unalterably opposed to the use of work-for-hire contracts, in which authorship and all rights that go with it are transferred to the commissioning party and the independent artist is treated as an employee for copyright purposes only. The independent artist receives no employee benefits and loses the right to claim authorship or profit from future use of the work forever. Additional information on work for hire can be found in the chapter on Legal Rights and Issues.
11. Customary and usual expenses such as unusual props, costumes, model fees, travel costs, production costs, consultation time, and so on should be billed to the client separately. An expense estimate should be included in the original written agreement or as an amendment to the agreement.

All prices for illustration in the *Guidelines* are based on a survey of the United States and Canada that was reviewed by a special committee of experienced professionals through the Graphic Artists Guild. These figures, reflecting the responses of established professionals, are meant as a point of reference only and do not necessarily reflect such important factors as deadlines, job complexity, reputation and experience of a particular illustrator, research, technique or unique quality of expression, and extraordinary or extensive use of the finished art. Please refer to related material in other sections of this book, especially in the Pricing and Marketing Artwork and Standard Contracts and Business Tools chapters.

Packaging Illustration

MUSIC RECORDINGS*	POPULAR & ROCK	CLASSICAL & JAZZ	OTHER
Major studio or distribution	$1300 - 5000	$1000 - 3000	$500 - 3500
Small studio or distribution	1300 - 3000	1000 - 3000	500 - 2000
Re-released recording	1300 - 1500	1000 - 3000	500 - 2000

VIDEOS*	SPECIAL/SINGLE INTEREST	GENERAL INTEREST
Major studio or distribution	$1000 - 3500	$1500 - 3000
Small studio or distribution	500 - 1000	1000 - 2000
Re-released recording	500 - 1000	1000 - 2000

SOFTWARE*	TEST RUN[†]	LIMITED DISTRIBUTION[†]	NATIONAL DISTRIBUTION[†]
Business software	$1000 - 2000	$1500 - 3500	$3000 - 7000
Educational software	1000 - 1500	2000 - 3000	3000 - 4000
Video games software	1500 - 2000	2500 - 3500	2500 - 4500

RETAIL PRODUCTS BY CATEGORY			
Apparel	-	-	$300 - 4700
Electronics	-	$3000	-
Food/beverages	$300 - 3000	500 - 5000	1500 - 4000
Footwear	-	-	1000
Furniture/home furnishings	-	1200	-
Gifts/novelties	1200	-	-
Health/beauty aids	400 - 1000	500 - 3500	1500 - 5500
Housewares	400	1500 - 2000	2500
Infant products	-	-	750 - 2000
Sporting goods	500	500	500
Stationery	500	500	500
Toys/games	1000 - 4500	1000	1000 - 7500
Video games/software	2500	2500 - 3500	2000 - 4500
Other (cards, labels, pet food)	4000	1200 - 2500	3000 - 9000

* One piece of art used on CD and cassettes.

† Test run and limited distribution products usually have a short shelf life. National distribution indicates an extended shelf life.

The prices shown represent only the specific use for which the illustration is intended and do not necessarily reflect any of the above considerations. The buyer and seller are free to negotiate, with each artist independently deciding how to price his or her artwork and taking into account all the factors involved.

Fashion illustration

These graphic artists illustrate clothed figures and accessories in a specific style or "look" for retailers, advertising, graphic design studios, corporations/manufacturers, and in editorials for magazines and newspapers.

Sometimes fashion illustrators are required to create an illustration with only a photo or croquis (working sketch) of the garment for reference (i.e., the illustrator must invent the drape of the garment on a model, the light source, or even the garment itself).

Although the advertising market for apparel and accessory illustration has declined in recent years, it has been offset in part by growth in the beauty and cosmetic areas, including package and collateral illustration, as well as the development of crossover markets to which a fresh and flexible style is well-suited.

Beauty/cosmetic illustration generally is used as finished or comp art for print advertising, television/video, storyboards, packaging, display, collateral material, magazine, or newspaper editorial and product development presentation.

Current data indicate that factors determining fees are type and extent of usage, market (such as corporate, advertising, or editorial), size and prestige of account, volume of work, the illustrator's experience and desirability, job complexity, and deadlines.

Most apparel illustration is paid on a per-figure basis, with an additional charge for backgrounds. When more than three figures are shown 4 to 10), a group rate can be charged at a lower rate, usually 80 to 90 percent of an artist's single figure rates. In volume work (considered any amount over 10 figures), such as catalog, brochure, or instructional use, the per-figure price is negotiated at a volume rate, usually 75 percent. Accessory illustration generally is paid on a per-item basis. When more than three items are shown, additional items can be charged at a lower unit price, as above. With the exception of specialized work, accessory illustration rates are generally 50 to 75 percent of an artist's per-figure prices.

The price ranges listed reflect current data based on surveys of fees for women's, men's, and children's fashion, beauty, and cosmetic illustration. These ranges do not reflect complexity of style and fees for highly rendered and photographic styles of illustration, which data indicate command a 50 percent premium over the high ranges in all categories.

Trade practices

The following trade practices have been used historically and, through such traditions, are accepted as standard:

1. The intended use of the art must be stated clearly in a contract, purchase order, or letter of agreement stating the price and terms of sale.
2. Artists normally sell first reproduction rights unless otherwise stated.
3. Current data indicates that additional uses of artwork in the same (or other) media occasions additional fees ranging between 20 to 100 percent of the standard initial fee for the same medium usage.
4. If artwork is to be used for other than its original purpose, the price usually is negotiated as soon as possible. The secondary use of an illustration may be of greater value than the primary use. Although there is no set formula for reuse fees, current surveys indicate artists add a reuse fee ranging from 20 to 100 percent of the fee that would have been charged had the illustration originally been commissioned for the anticipated usage.
5. Illustrators should negotiate reuse arrangements with the original commissioning party with speed, efficiency, and all due respect to the client's position.
6. All rights transferred (reproduction *or* original artwork): If a client wishes to purchase all reproduction rights *or* original artwork, current data indicates that a typical charge is 100 percent of the assignment price or higher, depending on the value of the original art for the individual artist. The artist retains the copyright.
7. All rights transferred (reproduction *and* original artwork): If a client wishes to purchase all reproduction rights *and* original artwork, current data indicates that 200 percent of the assignment price or higher, depending on the value of the original art for the individual artist, is charged. The artist retains the copyright.
8. Return of original artwork to the artist is automatic unless otherwise negotiated.

Fashion/Beauty Illustration for
Collateral and Direct Mail

Direct Mail Brochures

PRINT RUN OVER 100,000
OR LARGE CIRCULATION

	B/W[†]	COLOR
Cover	$1500 - 5000	$1800 - 5000
Figure*	1000	1700
Spot-quarter page	500 - 1500	500 - 2500

PRINT RUN 10,000-100,000
OR MEDIUM CIRCULATION

Cover	$850 - 4000	$1000 - 4000
Figure*	750	1400
Spot-quarter page	350 - 2000	400 - 2500

PRINT RUN UNDER 10,000
OR SMALL CIRCULATION

Cover	$500 - 2000	$500 - 3000
Figure*	350	900
Spot-quarter page	350 - 1000	500 - 1500

Instructional Booklets

PRINT RUN OVER 100,000
OR LARGE CIRCULATION

Cover	$2000 - 2500	$2000 - 3500
Figure*	800	1400
Spot-quarter page	500 - 750	500 - 1000

PRINT RUN 10,000-100,000
OR MEDIUM CIRCULATION

Cover	$1000 - 2000	$2000 - 3000
Figure*	450	900
Spot-quarter page	400 - 750	500 - 1000

PRINT RUN UNDER 10,000
OR SMALL CIRCULATION

Cover	$1000 - 2000	$1000 - 2000
Figure*	275	550
Spot-quarter page	250 - 500	300 - 500

Retail Catalogs

PRINT RUN OVER 100,000
OR LARGE CIRCULATION

	B/W[†]	COLOR
Cover	$1500 - 4000	$2000 - 5000
Figure*	800	1300
Spot-quarter page	500 - 700	500 - 1000

PRINT RUN 10,000-100,000
OR MEDIUM CIRCULATION

Cover	$1300 - 3000	$1750 - 4000
Figure*	550	900
Spot-quarter page	250 - 500	300 - 500

PRINT RUN UNDER 10,000
OR SMALL CIRCULATION

Cover	$800 - 2000	$800 - 3000
Figure*	350	600
Spot-quarter page	175 - 500	300 - 500

Trade Catalogs

PRINT RUN OVER 100,000
OR LARGE CIRCULATION

Cover	$2000 - 4000	$2000 - 5000
Figure*	800	1400
Spot-quarter page	500 - 1000	500 - 1500

PRINT RUN 10,000-100,000
OR MEDIUM CIRCULATION

Cover	$2000 - 3000	$2000 - 4000
Figure*	450	900
Quarter page	250 - 500	500 - 1500

PRINT RUN UNDER 10,000
OR SMALL CIRCULATION

Cover	$2000	$2000 - 2500
Figure*	350	600
Spot-quarter page	150 - 500	200 - 500

* Based on 1994 data.

† Current data indicates that an additional 25% is added for each color overlay in addition to black.

Fashion/Beauty Illustration for
Collateral and Direct Mail (cont'd)

Other	B/W†	COLOR		B/W†	COLOR
Hang tag/labels	$750 - 800	$1000 -2000	**Line sheets/price list***		
Patterns	150	250 - 375	Figure‡	$50	$100 - 125
Store fixtures	1000*	1500 -2500	Flat‡	20	50
T-shirt apparel			**Retail buying service/mat service***		
Flat fee	$500 -1000	$500 -1500	Figure‡	$100	-
Advance	250	500 - 750	Flat‡	10	-
Royalty	2 - 10%	5 - 15%			
Showroom/presentation boards*					
Figure	$150 - 300	$250 - 500			
Flat	30 - 50	50 - 100			

* Current prices listed are per piece, based on volume quantities (defined as minimum of 5 pieces).

† Current data indicates that an additional 25% is added for each color overlay in addition to black.

‡ Based on 1994 data.

Fashion/Beauty Advertising Illustration
please see general illustration advertising section.

Fashion/Beauty Editorial Illustration
please see general illustration editorial section.

9. Historically, artists have charged higher fees for rush work than those listed here, often by an additional 20 to 150 percent.

10. All corrections/revisions should be made in preliminary sketch. All client changes, particularly in finished art, historically engender an additional charge; the amount depends on the amount and complexity of the change. (Refer to cancellation fees below.)

11. If a job is canceled after the work is begun, through no fault of the artist, historically, a cancellation or kill fee often is charged. Depending upon the stage at which the job is terminated, the fee has covered all work done, including research time, sketches, billable expenses, and compensation for lost opportunities resulting from an artist's refusing other offers to make time available for a specific commission. Current data indicate that these fees are calculated as follows: prior to finish-in-progress, 50 percent; finished art-in-progress, 70 percent; after completion of finished art, 100 percent. In addition, clients who put commissions "on hold" or withhold approval for commissions for longer than 30 days usually secure the assignment by paying a deposit.

12. Historically, a rejection fee has been agreed upon if the assignment is terminated because the preliminary or finished work is found not to be reasonably satisfactory and steps to correct the problem have been exhausted. The rejection fee for finished work often has been over 50 percent of the full price, depending upon the reason for rejection and the complexity of the job. When the job is rejected at the sketch stage, current surveys indicate a fee of 20 to 50 percent of the original price is cus-

tomary. This fee may be less for quick, rough sketches and more for highly rendered, time-consuming work.

13. Artists considering working on speculation often assume all risks and should take these into consideration when offered such arrangements; see Speculation section in the Professional Issues chapter for details.

14. The Graphic Artists Guild is unalterably opposed to the use of work-for-hire contracts, in which authorship and all rights that go with it are transferred to the commissioning party and the independent artist is treated as an employee for copyright purposes only. The independent artist receives no employee benefits and loses the right to claim authorship or profit from future use of the work forever. Advertising is not eligible to be work for hire, as it does not fall under any of the eligible categories defined in the law. Additional information on work for hire can be found in the chapter on Legal Rights and Issues.

15. Customary and usual expenses such as unusual props, costumes, model fees, travel costs, production costs, consultation time, and so on should be billed to the client separately. An expense estimate should be included in the original written agreement or as an amendment to the agreement.

All prices for illustration in the *Guidelines* are based on a survey of the United States and Canada that was reviewed by a special committee of experienced professionals through the Graphic Artists Guild. These figures, reflecting the responses of established professionals, are meant as a point of reference only and do not necessarily reflect such important factors as deadlines, job complexity, reputation and experience of a particular illustrator, research, technique or unique quality of expression, and extraordinary or extensive use of the finished art. Please refer to related material in other sections of this book, especially in the Pricing and Marketing Artwork and Standard Contracts and Business Tools chapters.

The prices shown represent only the specific use for which the illustration is intended and do not necessarily reflect any of the above considerations. The buyer and seller are free to negotiate, with each artist independently deciding how to price his or her artwork and taking into account all the factors involved.

Greeting card, novelty, and retail goods illustration

The greeting card and paper novelty fields have grown more competitive after experiencing a business boom during the 1980s. New greeting card companies and fresh card lines continue to enter—and leave—the industry, while the largest card publishers continue to hold the lion's share of the market. Since success or failure in this business is based largely on the buying responses of the public, greeting card designs lend themselves particularly well to royalty or licensing arrangements.

Artwork for retail products such as novelty merchandising, apparel, china, giftware, toys, and other manufactured items is purchased through licensing agreements. Calendars and posters for retail sale may use licensing or royalty agreements.

Please refer to the Royalties and Licensing sections in the chapter on Pricing and Marketing Artwork and to the Book Illustration section in this chapter.

Trade practices

The following trade practices have been used historically and, through such traditions, are accepted as standard:

1. The intended use of the art must be stated clearly in a contract, purchase order, or letter of agreement stating the price and terms of sale.

2. Artists normally sell only first reproduction rights unless otherwise stated.

3. If artwork is to be used for other than its original purpose, the price usually is negotiated as soon as possible. The secondary use of an illustration may be of greater value than the primary use. Although there is no set formula for reuse fees, current surveys indicate artists add a reuse fee ranging from 20 to 100 percent of the fee that would have been charged had the illustration originally been commissioned for the anticipated usage.

4. Illustrators should negotiate reuse arrangements with the original commissioning party with speed, efficiency, and all due respect to the client's position.

5. Return of original artwork to the artist is automatic unless otherwise negotiated.

6. Historically, artists have charged higher fees for rush work than those listed here, often by an additional 20 to 150 percent.

7. If a job is canceled after the work is begun, through no fault of the artist, his-

torically a cancellation or kill fee often is charged. Depending upon the stage at which the job is terminated, the fee has covered all work done, including research time, sketches, billable expenses, and compensation for lost opportunities resulting from an artist's refusing other offers to make time available for a specific commission. In addition, clients who put commissions "on hold" or withhold approval for commissions for longer than 30 days usually secure the assignment by paying a deposit.

8. Historically, a rejection fee has been agreed upon if the assignment is terminated because the preliminary or finished work is found to be not reasonably satisfactory and steps to correct the problem have been exhausted. The rejection fee for finished work often has been over 50 percent of the full price, depending upon the reason for rejection and the complexity of the job. When the job is rejected at the sketch stage, current surveys indicate a fee of 20 to 50 percent of the original price is customary. This fee may be less for quick, rough sketches and more for highly rendered, time-consuming work.

9. Artists considering working on speculation often assume all risks and should take these into consideration when offered such arrangements; see section called Speculation in the Professional Issues chapter for details.

10. The Graphic Artists Guild is unalterably opposed to the use of work-for-hire contracts, in which authorship and all rights that go with it are transferred to the commissioning party and the independent artist is treated as an employee for copyright purposes only. The independent artist receives no employee benefits and loses the right to claim authorship or profit from future use of the work forever. Additional information on work for hire can be found in the chapter on Legal Rights and Issues.

11. Customary and usual expenses such as unusual props, costumes, model fees, travel costs, production costs, consultation time, and so on should be billed to the client separately. An expense estimate should be included in the original written agreement or as an amendment to the agreement.

All prices for illustration in the *Guidelines* are based on a survey of the United States and Canada that was reviewed by a special committee of experienced professionals through the Graphic Artists Guild. These figures, reflecting the responses of established professionals, are meant as a point of reference only and do not necessarily reflect such important factors as deadlines, job complexity, reputation and experience of a particular illustrator, research, technique or unique quality of expression, and extraordinary or extensive use of the finished art. Please refer to related material in other sections of this book, especially in the Pricing and Marketing Artwork and Standard Contracts and Business Tools chapters.

The prices shown represent only the specific use for which the illustration is intended and do not necessarily reflect any of the above considerations. The buyer and seller are free to negotiate, with each artist independently deciding how to price his or her artwork and taking into account all the factors involved.

Greeting cards

Although the major companies publish mostly cards developed by staff artists, they do commission or buy some outside work. The rest of the industry depends heavily on freelance illustration and design. Freelance greeting card illustrators work on inventory of their own designs, creating for sale to producers/manufacturers rather than on specially commissioned works. Designs generally are developed to fit into everyday or seasonal lines. Everyday cards include friendship, birthday, anniversary, get well, juvenile, religious/inspirational, congratulations, sympathy, and similar sentiments. Christmas cards comprise the vast majority of seasonal greetings, making up more than one third of all cards sold and as much as 50 to 100 percent of some card companies' offerings. Other seasonal cards include Valentine's Day, Easter, Mother's and Father's Day, Hanukkah, and other holidays. Most greeting cards are created in full color. Current survey data indicate that special effects, such as embossed, die-cut, or pop-up cards, command larger fees.

Sales in mass market outlets such as supermarkets experienced tremendous growth over the last decade, a factor emphasizing the benefits of royalty agreements. Emphasis in the future is expected to be on addressing specific consumer audiences. New market niches, such as cards for Hispanics, working women, and seniors, are being introduced and expect some growth in sales during the next decade. Generally, freelance graphic artists create individual designs that they sell to publishers for

Merchandising & Retail Illustration

COLOR GREETING CARDS	FLAT FEE	ADVANCE	ROYALTY %
Original design	$300 - 750	$200 - 750	4 - 10%
Licensing of character	-	500 - 2000	4 - 6%
Pop-up or specialty cards	1000 - 4000	350 - 600	5%
COLOR POSTERS			
Original design	$1500 - 6000	$500 - 1500	5 - 50%
Licensed artwork	1000 - 5000	750 - 1500	8 - 14%
COLOR CALENDARS			
12 illustrations and cover	$3600 - 14000	$1200 - 7000	5 - 10%
Advance as percent of			
projected sales	10 - 33%	5 - 10%	
DISPLAY/NOVELTY PRODUCTS *			
Original design	$1500 - 2500	$700 - 1000	3 - 5%
Licensed artwork	1000 - 1500	500 - 800	5 - 10%
SHOPPING BAGS			
Limited use	$500 - 3500		
Extensive use	5000		
DOMESTIC PRODUCTS †			
Original design	$700 - 800	$500 - 3000	5 - 10%
Licensed artwork	1000 - 4000	500 - 2000	10%
PAPER PRODUCTS ‡			
Original design	$700 - 3000	$500 - 2000	5 - 10%
Licensed artwork	500 - 2000	300 - 1000	6 - 10%

* Illustrations used on T-shirts, gifts, caps, mugs, game boards, key chains, etc.

† Includes illustrations used on sheets, towels, wallpaper, tablecloths, napkins, fabrics, window treatment.

‡ Includes illustrations used on gift wrap, gift cards, napkins, paper plates, tablecloths.

Note: Royalties are based on the wholesale price of item. Advances and royalties may vary widely depending on the client and the distribution. Current data indicates that an additional 25% is added for each color overlay in addition to black.

greeting card use. Revisions on a proposed design should not take place before reaching agreement on payment and terms. Graphic artists who base their business on greeting card designs usually develop a different style for different clients to minimize competition.

Artists whose cards sell well may propose or be commissioned to develop an entire line of cards for a company, which involves creating from 20 to 36 stylistically similar cards with a variety of greetings. In cases where an artist's cards have become top sellers and the style strongly identified with the company, the value of the artist's work to the company has been recognized with equity and other compensation. Exclusive arrangements providing royalties are negotiated on occasion; artists are advised, however, to develop a solid relationship with the client before considering such an agreement.

Greeting card designs are sold either on an advance against royalty basis or for a flat fee. According to current survey data, the royalty is usually a percentage of the wholesale price. In most cases a nonrefundable advance is paid in anticipation of royalties. This reflects the fact that production and distribution schedules require a year to 18 months before a design reaches the marketplace.

Many greeting card companies purchase greeting card rights only, with the artists retaining all other rights. Limited rights are appropriate, since most cards, particularly holiday greetings, are only marketed for one year.

Royalties and the related topic of licensing are discussed further in the chapter on Pricing and Marketing Artwork.

Retail products

When a design or illustration is developed for resale and marketing as a product, it usually is done under a licensing agreement. Art for T-shirts, towels, mugs, tote bags, and other such items, whether developed and sold by the artist or as spin-offs from nationally known characters, is sold in this manner.

In licensing agreements an artist, designer, or owner of rights to artwork permits ("licenses") another party to use the art for a limited specific purpose, for a specified time, in a specified territory, in return for a fee or royalty. For a detailed discussion of licensing, please refer to the Pricing and Marketing Artwork chapter. An excellent book on licensing is *Licensing Art and Design* by Caryn Leland, published by Allworth Press (see the Resources and References chapter for ordering

information). Model licensing agreements appear in the Standard Contracts and Business Tools chapter, reprinted by permission of the author.

Medical illustration

Medical illustration is one of the most demanding and highly technical areas of the graphic arts. Medical illustrators are specially trained graphic artists who combine a ready scientific knowledge of the human body with a mastery of graphic techniques to create medical and health illustrations. The work of a medical illustrator ranges from highly realistic, anatomically precise pieces emphasizing instructional content to imaginative and conceptual pieces emphasizing subjective impact.

Accuracy of content and effectiveness of visual presentation are paramount in this field. Many medical illustrators hold master's degrees from one of the five medical schools offering training in the field; the five schools are accredited by an American Medical Association (AMA) accrediting body. Formal medical studies include gross anatomy, physiology, embryology, pathology, neuroanatomy, and surgery, plus commercial art techniques, television, photography, and computer graphics. Medical illustrators may be certified by the Association of Medical Illustrators (AME) through written examination and portfolio review. Certification is maintained and renewed every five years through an organized continuing education program.

Most medical illustrators work with a wide variety of rendering techniques, including pen and ink, pencil, carbon dust, watercolor, colored pencil, acrylic, and computers. Many of these artists also design and construct anatomical models, exhibits, and prosthetics. Some medical illustrators also specialize in techniques for film, video, and interactive media.

Because of their extensive backgrounds in science and medicine, medical illustrators often work directly with clients, editors, and art directors in the conceptual development of projects.

A growing market for medical illustration is the legal field. Medical illustration is commissioned specifically for use in courtroom proceedings to clarify complex medical or scientific information for judges and juries.

Trade practices

The following trade practices have been used historically and, through such traditions, are

accepted as standard:

1. The intended use of the art must be stated clearly in a contract, purchase order, or letter of agreement stating the price and terms of sale.
2. Artists normally sell only first reproduction rights unless otherwise stated.
3. If artwork is to be used for other than its original purpose, the price usually is negotiated as soon as possible. The secondary use of an illustration may be of greater value than the primary use. Although there is no set formula for reuse fees, current surveys indicate artists add a reuse fee ranging from 20 to 100 percent of the fee that would have been charged had the illustration originally been commissioned for the anticipated usage.
4. Illustrators should negotiate reuse arrangements with the original commissioning party with speed, efficiency, and all due respect to the client's position.
5. Return of original artwork to the artist is automatic unless otherwise negotiated.
6. Historically, artists have charged higher fees for rush work than those listed here, often by an additional 50 percent.
7. If a job is canceled after work is begun, through no fault of the artist, historically, a cancellation or kill fee often is charged. Depending upon the stage at which the job is terminated, the fee has covered all work done, including research time, sketches, billable expenses, and compensation for lost opportunities resulting from an artist's refusing other offers to make time for a specific commission.
8. Historically, a rejection fee has been agreed upon if the assignment is terminated because the preliminary or finished work is found to be not reasonably satisfactory and steps to correct the problem have been exhausted. The rejection fee for finished work has often been over 50 per-

COMPARATIVE FEES FOR

Medical Illustration

Advertising*

CONCEPTUAL	LINE		TONE-COLOR	
Spread	$2000 -	5000†	$4000 -	8000
Full page	1500 -	4000†	2500 -	3500
Spot	500 -	1000†	1200 -	1500
ANATOMICAL AND SURGICAL				
Spread	$1500 -	2000†	$3000 -	5000
Full page	1000 -	1500†	1500 -	3000
Spot	400 -	750†	500 -	1500
PRODUCT				
Spread	$1500 -	2000†	$2500 -	5000
Full page	1000 -	1500†	1000 -	3500
Spot	400 -	750†	700 -	1200

POSTER	SIMPLE	MODERATE	COMPLEX
	-	$5000 - 10000	$10000 20000

CONSULTATION AND RESEARCH (Per day)	$350 - 500

Notes:

1. The ranges in advertising rates reflect the difference between first-use rights and all-rights transfer, size and complexity of the work, as well as the experience of the illustrator.

2. Reuse fees historically ranging between 25-100% are based on when, where and how the art is to be reused.

3. Historically, sketches or comps range between 30-50% of the above rates.

* For this section, assume your fee covers a limited use of up to five insertions (within the media specified) for one year from date of first insertion.

† Based on 1994 data.

Medical Illustration (cont'd)

Editorial Publications

PROFESSIONAL PUBLICATIONS:

MEDICAL JOURNALS	LINE	TONE-COLOR
Cover	$500 - 1200	$1000 - 2000
Spread	700 - 1500	900 - 2400
Full page	300 - 800*	500 - 2000
Spot[†]	250 - 600*	250 - 1000

CONSUMER PUBLICATIONS:

BOOKS, HEALTH AND SCIENCE MAGAZINES	LINE	TONE-COLOR
Cover	$750 - 1500*	$2000 - 2500
Spread	1500 - 2500*	1500 - 3000
Full page	750 - 1500*	800 - 1000
Spot[†]	250 - 800*	200 - 800

* Based on 1994 data.

[†] Because of the scientific complexity of the subject matter, reproduction size is often irrelevant in pricing. For the purpose of these charts, a spot is considered to be any illustration smaller than a quarter page.

INSTRUCTIONAL TEXTS:
COLLEGE, MEDICAL, SURGICAL TEXTBOOKS,
PATIENT EDUCATION PUBLICATIONS

	LINE	TONE-COLOR
Complex	$300 - 750	$650 - 1200
Moderate	250 - 500	350 - 650
Simple	150 - 250	250 - 500

Note: Rates shown are for limited noncommercial rights only. Current data indicates reuse fees averaging 10-50% of the original fee, based on the intended use.

Medical Legal Exhibits

	SIMPLE	COMPLEX
Computer animation	$5000 - 8000	$10000 - 20000
Each image (per panel)	500 - 600	$600 - 1200
Overlays	75 - 200	250 - 500
Hourly rate for consultation		
(usually billed in addition to fee), excluding expenses		$100 - 200
Day rate for testimony		$1000 - 2500

Note: An exhibit, usually 30" x 40", is comprised of one or more images on a single panel. Related images for an inset or secondary part of the primary image may be less depending on the complexity. Production costs and expenses are billed separately.

Construction of Models for Medical Use

	SIMPLE	COMPLEX
Model construction	$5000 - 10000	$10000+
Hourly rate	$100 - 200	

Note: Unusual materials and expenses are billed separately.

cent of the full price, depending upon the reason for rejection and the complexity of the job. When the job is rejected at the sketch stage, current surveys indicate a fee of 20 to 50 percent of the original price is customary. This fee may be less for quick, rough sketches and more for highly rendered, time-consuming work.

9. Artists considering working on speculation often assume all risks and should take these into consideration when offered such arrangements; see Speculation section in the Professional Issues chapter for details.

10. The Graphic Artists Guild is unalterably opposed to the use of work-for-hire contracts, in which authorship and all rights that go with it are transferred to the commissioning party and the independent artist is treated as an employee for copyright purposes only. The independent artist receives no employee benefits and loses the right to claim authorship or profit from future use of the work forever. Additional information on work for hire can be found in the Legal Rights and Issues chapter.

11. Customary and usual expenses such as shipping fees, travel costs, consultation time, and other unusual expenses should be billed to the client separately. An expense estimate should be included in the original written agreement or as an amendment to the agreement.

Pricing information in this section is based on a broad survey of medical illustrators in cooperation with the Graphic Artists Guild and the Association of Medical Illustrators. The ranges shown are meant as points of reference from which both buyer and seller are free to negotiate, taking into account usage, copyright, complexity, and research and the artist's experience, skill, and reputation. They do not necessarily reflect such important factors as deadlines, job complexity, research, technique or unique quality of expression, and extraordinary or extensive use of the finished art. Please refer to related material in other sections of this book, especially in the Pricing and Marketing Artwork and Standard Contracts and Business Tools chapters.

The prices shown represent only the specific use for which the illustration is intended and do not necessarily reflect any of the above considerations. The buyer and seller are free to negotiate, with each artist independently deciding how to price his or her artwork and taking into account all the factors involved.

Scientific (biological) illustration

Scientific illustrators create accurate and detailed images of scientific subjects, including anthropology, astronomy, botany, cartography, geology, paleontology, and zoology, often working directly with scientists and designers for exhibits and educational materials.

Increasingly, natural science illustration is expanding into all areas of graphic communications and commercial applications, such as special interest magazines, environmental design, merchandise and package illustration, advertising, computer graphics, and audiovisuals.

Scientific illustrators must be versatile in more than one technique or medium, using everything from traditional pencils and paints to the new electronic media, and often must be skilled in the use of optical equipment and precision measuring devices. A thorough understanding of the subject matter also is required. Specimens must be correctly delineated to show proportion, coloration, anatomical structures, and other diagnostic features. The illustrator must often pictorially reconstruct an entire object from incomplete specimens or conceptualize an informed interpretation. Scientific illustrations are judged for their accuracy, readability, and beauty.

In additional to intended usage and rights transferred, the factors found in Guild research to affect pricing in this field include: research and consultation time; travel; reference materials; and complexity of project.

Trade practices

The following trade practices have been used historically and, through such traditions, are accepted as standard:

1. The intended use of the art must be stated clearly in a contract, purchase order, or letter of agreement stating the price and terms of sale.

2. Artists normally sell only first reproduction rights unless otherwise stated.

3. If artwork is to be used for other than its original purpose, the price usually is negotiated as soon as possible. The secondary use of an illustration may be of greater value than the primary use. Although there is no set formula for reuse fees, current surveys indicate artists add a reuse fee ranging from 20 to 100 percent of the fee that would have been charged had the illustration originally been commissioned for the anticipated usage.

4. Illustrators should negotiate reuse arrangements with the original commissioning party with speed, efficiency, and all due respect to the client's position.

5. Return of original artwork to the artist is automatic unless otherwise negotiated.

6. Historically, artists have charged higher fees for rush work than those listed here, often by an additional 20 to 150 percent.

7. If a job is canceled after the work is begun, through no fault of the artist, historically, a cancellation or kill fee often is charged. Depending upon the stage at which the job is terminated, the fee has covered all work done, including research time, sketches, billable expenses, and compensation for lost opportunities resulting from an artist's refusing other offers to make time available for a specific commission. In addition, clients who put commissions "on hold" or withhold approval for commissions for longer than 30 days usually secure the assignment by paying a deposit.

8. Historically, a rejection fee has been agreed upon if the assignment is terminated because the preliminary or finished work is found to be not reasonably satisfactory and steps to correct the problem have been exhausted. The rejection fee for finished work has often been over 50 percent of the full price, depending upon the reason for rejection and the complexity of the job. When the job is rejected at the sketch stage, current surveys indicate a fee of 20 to 50 percent of the original price is customary. This fee may be less for quick, rough sketches and more for highly rendered, time-consuming work.

9. Artists considering working on speculation often assume all risks and should take these into consideration when offered such arrangements; see Speculation section in the Professional Issues chapter for details.

10. The Graphic Artists Guild is unalterably opposed to the use of work-for-hire contracts, in which authorship and all rights that go with it are transferred to the commissioning party and the independent artist is treated as an employee for copyright purposes only. The independent artist receives no employee benefits and loses the right to claim authorship or profit from future use of the work forever. Additional information on work for hire can be found in the Legal Rights and Issues chapter.

11. Customary and usual expenses such as shipping fees, travel costs, consultation time, and other unusual expenses should be billed to the client separately. An expense estimate should be included in the original written agreement or as an amendment to the agreement.

Artwork appearing on-screen in motion picture, television, and video

Producers of audiovisual works (including motion pictures or television or video programs) generally must obtain a license to illustrations, drawings, paintings, or other two- or three-dimensional works of graphic or visual art.

Licenses permitting the use of art in connection with a specific program, movie, or video can be obtained either from the artist or artist's representative or gallery. According to recent survey responses, no reuse fee or royalty is paid for reruns of television programs or when motion pictures are released on video or shown on television.

License fees have been found, in the same surveys, to be set as either a flat fee or a rental fee, with more paid for a major use (i.e., more than 10 seconds, full frame, or close-up) than for a minor use. License fees are not usually paid for incidental uses (i.e., less than two seconds or less than 20 percent of the work shown on screen). These surveys also reveal that flat fees for using art in a full-length feature motion picture, nationally broadcast video, or television program range from $1,000 to $5,000 for a major use and between $500 and $2,500 for a minor use. Rental fees range from 10 to 25 percent of the retail price of the art for each week (or part of a week) the art is used by the production entity.

Retroactive licenses in the above ranges are paid when art is inadvertently used without permission, plus a reasonable additional sum (10 to 40 percent of the license fee) if the services of an attorney are required.*

Trade practices for artists creating artwork appearing on-screen in motion picture, television, and video follow the same general protocols as other areas of illustration.

* This section, for artwork appearing on-screen in motion pictures, television, and, video is copyright © 1993 Greg Victoroff, Esq., and used with permission.

Technical illustration

Technical illustrators create highly accurate renderings of machinery, charts, instruments, scientific subjects (such as biological studies, geological formations, and chemical reactions), space technology, cartography (maps), or virtually any subject that requires precision of interpretation in illustration. Technical illustrators often work directly with a scientist, engineer, or technician to achieve the most explicit and accurate visualization of the subject and/or information.

Technical illustration is used in all areas of graphics communication in this age of high technology. Some of the areas most commonly requiring this specialized art are: annual reports, special or single interest magazines, industrial publications, package illustrations, advertising, corporate, editorial, computer graphics, and audiovisuals.

These artists may work in a variety of media: ink, wash, airbrush, pencil, watercolor, gouache, computers, etc., and are often trained in mechanical drafting, mathematics, diagrams, blueprints, and production.

In addition to intended usage and rights transferred, the factors found in Guild research to affect pricing in this field include: research and consultation time; travel; reference materials; and complexity of project.

Trade practices

The following trade practices have been used historically and, through such traditions, are accepted as standard:

1. The intended use of the art must be stated clearly in a contract, purchase order, or letter of agreement stating the price and terms of sale.

2. Artists normally sell only first reproduction rights unless otherwise stated.

3. If artwork is to be used for other than its original purpose, the price usually is negotiated as soon as possible. The secondary use of an illustration may be of greater value than the primary use. Although there is no set formula for reuse fees, current surveys indicate artists add a reuse fee ranging from 20 to 100 percent of the fee that would have been charged had the illustration originally been commissioned for the anticipated usage.

4. Illustrators should negotiate reuse arrangements with the original commissioning party with speed, efficiency, and all due respect to the client's position.

5. Return of original artwork to the artist is automatic unless otherwise negotiated.

6. Historically, artists have charged higher fees for rush work than those listed here, often by an additional 20 to 150 percent.

7. If a job is canceled after the work is begun, through no fault of the artist, historically a cancellation or kill fee often is charged. Depending upon the stage at which the job is terminated, the fee has covered all work done, including research time, sketches, billable expenses, and compensation for lost opportunities resulting from an artist's refusing other offers to make time available for a specific commission. In addition, clients who put commissions "on hold" or withhold approval for commissions for longer than 30 days usually secure the assignment by paying a deposit.

8. Historically, a rejection fee has been agreed upon if the assignment is terminated because the preliminary or finished work is found to be not reasonably satisfactory and steps to correct the problem have been exhausted. The rejection fee for finished work often has been over 50 percent of the full price, depending upon the reason for rejection and the complexity of the job. When the job is rejected at the sketch stage, current surveys indicate a fee of 20 to 50 percent of the original price is customary. This fee may be less for quick, rough sketches and more for highly rendered, time-consuming work.

9. Artists considering working on speculation often assume all risks and should take these into consideration when offered such arrangements; see the Speculation section in the Professional Issues chapter for details.

10. The Graphic Artists Guild is unalterably opposed to the use of work-for-hire contracts, in which authorship and all rights that go with it are transferred to the commissioning party and the independent artist is treated as an employee for copyright purposes only. The independent artist receives no employee benefits and loses the right to claim authorship or profit from future use of the work forever. Additional information on work for hire can be found in the Legal Rights and Issues chapter.

11. Customary and usual expenses such as shipping fees, travel costs, consultation time, and other unusual expenses should

Technical Illustration

Advertising

GENERAL INTEREST (READER'S DIGEST, PEOPLE WEEKLY) OR NATIONAL-CIRCULATION MAGAZINES

	LINE	TONE-COLOR
Spread	$2000 - 2500	$2500 - 5000
Full page	1500 - 2000	2000 - 4000
Half page	1000 - 1500	1500 - 3000
Spot quarter page	500 - 1000	750 - 1500

SPECIAL INTEREST (THE NEW YORKER OR THE ATLANTIC MONTHLY) OR MEDIUM-CIRCULATION MAGAZINES

Spread	$2000 - 3500	$2500 - 5000
Full page	1500 - 2500	2000 - 3500
Half page	1000 - 1500	1500 - 2500
Spot-quarter page	250 - 1000	500 - 1500

SINGLE INTEREST (SCIENTIFIC AMERICAN, GOLF DIGEST) OR SMALL-CIRCULATION MAGAZINES

Spread	$1500 - 2500	$2000 - 3500
Full page	800 - 1500	1500 - 3000
Half page	400 - 1000	1000 - 2000
Spot-quarter page	250 - 750	350 - 1000

NATIONAL NEWSPAPERS OR NEWSPAPER SUPPLEMENTAL MAGAZINES

Section cover	$1500 - 2500	$2000 - 3500
Spread	1000 - 2000	1500 - 2500
Full page	750 - 1500	1000 - 2000
Half page	500 - 1000	500 - 1500
Spot-quarter page	250 - 750	350 - 1000

Editorial Publications

MAGAZINES

Cover	-	$1750 - 5000
Spread	-	1500 - 4000
Full page	$350 - 2000	1000 - 3500
Half page	250 - 1000	500 - 2000
Spot-quarter page	125 - 500	250 - 1000

NEWSPAPERS

	LINE	TONE-COLOR
Section cover	$500 - 2000	$1200 - 3000
Spread	750 - 2000	1000 - 2500
Full page	500 - 1500	700 - 2000
Half page	250 - 1000	350 - 1500
Spot-quarter page	200 - 700	250 - 1000

BOOKS

Full page	$250 - 1000	$400 - 1500
Half page	175 - 750	250 - 1000

Corporate Clients

EMPLOYEE PUBLICATIONS

Cover	$1000 - 2000	$1500 - 3500
Spread	1000 - 1500	1500 - 2500
Full page	500 - 1000	1000 - 2000
Half page	350 - 800	500 - 1000
Spot-quarter page	200 - 500	250 - 750

INSTRUCTION MANUALS

Cover	$500 - 1300	$800 - 2000
Spread	800 - 1000	1500 - 2500
Full page	250 - 750	900 - 1500
Half page	150 - 500	600 - 1000
Spot-quarter page	100 - 300	250 - 750

COLLATERAL/DIRECT RESPONSE

Cover	$1000 - 2500	$1500 - 3500
Spread	1000 - 2500	1500 - 3500
Full page	500 - 1500	1000 - 2000
Half page	250 - 1000	500 - 1500
Spot-quarter page	100 - 500	250 - 750

PRESENTATIONS

Color flip charts	$750 - 1000
Trade show exhibits	750 - 2500

Technical Illustration

Noncorporate

INSTRUCTIONAL MANUALS	LINE	TONE-COLOR
Cover	$450 - 2000	$800 - 2500
Spread	550 - 2500	1000 - 3000
Full page	200 - 1500	500 - 2000
Half page	150 - 1000	250 - 1200
Spot-quarter page	50 - 750	100 - 1000
Instruction on packaging		$350 - 800
Hourly rate for data sheets		$40 - 75
Hourly rate for product user and service manuals		$30 - 75

INSTRUCTIONAL CONSULTATION	
Per hour	$50 - 150
Per day	400 - 1000

be billed to the client separately. An expense estimate should be included in the original written agreement or as an amendment to the agreement.

All prices for illustration in the *Guidelines* are based on a survey of the United States and Canada that was reviewed by a special committee of experienced professionals through the Graphic Artists Guild. These figures, reflecting the responses of established professionals, are meant as a point of reference only and do not necessarily reflect such important factors as deadlines, job complexity, reputation and experience of a particular illustrator, research, technique or unique quality of expression, and extraordinary or extensive use of the finished art. Please refer to related material in other sections of this book, especially in the Pricing and Marketing Artwork and Standard Contracts and Business Tools chapters.

The prices shown represent only the specific use for which the illustration is intended and do not necessarily reflect any of the above considerations. The buyer and seller are free to negotiate, with each artist independently deciding how to price his or her artwork and taking into account all the factors involved.

Architectural/Interior illustration

Architectural/interior illustrators (also known as perspectivists) are hired by an architect or designer to create accurate sketches, drawings, and paintings in design presentations to clients. The original illustration itself is often sold for design presentation purposes, but the copyright and the reproduction rights usually are retained by the artist. Increasingly, artists are providing their drawings to clients on a temporary "use basis," with eventual return of the original. Illustrators are commissioned by real estate project developers also and/or their advertising agencies to create art for promotional purposes. Advertising and promotional reproduction rights are negotiated separately from the sale or primary use of the original art, and surveys indicate that the intended uses for the work will affect the fee. (Please refer to the Advertising Illustration section for more information).

The finished art is in the form of one or a combination of several media: airbrush, gouache, watercolor, pastel, colored pencil, marker, and/or pen and ink. Technology is progressing at a rapid rate, so more illustrators are taking increasing advantage of the computer. Computer-aided design programs also are used by illustrators for speed and accuracy and allow the artist to choose quickly the views that serve the client's needs. However, due to the cost of hardware and the time required to use existing software, computer-generated final art has limited this option to but a small number of practitioners. Architectural/interior artists are hired for their unique illustrative styles and their accuracy in depicting the building, space, color, and/or materials. They usually have a design background (in either architectural, interior, or industrial design) and have chosen this specialized technical/artistic field as a career after part-time or freelance experience in the business. As a result of these unique qualifications, they are often involved in a project before it is designed completely. These illustrators often work from a variety of reference materials, ranging from rough schematic design sketches with verbal descriptions to completely detailed working drawings, depending on the end use and level of detail required by the client.

Recent surveys show that factors involved in pricing include the complexity of the design project (which depends upon required views and the amount of detail required); the number of images; the media to be used; and the

Architectural/Interior/Exterior Illustration

In Design Presentation

SKETCH PERSPECTIVES*	+/- 11" x 17"	+/- 16" x 24"	+/- 20" x 30"
Marker	$500 - 1500	800 - 2000	$1200 - 2500
Pencil	500 - 1500	600 - 2000	800 - 3000
Watercolor	800 - 2000	1000 - 2500	1250 - 3500
Pen & ink	500 - 1000	750 - 2500	600 - 3000
Airbrush	1200 - 2500	1500 - 3000	2400 - 3500
Combined media	1000 - 2500	1500 - 3000	2000 - 3500
Computer	700 - 2000	1000 - 3000	1500 - 3500

* Based on a 2-point perspective of a single building or interior with no background or environmental context; simple exteriors, elevations, etc.

FORMAL ILLUSTRATIONS*			
Marker	$500 - 2000	$1000 - 2000	$1500 - 3000
Pencil	600 - 2000	1000 - 3000	1200 - 5000
Watercolor	600 - 3000	1200 - 4000	2200 - 5000
Pen & ink	600 - 1200	1200 - 3000	1500 - 3500
Airbrush	1000 - 3000	1500 - 3500	2200 - 4000
Combined media	1500 - 3000	1500 - 3500	2000 - 4000
Computer	1200 - 3000	1200 - 3500	1200 - 4000

* Based on exteriors and perspectives of several buildings or interiors with environmental context site plans, etc.

COMPLEX PRESENTATION ILLUSTRATIONS*			
Marker	$1000 - 2500	$1500 - 3000	$2000 - 3500
Pencil	750 - 2500	1500 - 3000	2000 - 7000
Watercolor	750 - 4000	2500 - 6000	3000 - 7000
Pen & ink	750 - 3000	2000 - 4000	2000 - 4000
Airbrush	1200 - 3500	1500 - 4000	2500 - 5000
Combined media	2000 - 3500	3000 - 4000	3500 - 5000
Computer	1500 - 4000	1500 - 4000	1500 - 5000

* Based on elaborate architectural detailing with complex perspectives: cityscapes, aerial views, fully illustrated exteriors or interiors, etc.

amount of time required for travel and consultation for the project.

Trade practices

The following trade practices have been used historically and, through such traditions, are accepted as standard:

1. The intended use of the art must be clearly in a contract, purchase order, or letter of agreement stating the price and terms of sale.

2. Artists normally sell only first reproduction rights unless otherwise stated.

3. If artwork is to be used for other than its original purpose, the price usually is negotiated as soon as possible. The secondary use of an illustration may be of greater value than the primary use. Although there is no set formula for reuse fees, current surveys indicate artists add a reuse fee ranging from 20 to 100 percent of the fee that would have been charged had the illustration originally been commissioned for the anticipated usage.

4. Illustrators should negotiate reuse arrangements with the original commissioning party with speed, efficiency, and all due respect to the client's position.

5. Return of original artwork to the artist is automatic unless otherwise negotiated.

6. Historically, artists have charged higher fees for rush work than those listed here, often by an additional 20 to 150 percent.

7. If a job is canceled after the work is begun, through no fault of the artist, historically a cancellation or kill fee often is charged. Depending upon the stage at which the job is terminated, the fee has covered all work done, including research time, sketches, billable expenses, and compensation for lost opportunities resulting from an artist's refusing other offers to make time available for a specific commission. In addition, clients who put commissions "on hold" or withhold approval for commissions for longer than 30 days usually secure the assignment by paying a deposit.

8. Historically, a rejection fee has been agreed upon if the assignment is terminated because the preliminary or finished work is found to be not reasonably satisfactory and steps to correct the problem have been exhausted. The rejection fee for finished work often has been over 50 percent of the full price, depending upon the reason for rejection and the complexity of the job. When the job is rejected at the sketch stage, current surveys indicate a fee of 20 to 50 percent of the original price is customary. This fee may be less for quick, rough sketches and more for highly rendered, time-consuming work.

9. Artists considering working on speculation often assume all risks and should take these into consideration when offered such arrangements; see the Speculation section in the Professional Issues chapter for details.

10. The Graphic Artists Guild is unalterably opposed to the use of work-for-hire contracts, in which authorship and all rights that go with it are transferred to the commissioning party and the independent artist is treated as an employee for copyright purposes only. The independent artist receives no employee benefits and loses the right to claim authorship or profit from future use of the work forever. Additional information on work for hire can be found in the Legal Rights and Issues chapter.

11. Customary and usual expenses such as shipping fees, travel costs, consultation time, and other unusual expenses should be billed to the client separately. Travel costs, production costs, consultation time, and so on normally are billed to the client separately. An expense estimate should be included in the original written agreement or as an amendment to the agreement.

All prices for illustration in the *Guidelines* are based on a survey of the United States and Canada that was reviewed by a special committee of experienced professionals through the Graphic Artists Guild. These figures, reflecting the responses of established professionals, are meant as a point of reference only and do not necessarily reflect such important factors as deadlines, job complexity, reputation and experience of a particular illustrator, research, technique or unique quality of expression, and extraordinary or extensive use of the finished art. Please refer to related material in other sections of this book, especially in the Pricing and Marketing Artwork and Standard Contracts and Business Tools chapters.

The prices shown represent only the specific use for which the illustration is intended and do not necessarily reflect any of the above considerations. The buyer and seller are free to negotiate, with each artist independently deciding how to price his or her artwork and taking into account all the factors involved.

Dimensional illustration (3-D illustration)

Dimensional illustrators create original artwork in "dimension," from low-relief collage to sculptural assemblages, that is viewed from one vantage point. This genre includes traditional illustrators, modelmakers, paper sculptors, etc., whose original dimensional work is created for a wide range of uses. The work appears in the same markets as that of other illustrators, predominantly in advertising and editorial. Some dimensional illustrators also seek work in related markets, such as architecture, window displays, museum exhibits, convention display booths, sculpture for building interiors, food styling, and puppets for TV commercials and performances. Dimensional illustration includes, but is not limited to, paper, soft, or relief sculpture; paper/photo collage; assemblage; plastic, wood, and/or metal fabrications; clay imagery; dimensional mixed media (which is similar to but more dimensional than collage); or fabric/stitchery.

In creating dimensional illustration, there are two images created: the original dimensional art and the photograph (transparency or slide). Typically, the client buys one-time usage rights.

Working with a photographer

As the creator of the original work, dimensional illustrators implicitly grant authorization to create a two-dimensional derivative of their work, i.e., the photograph that is used for reproduction. Frequently, however, once an artwork is photographed for use, it is difficult for modelmakers and other dimensional illustrators to control or obtain copies of that work. This situation can occur under the most commonplace arrangements: when the client hires both the artist and photographer; when the photographer hires the artist; and even when the artist hires the photographer.

Fortunately, most art directors and photographers function under the assumption that the final photographic image does not belong either to the dimensional illustrator or the photographer, but to both. The reasons for this are logical; the photo could not have been created without the dimensional illustration or model and is therefore a derived image. In the well-known case of *Rogers v. Koons*, a photographer, Art Rogers, successfully sued sculptor Jeff Koons for producing unauthorized life-size dimensional derivatives of Rogers's photograph. Earlier cases, in which sculptors who

sued photographers were vindicated, provided precedents for Rogers's suit. Photographers should not assume ownership and full rights of an image when the image is derived fully from a sculptor's (dimensional illustrator's) work. In most relationships involving modelmakers, a photographer or client who wants to assume all rights to the work and the derivative photograph will offer to buy out the artist for a fee significantly higher than that initially offered for first rights. It is sound practice, as always, to ascertain in advance what rights the client and the photographer want.

The best protection for dimensional illustrators and modelmakers is to express their agreements in writing, even if a simple letter is sent to the other party confirming basic terms. Dimensional illustrators/modelmakers should consider the following:

When the client hires both the photographer and illustrator:

♦ *license:* specify the precise scope of the license granted to the client for the use of the illustration/model and its photographic reproductions;

♦ *assignments:* limit the client's agreements with all third parties (including the photographer) for use of any reproductions of the illustration/model (photographic and otherwise);

♦ *rights reserved:* obtain permission to make unfettered use of the photograph (e.g., a transparency to make future reproductions);

♦ *credit:* require the client and the photographer to provide a specific credit to the artist whenever the photograph is used (e.g., Photography © 1997 John Photographer, Artwork © 1997 Jane Artist);

♦ *pricing:* take into account the number of images to be made when setting a fee.

When a dimensional illustrator/modelmaker is retained by the photographer:

♦ *license:* specify the rights you are granting to the photographer and the photographer's permitted uses of the photograph depicting your work;

♦ *authorship:* retain the copyright in the illustration/model and, if possible, share joint copyright in the photograph;

♦ *rights reserved:* specify that you may use your illustration/model freely and without restriction (including having it rephotographed by another photographer);

♦ *credit:* specify the credit that the photograph must carry;

♦ *access:* obtain rights to use the photograph and obtain a transparency or copy of the negative;

- *fees:* specify compensation for the initial use; take into account the number of images to be made when setting a fee.

When a dimensional illustrator/modelmaker hires the photographer directly:

- *grant of rights:* specify the rights you are granting the photographer and limit the photographer's exercise of copyright in the photograph;
- *credit:* specify the credit the photograph will require whenever used;
- *permission:* specify the anticipated use permitted by you of the photograph;
- *access:* If you are free to reproduce the photograph without using the photographer's services, obtain a negative from which the prints or a transparency (more likely in color photography) can be made.
- *pricing:* take into account the number of images to be made when setting a fee.

Pricing dimensional illustration

Recent Guild surveys show that there are several factors affecting pricing for dimensional illustration that should be considered when negotiating with a client. In today's cost-cutting atmosphere, the three-dimensional illustrator often is asked to price his or her work on a scale similar to that for two-dimensional art, e.g., art that is painted, drawn, or bitmapped on a flat surface. However, because the three-dimensional illustrator offers the client greater potential for use (by varying the lighting and perspective when photographing it), and because the materials to create the piece are expenses only dimensional illustrators absorb, it is not readily comparable to two-dimensional art. The dimensional illustrator should consider how many images may be made from the work submitted when estimating a fee.

Many 3-D pieces may be used for display, to promote the client's product in a public place (e.g., a shop window or a counter display). Generally, a 3-D display is more valuable to a client than a flat picture, because of the wider uses that can be employed to exploit the work. (See the Point of Purchase section in this chapter.)

If cost is a concern to the client, dimensional illustrators frequently choose one of two options: simplify the intricacy of the artwork; or, create a smaller original.

Added costs of creating dimensional art

The materials used to build a 3-D project can be much more expensive than the traditional art supplies used in 2-D. The modelmaking wood used in miniature sets or architectural models, rare fabrics used in picture quilts or fabric collages, and casting resins for molded sculpture can add significantly to the cost of a job.

It is up to the individual artist to determine if the additional expenses will be included in the original creator's fee or billed separately. If included, the artist should consider the unforeseen circumstances that may cause additional expenses and leave room for changes.

Few clients like surprises, so it is advisable to estimate costs as closely as possible at the time of agreement. Clients should be made aware of the potential for additional expenditures for supplies and be alerted in advance when materials will be billed separately. It is good practice, when billing separately, to submit receipts, and/or an itemized list, with the invoice.

Projects that require support services (e.g., mold-making, vacuum forming, plating, or foundry casting) can increase expenses significantly. The client should be informed fully of these anticipated expenses, which, again, can be billed separately or reflected in the artist's creative fee.

Modelmakers especially need to maintain large studios or facilities to produce their work. Because the overhead is higher than that for the typical two-dimensional illustrator, these added expenses generally will be reflected in modelmakers' fees. A client requesting a piece of sculpture that has been cast from a living model, molded on a vacuum-forming unit, and "gold" plated should expect to pay considerably more than the price of an airbrush painting.

Under special circumstances, modelmakers may require additional help. A detailed or large project may require the modelmaker to hire extra help. If the deadline is short, the modelmaker may have to hire extra help and possibly refuse other valuable work to serve the client's needs by the deadline. The client should be aware that giving the artist ample time to complete the project is important if a lower price is expected.

Trade practices

The following trade practices have been used historically and, through such traditions, are accepted as standard:

1. The intended use of the art must be stated clearly in a contract, purchase order, or letter of agreement stating the price and terms of sale. This contract should be

signed by both parties before the artist commences the work. The agreement should state the usage rights; e.g.: "For one-time, nonexclusive, English-language, North American print rights only, in one hardcover edition, to be published by XXX, entitled 'YYY.' All additional requests for usage by [client] or any other publication, except as specified above, are to be referred to [name of artist] to determine the appropriate reprint fee."

2. The terms of payment should be negotiated prior to the sale and these terms should be stated on the invoice, including provisions for late payment. As they largely reflect the designer's labor, invoices should be made payable upon receipt.

3. The terms of (joint) authorship and ownership of the photographic image should be accepted by all parties (the dimensional illustrator, the photographer and, where applicable, the client) and stated in the agreement. The Guild's survey data indicate that a dimensional illustrator who allows his or her copyright to become the property of the photographer receives substantially higher compensation than for work with shared copyright.

4. If a job is canceled after the work is begun, through no fault of the artist, historically, a cancellation or kill fee often is charged. Depending upon the stage at which the job is terminated, the fee has covered all work done, including research time, sketches, billable expenses, and compensation for lost opportunities resulting from an artist's refusing other offers to make time available for a specific commission.

 Ownership of all copyright and artwork is retained by the artist. If a job based on "documentary" work or other original art belonging to a client is canceled, recent surveys reveal payment of a time and/or labor charge is a widely accepted practice.

5. Historically, a rejection fee has been agreed upon if the assignment is terminated because the preliminary or finished work is found to be not reasonably satisfactory and steps to correct the problem have been exhausted. The rejection fee for finished work often has been over 50 percent of the full price, depending upon the reason for rejection and the complexity of the job. When the job is rejected at the sketch stage, current surveys indicate a fee of 20 to 50 percent of the original price is customary. This fee may be less for quick, rough sketches and more for highly rendered, time-consuming work.

6. Guild surveys show that additional payment routinely is paid to an artist when: (a) the client requests artwork changes that were not part of the original agreement; and (b) all sales taxes due must be collected on all artwork, except when original work is returned to the designer/artist.

7. Customary and usual expenses such as travel costs, consultation time, shipping and mailing charges, and other out-of-pocket expenses for materials (e.g., modelmaking wood, model-casting resins, and fabric) as well as fees for services not performed by the dimensional illustrator (e.g., vacuum forming), outside services, model fees, and additional production staff, usually are billed to the client separately as they occur. An expense estimate can be included in the original written agreement with the client, making it clear that the estimate is subject to amendment.

8. An advance payment, termed a "material advance," may be requested for large projects.

9. Historically, artists have charged higher fees for rush work than those listed here, often by an additional 20 to 150 percent.

10. Return of original artwork to the artist or designer is automatic unless otherwise negotiated. If the client wishes to display the artwork, dimensional illustrators reportedly have charged fees ranging from 100 percent to 200 percent in addition to the base one-time use price. The display usage should be agreed upon in the initial purchase order.

11. The Graphic Artists Guild is unalterably opposed to the use of work-for-hire contracts, in which authorship and all rights that go with it are transferred to the commissioning party and the independent artist is treated as an employee for copyright purposes only. The independent artist receives no employee benefits and loses the right to claim authorship or profit from future use of the work forever. Sculpture is not eligible to be work for hire, as it does not fall under any of the eligible categories defined in the law. Additional information on work for hire can be found in the Legal Rights and Issues chapter.

Marbling (marbled printing)

Marblers are artists who create unique contact prints by floating paints and inks on a liquid size, manipulating the colors with special combs and tools to form designs, and applying paper, fabric, or other materials to pick up the design.

Although no two pieces of marbling are exactly alike, mastery of technical variables can enable a marbler to produce designs that are quite similar to each other or to centuries-old patterns. Many concentrate on creating images based on historic classical designs that are used traditionally to decorate the covers or endpapers of hand-bound books. Other artists pursue oil color, watercolor, or Japanese *sumi-nagashi* marbling specialties by producing more contemporary images.

The immense popularity of marbling (or marblizing) accompanying the renaissance of this long-neglected art has heightened demand for the graphic images marblers produce. Marbled designs are sought by ad agencies, graphic designers, clothing, home furnishing and stationery manufacturers, magazine and book publishers, and others in various markets for reproduction on everything from promotional brochures and package design to backdrops for television spots.

Because the expense of operating a mar-

COMPARATIVE FEES FOR

Marbling*

Corporate Employee Publications and Annual Reports

EMPLOYEE PUBLICATIONS†	LARGE COMPANY	MEDIUM COMPANY	SMALL COMPANY
Cover	$500	$450	$400
Spread background	450 - 550	400 - 500	350 - 425
Full page background	400 - 425	375 - 400	350 - 375
Full page border/frame	300 - 325	275 - 300	200 - 275
Spot border/frame	200 - 250	175 - 225	125 - 200

† Fees reflected may correspond to the size of the client or to the extent of distribution.

Book Publishing

PAPERBACK/HARDCOVER

BOOK COVERS	MASS MARKET	MAJOR MARKET	MINOR TRADE	YOUNG ADULT	TEXT BOOK
Wraparound background	$675 - 750	$625 - 700	$600 - 650	$600 - 650	$500 - 600
Wraparound border/frame	600 - 625	550 - 600	500 - 550	500 - 550	450 - 475
Front cover background	600	550 - 600	500	500	450 - 475
Front cover border/frame	525	500	475	450	450

HARDCOVER

BOOK INTERIORS	MAJOR PUBLISHER	MINOR PUBLISHER
Spread	$750 - 1000	$750
Full page background	500 - 750	500
Full page border/frame	350 - 400	350
Chapter headings	300 - 400	350

Note: Includes young adult, juvenile workbooks and educational texts

* The information in this section is based on 1994 data.

Marbling*

Advertising

MAGAZINES AND ADVERTORIALS[†]

	NATIONAL	REGIONAL
Cover	$850	$550 - 750
Spread background	650 - 750	500 - 650
Full-page background	500	400
Full-page border/frame	350 - 375	325 - 350
Spot border/frame	350	275 - 300

[†] Fees reflected may correspond to the size of the client or to the extent of distribution. Advertorials are special advertising sections added to magazines and newspapers.

NEWSPAPERS[†]

	MAJOR METRO	SMALL CITY
Cover	$525	$500
Spread background	375	375
Full-page background	300	300
Full-page border/frame	300	300
Spot border/frame	300	300

[†] Fees reflected may correspond to the size of the client or to the extent of distribution.

COLLATERAL AND DIRECT MAIL[†]

	>10,000	10,000 -100,000	<10,000
Cover	$800	$650	$500
Spread background	750	600	350
Full-page background	650	500	325
Full-page border/frame	400	300	250
Spot border/frame	300	275	225

[†] Prices reflect discount for quantity orders.

Novelty, Retail Goods and Surface Design

FLAT FEE ONLY

Gift wrap (original design)	$900 - 2000
Calendars	1500 - 3000
Shopping bags	800
Greeting cards	250 - 500

STATIONERY

Notepad cover/phone/address	$250 - 500
Photo album (large)	3500

TABLEWARE

Plate, napkin, cup, cloth[†]	$1500 - 3000
Paper napkins/Placemats[‡]	500 - 700

[†] Same pattern

[‡] Depending on full design or full design & border.

Surface Design

Wallpaper	$650 - 700
Wallpaper mural	1500 - 3000
Croquis/sketch	350 - 700
Domestics/home decorative	875 - 950
Liquor/tissue box	2400 - 5000
Recording cover	800 - 1200
Software (educational)	300

* The information in this section is based on 1994 data.

bling business are similar to the expenses incurred by other graphic artists, and because the marbler's creations enhance the value of the client's product or service, recent survey data indicate that marblers are routinely paid reproduction fees. Most marblers protect their copyrights by registering their designs with the Library of Congress and by stamping a copyright notice that includes their name, address, and phone number on the backs of papers offered for sale in art supply and paper stores. Because many papers are cut after purchase, some artists stamp their work in several places so that even small sections of their work can be identified. Despite these precautions, some users wrongfully assume that purchasing a marbled paper authorizes them to reproduce the design. For this reason, marblers must vigilantly protect their work against copyright infringement.

Recent Guild research has found that factors affecting the pricing for custom work most often include: when different, specific coloring is desired; set-up and actual printing time; complexity of design; number of samples required; altering pattern scale; matching ink specifications; and cost of materials.

Usual and customary considerations in fees for reproduction rights may include: consultation time, intended use, extent of use (i.e., border, full

page, spread, etc.), length of time for the specified use, and the number of rights purchased.

Trade practices

The following trade practices have been used historically and, through such traditions, are accepted as standard:

1. The intended use of the art must be stated clearly in a contract, purchase order, or letter of agreement stating the price and terms of sale.

2. Artists normally sell only first reproduction rights unless otherwise stated.

3. If artwork is to be used for other than its original purpose, the price usually is negotiated as soon as possible. The secondary use of an illustration may be of greater value than the primary use. Although there is no set formula for reuse fees, current surveys indicate artists add a reuse fee ranging from 20 to 100 percent of the fee that would have been charged had the illustration originally been commissioned for the anticipated usage.

4. Illustrators should negotiate reuse arrangements with the original commissioning party with speed, efficiency, and all due respect to the client's position.

5. Return of original artwork to the artist is automatic unless otherwise negotiated. Clients usually are expected to make their selection of marbled papers for use within fourteen days.

6. Payment is expected upon delivery of the assignment, not upon its publication.

7. If a job is canceled after the work is begun, through no fault of the artist, historically a cancellation or kill fee often is charged. If a custom job is canceled, current data indicate that 100 percent of the fee is expected. Cancellation fees for reproduction rights after the contract is signed but prior to execution of finished art has been found to be 50 percent of the negotiated fee.

8. Historically, a rejection fee has been agreed upon if the assignment is terminated because the preliminary or finished work is found to be not reasonably satisfactory. The rejection fee for finished work often has been over 50 percent of the full price, depending upon the reason for rejection and the complexity of the job. When the job is rejected at the sketch stage, current surveys indicate a fee of 20 to 50 percent of the original price is customary. This fee may be less for quick, rough sketches and more for highly rendered, time-consuming work.

9. Artists considering working on speculation often assume all risks and should take these into consideration when offered such arrangements; see Speculation section in the Professional Issues chapter for details. However, the creation of work initiated by a marbler for presentation and sale commonly is accepted in the textile and greeting card industries. Recent surveys have found that it is also standard practice to obtain a written guarantee of payment for creating any new work specifically requested by clients.

10. The Graphic Artists Guild is unalterably opposed to the use of work-for-hire contracts, in which authorship and all rights that go with it are transferred to the commissioning party and the independent artist is treated as an employee for copyright purposes only. The independent artist receives no employee benefits and loses the right to claim authorship or profit from future use of the work forever. Additional information on work for hire can be found in the Legal Rights and Issues chapter.

11. Historically, artists have charged higher fees for rush work than those listed here, often by an additional 20 to 150 percent.

12. Current data also indicate that fees are greater for the requirement of an unusually large number of custom samples. Additional payments are routinely made by the client for changes or alterations requested after the original assignment is agreed upon. Fees for custom work normally are charged separately from any reproduction rights sold.

13. Surveys show that fees for multiples of a marbled pattern(s) are often discounted below the per-pattern fee.

14. Samples of the finished product customarily are sent to the marbler upon completion, and this is usually specified in the contract.

All prices for illustration in the *Guidelines* are based on a survey of the United States and Canada that was reviewed by a special committee of experienced professionals through the Graphic Artists Guild. These figures, reflecting the responses of established professionals, are meant as a point of reference only and do not necessarily reflect such important factors as deadlines, job complexity, reputation and experience of a particular marbler, their research,

technique or the unique quality of expression, and extraordinary or extensive use of the finished art. The buyer and seller are free to negotiate, with each artist independently deciding how to price his or her artwork and taking into account all the factors involved. Please refer to related material in other sections of this book, especially in the Pricing and Marketing Artwork and Standard Contracts and Business Tools chapters.

Postage stamp illustration

There are several markets for stamp illustration, including the United States Postal Service (U.S.P.S.), the United Nations, European nations, and small country stamp producers. Stamps often are offered to collectors; the U.S.P.S. has a very active branch that caters specifically to philatelists (people who collect and study postage stamps and postmarked materials; that is, first-day-of-issue envelopes, postcards, and stamps canceled by a specific post office). Sometimes the debut of a postage stamp will be accompanied by a media campaign, as with the release of the Elvis Presley stamp, where the public was asked to vote on which of two images (the young Elvis or the old Elvis) would be produced.

United States stamp program

The commission to do a stamp can come from the U.S.P.S. directly or from one of the many designers who work with the postal service. U.S. postage stamp illustrations normally are priced per image. The U.S.P.S. insists on retaining the copyright and artwork, which may be deposited either in the Postal Museum or at the Smithsonian Institute. The contract usually calls for the artist to produce three sketches per image, and sketches are priced at $1,000 apiece, regardless of whether the project is completed by the U.S.P.S.; i.e., the normal fee total per final stamp image is $3,000.

If the stamp is a popular issue, the artist may be asked to sign open or a limited edition series for sale to collectors. This is a new program for the U.S.P.S., and only one or two stamps per year are offered with artists' signatures. The artist may be asked to sign from 5,000 to 20,000 uncut sheets. An uncut sheet consists of six sets of usually 20 stamps per "pane" (the stamp sheet normally purchased from the post office) and is the way the stamps come off the printer's press before they are cut for retail sale. The fee paid to the artist for signing the uncut sheets ranges from $1 to $4

COMPARATIVE FEES FOR

Postage Stamp Illustration*

	PER IMAGE	ADDITIONAL IMAGES
United States	$3000	$3000
Small country	300 - 1700	300 - 1700
United Nations	1000 - 2000	1000 - 2000

* per stamp image

Additional fee for sale of original art	$300 - 2000

Additional fee for signing limited numbers of stamp items (panes, sheets, postcards, etc.) to sell as collector's items	$1-4 per signature

per signature depending on the edition and the number of sheets being signed.

United Nations stamp program

The United Nations maintains a stamp program through the United Nations Postal Administration (U.N.P.A.). Fees average $2,000 for a single image, $1,000 each for multiple images, with a maximum fee of $12,000 for a series. The U.N. usually retains the copyright, but the artwork belongs to the artist. The U.N. seeks out artists from around the world in order to maintain a global perspective.

European stamp programs

European stamp programs pay $2,500 to $5,000 per stamp image. Each country differs slightly on rights belonging to the artist, but the contracts are quite similar to those used in the United States. Some European countries, Great Britain for example, require stamp illustrators to be citizens of the country for which the stamp will be produced.

Small country stamp programs

Small countries that have stamp programs pay an average of $500 per stamp image. The work usually is created through an ad agency. The agency usually insists on owning the rights and copyright, but the artist sometimes retains ownership of the artwork

graphic

DESIGN

prices
and trade customs

Graphic design
prices &
trade customs
• • • • • • • • • • • • •

Graphic designers use both design and production elements (including color, type, illustration, photography, animation, and printing or programming techniques) to organize ideas visually to convey a desired impact and message. In addition to exercising aesthetic judgment and project management skills, the professional graphic designer is experienced in evaluating and developing effective communication strategies that enhance a client's image, service, or product.

A wide variety of visual communications involve graphic design, including but by no means limited to printed materials such as magazines and books, three-dimensional packaging and products, and the identity systems and sales campaigns of business and industry, through logos and collateral promotion (including annual reports, catalogs, brochures, press kits, and direct mail packages). The talents of graphic designers are also crucial to broadcasting and the growing multimedia and network communications industries.

Graphic designers generally work with or hire other graphic designers, illustrators, production artists, or photographers on either a salaried or freelance basis. Almost all graphic designers buy and sell art. Some, who handle many different projects within a range of industries, refer to themselves as general graphic designers; their clients include corporations, publishers, advertising agencies, retailers, manufacturers, and entrepreneurs.

Graphic designers may be freelancers or employed on a regular basis by a design firm

or other entity as a principal or a staff designer. A small design firm usually has one to nine employees; a medium-size firm has 10 to 49 employees; and a large design firm has over 50 employees. The vast majority of design firms in the United States are small or medium size. By and large, small- to medium-size design firms are run by the graphic designers who are the principals or partners of the firm. Because the overhead expenses and the level of experience of a design practice can vary considerably, graphic design is one of the most difficult areas for which to identify pricing practices. Most design firms rely upon a flat fee, while freelancers usually bill for their time.

Client relationships

Graphic designers often are retained by clients to develop and then provide creative direction for a project and to coordinate all production details. As professional consultants, they can assess the feasibility of a project by utilizing their knowledge of the market and the resources available.

Sometimes, though, clients choose to develop projects and then bring in a designer. This is often inefficient, since many decisions may have been made about which a designer should have been consulted, resulting in unnecessary delays, additional costs, and inadequate design solutions. The earlier designers are called in to consult on a project, the more efficient it is for them to help develop the project to a superior graphic solution.

Some of the factors that affect a client's decision to hire a designer include:

♦ *talent/expertise:* Talent may be difficult to define, especially for corporate clients who must rely on measurable standards to conduct their business. Clients often will judge (and sometimes misjudge) design talent based on perceptions of the designer's appearance, ability to communicate an understanding of the client's needs effectively, or the chemistry between them. The standard measure of talent/expertise is based on evaluation of the portfolio of the firm, references, and the forthcoming design proposal (see below).

♦ *capacity:* The scope and scale of the client's project(s), and/or the design firm's technological capability to accommodate a client's special needs, often dictate the choice of the design firm.

♦ *location:* While the use of new technologies to deliver work make proximity to the client less important, geographic closeness may facilitate better communication. A face-to-face relationship creates a stronger bond and perception of involvement than one that exists only on the telephone or online. But this is certainly not true in all cases, and conducting more business at a distance is becoming an efficient reality through enhanced means of communication.

A client may seek a long-term relationship wih a graphic designer, particularly when planning a series of projects that needs design continuity. When such a relationship is envisioned, a designer may be retained during the early stages of a project as a consultant to help strategize, plan, schedule, and budget.

Design proposal

Once chosen, graphic designers use initial meetings to understand the client's design problem and conceptualize possible solutions. They will determine the targeted audience, desired response, and the overall effect or feeling to be achieved. Responsible clients communicate clearly, at the beginning of a project, any limitations such as budget, deadlines, and elements to be provided, such as text, photographs, or charts.

Based on these initial discussions, industry sources indicate that designers will "walk through" a project step-by-step, calculating the time needed for every activity and multiplying that time by the appropriate rate(s) to determine the appropriate fee estimate. Or if the situation warrants, the designer occasionally bases the fee on market conditions and/or the value the client expects to derive from the work. For example, a company desiring top talent to develop a new identity program may pay a substantially higher fee than if calculated according to expended time. Conversely, a designer may design a greeting card for a long-term client for substantially less than if billed hourly, as a client accommodation.

On major projects, once the designer assesses these variables he/she writes a design proposal estimating fees, expenses, and schedules to present to the client for approval before work begins. The proposal includes, as necessary, many of the following factors: objectives and requirements of the project; research; art and/or copy that will be developed by the designer; typography; computer programming, and other production services; printing requirements; intended use of the printed piece

(which may directly correlate to the price); schedule. Additionally, designers frequently prepare documents explaining relationships with subcontractors (such as illustrators or photographers), billing procedures, and contract terms. (For more information, please refer to the Writing a Proposal section in the Standard Contracts and Business Tools chapter.)

It is customary for project descriptions and cost proposals to be submitted to clients as a complimentary service. Creative proposals, however—those entailing solutions to client problem—usually are billable. Any fees and expenses incurred thereafter on a client's behalf and with the client's consent are billable. If the client accepts the proposal, the terms and conditions expressed in writing are signed by authorized representatives from both parties.

Getting started

Once the agreement is signed, the designer begins researching the project and exploring creative alternatives. With one or more concepts in mind, he or she may prepare a presentation that shows a general direction and format. Depending on the client's needs and the understanding between the client and the designer, the presentation may be "tight" or "loose." These preliminary renderings, or "comps," show the layout of the piece and are presented to the client for approval. Once approved, the designer begins assembling the elements and services necessary to carry out the project within the client's agreed-on budget.

With the client's approval and/or involvement, the designer makes key decisions on the specific "look" of the piece or package, including the use of illustration or photography. Any alterations or additions at this point—the comp stage—often are relatively easy and inexpensive, since this is the last step before the designer commissions illustration or other work and begins to produce the finished art. Since many clients don't buy art on a regular basis, it is the designer who negotiates with individual artists on the client's behalf within the scope of the client's approved art budget. Designers often assume the responsibility to educate the client on the intent, content, and ethics of trade customs and copyright law.

Designers must also remember their own responsibility to the artists whose work they are considering. The increasing practice of using images from artists' portfolio and talent sourcebooks at the presentation or comp stages—without permission—prompted the Graphic Artists Guild to initiate the "Ask First" campaign to educate designers, art directors, and other art buyers to respect private intellectual property and the copyright laws that govern it. Art or photography should not be copied or "swiped" for any use, including client presentations or "comping," without the creators' permission. In addition, portfolios must be returned intact and in good condition; a side effect of using sample work without permission has been artwork and portfolios damaged by those utilizing the work in comps. Please turn to the section on the "Ask First" campaign in the Graphic Artists Guild chapter for further information, or contact the Guild directly.

It is important to note that changes that come after approval of the layouts are considered author's alterations (AAs) and are billable. AAs can become expensive to the client because the changes usually are billed at an hourly rate or they may increase the difficulty of completing the project within the time scheduled, causing overtime charges.

The agreement

Since graphic designers work with so vast an array of graphic resources, it is important that all conditions and expectations be spelled out before the work begins. The following points should be considered:

♦ *payment:* For larger projects, it is usual and customary for one third of the payment to be made upon signing the agreement, one third upon approval of design comps, and the final third within 30 days of delivery of production-ready designs.

♦ *rights*: Most contracts include a section specifying how, when, where, and the duration for which the design will be used. The extent of use determines which rights of copyright the client needs and may be a factor in establishing appropriate fees. Graphic designers are entitled to credit and copyright, unless another arrangement is negotiated. Designers often contract with freelance illustrators, designers, and photographers for work to be used on a limited-use basis for specific projects. Unless specified otherwise in writing, it is assumed the individual creator owns the copyrights in the work, not the client or the designer. It is not uncommon, therefore, for copyrights to be held by several different contributors to a project, who may all deserve the same

acknowledgment and rights on the piece or package of pieces. See the Legal Rights and Issues chapter for a more in-depth discussion of these issues.

In addition to copyright concerns, global terms and conditions should be outlined clearly in writing and generally are reviewed prior to the first commission. These standard customs are contained in a contract, letter of agreement, or confirmation of engagement form (see the Standard Contracts and Business Tools chapter).

♦ *expenses:* In addition to the designer's fee, expenses reimbursed by the client typically include: subcontractors' fees, typesetting, supplies, photostats, travel, long-distance phone calls, overnight couriers, and messenger services. Current data indicate that the markup for these services typically ranges from 15 to 25 percent, with 16.85 percent being the average. The markup reimburses the designer for supervisory and handling time and insures that all work is done to the designer's specifications and standards for quality. Reimbursable expenses are billed monthly, upon completion of project phases or upon completion of the project.

♦ *responsibilities of the client:* copywriting, proofreading.

♦ *consultation fees:* When a graphic designer is called in by a client to advise on a project or design decision, surveys show that consultation fees usually are based on an hourly rate. Consultation fees historically have ranged from $75 to $200 per hour.

Trade practices

The following trade practices have been used historically and, through such traditions, are accepted as standard.

1. The intended use of the design must be stated clearly in a contract, purchase order, or letter of agreement stating the price and terms of sale.

2. If a design is to be used for other than its original purpose, a revised price usually is negotiated as soon as possible. The secondary use of a design may be of greater value than the primary use. Although there is no set formula for reuse fees, current surveys indicate designers add a reuse fee ranging from 50 to 100 percent of the fee that would have been charged had the work originally been commissioned for the anticipated usage.

Hourly Rates

	PER HOUR
Owner/principal	$100 - 200
Vice president	60 - 140
Creative director	100 - 175
Senior art director	80 - 150
Art director	70 - 130
Junior art director	50 - 100
Senior graphic designer	60 - 130
Graphic designer	50 - 100
Junior graphic designer	30 - 60

Note: Overtime rates generally range between 1.5 and 2 times the hourly rate.

3. Designers should negotiate reuse arrangements with the original commissioning party with speed, efficiency, and all due respect to the client's needs.

4. Return of original artwork, mechanicals, or portable digital media and files to the designer is automatic unless otherwise negotiated and may affect sales tax requirements.

5. The use of design historically has always influenced the price. If the design is to be featured over an extensive area or is an all-rights sale, fees are usually significantly higher than when used within a selected area or for limited usage.

6. Historically, designers have charged higher fees for rush work than those listed here, often by an additional 50 to 100 percent.

7. If a job is canceled through no fault of the designer, historically a cancellation fee often is charged. Depending upon the stage at which the job is terminated, the fee paid should reflect all work completed or hours spent and any out-of-pocket expenses.

8. Historically, a rejection fee has been agreed upon if the assignment is terminated because the preliminary or finished work is found to be not reasonably satisfactory. The rejection fee for finished work often has been equivalent to the number of hours spent on the job, depending on the reason for the dissatisfaction.

9. Designers considering working on speculation often assume all risks and should take these into consideration when offered such

arrangements; see the section called Speculation in the Professional Issues chapter for further discussion.

10. The Graphic Artists Guild is unalterably opposed to the use of work-for-hire contracts, in which authorship and all rights that go with it are transferred to the commissioning party and the independent designer is treated as an employee for copyright purposes only. The independent designer receives no employee benefits and loses the right to claim authorship or profit from future use of the work forever. Additional information on work for hire can be found in the chapter on Legal Rights and Issues. *Note:* Corporate logo designs are ineligible for work for hire, because they do not fit its legal definition, but all-rights transfers of such work to the client are common.

11. No new or additional designer or firm should be hired after a commission begins without the original designer's knowledge and consent. The original designer may then choose (without prejudice or loss of fees owed for work completed) to resign the account or to agree to collaborate with the new design firm.

Prices for design in the *Guidelines* are based on a survey of the United States and Canada that was reviewed by a special committee of experienced professionals through the Graphic Artists Guild. These figures, reflecting the responses of established professionals, are meant as a point of reference only and do not necessarily reflect such important factors as deadlines, job complexity, reputation and experience of a particular designer, research, technique or unique quality of expression, and extraordinary or extensive use of the finished design. Please refer to related material in other chapters of this book, especially in the Pricing and Marketing Artwork and Standard Contracts and Business Tools chapters.

Corporate graphic design

Corporate (institutional) graphic designers specialize in the design of corporate communications and identity programs, signage, internal and promotional publications, and/or annual reports. A team specializing in this area of design may include a principal of the firm, a production manager, a copywriter, and an account executive.

Since these projects often involve long-term research and development, corporate designers are often brought in at the earliest stages of a project. In addition, many corporate design offices work on retainer and also act as design consultants in peripheral areas in addition to their main projects.

Project proposals

The project begins once a client accepts the design proposal outlining the scope of the project, its budget, schedule, and the terms under which it will be executed. Historically, most design projects typically are quoted and billed by phase, with an initiating fee representing 10 to 30 percent of total estimated fees and reimbursable expenses.

Phase 1, Programming: This phase is concerned with gathering information and establishing design criteria, and often requires spending a great deal of time with the client to define the needs and problems that are to be solved.

Phase 2, Concept development: After the designer and client have reached an agreement concerning the basic program, visual solutions are pursued that solve the stated problems. Much of this phase results in a presentation showing only those ideas that the design team feels are viable, appropriate, and meet the prescribed criteria.

Phase 3, Design development: At this stage, the design team refines the accepted design, which may include the general format, selected typefaces and other elements, and the assignment of illustration and/or photography. A final presentation may be made to the client explaining the applications. Once the client and designer have chosen a definite direction, any changes in budget and/or schedules are agreed upon.

Phase 4, Design implementation: Decisions on all related art direction, including commissioned illustrations and photography, typography, copywriting, mechanicals, and all other elements are final at this point. Any changes made by the client after this point are billable as "author's alterations" (AAs), although designer errors or printer errors (PEs) are not.

Phase 5, Production: Depending on the end product(s) a design firm or designer has been commissioned to produce, this phase may be a matter of going on press and/or supervising the fabrication or manufacturing of products and/or unveiling a World Wide Web site. Supervision is the key to this phase, since achieving the designer's vision depends on the precision and quality achieved in this final step. After the end product is approved, the project is considered billable. The client can make changes to the mechanical and on press only through the designer. Conversely, the designer may only execute design alterations on either the mechanicals or on press with the client's final approval. Costs related to production or technical changes to printing as required by a supervisor are the responsibility of the client.

Billing

Billing expenses and fees are handled in a number of ways. During the first phase, the

Organizational Identity Design

Large-Scale Comprehensive Identity Projects*

ANNUAL REVENUES

Over $500 million	$100,000 and up
$100 - 500 million	50000 - 500,000
$50 - 100 million	25000 - 250,000
$10 - 50 million	20000 - 100,000
$1 - 10 million	10000 - 45000
Below $1 million	5000 - 40000

* Based on comprehensive research, consultation, and design audit; design of an integrated identity system including links to divisions and affiliates; presentation of three to six schematics, final applications to business papers and other corporate formats, implementation guidelines (standard manual), and client consultation. All reimbursable and out-of-pocket expenses incurred, including file preparation, service bureau output, or production of mechanicals, are billed separately.

Corporate Logo Design Projects

ANNUAL REVENUES

Over $500 million	$25000 - 200,000
$100 - 500 million	15000 - 100,000
$50 - 100 million	10000 - 60000
$10 - 50 million	10000 - 40000
$1 - 10 million	6000 - 20000
Below $1 million	3000 - 20000

† Based on research and application of primary logo identity to all corporate materials including advertising, business papers, signage, and in-house publications; presentation of three to six schematics, final applications to stationery; implementation guide-lines and client consultation. All reimbursable and out-of-pocket expenses incurred, including file preparation, service bureau output, or production of mechanicals, are billed separately.

Corporate Stationery Systems Projects‡

ANNUAL REVENUES

Over $500 million	$20000	- 50000
$100 - 500 million	10000	30000
$50 - 100 million	10000	- 20000
$10 - 50 million	5000	- 15000
$1 - 10 million	2500	- 10000
Below $1 million	1500	- 6000

‡ Based on research and design of letterhead, envelope, and business card only; presentation of up to three comprehensive layouts showing format. All reimbursable and out-of-pocket expenses incurred, including file preparation, service bureau output, or production of mechanicals, are billed separately.

Limited Projects

···

Corporate Annual Reports*

ANNUAL REVENUES

Over $500 million	$20000	-	75000
$100 - 500 million	15000	-	70000
$50 - 100 million	12500	-	65000
$10 - 50 million	10000	-	40000
$1 - 10 million	7500	-	30000
Below $1 million	5000	-	25000

* Based on research and design of 8 pages of financial, 24 pages of text; presentation of up to three comprehensive layouts showing format. All reimbursable and out-of-pocket expenses incurred, including file preparation, service bureau output, or production of mechanicals, are billed separately.

Corporate Newsletter Prototype Design

PUBLICATION SIZE

16 pages + cover	$12000	-	20000
12 pages	9000	-	15000
8 pages	6500	-	10000
4 Pages	4500	-	7500

† Based on research and design of 12 page, two-color newsletter; presentation of up to three comprehensive layouts showing format, supervision of illustration, and photography. All reimbursable and out-of-pocket expenses incurred, including file preparation, service bureau output, or production of mechanicals, are billed separately.

designer may arrange to bill on an hourly or project basis. If clients prefer to be billed on a project basis, they usually will establish an acceptable "cap" on the total amount.

Recent surveys indicate that expenses usually are billed with markups included, except for costs incurred for client-approved travel. Sales tax and freight rarely are included in expense estimates and usually are billed periodically or at the end of the project along with client alterations (AAs), which are billed at a predetermined hourly rate.

The printing or manufacturing part of the project may be billed by the studio or directly to the client, depending on the particular designer's practice. The printer and all other professionals working with the designer are accountable to the designer and ethically are bound to follow the designer's direction while working on the project, regardless of to whom the invoice is sent. This, of course, becomes a matter of practicality as well, since the designer is orchestrating many elements and must control them all to ensure consistency.

The pricing ranges shown in the accompanying charts do not constitute specific prices for particular jobs. The buyer and seller are free to negotiate, with each designer independently deciding how to price his or her work and taking into account all the factors involved.

Corporate identity

The objective of a properly executed corporate

Other Identity Campaigns*

···

Recording Artist Tour†

World tour	$20000	-	45000
National tour	10000	-	30000
Local engagements	5000	-	15000

* Based on 1994 data.

† Based on concept and design of a consistent visual identity to include recording cover(s), print and newspaper advertising, security badges, crew I.D.'s, point-of-sale displays merchandising material (team jackets, T-shirts, caps, souvenir books and posters.) All reimbursable and out-of-pocket expenses incurred, including file preparation, service bureau output, or production of mechanicals, are billed separately.

identity program is the accurate visual presentation of an organization's unique personality. Although the client's initial focus may be on the development of a new "graphic mark" or logo, a complex procedure that involves several phases and a wide range of expertise is required in order to furnish a professional level of service.

A typical, three-phase program would include the following:

Phase 1, Orientation: This phase of the program is concerned with gathering informa-

tion and establishing design image criteria. A significant sampling of visual materials is collected and evaluated. Interviews are conducted with the various relevant audiences. Communication objectives, a plan of action, and a nomenclature are established.

Phase 2, Design development: In this creative phase, design ideas for the logo or other primary identification device are developed. Applications to stationery and signage must also be designed in order to demonstrate the specific advantages of each design. Recommendations also are made regarding color schemes and secondary typography. The design selection process should be made according to the approved image criteria, not based on individual taste or subjective preference.

Phase 3, Implementation: This phase of the program is unquestionably the most important. Sufficient application formats must be developed in order to demonstrate visually the nature of the corporate identification system. Guidelines, usually in the form of a graphics standards manual, establish the management-endorsed design policy and implementation procedures. Rules governing proper usage of the program's design elements and formats are presented, which include reproduction materials for graphics and colors.

Finally, organizations that have made the most effective use of a visual corporate identity program have either contracted for a long-term consulting agreement with a qualified designer or design firm, established a properly administered in-house communications department, or both.

Chart and map design

Chart and map designers rely upon the pictorial abilities of illustrators to solve a client's specific problems. The chart or map designer frequently works from raw data provided by the client's research; however, map designers often find it necessary to do additional research to supplement what is provided.

Though related, there is a difference between the term "map design" and the traditional task of cartography. Map design generally involves editing, combining, and restyling data from preexisting maps. Cartography includes these tasks, but also requires independent confirmation and correction of data on existing maps. Both map design and cartography require an understanding of projections (reproductions of spatial objects such as the earth upon flat or curved surfaces) and their significant implications, but it is more useful in the latter discipline. Map designers often begin with a projection provided by the client.

Chart design ranges from the whimsical and highly illustrative to the scientific and highly technical. On the editorial end, the map or chart designer is treated much like a traditional illustrator. The designer is asked to provide artwork to fit a prescribed space, and prices for such work are comparable to pricing for illustration in similar markets. Current data indicate that larger works of map and chart design usually command higher fees than traditional illustration, especially when they are highly complex, requiring considerable detail and accuracy (see the Illustration Prices and Trade Customs chapter for more information).

Other uses include advertising and collat-

COMPARATIVE FEES FOR

Chart and Map Design*

	SPREAD	FULL PAGE	1/2 PAGE	1/4 PAGE
Corporate/advertising	$3000 - 5500	$2500 - 4000	$1500 - 2500	$800 - 1500
Corporate in-house	2000 - 4500	1500 - 2500	1000 - 2000	800 - 1250
Editorial	1500 - 3500	1000 - 2000	700 - 1500	350 - 1000
Textbook	300 - 800	300 - 800	300 - 800	300 - 800

* Based on 1994 data.

Note: Ranges represent simple to complex projects.

Hotel Signage

Comprehensive Signage and Graphics*

Five-star property	$50000	- 250,000
Four-star property	40000	- 150,000
Three-star property	30000	- 75000
Two-star property	20000	- 50000
One-star property	10000	- 25000

* Based on research and design of all exterior and interior signage system, excluding tenant signage; includes presentation of three tissue layouts showing format; comprehensive layout; and final art. All reimbursable and out-of-pocket expenses incurred, including file preparation, service bureau output, or production of mechanicals, are billed separately.

Internal Signage System†

Five-star property	$30000	- 80000
Four-star property	30000	- 80000
Three-star property	20000	- 60000
Two-star property	10000	- 40000
One-star property	3000	- 10000

† Based on research and design of all directories, meeting, dining, banquet, service and back of house areas; includes presentation of three tissue layouts showing format; comprehensive layout; and final art. All reimbursable and out-of-pocket expenses incurred, including file preparation, service bureau output, or production of mechanicals, are billed separately.

eral materials, corporate literature, and technical publications. Often the designer is treated as an integral part of the project by the project directors and art directors working on it. This involvement can include page layout, determination of style, size, content and color, and even the printing method. Historically, the greater the designer's involvement in a project, the greater the fees. In these circumstances, it generally is recognized that map and chart design is not illustration per se, and projects are more often priced on a fee-plus-expenses basis. Billable expenses include everything required, from messengers and miscellaneous art supplies to typography and digital media service bureau output, as well as reference materials (e.g., topographical maps) and the time it takes to do research.

The map or chart designer's responsibilities usually include provision of a tight sketch in color and all typography in position; a revision, if necessary; and finished artwork. This finished artwork can be in almost any form, including full-color artwork for separation, mechanical artwork, disk, film provided by a computer program, Linotronic output, traditional illustration, or any combination.

The price ranges listed here do not constitute specific prices for particular jobs. The buyer and seller are free to negotiate, with each artist independently deciding how to price his or her work and taking into account all the factors involved. Please refer to related material in other sections of this book.

Environmental graphic design

Environmental graphic designers plan, design, and specify sign systems (signage) and other forms of visual communication in the built and natural environment. The field can be broken down into several areas: information and interpretation; direction and orientation; identification; ornamentation; and regulation.

EGD deals primarily with guiding people through complex spaces such as cities, buildings, and parks; it includes the science of "wayfinding," an industry term referring to the design and implementation of directional systems that use design elements such as sculptural or architectural features and aids such as color coding and graphic symbols.

These designers come predominantly from the fields of graphic, product, and landscape design and architecture. They work closely with architects, real estate developers, and individual clients on projects that vary widely in scale and size. Consequently, environmental graphic designers have extensive knowledge of building design and construction, among other areas, including: the design possibilities and limitations of materials and how they react to weather; how distance affects the visibility of fonts; basic shop practices, including routing, bending, and cutting; legal requirements for signage; Braille, tactile letters, and audio wayfinding systems to enhance accessibility for

individuals with disabilities; project management.

Project budgets can be as high as $200,000 and sometimes reach $1,000,000, according to the industry trade press. Current data indicate that a large, internally luminated exterior sign can cost $30,000 or more.

Artists seeking employment in environmental graphic design should try to apprentice either with someone already working in the field of display design and production or in the graphics department of an architectural firm. They must be able to read working drawings and understand architectural scale. Useful study includes architectural drafting, computer-aided design, corporate identity and information systems design, packaging, mathematics, fine art, literature, and history.

There are specific professional and government codes that regulate and guide how a sign must be designed and where it must be located. Consequently, environmental graphic designers are required to know and follow standards established by the Construction Specifications Institute (CSI), the American Institute of Architects (AIA), and the Society of Environmental Graphic Designers (SEGD), as well as local zoning laws, municipal sign ordinances, state and local building codes, fire codes, and government regulations. A recent and significant example of such regulations are those resulting from the passage of the Americans with Disability Act (ADA), which affect the interior and exterior signs of all public facilities.

The passage of the ADA caused the cost of signage to almost double. This legislation called for the removal of all architectural and communications barriers to those with special needs.

ADA Accessibility Guidelines are available from the U.S. Department of Justice (800.514.0301, voice, or 800.514.0383, TDD).

The Graphic Artists Guild Foundation and the National Endowment for the Arts have published the Disability Access Symbols Project, a graphics package available digitally and as hard copy. The project collected and standardized a graphic vocabulary of 12 symbols indicating accessibility, such as wheelchair access for mobility impaired persons, audio description services for visually impaired people, and assistive listening devices for the hard of hearing. The symbols may be used in signage, floor plans, and other material promoting the accessibility of places, events, or programs. Information on ordering the materials can be found in the Resources and References chapter.

One of the growing areas in environmental graphic design is interior exhibition design. This includes permanent installation work in natural history and art museums, science and technology education centers, and travel and tourism information centers as well as temporary exhibit and promotional venues such as trade shows, conventions, and conferences. There are many companies who specialize only in the unique design, production, and logistical problems relating to these assignments.

An example of this growing area is the development of a permanent installation. The designing architects will work closely with a design exhibit planning firm to customize the space needs for the communications needs of the audience. These jobs generally are estimated on a project basis by the design firm and they may consult with other specialists, including graphic designers, signage specialists, pho-

COMPARATIVE FEES FOR

Environmental Graphic Design

Exterior Supergraphic*

Large client	$10000 - 50000
Small client	5000 - 25000

* Based on research, design and creation of 150-foot-wide image on 15-story midtown building, includes placement of logo; presentation of up to three layouts showing format; comprehensive layout; and final art. Supervision of execution and billable expenses are billed separately.

Exhibit Design†

Large project for large client	$10000 -100,000
Small project for small client	5000 - 30000

† Based on research, consultation and design of exhibit covering 2,500 square feet, including all structural forms and organization of illustrative, photographic and editorial material; presentation of up to three tissue layouts showing format; comprehensive layout; and final art. Supervision of execution and billable expenses are billed separately.

Outdoor Advertising*

Billboards	NATIONAL	REGIONAL	LOCAL
Large client	$7500 -10000	$3500 - 7500	$2000 - 5000
Small client	3500 - 7500	2500 - 5000	1000 - 2500

Bus & Transit			
Large client	2500 - 5000	1500 - 4000	1000 - 3000
Small client	2000 - 4000	1000 - 3000	500 - 2000

Station Posters			
Large client	2500 - 5000	1500 - 4000	750 - 3000
Small client	2000 - 4000	1000 - 3000	500 - 2500

* Based on concept and design of up to three layouts and final comprehensive for each component indicated and supervision of photography or illustration. All reimbursable and out-of-pocket expenses incurred, including file preparation, service bureau output, or production of mechanicals, are billed separately. Fee covers a limited use for one year from date of first placement within the media specified.

tography and film output vendors, and illustrators. The permanence of the display is often a factor in negotiating prices.

In trade show exhibit design, a client usually will have a group of specialists, an "exhibits group," design the traveling exhibition, in consideration of the detailed and specific needs of the design message, the need to customize the exhibit from venue to venue, and the unique traveling and setup/takedown requirements. Freelance artists are often hired to fulfill particular graphic design needs such as typography, photography, illustration, and overall creative direction. Collateral printed materials also are often utilized at the show sites and are often prepared in parallel fashion to the overall exhibition design. When pricing for these assignments, the artist-designer should consider not only the specific nature of the usage but also that these shows have a limited calendar life of a year or two. Advertising and institutional pricing guidelines should be the starting points for negotiation of prices, realizing that EGD usages are not as extensive as those for advertising and broadcast.

An environmental graphic design team often includes a principal of the firm, a project designer, and assistant designers. Since these projects often involve long-term research and development, environmental graphic designers are often brought in at the earliest stages of a project. In addition, many environmental graphic design offices work on retainer and act as design consultants in peripheral areas in addition to their main projects.

Project proposals

The project begins once a client accepts a design proposal, which outlines the scope of the project, the services to be provided, the project's budget, schedule, and the terms under which it will be executed. Historically, most environmental graphic design projects typically have been quoted and billed by phase, with an initiating fee representing 10 to 30 percent of total fees and reimbursable expenses.

Phase 1, Programming: This phase is concerned with gathering information and establishing design criteria, and often requires spending a great deal of time with the client or on site to define the needs and problems that are to be solved.

Phase 2, Schematic design: After the designer and client have reached an agreement concerning the basic program, visual solutions

are pursued that solve the stated problems. Much of this phase is concept development, which results in a presentation showing only those ideas that the design team feels are viable, appropriate, and meet the prescribed criteria.

Phase 3, Design development: At this stage, the design team refines the accepted design and a final presentation is offered explaining the applications. Once the client and designer have chosen a definite direction, any changes in budget and/or schedules are also agreed upon.

Phase 4, Contract documentation: Decisions are final at this point. The project is fully documented for implementation, which includes preparing working drawings, specifications, and reproducible artwork where appropriate. Any changes made by the client after this point become billable as additional work, although designer errors are not.

Phase 5, Production: Depending on the end product(s) a studio has been commissioned to produce, this phase may mean quality checking and coordinating the manufacturing of products. Supervision is the key to this phase, since so much depends on the precision and quality achieved in this final step. After the end product is approved, the project is considered billable; billing is usually monthly or in phases. The designer normally retains the right to execute any design alterations, corrections, and fabrication.

Billing

Billing expenses and fees may be handled in a number of ways. The designer may arrange to bill on an hourly or project, or lump sum, basis during the first phase. If clients prefer to be billed on a project basis, the client usually will establish an acceptable "cap" on the total amount billed.

Recent surveys indicate that expenses for work done directly with clients usually are billed with markups, including costs incurred for client-approved travel. Work for architects does not usually include a markup. Sales tax, if it is applicable, is usually not included in estimates and normally is billed periodically or at the end of the project along with client alterations, which are billed at a predetermined hourly rate.

The final fabrication and installation of the project is normally handled by a contract directly between the client and the fabricator. The fabricator is accountable to the designer and ethically is bound to follow the designer's direction while working on the project, regardless of who is invoiced. This, of course, becomes a matter of practicality, since the designer is orchestrating many elements and must control them all to ensure consistency.

The pricing ranges listed here do not constitute specific prices for particular jobs. Depending on the practice of the studio principals, the printing or manufacturing part of the project may be billed directly to the client. The buyer and seller are free to negotiate, with each artist independently deciding how to price his or her work and taking into account all the factors involved.

Advertising and promotion design

Advertising designers must have a sophisticated knowledge of marketing, sales, and advertising print production in addition to their design skills. Because they have expertise in a variety of disciplines, they can successfully coordinate a company's visual identity with its marketing. Consequently, more and more of these designers are being asked by clients to replace advertising agencies. In these cases, the designers often apply for agency status in order to be eligible for the "agency discount" when placing advertising with magazines and newspapers.

Advertising agency fees usually are tied to the total advertising budget, historically a 15 to 20 percent commission for creative work and media placement. However, in today's competitive marketplace, many clients attempt to lower this fee if their advertising budget is large enough to use as bargaining leverage.

It is common practice for several agencies to pitch the client (e.g., the account) on speculation, presenting ideas for their upcoming advertising campaigns. The investment and risks involved usually are accepted by advertising agencies because of the tremendous (and on-going) rewards that may be reaped from media placement should the agency win the account. Graphic designers, however, who do not enjoy these rewards, typically examine these speculative risks much more critically.

In an agreement with an advertising agency, the client is committing to work with it for at least the length of the entire advertising campaign, a long-term rather than project-based relationship. However, the fees of most graphic design firms traditionally have been based on hourly or per project estimates and

Advertising and Promotion Design

Advertising Campaigns

	NATIONAL	REGIONAL	LOCAL
Print	$7500 - 50000	$5000 - 30000	$2500 - 15000
Television/broadcast	10000 - 50000	7500 - 30000	5000 - 20000

Consumer Magazines

	COVER	SPREAD	FULL PAGE	1/2 PAGE	1/4 PAGE
General interest (*Reader's Digest, People Weekly*)	$5000 -15000	$5000 -15000	$2500 - 8000	$2500 - 6000	$2000 - 5000
Special interest (*The New Yorker, Atlantic Monthly*)	4000 -15000	4000 -12000	2000 - 8000	2000 - 6000	2000 - 5000
Single interest (*Golf Digest, Scientific American*)	3500 -10000	3500 -10000	2000 - 7500	2000 - 6000	2000 - 5000

Business Magazines

	COVER	SPREAD	FULL PAGE	1/2 PAGE	1/4 PAGE
General (*Fortune, Business Week, Forbes*)	$5000 -15000	$5000 -15000	$2500 -10000	$2500 - 6000	$2000 - 5000
Trade, Institutional (*Convene, Hospitals*)	3000 -12000	3000 -12000	2000 - 8000	2000 - 6000	1000 - 4000
Professional (*Architectural Record*)	3000 -10000	3000 - 1000	2000 - 5000	1000 - 4000	1000 - 3000

Advertorials (inserts or outserts)

	COVER	SPREAD	FULL PAGE	1/2 PAGE	1/4 PAGE
General interest, consumer, general business	$2000 -7500	$1500 - 7500	$1000 - 5000	$500 - 4000	$500 - 3000
Special interest, trade, institutional, professional	1500 -5000	1000 - 5000	1000 - 5000	500 - 4000	500 - 3000

Newspapers

	INSERT	FULL PAGE	1/2 PAGE	< 1/2 PAGE
National, major metro or circulation > 250,000	$3000 - 7500	$3000 - 10000	$1500 - 2500	$750 - 2000
Midsize metro or circulation 100,000-250,000	3000 - 7500	3000 - 10000	1000 - 2500	500 - 2000
Small metro or circulation < 100,000	2000 - 5000	2000 - 7500	1000 - 6000	500 - 1500
Weekly newspaper	2000 - 5000	1500 - 4000	1000 - 2000	500 - 1500

* Based on concept and design of a campaign using three different sizes and shapes that employ the elements of photography or illustration, headline, subhead, body copy, and company logo or sign off. Includes two to three layouts and final comprehensive for each component indicated and supervision of art. All reimbursable and out-of pocket expenses, including file preparation, service bureau output, or production of mechanicals, are billed separately. Fee covers a limited use of from one to five placements (within the media specified) for one year from date of first placement.

Package Design

··

Retail Products (by category)*

	GENERAL	SPECIALIZED CONSUMER	CONSUMER TEST RUN
Apparel	$5000 - 15000	$5000 - 10000	$5000 - 8000
Domestics	8000 - 40000	8000 - 40000	5000 - 15000
Electronics	8000 - 20000	8000 - 20000	5000 - 8000
Food/beverages	10000 - 75000	10000 - 50000	5000 - 15000
Footwear	4000 - 10000	4000 - 8000	4000 - 8000
Gifts/novelties	4000 - 10000	4000 - 8000	4000 - 8000
Home furnishings	4000 - 10000	4000 - 8000	4000 - 8000
Housewares	8000 - 30000	8000 - 20000	5000 - 10000
Toys/games	8000 - 40000	8000 - 30000	5000 - 10000

* Based on concept and design, including rough layouts; finished comp layout; supervision of illustration or photography. All reimbursable and out-of pocket expenses, including file preparation, service bureau output, or production of mechanicals, are billed separately.)

Music/Video†

	MAJOR DISTRIBUTION	LIMITED DISTRIBUTION	RE-RELEASED RECORDING
Pop/rock	$7500 - 10000	$1500 - 7500	$1500 - 2500
Classical/jazz	10000	1250 - 5000	1000 - 1200

† Based on concept and design for compact discs (CD), audiocassette and/or vinyl discs (LP); up to three layouts for enclosure or box set, jewel case, label and liner notes (where applicable); finished comprehensive; supervision of illustration or photography. All reimbursable and out-of pocket expenses, including file preparation, service bureau output, or production of mechanicals, are billed separately.

Software/Video Games‡

	MAJOR DISTRIBUTION	LIMITED DISTRIBUTION	TEST RUN
Business software	$10000 - 40000	$8000 - 18000	$7000 - 9000
Educational software	10000 - 40000	3000 - 12000	5000 - 9000
Video games software	8000 - 25000	5000 - 12000	7000 - 10000

‡ Based on concept and design for up to three layouts for enclosure, CD or diskette label, manual cover; finished comprehensive; supervision of illustration or photography. All reimbursable and out-of pocket expenses, including file preparation, service bureau output, or production of mechanicals, are billed separately.

Collateral Advertising Design

Direct Mail Package*

Annual corporate revenues	COMPLEX	AVERAGE	SIMPLE
Over $500 million	$7000 - 25000	$5000 - 18000	$3000 - 12000
$100-500 million	5000 - 25000	3500 - 15000	2000 - 12000
$50-100 million	5000 - 20000	5000 - 15000	2000 - 12000
$1-10 million	3500 - 15000	3000 - 12000	2000 - 8000
Below $1 million	2000 - 15000	1000 - 12000	750 - 5000

* For design of a basic package including outer envelope, personalized letter, brochure, reply card and return envelope.

Press or Media Kit†

Annual corporate revenues			
Over $100 million	$7500 - 35000	$5000 - 25000	$3000 - 15000
$50-100 million	6000 - 25000	3000 - 20000	2700 - 10000
$1-10 million	3500 - 15000	2200 - 10000	1500 - 7500
Below $1 million	2400 - 10000	1500 - 7500	1000 - 6000

† For design of a basic kit including cover or folder, letterhead for text and formatting for other insert material.

Product and Service Catalog (12 pages at 8.5 x 11)‡

Annual corporate revenues			
Over $500 million	$5000 - 40000	$8000 - 20000	$6000 - 15000
$100-500 million	13000 - 30000	8000 - 20000	6000 - 15000
$50-100 million	11000 - 25000	7000 - 18000	6000 - 15000
$1-10 million	10000 - 20000	7000 - 18000	5000 - 15000
Below $1 million	3500 - 15000	8000 - 10000	2500 - 8500

Brochure Design (4+ colors) ‡

Annual corporate revenues	12 PAGES AT 8.5 X 11	12 PAGES AT 6 X 9	6 PANELS AT 4 X 9
Over $500 million	$11000 - 40000	$6500 - 35000	$4000 - 30000
$100-500 million	11000 - 40000	6500 - 25000	3000 - 25000
$50-100 million	7500 - 35000	5000 - 25000	3000 - 20000
$1-10 million	5000 - 20000	5000 - 22000	3000 - 15000
Below $1 million	3000 - 15000	3000 - 10000	1500 - 6500

Brochure Design (2-3 COLORS) ‡

Annual corporate revenues			
Over $500 million	$8000 - 40000	$7200 - 30000	$3500 - 25000
$100-500 million	6500 - 40000	1700 - 25000	3000 - 20000
$50-100 million	6500 - 30000	4000 - 20000	3000 - 15000
$1-10 million	4000 - 15000	2500 - 15000	2500 - 10000
Below $1 million	2500 - 10000	2000 - 8000	1500 - 5000

‡ Creative fees are largely dependent on size of company, complexity of design, number of images (photographic or illustrative), copy length, audience, etc. Fees are based on usual and customary projects as described, assuming concept and design of up to three layouts and final comprehensive for each component, and supervision of art. All reimbursable and out-of-pocket expenses incurred, including file preparation, service bureau output, or production of mechanicals, are billed separately.

they have not enjoyed a percentage of the on-going revenue generated from a successful campaign.

Because the risk to a client's investment in advertising is often sizable, agencies often limit the designer's creative input, despite the potential benefits of the designer's expertise to the client. The designer's role is to work as part of a team comprised of a copywriter, possibly an account executive, and/or a public relations professional. When the designer is working as part of a creative team, the proposal presented to the client usually includes a strategy as well as a design solution.

When a design firm or individual designer is hired instead of an agency, many alternative arrangements are possible. For example, the designer may handle only the creative work, not the placement; in these cases some designers historically have charged 10 percent of the total advertising budget for the duration of the campaign. The designer may also negotiate a retainer. Or they may be hired to create only a single ad and negotiate a price based on the type of placement (e.g., recent surveys indicate that a full-color, full-page advertisement in *Rolling Stone* magazine usually commands a higher fee than a small black-and-white ad in a limited-run trade publication). See the Pricing and Marketing Artwork chapter for more information.

Graphic designers who specialize in advertising and promotion design often handle posters, billboards, and press kits besides the design and placement of magazine and newspaper advertising. Since they hire other graphic artists on a freelance basis and purchase art and photography on behalf of their clients, they must have a good working knowledge of advertising illustration and photography, including the trade customs that govern both.

The price ranges following assume limited use of the advertising design of up to five insertions within a specified media for one year. Recent surveys indicate that unlimited usage within the same media generally will increase the fees by up to 75 percent; unlimited use in any media will increase the fees by up to 90 percent; and a complete transfer of copyrights will increase fees by up to 175 percent. The price ranges listed here do not constitute specific prices for particular jobs. The buyer and seller are free to negotiate, with each artist independently deciding how to price his or her work and taking into account all the factors involved.

All reimbursable and out-of-pocket expenses incurred, including file preparation, service bureau output, or production of mechanicals, are billed separately.

Collateral advertising design

These graphic designers specialize in collateral material: catalogs, packaging, brochures, press kits, and direct mail packages. While clients generally retain advertising agencies to handle major campaigns for products and/or services, they will often commission or retain a design firm to furnish these pieces.

Like advertising designers whose work is targeted to elicit a specific response, collateral designers must have a sophisticated awareness of advertising, marketing, and sales. They are often supplied with art and photography by the client, so it is important to know how the rights to those visuals are transferred. If additional rights are needed, their transfer should be negotiated before the design or production stage. Graphic designers traditionally sell specific uses to the client; for example, first-time print runs.

The price ranges following do not constitute specific prices for particular jobs. The buyer and seller are free to negotiate, with each artist independently deciding how to price his or her work and taking into account all the factors involved.

Display and novelty design

Display and novelty design often is handled by graphic designers, surface designers, and illustrators, although some artists specialize in this field. This work includes posters, greeting cards, gift or boutique-type items, holiday decorations, eyeglass covers, and similar items.

Since manufacturing materials, resources, and requirements for production of these items often limit the type of display and design, research into those factors can be an important part of an assignment of this type. The resourcefulness of artists in combining these limits with creative design is often the key to a successfully marketed display or novelty item.

Some specialists in this field develop their own designs and attempt to license their work to manufacturers on a speculative basis in order to maximize the income potential in the stationery and gift industry. This gives the artists the ability to have their design appear on many products and to collect revenue from a

Display and Novelty Design

Shopping Bags*

	COMPLEX/4 COLOR	SIMPLE/1 COLOR
Extensive use	$4000 - 15000	$1000 - 5000
Limited use	2500 - 5000	1000 - 2500

* Based on concept and design including three layouts and final comprehensive for each component indicated and supervision of photography or illustration. All reimbursable and out-of-pocket expenses incurred, including file preparation, service bureau output, or production of mechanicals, are billed separately.

Point-of-Sale Display Material†

	COUNTER CARDS	COUNTER DISPLAY	POSTERS	BANNERS
Extensive use	$1000 - 7500	$1200 - 8000	$1000 - 7500	$1200 - 6000
Limited use	600 - 2500	1000 - 5000	1000 - 5000	800 - 4500

† Based on concept and design including three layouts and final comprehensive for each component indicated and supervision of photography or illustration. All reimbursable and out-of-pocket expenses incurred, including file preparation, service bureau output, or production of mechanicals, are billed separately.

Merchandising‡

	FLAT FEE	ADVANCE	% ROYALTY
Greeting cards	$200 - 550	$100 - 300	4 - 6%
Mugs	175 - 400	75 - 250	4 - 6%
Paper plates	500 -1000	200 - 500	4 - 6%
T-shirts	200 - 600	150 - 250	5 -10%
Stationery	250 - 500	100 - 300	4 - 6%
Gift wrap (no repeat)	400 -1000	200 - 400	4 - 6%
Gift wrap (with repeat)	500 -1250	200 - 400	4 - 6%

‡ Based on concept and design including three layouts and final comprehensive for each component indicated and supervision of photography or illustration. All reimbursable and out-of-pocket expenses incurred, including file preparation, service bureau output, or production of mechanicals, are billed separately. Figures based on 1994 data.

variety of sources. Naturally, not all designs can make the transition from a card to a mug to a paper plate, but many of them do, proving to be profitable ventures for their creators. Historically, artists and designers commonly have licensed the use of a design for a specific product (e.g., greeting cards) over a specific time period (e.g., three years) in a specific territory (e.g., North America) for a specific fee (e.g., a $400 flat fee, or an advance of $200 against a 5 percent royalty). Artists are paid for their designs in two basic ways: flat fee or royalties.

Guild surveys have indicated that artists usually receive royalties on gross sales ranging between 5 and 10 percent. Flat fees are common and usually are negotiated with the client, with the intended uses and other market conditions taken into consideration. For additional information, please refer to the Greeting Card Design section in the Illustration Prices and Trade Customs chapter.

The price ranges following do not constitute specific prices for particular jobs. The buyer and seller are free to negotiate, with each artist independently deciding how to price his or her work and taking into account all the factors involved. Please refer to related material in other sections of this book.

Publication design

Publication designers create the formats and "look" of magazines or tabloid newspapers. These publications have an editorial point of view and often contain advertising.

While most publication design is executed

Publication Design*

Consumer Magazine

STARTUP	GENERAL INTEREST	SPECIAL INTEREST
Circulation		
Over 1 million	$50000 - 100,000	$35000 - 65000
500 M to 1 million	50000 - 100,000	20000 - 45000
100 M to 500 M	30000 - 80000	15000 - 30000
50 M to 100 M	25000 - 40000	7500 - 20000
Less than 50 M	7500 - 30000	7500 - 20000

REDESIGN OF EXISTING FORMAT		
Circulation		
Over 1 million	$50000 - 75000	$25000 - 50000
500 M to 1 million	50000 - 75000	15000 - 40000
100 M to 500 M	30000 - 60000	10000 - 30000
50 M to 100 M	15000 - 30000	7500 - 15000
Less than 50 M	7500 - 15000	7500 - 15000

Trade Magazine

STARTUP	GENERAL INTEREST	PROFESSIONAL
Circulation		
Over 1 million	$25000 - 65000	$20000 - 45000
500 M to 1 million	25000 - 65000	20000 - 40000
100 M to 500 M	20000 - 45000	15000 - 30000
50 M to 100 M	15000 - 30000	10000 - 15000
Less than 50 M	5000 - 25000	5000 - 20000

REDESIGN OF EXISTING FORMAT		
Circulation		
Over 1 million	$30000 - 65000	$20000 - 45000
500 M to 1 million	30000 - 65000	15000 - 40000
100 M to 500 M	25000 - 50000	10000 - 30000
50 M to 100 M	15000 - 30000	7500 - 15000
Less than 50 M	7500 - 15000	7500 - 15000

Corporate/In-house Magazine

STARTUP	64 PAGE MAGAZINE		12 PAGE TABLOID/NEWSLETTER	
	4-COLOR	1-COLOR	4-COLOR	1-COLOR
Circulation				
Over 100,000	$20000 - 75000	$10000 - 50000	$4000 - 24000	$3000 - 15000
50 M to 100 M	20000 - 75000	10000 - 50000	3600 - 18000	2400 - 12000
25 M to 50 M	15000 - 50000	8000 - 40000	3600 -15000	2400 - 12000
Less than 25 M	12000 - 40000	8000 - 25000	3600 - 12000	2400 - 6000

REDESIGN OF EXISTING FORMAT				
Circulation				
Over 100,000	$18000 - 60000	-	4000 - 24000	$3000 - 7200
50 M to 100 M	18000 - 60000	-	3600 - 18000	3000 - 6000
25 M to 50 M	6000 - 36000	-	3600 - 12000	2400 - 6000
Less than 25 M	4000 - 30000	-	3600 - 12000	2400 - 6000

* Creative design fees are largely dependent on whether it's a "startup" or a "redesign," complexity of assignment, number of pages, circulation, production needs and schedules, the client's budget, the design team and deadline and printing schedules. Experienced design professionals work collaboratively with editors/publishers in establishing creative and workable design solutions for a publication. All reimbursable and out-of-pocket expenses incurred, including file preparation, service bureau output, or production of mechanicals, are billed separately.

by designers on the publisher's staff, there are many freelance publication designers. There are also independent offices that regularly produce magazines and/or tabloids, but they are not the norm in this field.

A publication designer may, on a freelance basis, design the format for a magazine or a tabloid and be retained as a consultant for periodic oversight. In this case, this role is called art director and is filled by someone who may work with one or more associate art directors, assistant art directors, and/or designers and production artists.

At the planning stages for each issue of the publication, the key editorial staff (most often the editor-in-chief, section editors, and key writers for the issue) meet with the art director and appropriate staff to hold a story and cover conference. During this session, the strategy for several issues is mapped out, with the major focus being on the current issue. A direction is established and concepts may be determined at this time. From this point on, the art director commissions art for the issues within yearly budget constraints. However, editors of a publication have approval over dummies and storyboards, since they are accepted as the authority for the publication. The publisher most often has final approval over the package, and revisions are often required.

Freelance artists who are commissioned to work on publications often are expected to sell all rights or to provide work for hire. These types of contracts limit the pool of talent available to publications, since work-for-hire and all-rights agreements are unacceptable terms for many artists (see the Work for Hire section of the Legal Rights and Issues chapter for more information).

Frequently, freelance or independent designers are commissioned to redesign an existing magazine and continue on as consultants, either on retainer or for a fee based on an estimated number of hours per issue.

Since logos are the anchors of most magazines, they are the anchor of most magazine design work. Consequently, fees for magazine design are front-loaded toward the logo. Designers are never called upon to design or redesign a "spread" of a magazine all by itself. If no logo design is required (i.e., an existing magazine wishes a new design without changing its logo), then the design fee would be weighted toward cover rather than logo design.

Standard procedure is to bill the design and development fee in segments, no matter what the size or cost of the job. For larger projects, it is usual and customary for one third of the payment to be made upon signing the agreement, one third upon approval of design comprehensives, and the final third within 30 days of delivery of mechanicals or printed pieces. Smaller projects historically have been one half at the outset and the balance upon submission of finished layouts. Billable expenses and production charges are billed regularly, usually weekly or monthly, in order to better manage the designer's out-of-pocket expenses.

Possible fees for editorial design vary as widely as the magazines themselves. Some of the factors affecting prices are: the size (number of pages) of the magazine; the numerical and geographical circulation of the magazine; its production values and capacity (black-and-white versus color, printing methods, etc.); whether the publisher is an individual or corporation, large or small; the size and stature of the designer or design firm; the urgency of the schedule. The complexity of the work involved is always an element. The lower end of a fee range is appropriate for a redesign that only requires the designer to demonstrate one or two covers and a few inside pages. If the client requires a full-blown dummy issue in order to demonstrate every possible variation that might occur in an issue of the magazine, a higher fee is charged customarily.

With such factors in mind, current surveys indicate the fee for designing a small-circulation, black-and-white magazine, based on concept and design, rough tissue and comprehensive layouts, and client consultation, ranges from $3,000 to $15,000. Production of mechanicals and all reimbursable/out-of-pocket expenses incurred to produce sketches, comps, and mechanicals are billed separately.

The price ranges following do not constitute specific prices for particular jobs. The buyer and seller are free to negotiate, with each artist independently deciding how to price his or her work and taking into account all the factors involved.

Book jacket design

Book jacket designers create the look of the jacket or cover of a book or of a series of books using the graphic elements of typography, illustration, photography, and/or designed letterforms.

After accepting the publisher's offer, the designer will be given a brief synopsis of the book and a marketing and sales strategy. The

Book Jacket Design*

HARDCOVER	ONE CONCEPT (PER SKETCH)	ADDITIONAL CONCEPTS	WRAPAROUND (% OF FEE)	VOLUNTARY TERMINATION (% OF FEE)
Mass market	$1000 - 4000	$250 -1000	25 - 125	50 - 100
Major trade	1000 - 3000	250 -1000	50 - 125	50
Minor trade	450 - 2000	200 -1000	50 - 125	50
Textbook	675 - 1200	250 - 600	25 - 125	50
Young adult	750 - 1500	250 - 500	50 - 125	50 - 125
PAPERBACK				
Mass market	$1000 - 4000	$500 -1200	25 - 125	50 - 100
Major trade	750 - 2500	250 -1000	50 - 125	50
Minor trade	350 - 2000	250 -1000	50 - 125	50
Textbook	350 - 1500	250 - 750	25 - 125	50
Young adult	750 - 1500	250 - 500	50 - 125	50 - 125

* Based on consultation with publisher, preparation of design brief, three concepts showing layout of major design elements, including composition order; checking of galleys, page proofs, and dummying; supervision of illustration or photography. "Simple" includes title page, chapter opening, double spread of text, and spreads for front matter. "Average" includes front matter, part opening, chapter opening, text comprising from three to six levels of heads, tabular matter, extracts, footnotes, and simple back matter. "Complex" designs require special treatment for each page, two-color basic texts, or other books of greater complexity than average format.

purchase order (PO) or contract usually reflects terms (e.g., deadlines and credit) and fees, which are agreed upon in writing by the publishing house's art director and the designer. The designer may prepare anywhere from one to three sketches or comprehensives (comps) for presentation; most publishers require only one initial comp. Sometimes a black-and-white or color printout (laser proof) of a computer design is provided, and then another one or two comps may be requested. If more than three comps are required, industry sources indicate that it is customary for an additional fee to be paid.

Once the comp is approved, the designer executes or commissions the illustration, lettering, or other graphic elements he or she plans to use in the finished art. Generally, the comp is as close as possible in appearance to the finished piece. Such tight comps often entail expenses; historically, all out-of-pocket expenses in the sketch and finished stages have been billable to the client. Today most comps are done with high-quality color laser prints, either an iris print or a fiery, billable directly to the client.

The nature of publishing leads to a high rate of rejection of comp presentations. Current industry practices indicate that this risk is accepted by designers and publishers, with a rejection fee, reflecting the amount of work completed at the time of the project's termination, usually paid; recent data indicate a usual fee of one half the agreed-upon amount for an accepted job. Additionally incurred expenses also are paid.

Copyright and credit for the designer should be agreed upon before work begins. When credit is given, it usually appears on the flap or on the back cover, though it occasionally appears on the copyright page. If other creative elements (e.g., illustration or lettering) appear on the cover, they should be credited as well. If the publisher is preparing the flaps of the jacket or the back cover where the copyright will appear, all credit should be noted on the mechanical but outside of the reproduction area. When the rest of the jacket or cover is set in type, the credit naturally will be added; otherwise, it is easily overlooked. In any event, when confirming a job and on the invoice, book jacket designers should specify that artwork is prepared only for the named edition and title.

Designers usually sell one-time reproduction rights; however, current practice varies. With some publishers, artists will find their work appearing in paperback years after a

hardcover jacket is issued without receiving additional payment, while other publishers pay for the additional paperback rights. Designers should clarify this provision, as well as any additional payments for use of the art by another domestic publisher, by foreign publishers or book clubs, by film or television or in other media, in a written agreement with the publisher

Production costs for necessities such as (but not necessarily limited to) photographic processing, type, and digital outputs such as iris prints or fierys generally are billed by the designer over and above the design fee. Such costs can also be assumed directly by the client.

Current data indicates that markups (handling fees) are in the range of 10 to 25 percent. This is applied to cover expenses incurred (type, hard-copy output, etc.) when the publisher does not pick them up directly.

The right of the original client to make additional use of the finished art usually is limited to advertising and promoting the original book in the edition for which the contract was initially signed. If any other rights are negotiated, a statement of those rights should appear on the designer's bill if they are not reflected in writing at the time they are negotiated. The bill should also state that all other rights are reserved by the designer and that original art should be returned to the designer.

The price ranges following do not constitute specific prices for particular jobs. The buyer and seller are free to negotiate, with each artist independently deciding how to price his or her work and taking into account all the factors involved.

Book design

Book designers develop the style and visual flow of a book's interior by using the graphic elements of typography, illustration, and photography. The functions of book designers range from highly creative to purely mechanical.

Basic design fee

Historically, a basic fee has included an initial consultation with the publisher to discuss the project; analysis of the manuscript or representative sample pages; a castoff or page count based on design; preparation of tissue layouts; a composition order (detailed written type specifications); manuscript markup; and presentation of completed design (also called tissues or layouts). When sample pages are to be set by a typesetter, the basic fee has also includes "specing"—writing design specifications or codes on the sample manuscript—and a review of sample pages after they have been set.

If a publisher requests minor changes in the design, revisions have been included in the basic design fee. If major changes are requested, the design fee may have to be renegotiated, or changes may be billed at the designer's hourly rate.

The prices following are based on preparation of as many layouts as the designer feels are necessary to show major design elements. When the client wishes to see highly detailed layouts, an increase of the fee usually is charged. Any additional considerations (such as two or more colors) are also usually reflected in an increased fee.

Before the designer can tackle the creative aspects of a job, it is necessary for someone— either the publisher or the designer—to analyze the project and prepare a design brief, which is also known as a design survey or design extract.

The design brief

The design brief includes: a copy of the manuscript, and/or a selection of representative copy for sample pages and a summary of all typographic problems, copy areas, code marks, etc.; the compositor's name, method of composition, and a listing of typefaces; a description of the proposed physical characteristics of the book (e.g., trim size, page length, number of columns, gutter widths, number of colors, if more than one). The publisher (or packager or other contractor) should also indicate whether any particular visual style is expected. Pricing is based on the preparation of the design brief by the publisher. When the designer's assignment includes this responsibility, it usually is reflected by an increase in the fee.

Design

After the fee is agreed upon, the designer prepares layouts for chapter openings, table of contents, the title page and double-page spreads of the text that include most or all typographic elements, and a sample treatment of how illustrations or photographs might be used. These examples clearly show the design to the publisher and are used as a guide in production. Designers usually provide a "composition order" (comp order) for a typesetter that indicates all type specifications in detail based on the layouts; sometimes publishers will prepare the comp order based on the

Book Design*

MASS MARKET/TRADE	COMPLEX FORMAT†	AVERAGE FORMAT†	SIMPLE FORMAT†
Mass market	$10000 - 20000	$8000 - 16000	$5000 - 12000
Trade	1200 - 20000	750 - 12000	750 - 6000
Each additional book in series (% of fee)	25 - 75	25 - 75	25 - 100
Young adult trade	1500 - 3500	400 - 2000	300 - 1000
Each additional book in series (% of fee)	25 - 50	25 - 50	25 - 50

TEXTBOOK			
College	$2000 - 3000	$1200 - 2500	$600 - 2000
Each additional book in series (% of fee)	25 - 75	25 - 75	25 - 100
Elementary/high school	3000 - 7500	1500 - 3000	1000 - 2000
Each additional book in series (% of fee)	10 - 75	10 - 200	10 - 100

DUMMY FEES			
Dummy fee (per page)	$12 - 150		$8 - 25
"Casting off" (per hour)	35 - 120		50 - 100

* Ranges reflect consultation with publisher, preparation of design brief, design of up to three concepts showing layouts of major design elements including composition order; checking of galleys, page proofs, and dummying; supervision of illustration and photography.

† *Complex format*: Books requiring special treatment of each page, two-color basic texts, or other books of greater complexity that the average format.

Average format: Design of front matter, part opening, chapter opening, text comprising from three to six levels of heads, tabular matter, extracts, footnotes, and simple back matter.

Simple format: Layout of title page, chapter opening, double spread of text, and spreads for front matter.

designer's specs.

Since the publisher often has different preconceived ideas of what a comp order should include and look like, it is best that the designer request the publisher's guidelines if available and/or samples of previous comp orders. Designers may also mark up all or part of the manuscript, which may also include a bibliography, index, etc., when written specs are not required by the publisher.

Most publishers use in-house or a compositor's production facilities to take the book from layouts to page makeup. In some cases the designer will be required to check galleys and page proofs to make sure the compositor has followed all design specifications. Designers are also sometimes supplied with electronic files of type and art, allowing them to make up the pages electronically.

With complicated layouts, the publisher may request a page dummy for the book. Dummying is taking actual copies of galleys and stats or photocopies of art and photographs, sizing them, and placing them in the exact position on dummy sheets, also called page boards. Dummies usually are intended for either another editor (e.g., a production editor) or the publisher or author to approve the design before final mechanicals are produced. The approved dummy is then used by the production staff or designer, and in many cases the compositor, to prepare the mechanicals for the printer.

Dummy fee

Recent surveys report that the dummy fee currently ranges between $8 and $25 per page (depending on the complexity of the design) and covers the cutting up of galleys, layout, sizing art and photographs, and presenting the final dummies to the publisher; it does not include a design check. If the dummier also checks the galleys or page proofs to insure the designer's specifications were followed, then an additional $2 to $3 per page customarily is charged. These checks, however, can be either

a separate function performed by a "page checker," usually a freelancer, or a member of the publisher's staff. Dummiers will sometimes cast off the manuscript or galleys, including art (estimate the typeset length or the number of pages), but this is normally the responsibility of the publisher and is done in-house by the editorial department, production department, the designer, or the composition house (typesetter). When a publisher asks the dummier to cast off a book, an hourly fee currently ranging between $35 and $50 customarily is charged.

Mechanical fee

Advances in new technologies that can generate camera-ready output or film are rapidly becoming the new standard for production; please refer to the Production section later in this chapter and to the New Technology Issues chapter for in-depth discussions of this topic. However, some publishers continue to use traditional production methods, and current data show that a mechanical fee of $15 to $40 per hour is paid to cover the preparation of mechanical boards, finished art for ornaments, maps, etc., and for the final corrections made by the publisher.

Extra charges

Supervision (art direction) of an art program, including the hiring of and coordination with illustrators or photographers, extra conference time and trips to the publisher, and time spent handling stats or type (or other production work) are billed at an hourly design rate (though the cost of type, stats, and other supplies are billable expenses).

Book packaging design

Occasionally, a writer and book designer collaborate to create a package for presentation to a publisher. Such a package includes camera-ready mechanicals or pasteups, relieving the publisher of these production responsibilities. This way of working generally is used when the idea of the book originated with the writer or designer.

Book design categories

There are some unusual projects or books for small presses that may not fit easily into the following categories. In these cases, designers traditionally use their hourly rates as the basis for a fee. If the design is to be used for a series of books, a reuse fee should be negotiated.
Trade books
♦ *simple:* A straightforward book such as a novel or short book of poetry. Design includes a layout showing a title page, a chapter opening, a double spread of text, and spreads for front matter. These simple books generally are done in-house, but may be given to a freelance designer if the publisher is small and does not have an in-house design department.
♦ *average:* Nonfiction trade books, cookbooks, poetry or drama, anthologies, or illustrated books that are designed on a grid system. Design may include front matter (half title, ad card, title, copyright, dedication, acknowledgments, preface, contents, list of illustrations, introduction), part opening, chapter opening, text comprising from three to six levels of heads, tabular matter, extracts, footnotes, and simple back matter such as a bibliography and index. The design, exclusive of the front matter, may be set into sample pages by the publisher, to be okayed before typesetting of the complete manuscript begins.
♦ *complex:* These are books, such as workbooks, catalogs, and elaborate art or picture books, requiring special treatment of each page; this category also includes two-color basic texts, cookbooks, or other books of greater complexity than in the previous category. As with the other categories, current data indicate that fees for complex book design projects generally are paid by a flat fee. In this case, a separate mechanical fee is often billed hourly. The current range for a complex book design project is $2,000 to $10,000.
Textbooks
♦ *simple:* These are mostly straight text with up to three levels of heads, simple tables, and/or art.
♦ *average:* These have up to six levels of heads, tables, extracts, footnotes, and illustrations, diagrams, and/or photographs in a grid system.
♦ *complex:* These are usually foreign language texts, two-, three-, or four-color texts, complicated workbooks, catalogs, or illustrated books that require special treatment of each page. Design fees for complex textbooks currently range from $3,000 to $3,500.

The price ranges listed here do not constitute specific prices for particular jobs. The buyer and seller are free to negotiate, with each artist independently deciding how to price his or her work and taking into account all the factors involved.

Lettering and typeface design

Lettering is used in all areas of the communications industry: advertising; corporate identity and promotion; self-promotion; packaging; and publishing. Many lettering artists also offer graphic design.

In the strictest sense, calligraphic letters are formed directly from the broad-edged pen or with a brush. But in modern usage the term calligraphy is applied more generally to letters that show evidence of handwork. These letters may be drawn first and then refined; they may be outlined and then filled in; they may begin on a computer or eventually be scanned in and further refined; or they may actually begin with an already drawn form or typeface and then hand-altered, either on paper or on a computer.

Although the computer has made a major impact on the lettering industry, there are still aspects of lettering that are done entirely by hand; e.g., unique headlines of all kinds such as those used in magazines, books, and movie titling. Envelopes, invitations, award certificates, and illuminated scrolls are some of the jobs often commissioned, some to be done by hand. While many surveyed calligraphers price envelope addressing by the line or a standard three lines (name line, street address, and city-state address), they have found the fees for certificates and illuminated scrolls are more difficult to gauge because of the varying amount of design and color work that may be involved.

Among the many factors found affecting the prices for lettering are the following: intended uses and distribution; amount of design and its complexity; size of original art; time allowed to complete the project (rush job, holiday, etc.); surface upon which work will be executed, as well as the materials involved (matte or glossy paper, glass or a can, use of gold leaf, etc.).

The work of lettering artists is similar to that of illustrators. Upon agreement on the terms and fee for the project, a letterer prepares a sketch or sketches of possible solutions to a specific problem. Historically, artists have received one third of the total fee upon delivery of sketches, and "buyouts" (all-rights transfer) may currently cost up to 50 percent or more above the original price of the art. In packaging design, fees will depend on (among other factors) whether the client hired the artist directly (which is unusual) or a design/ad agency hired the artist (which is more common). In the latter case, the fee is usually significantly less, reflecting "in-house" efforts and the agency's reluctance to part with more of the client's fee for services than is absolutely necessary. Upon acceptance of the sketches, or comp, finished art is prepared for reproduction.

Ketubot

Ketubot (the plural of the Hebrew word *ketubah*) are illustrated or illuminated Jewish marriage contracts. They fall into two different categories: prints and originals. Prints require that the lettering artist fill in the spaces provided in English, Hebrew, or both. An original requires lettering a blank surface (usually parchment or paper) and possibly adding decoration. Decorations range from simple to elaborate and may include color and gold. Prices for an original *ketubah* vary depending on the length of the text and whether the lettering artist is adding the decorative elements.

Typeface design

Among the fundamental tools of graphic communication are typographic symbols. Thousands of typefaces exist today, giving graphic designers the ability to depict, through type, the feeling, mood, tone, and very essence of a message.

Type classification is based on the following factors:

- Families are clusters of related type designs that bear the names of their parent typefaces. They vary only in style (e.g., width, stance, or special treatment) and/or weight (e.g., bold or light) and/or style.
- Fonts are the complete set of characters of a single typeface. These include alphanumerics (letters and numbers), ligatures (letter combinations), punctuation marks,

	FLAT FEE	ADVANCE	% ROYALTY
Manufacturer, complex	$3750 - 15000	$1900 - 7500	50
Manufacturer, simple	2500 - 10000	1250 - 5000	50
Magazine, complex	1900 - 7500	1000 - 4000	25
Magazine, simple	1250 - 5000	750 - 3000	25

"Simple" means new design or modification of approximately 70 characters; upper and lowercase letters and numerals for one style and one weight. "Complex" means new design or modification of the above for two styles, four weights. All reimbursable and out-of-pocket expenses incurred, including file preparation, service bureau output, or production of mechanicals, are billed separately. Figures based on 1994 data.

alternate characters (e.g., special initial caps), and symbols that correspond to a single weight and style.

Typeface design for text faces involves design of the alphabet (upper and lower), numbers, punctuation, and special characters (e.g., foreign or mathematical symbols and accent marks). Creating or styling complete families of fonts (or portions thereof) could require up to eight sets of finished drawings reflecting styles (roman and italic), weights (normal, condensed, bold), upper- and lowercase, and very often alternative sets (e.g., small caps, lining, and old-style numbers— numbers containing ascenders and descenders corresponding to the varying heights of lowercase letters), alternate characters, and kerning sets (to solve the problem of proper space adjustment between normally set individual letters). Display faces differ from text faces in that they are meant for headline use rather than smaller body text.

Computer-designed typefaces are being used extensively, enabling designers to explore options more easily than ever before. Some computer-typesetting devices are programmed even for automatic kerning. The downside of computer-generated typography is that without the application of good proportion and design, the final product can be a disaster.

The price ranges following do not constitute specific prices for particular jobs. The buyer and seller are free to negotiate, with each artist independently deciding how to price his or her work and taking into account all the factors involved.

Trade practices

The following trade practices have been used historically and, through such traditions, are accepted as standard.

1. The intended use of the design, the price, and terms of sale should be stated clearly in a contract, purchase order, or letter of agreement.
2. If a design is to be used for other than its original purpose, the price usually is negotiated as soon as possible. The secondary use of a design may be of greater value than the primary use. Although there is no set formula for reuse fees, recent surveys indicate designers add a reuse fee ranging from 50 to 100 percent of the fee that would have been charged had the work originally been commissioned for the anticipated usage.
3. Designers should negotiate reuse arrangements with the original commissioning party with speed, efficiency, and all due respect to the client's needs.
4. Return of original artwork, mechanicals, or computer disks to the designer is automatic unless otherwise negotiated.
5. The use of design always influences the price. If the design is to be featured over an extensive area or is an all-rights sale, fees are usually significantly higher than when used locally or within a selected area.
6. Historically, designers have charged higher fees for rush work than those listed here, often by an additional 50 to 100 percent.
7. If a job is canceled through no fault of the designer, historically a cancellation fee often has been charged. Depending upon the stage at which the job is terminated, the fee paid should reflect all work completed or hours spent and any out-of-pocket expenses.
8. Historically, a rejection fee has been agreed upon if the assignment is terminat-

Lettering & Calligraphy

Titling*

ROUGHS	MASTHEAD		FILM/VIDEO		RECORDING/ COVERS	
National distribution	$1275 -	2500	$1250 -	3000	$550 -	2000
Regional distribution	1025 -	2000	1050 -	2500	500 -	1500
Local distribution	725 -	1750	750 -	2000	475 -	1200
Corporate or in-house	650 -	1500	650 -	1500	475 -	1000

FINISHED WORK						
National distribution	$1425 -	3500	$2000 -	5000	$1250 -	3000
Regional distribution	1375 -	2500	1500 -	4000	1025 -	2000
Local distribution	850 -	3000	1000 -	3000	875 -	1500
Corporate or in-house	725 -	2000	1000 -	2500	725 -	2000

Note: Includes three comps, one finish, unlimited rights.

Headline*

	COMPLEX		SIMPLE	
Consumer/wide circulation	$1300 -	2500	$700 -	1500
Trade/medium circulation	1000 -	2000	600 -	1200
Special interest/narrow	800 -	1700	525 -	1000
Corporate/in-house	750 -	1700	525 -	1000

Note: For specific article: one comp, one finish on books, magazines, brochures, shopping bags, etc.

Hardcover Book Jacket*

	COMPLEX		AVERAGE		SIMPLE	
Mass market	$1000 -	1500	$700 -	1150	$550 -	950
Major trade	750 -	1125	500 -	825	350 -	650
Minor trade	600 -	950	500 -	700	350 -	500
Textbook	600 -	900	500 -	625	350 -	450
Young adult	600 -	800	500 -	550	350 -	400

Note: Used as a design solution component. One-time rights only for the specific edition involved: one comp, one finish on books, magazines, brochures, shopping bags, etc.

Paperback Cover*

Mass market	$1000 -	1500	$700 -	1150	$550 -	950
Major trade	650 -	1125	450 -	825	350 -	650
Minor trade	550 -	950	400 -	675	300 -	500
Textbook	500 -	900	350 -	625	300 -	450
Young adult	500 -	800	300 -	550	300 -	400

Note: Used as a design solution component. One-time rights only for the specific edition involved: one comp, one finish on books, magazines, brochures, shopping bags, etc.

* Based on 1994 data.

Lettering & Calligraphy (cont'd)

Certificates

	COMPLEX	AVERAGE	SIMPLE
Design and fill-in	$200 - 425	$150 - 275	$100 - 150
Preprinted/name only	4 - 20	3 - 15	3 - 7.50
Name and date	5 - 22	3 - 12	4 - 10
Additional line	3 - 12	2.50 - 10	1.50 - 7
Additional gold capitals	10 - 50	9 - 30	5.50 - 25

Note: All reimbursable and out-of-pocket expenses incurred, including custom color mixing, file preparation, service bureau output, or production of mechanicals, are billed separately.

Menus*

Lettering only	$300 - 1000	$350 - 1500	$300 - 1000
Lettering & design (ome-color, camera ready)	450 - 2000	550 - 2500	450 - 2000
Lettering & design (full color, camera ready)	650 - 2000	800 - 3000	650 - 2000

Stationery

LETTERHEAD & ENVELOPE

Corporation	$2000 - 5000	$1000 - 3500	$500 - 1500
Small business	1500 - 2300	600 - 2200	400 - 1800
Individual	700 - 1500	300 - 1200	300 - 900

BUSINESS CARD

Corporation	$500 - 1500	$300 - 1000	$250 - 850
Small business	500 - 1250	200 - 1000	175 - 750
Individual	200 - 750	150 - 650	100 - 500

SOCIAL/PERSONAL*

Monogram	$300 - 1250	$200 - 750	$150 - 500
Name only	250 - 1250	175 - 750	125 - 500
Name & address	300 - 1500	225 - 1000	175 - 750
Envelope/return address	200 - 1500	150 - 1000	100 - 750

Envelope addressing (Wedding, anniversary, party, corporate, etc. Price per piece)*

Envelopes (3 lines, centered)	$10.00	$6.50	$4.50
Envelopes (3 lines, flush left)	10.00	4.50	3.00
Each additional line	2.25	1.75	1.25
Inner envelope	4.50	3.00	1.75
Return address	5.25	4.50	3.00

Note: Based on creative fees only - including custom color mixing. All reimbursable and out-of-pocket expenses incurred, including file preparation, service bureau output, or production of mechanicals, are billed separately.

* Based on 1994 data

Lettering & Calligraphy (cont'd)

Logotypes, Taglines and Slogans*

	LOGOTYPES	TAGLINES[†]	SLOGANS[†]
Large company/national distribution	$4000 - 10000	$2500 - 2800	$1600 - 3500
Small company/regional distribution	1800 - 6000	1500 - 1600	750 - 2000
Individual	900 - 4000	800 - 1000	500 - 1500

Note: Based on creative fees only; three to six sketches, one finish, unlimited rights. All reimbursable and out-of-pocket expenses incurred are billed separately.

[†] "Taglines" are used with a logo to promote a corporate image. "Slogans" are ancillary copy or word treatment promoting an ad campaign.

Packaging

COMPS ONLY (EXPLORATION)	COMPLEX		AVERAGE		SIMPLE	
Presentation (per piece)	$350	1500	$250 -	750	$150 -	500
Rough tissues (per piece)	500 -	2500	300 -	2000	200 -	1000

Note: Assume one-year license and national distribution.

DEVELOPMENT THROUGH FINAL ART, USED				
Brand name (e.g., "Kraft")	$10000 - 25000	$5000 - 10000	$1500 - 7000	
Secondary product line (e.g., "Velveeta cheese")	3000	2000	1500	
Accent or descriptive copy (e.g., "Lite" or "Simply delicious")	1500	1000	800	

Note: Geographic distribution and length of time for use are among the factors to be considered when determining fees.

Ketubot

Print, text only*	$100 -	135	$60 -	100	$50 -	75
Original, text only	500 -	1000	350 -	750	250 -	500
Original, text/illustrated border	1000 -	2000	800 -	1500	500 -	1000

Note: Fees do not reflect transfer of reproduction rights.

Illuminated Scrolls

	$350 - 1500	$250 - 1000	$100 - 500

Note: Fees do not reflect transfer of reproduction rights

* Based on 1994 data.

ed because the preliminary or finished work is found not to be reasonably satisfactory. The rejection fee for finished work often has been equivalent to the number of hours spent on the job, depending on the reason for the rejection.

9. Designers considering working on speculation often assume all risks and should take these into consideration when offered such arrangements; see the section called Speculation in the Professional Issues chapter for details.

10. The Graphic Artists Guild is unalterably opposed to the use of work-for-hire contracts, in which authorship and all rights that go with it are transferred to the commissioning party and the independent designer is treated as an employee for copyright purposes only. The independent designer receives no employee benefits and loses the right to claim authorship or profit from future use of the work forever. Additional information on work for hire can be found in the chapter on Legal Rights and Issues. Note: Corporate logo designs are ineligible as work for hire because they do not fit the legal definition, but all-rights transfers to the client are common.

11. No new or additional designer or firm should be hired after a commission begins without the original designer's knowledge and consent. The original designer may then choose (without prejudice or loss of fees owed for work completed) to resign the account or to agree to collaborate with the new design firm.

Prices for design in the *Guidelines* are based on a survey of the United States and Canada that was reviewed by a special committee of experienced professionals through the Graphic Artists Guild. These figures, reflecting the responses of established professionals, are meant as a point of reference only and do not necessarily reflect such important factors as deadlines, job complexity, reputation and experience of a particular designer, research, technique or unique quality of expression, and extraordinary or extensive use of the finished

Digital Photo-illustration/Manipulation*

	ADVERTISING	PUBLISHING	CORPORATE
General interest/national	$45 - 120	$50 - 125	$60 - 125
Special interest/regional	75 - 120	75 - 120	80 - 125
Internet/World Wide Web	75 - 120	75 - 120	75 - 120
Rush deadlines	75 - 150	100 - 150	100 - 150

* Excludes scanning

design. Please refer to related material in other chapters of this book, especially in the Pricing and Marketing Artwork and Standard Contracts and Business Tools chapters.

Retouching and photo-illustration

Retouchers are graphic artists who alter, enhance, or add to a photograph. This is done either by manually applying bleach, dyes, gouache, or transparent watercolor to the photograph or transparency/chrome with a paintbrush or airbrush, or digitally, using a computer and software. The resulting image usually appears untouched. This "invisible art" requires a highly skilled hand and eye in order to be successful. Therefore, the retoucher most often specializes in one area of retouching and concentrates on the skills and technical knowledge of that area.

Recent advances in technology allow electronic scanning and manipulation of images, including color correction, cloning a subject, distorting or enhancing an image, or preserving an image, as in the restoration of old photos.

Specialists in the new discipline of "photo illustration" are experts in manipulating and altering photographs in order to better meet a client's needs. As clients become more aware of the creative capacities that computers present, creative professionals will have to expand their skills inventory to meet client needs. Photo-illustration is a powerful tool that can have dramatic consequences. For example, the public response to an artist's photo illustration of O. J. Simpson that appeared on the cover of *Time* magazine raised ethical questions about the role of photo illustration in journalism and whether such works should be labeled clearly so as to be careful about possibly misleading the public.

Computers versus handwork

Retouching electronically is faster than working manually, since it dispenses with the intermediate step of a dye transfer or copy negative and the re-creation of a facsimile of the original artwork. Perhaps one of its greatest advantages is that it saves one or two generations, which is critical in stringent quality-oriented jobs. It also can do very subtle things (e.g., define individual hairs in a hairdo, remove crow's feet, or create subtleties in skin tones). However, one still needs to know the basics of light and shadow, the direction of reflected light, and how to shade an object—basic drawing and painting skills—to render enhanced "invisible" results.

Electronic retouching also is more compatible with the mechanics of the prepress process. It integrates color management, i.e., calibration of color from what the scanner sees as warm gray number 2 to what the monitor displays to what the output device (printer, transparency, etc.) finally produces. A compromise adjustment mechanism (a profile) must be used to compensate for each device and keep control of consistency.

The primary drawback of digital retouching is the artist's loss of control obtained when the airbrush, paintbrush, pencil, or pen are in hand and results are immediate. When working digitally, the artist is looking at a screen that has projected light, rather than a photo that has reflected light.

As these technologies become more widely available, scanning and output fees will continue to drop. Please refer to the New Technology Issues chapter for a more detailed discussion.

Pricing

When pricing a traditional retouching project, many factors come into play:
♦ *surface:* Most color work of high quality is done on transparencies or dye transfers.

Production*

	ADVERTISING	PUBLISHING	CORPORATE
Pasteups	$40 - 85	$35 - 85	$50 - 85
Mechanicals	25 - 100	35 - 100	40 - 100
Electronic prepress	25 - 100	20 - 100	40 - 100
Rush deadlines	50 - 170	60 - 150	75 - 150

* Usual and customary hourly rates for preparing camera-ready art, electronic prepress.

The dyes used are the same as those on the actual print, so the scanner cannot tell which parts have been altered. They also allow the artist to combine different images through multiple exposures and retouch the seams to make a single image. Because of the extreme detail that C-prints can represent, they often are used for presentations but are limited to being painted with airbrush opaques. C-prints require up to seven hours to retouch, including drying.

♦ *dye transfer:* a process that creates richer and sharper images and are extremely dependable for printers to reproduce, as are chromes. Dye transfers may require 30 hours or more to retouch; they require a test print, an adjustment, another test print, and finally the retouching.

♦ *brush, pencil, dyes, bleaching, etching, and airbrush techniques:* These are used on all surfaces. In black-and-white retouching, high-quality photographic prints are used most commonly. R prints are from transparencies; they are softer and more saturated in color. C prints are from negatives; they are less saturated in color but have sharper definition. Upscale markets who can afford it, i.e., cosmetics, often prefer R prints, though C prints are more economical to produce.

♦ *complexity:* Photo illustration and retouching can run the gamut in the extent of changes to the photo, from simply adding a few highlights to actually creating realistic, hand-wrought backgrounds, shapes, or figures or stripping two or more photos together to create a montage.

♦ *expenses:* typography, photography, props, and other out-of-pocket expenses generally are billed as additional expenses, according to recent surveys. Artists also should take into consideration the initial cost of hardware and software when setting prices.

♦ *overtime:* Retouching, by its nature, should not be a last-minute project. It's important, therefore, to know how retouchers report charging for extraordinary time requirements. Normal timing for any average-size project is three days. Overtime rates for less than three days' turnover are figured as follows: two days, 50 percent more; one day, 100 percent more (rush job). If the job requires evening, weekend, or holiday time, there is often a 100 percent overtime charge.

♦ *rights:* Unlike other graphic artists, retouchers always work on an existing piece of art and usually are not entitled to copyright or reuse fees. The fee that they charge represents the total income from that project, unlike artists who may benefit from future uses of a work. Photo illustrators, on the other hand, are creators who, similar to other artists, control all the rights of their creation.

Production artist

The role and responsibilities, as well as the perception and mode of work, of the production artist has changed with the introduction of electronic technology into the graphic workplace. Before computers, production artists were responsible for quickly and precisely combining type and art as directed by the designer's specifications and, using knowledge of printing, preparing the final forms, called mechanicals, to go on press. In order to accommodate the limits of the print medium, many details, including the kind of overlay used on the keyline to the way the ink sat on the paper, had to be understood and considered in the construction of the mechanicals.

With the advent of desktop computers, typographers, strippers, camera personnel, and others involved in lithographic processes were

replaced by computers and service bureaus. These latter are companies that can translate digital files directly to film or other necessary hard copy output. As a result, designers now are expected to have the skills of production artists.

Responsibilities

Once the designer and client have agreed upon the final design, the production artist begins preparing the art for the printer. The production artist provides the link between the conceptual design and the tangible result, between the graphic designer and the printer. The essential elements a PA handles include: fonts, graphic files, software, trapping, color matching, instructions for resolution and screens, and service bureau and printer's guidelines.

To ensure the integrity of the final product, the PA's responsibilities include: completing work by the deadline; using appropriate tools (i.e., choosing the correct computer hardware and software); conveying to designers the expense of producing their design electronically, giving designers options to be more cost effective; and maintaining the integrity of all the design elements. Production artists must be detail-oriented and keep current on technological changes in computing and printing. The scope of knowledge that a production artist must have includes design, printing processes—conventional and electronic—and current computer capabilities.

Where does the production artist's responsibility end and the service bureau/printers begin? Production artists can save significant costs if skilled in areas traditionally in the domain of printers, such as trapping, high-end scanning, photo retouching, or imposition. These responsibilities usually fall on the printer, who has the expertise in this area. If a pro-

duction artist is able to assume one or more of these responsibilities, he or she has been highly trained in this area and should be appropriately compensated.

Levels of expertise

Finally, the PA's level of expertise and training will vary based on the services they provide. For example, a production artist working at a printer or service will have different skills and responsibilities from a production artist working at a design firm. Therefore, pricing is determined in part by the level of services provided.

Pricing

A production artist's level of pricing will vary based on the complexity of the job. Some factors production artists take into account when pricing their work include:

♦ level of complexity in preparing electronic files (i.e., a 4-page newsletter compared to a 100-page catalog)
♦ scanning (low-end, high-end)
♦ page layout (simple to complex)
♦ file conversions (Mac to PC or PC to Mac)
♦ on-site or off-site work
♦ last-minute decisions/rush jobs
♦ preparation of all paperwork: specifications for printer, composite laser proof (marked up), laser-proof separations, folding dummy (a model of how a finished piece will fold)
♦ produce rough color proof vs. high-quality color proof

The price ranges following do not constitute specific prices for particular jobs. The buyer and seller are free to negotiate, with each artist independently deciding how to price his or her work and taking into account all the factors involved. Please refer to related material in other sections of this book.

Multimedia
prices &
trade customs

• • • • • • • • • • • • • •

Multimedia is one of the fastest growing markets in the world today. The Information Workstation Group, a multimedia research company, has forecast that multimedia will be a $30 billion industry by 1998. Forrester Research, an industry research firm, predicts that the multimedia service market (subscriber services such as America Online and CompuServe) will grow from $530 million in 1994 to $3 billion by 1998 and projects that online ad revenues will soar from $80 million in 1996 to $4 billion in 2001.

As technical advancements continue in speed-of-transmission hardware and storage capacity, new markets for multimedia applications and related services will become more viable. For example, technologies that create a virtual reality, complete with interactive sensual stimulation, have been capturing a bigger market share in the communication field, and future new markets are as yet unclear.

Multimedia—short for multiple media—at its very basic level is the combination of one or more of the following: text, graphics, animation sound, and motion video. Computers give users the ability to navigate related multimedia elements, bringing traditional print to life by adding the impact of sound and video.

Interactive media designers create digital graphics, illustration, and animation for presentation programs, consumer CD-ROMs and online services, touch-screen kiosks, and video

games. These designers work for a wide range of industries including entertainment, marketing, education, commerce, and training.

New markets invariably bring great excitement—and new dilemmas and questions. Artists are discovering the creative possibilities of not only drawing for but producing multimedia work; entrepreneurs are creating production companies that grow quickly and creatively all at once. Embedded in the race are important traditional flags and guideposts: copyright protection; the need for clear contracts and communication between clients and artists; the basic essentials of respectful treatment despite pressing deadlines. These practices provide the underpinnings of a successful enterprise, whether an 18-month Website contract or a screen saver for new operating system. It behooves both artists and clients to recall these protocols as the deadlines rush up at breakneck pace, along with the images accompanied by the latest New Age hit.

Some designers and illustrators working in other markets are beginning to explore the possibilities of new markets for their work in multimedia. Others have held off, simultaneously immersed in their day-to-day responsibilities and a bit wary of unusual and complicated new technologies. This new chapter of *The Graphic Artists Guild Handbook: Pricing and Ethical Guidelines* provides a straightforward overview of several of the hotter markets, and a handy and abbreviated glossary is included for readers' ease of use.

Since technological means of protecting copyright and reuse are developing simultaneously with the media, and trade practices for other media may not always apply, this chapter also gives some of the terms and protective mechanisms artists themselves began developing.

As a new chapter in the *Guidelines,* and one in a discipline that is changing rapidly, it is challenging—and extremely exciting—to continue exploring these new fields and opportunities. Readers are welcome to send information, comments, and updates to the Guild for future editions of the *Guidelines.*

Markets

Many of the new markets are simply extensions of the old. That is, old clients—publishers, media companies, advertising agencies—have added a multimedia option to the services they already provide, and need artwork to accompany them. Then there are the new entrepreneurs, which comprise a growing portion of the new markets: the startup software company; the individual game developer; the multimedia production company that resembles and operates much like a video production firm; and "publishers" who have very high margins (more than 5 percent).

Great emphasis is being placed on the development of preschool and elementary education programs. Much of this work is called "edutainment," which translates as a program of educational material presented in an entertaining format, such as a numbers game that teaches children math or an adventure game that features actual historic characters or events. Museums and zoos, for example, exploit multimedia to enhance visitors' experiences.

Joint research projects, development efforts, and diagnostics are now less constrained by time or distance. For example, hospitals and doctors use multimedia technology to send image data of medical samples to distant labs for diagnosis.

Reference materials (i.e., encyclopedias) are compressed, and video, animation, and sound are being added to the text, graphics, and photos. Development budgets for a reference project can range from $100,000 to as high as $1 million, with project teams consisting of from 20 to over 100 people. CD-ROMs are stored easily and, in many cases, are equipped with search engines that help define the subject of interest, pinpoint its location, and cross-reference it with other material on the disk.

Commercial transactions, such as banking and shopping, are proposed for home convenience, though there are some concerns about security problems when credit cards are used. Advertisers can either publish whole catalogs on disk or locate it on a Website. These digital catalogs must be updated as stock is depleted or added, saving on printing and postage costs; the need for images to illustrate new products is becoming an avenue of steady work for freelance artists.

Other related services are expected to become popular as technology improves, including software that will allow prospective real estate clients and home builders to view simulated living space and property without ever setting foot out of the realtor's or designer's office—or eventually their own home. Digitized prints of entire catalogs can be stored on a CD-ROM, and programs can be written to allow for interactive ordering of merchandise online. This is done currently with office buildings.

Industrial applications include using workstations and a network of personal computers to make it possible for people in remote places to work together and communicate. Multimedia is also used extensively for training and retraining of personnel. The Defense Department is the largest user of multimedia within the federal government, where such training programs have been designed for use by most military service branches.

Corporate communications and public relations departments in large companies hire multimedia professionals to design presentations for product introductions, technical training, management development, trade shows, motivational sales meetings, and meetings of the board or shareholders. Designers incorporate charts, graphs, photography, film, computer graphics, and video, and then sometimes enhance the piece with sound effects and music. Of course, designers must respect and purchase appropriate licenses for materials they have not created or confirm that they are in the public domain; see the Copyright section in the Legal Rights and Issues chapter.

Contract terms

Many of the standard characteristics of illustration and design contracts apply to multimedia as well, and the Trade Practices sections of the Illustration and Graphic Design chapters of this book, as well as the model contracts in the Standard Contracts and Business Tools chapter, give in-depth descriptions of these by type of work provided. There are some terms specific to multimedia work, however, and these follow:

♦ *deliverables*: final or interim products. Many contracts do not describe these in appropriate detail, leaving both artist and client in peril of miscommunication and dissatisfaction during the contract and with the results.

A full and clear description will include: size of work, using appropriate measurements (i.e., time, file size, or segment of programming source code); modules that conform to the function specifications; acceptance, time for review, kinds and types of revisions included in fee, etc.; technical needs of product, i.e., medium, electronic file format, style guides, etc.; intermediate review timetables and deliverables required at those stages; copyright ownership of deliverables.

♦ *expenses*: Widespread industry practice indicates that the contract usually provides for the reimbursement of both direct and indirect expenses. If exact amounts are not known at the time of signing, they should be estimated and the client should be given the option to approve any costs in excess of those projected in the original agreement. Direct costs include: commissioning new or leasing existing images, voice talent, run-time licenses, etc. Other expenses include: travel, research materials, postage and delivery charges, photocopying, and media costs (recordable CDs and Syquest cartridges).

For artists who bill hourly, capital investment needs to be considered in determining fees. Please see the Hourly Rate Formula section of the Pricing and Marketing Artwork chapter.

♦ *kill and cancellation fees:* A negotiated kill fee in most markets of the graphic communications industries usually reflects the amount of work completed.

♦ *payment terms:* Depending on the length of the project, fees may be paid in a lump sum within a set period (i.e., 30 days) of completion or, for longer deadlines, at obvious intervals. These often are tied to deliverable reviews; i.e., if there is one review, payment may be divided into three increments: one third on signing of the contract; one third upon review; the last third upon completion.

♦ *schedule:* While timing of deliverables is an obvious contract commitment, multimedia projects without deliverables as such also require specific timeframes; for example, provision of services. Contracts including schedules should include provisions to be met in the event deadlines are missed by either artist or client.

♦ *copyright:* For a full discussion of copyright issues, please see the Legal Rights and Issues and New Technology Issues chapters of this book.

One specific multimedia-related copyright concern is ownership of the rights in deliverables. Obviously the creator should ensure that the necessary rights to all work used to create the final product is purchased or confirmed to be in the public domain. Multimedia creators often negotiate for the copyright to the final deliverable; if this proves difficult, creators often attempt to retain rights to the intermediate deliverables.

♦ *noncompete clauses:* These are contract provisions that restrict an artist from creating

works perceived to be in competition with a client's. Noncompete clauses are troublesome for creators, as they limit their potential client base. Clients, however, have legitimate concerns that work resembling theirs will appear in the same market at an overlapping time. A compromise may be a stipulation that the artist will not create work that is in conflict with the client's. Artists also on occasion propose clauses that offer the client the right to refuse new product ideas before they are offered to other clients.

If it appears difficult to eliminate the noncompete clause, there are appropriate limitations that may be negotiated, such as time limits, geography, usage, etc.

♦ *credit:* Appropriate attribution and publicizing of credit can enhance an artist's reputation and ability to get work, and is therefore an important point of negotiation; production studios have taken the initiative in negotiating them with clients. As in film, video, and television, there are many creators, and credit may be difficult to negotiate initially. As creators' work and reputations grow, however, this should become easier.

♦ *samples:* This is particularly valuable for consumer products and useful for self-promotion. An appropriate number should be determined at the time of negotiation, as well as a reduced rate for future purchases.

♦ *demonstration rights:* These are essential for self-promotion. Clients, however, may be wary due to fears of preempting launch publicity or revealing work to possible competitors. Compromises have been negotiated with provisions such as the right to show limited portions or unlimited rights after the product is released.

Pricing

It is difficult to apply traditional print pricing guidelines to multimedia. Criteria based on size, placement, or number of insertions loses credibility for artwork used in interactive media, which has the end user determining the sequence, timing, and repetitions of the work. Geographic distribution remains relevant for some multimedia markets such as games, kiosks, and point-of-purchase displays, and training programs, though the global nature of the Internet makes locale moot for Website design.

Recent research indicates that artists are beginning by transferring rights only for known delivery media, which are listed specifically in the contract. Some payments are being made as flat fees; others are treated as an advance against a royalty based on total distribution. Companies can allocate some of their royalties to freelancers they have hired for particular jobs.

Recent survey data indicate that royalty payments vary dramatically depending on the type of product; the relationship of creator to product; and the economics of how the product is going to be created and distributed. These variables may include: independent distributors; overhead; unit production costs; and what portion of the overall work the artist has contributed, etc. Since the market is still in flux, royalty rates vary dramatically.

Some artists and designers also are keeping their prices to the value their artwork helps earn for the client. Generally, the wider and greater benefit or viewing, the higher the value to the client. This may be gauged in relation to projected sales or the client's track record on previous similar projects.

Some artists estimate the hours the job should take as an additional gauge of a job's worth. Fees for meeting time, usually charged at a lower-than-usual hourly rate, usually are added. Occasionally a client prefers to set a fixed price for a project. At such times, an accepted industry practice is for artists to increase fees to accommodate unexpected changes, rush work, and other overages that can occur during the course of a job.

A flow chart and simple storyboard can serve to assess the scope of the Web design task as an early catalog of the amount of graphics required. Web designers often determine file names and sizes on these charts before beginning design concepts. Planning this way helps the designer to determine how many unique graphics have to be produced. On occasion, an artist may negotiate payment for a sample to determine the time and therefore the overall scope of the project.

Artists should be aware that although Web server software collects data about how many "hits," or requests (i.e., someone has called it up to look at), a page gets, it can be manipulated easily. This makes using the number of hits for pricing questionable. For example, if a page has text and three graphics on it, that page will register four "hits" every time it is called up, dramatically inflating the statistics. Also, Web pages often change constantly (unlike book or magazine pages that exist permanently); some graphics may only be on the

site for a few weeks or months, while others remain constant.

Project team

Most multimedia projects require a number of skilled workers. The designer, as creator, is the keeper of the product's "vision," of what the product is supposed to be, what the player will experience, how the game is played, what features will and won't be included, etc. The designer strongly influences the work of programmers, artists, and sound technicians but, as with the best art directors in other markets and product categories, he or she allows craftspeople to carry out their work as independently as necessary. The "developer" of a product is this entire creative team, since it's almost impossible for one person to successfully perform all phases of good product development in a reasonable period of time.

Both creators and clients should guard against micromanaging the project. Clients should review any materials received from the creator and give a detailed list of comments and suggestions for revision. As in other fields of design, changes are easiest to implement if they are made before construction or production of the finished work. Corrections are far more expensive if they occur after the product is finished. Artists surveyed report treating these changes as author's alterations and charging fees accordingly.

The proposal

A design proposal estimating fees, expenses, and schedule generally is presented to the client before work on a major project begins. The proposal details, as necessary, many of the following factors: objectives and requirements of the project; research; the art and/or copy that will be developed by the designer; intended use of the piece; the schedule. Additionally, designers frequently prepare documents explaining relationships with subcontractors (such as animators or programmers), billing procedures, and contract terms. (For more information, please refer to the Writing a Proposal section in the Standard Contracts and Business Tools chapter.)

It is customary for project description and cost proposals to be submitted to clients as a complimentary service, although any fees and expenses included thereafter on a client's behalf and with the client's consent are billable. If the client accepts the proposal, the term and conditions expressed in writing are confirmed with the signatures of the client and the developer. Actual work begins once a client accepts the design proposal.

Website design

Website design is not the end of print. If anything, the Web is creating a need for a whole new level of print and broadcast collateral material. People have to be told, through other channels, where to find a Website.

If we use the familiar metaphor describing the Internet as a superhighway of information, Websites can be seen as destinations or billboards that flash along the way. As in other media, information on the Web is intended to inform, promote, or persuade. Each of these objectives convey varying value to be considered when developing a particular site.

Putting up a Website can be like putting up a handbill in Times Square; there are thousands of new sites being added to the Web every day. In order for a site to grab someone's attention and communicate a client's message, good graphic design and its components, like illustration, are essential.

Visual design is just a part of what a Website client and user experience, and designers must take into consideration the overall information structure, presentation, and delivery mode. In fact, many Web designers are calling themselves "information architects"; another term in use is "interface designer."

Similar to architects of three-dimensional space, designers need to coordinate a team of specialists, including photo illustrators, copywriters, animators, multimedia experts, and computer programmers; the designer may also be brought on as a member of the team by a project manager.

The life force behind many Websites is the programming, and a clearly structured relationship with a trusted programmer is essential. Designers are advised to define the ownership rights of the program code in their contractual arrangements with a programmer. Authored as source code from a variety of computer languages, the programmer will want to retain rights to it, and that ownership should be considered in light of the client's needs, including whether the programmer is able to maintain the code indefinitely. For highly complex Websites or those central to the client's mission, the source code sometimes is provided to the customer with limited-usage rights.

Before proposing how a Website will work,

Electronic/Digital Illustration (Offline)

CD-ROM, CD-Interactive, Other Portable Media (per image)

ADVERTISING/PROMOTION	LARGE COMPANY/WIDE DISTRIBUTION		SMALL COMPANY/LIMITED DISTRIBUTION	
Splash screen	$1500	- 3000	$1000	- 2500
Full screen	1000	- 2000	700	- 1875
Half screen	750	- 1500	500	- 1000
Icon/button	350	- 500	250	- 400
CATALOG				
Splash screen	$1500	- 2500	$1000	- 2000
Full screen	1000	- 2000	700	- 1500
Half screen	700	- 1500	300	- 700
Icon/button	200	- 500	150	- 350
CONSUMER/GENERAL INTEREST				
Splash screen	$1500	- 3000	$1000	- 2000
Full screen	1000	- 2000	750	- 1500
Half screen	750	- 1500	500	- 1000
Icon/button	200	- 400	150	- 300
BUSINESS/SPECIAL INTEREST				
Splash screen	$1500	- 3000	$1000	- 2000
Full screen	1000	- 2000	750	- 1500
Half screen	750	- 1500	500	- 1000
Icon/button	250	- 500	200	- 400
EDUCATIONAL/CHILDREN				
Splash screen	$600	- 1200	$500	- 1000
Full screen	400	- 900	300	- 700
Half screen	250	- 600	150	- 500
Icon/button	150	- 350	100	- 400
Storyboards (per screen)	400		150	
ENTERTAINMENT/GAMES				
Splash screen	$1500	- 3000	$1000	- 2000
Full screen	1000	- 2000	750	- 1000
Half screen	500	- 1000	400	- 700
Icon/button	250	- 600	150	- 400
Storyboards (per screen)	400		400	

the programmer must detail the tasks involved in making the interactivity work. The designer is expected to provide the programmer with all of the multimedia and interactivity objectives and details.

Thorough advance planning is necessary because, once the programming has begun, any changes to the programming or artistic elements will incur high charges. Programmers don't work in "comps" as do designers or illustrators. When they sit down at the keyboard, they are on the clock and, if changes are made, the original estimate could double or triple.

Developing the site

Before developing a proposal, ask questions of your client, including:

♦ Has the client seen the Web?
♦ Does the client understand the difference between the Web and an online service such as America Online or CompuServe?

 This answer to this question is an indicator of the client's overall Web knowledge. If the client does not understand the difference between the Web and an online service, designers may want to assume an added time factor in determining fees, as they will likely find themselves more involved in training and education than usual.

♦ Is the site to be hosted in-house or with another provider?
♦ Does the client have an Internet account somewhere?
♦ Is the account with a true Internet service provider (ISP) or with an online service such as America Online or CompuServe? If the account is with an online service rather than a true ISP, there may be extra costs or special arrangements that need to be made to host the Website. If the designer is handling the arrangements for putting the Website online, then it's important that he or she know this before the design is done (there may be special requirements for the design as well). The cost issues of this arrangement will most likely be between the designer's client and the online service. The designer may see added costs in the time he or she takes to deal with the online service.
♦ Is the account only for email or does it allow server space for the Website?
♦ What requirements/limitations are there for including interactivity in the Website? Keeping a Web server running is a delicate balancing act. Most ISPs and in-house technicians are cautious about allowing custom programming.
♦ If the site is to be hosted in-house, has the client's information services department been included in the planning meetings?
♦ Does the client have the staff to respond to email? People on the Internet expect immediate responses to their questions and comments. If the owners of a Website don't respond, the client will develop a bad reputation in the online world.
♦ Does the client have a plan set up for in-house site maintenance, or does the client want the designer to do it? Designers considering site maintenance arrangements should look carefully at the ability of their own organization to do, at least, biweekly or monthly changes.
♦ Does the client want interactivity and/or multimedia?
♦ What is the client's target market and how well connected to the Internet is this market? If the target is a broad-based, international audience, potentially with slow modems, old browsers, or expensive service, this will limit the design options.
♦ Are the client's source materials in electronic form, and if so, is the designer prepared to handle file conversions?

Copyright

As soon as a site is up on the Web, it can't be protected easily from copying; the information or graphics are available freely to anyone who can see it; in fact, the user's computer will download all the files on a specific Web page. Graphics appear as very low resolution images, however, and viewers can't do much with it other than put it on another Web page or make a screen saver out of it. A much better quality image can be scanned out of a book.

American copyright and libel law is being applied to Internet content, but the fact that the Internet is global makes it difficult to sue over infringement. If an artist sees one of his or her graphics on someone else's page (the most common offense), common practice is to send an email and ask the person to take it down, as Web etiquette requires. Most frequently it's someone who put up the page in their spare time and didn't realize that it was illegal to use other people's graphics. It is common to use a button or graphic from a target, or linked, page as a graphical pointer. Since linkages may increase the chance of capturing a customer, Web content providers generally allow this specific use.

Beware the worms. Bitmap worms are programs that scan the Web for graphics, collecting them into icon collections and so-called clip art collections. Buttons might be picked up by a worm and then presented on a different site as so-called public domain art. Once again, enforcing one's rights may be difficult. Designers and artists are encouraged to register their sites/images with the U.S. Copyright Office (see the Legal Rights and Issues chapter for information on registration procedures).

Computer games

The computer games industry can be considered over two decades old, dating from the first

Electronic/Digital Illustration (Online)*

Online services (America Online, CompuServe, Internet providers, etc.)

	MAJOR SERVICE	SMALLER SERVICE
Image map	$200 - 2500	$1000 - 1500
Spot	1000 - 1500	500 - 750
Icon/buttons	150 - 500	125 - 300

WORD WIDE WEB	LARGE COMPANY/MANY "HITS"	SMALL COMPANY/FEW "HITS"
Advertising	-	
Image map	$2000 - 4000	$1500 - 3000
Billboard	1500 - 2500	1000 - 2000
Spot	500 - 1500	500 - 1000
Icon/buttons	250 - 750	250 - 500
Corporate		
Image map	1500 - 4000	1000 - 3000
Billboard	1200 - 2000	750 - 1500
Spot	500 - 1200	400 - 1000
Icon/buttons	250 - 500	200 - 500
Editorial		
Image map	1500 - 4000	800 - 1500
Billboard	1200 - 2000	500 - 1000
Spot	300 - 1000	250 - 1000
Icon/buttons	150 - 500	125 - 250

INDIVIDUAL/PERSONAL		
Spot		$300 - 500

* Assumes limited rights transfer.

appearance of Pong and, a bit later, Apple and Tandy computers, in the seventies. There are three different possible markets: arcade, personal computer (PC), and video games. Future prospects are expansive, however: the next frontier is considered to be true online games with hundreds of players involved simultaneously—in real time. Only a few of these games exist right now, and they are doing exceptionally well.

Development costs vary, depending on the platform, scope, and scale of the title, and the amount of chrome desired. A PC CD-ROM game can have a budget of $250,000 to $1 million; a video game may range from $500,000 to $2 million or more. Game development budgets can range from $1 to $2 million, with promotional budgets twice that amount. Independent developers often must seek out investors if they ever hope to see their game on

the market. Many developers choose to license their product to a publisher or, particularly in PC games, make their products available through shareware. Projects often take 12 to 18 months to complete. Video game developers almost always seek outside investors and avoid shareware introductions.

Most publishers prefer freelancers to be part of a team responsible for the whole project, rather than subcontracting with individual freelancers. A competent development team needs designers, programmers, artists (of varying skills, depending on the title), and sound technicians. A project manager is valuable if the team is greater than five or six people. A good team of well-rounded generalists is valuable, since they are invariably more efficient, find the most attractive answers, and get the product done faster. If not, it may be best to break up

Animation/Audiovisual/Multimedia

AUDIOVISUALS*	PER COLOR FRAME
Advertising	$600 - 1000
Corporate and promotional	225 - 600
Educational	150 - 500

* Illustrations used in corporate slide presentations.

TV ANIMATION	SIMPLE	COMPLEX
Illustrations used in animated television commercials		
Original design/development (30 seconds)	$2000 - 6000	$5000 - 10000
Licensing of character (30 seconds)	1000	2000
Television advertising (per frame)	150 - 500	350 - 800
Styling of key frames for 15-second ad	10000 - 20000	15000 - 30000
Styling of key frames for 30-second ad	20000 - 50000	30000 - 75000

CORPORATE AND PROMOTIONAL (per frame)		
Styling of key frames for 30-second ad	$5000 - 10000	$7000 - 15000

EDUCATIONAL (per frame)		
Styling of key frames for 30-second ad	$2000 - 5000	$5000 - 10000

ANIMATICS (see preproduction section)

COMPUTER ANIMATION	2-D	3-D
Rate per second	$100 - 300	$400 - 1000
Rate per frame	30 - 65	75 - 130

the basic disciplines into subdisciplines to get the expertise needed in that particular product. For example, a text or dialogue-heavy game with a designer unfamiliar in that area needs a scriptwriter. A game with a lot of animation and with artists unfamiliar with animation work will need an animation specialist, etc.

It is unwise for a designer to "type" games too strongly, as good games are built of various design elements. The trick is to determine which design features work harmoniously together. Successful designers either make inspired guesses based on personal taste or reuse formulas successful in the past, with a few modifications. The most common categories are: action, sports, adventure, role-playing, simulation, strategy, card games, and educational.

Royalties

Industry practice indicates that teams usually get a significant advance on royalties, paid in pieces as milestones are reached. Royalties are commonly a percentage of the publisher's sales; recent data show that they are usually in the 10 to 20 percent range, with high-end amounts going to aggressive and/or famous designers/developers. Returns are subtracted from royalties, and since returns can occur up to 12 months after sale, it's not uncommon for bad games to show negative royalties at some point. Savvy artists anticipate this eventuality by insuring the advance is nonrefundable.

Some titles involve advances of less than $25,000, while others are in the $1 to $2 million range. A modest PC title includes a $250,000 to $500,000 advance, while a big PC title is about $600,000 to $1.2 million in advances. Good console action games tend to cost about 50 percent more, due to steep graphic expenses. Publishers usually try to keep advances to a minimum so that developers and designers share in the product's risks—and its

rewards—if sales are strong later.

The advance is sometimes "recoupable" from the future royalties due the developer; that is, it is subtracted from royalty payments until the publisher has been repaid. Care should be taken to determine whether the contract requires the advance to be refunded in the event sufficient numbers of product are not sold to earn it back. It is to the developer's advantage to secure nonrefundable advances only. Developers with a proven track record are most often able to negotiate nonrecoupable advances. Very few publishers include cancellation or kill fees in their contracts.

However, some designer/developers ask for royalty guarantees. In this scenario, the publisher guarantees to the designer/developers that royalties from sales will reach at least a specified figure of dollars or units. However, about the only time a publisher will consider this is when the designer/developer has a finished product (i.e., there was little or no advance) and he or she can evaluate reasonably whether the product can achieve the specified sales level.

Rights

For a computer game, publishers prefer to buy all rights, worldwide, on all platforms, and often insist on total copyright transfer or at least joint rights. As with all markets and products, designers and developers stand to gain the most by retaining their rights as creators. Sometimes it's only for limited platforms, since few publishers handle all platforms well. Sometimes it's only for a limited part of the world, especially if the publisher is unable to cover other areas of the world. Clarify that "all rights" refer to all computer entertainment rights on the specified platforms and in specified parts of the world. Online rights are usually another platform, but since they're closely related to personal computers, these publishers usually insist on online rights as well.

Savvy artists will retain ancillary rights such as character licensing of toys, games, cartoons, and movies. While publishers may attempt to buy these for the same initial fee, artists and developers will at most consider including veto rights or rights of first refusal— for additional compensation.

The only licensing in the computer game business is the application of a general entertainment title license (usually a book, toy, or movie title) to a game. Please see the Reuse and Other Markets section of the Pricing

and Marketing Artwork chapter for further information on licensing and merchandising opportunities.

Credit

Traditionally credits appear on-screen and in the game manual. Some publishers so skimp on the game manual that the on-screen location is the only location left. Credits on the box are uncommon.

Contracts

Provisions such as indemnity, noncompete or conflict, or exclusivity clauses are included in some contracts, but the most common is the right of first refusal on future products in general, or on future products with any relation to the product developed.

Agents

Some developers use agents, and current surveys indicate fees of 10 to 20 percent. However, the percentage may be higher if an agent specializes in individual designers, since the agent may have to find a team of programmers, artists, and/or sound technicians to work with the designer.

Software

Software programs include productivity, entertainment, education, and utilities. Though many associate games with software, designers and developers distinguish between the two genres; games are covered previously in this chapter.

Publishers either do complete development in-house or, occasionally, pull together creators into project teams for individual titles; in some instances, they contact an independent production studio. Budgets for software titles range from $200,000 to $700,000; if the product is a reference title, the budget can go as high as $1,000,000. Financing normally is provided through entertainment companies, book publishers, and software companies, although private investors will sometimes provide seed money for a designer to create a prototype that can be taken to a publisher, who may then provide the remaining development funds.

The advance normally is designed to help fund the development of the title and reflects the anticipated earnings of the product, and rarely exceeds the royalty due on the sales generated by the product's first printing. Similar to book publishing advances, the

Audiovisual/Multimedia Design*

BUSINESS PRESENTATIONS	PER SLIDE			PER SECOND
Single projector	$120	-	300	$120
Multiple projectors	140	-	425	140

EDUCATIONAL /LEGAL PRESENTATIONS				
Single projector	100			100
Multiple projectors	120			120
Courseware (25 screens, per screen)	120	-	300	-
Storyboards (per frame)	25	-	60	-

ANIMATION (per second)	2 - D			3 - D		
Animatics	150			200		
Industrial	120			120		
Broadcast	30	-	100	45	-	100
Medical imaging	80	-	120	80	-	120

* Creative design fees are largely dependent on complexity of assignment, the client's size and budget, number of slides, screens (or pages), production needs and schedules, deadlines and rights transferred. Chart reflects transfer of limited rights only for three years. A typical project entails concept, design, layout, and supervision of illustration/photography and limited animated elements. All reimbursable and out-of-pocket expenses incurred are billed separately.

advance is sometimes "recoupable" from the future royalties due the developer; that is, it is subtracted from royalty payments until the publisher has been repaid. Care should be taken to determine whether the contract requires the advance to be refunded in the event sufficient numbers of product are not sold to earn it back. It is to the developer's advantage to secure nonrefundable advances only. Developers with a proven track record are most often able to negotiate nonrecoupable advances.

Other multimedia markets

Other growing multi- and interactive media markets include, but are by no means limited to, kiosks and point-of-information/purchase displays; laptop-based presentations; and computer-based training. The primary concern for artists seeking work in these fields, reports the head of one medium-size multimedia production firm, is becoming comfortable with the digital tools—and with the limitations of on-screen production such as fewer dpi than print, fewer color options, and smaller file size options.

A kiosk is a freestanding computer system used to access information and advice, typically through a series of interactive menus and a touch screen. They are utilized in malls, banks (automated teller machines), museums, airports, exhibit booths at trade shows, and libraries. Another form of kiosk is the point-of-purchase (POP) or information display used to promote or provide information on products such as books, music, cosmetics, automotive parts, and even personalized greeting cards and children's books.

Most kiosks are multilingual, giving the user a choice of English or some other foreign language such as Spanish or Russian, and have a video/audio interface that leads the user to the desired result, be it a purchase, a destination, or a banking transaction.

Laptop-based presentations are in great demand for trade shows and marketing. The portability of these computers, coupled with the increasing memory, speed, and skill of designers working in the media, provide increasingly sophisticated presentation capabilities.

Computer-based training programs save clients from flying in staff to a central location for skills or information upgrades; the programs make cost-effective individual or small-

Digital/ Electronic Design*

CD-ROM, CD-Interactive, Other Portable Media*

	ADVERTISING/PROMOTION	PRODUCT/CATALOG
International distribution	$25000	$10000 - 25000
National distribution	25000	7000 - 15000
Regional distribution	25000	5000 - 12000
Limited distribution	12000	4000 - 8000

Online*†

ADVERTISING/ PROMOTION	WEBSITE CAMPAIGN	PRODUCT/SERVICE CATALOG	OPENER OR SPLASH SCREEN	FULL SCREEN	BANNER OR BILLBOARD
International organization or more than 10,000 hits per day	$75000 -150,000	$40000 - 80000	$5000	$2500	$1000
National organization or 5,000-10,000 hits per day	20000 - 70000	20000 - 60000	5000	2500	1000
Regional organization or 1,000 - 5,000 hits per day	10000 - 50000	10000 - 25000	5000	2000	1000
Local organization or less than 1,000 hits per day	5000 - 30000	5000 - 15000	3500	1500	500
Hourly rate:	$60 - 200	$50 - 185	$40 - 150	$40 - 150	$40 - 150

CORPORATE EDUCATIONAL/ PUBLIC RELATIONS	ENTIRE WEBSITE	OPENER OR SPLASH SCREEN	FULL SCREEN	BANNER OR BILLBOARD	ADDITIONAL PAGES
International organization or more than 10,000 hits per day	$100,000	$10000	$2500	$2500	$2500
National organization or 5,000 - 10,000 hits per day	100,000	7500	2000	2000	2000
Regional organization or 1,000 - 5,000 hits per day	20000 - 70000	5000	1500	2000	1500
Local organization or less than 1,000 hits per day	10000 - 50000	3500	1000	1500	1000
Hourly rate:	$60 - 200	$50 - 150	$50 - 150	$50 - 150	$50 - 150

* Creative design fees are largely dependent on complexity of assignment, the client's size and budget, number of screens (pages), pressings, production needs, deadlines and rights transferred. Chart reflects usual and customary creative fees for a typical project that entails concept, design, layout, supervision of illustration and/or photography and limited animated elements. One-time publication rights for off-line media only. All reimbursable and out-of-pocket expenses incurred, including file preparation, service bureau output, or production of mechanicals, are billed separately.

† These include projects to appear on online services such as America On-Line, CompuServe, Prodigy, etc., the Internet and the World Wide Web.

group trainings at separate locations viable.

The project generally is contracted to a multimedia production company, which functions much as a video production firm. These firms, often listed under multimedia in the phone directory, contract for artists, voice talent, programmers, etc. The teams, however, rarely work closely together. The production company assigns and manages the tasks and coordinates the final product. Some larger clients have attempted to contract work themselves, reportedly with limited success.

Length of project work varies, sometimes as short as four to five days, others as long as a year. Occasionally, projects such as computer-based training programs, may last for several years.

Glossary

applications: a software program that performs a specific task such as page layout, word processing, or illustration.

binary: a system with only two possible states such as on or off, 1 or 0, high or low.

bitmap: image created when coloration is added to pixels on-screen; the file that gives instructions for coloration.

chrome: amount and quality of graphics, animation, sound effects, interactivity, etc.

digital: the representation of a signal by a set of discrete numerical values. Commonly represented on a computer in binary form.

file conversions: changing one kind of file to another, usually from one platform to another; i.e., from a file for a DOS-compatible PC to a file for a MacIntosh.

homepage: a viewable document on the World Wide Web—usually the first page of a site.

interactive: productions and services that respond quickly to the choices and commands users make.

interface: the point where hardware, software, and user connect; physical, i.e., electrical or mechanical, connection between elements of computer hardware.

Internet: a network of computers connected by telephone lines. First created by the U.S. Department of Defense to send information, particularly in the event of a war that caused the destruction of one or more terminals. The Internet is now a "network of networks" that has expanded in recent years to include companies that provide access for a fee to anyone with appropriate equipment.

Internet service provider (ISP): company that provides a hookup to the Internet. All vary in kind and level of service; some provide direct access, others provide added services such as news, chat rooms, downloadable software sections, and entertainment.

link: a connection between one area and another. A primary feature of interactive products is the ability for users to explore linked materials.

pixel: the smallest lighted segment on a computer monitor's screen; the smallest segment of color in a digital image file.

platform: a set of hardware components, operating system, and delivery media that provides specific functions and capabilities for the production or playback of digital programming.

productivity tools: software applications used by business professionals such as word processors, databases, and spreadsheets. Usually character-based, allowing users to organize and manipulate text and numbers in various ways.

search engine: a Web page that allows Web users to enter their own homepage information and URL in a database; also allows Internet users to search for specific URLs from a database list using the needed homepage information as a search criteria.

server: an Internet computer established by ISPs to respond to information requests from other computers on the network.

shareware: software users may test without initial payment. If use is continued, however, a fee is paid.

site: all the Web pages that branch from a homepage

URL: "Uniform Resource Locator" is an address for a file or location on the Internet.

utilities: programs designed to improve or enhance the user's ability to use system software.

virtual reality (VR): refers to the use of computer hardware (visual displays, and tracking and mobility devices) in conjunction with special software programs to produce an experience that immerses the user in a highly interactive environment.

World Wide Web: a part of the Internet made up of the collective Websites that are often linked to various other sites to create a "web" of information.

[Thanks to Tad Crawford for use of pricing perspectives from his *Legal Guide for the Visual Artist,* 3rd ed., Allworth Press, 1995]

Cartooning

prices
and trade
customs

Cartooning
prices &
trade customs

• • • • • • • • • • • • •

artoonists create single- or multipanel cartoons, comic strips, or comic books, and may specialize in subject matter ranging from editorial to political to adult to gags, among others. Cartoons look deceptively easy to create because they are familiar and have a relatively simple style, but in fact it is a highly demanding specialization that usually requires a long apprenticeship.

Overview

Although the field historically has been dominated by men, the number of published works by women is on the rise.

Most staff cartoonists work at newspapers, magazines, advertising agencies, greeting card publishers, television and motion picture studios, videotape production houses, and commercial art studios. Cartoons are also sought for books, training materials, in-house publications, novelty items, and posters.

The magazine cartoon is probably the most popular of the graphic arts; media surveys invariably place cartoons among readers' first preferences. These cartoonists bring a unique blend of writing and drawing skills to every

piece by staging a cartoon as graphic theater that instantly communicates the situation and characters. A good cartoon says it faster and with more impact than a paragraph of descriptive words and, most important, makes you laugh.

Magazine cartoons (or "gag" cartoons, which are a visual joke with a caption that provides the punchline) are created by freelance cartoonists who usually conceive the idea, draw the cartoon, and then offer it for sale to appropriate magazines.

The pricing of freestanding magazine cartoons is different from that of other forms of illustration. They are purchased as a complete editorial element, similar to a freelance feature article, at fixed rates determined by each publication. A handful of magazines (e.g., *The New*

Yorker) give additional compensation to those cartoonist contributors who are closely identified with their magazine. In these instances the cartoonist may have a contract providing an annual signature fee, bonuses, and, in a few cases, fringe benefits in return for first look at the cartoons.

Among the factors affecting prices for magazine cartoons are: whether the cartoon is black-and-white or color; the size of reproduction; the magazine's geographical distribution, circulation, impact, and influence; the importance of cartoons as a regular editorial element; the extent of rights being purchased; the national reputation of the cartoonist. Since the list is composed of objective and subjective factors, and the mix in each case is different, rates vary considerably. Readers should also refer to the Illustration chapter for related topics, since many cartoonists and humorous illustrators work in overlapping markets.

The fees following are meant as a point of reference only and do not necessarily reflect such important factors as deadlines, job complexity, the reputation and experience of a particular cartoonist, research, technique, or the unique quality of expression, and extraordinary or extensive use of the finished cartoon. The buyer and seller are free to negotiate, taking into account all the factors involved. Representative fees for specific categories of cartoons were collected from the responses of established professionals who have worked for the publications, directly from the publications themselves, or from current resource directories such as *The Artists' Market*; see the Resources and References chapter for more information.

Submissions

Unless a cartoonist is under contract to a magazine or newspaper, submission of art normally is done on a speculative basis, which means the artist assumes all risks with no promise of payment unless work is used. It is important to have an organized plan of attack. Artists should review cartoons found in their targeted publication and present work that reflects that style.

Several syndicates will send a copy of their submission guidelines if they receive a self-addressed stamped envelope, while others charge a small fee. Following are guidelines for submissions:

1. Send no more than 10 or 12 single- or multipanel cartoons to a magazine at one time. Each cartoon should fill about one half of an 8 ½" x 11" sheet.)

Representative fees for Original Cartoons

CONSUMER MAGAZINES*	B/W	COLOR
New Yorker	$575	-
Redbook	-	$400
Playboy	350	600[†]
National Enquirer	300	-
Better Homes & Gardens	300	-
Good Housekeeping	250	-
Cosmopolitan	225	-
Prevention	150	-
Saturday Evening Post	125	-
Modern Maturity	100	-
Women's Own	75	-
Esquire	50	-
Lady's Circle	10 - 50	-

* Prices are subject to change and/or negotiation

† Fee reportedly is negotiable, or "open."

TRADE MAGAZINES	B/W
Computer Shopper	$200
Home Office Computing	200
Meetings & Conventions	125
Graphic Arts Monthly	125
Medical Economics	100
The Consultant Pharmacist	100
ASPCA Animal Watch	75 - 100
Christian Science Monitor	75 - 100
Meeting Manager	50 - 100
The Artists	65
Golf Illustrated	50
Law Practice	50
Golf Journal	25 - 50
Dog/Cat Fancy	35
Electronics Now	25
Needlepoint Plus	25
Nurseweek	25

2. Send good quality photocopies. Do not send originals!

3. Never send the same cartoon to more than one U.S. publisher at a time. Multiple submissions are, however, acceptable to many European and other overseas publishers.

It is acceptable to send the same strip to several syndicates at the same time. Acceptance by more than one may give added negotiation leverage.

4. Work should be finished, or submission should include both finished pieces and rough sketches.

5. Label the back of each cartoon with name, address, and phone number/fax. For personal inventory control, discreetly number each piece in the upper right corner.

6. For magazine and syndicate cartoon strips, submit a presentation "kit" that includes a "character sheet" (drawings of each character, their names, and perhaps a descriptive paragraph). Include five or six finished strips and enough pencil roughs to complete the publication for a month of publishing.

7. To have cartoons returned, include a self-addressed stamped envelope.

8. If requested, send a short letter and concise resume stating where work has appeared in the past.

9. Keep good records regarding who was sent what when.

10. Syndicates prefer to be contacted by mail only.

Please see Standard Contracts and Business Tools chapter for a sample artwork inventory form.

Trade practices

The following trade practices have been historically accepted as standard:

1. Payment is due on acceptance of the work, net 30 days, not on publication.

2. Artists normally sell only first reproduction rights unless otherwise stated.

3. Under copyright law, cartoonists retain copyright ownership of all work they create. Copyright can only be transferred in writing.

4. Purchasers should make selections promptly (within two to four weeks) and promptly return cartoons not purchased.

5. Return of original artwork to the artist is automatic unless otherwise negotiated.

6. The Graphic Artists Guild is unalterably opposed to the use of work-for-hire contracts, in which authorship and all rights that go with it are transferred to the commissioning party and the independent artist is treated as an employee for copyright purposes only. The independent artist receives no employee benefits and

loses the right to claim authorship or profit from future use of the work forever. In any event, cartoons created by the initiative of the artist are ineligible to be work for hire.

7. Terms of sale should be specified in writing in a contract or on the invoice. For example, if the work is to appear in traditional print media, such as a reprint in a textbook, the following should be included:

For one-time, nonexclusive, English language, North American print rights only, in one hardcover edition, to be published by (*name of publisher*), entitled (*title of publication*). All additional requests for usage by your organization or any other publication, except as specified above, are to be referred to (*name of artist*) to determine the appropriate reprint fee.

Trade practices allow for additional printings of the same edition without additional fees, but any change in the content of a book or in the arrangements of its elements would constitute a new edition that would be considered an additional use. If the publisher wishes to purchase electronic publishing rights, which allow for the easy manipulation and arrangement of materials, the cartoonist should limit the license to use the work for a specific period of time, such as a year, after which any additional or continued rights would be renegotiated.

Syndication

The first cartoon syndicate, The International News Service, was founded by William Randolph Hearst in the early 1900s to manage the sale of reprint rights. Over the years it has evolved into King Features Syndicate, the largest in the country, with more than 6,000 subscribers. King Features Syndicate includes several previously independent syndicates, such as Cowles and North America (which was formerly called News America Syndicate).

Many freelance cartoonists develop comic strips, panels, or editorial cartoons for national and international syndicates that edit, print, package, market, and distribute them to newspapers throughout the world. Since the number of newspapers using syndicated material is limited, the field is highly competitive. Few new strips are introduced in any given year (perhaps two to three) and then often only when an existing feature is dropped. Recently, however, in an attempt to boost sales to youth and other targeted markets, several newspapers have increased the size of their comics sections, which is good news for cartoonists who

have been trying to break into the field for years. But even with this increase in demand, it is still very tempting for cartoonists whose strips or panels are accepted by a syndicate to sign the first contract offered.

Cartoonists owe it to themselves to prepare as well as they can and negotiate all terms thoroughly. There is no substitute for knowledgeable counsel in contract negotiations; it is important to get the best legal representation possible. A lawyer with expertise in cartooning, visual arts, copyright, and/or literary property contracts is recommended.

Foremost among the terms that are changing in the field are the monetary split between the syndicate and the artist, ownership of the feature, and the length of the contract. The split is no longer fixed at the customary 50-50, although it is still common. Artists are seeking a percentage of gross rather than net receipts.

Syndicates routinely used to demand ownership of the feature, but artists benefit so much economically and artistically from retaining ownership of the strip and its characters that it has become an important item in negotiations. Contracts that used to run for 20-year terms are being negotiated with much earlier renewal dates 5 to 7 years), and cartoonists are seeking unconditional termination of the contract rather than renewals that are conditional on the feature's performance. Such flexibility benefits the cartoonist, whose bargaining leverage may increase considerably over the contract period if the work is successful, and may therefore be able to negotiate a more beneficial renewal. If the artist is unable to negotiate such a contract, he or she should seek a five-year contract without automatic renewal and a periodic review of the work's performance.

A number of well-known cartoonists have negotiated or renegotiated contracts with major syndicates on terms more favorable to the artist, such as allowing the cartoonist to retain complete authorship and ownership of the work and the rights to it. Cartoonists who are offered a syndicate contract should keep these terms in mind.

Syndicated cartoonists' earnings are based on the number of newspapers carrying their strips or panels, as well as the circulation levels of the papers. This does not mean, however, that syndicates use standardized contracts. Syndicate contracts are complicated and vary considerably among the major firms.

Other terms being negotiated include the artist's share of merchandising income; quality control over products or animated versions of the feature; and the ability to leave an unsatisfactory contract relationship. All terms of a contract are negotiable.

If a syndicate offers a contract for a particular strip, that is an indication of serious interest. However reluctantly, the syndicate will probably be willing to negotiate. And if one syndicate recognizes that a strip is marketable, chances are good that other syndicates will like it also. Therefore, it may be worth walking away from an unsatisfactory contract offer to seek another syndicate as your partner.

Progressive changes in syndicated contract terms reflect the importance of character licensing in today's market and a decision by individual cartoonists to fight for more control of their creations. In their contracts, savvy artists stipulate that the syndicate has the right to sell the strip only to newspapers and periodicals, with the artist retaining all other rights, including book rights. Cartoonists who sharpen their negotiating skills can protect their income and art for the future rather than churn out work for 20 years under unfavorable terms negotiated when the artist was a relative beginner.

According to King Features Syndicate, cartoonists can make between $20,000 and $1,000,000 per year, depending on the number of newspapers who subscribe to the strip and how many products are made from the licensing of characters.

A current listing of syndicates can be found in *Editor and Publisher, Cartoonist Profiles* magazine, or the local library.

Electronic publishing

Electronic publishing revenue is the new frontier in cartooning. The income potential is enormous, once the mechanics of monitoring who is accessing an image and downloading a cartoon are refined. Like many publishers, syndicates today are attempting to retain electronic publication rights, and artists should consider this carefully when negotiating fees. This area is new and uncharted; artists should make every effort to retain these rights. For more information on copyright and the Internet, please see the Legal Rights and Issues and New Technology Issues chapters.

Reprints

Despite the fact that revenues from advertising and subscriptions have increased significantly over the last 20 years, magazines have refused to increase payments for cartoonists and other artists. In order to make a viable income, car-

North American Syndicates

MAJOR SYNDICATES

Creators Syndicate, Inc.
5777 West Century Blvd..
Suite 700
Los Angeles, CA 90045

King Features Syndicate
(Cowles, North America)
235 East 45th Street
New York, NY 10017

Tribune Media Services, Inc.
435 N. Michigan Avenue,
Suite 1500
Chicago, IL 60611

United Media (United Feature
Syndicate & Newspaper
Enterprise Association)
200 Park Avenue

New York, NY 10166

Universal Press Syndicate
4900 Main Street
Kansas City, MO 64112

SECONDARY SYNDICATES

Chronicle Features
870 Market Street, Suite
1011
San Francisco, CA 94102

Los Angeles Times Syndicate
218 S. Spring Street
Los Angeles, CA 90012

Washington Post Writers Group
1150 15th Street, NW
Washington, DC 20071-
9200

SMALL SYNDICATES WITH LIMITED DISTRIBUTION

Adventure Feature Syndicate
329 Harvey Drive, Suite 400
Glendale, CA 91206

Allied Feature Syndicate
P.O. Drawer 48
Joplin, MO 64802

American International
Syndicate
1324 1/2 N. 3rd Street
St. Joseph, MO 64501

Andromeda Publications, Ltd.
367 Queen Street Way
Toronto Ontario, M5V S4A
Canada

Bud Plant, Inc.
P.O. Box 1886
Grass Valley, CA 95945

Cartoonists & Writers Syndicate
67 Riverside Drive
New York, NY 10024

Future Features Syndicate
1923 Wickham Road
Melbourne, FL 32935

Metro Creative Graphics, Inc.
33 West 34th Street
New York, NY 10001

Midwest Features, Inc.
P.O. Box 9907
Madison, WI 53715

National News Bureau
Box 43039
Philadelphia, PA 19129

Oceanic Press Service
1030 Calle Cordillera, Suite
106
San Clemente, CA 92673

Photo Associates News Service,
Inc.
Station A
Box 306
Flushing, NY 11358

Press Associates, Inc.
806 15th Street, NW, Suite
632
Washington, DC 20005

Renegade Press
4201 W. Alameda #20
Burbank, CA 91505

United Cartoonist Syndicate
P.O. Box 7081
Corpus Christi, TX 78415

Whitegate Features Syndicate
71 Faunce Drive
Providence, RI 02906

toonists frequently sell drawings repeatedly, either to other periodicals, for use in merchandising (i.e., T-shirts, coffee mugs), or in books, as part of an anthology, a textbook, or a collection, which in turn will usually generate more reprints. These reprint sales can be made in the United States and in countries throughout the world. Please see the Reuse and Other Markets section of the Pricing and Marketing Artwork chapter for further information.

Surveyed artists have sold black-and-white reprints to *Time* for $200 and to *Forbes* for $300, but each publication will have its own criteria for establishing a fee. Drawing and

selling a cartoon initially does not guarantee reprint sales; obviously some drawings will generate additional fees and others will not. On a rare occasion, one will turn out to be immensely popular and more than cover the meager earnings from the others.

Licensing and merchandising

Cartoon character licensing and merchandising accounted for $16.2 billion in North American sales in 1995 (a 6 percent decrease over 1994), which accounted for 23 percent of all licensing and sales that year. When characters such as Snoopy, The Simpsons, or Teen Age

Mutant Ninja Turtles are licensed for a range of products from toys and apparel to designer sheets and stationery, their creators stand to earn considerable additional income if they retain all or a significant percentage of the subsidiary rights in the property. In fact, income from licensing can earn more than sales of the original character to newspapers and television broadcasters.

It is sometimes assumed that only nationally known syndicate characters are sought by licensing agents or manufacturers. With the tremendous growth in this area, however, there are now possibilities for cartoonists to develop characters specifically for product use. Cartoonists interested in pursuing this potentially lucrative application of their work should consult an attorney specializing in this field to assure adequate copyright protection before presenting work to licenser or manufacturers.

Trade shows for character licensing and merchandising are held several times a year around the country. They provide a place for creators, licensors, syndicates, and manufacturers to explore business opportunities. For an extensive discussion of these opportunities, please consult the Reuse and Other Markets section of the Pricing and Marketing Artwork chapter.

Editorial cartooning

Editorial cartoonists usually are salaried staff artists on individual daily newspapers. Salaries vary greatly with the circulation and status of the paper and the reputation and experience of the cartoonist.

Some editorial cartoonists are syndicated nationally while remaining on staff with their base papers. Usually their papers require that they do two locally oriented cartoons per week, and the syndicates want at least three cartoons a week relating to national issues. As with comic strips, the earnings received by editorial cartoonists from syndication depend on their contract and the number and size of the newspapers using their work regularly (see Syndication section earlier in this chapter).

Sometimes freelance cartoonists sell their work to major daily newspapers' op-ed pages or to weekly newsmagazines. Rates vary, but generally are based on the location (i.e., leisure or advertising section), the column width of the work used, whether the drawing is an original or reprint, and the reputation of the artist, with well-known artists generally being sought for large commissions such as covers.

COMPARATIVE FEES FOR

Cartoon Reprints*

TEXTBOOKS

Cover	$750 - 1200
Interior	250 - 400

HARDCOVER BOOKS (per run)[†]

Cover	$750 - 1200
Interior	250 - 400

PAPERBACK BOOKS (per run)

Cover	$750 - 1200
Interior	250 - 400

CARTOON ANTHOLOGIES[‡]

Cover	$750 - 1200
Interior	250 - 400

* The fees listed are per edition, unless stated otherwise; all languages; no electronic rights. The smaller fee would be for domestic rights only; the larger for worldwide rights. If electronic rights are sold, the fee would be higher and for a specified time.

[†] If book is reprinted in paperback, it is considered a second run.

[‡] Various artists; flat fee for all editions.

Editorial cartoonists, while paid less than illustrators in other markets, can make up the disparity by selling reprints; they also value the creative freedom they're given as well as the exposure and name recognition gained through being published in a widely circulated newspaper. It is best to check with individual papers regarding their interest in freelance contributions before sending work for consideration.

Original cartoon books or collections

In addition to collections of the published work of one or more cartoonists, there has been a recent trend toward publishing books of original cartoon works.

Book contracts vary as much as syndication contracts, so it is advisable to consult a qualified literary agent or lawyer. Historically,

standard contract terms have included an advance against royalties at the contract signing. Current data indicate that a first-time cartoonist-author may expect an advance ranging from a minimum of $3,000 up to $10,000, with a royalty ranging from 4 to 10 percent. Please refer also to the Syndication section in this chapter and to the Children's Book Illustration section of the Illustration Prices and Trade Customs chapter.

Comic books

Within the last three years, publishers have seen sales of comic books drop significantly and become more confined to the direct market (i.e., comic book specialty shops). In 1993, *Batman* was selling 300,000 units monthly; in 1996 the number had fallen to approximately 75,000. Many of DC's and Marvel's titles hover around 20,000 in sales, which just reaches the breakeven point of 17,000 to 28,000 for a color production; it's rare to see a book with healthy sales (*X-MEN*, at about 250,000 monthly copies, is one example). Industry experts suggest a range of causes for the drop: an increasing emphasis on specialty comic book stores, which are less plentiful and accessible than newsstands; and high cover prices.

There are over 600 individual comic book titles on the market today, although 95 to 98 percent of them are only sold in comic book shops and are not readily accessible at newsstands. Only four or five titles have sales in excess of 250,000, and these include *Spawn, Gen 13, X-MEN,* and *Spiderman* titles; *Heavy Metal,* at the height of its popularity, sold 300,000 copies; today, the average book sells 150,000.

Licensing prospects in TV, movies, video games, toys, and consumer products have emerged as a driving factor in decisions on continuation of comic book series. Sales rates that would have seemed low or of marginal profitability in the past are accepted because of the fear that discontinuation would affect licensing possibilities. Please see the Licensing and Merchandising section above and the Reuse and Other Markets section of the Pricing and Marketing Artwork chapter for further information.

Cinematic in style, comic book publishing often mimics film production. Writers conceive a story and develop a script or plot, often indicating specific views of the action to be portrayed. Some companies use a style where scene descriptions and full dialogue are given just like a screenplay. Others do not indicate panel breaks, or even specify the number of panels, and may or may not indicate page breaks, giving the artist much more freedom in which to make a graphic statement.

Each monthly comic book (averaging 22 pages of story, with another 10 of ads and letters) is produced in 21 days to meet distribution deadlines. These high-pressure working conditions result in comic books that are mass-produced in assembly-line fashion. Publishers divide comic book labor among people with special skills who complete a specific component in the process and then pass the work on to the next stage of production. Some talent agreements used in the industry may contain a clause that penalizes the artist if deadlines for work are not met.

The specialists in comic books generally include: writers; pencil artists (pencilers); lettering artists (letterers); ink artists (inkers); and coloring artists (colorists). The editor generally assumes a tracking role, guiding the path of the work from freelancer to freelancer hoping to meet the company's deadlines and, on rare occasions, may also serve as art director. The trend in the last decade seems to indicate a greater number of comic book artists who write, draw, and ink their own stories, but even for specialists, the rigors of the three-week deadline require severe discipline.

Pencilers lay out the action from the typewritten script and finish the art on bristol board. The penciled board is passed on to the letterer, who letters the balloon text in ink and inks the balloon and panel borders. The board is then passed on to the inker, who inks the figures and backgrounds on each panel. (Background artists, if used, are usually subcontractors, assistants, or interns.) The boards are then reduced onto 6" x 9" on 8 ½" x 11" Strathmore paper, and then passed on to the colorist, who hand-colors and color-codes the photocopies of all 22 pages of the book. The boards and coded reductions are then sent to the separator, and the colored photocopies are sent to the printer for manufacture.

With the introduction of new technologies, the process of hand-coloring and -coding guides on Strathmore paper may soon be obsolete; both DC Comics and Marvel already have begun to switch to computer-colored comics. Color artists will still be needed to do the computer coloring, but due to the cost of the equipment (a Mac capable of doing the job may cost as much as $8,000 to $12,000, including monitor, scanner, keyboard, software, and color

printer) and the required learning curve, it will take a much more sizable initial investment to get off the ground as a colorist than it used to. Many colorists hand in their work on disk. The disks are then "edited" at the publishing company and then sent to a separator for the creation of final films. Font programs capable of approximating a letterer's handwriting are replacing hand-letterers—at least three companies are now using pen fonts based on real comic book hand-lettering.

Freelance artists working in this industry are expected to meet minimum production quotas and report being paid a page rate set by the publisher for each page completed. Page rates vary according to the specialization. Contract artists at many of the companies still enjoy all the benefits of a salaried employee, including medical and dental insurance; however, with the downturn in the industry, many contracted freelancers are being asked to contribute toward their medical and dental insurance.

Since comic books are paid on the piece-work system, the faster an artist works, the more an artist will earn. However, to meet production deadlines, artists are expected to complete a minimum number of pages in each production cycle. Letterers, for example, are expected to complete at least 66 pages over three weeks but strive to complete 10 pages per day, five days a week. Many artists must work 10 hours a day, six days a week, in order to make a living wage. Comic book publishers generally will pay artists a lesser page rate for reprinting an original publication.

As in other genres, the more popular an artist or writer, the higher are the company's projected sales. Therefore all aspects of compensation, including royalties, are open to negotiation.

If a comic book's net domestic sales exceed 75,000 copies, a royalty on the excess usually is paid to the writer, penciler (or other layout artist), and inker. Recently, some companies have been paying royalties at 40,000 copies. Royalties are graduated according to the degree of creative input and the number of sales, but generally range from 2 to 5 percent of the cover price. Those artists who perform more than one function will receive a larger royalty; if more creators are involved in a project they will share the royalties. The general downturn in sales has made the payment of royalties almost a moot point, as few titles reach the 75,000 mark.

Freelance agreements with the major

COMPARATIVE PAGE RATES FOR

Comic Book Art*

ORIGINAL PUBLICATION

Writers (plot and script)	$75 - 120
Painted art	150 - 350
Layouts/breakdowns	35 - 100
Pencil art†	55 - 200
Background art	10 - 25
Ink art†	45 - 150
Lettering	18 - 35
Lettering on overlay	20 - 35
Coloring art	20 - 35

* Rates range from those paid by small companies to those paid by large ones and from those paid to "beginners" to those paid to seasoned professionals.

† Current data indicates that an additional 20% is added to the above fees for cover art use.

comic book publishers provide for the return of original art. The artist(s) may assign, sell, or transfer ownership only of the physical original. Since several artists work on a given piece, ownership of the original art must be negotiated; normally only the penciler and inker receive original artwork, though a hand-painted piece will be given to the colorist. However, the artists do not retain any of the copyrights in the work, as the contracts usually contain a work-for-hire clause, which transfers legal authorship and all rights with it to the publisher. Please see the Legal Rights and Issues chapter for more information on work for hire.

In the view of the Graphic Artists Guild, however, comic books are not a collective work as defined in the Copyright Act of 1976. Therefore, comic books are not eligible to be work for hire and freelance artists working in the comic book industry may actually be conventional employees, not independent contractors. While this would mean that all work created by them is work for hire, it also entitles the artists to at least the minimum benefits and entitlements afforded to any conventional employee, including unemployment, disability, workers compensation insurance, and the right to organize for the purposes of collective bargaining. For more information on employment issues, please refer to the Professional Issues chapter.

Trade practices

The following trade practices for comic book art have been used historically and, through such traditions, are accepted as standard.

1. The intended use of the art must be stated clearly in a contract, purchase order, or letter of agreement stating the price and terms of sale.

2. Artists normally sell first North American reproduction rights only unless otherwise stated. Ancillary rights (i.e., TV, movie, European distribution, paper or hardback printing, or character licensing) are negotiable and often are shared by the publisher and artist for a fixed period of up to five years, at which time the full rights revert to the artist.

3. If artwork is to be used for other than its original purpose, the price usually is negotiated as soon as possible. The secondary use of the art may be of greater value than the primary use. Although there is no set formula for reuse fees, current surveys indicate artists add a reuse fee ranging from 25 to 75 percent of the fee that would have been charged had the art originally been commissioned for the anticipated usage. Artists should negotiate reuse arrangements with the original commissioning party with speed, efficiency, and all due respect to the client's position.

4. Deadlines for delivery of finished art and rough sketches should be outlined in the contract. The clause should also specify what payments are due the artist in the event the project is canceled or rejected. See the sections describing kill and rejections fees in the Illustration chapter for negotiable fee suggestions.

5. The artist warranties that the art is original and does not infringe on the copyrights of others and that the artist has the authority to grant rights to the publisher.

6. An artist can request to be indemnified by the publisher for any suits arising from the use of the art by the publisher which might infringe on the rights of others and also against any suits arising from a request on the publisher's part, such as making a character look like a famous person or existing image.

7. In the case of creator-owned art (versus work for hire) the publisher agrees to copyright the work in the artist's name.

8. For non-work-for-hire contracts, revisions without the artist's consent are unacceptable; artist should be consulted to protect the integrity of their work.

9. Fees should be established to be paid to the artist in the event artwork is lost or damaged due to the publisher's negligence.

10. The publisher agrees to publish the book within a specific period of time and, upon failure to do so, the rights revert back to the artist (sometimes called reversion rights).

11. Royalties are graduated according to the degree of creative input and the number of sales, but generally range from 2 to 5 percent of the cover price. Royalties are paid on a quarterly basis, at which time the artist will receive a statement of sales.

12. Return of original artwork to the artist is automatic unless otherwise negotiated. The artwork often is divided between artists working on the project (primarily the penciler and inker). Most artists view original artwork as a subsidiary income, selling it either directly to collectors or through an agent.

13. Publishers usually provide the artist with 10 free copies of the book, but 20 to 50 copies often are negotiated. Most publishers offer the artist a 40 to 50 percent discount off the list price on purchases of the book.

14. Artists considering working on speculation often assume all risks and should take these into consideration when offered such arrangements; see section called Speculation in the Professional Issues chapter for details.

15. Despite the fact that work-for-hire contracts dominate this field, the Graphic Artists Guild is unalterably opposed to their use because authorship and all rights that go with it are transferred to the commissioning party and the independent artist is treated as an employee for copyright purposes only. The independent artist receives no employee benefits and loses the right to claim authorship or profit from future use of the work forever. Comic books are not eligible to be work for hire, as they do not fall under any of the eligible categories defined in the law. Additional information on work for hire can be found in the Legal Rights and Issues chapter.

ANIMATION
prices & trade customs

Animation
prices &
trade customs
• • • • • • • • • • • •

Animation artists are skilled at creating the illusion of movement. To be successful in today's market, an animator must have an in-depth understanding of real-life movement, traditional animation techniques, and technical film details that include timing, staging, texture mapping, lighting, squash and stretch, and easing in and easing out.

There is a huge demand for computer animation and effects today. Animation companies are growing, and movie studios and game companies are creating computer animation divisions. As interactive services come online, there will be an even greater demand for designers, animators, directors, and programmers.

Character animation began as a form of entertainment and has been around for over 50 years. It has since expanded into education and advertising, and has been effective in these areas as well.

In recent years, computers have given artists the ability to create images never before seen outside the imagination. Today the applications for animation span varied fields and interests such as biomedical research, scientific and educational films, litigation arts (forensic animation), television titles and station IDs, feature films, interactive games, CD-ROM books, multimedia projects, virtual-reality software, simulator rides for theme parks, and more. An estimated 20 percent of all TV commercials utilize animated sequences.

An art form different from traditional markets and distribution channels, with a broad spectrum of styles, can be found in independent animated films usually shown in film festivals or competitions that serve as showcases for the artist's work. Independent filmmakers often create production companies to solicit development funds, which can range from $5,000 to over $100,000.

Animation artists also may work as illustrators, cartoonists, and designers for film. Though occasionally cartoonists or illustrators who supply artwork may want to try animating

it, most are satisfied with seeing their drawings animated by someone else's hand.

Traditional animators work with line drawings that are inked and painted onto cels (celluloids). The process is difficult, time-consuming, and expensive. Often several animators will be assigned to specific characters, backgrounds, or other segments of a project. The end result is almost always a team effort by a number of artists each with their own area of expertise. Computer animation increasingly has added a level of sophistication, as in recent mass market successes such as *Beauty and the Beast* and *Aladdin*.

Animation studios

Almost all animation is the work of a team consisting of (among others):

♦ *producer:* hires the team, locates investors, manages expenses, handles distribution, and is responsible for the overall development of the film.

♦ *writer:* identifies the subject of the film, defines the characters, develops the story line and dialogue.

♦ *character developer:* makes model sheets, sometimes called "roughs" (thumbnail sketches and models of the figures depicting the range of movement, key poses, expressions and emotions of the characters) based on the designer's concepts and often supplied by an advertising agency when the product is a television commercial.

♦ *storyboard/layout artist:* creates storyboard representing the scope of the film's action, breaking the story down into specific scenes displaying the film's sequential development in proper scale.

♦ *background animator:* studies what's happening in the scene and draws appropriate backgrounds, usually in watercolor.

♦ *director:* responsible for the overall coordination of all animated characters within a project. Each individual must work together, including layouts, storyboards, and voice talent. Although there may be some interaction with the "environment" (background), the director usually is concerned only with the actions of the characters.

♦ *animators:* creates the key positions of characters (cel extremes) on sheets of paper and places them on the background; creates an exposure sheet.

♦ *assistant animator (inbetweeners):* prepares drawings to fill the intervals between key poses or frames. Inbetweeners also refine the sketches, clean and tighten up lines, and darken shadows.

♦ *inker:* traces the outline of each of the sketches onto an acetate sheet.

♦ *opaquer:* takes the outlined acetate sheets completed by the inker and paints the colors of the characters on the opposite side.

♦ *checker:* checks that all the cels, layers, exposure sheets, bar sheets, and backgrounds are executed, marked, and registered prior to the beginning of filming.

♦ *camera operator:* films the movie.

♦ *film editor:* cuts together the pieces of exposed film, matching the images to the sound track. Prepares the footage for duplication and printing.

Cel animation

The material of choice for cels today is cellulose acetate, but the term *cel* is used to describe any transparent plastic sheet used in animation. The character's outline is applied to one side of the acetate, sometimes indicating the placement of colors; then the appropriate colors are filled in on the opposite side of the cel. Even with the introduction of mechanical techniques of inking cels, hand inking often still is used for animated commercials and special-effects shots.

Computer animation

The field of computer animation is changing rapidly and opening to skilled artists at lower start-up costs. High-quality computer animation used to require access to sophisticated and expensive equipment, but with recent technological advances, broadcast-quality output (used primarily for TV commercials and video games) is readily possible, though by no means inexpensive, on a Mac, PC, or Amiga. The technology is changing so quickly that cutting-edge techniques used today can be outdated almost before a project is completed, so a significant part of a computer animator's job is keeping current with the evolution of animation technology (see also the Multimedia Prices and Trade Customs chapter).

Graphics software now available off the shelf runs not only on large computers but on desktop computers. The software is designed to run on different platforms, including Silicon Graphics (SGI), Sun Microsystems, IBM PCs and compatibles, Apple Macintoshes, and Commodore Amigas.

2-D and 3-D computer animation

Computer animation done in 2-D is used for cartoons and some special effects. A particularly startling example is "morphing," which utilizes a highly advanced fade-in/fade-out program that causes images to distort, giving them the appearance of changing seamlessly from one state to another.

3-D animation uses modeling and/or digitizing to create objects that not only have shape and dimension, but can be viewed from any angle. With the help of a complex rendering program, the artist can project the object onto a screen or into a virtual environment. 2-D texture maps (a surface pattern like wallpaper) often are applied to the 3-D image to give it a realistic surface. Computer-generated imagery (CGI) (images created digitally using a software program) commonly is used in 3-D computer graphics when doing special effects.

Architectural animation allows artists to create realistic simulations of environments, which clients can "walk in" or "fly through" even though they have not yet been built. An efficient design tool, it avoids expensive construction mistakes by either avoiding poorly conceived projects or allowing necessary alterations to be made before work begins.

Motion picture computer animation is the highest echelon of the field, and perhaps the most famous of all animation houses today are George Lucas's Industrial Light and Magic (ILM) and Steven Jobs's Pixar. These studios write a great deal of their own software because so much of what they produce is unprecedented in the industry.

Other forms of animation

Three-dimensional animation uses clay figures (claymation), puppets, or any other 3-D object to narrate a story. Puppet animation often requires the artist to create movie sets to scale that depict the storyline and can be filmed from many angles.

Animation is multicultural

Many animated features are sold internationally and dubbed in any number of foreign languages. So much of animation is based on action, movement, and physical humor that it works well in many different cultures and can be dubbed easily when necessary. Artists anticipating international markets pay particular attention to details such as making sure there are no written words or signage in the background that might be considered necessary to understanding the story. Writers must be aware of expressions in the dialogue (such as slang or colloquialisms) that may be difficult to translate.

Careers

Generally, animation artists work for a studio, but there are some in the Motion Picture Screen Cartoonists (MPSC), Local 839 of the International Alliance of Theatrical Stage Employees (IATSE), the animators' union, who freelance. There are nonunion animation artists, but most artists employed by animation studios are covered by collective bargaining agreements negotiated by MPSC. Some of the big-name studios that MPSC has negotiated contracts with are Hanna-Barbera Productions, Marvel, Universal Cartoon Studios, UPA Pictures, Walt Disney Pictures and Television, and Warner Bros. Animation.

The job market is varied, highly competitive, and rapidly growing. There are over a quarter of a million artists working in the field, three quarters of whom are male. Aspiring animators must have a good knowledge of the industry in general and, more specifically, the target employer's place within that industry.

The majority of work continues to be in advertising, specifically in 30-second commercial spots, but forecasters predict a continued market for animated feature films. Many large production houses have entry-level positions for animation assistants or inbetweeners, and it is not uncommon to later become an animator and, eventually, a director. TV commercial work usually lasts a few weeks to a few months, while television series projects can take from several months to three years to produce. Artists working in this area must be thinking continually about their next job, because layoffs are common when a project ends.

In showing work, portfolios of storyboards, backgrounds, model sheets, and similar items are useful. Artists seeking entry-level positions should include examples of basic artistic skills, especially life drawing. Almost every employer has a printed summary of portfolio requirements. Animation artists' samples often are condensed onto a film reel or a videocassette in order to show the true nature of their ability to animate movement.

Artists should be sure to include a clause in their contract that gives them the right to

Animation Artists

CLASSIFICATION	ENTRY SCALE	JOURNEY SCALE	MINIMUM REPORTED	AVERAGE[†] REPORTED	MAXIMUM REPORTED
Producers	-	$1273	$1500*	$4000	$6000
Directors	-	1273	1400*	2000	14000
Asst. directors	$833	1038	1150	1725	2300
Production board	1197	1273	1065*	1500	3500
Story sketch	800	991	580	1710	2200
Apprentice storyboard	798	-	800	1000	1200
Art directors	-	1273	2500	2950	3925
Visual development	1041	1107	1065	1600	3500
Model designers	1041	1107	1000*	1382	1700
Color key/stylists	782	941	775	1200	1600
Assistant models	876	941	1079	1093	1108
Layout	1041	1107	941*	1900	4000
Key asst. layout	-	1059	1200	1450	1600
Asst. layout	876	941	850*	995	1050
Background	1041	1107	1107	1600	2700
Asst. background	876	941	836	898	1040
Animators	1041	1107	750*	1750	6700
Key asst. animators	-	1059	1028	1370	2000
Asst. animators	876	941	553	1000	1650
Breakdown	799	822	798	850	1025
Inbetweeners	738	790	682	789	990
Sheet timers	833	1038	1400	1537	1800
Scene planners	939	980	1000	1400	1500
Animation checkers	782	941	806	1000	1640
CGI animators/modellers	1041	1107	900*	1400	1950
CGI compositors	876	941	775	1513	2250
CGI opaquers	692	775	750	780	1520
CGI scanners	692	775	750	850	1087
Trainees	703	774	536	738	900
Final checkers	758	809	1000	1000	1000
Mark-up	758	809	809	950	1009
Special effects (painters)	794	809	794	820	1190
Painters	692	775	775	815	855
Inkers	692	781	781	809	833

* reflect a nonunion wage figure

[†] The median average is the middle rate when the rates are listed from highest to lowest. All numbers were rounded off to the nearest dollar.
Source: Local 839, IATSE, *Member Wage Survey,* April 9, 1996.

show for any work created under contract for self-promotion. Rarely will an artist have the time to create a demo reel of his or her most current techniques and accomplishments, so retaining the right to show already produced work can be a tremendous advantage.

It pays the artist to do some research into what kind of images a company has used in the past and streamline the portfolio to reflect both the artist's strengths and the company's focus. Computer animation companies look for both artists and technical operators. Many traditionally trained animators are being hired by computer companies to do drawings on paper that are then scanned into the computer. Technical operators and directors take over at this point to complete the project. College graduates with a background in computers who do not draw well often become technical directors at computer graphics companies. Special skills are needed on almost every computer project, and the average artist rarely possesses the technical background to create new effects and other special elements. Trained computer animators will find positions with film and video production studios, special effects production houses, television stations, and video game producers. Companies are seeking artists with experience in ball-and-socket puppets; set and model building (creating highly realistic miniatures used in special effects); armatures; mold making; and costume design for puppets.

Salaries

According to the MPSC, the going rates for animation artists have been increasing dramatically, and industry trends suggest that the data in the accompanying chart will form only the basis for these rapidly rising pay rates.

One of the more comprehensive directories of animation companies in the United States is published by *Animation Magazine*. Some cities have regional directories covering film, video, and computer production companies. Trade magazines and newsletters also carry job listings. A listing of services and organizations useful to animators can be found in the *International Motion Picture Almanac* (see also the Resources and References chapter of this book).

Pricing

A key factor affecting pricing is whether one is working freelance or on staff. If the animation artist is freelancing, pricing is affected also by what category the animation falls under (e.g., the intricacy of the movement, how much movement there is, and how intricate the drawings must be). This is decided upon before work is begun.

A good method of determining freelance fees for animation is to look at the union wage scale for the same type of work. Local 839 IATSE maintains a web site at http://www.mpsc839.org.mpsc839. The site includes detailed information on their latest collective bargaining agreement, including wage scales, hours of employment, working conditions, and the general employment practices found in the industry. It should be noted that the contract provides for several levels of experience; more senior artists (known as journeymen) enjoy a higher wage scale than those artists who have only been in the business for less than a year or two.

The following examples of minimum rates were supplied by the Motion Picture Screen Cartoonists, Local 839, IATSE, and represents the union-negotiated pay scales for journeymen for the contract effective through October 31, 1996. See Salaries and Trade Customs chapter for staff salaries. Contact MPSC at their Website for the latest contract provisions and wage scales.

Animation

Production board	$1,273.05
Animator, background, layout, model designer, animation story person	1,107.00
Sheet timer	1,037.92
Asst. animator, asst. background, asst. layout, asst. model designer, color stylist	941.44
Breakdown	822.08
Ink checker, special effects, xerox checker, final checker, mark-up	809.24
Inbetweener	789.64
Painter, xerox processor	775.28

Minimum Unit Rates for Television or Theater by Classification*

SHORT SUBJECTS 4 - 7 MINUTES	WEEKLY EARNING
Synopsis and outline	$594.31
Storyboard only	824.15
Story in script form	1551.43
SHORT SUBJECTS 7 - 11 MINUTES	
Synopsis and outline	$602.64
Storyboard only	998.02
Story in script form	1965.58
HALF-HOUR SUBJECTS	
Synopsis and outline	$1012.60
Storyboard only	1790.09
Story in script form	3558.38
ONE HOUR OR MORE	
Synopsis and outline	$1499.58
Storyboard only	2670.03
Story in script form	5326.74

* The minimum unit rates for television or theatrical projects were supplied by the Motion Picture Screen Cartoonists, Local 839, IATSE, and represent the union-negotiated pay scales for journeymen for the contract effective through July 31, 1996.

In reference to the above Unit Storyboard rates, the employer may require two rewrites or reworks after the presentation by the story person without additional compensation. If an additional rewrite or rework is required by the employer, an additional 20 percent of the original Unit maximum shall be paid for each rewrite or rework. Any amount negotiated in excess of the above minimums may be applied against any additional compensation for rewrite or rework when done.

prices and
trade customs

SURFACE DESIGN

Surface design
prices &
trade customs

Textile and surface designers create repeating and nonrepeating patterns, illustrations, woven, or knitted designs to be used for apparel, home furnishings, giftware, and other markets. Many freelance textile/surface designers create individual designs or groups of designs that they sell or license to manufacturers and converters, often for a specific use or combination of uses.

These artists often are commissioned to create an entire line of designs for use on sheets, pillowcases, comforters, pillows, wall hangings, and other products for the home. Converters are companies that convert greige goods (fabric in its raw woven state) into finished printed or plain-dyed fabric for the use of the manufacturer, whose end product is a finished garment. Many manufacturers today have converting operations in-house. Some surface designers work with, and interpret, existing pieces of "documentary" reference. A documentary design is one that is adapted from a historical document or plate such as art deco, Egyptian, art nouveau, etc. Depending on the age of the source material, these references are in the public domain and designers own only the changes they make to these documents—any-

one else may freely use the originals from which they are adapted. In order to protect one's work, adaptations should be as original and unique as possible. As with other artists, surface designers should register their works with the Copyright Office to "perfect" their copyright.

Like other designers, they often work as problem solvers, conceptualizing solutions to the specific need of a client. Factors that may determine the designers' fee include: his or her track record of success; the complexity of the design relative to the rendering technique and the number of colors used; the transfer of copyright and/or usage rights; time spent researching and rendering the design; and advertising or selvedge credit for the designer.

The Graphic Artists Guild strongly recom-

mends confirming all agreements in writing. Designers should be sure to read any agreement carefully and should consider the benefits of restricting the sale of rights to specific markets only. Please see the chapters on Professional Issues, Pricing and Marketing Artwork, and Standard Contracts and Business Tools for detailed information on negotiating and model contract provisions.

Stencil design

Ever since Ice Age peoples used their hands to block out pigment sprayed onto a cave wall humans have decorated their dwellings with stencils. The itinerant stenciler was a welcome artisan in colonial America and then in Victorian times. Stenciling is once again enjoying popularity, not only as a process for restoring historic interiors, but also as a means of expression for the contemporary home decorator.

Stencils have, up until now, been cut from thin metal or oiled card stock. Today's stencil material of choice is mylar or acetate film. Mass-produced stencils for the retail market are cut with lasers, insuring an accurate reproduction of a design in large quantities.

Design sources for stencils are limited only by the imagination of the designer. However, translating a copyrighted image into a stencil may infringe the copyright holder's rights, so it is advisable to seek permission for any use. In most cases, if it has been printed or photographed it is copyrighted. There are available public domain materials, but the safest course is to work up original designs.

There are several manufacturers and distributors of stencils in the United States. Plaid Enterprises and Stencil Ease, two of the largest, purchase designs and have standard requirements for the submission of artwork (i.e. size, line work only, etc.). Most prefer designs in a clean line design but can also work from sketches.

Recent surveys show that the average fee for stencil design ranges from $150 to $250. All or limited rights can be purchased for this price, but artists generally are offered $150 for the use of a design for stencil manufacture only, and the manufacturer most often does not purchase the copyright; therefore, the designer is free to resell or use the design for other purposes.

The Stencil Artisan League, a nonprofit teaching organization, offers a two-tier certification program that recognizes varying degrees of stenciling proficiency, including faux-finishing (the ability to use specialized paint effects to mimic other materials, such as wood grain or marble) and other applied arts. Information about the Stencil Artisan League can be found in the Resources and References chapter.

Licensing

A license is an agreement through which an artist or designer who owns the reproduction rights to the art permits another party, usually a client, to use the art for a limited, specific purpose, for a specified time, and throughout a specific geographic area, in return for a fee or royalty. For example, a design may be licensed to one party for wall coverings and to others for paper goods, dinnerware, or barware. At the expiration of the license, the right to use the design reverts to the owner unless otherwise contractually agreed. A more thorough discussion on licensing can be found in the Pricing and Marketing Artwork chapter and in *Licensing Art & Design* by Caryn Leland (Allworth Press), which is available from the Graphic Artists Guild's National Office. Model licensing agreements appear in the Standard Contracts and Business Tools chapter.

In the textile and surface design industries, licensing agreements normally are negotiated for an entire line, collection, or group of products for a particular market. A licensing agreement for domestics, for example, would include designs for a number of entire "beds" (sheets, pillow slips, duvet and/or bedspread, ruffle, shams, etc.), or a license for bath products would include a shower curtain, a mat, and towels of various sizes. Although licenses sometimes are granted for a single product, such as a shower curtain or beach towel, this is an unusual practice. Any design can of course be licensed in the apparel market as well, although this is rare because of the short life of a design in this market.

Royalties

Historically, artists and clients have found that a good way to determine a fair price in relation to use is through a royalty arrangement, which in this market has been a percentage of total sales paid to the designer based on the wholesale price of a product. In practice, royalties historically have ranged between 2 and 10 percent of the wholesale price and currently hover around 5 percent, with some as low as a fraction of a percent (on high-volume items). Royalty arrangements historically have also included a nonrefundable advance payment to

Surface Design

Apparel*

TEXTILES

Corner	$100 - 350
Concept	100 - 350
Croquis	275 - 600
Design in repeat	475 - 1500
Tracing repeat layout	175 - 450
Colorways	60 - 300
Repeats	200 - 1000

PAINTED WOVENS

Stripe	$40 - 200
Design in repeat	100 - 400
Colorways	75 - 200

Domestics*

Sheets	$900 - 2000
Pillow slips (engineered)	300 - 700
Duvet/covers	900 - 2000
Repeats for domestics	
9 inches	65 - 1000
18 inches	800 - 1300
36 inches	1000 - 2000

* Fees indicated are for each design; ranges reflect design complexity.

Scarves and Handkerchiefs*

Concept	$175 - 1000
Design (engineered)	500 - 2400

Tabletop Products†

Tablecloths	$600 - 2000
Napkins	250 - 400
Placemats	275 - 600
Chinaware	400 - 1650

Kitchen Products*

Design, engineered or in repeat	
Potholders/oven mitts	$250 -500
Towels	275 -500

* Fees indicated are for each design; ranges reflect design complexity, size and number of colors.

† Fees indicated are for each design; ranges reflect design complexity.

the artist in anticipation of the royalties, before the product is sold. Many designers negotiate advances to cover their expenses, at minimum, and often they are equal to the cost of the artwork if it were sold outright.

Representatives

Surface designers frequently use representatives or agents, who have the legal right to act on behalf of the artists they represent only in the ways agreed to by both parties. A model "Surface Designer/Agent Agreement" can be found in the Standard Contracts and Business Tools chapter, and a complete discussion of author-representative relationships is in the Professional Relationship chapter.

Trade practices

Historically, the following trade practices have been followed by the industry and are particularly relevant to freelance textile and surface designers (see also the surface design business and legal forms in the Standard Contracts and Business Tools chapter).

1. *speculation:* Speculative ventures, whether in financial markets or in the visual communications industries, are fraught with risk. Individuals who choose this course risk loss of capital and expenses. Artists and designers who accept speculative assignments (whether directly from a client or by entering a contest or competition), risk anticipated fees, expenses, and the potential opportunity to pursue other, rewarding assignments. In some circumstances, all of the

Surface Design (Cont'd)

Home Decorative Items*

	WALLCOVERING/ CURTAINS	DRAPERY/UPHOLSTERY	RUG/CARPET
Corner	$150 - 550	$375	-
Croquis (sketch)	800 - 2000	800	-
Design in repeat	1000 - 2000	1400 - 2500	$2000
Tracing repeat layout	250 - 500	250 - 500	-
Colorways	175 - 1000	175 - 1000	250 - 750

REPEATS FOR HOME DECORATIVE PRODUCTS

9 inches	$750 - 2000
18 inches	1000 - 2000
36 inches	1250 - 2500

* Fees indicated are for each design; ranges reflect design complexity and number of colors.

Bath Products†

	CONCEPT/CROQUIS	DESIGN, ENGINEERED OR IN REPEAT	COLORWAY
Shower curtain	$500 - 1200	$900 - 2000	$175 - 250
Towels (guest, wash and hand)	200 - 350	450 - 500	
Towels (bath)	300 - 350	750 - 900	-
Towels (beach)	400 - 500	750 - 1000	-

Retail and Novelty Products†

	CONCEPT	DESIGN	COMPLETE DESIGN
T-shirts (engineered)	$300 - 600	$450 - 750	-
Greeting cards	125 - 250	400 - 500	-
Giftwrap (in repeat)	225 - 350	400 - 500	400 -1200

† Fees indicated are for each design; ranges reflect design complexity, size and number of colors.

risks are placed on the artist, with the client or contest holder assuming none; for example, some buyers decide only upon completion of finished art whether or not to purchase it. Each artist and designer should make his or her own independent decisions regarding acceptance of speculative assignments based upon a careful evaluation of the risks and benefits of accepting them in light of the artist's and designer's own individual circumstances.

Nonetheless, many surface/textile designers, acting as entrepreneurs, create their own work and to exploit those works in a variety of ways. For example, if an artist's designs for the domestics markets are accepted by a converter who agrees to pay an advance against a royalty on sales, the designer and the converter are sharing

the risks on their mutual investment. The compensation to both parties is speculative, meaning both are dependent on the market response to the product.

Each artist should decide individually whether to enter art contests or design competitions, provide free services, work on speculation, or work on a contingent basis. Each artist should independently decide how to price his or her work. The purpose of *The Graphic Artists Guild Handbook: Pricing and Ethical Guidelines* is to fully inform each artist so that he or she may decide independently how to price his or her work and negotiate a fair agreement.

Current data indicates that the vast majority of designers who create works on assignment or commission receive payment for any work created; see the esti-

Surface Design

	ADVANCE	ROYALTY (PERCENTAGE)
Domestics (per bed)	$5000	5
Home decorative (per program)	5000	5
Tabletop products (per program)	5000	5
Tabletop (paper goods)	-	5
Tableware	1500	5
Bath products	5000 - 10000	5
Kitchen products	5000	5
Novelty/retail	-	5

* Royalty percentages reflect arrangements with department stores and are based on wholesale price. For mass market distribution (i.e., chains and discount stores) percentages may be 2 points less.

MISCELLANEOUS*	HOURLY	DAY RATE
On-site	$35 - 75	$110 - 500
Off-premises	45 - 90	250 - 600
Mill work	-	150 - 600[†]

* Includes color separations, hand and machine knits, and hand-painted fabrics for the apparel and home decorative markets.

[†] Based on an eight-hour day; expenses for travel are generally billed in addition to the day rate.

mate and confirmation form in the Standard Contracts and Business Tools chapter.

2. *billing for a sale:* When a sale is made, a receipt or invoice is presented that states the terms of the sale and is signed by the client at that time. The terms of payment should be negotiated prior to the sale and these terms should be stated on the invoice. As they largely reflect the designer's labor, invoices for design should be made payable upon receipt. However, companies often take 30 days to pay invoices. If payment is legitimately delayed, the designer may wish to accommodate the buyer and grant a reasonable payment extension. The new payment deadline, however, should be in writing.

Granting extensions should be viewed as a professional courtesy on the part of the artist, not the buyer's right. Some artists may demand a late fee as compensation for the delay in payment, usually a percentage of the outstanding balance. Artists who employ this practice usually notify their clients of the policy in writing before any work is accepted. This practice should be used particularly when longer extensions are granted.

3. *cancellation (kill) fees:* According to current and historical data, clients usually pay the artist a cancellation fee if the assignment is canceled for reasons beyond the artist's control. According to current data, the amount of the fee varies considerably, ranging from 30 to 100 percent, depending upon the degree of the work's completion. A more detailed discussion on kill fees can be found in the Professional Issues chapter.

While the client usually obtains all of the originally agreed-upon rights to the use of the artwork upon payment of the cancellation fee, under a royalty arrangement, all rights to the artwork, as well as possession of the original art, generally revert to the artist upon cancellation.

If a job based on documentary work or other original art belonging to a client is canceled, payment of a time and/or labor charge has been a widely accepted industry custom.

4. *client responsibilities:* Historically, artists have received additional payment when: the client requests artwork changes that were not part of the original agreement; ordered corners (beginnings of designs presented for client approval, usually the upper left-hand corner rendered in the style, technique, color, and materials proposed for the finished design) were not developed into purchased sketches; sales taxes are due, which must be collected on all artwork, in accordance with state laws.

5. *credit to artist:* For the creative work they provide, many designers receive credit and their copyright notice on the selvedge of the fabric, or on the product if other than fabric.

6. *expenses:* Expenses such as travel costs, consultation time, shipping and mailing charges, and other out-of-pocket expenses should be billed to the client separately. Estimated expenses should be included in the original agreement or billed separately as they occur.

7. *holding work:* This practice is pertinent only to noncommissioned, speculative work. Although previous work experience with a client who wishes to hold work prior to committing to its purchase generally has been the guide for allowing this practice, artists should be aware that by consenting to an extended holding time they run the risk that the work may be damaged or lost. Most stylists and design directors have the authority to purchase artwork on the spot, and they should be encouraged to do so. When this is impossible, a maximum holding period of three days is permitted by some artists, but most limit this period to several hours or one day, and only upon completion of a written holding form. Longer periods are impractical due to the perishable nature of fashion items that are valid for only limited periods of time. However, on more standard or classic designs, some artists consider allowing clients to hold them for several weeks for consideration of a "leasing fee," which may be applied against a purchase price.

8. *knockoffs:* A textile/surface designer should not copy or "knock off" a design by another artist unless that work is in the public domain. It is the special talent of the designer to be able to create a work that is original yet satisfies the fashion dictates of the season or year. Designers hired to create a "knock-off" should expect the client to indemnify them from any legal actions that may arise from that work.

9. *quantity orders:* Each surface design is individual in nature, and its creation is labor intensive, a factor in pricing that in the view of many artists is not diminished by the quantity of the order. Nevertheless, each artist should independently decide how to price his or her work.

10. *return of original artwork:* Original artwork is rarely returned to textile designers. One reason for this is that the reproduction process mutilates the work to the point where it is rendered useless. Surface designers could negotiate obtaining samples of their printed designs for display and for portfolio use.

11. *rush work:* The median response for rush work may increase the original fee by a median of 50 percent. As is the case with all fees, the parties to the transactions must agree upon what they regard as a fair rush fee based upon their independent judgment and the specific circumstances of their arrangement.

12. *uses and limitations:* The intended use of commissioned or licensed work generally is stated clearly in a contract, purchase order, or letter of agreement stating the price and terms of sale. If the design is sold specifically for sheets and pillowcases, the surface designer may, upon agreement with the client, sell the same design in other markets (e.g., toweling, boutique items, or stationery).

Should a client who has commissioned work decide he or she wants to use the design for products other than those originally stated in the contract (e.g., a border originally designed for a top sheet is selected for use as a towel), the designer should be offered the first opportunity to redesign the artwork to fit the required format of the new product. Current and historical data indicate that additional compensation generally is paid for extended uses. If no specific limits on usage have been stated in the original contract, and changes do not have to be made to the artwork to render it usable for a new product, it is quite possible that the artist may not be offered additional payment for the use of the design in a new form.

Specific uses, and terms for uses other than those initially specified, should be negotiated in advance when possible. There are times that the secondary use of the art or design may be of greater value than its primary use and there is, therefore, no set formula for reuse fees.

Fees for surface design, reflecting the responses of established professionals to a survey of the United States and Canada, are meant as a point of reference only and do not necessarily reflect such important factors as deadlines, job complexity, reputation and experience of a particular surface designer, research, technique or unique quality of expression, and extraordinary or extensive use of the finished art. Please refer to related material in other sections of this book, especially in the Pricing and Marketing Artwork and Standard Contracts and Business Tools chapters.

The prices shown represent only the specific use for which the surface or textile design is intended and do not necessarily reflect any of the above considerations. The buyer and seller are free to negotiate, taking into account all the factors involved.

Standard contracts
&
Business Tools

Standard contracts & business tools

•••••••••••••

The Guild has created a number of standard contracts for use by its members and other professionals that conform to the JEC Code of Fair Practice and provide a basis for fair dealing between the parties. The purpose of these standard forms is to aid both creators and art buyers in reaching a thorough understanding of their rights and obligations.

A contract is a binding agreement between two or more parties. Normally each party gains certain benefits and must fulfill certain obligations. To be valid a contract must include the important terms of an assignment, such as the fee and the job description. It is best to spell out terms with as much specificity as possible; those that are not, such as when payment must be made, are presumed to be "reasonable." Although it is wise to have written contracts, oral contracts are also binding in many cases and can be the basis of legal suit. Thus, a contract can take many forms: oral, purchase order, confirmation form, an exchange of letters, or a more formal document.

Both parties need not sign a contract to make it binding, although it is wise to do so. For example, if a buyer receives a confirmation form

from an artist and does not object to the terms of the form, the artist is justified in starting work with the assumption that the uncontested form is a binding contract. Even a purchase order or invoice can be used as evidence to support the terms of the unwritten contract on which the artist relied to start his or her work.

A common way of entering into a contract is to have one party send a letter to the other. If the recipient agrees with the terms set forth in the letter, he or she signs at the bottom beneath the words "Agreed to" and returns a signed copy of it to the sender. While informal, such a "letter-of-agreement" is binding. If one party is signing a contract on behalf of a corporation, he or she should give the corporate name, his or her own name, and the title that authorizes them to sign for the corporation,

such as "XYZ Corp. By Alice Buyer, Art Director."

In creating a contract, there must be an offer and an acceptance. If one party makes an offer and the other makes a counteroffer, the original offer is terminated automatically. For a contract to be binding, each participant must give something of value to the other, called "consideration." The most common form of consideration is a promise to do something or refrain from doing something. A promise to work or a promise to pay could be consideration, although doing the work or making the payment would also be consideration.

For a contract to be enforceable, its purpose must be both legal and not against public policy, as might occur if, for example, it provided that the public be misinformed as to some aspect of a product.

One common problem that arises in contracts is the battle of the forms. Each party sends its own forms to the other, but the terms are rarely the same. The question then arises: whose form will govern if a dispute arises? If work is begun on the basis of one form, that form should take precedence over forms sent after completion of the work (such as invoices or a check with a condition on its back; see the Legal Rights and Issues chapter). However, the best way to resolve this problem is to deal with it directly. As soon as either party realizes that an agreement has not been reached, the other should be notified. The points of disagreement should be discussed then and worked out to the satisfaction of both parties. Only in this way can the ambiguities that cause contractual problems be avoided.

Each of the Guild's contracts is a model that can be used directly or that can be modified to suit individual needs and circumstances. By word processing the contracts and saving them to disk, they can then be tailored and personalized for each assignment.

Purchase orders and holding forms

Purchase orders often are used by clients at the beginning of an assignment. If the purchase order is merely an assignment description, artists will want to use an estimate and confirmation form, detailing rights, payments, and other terms. An estimate normally is given before a purchase order is used.

Holding forms are used by artists when they leave work for consideration by a client. These forms describe the work that is being left by the artist, the date and time the client received it, and the projected response date.

An *invoice* normally is presented to a client with the finished work.

Most of the forms have been discussed in detail in various parts of the text (the Surface/Textile Designer–Agent Agreement is accompanied by its own introduction). All contracts and forms in this book are based on U.S. copyright law, which provides for the sale of individual reproduction rights by artists based on the needs expressed by their clients. Each right of usage should be specified clearly, as are all terms for usage.

Usage limitations take the following format:

Title of publication or name of product.

Category of use: Limits specific uses to advertising, promotion, editorial, corporate, or other uses, so that artwork purchased for one market (e.g., editorial art) may not be used in another market (e.g., advertising) without further agreement or consideration.

Medium of use: Specifies the form in which the art will reach the public, such as trade magazine, brochure, annual report, album cover, etc.

Edition: Limits usage to a given edition, such as a hardcover, quality paperback, or other edition.

Geographic area: Limits the territory in which the art can be distributed.

Time period: Limits the length of time during which the art can be used.

All of these concepts can be refined to fit the exact needs of artist and client. The client establishes the usage needed, and the artist suggests the appropriate fees. If further uses are necessary after the contract is negotiated, an appropriate reuse fee can be established in most cases.

Writing a proposal

Graphic designers often provide clients with full-service design projects, from concept through production and final delivery. In providing this service, they often coordinate their art direction and design services with copywriters, illustrators, photographers, retouchers, and printers and bill the client for the entire package.

Standard contracts, like those appearing in this book, do not provide the detail and explanatory material required by this kind of complex, multiphased project. In such cases a design proposal can provide greater scope and,

when bidding on a major commission, a more comprehensive structure.

At their initial meeting, it is important for both client and artist to discuss specific directions about what is being bid upon. Being specific serves two purposes: it will ensure that the proposal will cover the same project and items as other proposals submitted; and both parties will be able to avoid surprises in the scope and estimates of the project after the proposal is accepted.

The information supplied in the proposal is only for the design directions already discussed, specified, and agreed upon by client and artist at their initial meetings. Since clients often compare a number of proposals before choosing a designer for the job, a proposal should be clear and thorough enough to be reviewed without the designer present. It is customary for design proposals to be submitted to clients as a complimentary service, although any fees and expenses incurred thereafter on a client's behalf and with the client's consent are billable. If the client accepts the proposal, the terms and conditions expressed in writing are signed by the client and the designer. Always make at least two copies of the proposal for both client and artist to retain as original signed copies if the commission is accepted. When signed by both client and designer, a proposal is legally binding as a contract.

The organization and appearance of a design proposal can be crucial in winning a job, especially if a design firm is competing against others. A proposal's appearance reflects a designer's ability and polish as much as the information contained within it. Consequently, proposals should be organized logically, well written, well designed, and professionally presented.

When preparing a proposal for a new client, it helps to include collateral material such as biographies of those involved in the project, promotion pieces, reprints of published work, examples of similar projects produced by the designer, etc.

What to include

The proposal should reflect many of the following factors: objectives and requirements of the project; research; art and/or copy that will be developed by the designer; typography and other production services; printing requirements; intended use of the printed piece; and schedule. Additionally, designers frequently prepare documents explaining subcontractor (such as illustrator or photographer) relation-ships, billing procedures, and contract terms.

A proposal should begin with an overview—a clear and concise description of the project. All proposals should also include a disclaimer that says that prices and fees quoted are based on rough verbal specifications of the items listed; if the items change, fees will change accordingly.

Proposals, like the projects they reflect, are divided into parts. These parts include: a description of design and production; a description of fees; a payment schedule for the phases of work involved; rights, usages terms, and conditions; and collateral material to help sell the designer's abilities to the client.

Defining and describing the phases for a project helps facilitate the billing process and insures the work will not proceed to the next phase until payment is received according to the agreed upon schedules. These checkpoints also give clients very clear and tangible input at appropriate times as the project develops.

Parts and phases of a proposal

Part 1: Design and production

Phase 1, Design: Describes the design phase of the project fully, including what form the design presentation will take, how many versions will be presented, the client approval process, and the time schedule for this phase.

Phase 2, Mechanical preparation: After client approval of the design phase, explains the production process, including: assigning of illustration and/or photography; copywriting; typesetting; proofreading; supervision of those components; exact print/production time estimates; client approval schedules; and time required.

Phase 3, Final production: After client approval of the previous phases, final production begins. Depending on the end product(s) a design firm has been commissioned to produce, this phase may be a matter of going on press and/or supervising the fabrication or manufacturing of products within a prescribed schedule. After the endproduct is approved, the project is considered billable.

Part 2: Fees

Fees and expenses may be handled in a number of ways. During the first phase, the studio may arrange to bill on an hourly or project

basis. If clients prefer to be billed on a project basis, they usually will establish an acceptable "cap" on the total amount billed. The project is outlined in briefer form than for Part 1, including the fees required for design, copywriting, photography, illustration, etc. Clients sometimes request estimates for a variety of solutions to a design project. This is common practice and gives the client a choice of directions.

It is important to explain what these fees include (i.e., design, mechanical, production, type specification, preliminary proofreading, etc.) and, more important, what they do not include (i.e., out-of-pocket expenses, author's alterations, overtime charges, photographic art direction, long-distance travel, etc.). These nonfee expenses, including markups, should be stated and estimates of charges should be included if possible.

When supplying production prices such as for printing, be sure to state that these estimates are based on rough verbal specifications and are budget estimates only. More exact quotations can be furnished at such time as a comp or mechanicals are viewed by the printer.

Part 3: Payments

Most design projects typically are quoted and billed by phase, with an initiating fee representing 10 to 30 percent of the total estimated fees and reimbursable expenses. An outline of this payment schedule should be provided.

Part 4: Rights, usage, and credit

Discuss usage, ownership of rights and artwork, credit lines, approvals, interest charged for late payments, and any other terms deemed necessary. For clarification on these items, refer to the standard contracts in this book.

Signature lines for both client and artist and the date that the agreement is signed should follow. A signed original and copy should be retained by both parties.

Part 5: Collateral material

Include material that will help sell your abilitioo to the client. These may include background material or biographies, awards, and a list of other clients and examples of work completed for them.

The following pages contain the standard Graphic Artists Guild contract forms. It should be noted that while these forms are as comprehensive as possible, some terms may not be suited to a given assignment; they can be used, however, as starting points for customized contacts. However, legal language is written to be precise, and simplification of contact terms into "plain English," or deletion of contract terms altogether, may leave the artist exposed to misinterpretation and misunderstanding of important aspects of an agreement.

All-Purpose Purchase Order

Art Buyer's Letterhead

TO

Commissioned By

Date

Purchase Order Number

Job Number

ASSIGNMENT DESCRIPTION

(remove all italics before using this form)

(indicate any preliminary presentations required by the buyer)

Delivery Date

Fee

BUYER SHALL REIMBURSE ARTIST FOR THE FOLLOWING EXPENSES:

RIGHTS TRANSFERRED. BUYER PURCHASES THE FOLLOWING EXCLUSIVE RIGHTS FOR USAGE:

Title or Product *(name)*

Category or Use *(advertising, corporate, promotional, editorial, etc.)*

Medium of Use *(consumer or trade magazine, annual report, TV, book, etc.)*

Edition (if book) *(hardcover, mass market paperback, quality paperback, etc.)*

Geographic Area *(if applicable)*

Time Period *(if applicable)*

Artist reserves any usage rights not expressly transferred. Any usage beyond that granted to buyer herein shall require the payment of a mutually agreed upon additional fee. Any transfer of rights is conditional upon receipt of full payment.

1. Time for Payment
All invoices shall be paid within thirty (30) days of receipt. The grant of any license or right of copyright is conditioned on receipt of full payment.

2. Default in Payment
The Buyer shall assume responsibility for all collection of legal fees necessitated by default in payment.

3. Changes
Buyer shall make additional payments for changes requested in original assignment. However, no additional payment shall be made for changes required to conform to the original assignment description. The Buyer shall offer the Artist first opportunity to make any changes.

4. Expenses
Buyer shall reimburse Artist for all expenses arising from this assignment, including the payment of any sales taxes due on this assignment. Buyer's approval shall be obtained for any increases in fees or expenses that exceed the original estimate by 10% or more.

5. Cancellation
In the event of cancellation of this assignment, ownership of all copyrights and the original artwork shall be retained by the Artist, and a cancellation fee for work completed, based on the contract price and expenses already incurred, shall be paid by the Buyer.

6. Ownership of Artwork
The Artist retains ownership of all original artwork, whether preliminary or final, and the Buyer shall return such artwork within thirty (30) days of use.

7. Credit Lines
The Buyer shall give Artist and any other creators a credit line with any editorial usage. If similar credit lines are to be given with other types of usage, it must be so indicated here:

☐ If this box is checked, the credit line shall be in the form:
© 199__ _____.

8. Releases
Buyer shall indemnify Artist against all claims and expenses, including reasonable attorney's fees, due to uses for which no release was requested in writing or for uses which exceed authority granted by a release.

9. Modifications
Modification of the Agreement must be written, except that the invoice may include, and Buyer shall pay, fees or expenses that were orally authorized in order to progress promptly with the work.

10. Warranty of Originality
The Artist warrants and represents that, to the best of his/her knowledge, the work assigned hereunder is original and has not been previously published, or that consent to use has been obtained on an unlimited basis; that all work or portions thereof obtained through the undersigned from third parties is original or, if previously published, that consent to use has been obtained on an unlimited basis; that the Artist has full authority to make this agreement; and that the work prepared by the Artist does not contain any scan-dalous, libelous, or unlawful matter. This warranty does not extend to any uses that the Buyer or others may make of the Artist's product which may infringe on the rights of others. Buyer expressly agrees that it will hold the Artist harmless for all liability caused by the Buyer's use of the Artist's product to the extent such use infringes on the rights of others.

11. Limitation of Liability
Buyer agrees that it shall not hold the Artist or his/her agents or employees liable for any incidental or consequential damages which arise from the Artist's failure to perform any aspect of the Project in a timely manner, regardless of whether such failure was caused by intentional or negligent acts or omissions of the Artist or a third party.

12. Dispute Resolution
Any disputes in excess of $_____ (maximum limit for small claims court) arising out of this Agreement shall be submitted to binding arbitration before the Joint Ethics Committee or a mutually agreed upon arbitrator pursuant to the rules of the American Arbitration Association. The Arbitrator's award shall be final, and judgment may be entered in any court having jurisdiction thereof. The Buyer shall pay all arbitration and court costs, reasonable attorney's fees, and legal interest on any award of judgment in favor of the Artist.

13. Acceptance of Terms
The signature of both parties shall evidence acceptance of these terms.

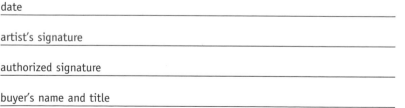

consented and agreed to

date

artist's signature

authorized signature

buyer's name and title

Artist-Agent Agreement

Agreement, this_____ day of _____ 19_____, between (hereinafter referred to as the "Artist"), residing at,

_____,

and, _____, (hereinafter referred to as the "Agent"), residing at.

_____.

Whereas, the Artist is an established artist of proven talents; and
Whereas, the Artist wishes to have an agent represent him or her in marketing certain rights enumerated herein; and
Whereas, the Agent is capable of marketing the artwork produced by the Artist; and
Whereas, the Agent wishes to represent the Artist;
Now, therefore, in consideration of the foregoing premises and the mutual covenants hereinafter set forth and other valuable consideration, the parties hereto agree as follows:

1. **Agency**
The Artist appoints the Agent to act as his or her exclusive representative: (A) in the following geographical area:

(B) for the markets listed here (specify publishing, advertising, etc.):

The Agent agrees to use his or her best efforts in submitting the Artist's work for the purpose of securing assignment for the Artist. The Agent shall negotiate the terms of any assignment that is offered, but the Artist shall have the right to reject any assignment if he or she finds the terms thereof unacceptable.

2. **Promotion**
The Artist shall provide the Agent with such samples of work as are from time to time necessary for the purpose of securing assignments. These samples shall remain the property of the Artist and be returned within thirty (30) days of termination of this Agreement. The Agent shall take reasonable efforts to protect the work from loss or damage, but shall be liable for such loss or damage only if caused by the Agent's negligence. Promotional expenses, including but not limited to promotional mailings and paid advertising, shall be paid____% by the Agent and____% by the Artist. The Agent shall bear the expenses of shipping, insurance, and similar marketing expenses.

3. **Term**
This Agreement shall take effect on the____day of_____, 19__, and remain in full force and effect for a term of one year, unless terminated as provided in Paragraph 9.

4. **Commissions**
The Agent shall be entitled to the following commissions: (A) On assignments secured by the Agent during the term of this Agreement, twenty-five percent (25%) of the billing. (B) On house accounts, ten percent (10%) of the billing. For purposes of this Agreement, house accounts are defined as accounts obtained by the Artist at any time or obtained by another agent representing the Artist prior to the commencement of this Agreement and are listed in Schedule A attached to this Agreement. It is understood by both parties that no commission shall be paid on assignments rejected by the Artist or for which the Artist fails to receive payment, regardless of the reason payment is not made. Further, no commissions shall be payable in either (A) or (B) above for any part of the billing that is due to expenses incurred by the Artist in performing the assignment, whether or not such expenses are reimbursed by the Client. In the event that a flat fee is paid by the Client, it shall be reduced by the amount of expenses incurred by the Artist in performing the assignment, and the Agent's commission shall be payable only on the fee as reduced for

5. **Billing**
The ☐ Artist ☐Agent shall be responsible for all billings.

6. **Payments**
The party responsible for billing shall make all payments due within ten (10) days of receipt of any fees covered by this Agreement. Late payments shall be accompanied by interest calculated at the rate of___% per month thereafter.

7. **Accountings**
The party responsible for billing shall send copies of invoices to the other party when rendered. If requested, that party shall also provide the other party with semiannual accountings showing all assignments for the period, the Clients' names, the fees paid, expenses incurred by the Artist, the dates of payment, the amounts on which the Agent's commissions are to be calculated, and the sums due less those amounts already paid.

8. **Inspection of the Books and Records**
The party responsible for the billing shall keep the books and records with respect to commissions due at his or her place of business and permit the other party to inspect these books and records during normal business hours on the giving of reasonable notice.

9. **Termination**
This Agreement may be terminated by either party by giving thirty (30) days written notice to the other party. If the Artist receives assignments after the termination date from Client(s) originally obtained by the Agent during the term of this Agreement, the commission specified in Paragraph 4(A) shall be payable to the Agent under the following circumstances: If the Agent has represented the Artist for six months or less, the Agent shall receive a commission on such assignments received by the Artist within ninety (90) days of the date of termination. This period shall increase by thirty (30) days for each additional six months that the Agent has represented the Artist, but in no event shall such period exceed one hundred eighty (180) days.

10. **Assignment**
This Agreement shall not be assigned by either of the parties hereto. It shall be binding on and inure to the benefit of the successors, administrators, executors, or heirs of the Agent and Artist.

11. **Dispute Resolution**
Any disputes in excess of $_____maximum limit for small claims court) arising out of this Agreement shall be submitted to binding arbitration before the Joint Ethics Committee or a mutually agreed upon arbitrator pursuant to the rules of the American Arbitration Association. The Arbitrator's award shall be final and judgment may be entered in any court having jurisdiction thereof. The Agent shall pay all arbitration and court costs, reasonable attorney's fees, and legal interest on any award of judgment in favor of the Artist.

12. **Notices**
All notices shall be given to the parties at their respective addresses set forth above.

13. **Independent Contractor Status**
Both parties agree that the Agent is acting as an independent contractor. This Agreement is not an employment agreement, nor does it constitute a joint venture or partnership between the Artist and Agent.

14. **Amendments and Merger**
All amendments to this Agreement must be written. This Agreement incorporates the entire understanding of the parties.

15. **Governing Law**
This Agreement shall be governed by the laws of the State of

In witness whereof, the parties have signed this Agreement as of the date set forth above.

BACK:

SCHEDULE A: HOUSE ACCOUNTS

Date _____ *(remove all italics before using this form)* _____

1. _____ *(name and address of Client)* _____

2. _____

3. _____

4. _____

5. _____

6. _____

7. _____

8. _____

9. _____

10. _____

11. _____

12. _____

artist _____

agent _____

Artwork Inventory Form

Artist's Letterhead

ID #

Final or Rough

Name of Publication

Date Sent

Date Accepted

Date Final Due (if applicable)

Fee Negotiated

Rights Purchased

Fee Paid/Date

Date Rejected

Date Artwork Returned

Computer-Generated Art Job Order Form

TO

Date _____

Commissioned By _____

Purchase Order Number _____

Job Number _____

For Use In Issue Date _____

DEFINITION/TYPE OF ASSIGNMENT/NATURE OF MARKET

(remove all italics before using this form)

Additional Uses _____ *(promotional, packaging, etc.)* _____

Number of Screens or Images Still Frame ___ *(single frame, multiple frame)* ___

Sector Length Per Screen: Maximum Preferred: Minimum: _____

Copy to Read (be sure copy is spelled and titled correctly; the artist is not responsible for any copy other than exactly what appears below)

Disk(s) can be used only for the purposes stated below. All other use(s) and modification(s) is (are) prohibited. Disk(s) may not be copied without the Artist's permission and must be returned after use.

RIGHTS TRANSFERRED ANY TRANSFER OF RIGHTS IS CONDITIONAL UPON RECEIPT OF FULL PAYMENT.

Type of Use _____ *(game program, advertising, etc.)* _____

Medium of Use _____ *(floppy, documentation, packaging, promotion, etc.)* _____

Distribution/Geographical Area ___ *(method of distribution, electronically downloaded, floppy disk, store distribution)* ___

Time/Number of Printings _____ *(one-time use, etc.)* _____

System Applications _____ *(for use on specific machine, or compiled into other operation languages)* _____

PRODUCTION SCHEDULE

First Showing _____

Review _____

Final Acceptance _____

Purchase Price _____

Payment Schedule _____

TERMS:

1. Time for Payment
All invoices are payable within thirty (30) days of receipt. A 1 ½% monthly service charge is payable on all overdue balances. The grant of any license or right of copyright is conditioned on receipt of full payment.

2. Default in Payment
The Client shall assume responsibility for all collection of legal fees necessitated by default in payment.

3. Estimates
If this form is used for an estimate or assignment confirmation, the fees and expenses shown are minimum estimates only. Final fees and expenses shall be shown when invoice is rendered. The Client's approval shall be obtained for any increases in fees or expenses that exceed the original estimate by ten percent (10%) or more.

4. Expenses
The Client shall reimburse the Artist for all expenses arising from this assignment, including the payment of any sales taxes due on this assignment, and shall advance $_____ to the Artist for payment of said expenses.

5. Artist's Guarantee for Program Use
The Artist guarantees to notify the Client of any licensing and/or permissions required for art-generating/driving programs to be used.

6. Changes
The Client shall be responsible for making additional payments for changes requested by the Client in original assignment. However, no additional payment shall be made for changes required to conform to the original assignment description. The Client shall offer the Artist the first opportunity to make any changes.

7. Cancellation
In the event of cancellation of this assignment, ownership of all copyrights and the original artwork shall be retained by the Artist, and a cancellation fee for work completed, based on the contract price and expenses already incurred, shall be paid by the Client.

8. Ownership and Return of Artwork
The Artist retains ownership of all original artwork, whether preliminary or final. The Client waives the right to challenge the validity of the Artist's ownership of the art subject to this agreement because of any change or evolution of the law and will return all artwork within thirty (30) days of use.

9. Copy-Protection
The Client must copy-protect all final art which is the subject of this agreement against duplication or alteration.

10. Credit Lines
The Artist shall be given credit in: (a) floppy disk, (b) documentation, (c) packaging, (d) Artist's mark on art.
☐ If this box is checked, the Artist shall receive copyright notice in this form © 199__ _____.

11. Alterations
Any electronic alteration of original art (color shift, mirroring, flopping, combination cut and paste, deletion) creating additional art is prohibited without the express permission of the artist. The Artist will be given first opportunity to make any alterations required. Unauthorized alterations shall constitute additional use and will be billed accordingly.

12. Other Operating Systems Conversions
The Artist shall be given first option at compiling the work for operating systems beyond the original use.

13. Unauthorized Use and Program Licenses
The Client will indemnify the Artist against all claims and expenses arising from uses for which the Client does not have rights to or authority to use. The Client will be responsible for payment of any special licensing or royalty fees resulting from the use of graphics programs that require such payments.

14. Warranty of Originality
The Artist warrants and represents that, to the best of his/her knowledge, the work assigned hereunder is original and has not been previously published, or that consent to use has been obtained on an unlimited basis; that all work or portions thereof obtained through the undersigned from third parties is original or, if previously published, that consent to use has been obtained on an unlimited basis; that the Artist has full authority to make this agreement; and that the work prepared by the Artist does not contain any scandalous, libelous, or unlawful matter. This warranty does not extend to any uses that the Client or others may make of the Artist's product which may infringe on the rights of others. Client expressly agrees that it will hold the Artist harmless for all liability caused by the Client's use of the Artist's product to the extent such use infringes on the rights of others.

15. Limitation of Liability
Client agrees that it shall not hold the Artist or his/her agents or employees liable for any incidental or consequential damages which arise from the Artist's failure to perform any aspect of the Project in a timely manner, regardless of whether such failure was caused by intentional or negligent acts or omissions of the Artist or a third party.

16. Dispute Resolution
Any disputes in excess of $_____ (maximum limit for small claims court) arising out of this Agreement shall be submitted to binding arbitration before the Joint Ethics Committee or a mutually agreed upon arbitrator pursuant to the rules of the American Arbitration Association. The Arbitrator's award shall be final, and judgment may be entered in any court having jurisdiction thereof. The Client shall pay all arbitration and court costs, reasonable attorney's fees, and legal interest on any award of judgment in favor of the Creator.

17. Acceptance of Terms
The signature of both parties shall evidence acceptance of these terms.

date _____

artist's signature _____

authorized signature _____

client's name and title _____

Digital Media Invoice

● ●

F R O N T :

Developer's Letterhead

TO

Date _____

Commissioned By _____

Purchase Order Number _____

Job Number _____

DESCRIPTION OF ASSIGNMENT:

Primary Use: _____

Additional Uses: _____

Number of Screens or Images Still Frame _____ *(single frame, multiple frame)* _____

Sector Length Per Screen: _____ Maximum Preferred: _____

Minimum: _____

Description of Materials to Be Supplied by Client: _____

Date Due: _____

Disk(s) can be used only for the purposes stated below. All other use(s) and modification(s) is (are) prohibited. Disk(s) may not be copied without the Developer's permission and must be returned after use.

RIGHTS TRANSFERRED ANY TRANSFER OF RIGHTS IS CONDITIONAL UPON RECEIPT OF FULL PAYMENT.

Distribution/Geographical Area: _____

System Applications: _____ *(for use on specific machine or compiled into other operation languages)*

PRODUCTION SCHEDULE INCLUDING MILESTONES, DATES DUE, AND APPROPRIATE FEES:

Milestone	Due Date	Payment Upon Acceptance
Contract Signing	_____	$ _____
Delivery of Website design	_____	$ _____
Delivery of Beta Version	_____	$ _____
Delivery of Final Version (includes return of source materials to Client)	_____	$ _____
Acceptance of Final Version	_____	$ _____
Total	_____	$ _____

Bonus: Client agrees to pay Developer a bonus of _____ payable to the Developer in the event an acceptable Final Version of the Website is delivered to the Client prior to _____ (date).

● ●

TERMS:

1. Time for Payment
Each milestone is payable upon the Client's acceptance of the Deliverables. All invoices are payable within thirty (30) days of receipt. A 1 ½% monthly service charge is payable on all overdue balances. The grant of any license or right of copyright is conditioned on receipt of full payment.

2. Default in Payment
The Client shall assume responsibility for all collection of legal fees necessitated by default in payment.

3. Estimates
If this form is used for an estimate or assignment confirmation, the fees and expenses shown are minimum estimates only. Final fees and expenses shall be shown when invoice is rendered. The Client's approval shall be obtained for any increases in fees or expenses that exceed the original estimate by 10% or more.

4. Expenses
The Client shall reimburse the Developer for all expenses arising from this assignment, including the payment of any sales taxes due on this assignment and shall advance $_____ to the Developer for payment of said expenses.

5. Internet Access
Access to Internet will be provided by a separate Internet Service Provider (I.S.P.) to be contracted by the Client and who will not be party to this agreement.

6. Progress Reports
The Developer shall contact or meet with the Client on a mutually acceptable schedule to report all tasks completed, problems encountered, and recommended changes relating to the development and testing of the Website. The Developer shall inform the Client promptly by telephone upon discovery of any event or problem that may significantly delay the development of the work.

7. Developer's Guarantee for Program Use
The Developer guarantees to notify the Client of any licensing and/or permissions required for art generating/driving programs to be used.

8. Changes
The Client shall be responsible for making additional payments for changes requested by the Client in original assignment. However, no additional payment shall be made for changes required to conform to the original assignment description. The Client shall offer the Developer the first opportunity to make any changes.

9. Testing and Acceptance Procedures
The Developer will make every good faith effort to thoroughly test all deliverables and make all necessary corrections as a result of such testing prior to handing over the deliverables to the Client. Upon receipt of the deliverables, the Client shall either accept the deliverable and make the milestone payment set forth or provide the Developer with written notice of any corrections to be made and a suggested date for completion which should be mutually acceptable to both the Developer and the Client. The Developer shall designate _____ (name) and the Client shall designate _____ (name) as the only designated persons who will send and accept all deliverables, and receive and make all communications between the Developer and the Client. Neither party shall have any obligation to consider for approval or respond to materials submitted other than through the designated persons listed above. Each party has the right to change its designated person upon _____ day(s)' notice to the other.

10. Website Maintenance
The Developer agrees to provide the Client with reasonable technical support and assistance to maintain and update the Website on the Internet during the Warranty Period of _____ (dates) at no cost to the Client. Such assistance shall not exceed _____ hours per calendar month. After the expiration of the Warranty Period the Developer agrees to provide the Client with reasonable technical support and assistance to maintain and update the Website on the Internet for an annual fee of $_____ for a period of _____ years after the last day of the Warranty Period payable thirty (30) days prior to the commencement date of each year of the Maintenance Period. Such maintenance shall include correcting any errors or any failure of the Website to conform to the specifications. Maintenance shall not include the development of enhancements to the originally contracted project.

11. Enhancements
Under the maintenance agreement, if the Client wishes to modify the Website, the Developer shall be given first option to provide a bid to perform such enhancements.

12. Confidential Information
The Developer acknowledges and agrees that the source materials and technical and marketing plans or other sensitive business information, including all materials containing said information, which are supplied by the Client to the Developer or developed by the Developer in the course of developing the Website are to be considered confidential information. Information shall not be considered confidential if it is already publicly known through no act of the Developer.

13. Return of Source Information
Upon the Client's acceptance of the Final Version, or upon the cancellation of the project, the Developer shall provide the Client with all copies and originals of the source materials provided to the Developer.

14. Cancellation
In the event of cancellation of this assignment, ownership of all copyrights and any original artwork shall be retained by the Developer, and a cancellation fee for work completed, based on the pro-rated portion of the next payment and expenses already incurred, shall be paid by the Client.

15. Ownership and Return of Artwork
The Developer retains ownership of all original artwork, whether preliminary or final. The Client waives the right to challenge the validity of the Developer's ownership of the art subject to this agreement because of any change or evolution of the law and will return all artwork within thirty (30) days of use.

16. Copy-Protection
The Client must copy-protect all final art which is the subject of this agreement against duplication or alteration.

17. Credit Lines
The Developer shall be given credit in: (a) floppy disk, (b) documentation, (c) packaging, (d) Developer's mark on art.
☐ If this box is checked, the Developer shall receive copyright notice in this form:
© 199__ _____.

18. Alterations
Any electronic alteration of original art (color shift, mirroring, flopping, combination cut and paste, deletion) creating additional art, is prohibited without the express permission of the

developer. The Developer will be given first opportunity to make any alterations required. Unauthorized alterations shall constitute additional use and will be billed accordingly.

19. Other Operating Systems Conversions
The Developer shall be given first option at compiling the work for operating systems beyond the original use.

20. Unauthorized Use and Program Licenses
The Client will indemnify the Developer against all claims and expenses arising from uses for which the Client does not have rights to or authority to use. The Client will be responsible for payment of any special licensing or royalty fees resulting from the use of graphics programs that require such payments.

21. Warranty of Originality
The Developer warrants and represents that, to the best of his/her knowledge, the work assigned hereunder is original and has not been previously published or that consent to use has been obtained on an unlimited basis; that all work or portions thereof obtained through the undersigned from third parties is original or, if previously published, that consent to use has been obtained on an unlimited basis; that the Developer has full authority to make this agreement; and that the work prepared by the Developer does not contain any scandalous, libelous, or unlawful matter. This warranty does not extend to any uses that the Client or others may make of the Developer's product which may infringe on the rights of others. Client expressly agrees that it will hold the Developer harmless for all liability caused by the Client's use of the Developer's product to the extent such use infringes on the rights of others.

22. Limitation of Liability
Client agrees that it shall not hold the Developer or his/her agents or employees liable for any incidental or consequential damages which arise from the Developer's failure to perform any aspect of the Project in a timely manner, regardless of whether such failure was caused by intentional or negligent acts or omissions of the Developer or a third party. Furthermore, the Developer disclaims all implied warranties, including the warranty of merchantability and fitness for a particular use.

23. Dispute Resolution
Any disputes in excess of $_____ (maximum limit for small claims court) arising out of this Agreement shall be submitted to binding arbitration before the Joint Ethics Committee or a mutually agreed upon arbitrator pursuant to the rules of the American Arbitration Association. The Arbitrator's award shall be final, and judgment may be entered in any court having jurisdiction thereof. The Client shall pay all arbitration and court costs, reasonable attorney's fees, and legal interest on any award of judgment in favor of the Developer.

24. Acceptance of Terms
The signature of both parties shall evidence acceptance of these terms.

consented and agreed to

date _____

developer's signature _____

authorized signature _____

client's name and title _____

Graphic Designer's Estimate and Confirmation Form

F R O N T :

Designer's Letterhead

TO

(remove all italics before using this form)

Date

Commissioned By

Assignment Number

Client's Purchase Order Number

ASSIGNMENT DESCRIPTION

Delivery Date

(predicated on receipt of all materials to be supplied by Client)

Materials Supplied By

Fee

FEE PAYMENT SCHEDULE

ESTIMATED EXPENSES

The Client shall reimburse the Designer for all expenses. Expense amounts are estimates only.

Illustration	Printing (If Brokered by Designer)
Photography	Client's Alterations
Models & Props	Toll Telephones
Materials & Supplies	Transportation & Travel
Type	Messengers
Stats, Proofing & Copies	Shipping & Insurance
Mechanicals	Other Expenses
	Subtotal
	Sales Tax
	Total

RIGHTS TRANSFERRED

The Designer transfers to the Client the following exclusive rights of usage.

Title or Product	*(name)*
Category of Use	*(advertising, corporate, promotional, editorial, etc.)*
Medium of Use	*(consumer or trade magazine, annual report, TV, book, etc.)*
Edition (if book)	*(hardcover, mass market paperback, quality paperback, etc.)*
Geographic Area	*(if applicable)*
Time Period	*(if applicable)*

Any usage rights not exclusively transferred are reserved to the Designer. Usage beyond that granted to the Client herein shall require payment of a mutually agreed upon additional fee subject to all terms. Any transfer of rights is conditional upon receipt of full payment.

BACK:

TERMS:

1. Time for Payment
All invoices are payable within thirty (30) days of receipt. A 1 ½% monthly service charge is payable on all overdue balances. The grant of any license or right of copyright is conditioned on receipt of full payment.

2. Default in Payment
The Client shall assume responsibility for all collection of legal fees necessitated by default in payment.

3. Estimates
The fees and expenses shown are minimum estimates only. Final fees and expenses shall be shown when invoice is rendered. The Client's approval shall be obtained for any increases in fees or expenses that exceed the original estimate by ten percent (10%) or more.

4. Changes
The Client shall be responsible for making additional payments for changes requested by the Client in original assignment. However, no additional payment shall be made for changes required to conform to the original assignment description. The Client shall offer the Designer the first opportunity to make any changes.

5. Expenses
The Client shall reimburse the Designer for all expenses arising from this assignment, including the payment of any sales taxes due on this assignment, and shall advance $_____ to the Designer for payment of said expenses.

6. Cancellation
In the event of cancellation of this assignment, ownership of all copyrights and the original artwork shall be retained by the Designer, and a cancellation fee for work completed, based on the contract price and expenses already incurred, shall be paid by the Client.

7. Ownership and Return of Artwork
The Designer retains ownership of all original artwork, whether preliminary or final, and the Client shall return such artwork within thirty (30) days of use unless indicated otherwise below:

8. Credit Lines
The Designer and any other creators shall receive a credit line with any editorial usage. If similar credit lines are to be given with other types of usage, it must be so indicated here:

9. Releases
The Client shall indemnify the Designer against all claims and expenses, including reasonable attorney's fees, due to uses for which no release was requested in writing or for uses which exceed authority granted by a release.

10. Modifications
Modification of the Agreement must be written, except that the invoice may include, and the Client shall pay, fees or expenses that were orally authorized in order to progress promptly with the work.

11. Uniform Commercial Code
The above terms incorporate Article 2 of the Uniform Commercial Code.

12. Code of Fair Practice
The Client and the Designer agree to comply with the provisions of the Code of Fair Practice, a copy of which may be obtained from the Joint Ethics Committee, P.O. Box 179, Grand Central Station, New York, New York, 10017.

13. Warranty of Originality
The Designer warrants and represents that, to the best of his/her knowledge, the work assigned hereunder is original and has not been previously published, or that consent to use has been obtained on an unlimited basis; that all work or portions thereof obtained through the undersigned from third parties is original or, if previously published, that consent to use has been obtained on an unlimited basis; that the Designer has full authority to make this agreement; and that the work prepared by the Designer does not contain any scandalous, libelous, or unlawful matter. This warranty does not extend to any uses that the Client or others may make of the Designer's product which may infringe on the rights of others. Client expressly agrees that it will hold the Designer harmless for all liability caused by the Client's use of the Designer's product to the extent such use infringes on the rights of others.

14. Limitation of Liability
Client agrees that it shall not hold the Designer or his/her agents or employees liable for any incidental or consequential damages which arise from the Designer's failure to perform any aspect of the Project in a timely manner, regardless of whether such failure was caused by intentional or negligent acts or omissions of the Designer or a third party.

15. Dispute Resolution
Any disputes in excess of $_____ (maximum limit for small claims court) arising out of this Agreement shall be submitted to binding arbitration before the Joint Ethics Committee or a mutually agreed upon arbitrator pursuant to the rules of the American Arbitration Association. The Arbitrator's award shall be final, and judgment may be entered in any court having jurisdiction thereof. The Client shall pay all arbitration and court costs, reasonable attorney's fees, and legal interest on any award of judgment in favor of the Designer.

16. Acceptance of Terms
The signature of both parties shall evidence acceptance of these terms.

consented and agreed to

date

designer's signature

authorized signature

client's name and title

Graphic Designer's Invoice

· ·

FRONT:

Designer's Letterhead

TO

(remove all italics before using this form)

Date

Commissioned By

Assignment Number

Invoice Number

Client's Purchase Order Number

ASSIGNMENT DESCRIPTION

FEE PAYMENT SCHEDULE

ITEMIZED EXPENSES (OTHER BILLABLE EXPENSES)

Illustration	Printing (If Brokered by Designer)
Photography	Client's Alterations
Models & Props	Toll Telephones
Materials & Supplies	Transportation & Travel
Type (Linotronic Output)	Messengers
Stats, Proofing & Copies	Shipping & Insurance
Mechanicals	Other Expenses
	Subtotal
	Sales Tax
	Total

RIGHTS TRANSFERRED

The Designer transfers to the Client the following exclusive rights of usage.

Title or Product *(name)*

Category of Use *(advertising, corporate, promotional, editorial, etc.)*

Medium of Use *(consumer or trade magazine, annual report, TV, book, etc.)*

Edition (if book) *(hardcover, mass market paperback, quality paperback, etc.)*

Geographic Area *(if applicable)*

Time Period *(if applicable)*

Any usage rights not exclusively transferred are reserved to the Designer. Usage beyond that granted to the Client herein shall require payment of a mutually agreed upon additional fee subject to all terms. Any transfer of rights is conditional upon receipt of full payment.

TERMS:

1. Time for Payment
All invoices are payable within thirty (30) days of receipt. A 1 ½% monthly service charge is payable on all overdue balances. The grant of any license or right of copyright is conditioned on receipt of full payment.

2. Default in Payment
The Client shall assume responsibility for all collection of legal fees necessitated by default in payment.

3. Expenses
The Client shall reimburse the Designer for all expenses arising from this assignment, including the payment of any sales taxes due on this assignment.

4. Changes
The Client shall be responsible for making additional payments for changes requested by the Client in original assignment. However, no additional payment shall be made for changes required to conform to the original assignment description. The Client shall offer the Designer the first opportunity to make any changes.

5. Cancellation
In the event of cancellation of this assignment, ownership of all copyrights and the original artwork shall be retained by the Designer, and a cancellation fee for work completed, based on the contract price and expenses already incurred, shall be paid by the Client.

6. Ownership and Return of Artwork
The Designer retains ownership of all original artwork, whether preliminary or final, and the Client shall return such artwork within thirty (30) days of use unless indicated otherwise below:

7. Credit Lines
The Designer and any other creators shall receive a credit line with any editorial usage. If similar credit lines are to be given with other types of usage, it must be so indicated here:

8. Releases
The Client shall indemnify the Designer against all claims and expenses, including reasonable attorney's fees, due to uses for which no release was requested in writing or for uses which exceed authority granted by a release.

9. Modifications
Modification of the Agreement must be written, except that the invoice may include, and the Client shall pay, fees or expenses that were authorized orally in order to progress promptly with the work.

10. Uniform Commercial Code
The above terms incorporate Article 2 of the Uniform Commercial Code.

11. Code of Fair Practice
The Client and the Designer agree to comply with the provisions of the Code of Fair Practice, a copy of which may be obtained from the Joint Ethics Committee, P.O. Box 179, Grand Central Station, New York, New York, 10017.

12. Warranty of Originality
The Designer warrants and represents that, to the best of his/her knowledge, the work assigned hereunder is original and has not been previously published, or that consent to use has been obtained on an unlimited basis; that all work or portions thereof obtained through the undersigned from third parties is original or, if previously published, that consent to use has been obtained on an unlimited basis; that

the Designer has full authority to make this agreement; and that the work prepared by the Designer does not contain any scandalous, libelous, or unlawful matter. This warranty does not extend to any uses that the Client or others may make of the Designer's product which may infringe on the rights of others. Client expressly agrees that it will hold the Designer harmless for all liability caused by the Client's use of the Designer's product to the extent such use infringes on the rights of others.

13. Limitation of Liability
Client agrees that it shall not hold the Designer or his/her agents or employees liable for any incidental or consequential damages which arise from the Designer's failure to perform any aspect of the Project in a timely manner, regardless of whether such failure was caused by intentional or negligent acts or omissions of the Designer or a third party.

14. Dispute Resolution
Any disputes in excess of $_____ (maximum limit for small claims court) arising out of this Agreement shall be submitted to binding arbitration before the Joint Ethics Committee or a mutually agreed upon arbitrator pursuant to the rules of the American Arbitration Association. The Arbitrator's award shall be final, and judgment may be entered in any court having jurisdiction thereof. The Client shall pay all arbitration and court costs, reasonable attorney's fees, and legal interest on any award of judgment in favor of the Designer.

Illustrator's Estimate and Confirmation Form

FRONT:

Illustrator's Letterhead

TO

(remove all italics before using this form)

Date

Commissioned By

Illustrator's Job Number

Client's Job Number

ASSIGNMENT DESCRIPTION

DELIVERY SCHEDULE

FEE (PAYMENT SCHEDULE)

ESTIMATED EXPENSES (OTHER BILLABLE ITEMS)

Toll Telephones

Transit & Travel

Messengers

Cancellation Fee (Percentage of Fee)

Shipping & Insurance

Other Expenses

Client's Alterations

Before Sketches

After Sketches

After Finish

Sale of Original Art

RIGHTS TRANSFERRED

Any usage rights not exclusively transferred are reserved to the Illustrator. Usage beyond that granted to the Client herein shall require payment of a mutually agreed upon additional fee subject to all terms.

For Use in Magazines and Newspapers, First North American Reproduction Rights Unless Specified Otherwise Here:

For all other uses, the Client acquires only the following rights:

Title or Product *(name)*

Category of Use *(advertising, corporate, promotional, editorial, etc.)*

Medium of Use *(consumer or trade magazine, annual report, TV, book, etc.)*

Geographic Area *(if applicable)*

Time Period *(if applicable)*

Number of Uses *(if applicable)*

Other *(if applicable)*

Original artwork, including sketches and any other preliminary material, remains the property of the Illustrator unless purchased by a payment of a separate fee. Any transfer of rights is conditional upon receipt of full payment.

BACK:

TERMS:

1. Time for Payment
Payment is due within thirty (30) days of receipt of invoice. A 1 ½% monthly service charge will be billed for late payment. The grant of any license or right of copyright is conditioned on receipt of full payment. Any advances or partial payments shall be indicated under Payment Schedule on front.

2. Default in Payment
The Client shall assume responsibility for all collection of legal fees necessitated by default in payment.

3. Grant of Rights
The grant of reproduction rights is conditioned on receipt of payment.

4. Expenses
The Client shall reimburse the Illustrator for all expenses arising from the assignment.

5. Estimates
The fees and expenses shown are minimum estimates only. Final fees and expenses shall be shown when invoice is rendered. The Client's approval shall be obtained for any increases in fees or expenses that exceed the original estimate by ten percent (10%) or more.

6. Sales Tax
The Client shall be responsible for the payment of sales tax, if any such tax is due.

7. Cancellation
In the event of cancellation or breach by the Client, the Illustrator shall retain ownership of all rights of copyright and the original artwork, including sketches and any other preliminary materials. The Client shall pay the Designer according to the following schedule: fifty percent (50%) of original fee if canceled after preliminary sketches are completed, one hundred percent (100%) if canceled after completion of finished art.

8. Alterations
Alteration to artwork shall not be made without consulting the initial Illustrator, and the Illustrator shall be allowed the first option to make alterations when possible. After acceptance of artwork, if alterations are required, a payment shall be charged over the original amount.

9 Revisions
Revisions not due to the fault of the Illustrator shall be billed separately.

10. Credit Lines
On any contribution for magazine or book use, the Illustrator shall receive name credit in print. If name credit is to be given with other types of use, it must be specified here:

☐ If this box is checked, the Illustrator shall receive copyright notice adjacent to the work in the form:© 199__ _____

11. Return of Artwork
The Client assumes responsibility for the return of the artwork in undamaged condition within thirty (30) days of first reproduction.

12. Loss or Damage to Artwork
The value of lost or damaged artwork is placed at no less than $_____ , per piece.

13. Unauthorized Use
The Client will indemnify the Illustrator against all claims and expenses, including reasonable attorney's fees, arising from uses for which no release was requested in writing or for uses exceeding the authority granted by a release.

14. Warranty of Originality
The Illustrator warrants and represents that, to the best of his/her knowledge, the work assigned hereunder is original and has not been previously published, or that consent to use has been obtained on an unlimited basis; that all work or portions thereof obtained through the undersigned from third parties is original or, if previously published, that consent to use has been obtained on an unlimited basis; that the Illustrator has full authority to make this agreement; and that the work prepared by the Illustrator does not contain any scandalous, libelous, or unlawful matter. This warranty does not extend to any uses that the Client or others may make of the Illustrator's product which may infringe on the rights of others. Client expressly agrees that it will hold the Illustrator harmless for all liability caused by the Client's use of the Illustrator's product to the extent such use infringes on the rights of others.

15. Limitation of Liability
Client agrees that it shall not hold the Illustrator or his/her agents or employees liable for any incidental or consequential damages which arise from the Illustrator's failure to perform any aspect of the Project in a timely manner, regardless of whether such failure was caused by intentional or negligent acts or omissions of the Illustrator or a third party.

16. Dispute Resolution
Any disputes in excess of $_____ (maximum limit for small claims court) arising out of this Agreement shall be submitted to binding arbitration before the Joint Ethics Committee or a mutually agreed upon arbitrator pursuant to the rules of the American Arbitration Association. The Arbitrator's award shall be final, and judgment may be entered in any court having jurisdiction thereof. The Client shall pay all arbitration and court costs, reasonable attorney's fees, and legal interest on any award of judgment in favor of the Illustrator.

17. Acceptance of Terms
The signature of both parties shall evidence acceptance of these terms.

consented and agreed to

date

Illustrator's signature

authorized signature

Illustrator's invoice

· ·

F R O N T :

Illustrator's Letterhead

TO

(remove all italics before using this form)

Date _____

Commissioned By _____

Illustrator's Job Number _____

Client's Job Number _____

ASSIGNMENT DESCRIPTION

FEE (PAYMENT SCHEDULE)

ITEMIZED EXPENSES (OTHER BILLABLE ITEMS)

Toll Telephones _____

Transportation & Travel _____

Messengers _____

Shipping & Insurance _____

Client's Alterations _____

Sale of Original Art _____

Cancellation Fee _____

Miscellaneous _____

Subtotal _____

Sales Tax _____

Payments on Account _____

Balance Due _____

RIGHTS TRANSFERRED

Any usage rights not exclusively transferred are reserved to the Illustrator. Usage beyond that granted to the Client herein shall require payment of a mutually agreed upon additional fee subject to all terms.

For Use in Magazines and Newspapers, First North American Reproduction Rights Unless Specified Otherwise Here:

For all other uses, the Client acquires only the following rights:

Title or Product _____ *(name)*

Category of Use _____ *(advertising, corporate, promotional, editorial, etc.)*

Medium of Use _____ *(consumer or trade magazine, annual report, TV, book, etc.)*

Geographic Area _____ *(if applicable)*

Time Period _____ *(if applicable)*

Number of Uses _____ *(if applicable)*

Other _____ *(if applicable)*

Original artwork, including sketches and any other preliminary materials, remain the property of the Illustrator unless purchased by payment of a separate fee subject to all terms.

Any transfer of rights is conditional upon receipt of full payment.

· ·

TERMS:

1. Time for Payment
Payment is due within thirty (30) days of receipt of invoice. A 1 ½% monthly service charge will be billed for late payment. The grant of any license or right of copyright is conditioned on receipt of full payment.

2. Default in Payment
The Client shall assume responsibility for all collection of legal fees necessitated by default in payment.

3. Expenses
The Client shall reimburse the Illustrator for all expenses arising from the assignment.

4. Sales Tax
The Client shall be responsible for the payment of sales tax, if any such tax is due.

5. Grant of Rights
The grant of reproduction rights is conditioned on receipt of payment.

6. Credit Lines
On any contribution for magazine or book use, the Illustrator shall receive name credit in print. If name credit is to be given with other types of use, it must be specified here:

☐ If this box is checked, the Illustrator shall receive copyright notice adjacent to the work in the form: ©199___ _____.

7. Additional Limitations
If the Illustrator and the Client have agreed to additional limitations as to either the duration or geographical extent of the permitted use, specify here:

8. Return of Artwork
The Client assumes responsibility for the return of the artwork in undamaged condition within thirty (30) days of first reproduction.

9. Loss or Damage to Artwork
The value of lost or damaged artwork is placed at no less than $_____, per piece.

10. Alterations
Alteration to artwork shall not be made without consulting the initial Illustrator, and the Illustrator shall be allowed the first option to make alterations when possible. After acceptance of artwork, if alterations are required, a payment shall be charged over the original amount.

11. Unauthorized Use
The Client will indemnify the Illustrator against all claims and expenses, including reasonable attorney's fees, arising from uses for which no release was requested in writing or for uses which exceed the authority granted by a release.

12. Warranty of Originality
The Illustrator warrants and represents that, to the best of his/her knowledge, the work assigned hereunder is original and has not been previously published, or that consent to use has been obtained on an unlimited basis; that all work or portions thereof obtained through the undersigned from third parties is original or, if previously published, that consent to use has been obtained on an unlimited basis; that the Illustrator has full authority to make this agreement; and that the work prepared by the Illustrator does not contain any scandalous, libelous, or unlawful matter. This warranty does not extend to any uses that the Client or others may make of the Illustrator's product which may infringe on the rights of others. Client expressly agrees that it will hold the Illustrator harmless for all liability caused by the Client's use of the Illustrator's product to the extent such use infringes on the rights of others.

13. Limitation of Liability
Client agrees that it shall not hold the Illustrator or his/her agents or employees liable for any incidental or consequential damages which arise from the Illustrator's failure to perform any aspect of the Project in a timely manner, regardless of whether such failure was caused by intentional or negligent acts or omissions of the Illustrator or a third party.

14. Dispute Resolution
Any disputes in excess of $_____ (maximum limit for small claims court) arising out of this Agreement shall be submitted to binding arbitration before the Joint Ethics Committee or a mutually agreed upon arbitrator pursuant to the rules of the American Arbitration Association. The Arbitrator's award shall be final, and judgment may be entered in any court having jurisdiction thereof. The Client shall pay all arbitration and court costs, reasonable attorney's fees, and legal interest on any award of judgment in favor of the Illustrator.

Illlustrator's Release Form for Models

● ●

In consideration of _____ Dollars ($ _____) receipt of which is

acknowledged, I, _____, do hereby give _____, his or her assigns,

licensees, and legal representatives the irrevocable right to use my name (or any fictional name), picture,

portrait, or photograph in all forms and media and in all manners, including composite or distorted represen-

tations, for advertising, trade, or any other lawful purposes, and I waive any right to inspect or approve the

finished version(s), including written copy that may be created in connection therewith. I am of full age.* I

have read this release and am fully familiar with its contents.

Witness _____

Model _____

Address _____

Address _____

Date _____ , 19 _____

CONSENT (IF APPLICABLE)

I am the parent or guardian of the minor named above and have the legal authority to execute the above

release. I approve the foregoing and waive any rights in the premises.

Witness _____

Parent or Guardian _____

Address _____

Address _____

Date _____ , 19 _____

Delete this sentence if the subject is a minor. The parent or guardian must then sign the consent.

(Reproduced with permission from *Business and Legal forms for Illustrators* by Tad Crawford, Allworth Press.)

Licensing Agreement (Short Form)

● ●

F R O N T :

Licensor's Letterhead

1. _____
 (The "Licensor") hereby grants to

 (the "Licensee") a nonexclusive
 license to use the image

 (the "Image") created and owned by
 Licensor on ("Licensed Products")
 and to distribute and sell these
 Licensed Products in

 (territory)
 for a term of _____ years commenc-
 ing _____, 19___, in
 accordance with the terms and con-
 ditions of this Agreement.

2. Licensor shall retain all copyrights in
 and to the Image. Licensee shall
 identify the Licensor as the artist on
 the Licensed Products and shall repro-
 duce thereon the following copyright
 notice: © 199__ _____.

3. Licensee agrees to pay the Licensor
 a nonrefundable royalty of_____
 (___%) percent of the net sales of
 the Licensed Products. "Net Sales"
 as used herein shall mean sales to
 customers less prepaid freight and
 credits for lawful and customary vol-
 ume rebates, actual returns, and
 allowances. Royalties shall be
 deemed to accrue when the
 Licensed Products are sold, shipped,
 or invoiced, whichever first occurs.

4. Licensee shall pay Licensor a non-
 refundable advance in the amount
 of $_____ upon signing of this
 Agreement. Licensee further agrees
 to pay Licensor a guaranteed nonre-
 fundable minimum royalty of
 $_____ every month.

5. Royalty payments shall be paid on
 the first day of each month com-
 mencing_____, 19___, and
 Licensee shall furnish Licensor with
 monthly statements of account
 showing the kinds and quantities of
 all Licensed Products sold, the
 prices received therefor, and all
 deductions for freight, volume

rebates, returns, and allowances.
The first royalty statement shall be
sent on_____, 19___.

6. Licensor shall have the right to ter-
 minate this Agreement upon thirty
 (30) days notice if Licensee fails to
 make any payment required of it
 and does not cure this default with-
 in said thirty (30) days, whereupon
 all rights granted herein shall revert
 immediately to the Licensor.

7. Licensee agrees to keep complete
 and accurate books and records
 relating to the sale of the Licensed
 Products. Licensor shall have the
 right to inspect Licensee's books
 and records concerning sales of the
 Licensed Products upon prior writ-
 ten notice.

8. Licensee shall give Licensor, free of
 charge, *(number)* samples of each of
 the Licensed Products for Licensor's
 personal use. Licensor shall have
 the right to purchase additional
 samples of the Licensed Products at
 the Licensee's manufacturing cost.
 "Manufacturing cost" shall be
 $_____ per Licensed
 Product.

9. Licensor shall have the right to
 approve the quality of the reproduc-
 tion of the Image on the Licensed
 Products and on any approved
 advertising or promotional materials
 and Licensor shall not unreasonably
 withhold approval.

10. Licensee shall use its best efforts to
 promote, distribute, and sell the
 Licensed Products and said
 Products shall be of the highest
 commercial quality.

11. All rights not specifically trans-
 ferred by this Agreement are
 reserved to the Licensor. Any trans-
 fer of rights is conditional upon
 receipt of full payment.12. The
 Licensee shall hold the Licensor
 harmless from and against any loss,

expense, or damage occasioned by
any claim, demand, suit, or recovery
against the Licensor arising out of
the use of the Image.

13. Nothing herein shall be construed to
 constitute the parties hereto joint
 ventures, nor shall any similar rela-
 tionship be deemed to exist between
 them. This Agreement shall not be
 assigned in whole or in part without
 the prior written consent of the
 Licensor.

14. This Agreement shall be construed
 in accordance with the laws of
 (state); Licensee consents to juris-
 diction of the courts of *(state)*.

15. All notices, demands, payments,
 royalty payments, and statements
 shall be sent to the Licensor at the
 following address:

 and to the Licensee at:

16. Any disputes arising out of this
 Agreement shall be submitted to
 binding arbitration before the Joint
 Ethics Committee or a mutually
 agreed upon arbitrator pursuant to
 the rules of the American
 Arbitration Association in the city
 of *(city)*. The Arbitrator's award
 shall be final, and judgment may be
 entered in any court having juris-
 diction thereof. The Licensee shall
 pay all arbitration and court costs,
 reasonable attorney's fees, and legal
 interest on any award of judgment
 in favor of the Licensor.

17. This Agreement constitutes the
 entire agreement between the par-
 ties hereto and shall not be modi-
 fied, amended, or changed in any
 way except by written agreement
 signed by both parties hereto. This
 Agreement shall be binding upon
 and shall inure to the benefit of the
 parties, their successors, and
 assigns.

in witness whereof, the parties have executed this Licensing Agreement on the _____day of_____, 19____.

licensee (company name) _____

by (name, position) _____

licensor _____

© Caryn Leland 1990

Licensing Agreement (Long Form)

1. Grant of License

Agreement made this _____ day of _____, 19___between _____ (the "Licensor"), having an address at _____ *(address)* and

_____ (the "Licensee"), located at _____ *(address)* whereby Licensor grants to Licensee a license to use the designs listed on the attached Schedules A and B (the "Designs") in accordance with the terms and conditions of this Agreement and only for the production, sale, advertising, and promotion of certain articles (the "Licensed Products") described in Schedule A for the Term and in the Territory set forth in said Schedule. Licensee shall have the right to affix the Trademarks: _____ and _____ on or to the Licensed Products and on packaging, advertising, and promotional materials sold, used, or distributed in connection with the Licensed Products.

2. Licensor's Representation and Credits

A. Licensor warrants that Licensor has the right to grant to the Licensee all of the rights conveyed in this Agreement. The Licensee shall have no right, license, or permission except as herein expressly granted. All rights not specifically transferred by the Agreement are reserved to the Licensor.

B. The Licensee shall display and identify prominently the Licensor as the designer on each Licensed Product and on all packaging, advertising, and display and in all publicity therefor and shall have reproduced thereon (or on an approved tag or label) the following notices: "© Licensor's name, 19__ . All rights reserved." The Licensed Products shall be marketed under the name:

_____ for_____. The name shall not be cojoined with any third party's name without the Licensor's express written permission.

C. The Licensee shall have the right to use the Licensor's name, portrait, or picture in a dignified manner consistent with the Licensor's reputation in advertising or other promotional materials associated with the sale of the Licensed Products.

3. Royalties and Statements of Account

A. Licensee agrees to pay Licensor a nonrefundable royalty of_____ (____%) percent of the net sales of all of the Licensed Products incorporating and embodying the Designs. "Net sales" is defined as sales direct to customers less prepaid freight and credits for lawful and customary volume rebates, actual returns, and allowances; the aggregate of said deductions and credits shall not exceed three percent (3%) of accrued royalties in any year. No costs incurred in the manufacture, sale, distribution, or exploitation of the Licensed Products shall be deducted from any royalties due to Licensor. Royalties shall be deemed to accrue when the Licensed Products are sold, shipped, or invoiced, whichever first occurs.

B. Royalty payments for all sales shall be due on the 15th day after the end of each calendar quarter. At that time and regardless if any Licensed Products were sold during the preceding time period, Licensee shall furnish Licensor an itemized statement categorized by Design, showing the kinds and quantities of all Licensed Products sold and the prices received therefor, and all deductions for freight, volume rebates, returns, and allowances. The first royalty statement shall commence on:,_____ 19___.

C. If Licensor has not received the royalty payment as required by the foregoing paragraph 3B within twenty-one (21) days following the end of each calendar quarter, a monthly service charge of one-and-a-half percent (1.5%) shall accrue thereon and become due and owing from the date on which such royalty payment became due and owing.

4. Advances and Minimum Royalties

A. In each year of this Agreement, Licensee agrees to pay Licensor a Guaranteed Minimum Royalty in the amount of $_____ of which $_____ shall be deemed a Nonrefundable Advance against royalties. The difference, if any, between the Advance and the Guaranteed Minimum Royalty shall be divided equally and paid quarterly over the term of this Agreement, commencing with the quarter beginning _____,19__.

B. The Nonrefundable Advance shall be paid on the signing of this agreement. No part of the Guaranteed Minimum Royalty or the Nonrefundable Advance shall be repayable to Licensee.

C. On signing of this Agreement, Licensee shall pay Licensor a nonrefundable design fee in the amount of $_____ per Design. This fee shall not be applied against royalties.

D. Licensor has the right to terminate this Agreement upon the giving of thirty (30) days' notice to Licensee if the Licensee fails to pay any portion of the Guaranteed Minimum Royalty when due.

5. Books and Records

Licensee agrees to keep complete and accurate books and records relating to the sale and other distribution of each of the Licensed Products. Licensor or its representative shall have the right to inspect Licensee's books and records relating to the sales of the Licensed Products upon thirty (30) days prior written notice. Any discrepancies over five percent (5%) between the royalties received and the royalties due will be subject to the royalty payment set forth herein and paid immediately. If the audit discloses such an underpayment of ten percent (10%) or more, Licensee shall reimburse the Licensor for all the costs of said audit.

6. Quality of Licensed Products, Approval, and Advertising

A. Licensee agrees that the Licensed Products shall be of the highest standard and quality and of such style and appearance as to be best suited to their exploitation to the best advantage and to the protection and enhancement of the Licensed Products and the good will pertaining thereto. The Licensed Products shall be manufactured, sold, and distributed in accordance with all applicable national, state, and local laws.

B. In order to insure that the development, manufacture, appearance, quality, and distribution of each Licensed Product is consonant with the Licensor's good will associated with its reputation, copyrights, and trademark, Licensor shall have the right to approve in advance the quality of the Licensed Products (including, without limitation, concepts and preliminary prototypes, mechanicals, or camera-ready art prior to production of first sample; production sample and revised production sample, if any) and all

packaging, advertising, literature, and displays for the Licensed Products.

C. Licensee shall be responsible for delivering all items requiring prior approval pursuant to Paragraph 6B without cost to the Licensor. Licensor agrees not to withhold approval unreasonably.

D. Licensee shall not release or distribute any Licensed Product without securing each of the prior approvals provided for in Paragraph 6B. Licensee shall not depart from any approval secured in accordance with Paragraph 6B without Licensor's prior written consent.

E. Licensee agrees to expend at least ____% percent of anticipated gross sales of the Licensed Products annually to promote and advertise sales of the Licensed Products.

7. Nonexclusive Rights

Nothing in this Agreement shall be construed to prevent Licensor from granting other licenses for the use of the Designs or from utilizing the Designs in any manner whatsoever, except that the Licensor shall not grant other Licenses for the use of the Designs in connection with the sale of the Licensed Products in the Territory to which this License extends during the term of this Agreement.

8. Nonacquisition of Rights

The Licensee's use of the Designs and Trademarks shall inure to the benefit of the Licensor. If Licensee acquires any trade rights, trademarks, equities, titles, or other rights in and to the Designs or in the Trademark, by operation of law, usage, or otherwise during the term of this Agreement or any extension thereof, Licensee shall forthwith upon the expiration of this Agreement or any extension thereof or sooner termination, assign and transfer the same to Licensor without any consideration other than the consideration of this Agreement.

9. Licensee's Representations

The License warrants and represents that during the term of this License and for any time thereafter, it, or any of its affiliated, associated, or subsidiary companies, will not copy, imitate, or authorize the imitation or copying of the Designs, Trade names, and Trademarks, or any distinctive feature of the foregoing or other designs submitted to the Licensee by Licensor. Without

prejudice to any other remedies the Licensor may have, royalties as provided herein shall accrue and be paid by Licensee on all items embodying and incorporating imitated or copied Designs.

10. Registrations and Infringements

A. The Licensor has the right but not the obligation to obtain, at its own cost, appropriate copyright, trademark, and patent protection for the Designs and the Trademarks. At Licensor's request and at Licensee's sole cost and expense, Licensee shall make all necessary and appropriate registrations to protect the copyrights, trademarks, and patents in and to the Licensed Products and the advertising, promotional, and packaging material in the Territory in which the Licensed Products are sold. Copies of all applications shall be submitted for approval to Licensor prior to filing. The Licensee and Licensor agree to cooperate with each other to assist in the filing of said registrations.

B. Licensee shall not at any time apply for or abet any third party to apply for copyright, trademark, or patent protection which would affect Licensor's ownership of any rights in the Designs or the Trademarks.

C. Licensee shall notify Licensor in writing immediately upon discovery of any infringements or imitations by others of the Designs, Trade names, or Trademarks. Licensor in its sole discretion may bring any suit, action, or proceeding Licensor deems appropriate to protect Licensor's rights in the Designs, Trade names, and Trademarks, including, without limitation, for copyright and trademark infringement and for unfair competition.

If for any reason, Licensor does not institute any such suit or take any such action or proceeding, upon written notice to the Licensee, Licensee may institute such appropriate suit, action, or proceeding in Licensee's and Licensor's names. In any event, Licensee and Licensor shall cooperate fully with each other in the prosecution of such suit, action, or proceeding. Licensor reserves the right, at Licensor's cost and expense, to join in any pending suit, action, or proceeding.

The instituting party shall pay all costs and expenses, including legal fees, incurred by the instituting party. All recoveries and awards, including settlements received, after payments of costs and legal fees,

shall be divided seventy-five percent (75%) to the instituting party and twenty-five percent (25%) to the other party.

11. Indemnification and Insurance

A. The Licensee hereby agrees to indemnify and hold the Licensor harmless against all liability, cost, loss, expense (including reasonable attorney's fees), or damages paid, incurred, or occasioned by any claim, demand, suit, settlement, or recovery against the Licensor, without limitation, arising out of the breach or claim of breach of this Agreement; the use of the Designs by it or any third party; the manufacture, distribution, and sale of the Licensed Products; and for any alleged defects in the Licensed Products. Licensee hereby consents to submit to the personal jurisdiction of any court, tribunal, or forum in which an action or proceeding is brought involving a claim to which this foregoing indemnification shall apply.

B. Licensee shall obtain at its sole cost and expense product liability insurance in an amount providing sufficient and adequate coverage, but not less than $1,000,000 combined single limit coverage protecting the Licensor against any claims or lawsuits arising from alleged defects in the Licensed Product.

12. Grounds for and Consequences of Termination

A. Licensor shall have the right to terminate this Agreement by written notice, and all the rights granted to the Licensee shall revert forthwith to the Licensor and all royalties or other payments shall become due and payable immediately if:

i. Licensee fails to comply with or fulfill any of the terms or conditions of this Agreement;

ii. the Licensed Products have not been offered or made available for sale by Licensee _____ months from the date hereof;

iii. Licensee ceases to manufacture and sell the Licensed Products in commercially reasonable quantities; or

iv. the Licensee is adjudicated a bankrupt, makes an assignment for the benefit of creditors, or liquidates its business.

B. Licensee, as quickly as possible, but in no event later than thirty (30) days after such termination, shall submit to Licensor the statements required in Paragraph 3 for all sales

and distributions through the date of termination. Licensor shall have the right to conduct an actual inventory on the date of termination or thereafter to verify the accuracy of said statements.

C. In the event of termination all payments theretofore made to the Licensor shall belong to the Licensor without prejudice to any other remedies the Licensor may have.

13. Sell-off Right

Provided Licensee is not in default of any term or condition of this Agreement, Licensee shall have the right for a period of _____ months from the expiration of this Agreement or any extension thereof to sell inventory on hand subject to the terms and conditions of this Agreement, including the payment of royalties and guaranteed minimum royalties on sales which continue during this additional period.

14. Purchase at Cost

A. Licensor shall have the right to purchase from Licensee, at Licensee's manufacturing cost, such number of Licensed Products as Licensor may specify in writing to Licensee, but not to exceed (_____) for any Licensed Product. For pur-

poses of this Paragraph, "manufacturing cost" shall mean $_____ per Licensed Product. Any amounts due to Licensee pursuant to this Paragraph shall not be deducted from any royalties, including any minimum royalties, owed to Licensor.

B. Licensee agrees to give the Licensor, without charge,_____ (_____) each of the Licensed Products.

15. Miscellaneous Provisions

A. Nothing herein shall be construed to constitute the parties hereto partners or joint venturers, nor shall any similar relationship be deemed to exist between them.

B. The rights herein granted are personal to the Licensee and shall not be transferred or assigned, in whole or in part, without the prior written consent of the Licensor.

C. No waiver of any condition or covenant of this Agreement by either party hereto shall be deemed to imply or constitute a further waiver by such party of the same or any other condition. This Agreement shall be binding upon and shall inure to the benefit of the parties, their successors, and assigns.

D. Whatever claim Licensor may

have against Licensee hereunder for royalties or for damages shall become a first lien upon all of the items produced under this Agreement in the possession or under the control of the Licensee upon the expiration or termination of this Agreement.

E. This Agreement shall be construed in accordance with the laws of _____.The Licensee hereby consents to submit to the personal jurisdiction of the _____Court, _____County, and Federal Court of the District of _____for all purposes in connection with this Agreement.

F. All notices and demands shall be sent in writing by certified mail, return receipt requested, at the addresses above first written; royalty statements, payments, and samples of Licensed Products and related materials shall be sent by regular mail.

G. This Agreement constitutes the entire agreement between the parties hereto and shall not be modified, amended, or changed in any way except by written agreement signed by both parties hereto. Licensee shall not assign this Agreement.

in witness whereof, the parties have executed this Licensing Agreement on the day of_____, 19__

licensee (company name) _____

by (name, position) _____

licensor _____

Magazine Purchase Order for Commissioned Illustration

F R O N T :

Magazine's Letterhead

This letter is to serve as our contract for you to create certain illustrations for us under the terms described herein.

1. **Job Description**
 We, the Magazine, retain you, the Illustrator, to create_____ Illustration(s) described as follows (indicate if sketches are required):

 to be delivered to the Magazine by _____, 199___ , for publication in our magazine titled

2. **Grant of Rights**
 The Illustrator hereby agrees to transfer to the Magazine first North American magazine rights in the illustration(s). All rights not expressly transferred to the Magazine hereunder are reserved to the Illustrator.

3. **Price**
 The Magazine agrees to pay the Illustrator the following purchase price: $_____ in full consideration for the Illustrator's grant of rights to the Magazine. Any transfer of rights is conditional upon receipt of full payment.

4. **Changes**
 The Illustrator shall be given the first option to make any changes in the work that the Magazine may deem necessary. However, no additional compensation shall be paid unless such changes are necessitated by error on the Magazine's part, in which case a new contract between us shall be entered into on mutually agreeable terms to cover changes to be done by the Illustrator.

5. **Cancellation**
 If, prior to the Illustrator's completion of finishes, the Magazine cancels the assignment, either because the illustrations are unsatisfactory to the Magazine or for any other reason, the Magazine agrees to pay the Illustrator a cancellation fee of fifty percent (50%) of the purchase price. If, after the Illustrator's completion of finishes, the Magazine cancels the assignment, the Magazine agrees to pay fifty percent (50%) of the purchase price if cancellation is due to the illustrations not being reasonably satisfactory and one hundred percent (100%) of the purchase price if cancellation is due to any other cause. In the event of cancellation, the Illustrator shall retain ownership of all artwork and rights of copyright, but the Illustrator agrees to show the Magazine the artwork if the Magazine so requests so that the Magazine may make its own evaluation as to the degree of completion of the artwork.

6. **Copyright Notice and Authorship Credit**
 Copyright notice shall appear in the Illustrator's name with the contribution. The Illustrator shall have the right to receive authorship credit for the illustration and to have such credit removed if the Illustrator so desires due to changes made by the Magazine that are unsatisfactory to the Illustrator.

7. **Payments**
 Payment shall be made within thirty (30) days of the billing date.

8. **Ownership of Artwork**
 The Illustrator shall retain ownership of all original artwork and the Magazine shall return such artwork within thirty (30) days of publication.

9. **Acceptance of Terms**
 To constitute this a binding agreement between us, please sign both copies of this letter beneath the words "consented and agreed to" and return one copy to the Magazine for its files.

consented and agreed to

date _____

artist's signature _____

magazine _____

authorized signature _____

name and title _____

Multimedia Job Order Form

*This job order form is a sample of a possible contract for digital media development. Since the field is so new,
artists should view this as a model and amend it to fit their particular circumstances.*

Developers's Letterhead

TO

Date _____

Commissioned By _____

Purchase Order Number _____

Job Number _____

DESCRIPTION OF ASSIGNMENT:

Primary Use: _____

Additional Uses: _____

Number of Screens or Images Still Frame _____ *(single frame, multiple frame)*

Sector Length Per Screen: _____ Maximum Preferred: _____ Minimum: _____

DESCRIPTION OF MATERIALS TO BE SUPPLIED BY CLIENT:

DATE DUE:

Disk(s) can be used only for the purposes stated below. All other use(s) and modification(s) is (are) prohibited. Disk(s) may not be copied without the Developer's permission and must be returned after use.

RIGHTS TRANSFERRED:

Any transfer of rights is conditional upon receipt of full payment.

DISTRIBUTION/GEOGRAPHICAL AREA:

SYSTEM APPLICATIONS (FOR USE ON SPECIFIC MACHINE OR COMPILED INTO OTHER OPERATION LANGUAGES):

PRODUCTION SCHEDULE (INCLUDING MILESTONES, DATES DUE, AND APPROPRIATE FEES):

Contract Signing _____ $ _____

Delivery of Website Design _____ $ _____

Delivery of Beta Version _____ $ _____

Delivery of Final Version _____ $ _____
(includes return of source materials to Client)

Acceptance of Final Version _____ $ _____

Total _____ $ _____

Bonus: Client agrees to pay Developer a bonus of _____ payable to the Developer in the event an acceptable Final Version of the Website is delivered to the Client prior to _____ (date).

TERMS:

1. Time for Payment

Each milestone is payable upon the Client's acceptance of the deliverables. All invoices are payable within thirty (30) days of receipt. A 1½% monthly service charge is payable on all overdue balances. The grant of any license or right of copyright is conditioned on receipt of full payment.

2. Default in Payment

The Client shall assume responsibility for all collection of legal fees necessitated by default in payment.

3. Estimates

If this form is used for an estimate or assignment confirmation, the fees and expenses shown are minimum estimates only. Final fees and expenses shall be shown when invoice is rendered. The Client's approval shall be obtained for any increases in fees or expenses that exceed the original estimate by ten percent (10%) or more.

4. Expenses

The Client shall reimburse the Developer for all expenses arising from this assignment, including the payment of any sales taxes due on this assignment, and shall advance $_____ to the Developer for payment of said expenses.

5. Progress Reports

The Developer shall contact or meet with the Client on a mutually acceptable schedule to report all tasks completed, problems encountered, and recommended changes relating to the development and testing of the digital media. The Developer shall inform the Client promptly by telephone upon discovery of any event or problem that may significantly delay the development of the work.

6. Developer's Guarantee for Program Use

The Developer guarantees to notify the Client of any licensing and/or permissions required for art generating/driving programs to be used.

7. Changes

The Client shall be responsible for making additional payments for changes in original assignment requested by the Client. However, no additional payment shall be made for changes required to conform to the original assignment description. The Client shall offer the Developer the first opportunity to make any changes.

8. Testing and Acceptance Procedures

The Developer will make every good faith effort to test all deliverables thoroughly and make all necessary corrections as a result of such testing prior to handing over the deliverables to the Client. Upon receipt of the deliverables, the Client shall either accept the deliverable and make the milestone payment set forth herein or provide the Developer with written notice of any corrections to be made and a suggested date for completion which should be mutually acceptable to both the Developer and the Client. The Developer shall designate *(name)* and the Client shall designate *(name)* as the only designated persons who will send and accept all deliverables and receive and make all communications between the Developer and the Client. Neither party shall have any obligation to consider for approval or respond to materials submitted other than through the designated persons listed above. Each party has the right to change its designated person upon _____ days notice to the other.

9. Enhancements

If the Client wishes to modify the digital media, the Developer shall be given first option to provide a bid to perform such enhancements.

10. Confidential Information

The Developer acknowledges and agrees that the source materials and technical and marketing plans or other sensitive business information, including all materials containing said information, which are supplied by the Client to the Developer or developed by the Developer in the course of developing the digital media are to be considered confidential information. Information shall not be considered confidential if it is already publicly known through no act of the Developer.

11. Return of Source Information

Upon the Client's acceptance of the Golden Master, or upon the cancellation of the project, the Developer shall provide the Client with all copies and originals of the source materials provided to the Developer.

12. Ownership of Copyright

Client acknowledges and agrees that Developer retains all rights to copyright in the subject material.

13. Ownership and Return of Artwork

The Developer retains ownership of all original artwork, in any media, including digital files, whether preliminary or final. The Client waives the right to challenge the validity of the Developer's ownership of the art subject to this agreement because of any change or evolution of the law and will return all artwork within thirty (30) days of use.

14. Cancellation

In the event of cancellation of this assignment, ownership of all copyrights and any original artwork shall be retained by the Developer, and a cancellation fee for work completed, based on the prorated portion of the next payment and expenses already incurred, shall be paid by the Client.

15. Ownership of Engine

The Developer retains ownership of all engines used in the production of the product unless those engines are provided by the Client.

16. Copy-Protection

The Client must copy-protect all final art which is the subject of this agreement against duplication or alteration.

17. Credit Lines

The Developer shall be given credit on: (a) floppy disk, (b) documentation, (c) packaging, (d) Developer's mark on art.

☐ If this box is checked, the Developer shall receive copyright notice in this form:

© 199__ _____.

18. Alterations

Any electronic alteration of original art (color shift, mirroring, flopping, combination cut and paste, deletion) creating additional art is prohibited without the express permission of the Developer. The Developer will be given first opportunity to make any alterations required. Unauthorized alterations shall constitute additional use and will be billed accordingly.

19. Other Operating Systems Conversions

The Developer shall be given first option at compiling the work for operating systems beyond the original use.

20. Unauthorized Use and Program Licenses

The Client will indemnify the Developer against all claims and expenses arising from uses for which the Client does not have rights to or authority to use. The Client will be responsible for payment of any special licensing or royalty fees resulting from the use of graphics programs that require such payments.

21. Warranty of Originality

The Developer warrants and represents that, to the best of his/her knowledge, the work assigned hereunder is original and has not been previously published, or that consent to use has been obtained on an unlimited basis; that all work or portions thereof obtained through the undersigned from third parties is original or, if previously published, that consent to use has been obtained on an unlimited basis; that the Developer has full authority to make this agreement; and that the work prepared by the Developer does not contain any scandalous, libelous, or unlawful matter. This warranty does not extend to any uses that the Client or others may make of the Developer's product which may infringe on the rights of others. Client expressly agrees that it will hold the Developer harmless for all liability caused by the Client's use of the Developer's product to the extent such use infringes on the rights of others.

22. Limitation of Liability

Client agrees that it shall not hold the Developer or his/her agents or employees liable for any incidental or consequential damages which arise from the Developer's failure to perform any aspect of the Project in a timely manner, regardless of whether such failure was caused by intentional or negligent acts or omissions of the Developer or a third party. Furthermore, the Developer disclaims all implied warranties, including the warranty of merchantability and fitness for a particular use.

23. Dispute Resolution

Any disputes in excess of $_____ (maximum limit for small claims court) arising out of this Agreement shall be submitted to binding arbitration before the Joint Ethics Committee or a mutually agreed upon arbitrator pursuant to the rules of the American Arbitration Association. The Arbitrator's award shall be final, and judgment may be entered in any court having jurisdiction thereof. The Client shall pay all arbitration and court costs, reasonable attorney's fees, and legal interest on any award of judgment in favor of the Developer.

23. Acceptance of Terms

The signature of both parties shall evidence acceptance of these terms.

consented and agreed to

date _____

developer's signature _____

authorized signature _____

client's name and title _____

Nondisclosure Agreement for Submitting Ideas

FRONT:

Illustrator's or Designer's Letterhead

Agreement, entered into as of this _____day of_____, 19___, between

(hereinafter referred to as the "Illustrator" or "Designer"), located at:

and _____
(hereinafter referred to as the "Recipient"), located at.

Whereas, the Illustrator (or Designer) has developed certain valuable information, concepts, ideas, or designs, which the Illustrator (or Designer) deems confidential (hereinafter referred to as the "Information"); and
Whereas, the Recipient is in the business of using such Information for its projects and wishes to review the Information; and
Whereas, the Illustrator (or Designer) wishes to disclose this Information to the Recipient; and
Whereas, the Recipient is willing not to disclose this Information, as provided in this Agreement.
Now, therefore, in consideration of the foregoing premises and the mutual covenants hereinafter set forth and other valuable considerations, the parties hereto agree as follows:

1. **Disclosure**
Illustrator (or Designer) shall disclose to the Recipient the Information, which concerns:

2. **Purpose**
Recipient agrees that this disclosure is only for the purpose of the Recipient's evaluation to determine its interest in the commercial exploitation of the Information.

3. **Limitation on Use**
Recipient agrees not to manufacture, sell, deal in, or otherwise use or appropriate the disclosed Information in any way whatsoever, including but not limited to adaptation, imitation, redesign, or modification. Nothing contained in this Agreement shall be deemed to give Recipient any rights whatsoever in and to the Information.

4. **Confidentiality**
Recipient understands and agrees that the unauthorized disclosure of the Information by the Recipient to others would damage the Illustrator (or Designer) irreparably. As consideration and in return for the disclosure of this Information, the Recipient shall keep secret and hold in confidence all such Information and treat the Information as if it were the Recipient's own property by not disclosing it to any person or entity.

5. **Good Faith Negotiations**
If, on the basis of the evaluation of the Information, Recipient wishes to pursue the exploitation thereof, Recipient agrees to enter into good faith negotiations to arrive at a mutually satisfactory agreement for these purposes. Until and unless such an agreement is entered into, this nondisclosure Agreement shall remain in force.

6. **Miscellany**
This Agreement shall be binding upon and shall inure to the benefit of the parties and their respective legal representatives, successors, and assigns.

© Tad Crawford 1990

in witness whereof, the parties have signed this Agreement as of the date first set forth above.

illustrator (or designer) _____

recipient _____

company name _____

by _____

authorized signatory, title _____

Surface/Textile Designer–Agent Agreement

Introduction

The Surface/Textile Designer–Agent Agreement seeks to clarify Designer–Agent relationships by providing a written understanding to which both parties can refer. Its terms can be modified to meet the special needs of either Designer or Agent. The Agreement has been drafted with a minimum of legal jargon, but this in no way changes its legal validity.

The Agreement balances the needs of both Designer and Agent. The agency in Paragraph 1 is limited to a particular market. In the market the Agent has exclusive rights to act as an agent, but the Designer remains free to sell in that market also, except to accounts secured by the Agent. Because both Agent and Designer will be selling in the same market, the Designer may want to provide the Agent with a list of clients previously obtained by the Designer and keep this list up-to-date.

If the Agent desires greater exclusivity, such as covering more markets, the Designer may want to require that the Agent exercise best efforts (although it is difficult to prove best efforts have not been exercised) and perhaps promise a minimum level of sales. If the level is not met, the Agreement would terminate.

Paragraph 2 seeks to protect the Designer against loss or damage to his or her artwork, in part by requiring the Agent to execute with the client contracts that protect the designs.

Paragraph 3 sets forth the duration of the Agreement. A short term is usually wise, since a Designer and Agent who are working well together can simply extend the term by mutual agreement in order to continue their relationship. Also, as time goes on, the Designer may be in a better position to negotiate with the Agent. The term of the Agreement has less importance, however, when either party can terminate the agency relationship on thirty (30) days' notice, as Paragraph 10 provides.

The minimum base prices in Paragraph 4 ensure the Designer of a minimum remuneration. Flexibility in pricing requires that the Designer and Agent consult one another in those cases in which a particular sale justifies a price higher than the base price. The Designer can suggest that the Agent follow the *Graphic Artists Guild Pricing & Ethical Guidelines* to establish the minimum base price.

The Agent's rate of commission in Paragraph 5 is left blank so the parties can establish an acceptable rate. If the Designer is not paid for doing an assignment, the Agent will have no right to receive a commission. Nor are commissions payable on the amount of expenses incurred by the Designer for work done on assignment. Discounts given by the Agent on volume sales of the work of many designers shall be paid out of the Agent's commission.

Paragraph 6 covers the Agent's obligations when commissioned work is obtained for the Designer. Of particular importance are the terms of the order form secured by the Agent from the client. The Agent should use the order form developed by the Graphic Artists Guild or a form incorporating similar terms.

Holding of designs by clients can present a problem which Paragraph 7 seeks to resolve by establishing a minimum holding time of five working days. Again, the Agent should use the holding form developed by the Graphic Artists Guild or a form with similar terms.

In Paragraph 8 the Agent assumes responsibility for billing and pursuing payments which are not made promptly. The reason for keeping any single billing under the maximum allowed for suit in small claims court is to make it easier to collect if a lawsuit is necessary. The Agent should use the invoice form of the Graphic Artists Guild or a form with similar provisions.

Paragraph 9 allows the Designer to inspect the Agent's books to ensure that proper payments are being made.

Termination is permitted on giving thirty (30) days written notice to the other party. Paragraph 10 distinguishes between sales made or assignments obtained prior to termination (on which the Agent must be paid a commission, even if the work is executed and payment received after the termination date) and those after termination (on which no commission is payable). Within thirty (30) days of notice of termination, all designs must be returned to the Designer.

Paragraph 11 provides that the Agreement cannot be assigned by either party, since the relationship between Designer and Agent is a personal one.

In Paragraph 12, arbitration is provided for disputes in excess of the maximum limit for suits in small claims court. For amounts within the small claims court limit, it is probably easier to simply sue rather than seek arbitration.

The manner of giving notice to the parties is described in Paragraph 13.

Paragraph 14 affirms that both Designer and Agent are independent contractors, which avoids certain tax and liability issues that might arise from the other legal relationships mentioned.

This Agreement is the entire understanding of the parties and can only be amended in writing. In stating this, Paragraph 15 points out a general rule that a written contract should always be amended in writing that is signed by both parties.

Paragraph 16 leaves room for the parties to add in any optional provisions that they consider necessary. Some of the optional provisions that might be agreed to appear below.

Paragraph 17 sets forth the state whose law will govern the Agreement. This is usually the law of the state in which both parties reside or, if one party is out of state, in which the bulk of the business will be transacted.

Finally, Paragraph 18 defines what constitutes acceptance of the contract terms.

Optional provisions

Additional provisions could be used to govern certain aspects of the Designer-Agent relationship. Such provisions might include:

♦ The scope of the agency set forth in Paragraph 1 is limited to the following geographic area:_____

♦ Despite any provisions of Paragraph 1 to the contrary, this agency shall be nonexclusive and the Designer shall have the right to use other Agents without any obligation to pay commissions under this Agreement.

♦ The Agent agrees to represent no more than *(number)* designers.

♦ The Agent agrees not to represent conflicting hands, such hands being designers who work in a similar style to that of the Designer.

♦ The Agent agrees to have no designers as salaried employees.

♦ The Agent agrees not to sell designs from his or her own collection of designs while representing the Designer.

♦ The Agent agrees to employ *(number)* full-time and *(number)* part-time sales people.

♦ The Agent agrees that the Designer's name shall appear on all artwork by the Designer that is included in the Agent's portfolio.

♦ The Agent agrees to seek royalties for the Designer in the following situations:

♦ The Agent agrees to hold all funds due to the Designer as trust funds in an account separate from funds of the Agent prior to making payment to the Designer pursuant to Paragraph 8 hereof.

♦ The Agent agrees to enter into a written contract with each client that shall include the following provision:

Credit line for designer: The designer shall have the right to receive authorship credit for his or her design and to have such credit removed in the event changes made by the client are unsatisfactory to the designer. Such authorship credit shall appear as follows on the selvage of the fabric:

☐ If this box is checked, such authorship credit shall also accompany any advertising for the fabric:

Copyright notice for designer: Copyright notice shall appear in the Designer's name on the selvage of the fabric, the form of notice being as follows:

© 199 __ _____.

The placement and affixation of the notice shall comply with the regulations issued by the Register of Copyrights. The grant of rights in this design is expressly conditioned on copyright notice appearing in the Designer's name.

☐ If this box is checked, such copyright notice shall also accompany any advertising for the fabric.

Surface/Textile Designer-Agent Agreement

Agreement, this_____day of_____, 19__, between

(hereinafter referred to as the "Designer"), residing at:

and_____
(hereinafter referred to as the "Agent"), residing at:

Whereas, the Designer is a professional surface/textile designer; and
Whereas, the Designer wishes to have an Agent represent him or her in marketing certain rights enumerated herein; and
Whereas, the Agent is capable of marketing the artwork produced by the Designer; and
Whereas, the Agent wishes to represent the Designer;
Now, therefore, in consideration of the foregoing premises and the mutual covenants hereinafter set forth and other valuable consideration, the parties hereto agree as follows:

1. **Agency**
 The Designer appoints the Agent to act as his or her representative for:
 ☐ Sale of surface/textile designs in apparel market,
 ☐ Sale of surface/textile designs in home furnishing market,
 ☐ Securing of service work in apparel market. Service work is defined to include repeats and colorings on designs originated by the Designer or other designers,
 ☐ Securing of service work in home furnishing market
 ☐ Other

 The Agent agrees to use his or her best efforts in submitting the Designer's artwork for the purpose of making sales or securing assignments for the Designer. For the purposes of this Agreement, the term artwork shall be defined to include designs, repeats, colorings, and any other product of the Designer's effort. The Agent shall negotiate the terms of any assignment that is offered, but the Designer shall have the right to reject any assignment if he or she finds the terms unacceptable. Nothing contained herein shall

prevent the Designer from making sales or securing work for his or her own account without liability for commissions except for accounts which have been secured for the Designer by the Agent. This limitation extends only for the period of time that the Agent represents the Designer. Further, the Designer agrees, when selling his or her artwork or taking orders, not to accept a price which is below the price structure of his or her Agent.

 After a period of_____ months, the Designer may remove his or her unsold artwork from the Agent's portfolio to do with as the Designer wishes.

2. **Artwork and Risk of Loss, Theft, or Damage**
 All artwork submitted to the Agent for sale or for the purpose of securing work shall remain the property of the Designer. The Agent shall issue a receipt to the Designer for all artwork which the Designer submits to the Agent. If artwork is lost, stolen, or damaged while in the Agent's possession due to the Agent's failure to exercise reasonable care, the Agent will be held liable for the value of the artwork. Proof of any loss, theft, or damage must be furnished by the Agent to the Designer upon request. When selling artwork, taking an order, or allowing a client to hold artwork for consideration, the Agent agrees to use invoice, order, or holding forms which provide that the client is responsible for loss, theft, or damage to artwork while being held by the client, and to require the client's signature on such forms. The Agent agrees to enforce these provisions, including taking legal action as necessary. If the Agent undertakes legal action, any recovery shall first be used to reimburse the amount of attorney's fees and other expenses incurred and the balance of the recovery shall be divided between Agent and Designer in the respective percentages set forth in Paragraph 5. If the Agent chooses not to require the client to be responsible as described herein, then the Agent agrees to assume these responsibilities. If the Agent receives insurance proceeds due to loss, theft, or damage of artwork while in the Agent's or client's possession, the Designer shall receive no less than that portion of the proceeds that have been paid for the Designer's artwork.

3. **Term**
 This Agreement shall take effect on the_____day of_____,19____, and remain in full force and effect for a term of one year, unless terminated as provided in Paragraph 10.

4. **Prices**
 At this time the minimum base prices charged to clients by the Agent are as follows:

 Sketch
 (apparel market): _____

 Repeat
 (apparel market): _____

 Colorings
 (apparel market): _____

 Sketch
 (home furnishing market):_____

 Repeat
 (home furnishing market):_____

 Colorings
 (home furnishing market):_____

 Other: _____

 The Agent agrees that these prices are minimum prices only and shall be increased whenever possible (i.e., when the work is a rush job or becomes larger or more complicated than is usual). The Agent also agrees to try to raise the base price to keep pace with the rate of inflation.

 The Agent shall obtain the Designer's written consent prior to entering into any contract for payment by royalty.

 No discounts shall be offered to clients by the Agent without first consulting the Designer.

 When leaving a design with the Agent for possible sale, the Designer shall agree with the Agent as to the price to be charged if the design should bring more than the Agent's base price.

5. **Agent's Commissions**
 The rate of commission for all artwork shall be_____. It is mutually agreed by both parties that no commissions shall be paid on assignments rejected by the Designer or for which the Designer does not receive payment, regardless of the reasons payment is not made.

 On commissioned originals and service work, expenses incurred in the execution of a job, such as photostats, shipping, etc., shall be billed to the client in addition to the fee. No Agent's commission shall be

TERMS:

paid on these amounts. In the event that a flat fee is paid by the client, it shall be reduced by the amount of expenses incurred by the Designer in performing the assignment, and the Agent's commission shall be payable only on the fee as reduced for expenses. It is mutually agreed that if the Agent offers a client a discount on a large group of designs including work of other designers, then that discount will come out of the Agent's commission since the Agent is the party who benefits from this volume.

6. Commissioned Work

Commissioned work refers to all artwork done on a nonspeculative basis. The Agent shall provide the Designer with a copy of the completed order form which the client has signed. The order form shall set forth the responsibilities of the client in ordering and purchasing artwork. To this the Agent shall add the date by which the artwork must be completed and any additional instructions which the Agent feels are necessary to complete the job to the client's satisfaction. The Agent will sign these instructions. Any changes in the original instructions must be in writing, signed by the Agent, and contain a revised completion date.

It is mutually agreed that all commissioned work generated by the Designer's work shall be offered first to the Designer. The Designer has the right to refuse such work.

The Agent agrees to use the order confirmation form of the Graphic Artists Guild, or a form that protects the interests of the Designer in the same manner as that form. The order form shall provide that the Designer will be paid for all changes of original instructions arising through no fault of the Designer. The order form shall also provide that if a job is canceled through no fault of the Designer, a labor fee shall be paid by the client based on the amount of work already done and the artwork will remain the property of the Designer. In a case in which the job being canceled is based on artwork which belongs to the client, such as a repeat or coloring, a labor fee will be charged as outlined above and the artwork will be destroyed. If the artwork is already completed in a satisfactory manner at the time the job is canceled, the client must pay the full fee.

7. Holding Policy

In the event that a client wishes to hold the Designer's work for consideration, the Agent shall establish a maximum holding time with the client. This holding time shall not exceed five (5) working days. Any other arrangements must first be discussed with the Designer.

The Agent agrees to use the holding form of the Graphic Artists Guild, or a form that protects the interests of the Designer in the same manner as that form. All holding forms shall be available for the Designer to see at any time.

8. Billings and Payments

The Agent shall be responsible for all billings. The Agent agrees to use the invoice form of the Graphic Artists Guild, or a form that protects the interests of the Designer in the same manner as that form. The Agent agrees to provide the Designer with a copy of all bills to clients pertaining to the work of the Designer. The Designer will provide the Agent with a bill for his or her work for the particular job. The Designer's bill shall be paid by the Agent within one (1) week after the delivery of artwork or, if the Agent finds it necessary, within ten (10) working days after receipt of payment from the client. The terms of all bills issued by the Agent shall require payment within thirty (30) calendar days or less. If the client does not pay within that time, the Agent must pursue payment immediately and, upon request, inform the Designer that this has been done. The Agent agrees to take all necessary steps to collect payment, including taking legal action if necessary. If either the Agent or Designer undertakes legal action, any recovery shall first be used to reimburse the amount of attorney's fees and other expenses incurred and the balance of the recovery shall be divided between the Agent and Designer in the respective percentages set forth in Paragraph 5. The Agent agrees, whenever possible, to bill in such a way that no single bill exceeds the maximum that can be sued for in small claims court.

Under no circumstances shall the Agent withhold payment to the Designer after the Agent has been paid. Late payments by the Agent to the Designer shall be accompanied by interest calculated at the rate of 1 ½% monthly.

9. Inspection of the Books and Records

The Designer shall have the right to inspect the Agent's books and records with respect to proceeds due the Designer. The Agent shall keep the books and records at the Agent's place of business and the Designer may make such inspection during normal business hours on the giving of reasonable notice.

10. Termination

This Agreement may be terminated by either party by giving thirty (30) days written notice by registered mail to the other party. All artwork executed by the Designer not sold by the Agent must be returned to the Designer within these thirty (30) days. In the event of termination, the Agent shall receive commissions for all sales made or assignments obtained by the Agent prior to the termination date, regardless of when payment is received. No commissions shall be payable for sales made or assignments obtained by the Designer after the termination date.

11. Assignment

This Agreement shall not be assigned by either of the parties hereto. It shall be binding on and inure to the benefit of the successors, administrators, executors, or heirs of the Agent and Designer.

12. Dispute Resolution

Any disputes in excess of $_____ (maximum limit for small claims court) arising out of this Agreement shall be submitted to binding arbitration before the Joint Ethics Committee or a mutually agreed upon arbitrator pursuant to the rules of the American Arbitration Association. The Arbitrator's award shall be final and judgment may be entered in any court having jurisdiction thereof. The Agent shall pay all arbitration and court costs, reasonable attorney's fees, and legal interest on any award of judgment in favor of the Designer.

13. Notices

All notices shall be given to the parties at their respective addresses set forth above.

TERMS:

14. Independent Contractor Status
Both parties agree that the Agent is acting as an independent contractor. This Agreement is not an employment agreement, nor does it constitute a joint venture or partnership between the Designer and Agent.

15. Amendments and Merger
All amendments to this Agreement must be written. This Agreement incorporates the entire understanding of the parties.

16. Other Provisions

17. Governing Law
This Agreement shall be governed by the laws of the State of

_____.

18. Acceptance of Terms
The signature of both parties shall evidence acceptance of these terms.

In witness whereof, the parties have signed this Agreement as of the date set forth above.

designer _____

agent _____

Surface/Textile Designer's Estimate and Confirmation Form

FRONT:

Designer's Letterhead

TO

Date

Pattern Number

Due Date

ESTIMATED PRICES

Sketch

Repeat

Colorings

Corners

Tracings

Other

DESCRIPTION OF ARTWORK

Repeat

Size

Colors

Type of Printing

½ Drop ☐Yes ☐No

SPECIAL COMMENTS

TERMS:

1. **Time for Payment**
Because the major portion of the above work represents labor, all invoices are payable fifteen (15) days net. A 1 ½% monthly service charge is payable on all unpaid balances after this period. The grant of textile usage rights is conditioned on receipt of payment.

2. **Default of Payment**
The Client shall assume responsibility for all collection of legal fees necessitated by default in payment.

3. **Estimated Prices**
Prices shown above are minimum estimates only. Final prices shall be shown in invoice.

4. **Payment for Changes**
Client shall be responsible for making additional payments for changes requested by Client in original assignment.

5. **Expenses**
Client shall be responsible for payment of all extra expenses rising from assignment, including but not limited to photostats, mailings, messengers, shipping charges, and shipping insurance.

6. **Sales Tax**
Client shall assume responsibility for all sales taxes due on this assignment.

7. **Cancellation Fees**
Work canceled by the client while in progress shall be compensated for on the basis of work completed at the time of cancellation and assumes that the Designer retains the project whatever its stage of completion. Upon cancellation, all rights, publication and other, revert to the Designer. Where Designer creates corners which are not developed into purchased sketches, a labor fee will be charged, and ownership of all copyrights and artwork is retained by the Designer.

8. **Insuring Artwork**
The client agrees when shipping artwork to provide insurance covering the fair market value of the artwork.

9. **Uniform Commercial Code**
The above terms incorporate Article 2 of the Uniform Commercial Code.

10. **Warranty of Originality**
The Designer warrants and represents that to the best of his/her knowledge, the work assigned hereunder is original and has not been previously published, or that consent to use has been obtained on an unlimited basis; that all work or portions thereof obtained through the undersigned from third parties is original or, if previously published, that consent to use has been obtained on an unlimited basis; that the Designer has full authority to make this agreement; and that the work prepared by the Designer does not contain any scandalous, libelous, or unlawful matter. This warranty does not extend to any uses that the Client or others may make of the Designer's product which may infringe on the rights of others. Client expressly agrees that it will hold the Designer harmless for all liability caused by the Client's use of the Designer's product to the extent such use infringes on the rights of others.

11. **Limitation of Liability**
Client agrees that it shall not hold the Designer or his/her agents or employees liable for any incidental or consequential damages which arise from the Designer's failure to perform any aspect of the Project in a timely manner, regardless of whether such failure was caused by intentional or negligent acts or omissions of the Designer or a third party.

12. **Dispute Resolution**
Any disputes in excess of $_____ (maximum limit for small claims court) arising out of this Agreement shall be submitted to binding arbitration before the Joint Ethics Committee or a mutually agreed upon arbitrator pursuant to the rules of the American Arbitration Association. The Arbitrator's award shall be final, and judgment may be entered in any court having jurisdiction thereof. The Client shall pay all arbitration and court costs, reasonable attorney's fees, and legal interest on any award of judgment in favor of the Surface/Textile Designer.

13. **Acceptance of Terms**
The signature of both parties shall evidence acceptance of these terms.

consented and agreed to

designer's signature _____

authorized signature _____

client's name and title _____

Surface/Textile Designer's Holding Form

··

F R O N T :

Designer's Letterhead

TO

Date

Pattern Number

NUMBER OF DESIGNS HELD

Design

Sketch

Number of Designs Held

Design

Sketch

Number of Designs Held

Design

Sketch

Number of Designs Held

Design

Sketch

Number of Designs Held

Design

Sketch

Number of Designs Held

Design

Sketch

Number of Designs Held

Design

Sketch

Number of Designs Held

Design

Sketch

Number of Designs Held

Design

Sketch

Number of Designs Held

Design

Sketch

Number of Designs Held

Design

Sketch

Number of Designs Held

Design

Sketch

Number of Designs Held

Design

Sketch

Number of Designs Held

TERMS:

The submitted designs are original and protected under the copyright laws of the United States, Title 17 United States Code. These designs are submitted to you in confidence and on the following terms:

1. **Ownership and Copyrights**
 You agree not to copy, photograph, or modify directly or indirectly any of the materials held by you, nor permit any third party to do any of the foregoing. All artwork, photographs, and photostats developed from these designs, including the copyrights therein, remain my property and must be returned to me unless the designs are purchased by you. Any transfer of rights is conditional upon receipt of full payment.

2. **Responsibility for Artwork**
 You agree to assume responsibility for loss, theft, or any damage to the designs while they are being held by you. It is agreed that the fair market value for each design is the price specified above.

3. **Holding of Artwork**
 You agree to hold these designs for a period not to exceed_____working days from the above date. Any holding of artwork beyond that period shall constitute a binding sale at the price specified above. You further agree not to allow any third party to hold designs unless specifically approved by me.

4. **Dispute Resolution**
 Any disputes in excess of $_____ (maximum limit for small claims court) arising out of this Agreement shall be submitted to binding arbitration before the Joint Ethics Committee or a mutually agreed upon arbitrator pursuant to the rules of the American Arbitration Association. The Arbitrator's award shall be final, and judgment may be entered in any court having jurisdiction thereof. The party holding the designs shall pay all arbitration and court costs, reasonable attorney's fees, and legal interest on any award of judgment in favor of the Surface/Textile Designer.

5. **Uniform Commercial Code**
 The above terms incorporate Article 2 of the Uniform Commercial Code.

6. **Acceptance of Terms**
 The signature of both parties shall evidence acceptance of these terms.

consented and agreed to

date _____

designer's signature _____

authorized signature _____

client's name and title _____

Surface/Textile Designer's Invoice

F R O N T :

Designer's Letterhead

TO

Date

Invoice Number

Purchase Order Number

Stylist

Designer

DESCRIPTION

Pattern Number

Price

Subtotal

ITEMIZED EXPENSES

Subtotal

Sales Tax

Payments on Account

Balance Due

TERMS:

1. **Receipt of Artwork**
 Client acknowledges receipt of the artwork specified above.

2. **Time for Payment**
 Because the major portion of the above work represents labor, all invoices are payable fifteen (15) days net. The grant of textile usage rights is conditioned on receipt of payment. A 1 ½% monthly service charge is payable on unpaid balance after expiration of period for payment.

3. **Default in Payment**
 The Client shall assume responsibility for all collection of legal fees necessitated by default in payment.

4. **Adjustments to Invoice**
 Client agrees to request any adjustments of accounts, terms, or other invoice data within ten (10) days of receipt of the invoice.

5. **Uniform Commercial Code**
 These terms incorporate Article 2 of the Uniform Commercial Code.

6. **Dispute Resolution**
 Any disputes in excess of $_____ (maximum limit for small claims court) arising out of this Agreement shall be submitted to binding arbitration before the Joint Ethics Committee or a mutually agreed upon arbitrator pursuant to the rules of the American

Arbitration Association. The Arbitrator's award shall be final, and judgment may be entered in any court having jurisdiction thereof. The Client shall pay all arbitration and court costs, reasonable attorney's fees, and legal interest on any award of judgment in favor of the Designer.

7. **Acceptance of Terms**
 The signature of both parties shall evidence acceptance of these terms.

consented and agreed to

date _____

designer's signature _____

authorized signature _____

client's name and title _____

Website Design and Maintenance Order Form

F R O N T :

This job order form is a sample of a possible contract for Website development and maintenance. Since the field is so new, artists should view this as a model and amend it to fit their particular circumstances.

Developer's Letterhead

TO

Date _____

Commissioned By _____

Purchase Order Number _____

Job Number _____

DESCRIPTION OF ASSIGNMENT:

Primary Use: _____

Additional Uses: _____

Number of Individual Screen Pages (if the page is a frame page, the number of frames per page): _____

Pixel Length Per Screen: _____ Maximum Preferred: _____ Minimum: _____

DESCRIPTION OF MATERIALS TO BE SUPPLIED BY CLIENT:

DATE DUE:

RIGHTS TRANSFERRED:

The material on the disk can be used only for the purposes stated below. All other use(s) and modification(s) is (are) prohibited. The material on the disk may not be copied without the Developer's permission and must be returned after use.

Any transfer of rights is conditional upon receipt of full payment.

SYSTEM APPLICATIONS:

(for use on specific machine or compiled into other operation languages)

PRODUCTION SCHEDULE (INCLUDING MILESTONES, DATES DUE, AND APPROPRIATE FEES)

Milestone	Due Date	Payment Upon Acceptance
Contract Signing	_____	$ _____
Delivery of Website Design	_____	$ _____
Delivery of Beta Version	_____	$ _____
Delivery of Final Version (includes return of source materials to Client)	_____	$ _____
Acceptance of Final Version	_____	$ _____
Total		_____ $

Bonus: Client agrees to pay Developer a bonus of _____ payable to the Developer in the event an acceptable Final Version of the Website is delivered to the Client prior to _____ (date).

TERMS:

1. **Time for Payment**
Payment is due at each milestone upon the Client's acceptance of the Deliverables. All invoices are payable within thirty (30) days of receipt. A 1½% monthly service charge is payable on all overdue balances. The grant of any license or right of copyright is conditioned on receipt of full payment.

2. **Default in Payment**
The Client shall assume responsibility for all collection of legal fees necessitated by default in payment.

3. **Estimates**
If this form is used for an estimate or assignment confirmation, the fees and expenses shown are minimum estimates only. Final fees and expenses shall be shown when invoice is rendered. The Client's approval shall be obtained for any increases in fees or expenses that exceed the original estimate by ten percent (10%) or more.

4. **Expenses**
The Client shall reimburse the Developer for all expenses arising from this assignment, including the payment of any sales taxes due on this assignment, and shall advance $_____ to the Developer for payment of said expenses.

5. **Internet Access**
Access to Internet will be provided by a separate Internet Service Provider (ISP) to be contracted by the Client and who will not be party to this agreement.

6. **Progress Reports**
The Developer shall contact or meet with the Client on a mutually acceptable schedule to report all tasks completed, problems encountered, and recommended changes relating to the development and testing of the Website. The Developer shall inform the Client promptly by telephone upon discovery of any event or problem that may delay the development of the work significantly.

7. **Developer's Guarantee for Program Use**
The Developer guarantees to notify the Client of any licensing and/or permissions required for art-generating/driving programs to be used.

8. **Changes**
The Client shall be responsible for making additional payments for changes in original assignment requested by the Client. However, no additional payment shall be made for changes required to conform to the original assignment description. The Client shall offer the Developer the first opportunity to make any changes.

9. **Testing and Acceptance Procedures**
The Developer will make every good faith effort to test all deliverables thoroughly and make all necessary corrections as a result of such testing prior to handing over the deliverables to the Client. Upon receipt of the deliverables, the Client shall either accept the deliverable and make the milestone payment set forth herein or provide the Developer with written notice of any corrections to be made and a suggested date for completion which should be mutually acceptable to both the Developer and the Client. The Developer shall designate *(name)* and the Client shall designate *(name)* as the only designated persons who will send and accept all deliverables and receive and make all communications between the Developer and the Client. Neither party shall have any obligation to consider for approval or respond to materials submitted other than through the designated persons listed above. Each party has the right to change its designated person upon _____ day(s) notice to the other.

10. **Website Maintenance**
The Developer agrees to provide the Client with reasonable technical support and assistance to maintain and update the Website on the Internet during the Warranty Period of *(dates)* at no cost to the Client. Such assistance shall not exceed _____ hours per calendar month. After the expiration of the Warranty Period the Developer agrees to provide the Client with reasonable technical support and assistance to maintain and update the Website on the Internet for an annual fee of $_____ for a period of _____ years after the last day of the Warranty Period payable thirty (30) days prior to the commencement date of each year of the Maintenance Period. Such maintenance shall include correct-ing any errors or any failure of the Website to conform to the specifications. Maintenance shall not include the development of enhancements to the originally contracted project.

11. **Enhancements**
Under the maintenance agreement, if the Client wishes to modify the Website, the Developer shall be given first option to provide a bid to perform such enhancements.

12. **Confidential Information**
The Developer acknowledges and agrees that the source materials and technical and marketing plans or other sensitive business information, as specified by the Client, including all materials containing said information, which are supplied by the Client to the Developer or developed by the Developer in the course of developing the Website are to be considered confidential information. Information shall not be considered confidential if it is already publicly known through no act of the Developer.

13. **Return of Source Information**
Upon the Client's acceptance of the Final Version, or upon the cancellation of the project, the Developer shall provide the Client with all copies and originals of the source materials provided to the Developer.

14. **Ownership of Copyright**
Client acknowledges and agrees that Developer retains all rights to copyright in the subject material.

15. **Ownership and Return of Artwork**
The Developer retains ownership of all original artwork, in any media, including digital files, whether preliminary or final. The Client waives the right to challenge the validity of the Developer's ownership of the art subject to this agreement because of any change or evolution of the law and will return all artwork within thirty (30) days of use.

16. **Cancellation**
In the event of cancellation of this assignment, ownership of all copyrights and any original artwork shall be retained by the Developer, and a cancellation fee for work completed, based on the prorated portion of the next payment and expenses already incurred, shall be paid by the Client.

16. Copy-Protection

The Client must copy-protect all final art which is the subject of this agreement against duplication or alteration.

17. Credit Lines

The Developer shall be given credit on: (a) floppy disk, (b) documentation, (c) packaging, (d) Developer's mark on art.

☐ If this box is checked, the Developer shall receive copyright notice in this form:

© 199__ _____.

18. Alterations

Any electronic alteration of original art (color shift, mirroring, flopping, combination cut and paste, deletion) creating additional art is prohibited without the express permission of the developer. The Developer will be given first opportunity to make any alterations required. Unauthorized alterations shall constitute additional use and will be billed accordingly.

19. Other Operating Systems Conversions

The Developer shall be given first option at compiling the work for operating systems beyond the original use.

20. Unauthorized Use and Program Licenses

The Client will indemnify the Developer against all claims and expenses arising from uses for which the Client does not have rights to or authority to use. The Client will be responsible for payment of any special licensing or royalty fees resulting from the use of graphics programs that require such payments.

21. Warranty of Originality

The Developer warrants and represents that, to the best of his/her knowledge, the work assigned hereunder is original and has not been previously published, or that consent to use has been obtained on an unlimited basis; that all work or portions thereof obtained through the undersigned from third parties is original or, if previously published, that consent to use has been obtained on an unlimited basis; that the Developer has full authority to make this agreement; and that the work prepared by the Developer does not contain any scandalous, libelous, or unlawful matter. This warranty does not extend to any uses that the Client or others may make of the Developer's product which may infringe on the rights of others. CLIENT EXPRESSLY AGREES THAT IT WILL HOLD THE DEVELOPER HARMLESS FOR ALL LIABILITY CAUSED BY THE CLIENT's USE OF THE DEVELOPER's PRODUCT TO THE EXTENT SUCH USE INFRINGES ON THE RIGHTS OF OTHERS.

22. Limitation of Liability

Client agrees that it shall not hold the Developer or his/her agents or employees liable for any incidental or consequential damages which arise from the Developer's failure to perform any aspect of the Project in a timely manner, regardless of whether such failure was caused by intentional or negligent acts or omissions of the Developer or a third party. Furthermore, the Developer disclaims all implied warranties, including the warranty of merchantability and fitness for a particular use.

23. Dispute Resolution

Any disputes in excess of $_____ (maximum limit for small claims court) arising out of this Agreement shall be submitted to binding arbitration before the Joint Ethics Committee or a mutually agreed upon arbitrator pursuant to the rules of the American Arbitration Association. The Arbitrator's award shall be final, and judgment may be entered in any court having jurisdiction thereof. The Client shall pay all arbitration and court costs, reasonable attorney's fees, and legal interest on any award of judgment in favor of the Developer.

24. Acceptance of Terms

The signature of both parties shall evidence acceptance of these terms.

consented and agreed to

date _____

developer's signature _____

authorized signature _____

client's name and title _____

The Graphic Artists Guild

••••••••••••

The mission of the Graphic Artists Guild is to promote and protect the economic interests of its members. It is committed to improving conditions for all creators of graphic art and raising standards for the entire industry.

Looking ahead to the Guild's next thirty years, its vision for the future would be that, through the work of the Guild...

Graphic artists are recognized, respected, and fairly compensated for their work. Baseline fee levels that protect all graphic artist are established. Buyers of art recognize the value of graphic art to their businesses, and their relationships with graphic artists are fair and ethical.

The Guild is recognized widely as the leading organization working on behalf of graphic artists. Through its large, active, and involved membership, the Guild has substantial impact on legislative issues and in the global marketplace.

Because of Guild programs and services, its members enjoy recognition, prosperity, and security.

Long-range goals

♦ *Financial and professional respect*
To assure that our members are recognized financially and professionally for the value they provide.
♦ *Education and research*
To educate graphic artists and their clients about ethical and fair business practices.
To educate graphic artists about emerging trends and technologies having an impact on the industry.
♦ *Valued benefits*
To offer programs and services that anticipate and respond to the needs of our members, helping them prosper and enhancing their health and security.
♦ *Legislative*
To advocate for the interests of our members in the legislative, judicial, and regulatory arenas.
♦ *Organizational development*
To be responsible stewards for our members by building an organization that works efficiently on their behalf.

The methods used to accomplish these goals correspond to our members' needs. Of our members who are employed traditionally, 1995 marked the first time in the Guild's nearly 30-year history that it negotiated its first bona fide collective bargaining agreement on behalf of staff and graphic designers. For the vast majority of our members who work for themselves, we work hard to help them improve the skills necessary to compete more

effectively in today's volatile markets. This *Handbook*, for example, helps artists, designers, and clients manage their businesses better. Noted illustrator Marshall Arisman (Guild member since 1982) says that if the Guild's *Pricing & Ethical Guidelines* were the only thing the Guild ever accomplished, that alone would justify our existence.

The year 1997 marks the thirtieth anniversary of our work to advance our mission. During that time, we've established a record that points out the Guild's noteworthy accomplishments on behalf of the industry:

History of the Guild

1967

♦ Organized in Detroit, Michigan, with initial membership of 113.

1968

♦ Organizing of Guild Chapters initiated in at least four cities.

1971

♦ New York City Chapter chartered.

1973

♦ First edition of *Graphic Artists Guild Handbook: Pricing & Ethical Guidelines* published as a 20-page booklet.
♦ Favorable decision obtained from Copyright Royalty Tribunal that raises fees and improves reporting procedures for 260 PBS stations regarding use of previously published art for broadcasting.

1975

♦ Formation of Professional Practices Committee to assist Guild members in resolution of disputes.
♦ Second edition of *Graphic Artists Guild Handbook: Pricing & Ethical Guidelines* published as a 40-page booklet.

1976

♦ First publication of talent directory, the first sourcebook serving the needs of illustrators.
♦ Illustrators Guild merges with Graphic Artists Guild.
♦ Major medical coverage added to benefits program.

1977

♦ Graphic Artists for Self-Preservation

(GASP) merges with Graphic Artists Guild.
♦ New York City Chapter becomes a cosponsor of the independent Joint Ethics Committee to promote the industry's oldest ethical practices code and to provide mediation and arbitration for industry practitioners.

1978

♦ Independent national Guild office organized; first national board and officers elected in 1979 and first national convention occurs in 1980.
♦ Atlanta Chapter chartered.
♦ Creative Designers Guild merges with Graphic Artists Guild.

1979

♦ Third edition of *Graphic Artists Guild Handbook: Pricing & Ethical Guidelines* published as a 48-page booklet.
♦ Textile Designers Guild merges with Graphic Artists Guild.
♦ Long-term legislative drive initiated that targets federal copyright and tax laws and promotes model legislation to establish legal rights for artists at federal and state levels.
♦ Model business forms drafted for various graphic art disciplines.
♦ Negotiation with several publishers results in their withdrawal of work-for-hire contracts.

1980

♦ Boston Chapter chartered.
♦ Guild assists a group of textile designers in obtaining a National Labor Relations Board investigation and filing of unfair labor practices complaint against Print-A-Pattern after the designers were terminated subsequent to their seeking to negotiate an employment contract. The designers were able to obtain unemployment insurance and entered into a private settlement regarding monies due.
♦ Favorable ruling from IRS provides Guild with nonprofit status as a labor organization, which allows flexibility and broader activities as a professional association beyond those of purely educational or philanthropic associations.
♦ Guild publishes *Protecting Your Heirs and Creative Work*, by Tad Crawford.

1981

♦ Professional Education Program started by

New York City Chapter.

♦ Oregon passes an "artists' fair practices" law (Sects. 359.350–359.365 of Rev. Stat.), based on Guild's model law.

1982

♦ Indiana Chapter chartered.

♦ Fourth edition of *Graphic Artists Guild Handbook: Pricing & Ethical Guidelines* published as a 136-page book.

♦ Guild succeeds in passage of California's "artists' fair practices" law (Sect. 988 of Civil Code).

♦ Assistance provided in the formation of the National Writers Union.

♦ Responding to Guild opposition, IRS withdraws proposed rule that would have disallowed a home-studio deduction where artist has a primary source of income at another location and from other type of work.

♦ Guild forms coalition of creators' groups, including photographers and writers, to lobby for work-for-hire reform in U.S. Congress. Forty-two organizations join coalition efforts, the largest creators' advocacy coalition in history.

♦ Graphic Artists Guild Foundation organized and receives NEA grant for study.

♦ New York City Chapter succeeds in passage of state's "artists' fair practices" law (Sects. 1401 & 1403 of Arts & Cult. Affairs. Law) and "artists' authorship rights" law (Art. 12-J of Gen. Bus. Law).

1983

♦ Vermont Chapter chartered.

1984

♦ Cartoonist Guild merges with Graphic Artists Guild.

♦ Fifth edition of *Graphic Artists Guild Handbook: Pricing & Ethical Guidelines* published as a 194-page book.

♦ Testimony is presented before the Democratic National Platform Committee on professional issues.

♦ Proposed "Copyright Justice Act" to reform work-for-hire provision of the copyright law by eliminating instances in which artists lose rights and benefits as creators of their work.

1985

♦ Contract terms renegotiated with Children's Television Workshop.

♦ Guild Foundation drafts ethical guidelines for contests and competitions.

♦ Boston Chapter succeeds in passage of state's "Arts Preservation Act."

♦ Formation of Giolito Communications Center, a specialized reference library operated by the Guild Foundation.

♦ National legal referral network established.

1986

♦ Testimony presented before Congressional Office of Technology Assessment regarding impact of technology on the profession.

♦ Guild members testify before U.S. Congress in support of Berne Convention (international copyright agreement).

1987

♦ At-Large Chapter organized to provide unaffiliated members with representation on national board.

♦ National Professional Practices Committee organized.

♦ Sixth edition of *Graphic Artists Guild Handbook: Pricing & Ethical Guidelines* published as a 208-page book.

1988

♦ Albany Chapter chartered.

♦ Guild spearheads formation of "Artists For Tax Equity" (AFTE) coalition to confront intended application of "uniform tax capitalization" requirements on all artists and designers. Coalition grows to 75 organizations representing nearly 1 million artists and designers.

♦ Volume 5 of the Guild's *Directory of Illustration* released in large, 9" x 12" format and begins annual publication.

1989

♦ Guild's leadership helps Artists For Tax Equity win necessary exemption from uniform tax capitalization for all artists and graphic designers.

♦ Guild, through the Copyright Justice Coalition, helps convince the Supreme Court to decide in favor of sculptor James Earl Reid in the landmark decision that virtually ends work for hire for freelancers in the absence of a written agreement.

♦ Testimony presented on work-for-hire abuses to Senate Judiciary's Subcommittee on Patents, Copyrights, and Trademarks.

1990

♦ Atlanta Chapter helps win protection for artists in Georgia, requiring printers to obtain written authorization of copyright

clearance for all print orders over $1,000.

♦ Guild, together with the AIGA and the SEGD, begin working to clarify sales tax collection guidelines for illustrators and graphic designers in New York State.

1991

♦ Expanded and updated seventh edition of *Graphic Artists Guild Handbook: Pricing & Ethical Guidelines* published as a 240-page book. Three printings bring the total number of copies in circulation to 53,000.

♦ Guild takes leadership role in addressing health care crisis for artists and designers, formally endorsing universal health legislation in Congress. Steps are taken to organize Artists United for Universal Health, a coalition of arts and artists organizations dedicated to this goal.

1992

♦ Guidelines for the Interpretation of Sales Tax Requirements for Graphic Designers and Illustrators, formulated by the Guild, AIGA, and SEGD, are approved by New York State Department of Taxation.

♦ Guild organizes "Eye to Eye," its first national conference and trade show, celebrating 25 years of advancing the interests of creators.

1993

♦ Chicago Chapter chartered.

♦ The National Labor Relations Board certifies the Guild as the exclusive bargaining agent for the graphic artists employed at Thirteen/WNET (Educational Broadcasting Corporation), a publicly funded television station in New York.

♦ The Immigration and Naturalization Service relies upon the Guild to provide references for foreign artists seeking temporary work visas.

♦ The Graphic Artists Guild Foundation produces award-winning set of disability access symbols, Disability Access Symbols Project: Promoting Accessible Places and Programs. Produced with the support and technical assistance of the National Endowment for the Arts, Office for Special Constituencies, the Disability Access Symbols Project, which is available in both disk and hard-copy formats, was distributed to hundreds of government and non-profit organizations.

1994

♦ Seattle's Society of Professional Graphic Artists, founded in the 1950s, merges with the Guild as the SPGA (Seattle) Chapter.

♦ The eighth edition of the *Graphic Artists Guild Handbook: Pricing & Ethical Guidelines* is published. Updated in design, organization, and information, it has grown to nearly 300 pages. The initial printing of the book is for approximately 30,000 copies.

1995

♦ Northern California Chapter of the Guild is chartered.

♦ Guild takes proactive lead on electronic rights issues, organizing "Clients vs. Creators: The Struggle Over E-Rights," an industry roundtable featuring Bruce Lehman, U.S. Commissioner of Patents and Trademarks.

♦ The Guild successfully negotiates its first collective bargaining agreement with Thirteen/WNET on behalf of staff designers it represents, improving hours, pay, and other working conditions.

1996

♦ Guild organizes coalition of 16 industry organizations and launches "Ask First," a copyright awareness campaign intended to end unauthorized use of images for client presentations.

♦ Guild reaches understanding with American Society of Media Photographers (ASMP), National Writers Union (NWU), and Copyright Clearance Center (CCC) to establish digital licensing agency.

♦ Guild reaches agreement with Kopinor, the Norwegian reprographic rights organization, to accept distribution of royalties attributed to U.S. illustrators and designers.

♦ Guild adopts its first strategic plan to adapt to changing industry conditions.

Unlike other organizations dedicated to promoting "excellence in graphic design" or "advancing illustration," the Guild is mandated by its constitution "to advance and extend the economic and social interest of (our) members" and to "promote and maintain high professional standards of ethics and practice and to secure the conformance of all buyers, users, sellers, and employers to established standards."

Foremost among the Guild's activities is the ongoing effort to educate members and nonmembers alike about the business of being

a graphic artist. Both nationally and at the Chapter level, the Guild organizes programs on negotiation and pricing strategies, tax issues, self-promotion, time management, and other essential business skills that are not, by and large, taught in art schools. The Guild provides a means for experienced artists to share their understanding of the advertising, publishing, and corporate markets with young artists, and a way for artists at every level of attainment to share concerns and information. Many artists join the Guild for the information and "net-working" it offers, and find themselves drawn into other activities as well.

The bottom line, though, is work, and the more the better. We want to help our members not only get jobs, but good jobs that recognize the valuable contributions of graphic artists financially and otherwise. One way is through the *Graphic Artists Guild Directory of Illustration* (published by Serbin Communications), which is designed to make it easier for advertising agencies, marketing executives, art directors, and design firms to find the right artist for the right assignment. For artists, it's one of the best advertising values around.

The New York Chapter offers the *Jobline News,* a weekly newsletter listing job opportunities in all areas of the graphic arts, ranging from freelance and part-time to long-term and full-time staff positions. Clients can list opportunities in *Jobline News* free of charge, simply by contacting the Guild offices by phone, fax, or mail and completing a classified advertisement that includes the job description and contact information.

Guild Chapters in New York, Boston, and Chicago hold annual illustration trade shows, where the work of illustrators are viewed by a steady stream of buyers who come to survey the talent available.

But it's not enough to help artist members cope in the market as it is. When the market stacks the deck unfairly against artists, the Guild is determined to do something about it, whether through education, legislative advocacy, or direct intervention.

Through lobbying, we've strengthened copyright laws, eased the tax burden on free-lancers, and gotten the graphic artist's point of view heard in the national health care debate. Our Professional Practices Committees help members resolve grievances, which in turn helps reinforce industry standards. Since knowledge is power (especially in the communication industries), we make special efforts to keep our members informed through our newsletters, programs, and events.

Active membership in the Graphic Artists Guild is the best way to ensure the advancement of creators' interests and equitable professional conditions for all. Today, most graphic artists join the Guild to act together to protect their professional integrity and their art by sharing information, discussing problems in the industry, and working to improve the profession. Guild members work together on contract issues, pricing, and artists' rights legislation—communicating with each other to take advantage of the experiences of the group.

Guild members have established a strong track record of successful lobbying on behalf of artists in state, federal, and regulatory venues, developing trail-blazing publications on professional practices and pricing strategies, and establishing educational seminars and group health, life, and disability insurance plans.

The Graphic Artists Guild is a national organization whose headquarters are located in New York City. Local Chapters of the Guild exist in Albany, New York; Atlanta, Georgia; Boston, Massachusetts; Burlington, Vermont; Chicago, Illinois; Indianapolis, Indiana; New York, New York; San Francisco, California; and Seattle, Washington, as well as an At-Large Chapter serving those individuals who do not reside near a geographic Chapter.

Member benefits and services

The needs and concerns of Guild members dictate all the projects, benefits, and services that are initiated to address those needs. In addition to national programs, each Chapter of the Guild orients its own programs to serve the needs of its region. When an issue is recognized as a concern that extends beyond any one Chapter, it is often referred to the National Board for assessment and possible action; or, in the case of successful events, implementation in all our Chapters.

World Wide Web site

The Guild's Website (http://www.gag.org) features a portfolio area for all disciplines, Chapter homepages highlighting events and programs, news briefs, and a members-only area.

Artist-to-artist hotline

Chapters across the country have established artist-to-artist hotlines that are staffed by member volunteers who are interested in helping fellow artists. This members-only service gives

members with questions about professional issues, such as pricing, contracts, or negotiating, referrals to other Guild members who are seasoned professionals willing to share their experience and know-how. Information received through the hotlines often is used in assessing markets and targeting problems in the field.

National and local newsletters

The *Guild News*, a national communication vehicle, is published quarterly and distributed to members, art supply stores, and teaching institutions with art and design programs. It features issues affecting graphic artists and how they work throughout the country. It also provides updated information on programs, legislative initiatives, event calendars, book reviews, and other items of national and local interest. Submissions of articles and artwork from members are welcome (subject to editor's discretion). Ads, which reach a nationwide audience, can be purchased by members at 15 percent off the regular rates. Subscriptions are available for $15 per year or $5 per single copy for nonmembers. Please contact the National Office for further information.

Most Chapters publish their own monthly or quarterly newsletter, covering issues of regional interest, announcing meetings and programs, and reporting on members' activities.

Professional education programs

Whether it's the business of art or to update the many skills needed to compete effectively in the market, the Guild offers events throughout the year on topics of special interest. Some may be discipline-specific (i.e., related to graphic design, illustration, surface/textile design, multimedia, cartooning, or computer design); others will appeal to the broad spectrum of Guild members, such as seminars and workshops on negotiation, marketing, self-promotion, and financial planning. Members receive announcements for general and discipline-specific meetings from their individual Chapters and through the national *Guild News*.

Another component of this program is curriculum development for art schools, in which teachers who are Guild members share information about teaching professional practices on the undergraduate level. The Guild also sponsors courses and workshops in cooperation with art schools, undergraduate art departments, and related organizations.

Professional practices monitoring and dispute resolution

The national organization monitors problems that occur throughout the industry and tracks member complaints on issues concerning standards, practices, and pricing. Grievance procedures for members who are experiencing contractual or professional disputes with clients exist in most Chapters. These Chapter committees help resolve disputes through informal contact with the client. If the dispute is not resolved through local committee assistance, the artist may submit the case to the National Professional Practices Committee. The national committee reviews grievances, makes recommendations for further action, communicates with the client, and may also provide support letters and expert witnesses for court cases.

Attorney and accountant referral network

Because independent contractors often face legal and financial questions particular to their type of business, the Guild has a referral system listing attorneys and accountants around the country who have been selected because of their familiarity with artists' issues and, in some cases, their willingness to work with our members for reduced fees. (Referrals may not be available in all areas of the country.) Chapters and individual members can recommend attorneys and accountants with whom they work for inclusion in the service by writing or calling the National Office.

Debt collection services

The Guild offers members access to a highly effective collection program through National Credit Alert (NCA). NCA communicates with clients in a polite and professional manner that results in successful collections for a flat fee.

Credit union

Guild members are eligible to join Members America Credit Union (MACU), one of the nation's leading member-owned financial cooperatives. Founded in 1940, MACU has $600 million in assets and 60,000 members. Members America offers savings, checking, and Christmas Club accounts, ATM access, living trusts, IRAs, mortgages and home equity loans, new and used auto loans, signature loans, and a Visa credit card.

Insurance

The Guild provides its members with access to health, life, and disability insurance coverage.

Through its longtime relationship with the companies offering these plans, the Guild is able to refer members to insurance professionals who can evaluate their special needs and design customized packages of protection.

Artist locator service

The Guild's National Office receives dozens of calls each week from potential clients who have seen an artist's work but don't know how to locate the artist. Artist members are contacted by the Guild on behalf of the prospective client. It's just one more way artists can enhance their self-promotion efforts.

(Note: Addresses and phone numbers of members are confidential and are not available to callers unless specifically instructed otherwise by the member.)

Discounts

Many Chapters have developed discount programs with suppliers in their areas, where members can receive from 5 to 20 percent off art supplies and services. Discounts are also available on the most popular talent directories and sourcebooks as well as books and trade publications.

Through various agreements, the Guild offers members discounts on such useful services as arts and office supplies, overnight delivery services, long-distance phone calls and car rentals.

Meetings and networks

Regular member meetings are features of most Guild Chapters. At these meetings, programs on issues such as self-promotion, pricing, negotiating, or resource swaps are highlighted. Members are able to confer directly with peers on business issues, keep updated on the latest developments in their field, and socialize.

National Board of Directors

The National Board of Directors, which has oversight responsibility for the organization, consists of elected artist members. Each local Chapter has representatives on the National Board and the full board meets at least twice a year to establish goals and priorities, share information on program development, and approve the organization's budget.

The Graphic Artists Guild Directory of Illustration

Published by Serbin Communications and sponsored by the Graphic Artists Guild, this advertising directory for illustrators offers discounted rates for Guild members and has a free distribution of over 21,000 art directors and buyers around the world. The publication date for Volume 14 is Fall 1997. For more information or to reserve pages in the *Directory of Illustration,* contact Serbin Communications at 1.800.876.6425.

The Graphic Artists Guild Foundation

The Graphic Artists Guild Foundation was formed in 1983 to "foster, promote, and advance greater knowledge, appreciation, and understanding of the graphic arts… by the presentation and creation of the graphic arts, activities designed to promote, aid and advance the study of existing work, and to promote the creation, presentation, and dissemination of new works; to sponsor workshops, training sessions, symposia, lectures, and other educational endeavors."

Further, the Foundation's constitution states among its goals, that it is "to help monitor and establish rules governing industry practices and to contribute to modifying these when necessary."

The Foundation receives grants and donations to conduct studies whose information will benefit the industry, the public, and the arts in general. It has concluded a two-year study, partially sponsored by the National Endowment for the Arts, of art contests and competitions. The study assessed the nature of contests and competitions and developed a set of ethical guidelines and standards for these events.

In 1993, with the support and assistance of the National Endowment for the Arts, Office for Special Constituencies, the Foundation developed the Disability Access Symbols Project: Promoting Accessible Places and Programs. These 12 graphic symbols address the communications needs of design firms, agencies, not-for-profits, and other entities who need to show that programs and services are accessible to people with mobility, sight, or hearing limitations. The symbols and accompanying text were reviewed by more than 15 organizations representing people with various disabilities in connection with the design community to achieve clarity and standardization.

The symbols are available on floppy disks (DOS or MAC) and as reproducible slicks. Please call 800.878.2753 for more information.

Donations to the Graphic Artists Guild Foundation are deductible to the fullest extent allowed by the law.

The Foundation also administers the Giolito Communication Center, a reference library containing over a 1,000 books and periodicals on subjects related to the graphic communications field, an industry talent directory archive, and a wide assortment of graphic software programs. The center also boasts a Mac workstation that is available for use at a nominal fee when reservations are made in advance.

The Graphic Artists Guild Foundation provides an avenue for tax-deductible donations and bequests that advance the interests of artists. Donations can be sent to the Foundation c/o the Graphic Artists Guild. Please make checks payable to the Graphic Artists Guild Foundation. Call 800.878.2753 for further information.

On joining the Guild

When you join the Guild, you're making a very definite statement of your conviction that graphic artists deserve the same respect our society affords other professionals.

Joining the Guild affirms the value of artists working together to improve standards of pay and working conditions in our industry. Joining is an endorsement of the highest standards of ethical conduct in the marketplace.

Joining the Guild is joining the effort to advance the rights and interests of artists through legislative reform, as discussed throughout this book. For example: Our ongoing fight to end the widespread abuse of the copyright law's work-for-hire language; our successful battle against unfair taxation of artists; our dedication to universal health care; and our commitment to creator empowerment by easing access to attorneys' fees and statutory damages when work is infringed.

Joining the Guild may provide you with a vehicle for contract bargaining—with your employer if you are a staff artist, or even with your client under the proper conditions.

Joining the Guild puts you in contact with other artists who share your concerns. It's a way to share ideas, information, and business skills with your colleagues.

The Graphic Artists Guild is the only union in the United States dedicated to advancing the interests of professional artists and designers. If you want to work together to cause positive change for artists in the marketplace and in society, you belong in the Guild!

Graphic Artists Guild Membership Application

Please photocopy this page, fill out all portions of this form and mail it with your dues payment and initiation fee to:

Graphic Artists Guild
90 John Street, Suite 403
New York, NY 10038

The Graphic Artists Guild is a national organization with local Chapters. Membership applications are processed at the National Office; you'll be enrolled either in a local Chapter serving your area or in the "At-Large" Chapter if there is no local Chapter near you.

Name _____

Address _____

City _____ State _____ Zip _____

Business Phone () _____

Home Phone () _____

Fax () _____

e-mail _____

MEMBERSHIP STATUS

Guild Membership comprises two categories: Member and Associate Member. Only working graphic artists are eligible to become full voting members. Interested people in related fields who support the goals and purposes of the Guild are welcome to join as Associate Members, as are graphic arts students and retired artists. Associate Members may participate in all Guild activities and programs, but not hold office or vote.

☐ I earn more than half of my income from my own graphic work; I am therefore eligible to join the Guild as a Member.

☐ I wish to join the Guild as an Associate Member.

EMPLOYMENT STATUS

If you are on staff and do freelance work as well, please mark "1" for staff and "2" for freelance.

____ Staff ____ Retired Graphic Artist
____ Freelance (includes busi- ____ Student
 ness owners, partners, and
 corporation principals)

School _____ Year of graduation _____

(Students must include photocopy of current college I.D.)

DISCIPLINE

Please mark "1" for the market in which you do most of your work, and "2" and "3" for additional specialties.

____ Animation/Multimedia ____ Illustration
____ Art Direction ____ Marbling
____ Artists' Representatives ____ Pre-production (comps,
____ Cartooning storyboards, animatics)
____ Digital/Electronic Arts ____ Surface/Textile Design
____ Dimensional Illustration/ ____ Teaching Professional
 Modelmaking ____ Video/Broadcast Design
____ Fashion Illustration ____ Other
____ Graphic Design

MARKETS

Please mark "1" for the market in which you do most of your work, "2," "3," and so on for additional markets.

____ Advertising/Collateral ____ Editorial
____ Architecture ____ Educational
____ Book ____ Entertainment
____ Charts/Maps ____ Fashion
____ Consumer ____ Novelty/Retail
____ Corporate ____ Packaging
____ Digital/Electronic (e.g., ____ Publication
 World Wide Web) ____ Syndication
____ Displays/Exhibits ____ Other

☐ On occasion, the Guild allows the use of its mailing list by companies selling products of interest to our members. Please check this box if you do not wish to have your name made available in this manner.

DUES AND INITIATION FEE

To offset the administrative expense of processing new memberships, the Guild collects a $25 one-time fee with membership application.

Guild dues depend upon membership category and income level. Income level refers to your total adjusted gross income from your federal tax return.

Full Member Dues (Please Check Category):

☐ Income under $12,000/yr $120 per year
☐ Income $12,000-$30,000/yr $165 per year
☐ Income $30,000-$55,000/yr $215 per year
☐ Income over $55,000/yr $270 per year

Associate Member Dues

☐ Students $55 per year
☐ Others $115 per year

METHOD OF PAYMENT

☐ Check ☐ Money Order ☐ Visa ☐ MasterCard ☐ AmEx

Card No. _____

Expiration Date _____

Signature _____

Dues * _____

Initiation fee $25

Total enclosed _____

Returned checks are subject to a $15 service charge.

For office use only: PEGS CARD AZW

* You may remit one-half of your dues with this application (plus the initiation fee); we will bill you for the second half, which must be paid within 120 days.

MEMBERSHIP STATEMENT

Please read and sign the following:

I derive more income from my own work as a graphic artist than I do as the owner or manager of any business which profits from the buying and/or selling of graphic artwork[†]

I, the undersigned, agree to abide by the Constitution[‡] of the Graphic Artists Guild and do hereby authorize the Guild to act as my representative with regard to negotiation of agreements to improve my wages, fees, hours, and conditions of work.

I further understand that my membership in the Graphic Artist Guild is continuous and that I will be billed for membership dues annually on the anniversary of my original application. If I wish to resign from the Graphic Artists Guild, I understand that I must resign in writing, and that I will be responsible for the payment of any dues owed prior to the date of my resignation.

Signature _____

Date _____

[†] This statement does not apply to Associate Members.

[‡] Your membership package will contain a copy of the Guild's Constitution. To obtain one prior to joining, send $1 with your request to the National Office. The document is also on file at National and Chapter offices for inspection.

Resources & references

• • • • • • • • • • • •

The Graphic Artists Guild bookshelf

These books and audiocassettes are available from the Graphic Artists Guild National Office, 90 John Street, Suite 403, New York, New York, 10038, 800.878.2753, by prepaid check or by Visa/MasterCard. The New York sales tax of 8.25% is applicable to orders mailed to addresses in New York State. Shipping and handling charges of $4.00 (U.S. Postal Service) and $5.00 (UPS) should be added for the first book or cassette ordered, and $1.00 added for each additional book or cassette. Guild members are entitled to a 15% discount off the list price.

CRAWFORD, TAD. *Legal Guide for the Visual Artist.* The professional's handbook. Revised and expanded. New York: Allworth Press, 1990. $18.95.

CRAWFORD, TAD, AND DOMAN BRUCK, EVA. *Business and Legal Forms for Graphic Designers.* 33 ready-to-use forms; use and negotiation checklists; extra tear-out forms. New York: Allworth Press, 1990. $15.95.

GOLDFARB, ROZ. *Careers by Design: A Headhunter's Secrets for Success & Survival in Graphic Design.* The well-known president of a leading New York City graphic design personnel agency offers her prescription for success in the industry. New York: Allworth Press, 1993. $16.95

GORDON, ELLIOTT AND BARBARA. *How to Sell Your Photographs and Illustrations.* A step-by-step business-building plan for freelance photographers and illustrators, including: building a selling portfolio and getting assignments; the secrets of self-promotion; how to price your work—ten key pricing questions to ask; setting up a profitable business plan. New York: Allworth Press, 1990. $16.95.

GRANT, DAN. *The Business of Being an Artist.* Includes how to get an exhibit; finding a dealer; contracts; selling work; using agents, publicists, and reps; education and work choices; health and safety issues; and how to obtain grants and commissions. New York: Allworth Press, 1991. $16.95

Graphic Artists Guild Directory of Illustration. Latest volume contains some of the world's most talented illustrators. More than 1,000 illustrations showcase a remarkable depth and range of talent. For use by art directors and buyers, graphic design firms, and educators. California: Serbin Communications, 1993. $39.95.

LELAND, CARYN R. *Licensing Art & Design.* A professional's guide for understanding and negotiating licenses and royalty agreements. New York: Allworth Press, 1990. $12.95.

ROSSOL, MONONA. *The Artist's Complete Health and Safety Guide.* Everything you need to know about art materials to make your workplace safe and comply with United States and Canadian right-to-know laws. New York: Allworth Press, 1990. $16.95.

WILSON, LEE. *Make It Legal.* A guide to copyright, trademark, and libel law; privacy and publicity rights; and false advertising law for graphic designers; advertising copywriters, art directors, and producers; commercial photographers; and illustrators. New York: Allworth Press, 1990. $18.95.

SEBASTIAN, LIANE. *Electronic Design and Publishing Business Practices.* Guidelines for print production: ethics, roles, responsibilities, ownership, communications, policies, and procedures. For: buyers of design, managers, writers, desktop publishers, graphic designers, art directors, photographers, illustrators, prepress houses, color separators, and

printers. New York: Allworth Press, 1992. $19.95.

SNYDER, JILL. *Caring for Your Art.* This book offers step-by-step guidance for the safekeeping of your artwork with the best methods to store, handle, document, photograph, pack, transport, insure, and secure your art. New York: Allworth Press, 1991. $14.95.

Audiocassette

CRAWFORD, TAD. *Protecting Your Rights & Increasing Your Income.* A guide for authors, graphic designers, illustrators, photographers. 60 minutes. New York: Allworth Press, 1990. $12.95.

Recommended reading

CAPLIN, LEE EVAN. *The Business of Art.* Englewood, NJ: Prentice-Hall, Inc., 1982.

CLAYMAN, TOBY, AND STEINBERG, COBETT. *The Artist's Survival Manual: A Complete Guide to Marketing Your Work.* New York: Charles Scribner & Sons, 1984. COCHRANE, DIANE. *The Business of Art.* New York: Watson-Guptill, 1978.

COLYER, MARTIN. *How to Find and Work with an Illustrator.* Cincinnati, OH: North Light Books, 1990

CRAIG, JAMES. *Graphic Design: A Career Guide and Educational Directory.* New York: Watson-Guptill, 1992.

DAVIS, SALLY. *The Graphic Artist's Guide to Marketing & Self-Promotion.* Cincinnati, OH: North Light Books, 1987.

DAVIS, SALLY. *Creative Self-Promotion on a Limited Budget: For Illustrators and Designers.* Cincinnati, OH: North Light Books, 1992.

FLEISHMAN, MICHAEL. *Getting Started as a Freelance Illustrator or Designer.* Cincinnati, OH: North Light Books, 1990

FLEISHMAN, MICHAEL. *Starting Your Small Graphic Design Studio.* Cincinnati, OH: North Light Books, 1993.

HOWARD, ROB. *The Illustrator's Bible.* New York: Watson-Guptill, 1992.

MCCANN, MICHAEL. *Artist Beware: The Hazards and Precautions of Working with Art and Craft Materials.* New York: Watson-Guptill, 1979.

METZDORF, MARTHA. *The Ultimate Portfolio.* Cincinnati, OH: North Light Books, 1991.

Meyerowitz, Michael, and Sanchez, Sam. *The Graphic Designer's Basic Guide to the Macintosh.* New York: Allworth Press, 1990.

Miller, Lauri. *Promo 2: The Ultimate in Graphic Designer's and Illustrator's Self-Promotion.* Cincinnati, OH: North Light Books, 1992.

MULHERIN, JENNY. *Presentation Techniques for the Graphic Artist.* Cincinnati, OH: North Light Books, 1987.

NEFF, JACK. *The Designer's Guide to Making Money with Your Desktop Computer.* Cincinnati, OH: North Light Books, 1991.

RIXFORD, ELLEN. *3-Dimensional Illustration: Designing with Paper, Clay, Casts, Wood, Assemblage, Plastics, Fabric, Metal, and Food.* New York: Watson-Guptill, 1992.

SELLERS, DON. *ZAP!—How Your Computer Can Hurt You—And What You Can Do About It.* Berkeley, CA: Peachpit Press, 1994. Stewart, Joyce. *How to Make Your Design Business Profitable.* Cincinnati, OH: North Light Books, 1992.

Yeung, Mary. *The Professional Designer's Guide to Marketing Your Work.* Cincinnati, OH: North Light Books, 1991.

Useful publications

Advanced Imaging
PTN Publications
445 Broad Hollow Road,
Ste. 21
Melville, NY 11747
516.845.2700
800.722.2346

Advertising Age
Crain Communications
740 Rush Street
Chicago, IL 60611
312.649.5200

Adweek
1515 Broadway
New York, NY 10036
212.536.5336
800.722.6658

AIGA Journal of Graphic Design
American Institute of
Graphic Arts
164 Fifth Avenue
New York, NY 10010
212.807.1990

Airbrush Action
P.O. Box 2052
Lakewood, NJ 08701
904.364.2111
800.876.2472

American Printer
29 N. Wacker Drive
Chicago, IL 60606
312.726.2802

Archive
American Showcase
915 Broadway
New York, NY 10010
212.673.6600
800.825.0061

Art & Design News
Boyd Publishing
P.O. Box 501100
Indianapolis, IN 46250
317.849.6110

The Artist's Magazine
F&W Publications
1507 Dana Avenue
Cincinnati, OH 45207
513.531.2222
800.289.0963

Artist's Market
F&W Publications
1507 Dana Avenue
Cincinnati, OH 45207
513.531.2222
800.289.0963

Board Report for Graphic Artists
Drew Allen Miller,
Publisher
Box 300789
Denver, CO 80203
303.839.9058

Communication Arts
P.O. Box 10300
410 Sherman Avenue
Palo Alto, CA 94303
415.326.6040
800.258.9111

Creative Business
275 Newbury Street
Boston, MA 02116
617.424.1368
FAX 617.353.1391

Desktop Communications
Gale Research
835 Penobscot Bldg.
Detroit, MI 48226
313.961.2242
800.877.4253

Folio
Cowles Business Media
6 Riverbend Center
P.O. Box 4949
Stamford, CT 06907
203.358.9900

Graphic Design:USA
Kaye Publishing
1556 Third Avenue, Ste.
405
New York, NY 10128
212.534.5500

Graphis Magazine
141 Lexington Avenue
New York, NY 10016
212.532.9387
800.351.0006

How
F&W Publications
1507 Dana Avenue
Cincinnati, OH 45207
513.531.2222
800.289.0963

ID: Magazine of International Design
250 West 57th Street
New York, NY 10107
212.956.0535
800.284.3728

In Motion
Phillips Business Info
1201 Seven Locks Road,
Ste. 300
Potomac, MD 20854
301.340.2100
800.777.5006

Letter Arts Review
(formerly *Calligraphy Review*)
1624 24th Avenue SW
Norman, OK 73072
405.364.8794

The Licensing Letter
EPM Communications
160 Mercer St. , 3rd fl.
New York, NY 10012
212.941.0099
FAX 212.941.1622

MacWeek
P.O. Box 1766
Riverton, NJ 08077
609.786.8230

Macworld
P.O. Box 54529
Boulder, CO 80323
415.243.0505
800.288.6848

PC Week
P.O. Box 1770
Riverton, NJ 08077
609.786.8230

PC World
P.O. Box 54529
Boulder, CO 80323
415.243.0500
800.234.3498

Photo District News
A/S/M Communications
1515 Broadway
New York, NY 10036
212.536.5222
800.669.1002

Print
RC Publications
3200 Tower Oaks
Boulevard
Rockville, MD 20852
301.770.2900
800.222.2654

Printing News East
PTN Publications
445 Broad Hollow Road,
Ste. 21
Melville, NY 11747
516.845.2700
800.722.2346

Publish!
P.O. Box 55400
Boulder, CO 80322
415.243.0600
800.685.3435

Publishers Weekly
19110 Van Ness Avenue
Torrence, CA 90501
800.278.2991

Sign Business
National Business Media
1008 Dept Hill Road
Broomfield, CO 80020
303.469.0424
800.769.0424

Step by Step Graphics
Dynamic Graphics
6000 N. Forest Park Drive
Peoria, IL 61614
309.688.8800
800.255.8800

Upper & Lower Case
International Typeface
866 2nd Avenue
New York, NY 10017
212.371.0699

Women's Wear Daily
Fairchild Publications
7 West 34th Street
New York, NY 10001
212.630.4000
800.289.0273

Industry directories

Artist's Market
F&W Publications
1507 Dana Avenue
Cincinnati, OH 45207
513.531.2222
800.289.0963

The Design Firm Directory
Wefler & Associates
P.O. Box 1167
Evanston, IL 60204
708.475.1866

Gale Research
835 Penobscot Bldg.
Detroit, MI 48226
313.961.2242
800.877.4253
publisher of:
*Gale Directory of
Publications*

*Gift and Decorative Accessory
Buyers Directory*
Gayer-McAllister
Publications
51 Madison Avenue
New York, NY 10010
212.689.4411

*National Association of
Schools of Art & Design
Directory*
11250 Roger Bacon Drive
#21
Reston, VA 22090
703.437.0700

*North American Licensing
Industry Buyers Guide*
A4 International
41 Madison Avenue, 5th
Floor
New York, NY 10010
212.685.0404
FAX 212.563.6552

*O'Dwyer's Directory of Public
Relations Firms*
J.R. O'Dwyer
271 Madison Avenue
New York, NY 10016
212.679.2471

*Standard Directory of
Advertising Agencies*
Reed Reference Publishing
P.O. Box 31
New Providence, NJ 07974
908.464.6800
800.521.8110

Standard Periodical Directory
Oxbridge Communications
150 Fifth Avenue
New York, NY 10011
212.741.0231
800.955.0231

*Standard Rate and Data
Service*
3004 Glenview Road
Wilmette, IL 60901
708.256.6067
800.323.4601

*Thomas Register of
Manufacturers*
Thomas Publishing
1 Penn Plaza
New York, NY 10001
212.695.0500

*Ulrich's International
Periodicals Directory*
Reed Reference Publishing
P.O. Box 31
New Providence, NJ 07974
908.464.6800
800.521.8110

Working Press of the Nation
Reed Reference Publishing
P.O. Box 31
New Providence, NJ 07974
908.464.6800
800.521.8110

Writer's Market
F&W Publications
1507 Dana Avenue
Cincinnati, OH 45207
513.531.2222
800.289.0963

Talent Databases

Creative Access
415 West Superior
Chicago, IL 60610
312.440.1140
800.422.2377
Graphic design firms, art
buyers, corporations, ad
agencies, illustrators,
graphic designers, film
directors, photographers,
artist representatives, and
production houses.

Steve Langerman Lists
148 Middle Street
Portland, ME 04101
207.761.2116
FAX 207.761.4753
Art directors in public rela-
tions firms, cosmetic com-
panies, department stores,
consumer magazines, and
ad agencies.

Related organizations

*Advertising Photographers of
America*
27 West 20th Street, Room
601
New York, NY 10011
212.807.0399

*American Institute of Graphic
Arts (AIGA)*
1059 Third Avenue
New York, NY 10021
212.752.0813

*American Society of
Architectural Perspectivists
(ASAP)*
52 Broad Street
Boston, MA 02109-4301
617.951.1433

*American Society of Media
Photographers (ASMP)*
13 Washington Road, Ste.
502
Princeton Junction, NJ
08850
609.799.8300
FAX 609.799.2233

*American Printed Fabrics
Council*
45 West 36th Street
New York, NY 10018
212.695.2254

Art Directors Club
250 Park Avenue South
New York, NY 10003
212.674.0500

*Association for the
Development of Electronic
Publication Techniques
(ADEPT)*
2251 South Michigan
Avenue
Chicago, IL 60616
312.326.6684

*Association of Imaging
Service Bureaus (AISB)*
5601 Roanne Way, Ste. 608
Greensboro, NC 27409
800.844.2472

*Association of Medical
Illustrators (AMI)*
1819 Peachtree Street, Ste.
712
Atlanta, GA 30309
404.350.7900

*Berkeley Mac Users Group
(BMUG)*
1442 A Walnut Street #62
Berkeley, CA 94709
510.549.2684

*Broadcast Designers
Association*
130 West 67th Street, Ste.
25C
New York, NY 10023-5914
212.873.5014

Cartoonists Society
P.O. Box 20267
Columbus Circle Station
New York, NY 10023
212.627.1550

Center for Safety in the Arts
5 Beekman Street, Ste.
1030
New York, NY 10038
212.227.6220

Children's Book Council
67 Irving Place
New York, NY 10276
212.254.2666

Greeting Card Association
1350 New York Avenue
NW #615
Washington, DC 20005
202.393.1778

*Guild of Natural Science
Illustrators*
P.O. Box 652
Ben Franklin Station
Washington, DC 20044
202.357.2128

*International Design by
Electronics Association
(IDEA)*
244 East 58th Street
New York, NY 10022
1-800-466-1163

*Motion Picture Screen
Cartoonists Union (MPSC)*
Local 839
International Alliance of
Theatrical Stage Employees
(IATSE)
4729 Lankershim
Boulevard
North Hollywood, CA
91602-1864
818.766.7151

*National Computer Graphics
Association*
2722 Merrilee Drive #200
Fairfax, VA 22031
703.698.9600
800.225.NCGA (6242)

*National Endowment for the
Arts (NEA)*
1100 Pennsylvania Avenue
NW
Washington, DC 20506
202.682.5400

*New York Mac Users Group
(NYMUG)*
873 Broadway
New York, NY 10003
212.473.1600

*Scitex Graphic Arts Users
Association* (publishers of
Computer Ready Electronic
Files [CREF] guidelines)
305 Plus Park Boulevard
Nashville, TN 37217
1-800-858-0489

*Society of Children's Book
Writers & Illustrators*
22736 Vanowen Street, Ste.
106
West Hills, CA 91307
818.888.8760
FAX 818.347.2617

*Society of Environmental
Graphic Designers (SEGD)*
1 Story Street
Cambridge, MA 02138
617.868.3381

Society of Illustrators
128 East 63rd Street
New York, NY 10021
212.838.2560
FAX 212.838.2561

*Society of Photographers and
Artists Representatives
(SPAR)*
60 East 42nd Street, Ste.
1166
New York, NY 10165
212.779.7464

*Society of Publications
Designers*
60 East 42nd Street #721
New York, NY 10165
212.983.8585

Type Directors Club
60 East 42nd Street #1130
New York, NY 10165
212.983.6042

*Visual Artists and Galleries
Association (VAGA)*
521 Fifth Avenue, Ste. 800
New York, NY 10017
212.808.0616

Merchandise markets and shows

Atlanta Merchandise Mart
240 Peachtree Street, NW
Atlanta, GA 30303
404.220.3000

Boston Gift Show
Contact: George Little
Management
Ten Bank Street, Ste. 1200
White Plains, NY 10606
800.272.SHOW (7469)
FAX 914.948.6194

Chicago Gift Show
Contact: George Little
Management
(see listing above, under
Boston Gift Show)

Dallas Trade Mart
2100 Stemmons Freeway
Dallas, TX 75207
214.760.2852

The Gourmet Products Show
including Bed, Bath &
Linen
San Francisco, CA
Contact: George Little
Management
(see listing above, under
Boston Gift Show)

International Showcase
225 Fifth Avenue
New York, NY 10010
212.684.3200

*Los Angeles Merchandise
Mart*
1933 South Broadway
Los Angeles, CA 90007
213.749.7911

The Merchandise Mart
222 Merchandise Mart
Plaza
Chicago, IL 60654
312.527.7600

National Stationery Show
New York, NY
Contact: George Little
Management
(see listing above, under
Boston Gift Show)

New York Home Textiles Show
Contact: George Little
Management
(see listing above, under
Boston Gift Show)

*New York International Gift
Fair*
including: Accent on
Design
American & International
Crafts
Contact: George Little
Management
(see listing above, under
Boston Gift Show)

*San Francisco International
Gift Fair*
including: Accent on
Design—West
American & International
Crafts—West
Just Kidstuff—West
The Museum Source—West
Contact; George Little
Management
(see listing above, under
Boston Gift Show)

San Francisco Mart
1335 Market Street
San Francisco, CA 94103
415.552.2311

Surtex Show
New York, NY
Contact: George Little
Management
(see listing above, under
Boston Gift Show)

Toy Manufacturers of America
The Toy Building
200 Fifth Avenue
New York, NY 10010
212.675.1141

Variety Merchandise Show
Contact: Miller Freeman
1515 Broadway
P.O. Box 939
New York, NY 10108
212.626.2375
800.950.1314

Washington, DC Gift Show
Contact: George Little
Management
(see listing above, under
Boston Gift Show)

Glossary

accessories, clothing: Hat, gloves, shoes or slippers, jewelry, socks, belt, suspender, necktie, collar, cuffs scarf, umbrella, hair decoration, apron, handbag, tote, etc.

accessories, home furnishings: Floral arrangement, basket, lamp, coat hanger, storage box, garment bag, shoe organizer, drying towel, pot holder, shower curtain, tissue cover, toilet lid cover, bolster, pillow, cushion, door stop, book ends, frame, appliance cover, laundry bag, etc. (*Note:* Some home accessories can overlap as novelties.)

account executive: A representative of an advertising agency who handles specific accounts and acts as a client liaison to the art director, creative director, and others creating advertising for the account.

accoutrement: An add-on adhered to a sculpture or to accompany it (like a charm).

adult clothing: Clothing in sizes for teenage girls, teenage boys, misses', miss petite, junior, junior petite, women's, half-sizes, and men's.

advance: An amount paid prior to the commencement of work or in the course of work. It may be to cover expenses or it may be partial payment of the total fee. An advance as partial payment is common for a time-consuming project.

advance on royalties or advance payment against royalties: An amount paid prior to actual sales of the commissioned item or work; sometimes paid in installments. Advances generally are not expected to be returned, even if unearned in sales. Both the terms and the size of the advance are negotiable.

afghan: A small blanket, sometimes called a nap blanket, designed for use by one person. It can be formed in a variety of techniques, such as crochet, knitting, weaving, etc.

agreement: See *contract.*

all rights: The purchase of all rights of usage for reproduction of an artwork forever.

alphanumerics: Letters and numbers.

animatic: A limited-animation film using camera movements, a select number of drawings, some animation, and a sound track.

animator: An artist who is responsible for articulation on characters' movements.

annual: Term used to describe a plate or other limited edition which is issued yearly. Many annual plates commemorate holidays or anniversaries, and they are commonly named by that special date, i.e., the Annual Bing & Grondahl Christmas Plate.

applications: A software program that performs a specific task such as page layout, word processing, or illustration.

applique or applied work: To apply or stitch one layer of fabric over another so that the applied pieces form a motif. See also *reverse applique.*

arbitration: A method of dispute resolution whereby a grievance is submitted to an arbitrator for judgment.

art director: Someone whose responsibilities include the selection of talent, purchase of visual work, and the supervision of the quality and character of visual work. Usually an employee of the advertising agency, publishing house, magazine, or other user of the graphic artist's work, although some organizations hire freelance art directors to perform these duties.

art staff: A group of artists working for a company such as an advertising agency, publisher, magazine, or large design studio and under art director supervision.

artist's proofs (also known as gallery or publisher's proofs): Originally, the first few prints in an edition of lithographs were used to test colors and then given to the artist. They were not numbered but were signed.

Artist's proofs are not considered part of the edition. Gallery and publishers' proofs are used as a means of increasing the number of prints in an edition.

artwork: Any finished work of a graphic artist.

ASCII (American Standard Code for Information Interchange): This code gives specific numbers to alphabetic characters and is one of the few ways in which different computers can exchange information.

assistant animator: Cleans up the animator's drawings according to a model sheet and does in-betweens. In some larger studios the assistants only do the clean-up work.

attribution: A basic artists' right whereby the artist retains authorship of a work and is acknowledged properly for its creation; it insures that an artist's name not be used on works they did not create. Also called *paternity.*

author's alterations (AAs): Alterations or corrections of type that has been set due to the client's errors, additions, or deletions. The typographer's or printer's costs for making AAs usually are passed on to the client. See also *printer's error.*

background: One who paints backgrounds that have been designed already.

backstamp: The information on the back of a plate or other limited edition that documents it as part of a limited edition. This information may be hand-painted onto the plate, or incised, or applied as a transfer (decal). Information that typically appears on the backstamp includes: the name of the series; names of the items; year of issue; some information about the subject; the artist's name and/or signature; the edition limit; the item's number within that edition; initials of the firing master or production supervisor, etc.

bailment: An obligation on the part of the individual(s) with whom art is left to take reasonable care of it. This is a legal requirement and applies to situations such as leaving a portfolio for review.

balancing color weights: The process of making colors look good together by lightening or darkening certain colors to make the combination attractive.

basketry: The art of forming baskets from wood, reeds, yarns, etc., by weaving, braiding, coiling, or other techniques.

bas-relief: A technique in which the collectible has a raised dimensional design. This design may be achieved by pouring liquid materials into a mold before firing or by applying a three-dimensional design element to the flat surface of a plate, figurine, or other "blank" piece.

bedspread: The final or top cover for a bed of any size, primarily used for decorative purposes. See also *quilt.*

bid: To offer an amount as the price one will pay or accept.

binary: A system with only two possible states such as on or off, 1 or 0, high or low.

bitmap: Image created when coloration is added to pixels on-screen; the file that gives instructions for coloration.

blanket: A layer of bed clothing placed over the top sheet and under the bedspread, used primarily for warmth. See also *quilt.*

bleed: A small extra area on the exterior dimensions of a page to allow for trimming; the printing that runs into this area. Also called the *trim.*

blues: Nonreproducible photographic prints made from negatives used in platemaking that enable an editor to verify that all art and text are in proper position and that pages are in sequence. Also known as *browns, silvers,* or *ozalids.*

boilerplate: A document containing formula text that can be used for a number of purposes or similar circumstances requiring only minor alterations, such as a contract.

bottomstamp: Usually refers to documentation material found on the bottom of a figurine or the inside of a bell. See also *backstamp.*

braiding: To plait together strands of yarn to strips of fabric to form a larger ply to be coiled and sewn together flat or dimensionally to make rugs, mats, baskets, etc.

bridge: A small tab of material that remains uncut to reinforce and connect the stencil material across the design and to differentiate distinct color areas.

broker: An agent or representative.

built-up lettering: Letters, numerals, or ampersands used to create various forms.

bumpers: Short clips of the opening animation ID for a broadcast.

buyout: An imprecise term for an all-rights transfer.

C print or inter neg: A full-color positive print from a negative transparency.

CAD/CAM (Computer Aided Design/Computer Aided Manufacture): Used to design and test parts, machinery, generate schematics, calculate manufacturing specifications, etc.

CD-ROM: Read-only-memory compact discs for computer use.

camera-ready art or camera copy: Usually a mechanical or pasteup accompanied with finished art that is prepared for photographing for plate-making.

canceled plate: A plate that was planned as part of a series but never produced because of technical problems or lack of interest in early issues.

cancellation fee: When a project is terminated or not used by the client, this fee is paid as compensation for the artist's or studio's effort in developing the illustration or design.

canvas transfer process: A lithograph is treated with a latex emulsion. The paper is removed and the image on the latex emulsion is placed on a cotton duck canvas. It is then topcoated, retouched, and highlighted by hand before being hand-numbered.

cartoonist: A professional artist who creates art in a humorous and satirical style and/or as political commentary.

cast: The process of creating a copy of an original model by pouring liquid clay or slip into a mold.

castoff: To provide a breakdown or estimate of length. In knitting, to put stitches on a knitting needle. In publishing, to estimate the typeset length or number of pages from manuscript or galley proof. In textiles, sometimes used as a synonym for a *knockoff;* refers to a pattern or design that a company wishes to alter for a new pattern while retaining similarity to the original.

cel: Short for celluloid. A transparent sheet of celluloid on which the finished drawings are inked.

center truck: The center page spread in a magazine or newspaper that is a premium space for the placement of advertisements.

certificate/Certificate of Authenticity: A document which accompanies a limited-edition item to establish its place within the edition. Certificates may include information such as the series name, item title, artist's name and/or signature, brief description of the item and its subject, signatures of sponsoring and marketing organizations' representatives, and other documentation material along with the item's individual number or a statement of the edition limit.

children's clothing: Sizes pertaining to boys and girls from toddlers to teens.

chips and tabs: Small squares of color used in surface/textile design to indicate colors when the color combination is not painted. The process is also called pitching the pattern or design.

Chromalin proofs: A proprietary term for a color proof process employing a photosensitized clear plastic. Color separation film negatives are exposed to the plastic in such a way that process color will adhere to dots on the plastic. Four sheets (one for each process color) are exposed, treated with the separate process colors, placed in register, and then laminated. Such proofs are used for presentations and for checking register, obvious blemishes, and size. The color may be very accurate but is subject to a variation due to exposure and the application of the process color; also called *transfer key.* See also *Color key* and *progressive proofs.*

chrome: Color transparencies usually larger than 35mm. See *transparency.* In multimedia work, *chrome* concerns the amount and quality of graphics, animation, sound effects, interactivity, etc.

Cibachrome: A proprietary term for a full-color positive photographic print made from a transparency.

claymation: Three-dimensional animation using clay figures or puppets.

client accommodation: To work at fees below the normal rate in order to accommodate budgetary restrictions and to preserve a long-term working relationship.

clip art: Public domain line art specifically designed for unfettered reuse.

closed edition: A limited edition that is no longer being issued because it has reached the designated limit or no longer has market appeal.

closed end edition: A series with a predetermined, and usually preannounced, number of issues.

collateral: Materials created to support or reinforce a design or promotional concept.

collective work: Term usually applied to something like a magazine, which is a collection of individual works. The individual works may be copyrighted by their creators for the use licensed to the magazine. The assemblage may be copyrighted by the publishing company as a collective work in that form.

collector plate: A limited-edition plate that is created to be collected for its decorative appearance.

Color Key: A proprietary term of the 3M Company; sometimes referred to as *3Ms.* A method for obtaining separate film positives showing the progressive color breakdown of the color separation negatives. Such proofs are useful for presentation and for checking register, obvious blemishes, and size; they are not a true indication of final printed color. *Chromalin proofs* are preferred for more accurate (though still not exact) color representation. *Progressive proofs* using process inks on press are the most accurate method for checking color. See also *Chromalin proofs* and *progressive proofs.*

color map/palette: Synonym for the range of colors from which a computer artist/operator chooses the particular colors used in an individual image.

color proofs: The first full-color printed pieces pulled off the press for approval before the press is considered ready to roll for the entire press run. Sometimes called *simple colored proofs,* these proofs are useful for making corrections in color on press, particularly for those problems resulting from improper registration and the effects of overprinting. *Progressive proofs* are the preferred methods for accurately checking color.

color separation: Photographic process that breaks up colors into basic components or separate pieces of film which are later recombined to re-create the original image.

commission (n); commission (v): Percentage of a fee paid by an artist to the artist's agent or gallery for service provided or business transacted. The act of giving an artist an assignment to create a work of art.

commemorative: An item created to mark a special date, holiday, or event.

compositor: One who sets type.

comprehensive or comp: A visualization of the idea for

an illustration or a design usually created for the client and artist to use as a guide for the finished art. *Tight comp* or *loose comp* refers to the degree of detail, rendering, and general accuracy used in the comprehensive.

confirmation form: A contract form that is used by an artist when no purchase order has been given or when the purchase order is incomplete with respect to important terms of the contract, such as amount of fee, rights transferred, etc.

contact prints: A photographic print made with the negative in contact with a sensitized paper, plate, or film.

contingency fee: A fee dependent on or conditioned by other circumstances.

contract: An agreement, whether oral or written, whereby two parties bind themselves to perform certain obligations. Synonyms: *agreement* or *letter of agreement* (if the contract takes the form of a letter).

converter: A company that converts greige goods into finished printed or plain-dyed fabric for the use of the manufacturer.

copy: The text of an advertisement, the editorial concern of a magazine or a newspaper, or the text of a book.

copyright: The right to copy or authorize the copying of creative work. Any freelance artist creating artwork automatically owns the right of that work unless provisions have been made prior to the commencement of the project to transfer the copyright to the buyer.

copywriter: A writer of advertising or publicity copy.

corner(s): The beginning of a design (usually the upper left corner) that is rendered in the style, technique, color, and materials proposed for the finished artwork. If approved, the design will be used to complete the repeated design on all four corners. Commonly used in home furnishings (e.g., the design for the corners of a tablecloth, napkin, or scarf).

creative director: Usually an employee or officer of an advertising agency whose responsibilities may include overall supervision of all aspects of the character and quality of the agency's work for its client. The creative director's background may be art, copy, or client contact.

crochet: A method of making a lace or a textile structure from any yarn, fabric strip, or stringy material with a hook, using the chain stitch or variations on the chain to form the textile.

croquis: Rough sketches made by an artist, particularly in fashion illustration and textile design.

decal: Also known as a transfer, this is a lithographic or silkscreen rendering of a piece of artwork, which is applied to ceramic or other materials and then fired on to fuse it to the surface. Fired decals use ceramic paints.

deescalation: A clause in a contact that allows for a decrease in extent, volume, or scope.

design brief: An analysis of a project prepared either by the publisher or the designer. When the designer assumes this responsibility it should be reflected in the design fee. The design brief may include: (1) a copy of the manuscript, with a selection of representative copy for sample pages and a summary of all typographical problems, copy areas, code marks, etc.; (2) an outline of the publisher's manufacturing program for the book: compositor and composition method, printer and paper stock, binder and method of binding; (3) a description of the proposed physical characteristics of the book, such as trim size, page length, list price, quantity of first printing, and whether the book will print in one color or more than one. The publisher should so indicate whether any particular visual style is expected.

digital: The representation of a signal by a set of discrete numerical values. Commonly represented on a computer in *binary* form.

director: One who oversees the complete picture from conception to finish. Has complete control over all phases: character design (which is usually supplied by an agency), layout, sound, etc.

documentary design: A design adapted from a historical document or plate, such as Art Deco, Egyptian, Art Nouveau, etc. These pieces are usually always public domain because of their age.

droit moral: French for moral rights; i.e., the right of integrity of the work (no alteration): the right of attribution (credit); and sometimes the *droit de suite*, which is the right of an artist to receive a portion of the resale of an original.

dummy: A book, brochure, or catalog idea in a roughly drawn form usually made up to contain the proper number of pages and used as a reference for positioning and pagination.

dye transfer: Similar in appearance to a color photograph but different in the important respect that it is produced from a transparency by printing continuous tones of color dyes.

edition: A term referring to the number of items created with the same name and decorations.

embossing: A process of producing an image in relief by using dies or punches on a surface.

embroidery: A general term referring to decorating the surface of any fabric with free-formed stitches that are based on plain sewing; stitches and fabric vary according to the will of the designer. *crewel embroidery*: Embroidery with wool or a wool-like yarn on fabric. *counted embroidery:* The formation of regimented stitches on even-weave fabrics on needlepoint canvas known by various names that denote their style of stitches (e.g., hardanger, black work, drawn-thread work). *cross-stitch embroidery:* Can be either free-formed embroidery over Xs printed on the fabric or counted embroidery worked on an even-weave fabric or canvas.

employee, freelance: Terms of freelance employment include: Work hours determined by assignment using one's own workspace and materials; freelancers generally provide their own benefits. The freelancer often collects state sales tax from clients and pays his or her own income taxes.

engineered design: A pattern specifically designed to fit certain size factors and to be repeated in a particular fashion (e.g., panel print to fit a Tressi blouse or dress design).

etched design: Decoration produced by cutting into a surface with acid. An acid-resistant paint or wax is applied and the design is inscribed through this coating. When immersed in acid, the acid etches the surface to form the design.

file conversions: Changing one kind of file to another, usually from one *platform* to another; i.e., from a file for a DOS-compatible personal computer to a file for a MacIntosh.

finished art: Usually an illustration, photograph, or mechanical that is prepared and ready for the engraver or printer.

first issue: The premiere item in a series, whether close-ended or open-ended.

first North American serial rights: The right to be the first magazine to publish art for use in one specific issue to be distributed in North America.

first rights: The right to be the first user of art for one-time use; frequently describes right to publish art in a magazine serial or drawn from a book in which the art will appear.

floor covering: Any textile structure or painting technique that is used to cover a floor partially or completely for either decorative or functional purposes.

fonts: The individual branches of a typeface design.

format: An arrangement of type and illustration that is used for many layouts; an arrangement used in a series.

Fortune double-500 company: Fortune magazine's annual listing based on sales revenues of the 1,000 largest corporations in the United States.

fugitive: Of a temporary nature; liable to fade or degrade.

general apprentice: One who does a little of everything except camera work.

generic works: Art that has the potential for wide application in a variety of markets.

graphic: A print produced by one of the "original" print processes such as etching, engraving, woodblocks, lithographs, and serigraphs. This term frequently is used interchangeably with "print."

graphic artist: A visual artist working in a commercial area.

graphic designer: A professional graphic artist who works with the elements of typography, illustration, photography, and printing to create commercial communications tools such as brochures, advertising, signage, posters, slide shows, book jackets, and other forms of printed or graphic communications. A visual problem-solver.

graphic film artist: One who is skilled in creating special effects on film by use of computerized stands, mattes, and/or by adding computerized movement to artwork (e.g., television logos with glows, set movement).

greige goods: Fabric in its raw, but woven, state.

group head: The leader of a group who supervises the work of art directors on various accounts within an advertising agency.

guild: An association of like-minded professionals seeking to protect and better their status and/or skills. When employees are members in equal proportion to freelancers, such a guild qualifies with the United States government as a union. In this capacity, a guild may represent employees who are its members in collective bargaining.

gutter: The area in a magazine, newspaper, or book where the left (verso) and right (recto) pages meet. Important elements are often not placed in this area because of the fold.

half-body garments: A garment that is worn either from the waist up or from the waist down, such as a vest, sweater, poncho, pants, skirt, etc.

hallmark: The mark or logo of the manufacturer of an item.

hand-letterer: A professional artist who creates letterforms for use in logotypes, alphabets, and specific titles or captions.

hard furniture: Any furniture that requires the designer to use a hard substance such as wood, metal, etc., for structural support or decorative purposes. It may also incorporate padding and a textile surface.

homepage: a viewable document on the World Wide Web—usually the first page of a site.

illustrator: A professional graphic artist who communicates a pictorial idea by creating a visual image using paint, pencil, pen, collage, or any other graphic technique except photography for a specific purpose.

image: A pictorial idea.

image-processing: Manipulation of an image (usually video-scanned), i.e., enhancement, colorizing, or distortions.

inased: A design that is cut into the surface of a product.

inbetweener: In animation, one who does the drawings depicting motion in between the drawings that have been cleaned up by the assistant, thereby animating them.

infant clothing: Refers to newborn and baby sizes up to toddler sizes.

inker: One who inks onto cels the lines of finished drawings.

interactive: Productions and services that respond quickly to the choices and commands users make.

interface: The point where hardware, software, and user connect; the physical, i.e., electrical or mechanical, connection between elements of computer hardware.

Internet: A network of computers connected by telephone lines. First created by the U.S. Department of Defense to send information, particularly in the event of a war that caused the destruction of one or more terminals. The Internet is now a "network of networks" that has expanded in recent years to include companies that provide access for a fee to anyone with appropriate equipment.

Internet service provider (ISP): any company that provides a hookup to the internet. All vary in kind and level of service; some just provide direct access, others provide added services such as news, chat rooms, downloadable software sections, and entertainment.

invoice: A statement given to a client showing the amount due on an assignment. Usually submitted after work has been completed unless advance payments are to be made. When advance payments are made, the invoice should reflect these and show the balance due.

issue: As a verb, to introduce. As a noun, the term means an item within a series.

jacquard sketches: A sketch usually done on graph paper to be used on jacquard-woven fabrics such as tablecloths, upholstery, and towels.

jaggies: The saw-toothed, stair-stepped quality of a line produced by most computer programs.

junior checker (paint and ink only): One who inspects cels for the proper and thorough application of the correct paint colors.

kerning: A process that solves the problem of proper space adjustment between normally set individual letters.

key line artist: A sometimes pejorative term for a mechanical or pasteup artist.

kickback: A sum of money or a large figure paid to an artist by a supplier for the artist's part in passing on work such as printing. Kickbacks may be demanded by art buyers from artists in exchange for awarding commissions. Kickbacks are illegal. Often the supplier's kickback costs are hidden in its invoices submitted to the client of work completed.

knitting: The method of forming a lace or a textile structure from any yarn, fabric strip, or stringy material with two or more eyeless needles, pegged tools, or sticks, etc., using various looped stitches to form the structure.

knock-off (n) knock off (v): A term most often used in the textile design industry to identify a design that at the request of the client or stylist has been copied by a different artist than the one who created it. Broadly used to mean the copying of an artist's style or artwork when no creative input and/or significant changes are made by the artist in creating the knock-off. Knock-offs are unethical and often illegal.

lace: A general term for any openwork or sheer fabric with holes formed by any technique, including knitting, crochet, bobbin lace, netting, hairpin lace, tatting, eyelet, needle lace, etc.

latch hook: A method of knotting short or long lengths of yarn over crosswise threads of a rug canvas with a latch hook tool. The technique generally is used for rug making, pillows, and wall hangings.

layette: A coordinated ensemble for the newborn consisting of a receiving blanket, cap, jacket, and booties.

layout: The design, usually in sketch form, of the elements of an advertisement, magazine, or book page or any other graphic work (e.g., brochures, catalogs, etc.) intended for reproduction. Used as a guide and usually executed by an art director or illustration graphic designer.

letter of agreement: See *contract.*

ligatures: Term for letter combinations used in type design.

limited edition: Item produced only in a certain quantity or only during a certain time period. *Collectible editions* are limited by: specific numbers, years, specific time periods. or firing periods.

line sheet: See *sales catalog.*

link: A connection between one area and another. A primary feature of interactive products is the ability for users to explore linked materials.

live area: The area on the camera copy of a page or a publication beyond which essential elements should not be positioned.

logo: A mark or symbol created for an individual, company, or product that translates the impression of the body it is representing into a graphic image.

logotype: Any alphabetical configuration that is designed to identify by name a producer, company, publication, or individual.

lucey: One of several optical devices used to enlarge or reduce images.

macrame: A method of ornamental knotting for cords and yarns, generally used to form cringes, hammocks, wall hangings, plant holders, etc.

markup (n) mark up (v): A service charge added to expense account items to reimburse the artist for the time to process the billing of such items to the client and the cost of advancing the money to pay such expenses; the process of adding such a charge.

markers: Felt-tipped pens used in a technique for illustrating comprehensives or for sketching a rough in black-and-white or color. Proprietary synonyms: *Magic Markers, Stabilo.*

mechanical: Ruled and pasted flats or boards composed by a production artist for the printer to use in the printing and engraving process.

montage: An image created from a compilation of other images.

moonlighting: A freelance commission taken on by a salaried person to be completed in the person's spare time.

needlepoint or canvas work: The formation of regimented stitches over the meshes or threads of a special open-weave fabric called canvas.

noncompeting rights: Uses other than the original commission that do not conflict or compete with the commissioning party's business or market.

novelties: A general term for gift or boutique-type items or for clever decorative or functional items such as an eyeglass, comb, or mirror case; Christmas decorations (stockings, tree skirt ornaments, etc.); calendar; clock; cosmetic bag; jewelry bag; typewriter cover; golf bag and club covers; exercise or beach mat, etc. Also, wax transfer patterns for embroidery or applique motifs. (*Note:* Some novelties can overlap as home accessories.)

opaque projector: A projector that uses reflected light to project the image of a nontransparent object onto a canvas, board, or screen; the image is then used by an artist to copy or show work.

overhead: Nonbillable expenses such as rent, phone, insurance, secretarial and accounting services, and salaries.

overlay: a stencil cut for use with only one color of the overall design; the equivalent of a color plate in other printing methods.

packagers: Vendors who coordinate all the components of a book publishing project and either present the finished concepts to publishers for execution or manufacture the books themselves and deliver bound volumes to the publisher.

page makeup: Assembling in sequence the typographic and/or illustrative elements of a brochure, catalog, book, or similar item.

pass-through clause: A contract term that takes effect when an illustrator's share of a subsidiary sale exceeds a predetermined amount and for which payment usually is received within thirty days of receipt.

pasteup (n); paste up (v): Usually reproduction copy of galley type fastened in position with wax or glue by a production artist for the use of the engraver in the platemeking process. The act of fastening type and/or artwork to create a mechanical.

patchwork: Piecing, sewing, or joining together pieces of fabric to form motifs or a complete fabric structure. Generally, the pieces are cut in planned shapes. When shapes are unplanned or take on a helter-skelter appearance, it is called *crazy patchwork* or *crazy quilt.*

patent: A provision of intellectual property law that protects an invention rather than an image or a name.

per diem: A day rate given to a professional by a client to complete an assignment.

pixel: A computer picture element; the individual dots on the display device, arranged in a grid, that comprise the image; the smallest lighted segment on a computer monitor's screen; the smallest segment of color in a digital image file.

plagiarism: The act of stealing and passing off as one's own the ideas or words of another; or to use a created production without crediting the source.

platform: A set of hardware components, operating system, and delivery media that provides specific functions and capabilities for the production or playback of digital programming.

portfolio or artist's book: Reproductions and/or originals that represent the body of an artist's work.

preplanner/checker: One who checks that the animation is in sync and flows correctly (before camera).

presentation boards: Color illustrations of a grouping of styles from the design collection that a manufacturer wishes to feature. Mounted on display boards with fabric swatches, they are used for presentation during market week sales.

print: A photo-mechanical reproduction process such as offset, lithography, collotypes, and letterpress.

printed remarque: A hand-drawn image by the artist that is photo-mechanically reproduced in the margin of a print.

printer's error (PE): A mistake made in the film negatives, platemaking, or printing that is not due to the client's error, addition, or deletion. The costs of these alterations normally are absorbed by the printer or typographer. See also *author's alterations.*

price list: See *sales catalog/line sheets.*

production artist: A professional artist who works with a designer in taking a layout through to mechanicals, pasteups, and often on through the printing process.

production coordinator: One who is responsible for making sure that everything is in order before it goes under the camera.

productivity tools: Software applications used by business professionals such as word processors, databases, and spreadsheets. Usually character-based, allowing users to organize and manipulate text and numbers in various ways.

professional: One who strives for excellence in business and follows fair practices in every professional endeavor.

profit: The difference remaining (i.e., net income) after overhead, expenses, and taxes are subtracted from income received (gross income).

progressive proofs or progs: Proofs of color separation negatives that have been exposed to offset plates and printed using process inks. Presented in the sequence of printing, i.e., (1) yellow plate alone, (2) red alone, (3) yellow and red, (4) blue alone, (5) yellow, red, and blue, (6) black alone and (7) yellow, red, blue, and black. The preferred way for checking the color of the separation negatives using the same inks, paper, ink densities, and color sequence as intended for the production run. See also *color proofs.*

proposal or estimate: A graphic designer's detailed analysis of the cost and components of a project. Used to firm up an agreement before commencing work on a project for a client.

public domain: Works without any copyright encumbrances that may be used freely for any purpose.

punch needle: Refers to both a fine, delicate embroidery technique (fine yarns or threads and fine fabrics and needles) and to heavy rug techniques (using heavy yarns and coarse fabrics and needles) where loops of varying lengths are formed on the surface of the fabric by pushing a handled-needle through the fabric from the wrong side. Fine versions generally are used for decorations in clothing or home accessories; coarse versions for chair cushions, mats, rugs, and wall hangings.

purchase order: A form given by a client to an artist describing the details of an assignment and, when signed by an authorized person, authorizing work to commence.

quilt: A bedcovering that functions as both a blanket and/or a bedspread that consists of two fabric layers, one placed above and the other below a filling layer. The filling can be a nonwoven layer of cotton or polyester batting or a woven layer of cotton or polyester batting or a woven fabric such as flannel. Small hand running stitches, machine stitches, or yarn tufts formed through all layers over the item produce the quilted structure and design. Also the quilted structure can be used as a technique to produce clothing and other decorative or functional items.

Raster system: A computer graphics system that draws shapes pixel by pixel.

readers: Copies with type prepared for the author or client to proofread and mark corrections on. They are nonreproduction quality and their value is only in checking corrections.

ready-made: Refers to clothing or fabric that was purchased in a store or available to the designer at the stage when it could have been purchased at retail.

reel: A film or number of films spliced together.

reference file: File compiled by an illustrator or designer made up of clippings from newspapers, magazines, and other printed pieces that are referred to for ideas and inspiration as well as technical information.

registration marks: marks on the stencil material that help to insure proper alignment of the overlays.

relief: A raised design in various levels above a background.

remarque: A hand-drawn original image by the artist, either in pencil, pen and ink, watercolor, or oil that is sketched in the margin of a limited-edition print.

repeat: The textile design process by which consecutive press impressions may be made to put together imperceptibly so that the textile will appear as one consecutive image and the process run may be continued indefinitely.

representative or rep: A professional agent who promotes specific talent in illustration, photography, or surface design and negotiates contracts for fees and commissions. Usually receives a percentage of the negotiated fee as payment for the services provided to the talent.

reprint rights: The right to print something that has been published elsewhere.

reproduction copy or repro: Proofs printed in the best possible quality for use as camera copy for reproduction. Also *reproduction proof.*

resident buying service: These services purchase fashion illustration depicting available styles and reproduce them on retail ad mats, which are sent to subscribing retail outlets.

residuals: Payments received in addition to the original fee, usually for extended usage of a work. See also *royalty.*

resolution: The absolute number of pixels across and down on a computer display device. This determines the fineness of detail available, much as grain in a photograph.

retoucher A professional artist who alters a photograph to improve or change it for reproduction. Usually working on transparencies or color and black-and-white prints.

reverse applique or cut-through applique: When two or more layers of fabric are handled together, with the upper layer(s) cut away and stitched separately in order to reveal the under layer(s) and thus form a motif.

reversion rights: A book-publishing contract provision that protects the artist in the event the publisher fails to publish within a specific period of time, at which time all rights revert back to the artist.

roughs: Loosely drawn ideas, often done in pencil on tracing paper, by an illustrator or designer. Usually several roughs are sketched out before a comprehensive is developed from them.

royalty: Payments to the artist that are based on a percentage of the revenue generated through the quantity of items sold (e.g., books, cards, calendars). See also *advance on royalties.*

sales catalog/line sheet: Used by apparel manufacturer's sales staff as a hand-out to buyers; a black-and-white illustrated list of all the styles in a collection or line, showing available size, color, pattern, and prices.

sales tax: Each state government establishes the rate of taxation of items sold. It varies between 4 and 8 percent of the amount billed the client, which the freelance graphic artist often is required to be licensed to charge, collect, and remit to the state on a quarterly basis.

search engine: A World Wide Web page that allows Web users to enter their own homepage information and URL in a database; also allows Internet users to search for specific URLs from a database list using the needed homepage information as a search criteria.

second rights: The right to use art that has appeared elsewhere. Frequently applied to use by magazines of art that has appeared previously in a book or another magazine.

serigraphy: A direct printing process used by artists to design, make, and print their own stencils. A serigraph differs from other prints in that its images are created with paint films instead of printing inks.

server: An Internet computer established by ISPs to respond to information requests from other computers on the network.

service mark: A provision of trademark law that identifies and protects the source of services rather than goods, indicated by the letters SM or by <s>.

shareware: Software users may test without initial payment. If use is continued, however, a fee is paid.

shoot (v): In advertising, a day's filming or a day's shooting of still photography.

showroom illustrations: Color illustrations of key styles from an apparel manufacturer's design collection or line, used to heighten showroom atmosphere and

promote showroom sales.

signed and numbered: Each print is signed and consecutively numbered by the artist, in pencil, either in the image areas or in the margin. Edition size is limited.

signed in the plate: The only signature on the artwork is reproduced from the artist's original signature. Not necessarily limited in edition size.

signed only: Usually refers to a print that is signed without consecutive numbers. May not be limited in edition size.

simultaneous rights: The right to publish art at the same time as another publication. Normally used when the two publications have markets that do not overlap.

site: All the Web pages that branch from a homepage.

sizing: The process of marking an original with a percentage or a multiplier for reduction or enlargement on camera.

sketch: Design for textiles not done in repeat. See also *roughs.*

soft furniture: Any furniture that uses only a soft filling such as batting, foam pillows, etc., to form the inner structure.

soft sculpture: A decorative dimensional item formed from fabrics or in one of the many textile structures that is stuffed with a soft filling.

specing: A part of the book design process whereby design specifications or codes are written for the sample manuscript.

speculation: Accepting assignments without any guarantee of payment after work has been completed. Payment upon publication is also speculation.

spine: The area between the front and back book bindings and on which the author, title, and publisher are indicated.

spot: A small drawing or illustration used as an adjunct to other elements in an advertisement, editorial, or book page. Also a television commercial.

stenciling: A method of painting on a surface using a template and a stiff bristle brush with a blunt end.

storyboards: A series of sketches drawn by artists in small scale to a television screen and indicating camera angels, type of shot (e.g., close-up, extreme close-up), backgrounds, etc. Essentially a plan for shooting a commercial for television; often accompanied by announcer's script and actor's lines.

storyboards: Sketches of action for animation. Synonyms: *story* or *story sketches.*

stripping: Involves the positioning and fastening of page and illustration films onto large sheets of paper or plastic the size of the printing plate. Also referred to as *image assembly.*

studio: The place where an artist works. Also an organization offering a complete graphic service. In surface design, an agency representing designs by more than one surface designer.

style: A particular artist's unique form of expression; also referred to as "a look." In surface design referred to as "hand."

stylists: Creative and managerial heads of departments, sometimes referred to as style directors or art buyers.

subsidiary rights: In publishing, those rights not granted to the publisher but which the publisher has the right to sell to third parties, in which case the proceeds are shared with the artist.

surface designer: A professional arist who creates art usually to be used in repeat on surfaces such as fabric, wallpaper, wovens, or ceramics.

syndication: Simultaneous distribution to print or broadcast media by a business concern that sells materials.

tablewear: Functional items that are used at the dining room or kitchen table, such as placemats, napkins, napkin rings, runners, tea cozys, hot pads, table-

cloths, coasters, etc.

talent: A group of artists represented by an agent or gallery.

tear sheet: A sample of a finished work as it was reproduced, usually in print media.

technique: Refers to the particular media used by a graphic artist.

telepad: A preprinted matrix with frames that are usually 2 ¾ x 3 ¾ inches.

textbook: In book publishing, applies to any book that is to be sold through schools and used for educational purposes.

thumbnail or thumbnail sketch: A very small, often sketchy visualization of an illustration or design. Usually several thumbnails are created together to show different approaches to the visual problem being solved.

trade book: In book publishing, applies to any book that is to be sold in bookstores to the general public.

trademark (TM): A work, symbol, design, slogan, or a combination of works and designs, that identifies and distinguishes the goods or services of one party from those of another.

transparency or chrome: A full-color translucent photographic film positive. Color slides also are referred to as transparencies.

triptych: A three-panel art piece, often of religious significance.

typography: The style, arrangement, or appearance of typeset matter.

underglaze: A decoration that is applied before the final glazing and firing of an item. Most often, such decorations are painted by hand.

union: A group of people in the same profession working together to monitor and upgrade the business standards in their industry.

URL (Uniform Resource Locator): An address for a file or location on the Internet.

utilities: Programs designed to improve or enhance the user's ability to use system software.

vector system: A computer graphics system that draws shapes in line segments rather than pixel by pixel. Many high-resolution drawings or presentation programs operate on vector systems.

virtual reality (VR): Refers to the use of computer hardware (visual displays, and tracking and mobility devices) in conjunction with special software programs to produce an experience that immerses the user in a highly interactive environment.

weaving: A method of interlacing yarns or any stringy material in both a lengthwise and crosswise manner simultaneously. A traditional loom generally is used to control the interlacing technique, but other devices may also be used.

whole-body garments: Any one-piece garment worn from the neck and stopping anywhere below mid-thigh, such as dresses, coats, capes, etc.

workbook: In book publishing, applies to any book accompanying a textbook, usually in the elementary school level, for students to complete exercises by following written and pictorial instructions.

work-for-hire: For copyright purposes, "work-for-hire" or similar expressions such as "done-for-hire" or "for-hire" signify that the commissioning party is the owner of the copyright in the artwork as if the commissioning party has, in fact, been the artist.

World Wide Web: A part of the Internet made up of the collective Websites that are often linked to various other sites to create a "web" of information.

wraparound: A book jacket design and/or illustration that encompasses front and back covers including book flaps, if appropriate.

Some of the definitions included here were reprinted from Collectibles Market Guide and Price Index with permission of The Collector's Information Bureau. © 1995 Collector's Information Bureau

Index

• • • • • • • • • • • • •

Electronic retouching, 191
Electronic scanning, 191
Electronic typesetting, 48
Email, 52, 59, 202
Embroidery, 299, 301-302
Employee, 7, 9, 20-22, 28, 29, 37-40,
42-43, 49, 54, 59-60, 66, 67-68,
69, 97, 102-106, 114, 119-120,
123, 131-132, 136, 141-142, 147-
150, 153, 156-157, 159, 163, 166,
190, 212, 217-218, 222, 241, 246,
249, 251, 253, 255, 257, 266, 269,
274, 281, 296, 297, 299, 300
 grievance procedures, 103
Employee publications, 123, 150, 157
Employer, 21, 28, 37-40, 54, 59-60,
102-104, 106, 113, 222, 225, 291
Employment, 3, 7, 20-22, 28, 37-39,
59-61, 69, 97, 103-104, 119, 171,
217, 224, 242, 272, 285, 292, 299
 agencies, 7, 59
 services, 3
Encryption, 57
End sales, 33, 77
Endpapers, 157
Engineered design, 299
Entertainment/character, 94
Entrepreneurs, 24, 41, 55, 162, 197,
231
Envelope addressing, 185, 188
Envelopes, 160, 185, 188
Environmental graphic design, 170-172
Environmental graphic designers, 34,
170-172, 296
Equal opportunity employment laws, 7
Equipment, 34, 36-37, 39, 51, 53-54,
60-61, 67-69, 94, 105, 119, 147,
208, 216, 221, 300
 rental, 69
Equity, 8, 13, 104, 144, 286, 289
Ergonomics, 59
Escalation, 127-128
Esquire magazine, 24
Estate, 17, 25, 28, 151, 170, 197
Estimate, 48, 53, 56, 67-68, 75, 90,
114, 120, 124, 131-132, 136, 141-
142, 147-148, 151, 153, 155-156,
163, 184, 199, 201, 237, 241, 246,
248, 250-251, 254-255, 265, 273,
280, 298, 302
Estimate and confirmation form, 237,
250, 254, 273
Ethical issues, 46, 49, 54
 professional practices, 3
 standards, 7
European Community (EC), 20
European stamp programs, 160
Exclusive, 4-5, 9, 12, 14, 18, 20, 27,
54, 65, 89-90, 97, 100, 144, 184,
240, 242, 250, 252, 268, 287
Exclusive grant, 100
Exclusive unlimited rights, 4
Exclusivity, 4-5, 54, 56, 65, 93, 97,
100, 205, 268
Exemption, 13, 33, 35-36, 286
Exempt-use certificate, 35
Exhibit design, 171-172
Exhibits, 35, 115, 144, 146-147, 150,
154, 172, 292
Expenses, 3, 5-6, 8, 38-41, 52-53, 59,
67, 69-70, 73, 75-77, 79, 83-84,
87, 90, 97-98, 100, 114, 120, 122,
124, 131-132, 136, 140-142, 145-
149, 153, 155-156, 158, 163-168,
170-182, 184, 186, 188-189, 192,
198, 200, 204, 206-207, 221, 230,
232-233, 238-242, 246, 248-257,
261, 265-266, 268, 270-271, 274,
277, 280-281, 297, 301
 estimates, 76, 168
 indirect, 198
 reimbursable, 77, 79, 165-166,
 172, 239

Expiration of the license, 100, 229
Exploratory work, 8
Extended rights, 47-48

F
• • • • • •
Fabricator, 173
Fair dealing provision, 29
Fair practices, 13, 25-26, 286, 301
Fair use, 18, 28, 70
Families, 185-186
Family Circle, 133
Federal district court, 87
Federal identification number, 77
Federal preemption, 24-25
Fee-for-use, 67
Fees, 3-4, 6-7, 13-15, 19, 24-25, 27,
35, 40-43, 47, 53, 55-56, 58, 65,
68-70, 73, 76-78, 83-84, 89-94,
96-98, 103, 113-143, 145-153,
155-160, 163-192, 198-207, 211-
215, 217-218, 224, 230-234, 237-
239, 241-242, 246-249, 251, 253,
255, 257, 259, 261, 264-266, 270-
271, 274, 276, 278-281, 285, 289,
291-292, 298, 302
 for editorial assignments, 133
 for services, 156
FICA, 38-40
Figurines, 94, 96
File maintenance, 51
File ownership, 48
Film festivals, 220
Film output, 50-51, 172
Film preproduction, 121
Finder's fee, 6, 91
Fine art, 19, 24, 171
Finish, 3, 67, 119, 187, 189, 216, 254,
299
First issue, 96, 299
First North American serial rights, 299
First reproduction rights, 65, 122, 131-
132, 136, 138, 141, 145, 147, 149,
153, 159, 212
First rights, 154, 299
Flat fee, 6, 38, 56, 65, 83-84, 97, 100,
125-126, 140, 143-144, 148, 158,
163, 178, 184, 186, 215, 242, 271,
289
Floor covering, 299
Flyers, 66, 83, 117
Folio, 68, 133, 295
Font programs, 217
Fonts, 47-48, 53-54, 93, 170, 185-186,
193, 217, 300
Forbes, 116, 133-134, 174, 214
Foreign piracy, 24
Foreign works, 24
Forrester Research, 196
Fortune double-500 company, 300
Foundry casting, 155
Free services, 8-9, 41, 231
Freelance artists, 3, 6, 13, 18, 22, 36-
38, 103, 113, 162-163, 172, 180,
197, 199, 203, 217, 286, 288, 299-
300
 illustration and design, 142
 as employee, 69
Freelancing, 97, 102, 105, 224
Freestanding inserts, 3
Fringe benefits, 38, 103, 105, 211
Fugitive, 120, 300
Full-time freelancers, 38, 69, 103
Full-time workers, 103
Future Features Syndicate, 214

G
• • • • • •
Gag cartoons, 210
Gallery, 13, 79, 99, 148, 297-298, 303
Gallery artists, 13, 79
Game boards, 143
Game developer, 197

General apprentice, 300
Generic works, 71, 300
Genre paperback covers, 124
Gift cards, 143
Gift or boutique-type items, 177, 301
Gift wrap, 143, 158, 178
Gifts/novelties, 94-95, 137, 175
Giftware, 66, 97, 141, 228
Giftwrap, 94, 231
Global marketplace, 20, 284
Global terms and conditions, 165
Gordon, Elliott and Barbara, 294
Gothics, 125
Government works, 29
Grant of rights, 14, 18, 35, 55-56, 65-
66, 97, 127, 155, 255, 257, 263,
269
Graphic Artists Guild, 5, 7, 10, 13, 19-
21, 23-24, 26, 34, 37-38, 40-41,
43-44, 58, 64, 72, 80, 82-83, 88,
92-94, 97, 103-106, 114-115, 120,
123-124, 127, 131-132, 136, 141-
142, 147-149, 151, 153, 156, 159,
164, 166, 171, 190, 197, 212, 217-
218, 228-229, 231, 239, 268, 271,
284-292, 294
 Foundation, 41, 44, 171, 286-
287, 290-291
 Seal of Compliance, 44
 Grievance Committee, 7, 79-80,
82-83
*Graphic Artists Guild Directory of
Illustration*, 5, 7, 288, 290, 294
Graphic design field, 68
Graphics standards manual, 169
Greeting Card Association, 296
Greeting cards, 33, 66, 88, 92, 94, 99,
113, 141-143, 144, 158, 159, 163,
177-178, 206, 210, 231, 296
Greige goods, 228, 299-300
Grievances, 10, 71, 82, 288-289
Gross national product, 20, 113
Group head, 300
Guild of Natural Science Illustrators,
296
Gutter, 182, 300

H
• • • • • •
Hackers, 57
Half-body garments, 300
Handbags, 94
Handling fees, 182
Hang tag/labels, 140
Hanna-Barbera, 222
Hard furniture, 300
Hardware, 46, 48-49, 51-53, 59, 69,
104, 151, 192-193, 196, 208, 300-
301, 303
Harris, Lesley Ellen, 29
Headhunters, 7
Health illustrations, 144
Health issues, 58-59
Hecker, Joel L., 78
Holding forms, 70, 233, 237, 268, 270-
271, 275
Holding work, 233
Holiday decorations, 177
Home decorative, 158, 231-232
Home office, 61, 119, 211
Home workers, 61
Hot type, 46
Hotel signage, 170
Hourly rate, 48, 52, 67-69, 146, 151,
164-165, 168, 173, 182, 198-199,
207
 formula, 67, 198
Hours of work, 39, 60, 67
House accounts, 5-6, 242-243
House list, 96